*Praise for*

# LEE KRASNER: A BIOGRAPHY

## A *Wall Street Journal* Best Art Book of the Year

"Ms. Levin's perceptive, judicious book reveals Krasner as a fine, important painter. . . . This is an insightful, sharply drawn portrait of twentieth-century America from the vantage point of a creative woman swept up in a realm of remarkable artistic productivity." —*Wall Street Journal*

"Art historian Gail Levin's *Lee Krasner* is a quintuple whammy of a biography—the story of a major artist; a description of a notorious marriage; an education in twentieth-century art; a gossipy immersion into bohemian New York; and a settling of scores against those who practiced gender bias." —*O, The Oprah* magazine

"Compelling. Art historian Gail Levin has drawn on her close association with Lee Krasner and extensive research to produce a biography that rings fair and true." —*Los Angeles Times*

"Gail Levin has taken on the formidable task of rescuing Lee Krasner from personal misrepresentation and artistic erasure by describing the life of the woman and the career of the artist. She has succeeded masterfully in this dual purpose. Levin . . . is an ideal biographer for her subject . . . measured, thoughtful, succinct." —*Boston Globe*

"It's about time someone set the record straight about artist Lee Krasner. . . . Absorbing . . . succinct . . . invaluable. . . . A compelling biography that is as important an addition to the library of American art as any book on Pollock." —*Chicago Sun-Times*

"Detailed and meticulously researched . . . essential reading." —*Library Journal*

"For the love of art. . . . Art historian Gail Levin frames the extremely colorful life of Lee Krasner, major ass-kicking Abstract Expressionist and formidable genius in her own right, better known for boosting the career of her splashier-than-life husband, Jackson Pollock." —*Vanity Fair*

"Art historian Levin befriended Krasner, starting when she was a grad student who interviewed the artist, and she gives Krasner a well-deserved full-fledged bio." —*New York Post* (Required Reading)

"Gail Levin's stunning new biography finally proves Krasner's relationship with Jackson Pollock was only a sliver of an enormously colorful life. . . . Levin's biography ensures that Lee Krasner will never again be known merely as 'Mrs. Jackson Pollock.'"
—*Minneapolis Star-Tribune*

"Gail Levin's biography of Lee Krasner beautifully evokes a period in American art that laid the groundwork for the women artists of today. Lee, who was my mother's close friend in art school (the National Academy of Design), not only contributed wonderful work but also encouraged a whole new generation of artists. She grew into true generativity. Bless her and her biographer!"                    —Erica Jong

"Thorough. . . . A biography worth celebrating."                    —*East Hampton Star*

"Beautifully written and engaging, Gail Levin offers a unique perspective on a colorful, often overlooked figure in American art."                    —*Charleston Post and Courier*

"Biographer Gail Levin sets the record straight: Krasner was a fierce, fascinating, and gifted artist. . . . Lee Krasner adds more luster, meticulously tracing the artist's life."
—*Cleveland Plain Dealer*

"For far too long, the artist Lee Krasner's reputation has been overshadowed by that of her renowned husband, artist Jackson Pollock. This lively, well-researched biography by Levin finally corrects that injustice. Writing with a novelist's flair for characterization and scene-setting, the author traces Krasner's life through the miseries of the Great Depression to the world of art and leftist politics of New York in the '30s and '40s."                    —*Publishers Weekly*

"Written with unassuming grace. This rigorously researched, straightforward account attempts to set the record straight about Krasner. . . . The artist could not have found a more gifted biographer to retell her story and argue her case. . . . [A] fascinating and absorbing biography."                    —*Jewish Daily Forward*

"Meticulous Gail Levin celebrates Krasner's accomplishments as an artist, distinct from her famous husband. The book . . . gives voice to the indomitable but not invulnerable force of nature that was Lee Krasner. . . . Energetic, stubborn, seductive . . . Krasner comes memorably alive."                    —*Dan's Papers* (Hamptons)

"At Gail Levin's bidding, the armor-plated Widow Pollock steps aside to reveal the complicated, gifted, vulnerable, and fascinating woman behind the legend. Rigorous research, deep knowledge of art and cultural history, penetrating analysis, and a flair for storytelling bring to life a fully formed Lee Krasner. Those who never knew her will wish they had, and those who did will be amazed."
—Helen A. Harrison, director of the Pollock-Krasner
House and Study Center

"A compelling portrait of Lee Krasner's magnificent obsession. . . . A whirlwind of non-stop action, emotion, and gritty integrity. . . . The portrait Levin paints of Krasner is a full-bodied treatment. . . . Levin's detailed portrait . . . frames Krasner in such a way that it's difficult to ever feel anything but great empathy for this woman who aspired to find the great, elusive sublime in her life and work."　　　　　　　　　—*Buffalo News*

"Levin . . . is now the first to tell Krasner's captivating story, writing with equal insight into her temperament, experiences, and art. . . . A consummate scholar, marvelously lucid writer, and gracefully responsible biographer, Levin redresses glaring omissions in the history of abstract art in this imperative portrait of a formidable artist."
　　　　　　　　　—*Booklist* (starred review)

"Levin deftly connects Krasner's biography to the social and political upheaval of the time. Her long experience in the art world gives insight into the landscape of twentieth-century artists, art dealers, and museums."　　　　　　　　　—*Kirkus Reviews*

"In *Lee Krasner: A Biography*, Gail Levin presents Krasner as a smart, dynamic, and sexy woman focused on making art while experiencing the life of a New York artist during the exciting years of the mid-twentieth century. Scrupulously researched, Levin's gripping biography seamlessly weaves together the voices of Krasner herself and of other artists and critics. . . . A compelling read."
　　　　　　　　　—Patricia Hills, author of *Modern Art in the USA:*
　　　　　　　　　*Issues and Controversies of the 20th Century*,
　　　　　　　　　Boston University

"Gail Levin provides a new perspective on Krasner's art and life. . . . She describes Krasner's evolution with precision and without simplifying the many turns it took. Painting a picture of the chaotic, contentious, and unquestionably male-dominated art work of New York in the mid-twentieth century, the biography both sets Krasner in that context and reveals how she rebelled against it."　　　　　　　　　—*Columbus Dispatch*

## ALSO BY GAIL LEVIN

*Becoming Judy Chicago: A Biography of the Artist*

*Ethics and Visual Arts* (coeditor and contributor)

*Aaron Copland's America* (coauthor)

*Edward Hopper: An Intimate Biography*

*Edward Hopper: A Catalogue Raisonné*

*Silent Places: A Tribute to Edward Hopper* (editor)

*The Poetry of Solitude: A Tribute to Edward Hopper* (editor)

*Theme and Improvisation: Kandinsky and the American Avant-Garde, 1912–1950* (principal coauthor)

*Marsden Hartley in Bavaria*

*Twentieth-Century American Painting: The Thyssen-Bornemisza Collection*

*Hopper's Places*

*Edward Hopper*

*Edward Hopper: The Art and the Artist*

*Edward Hopper as Illustrator*

*Edward Hopper: The Complete Prints*

*Abstract Expressionism: The Formative Years* (coauthor)

*Synchromism and American Color Abstraction, 1910–1925*

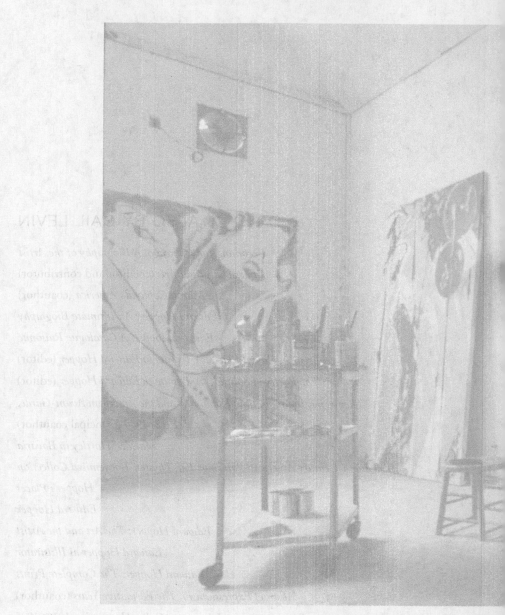

# GAIL LEVIN

# LEE KRASNER

## a biography

WILLIAM MORROW
*An Imprint of* HarperCollins*Publishers*

*For John*

Various family photographs throughout the text and in the photograph insert are courtesy of members of Lee Krasner's family.

Unless otherwise noted, the paintings by Lee Krasner that appear in the color photograph insert are copyright of the Pollock-Krasner Foundation and are courtesy of the Artists Rights Society (ARS), New York.

Grateful acknowledgment is made to Mark Patiky for the photograph on the title-page spread.

A hardcover edition of this book was published in 2011 by William Morrow, an imprint of HarperCollins Publishers.

LEE KRASNER. Copyright © 2011 by Gail Levin. All rights reserved. Printed in the United States of America. No part of this book may be used or reproduced in any manner whatsoever without written permission except in the case of brief quotations embodied in critical articles and reviews. For information, address HarperCollins Publishers, 195 Broadway, New York, NY 10007.

HarperCollins books may be purchased for educational, business, or sales promotional use. For information, please e-mail the Special Markets Department at SPsales@harpercollins.com.

FIRST WILLIAM MORROW PAPERBACK PUBLISHED 2012.

*Designed by Jamie Lynn Kerner*

The Library of Congress has catalogued the hardcover edition as follows:

Levin, Gail
   Lee Krasner : A biography / Gail Levin.
      pages cm
      ISBN 978-0-06-184525-3
1. Krasner, Lee, 1908–1984.   2. Painters—United States—Biography.
3. Painters' spouses—United States—Biography.   I. Title.
   ND237.K677L48   2011
   759.13—dc22
   [B]
                                                                 2010046347

ISBN 978-0-06-184527-7 (pbk.)

HB 11.03.2023

*You are not a woman. You may try—but you can never imagine what it is to have a man's force of genius in you, and yet to suffer the slavery of being a girl. To have a pattern cut out—this is the Jewish woman; this is what you must be; this is what you are wanted for; a woman's heart must be of such a size and no larger, else it must be pressed small, like Chinese feet . . .*

GEORGE ELIOT, *Daniel Deronda,* 1876

*You are not a woman. You may say that—but you can never imagine what it is to have a man's force of genius in you, and yet to suffer the slavery of being a girl. To have a pattern cut out—"this is the Jewish woman; this is what you must be; this is what you are wanted for; a woman's heart must be of such a size and no larger, else it must be pressed small, like Chinese feet..."*

Gwendolen Harleth, *Daniel Deronda*, 1876

# CONTENTS

# LEE KRASNER

LEE KRASNER

# Introduction

THE NAME LEE KRASNER HAS BECOME EVER MORE WIDELY known since Marcia Gay Harden won a Best Supporting Actress Oscar for her role in *Pollock* (2000), directed by Ed Harris, who played the title role. Harden portrayed Krasner's part as painter-wife to the gifted and troubled Jackson. Inaccuracy about Krasner's life, already endemic in the film, was aggravated in 2002, when John Updike claimed that Krasner had inspired the main character in his novel *Seek My Face*. Several other novels have expressly depicted Krasner or referred to her by name, so that her growing recognition owes more to fiction than to fact.

Who was the real Lee Krasner? To her friend and neighbor, Patsy Southgate, "she was a brilliant verbatim storyteller and raconteuse—dramatic pauses, perfect people imitations. . . . She could be caustic, abrasive, combative."[1] Krasner's talent and her charisma made her "just a phenomenon," recalled Lillian Olinsey Kiesler, who first met her about 1937, when both were students at the Hofmann School of Art; she was "unique."[2]

In the eyes of her nieces and nephews Krasner was inspiring, tender, and generous. Ronald Stein, her sister Ruth's son, referred to his Aunt Lee as "my alter-mother," telling how she "always put me to work drawing" and inspired him to become an artist.[3]

"They couldn't keep her down," said niece Rena Glickman, for whom Krasner served as a role model. Glickman reinvented herself as "Rusty Kanokogi," the renowned judo expert from Brooklyn.[4] "Lee was the first person who ever gave me credit for all I had come up through, all I had fought against," Kanokogi said. "She reinforced me."[5] To her mind, Aunt Lee was "honest, forthright. She would tell it the way it was."

Krasner's "honesty" also struck her close friend, the playwright Edward Albee, who called it "a no-nonsense thing."[6] Her "wit could be acid; she detested stupidity; and she never believed it was unwomanly to be intelligent," according to another friend, the art dealer and critic John Bernard Myers.[7] "Lee was unbelievably intelligent," said her close friend the art dealer and author Eugene V. Thaw.[8] The critic Clement Greenberg even admitted that he feared Krasner because she was so brilliant and had such a strong character.[9]

To a questionnaire that asked "What was the greatest sacrifice you have made for your art?" she replied, "I sacrificed nothing."[10] In 1977 she told interviewer Gaby Rodgers, "I am a strong character."[11] When asked if she would do anything otherwise if she had to do it all again, Krasner replied, "I doubt it. I am awfully stubborn. Somehow I would have made the same choices and decisions."[12]

Outspoken as she was, Krasner liked oral history. She readily gave—over more than three decades—interviews to journalists, critics, and art historians. The talks she gave before student audiences remain among the most important sources about her life. Beyond the oral records, Krasner left few hints about her work's meaning. She wrote very little—no essays, no regular journals— and her surviving letters are very scant. Other than her art, most of what she left behind consists of photographs, exhibition records, clippings from many publications, and her business and personal correspondence. She did record some notes and fragments of dreams—most probably to share with her therapist. Most of these offer little evidence of her conscious thoughts or activities.

"I was in on the formation of what all the history books now write about the abstract expressionists. I was in the WPA, part of the New York School, I knew Gorky, Hofmann, de Kooning, Clement Greenberg before Jackson did and in fact I introduced him to them. But there's never any mention of me in those history books, like I was never there," protested Krasner in 1973.[13] The lack of attention provoked Krasner to aver, "And being dogmatically independent, I stepped on a lot of toes. Human beings being what they are, one way to deal with that is denying me artistic recognition."[14]

Today Krasner's protest might be even more vehement, since artistic erasure has been compounded by personal misrepresentation and caricature—both inadvertent and willed. Gossip has crowded out the facts that are available, and Krasner's life has been picked over for tidbits to serve other agendas—from playing second fiddle in Jackson Pollock's very sensational life to bending aspects of her life to feminist stereotypes that do not fit. In reality, well before she met Pollock, Krasner had established herself as an artist and had won the respect of her peers; then, after scarcely fourteen years with him, she continued for nearly three decades to create and show her art.

Current interest in abstract expressionism, the New York School, or "action painting" is intense. This is true not only in the United States, but also in Europe, Australia, and Japan. Whereas Krasner would have been overlooked before, she is now routinely featured in major shows focusing on modernism or, more specifically, on "action painting."

"No one today could persist in calling hers a peripheral talent," wrote art critic Robert Hughes, praising her "harsh improvising search for form based on a highly critical grasp of the culture of modernism." He dubbed Krasner "the Mother Courage of Abstract Expressionism."[15]

Krasner has gained a certain recognition in death that she only dreamed about while living. Recent prices at public auction for

her work have made clear that museums and the public consider Krasner a major artist. On November 11, 2003, *Celebration,* a large painting from 1960 by Krasner, sold to the Cleveland Museum of Art for $1,911,500, setting a new auction record. By May 14, 2008, Krasner's prices had set yet another new record, when her painting *Polar Stampede* sold at Sotheby's for $3,177,000. Historically, prices for art by women have failed to match those for work by male artists, yet very few women artists command prices as high as these.

By now Krasner's work appears in the most prominent American public collections: the Museum of Modern Art, the Metropolitan Museum of Art, the Brooklyn Museum, the National Gallery, the Art Institute of Chicago, the Dallas Art Museum, and the Los Angeles County Museum—as well as in many others. Some of her pictures are also in major public collections in Europe, such as the Tate Modern in London, the Kunstmuseum in Bern, the Instituto Valenciano de Arte Moderna in Valencia, and the Museum Ludwig in Cologne, as well as in Australia at both the National Gallery of Victoria and the National Gallery of Australia in Canberra.

I FIRST MET LEE KRASNER AT THE MARLBOROUGH GALLERY ON FEBRUary 6, 1971, when I was twenty-two years old.[16] As a second-year graduate student at Rutgers I had just completed a seminar on abstract expressionism that featured Jackson Pollock. Having decided to investigate Pollock's debt to the art and ideas of Wassily Kandinsky, I decided to interview Krasner.

Although a colleague recently questioned how I could have taken such initiative at such a young age, contacting Krasner did not seem unusual to me at the time. Much less known than she is today, she was sixty-two when I met her, and she reminded me of my grandmother.

Both Lee and my grandmother had grown up with hardwork-

ing, long-suffering, Yiddish-speaking mothers who fled the Russian empire with their impoverished families. They emigrated from small towns in the same region of the Ukraine, and joined their religious husbands, who had preceded them to America. Both Lee and my grandmother grew plump in late middle age.

I never considered Lee ugly, as several of her contemporaries and some writers have emphasized since her death. Some of their emphasis may stem from anger felt by jealous artists, aggrieved friends, rejected biographers, and those who are unable to comprehend that some people make up in charisma and spirit what they lack in features that fit our stereotypes of classic beauty. Rather than being preoccupied by her looks or lack thereof, I was fascinated by her wit, her humor, and her ability to make history come alive.

Krasner agreed to see me and arranged for us to meet in New York at the Marlborough Gallery, which then represented both her work and the Pollock estate. I arrived a bit early and was welcomed by the director, Donald McKinney. He led me to a table, handed me a catalogue, and said, "Here, you'd better read this. She's an artist too." It was the catalogue for Krasner's first retrospective ever, organized by Bryan Robertson in 1965 at the Whitechapel Gallery in London.

Despite receiving positive critical reception in London, Krasner had not been included in the course I was taking, which was taught by a young male professor. Nor did her work appear in Irving Sandler's new book on abstract expressionism, which had just been published. Hardly surprising. At the time, I was teaching an introductory survey of art history at Rutgers, using the classic textbook, *A History of Art* by H. W. Janson, which, like Sandler's new book, contained no women artists.

In 1971 Krasner was being ignored by most critics as an early innovator of abstract expressionism, although she was beginning to attract the attention of women art historians, artists, and critics, who, affected by Second Wave feminism, were searching for im-

portant women artists and role models. The history of women artists had not yet caught my interest. Such a topic would have been unacceptable to my professors, almost all of whom were male.

I asked Krasner if Pollock had saved any books or exhibition catalogues related to Kandinsky. I also wanted to know whether there were any catalogues from the Museum of Non-Objective Painting in New York, where he had briefly worked in 1943. Its director, the Baroness Hilla Rebay, had exhibited many pictures by Kandinsky. Pollock had supposedly worked on the frames.

Krasner said that she did not recall what was in their library, but I was welcome to come out to visit her on Long Island the next summer to have a look for myself. At no time did Krasner try to inject her own art into my investigation of Pollock. In fact she had considered Kandinsky's art during the late 1930s and early 1940s, but she gave no indication that her interest in Kandinsky's work began before she got together with Pollock. I didn't press her on this at the time but discovered this years later.

In the intervening time, I went to Venice to interview Peggy Guggenheim, Pollock's former dealer when she had her New York gallery, Art of This Century. Though I shared my plans with Krasner, who had not gotten along with Guggenheim, she made no protest. When I returned from Europe, I took Krasner up on her offer and called her in East Hampton. I spent several days that August researching the books in the library of her old farmhouse, where she let me stay in her upstairs guest room.

Though focused on learning more about Pollock, I was very interested in the paintings hanging in Krasner's house. These included her early self-portraits from the time of her study at the National Academy of Design. I was fascinated to see that she had begun with such traditional figurative work. Her painting of a nude in the bath, reminiscent of Matisse, also recalled the old claw-footed bathtub in her bathroom, near which it hung. I was struck by the quality of her output, and I began to question why she had been left out of art histories from the period. This could have been

her motivation in inviting me to visit, since much later I learned that she already had an inventory of the books I went to see.

By 1976 I was working as a curator at the Whitney Museum of American Art. I had the opportunity to collaborate with Robert Hobbs on a show that would be called "Abstract Expressionism: The Formative Years." I was eager to see Krasner in the show along with her male colleagues. When we divided up the artists, I chose to write about both Krasner and Pollock (among others) in the catalogue. I called Krasner and arranged for Hobbs and me to interview her and discuss loans for the show we were planning.

Our visit was supposed to be over two days, August 27 and 28, 1977; but the critic Barbara Rose, who was making a film, *Lee Krasner: The Long View,* telephoned Krasner, and Rose decided that she and her crew could film us interviewing the artist if we stayed another day. Eventually Rose included many of Krasner's responses to our (unacknowledged) questions and a brief clip of me interviewing Krasner.

I encouraged Krasner to let us include in the show some works on paper that she had produced while still at the Hofmann School during the late 1930s. "Why that student work?" she wanted to know. I explained that it would document her interest in abstraction long before she was with Pollock: "Trust me, it's important." So she let us select whatever we wanted of both hers and Pollock's, including works that were still in her own collection. In addition to her abstract Little Image canvases from the second half of the 1940s, I added works on paper that were inspired by still life set-ups from the Hofmann School. Painted in brightly colored hues with the edges of objects no longer readable as representational, the works looked abstract. They reflected School of Paris modernism and made clear that Krasner's ability and sophistication as an abstract artist predated her contact with Pollock.

When our show opened, critics finally began to see that Krasner had been a significant artist before getting together with Pollock. They praised her work and, for the first time, declared that Kras-

ner was indeed a "first-generation abstract expressionist." Krasner enjoyed the belated recognition and basked in all the praise. The show traveled to a museum in Tokyo, which I visited. I came back with the catalogue, Japanese art journals, and the photographs I had taken of women in kimonos looking at Krasner's paintings, and this seemed to please her.

Krasner appreciated my intervention on her behalf, which, I believe, created a bond between us. After the show opened, I visited her in Springs (in East Hampton, New York) on many occasions, sometimes spending up to a week or two at a time. Krasner often cooked for me when I visited. She taught me how to make her pesto sauce (with fresh basil ground together with pignoli and olive oil), which she served slathered over broiled bluefish, an inexpensive fish very commonly caught in local waters.

I came to consider Krasner both as my mentor in the art world and as an older professional woman who had acquired experience and wisdom. She knew so many people and so much about how things worked in history and in the world at that time. Because I lived just a few blocks away from her apartment on East Seventy-ninth Street, we often got together for dinner in New York. Sometimes it was at her place, sometimes at mine. Often I invited friends who were artists so that they could meet her, and she seemed to enjoy that.

Krasner often introduced me to her friends, some of whom just happened to drop by while I was visiting. I recall meeting artists such as Jimmy Ernst or John Little (and his wife Josephine) in the Springs house. In Krasner's New York apartment, I recall meeting the designer Ray Kaiser "Buddha" Eames, who, like Little, had been a friend of Krasner's since their time at the Hofmann School. Lee had her studio in what had been the master bedroom of her apartment. She put up her guests in what was once the maid's room off the kitchen. Lee once introduced me to Bryan Robertson, visiting from London, where he had organized that first ret-

rospective. His essay was in the catalogue that had first introduced me to her art.

During our talks I made it clear that I was curious about Krasner's family's attitude toward her going to art school and becoming an artist. My family had threatened to disown me if I pursued my dream of becoming a painter. She was clear that her family had left her alone and did not care what she did, as long as she never asked anything of them. I admired her independence and her courage.

I never thought of recording our personal conversations, which often covered subjects that Krasner's interviewers never touched. For example, because it was often on my mind in those years (my early thirties), we discussed why certain women would or would not have children. Krasner insisted to me that having a baby with Pollock would have been completely out of the question because he was so needy and demanded so much attention. In effect he took the place of a child in her life. Contrary to the reports of others who interviewed her, she also spoke freely of her earlier relationship with Igor Pantuhoff, her lover before Pollock. She referred to their liaison as "a togetherness," but I understood that having a child during the Depression was out of the question because their own survival often seemed so precarious. She intimated that the anti-Semitism of Pantuhoff's family obstructed their relationship, and I now conclude that it kept her from marrying him.

Krasner and I often talked about anti-Semitism, which both of us had experienced not only in our childhoods but also in the art world. We had both refused to sing the obligatory Christmas carols in school. I sought her counsel about how to cope with blatantly anti-Semitic comments made in my presence at work.

In mid-October 1979, I saw Krasner when I traveled to speak in a symposium called "Abstract Expressionism: Idea and Symbol," at the University of Virginia. The event was organized by Elizabeth Langhorne, then an assistant professor of art history

there, who had written a dissertation offering a Jungian reading of Pollock's early imagery. Krasner attended this symposium, where Barbara Rose and Ellen Landau delivered papers about Krasner. At the request of Richard Pousette-Dart, another lesser-known artist (who had also been included in our abstract expressionism show), I gave a paper on his work entitled "Richard Pousette-Dart's Painting and Sculpture: Form, Poetry, and Significance."

During these years, Krasner wanted me to write about her. She decided that I should present a paper on her work in a symposium at New York University on December 5, 1981, coinciding with Barbara Rose's show at the Grey Art Gallery called "Krasner/ Pollock: A Working Relationship." Lee supplied me with lots of documentation (photocopies of articles annotated in her hand-writing), old photographs of her, and slides of her art. I agreed to speak, and she came to hear me.

Lee was quite enthusiastic and told a number of my colleagues that they should encourage me to publish my paper. Perhaps because I intuited that I should not interfere with Rose's work (she eventually curated Krasner's first American retrospective), I never published that paper.

I never forgot the impact Krasner had on my life. In 1989, five years after her death, I purchased a home in Springs, not far from Krasner and Pollock's house, where I had had my most extensive visits with her. In fact, for me, she seemed to embody that distant part of Long Island.

Before I bought my house, I had collected many souvenirs during my travels to distant places, including a collection of exotic sea-shells. When I moved into my new home, I decided to use them decoratively, placing the shells on a shelf in the bedroom. It just seemed natural.

It wasn't until I visited the newly opened Pollock-Krasner House and Study Center in 1991 that I rediscovered that Lee had kept shells on shelves in her bedroom. On some subconscious level, these shells had come to define for me how a house in Springs

ought to look. Knowing Krasner enriched my life. She had deeply affected me, and the shells were just one small clue to the many dimensions of her influence upon me.

As to the meaning of Krasner's art, she insisted, "I think my painting is so autobiographical if anyone can take the trouble to read it."[17] She allowed this remark to survive in her careful edit of an interview for publication, so we can assume that she wanted us to believe what she said. A few years later, she said, "I suppose everything is autobiographical in that sense, all experience is, but that doesn't mean it's naturalistic reading necessarily. I am sure that all events affect one—at least that's the way I feel about it— but I don't think it means using a camera and snapping events."[18]

The personal content of Krasner's art becomes even more apparent in a comment she made to John Bernard Myers that her early self-portraits "make it clear that my 'subject matter' would be myself."[19] She went on to explain: "The 'what' would be truths contained in my own body, an organism as much a part of nature and reality as plants, animals, the sea, or the stones beneath us. The words 'subject matter,' let me quickly say, are a useful verbal ploy for discussion. There is no separation between style, or forms, and so-called 'subject matter.'"[20]

When one interviewer mentioned Surrealism and "Jungian qualities" in art before pressing her about the psychological content in her work, Krasner snapped, "All work has psychological content."[21] However, to another interviewer, she did specify that "in terms of psychological content, my work . . . is riddled with it. The reading of it is another kind of thing."[22]

Implicit in Krasner's words is the suggestion that interpreting her work is difficult. Furthermore the context in which she made her art has been obscured up to the present by the huge gaps in knowledge about her life. Even the chronology in the catalogue raisonné of her work has serious errors and omissions.[23] Problems in understanding Krasner and her art have been compounded too by distortions—some inadvertent but too many willful, motivated

by contentious agendas and special interests. Krasner was also aware of the reevaluation of her place within abstract expressionism: "I think the process of re-interpretation will continue and that many things will now be re-evaluated. I'm sharply aware of my own re-evaluation."[24]

While most of Krasner's art is abstract and not easy to interpret, her early self-portraits, representational works, abstract pictures clearly titled by her, and later works with fragmented figurative imagery present less of a problem for interpretation. Even among her abstract pictures, entire series of paintings stand out for their distinctive palette, forms, or materials. Krasner's habit of creating collages from her own earlier work or from scraps of Pollock's discards also offers clues to the complex interaction of her life and work.

A purpose then of the present book is not only to tell Krasner's story but also to rectify mistakes of fact, some of which I chronicle in A Note About Sources. I also hope that I have filled in gaps by means of more thorough research, and have moved away from distorting agendas and theoretical fantasies, the better to cast light on the remarkable evolution by which Lena Krassner,* a daughter of immigrants, became Lee Krasner, an artist of still growing international renown.

---

* To avoid confusion, the author has decided to spell the artist's surname consistently as *Krasner* and to merely signal when she changed the spelling, dropping the second *s*.

# ONE

## Beyond the Pale: A Brooklyn Childhood, 1903–21

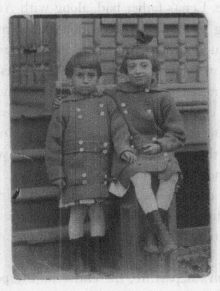

Lena Krasner (right) and her younger sister, Ruth, posing for a snapshot on their front stoop when they were about seven and five, wearing identical coats and boots as well as short, cropped straight hair. Unlike their older siblings, they were so eager to be American that they hardly bothered to speak Yiddish or Russian.

LENA KRASNER WAS BORN ON OCTOBER 27, 1903—NINE months and two weeks after her mother, Chane (Anna) Weiss Krasner, had arrived in New York from Shpikov, a shtetl located in the southern part of the Russian region then known as Podolia, now in central Ukraine, about thirty-five miles south of the city of Vinnytsia. Shpikov was then part of the Pale of Settlement, the area where the Russian Imperial government

restricted Jews.[1] Anna had sailed on a Dutch liner, the *Ryndam*, out of Rotterdam and had arrived at Ellis Island on January 14, 1908, to join her husband, who had reached America in September 1905, traveling out of Liverpool, England.

In Shpikov, Jews were predominantly Hasidic, followers of a mystical revival movement that began in eighteenth-century Eastern Europe. Lena's father had, along with Anna, worked for a rabbi, helping to manage ritual observances, including dietary laws, kosher slaughtering of animals, services on religious holidays and Sabbaths, weddings, funerals, bar mitzvahs, and circumcisions. Joseph Krasner had left behind his wife and four surviving children so he could earn money for their passage—a strategy that was painful, risky, and only too common among those who wanted to flee the Russian empire in the early years of the century.[2] But Anna's younger unmarried brother, William Weiss, had emigrated earlier, and his reports of life in America gave Joseph the confidence to sail. To the Jews oppressed by the tsar, America appeared to offer endless opportunity and the prospect of prosperity.

Before Joseph's departure, the entire family posed for a photograph before a landscape backdrop. The staid adults and four solemn children look well dressed, even elegant—typical of what a couple would want to remember of each other while being forced apart by the ordeal of emigration. Anna is carefully coifed and dressed with a ruffled and belted blouse, the children neatly accoutered and groomed, their father dressed in a modern secular style, wearing a dapper bow tie and white collar, with no sign of Hasidic or Orthodox garb. In the photograph, the edge of the painted landscape is visible. This imaginary background must be one of the first painted scenes that Lena ever saw.

The hints of prosperity visible in the photograph—and that it was commissioned—suggest that poverty was not the reason the Krasners left Russia. The motivations may have been more grave. There was a massive flight from Eastern Europe, and especially

from Russia, around the turn of the century, when Jews suffered anti-Semitism, oppressive taxation, and enforced conscription of their sons.

The Jewish population of Russian Podolia began to emigrate in the aftermath of the March 1881 assassination of Tsar Alexander II, which was blamed on Jews, causing anti-Jewish riots or pogroms. Pressure to emigrate grew more urgent after the Krasners heard the ominous news of a pogrom at Kishinev, a town in southern Russia. In the spring of 1903, anti-Semitic propaganda from reactionary local journalists led to bands of rioters staging an organized attack on Jews, looting and destroying their shops and homes while police and soldiers stationed on the streets stood by without interfering. The next day, the looting turned to savage violence—the police and soldiers raped women, destroyed the local synagogue, and tortured and killed forty-nine people. Nearly six hundred others were injured.[3]

"There was a well laid-out plan for the general massacre of Jews on the day following the Orthodox Easter," the *New York Times* wrote. "The mob was led by priests, and the general cry, 'Kill the Jews,' was taken up all over the city. The Jews were taken wholly unaware and were slaughtered like sheep. The dead number 120 and the injured about 500. The scenes of horror attending this massacre are beyond description. Babes were literally torn to pieces by the frenzied and bloodthirsty mob. The local police made no attempt to check the reign of terror. At sunset the streets were piled with corpses and wounded. Those who could make their escape fled in terror, and the city is now practically deserted of Jews."[4]

The Krasners did not need much more to imagine that this could happen elsewhere, including Shpikov. Just after Joseph left for America, a new wave of anti-Jewish pogroms swept the Pale of Settlement. In response to the pogroms, Tsar Nicholas II issued the October Manifesto in 1905, which granted fundamental civil rights and political liberties to Jews, which in turn sparked ethnic

and political tensions and hostilities that exacerbated popular un-
rest. Pogroms were directed not only at Jews but also at students,
intellectuals, and other minorities. In Odessa alone, at least 400
Jews and 100 non-Jews were killed and approximately 300 people,
mostly Jews, were injured. Many Jewish homes and stores also
suffered damage. Anna, alone with the children and eager to join
Joseph, must have anxiously waited for him to send her enough
money to escape. When Joseph arrived in America, he was among
the thousands of Jews (77,544 in 1904 alone, almost double the
number that fled in 1902)[5] who left Russia at this time for the
New World, many in response to the Kishinev pogrom. The im-
petus for Jews to flee the Russian empire had only intensified by
the time Anna and the children were able to join Joseph.

The desire for freedom had already inspired some Jews to
promote socialist revolution. Jewish socialists stressed that social
justice had a tradition in their religion: the moral command-
ments of the Torah (the five books of Moses read each year from
start to finish) and the Talmud (authoritative body of law and
commentary), and the customs of *tsedaka* or righteousness and
justice toward others, community responsibility, and mutual aid.
The radicals, who joined an underground labor movement that
organized massive strikes, also took the innovative step of praising
women as comrades and intellectual equals. These actions were in
sharp contrast to traditional Jewish men, who reinforced ancient
customs that seemed misogynistic to many women.

As conditions deteriorated in Russia, some Jews became fixed
on the idea of finding a Jewish homeland, but many like the Kras-
ners turned to America, though even there asylum was far from
settled. Prejudice toward the new Jewish immigrants meant that
a family like the Krasners had to struggle to earn a living, educate
their children, and obtain an improved standard of living.

At the time, controversy about the massive numbers of Jewish
immigrants from Eastern Europe and about the issue of race itself
pervaded American society. President Theodore Roosevelt had

even been criticized for asking the African American educator and author Booker T. Washington to the White House for lunch. The problem of what it meant to be Jewish in America and in the world at that time concerned United States Senator Simon Guggenheim of Colorado (the son of a Swiss-Jewish immigrant peddler). He asked that "the Immigration Commission cease to classify the Jews as a race," opposing W. W. Husband, secretary of the Immigration Commission, who wanted census enumerators to classify Jews as a race. "The Jew is a native of the country in which he is born, and a citizen of the country to which he swears allegiance," argued Rabbi T. Schanferber. "We are only differentiated from others as respects religious beliefs."[6] "It is a great question as to whether there is such a thing as a Jewish people," the noted rabbi Dr. Emil G. Hirsch agreed, saying. "Our blood is mixed with that of almost every other nationality."[7]

Others such as Rabbi Leon Harrisson of St. Louis, who had a specific problem with intermarriage, took issue with this point of view. In a 1909 speech in New York, he said, "History and experience have shown us that unless we keep our race separate from others our religion also will soon cease to be . . . diluted to extinction."[8]

At the same time, popular accounts of work by a Harvard professor, William Z. Ripley, warned in "Future Americans Will Be Swarthy" that "racial heterogeneity, due to the direct influx of foreigners in large numbers, is aggravated by their relatively high rate of reproduction after arrival, and, in many instances, by their surprisingly sustained tenacity of life, greatly exceeding that of the native-born American."[9]

Surrounded by these conflicts over the meanings of race and religion, a highly vocal and visible fraction of Jewish immigrants put forward their belief in social justice and political reform. They found in America such harsh working conditions that they felt compelled to continue the struggles begun in Europe, often becoming strike leaders and union organizers. This kind of Jew-

ish militancy no doubt reflected disillusion with the stories of a better life in America. At the time of Krasner's birth, United Hebrew Charities, led by Jacob H. Schiff, tried to raise funds to support the Jewish poor, especially some of the more than 170,000 immigrants who had arrived in two fiscal years. He spoke of "a condition of unparalleled distress" during a year of "financial and industrial depression" and declared that "the Jewish community was not doing its duty."[10]

Impoverished and often radicalized Jewish immigrants thronged the Krasners' Brownsville neighborhood in Brooklyn. Lena's birth just over nine months after her mother's landing provided the reunited family with a child who was by law immediately a citizen of their adopted country. Her father was thirty-seven and her mother was twenty-eight.[11]

At the time of their arrival in America, Krasner's four siblings included three sisters—Ides (also known as Ida, later changed to Edith) aged fourteen, Esther (Ester, later changed to Estelle) aged nine, and Rose (also known as Rosie) aged six—as well as one older brother, Isak (also know as Isadore or Izzy, later changed to Irving), who was then eleven.[12] A fourth sister, Riva, had died in Shpikov when she was just three or four years old.[13] Isak's situation had been especially precarious in the Old World because he was nearly the age when military conscription took Jewish sons away from their parents, often for periods of up to twenty-five years. Many times the children were as young as twelve. The outbreak of the Russo-Japanese War in 1904 had put Isak at greater risk.

Though Joseph was an Orthodox Jew, he had not followed the Hasidism of many of his neighbors in Shpikov. Instead of their search for spirituality and joy through Jewish mysticism, he favored the disciplined study of religious texts. Among the Orthodox, the most prestigious life for any man was to be a religious scholar. Women were excluded from such scholarly circles and expected to serve their families as both homemakers and bread-winners, enabling their husbands to devote themselves to study.

New World realities tempered that tradition in many immigrant households, including the Krasners', although Joseph was said to be sensitive and introspective.[14]

Their father was greatly loved by his children, and Lena adored him, even though, according to her, "he was very remote."[15] She loved to hear him tell stories to her and her siblings: "Marvelous tales! About forests. Beautiful, beautiful stories, always like Grimm. Scary things. The sleighs in winter going out with the dogs, and there would always be someone standing in the road to stop them. The forest, and always the snow, and sleighs. A foreign world to me."[16] These stories of romance and of life in the Russian empire entered into the children's collective memory. Lena liked to snuggle up close to her father and listen. She felt afraid of the dark and remained so all her life.

Her father's stories fueled her imagination. He spoke of his mother Pesa's magic. Just before Yom Kippur (the Day of Atonement), the shtetl neighbors visited the old woman and asked her to perform the folk ritual known as *shlogn kapores,* which involved her waving a chicken over the head of someone who wanted this act to transfer their sins to the fowl—three waves of a hen for women and one wave of a rooster for men. Afterward the applicant, now sin-free, hoped to be inscribed in the metaphorical "Book of Life" for the coming year.[17] *Shlogn kapores,* opposed by various rabbinical authorities since the Middle Ages, continues to exist among some Orthodox Jews as a folk practice.

Lena particularly cherished the story about her father's old aunt, said to have come from the city to the shtetl in the forest to help celebrate her parents' wedding. The aunt was so significant that "the bridal couple had to give up their bed to her. She was tough, dominant and nearly immortal. When she died at 103, she had outlived four husbands."[18] Krasner's memory of the aunt as "tough" and indomitable mirrors how she liked to think of herself later in life.

As an adult, Krasner remembered that when she was about five

years old, she was alone in their home's dark hall when something
that was "half man, half beast" seemed to vault the banister and
land on the floor by her side. She cried out—a childhood enigma
that resurfaced during psychoanalysis and made its way into a
painting.[19] Though we know that the adult Krasner remained
traumatized by this early experience, she did not elaborate on
what sort of monster she experienced. Though she picked up her
mother's fears and superstitions, Krasner longed to be strong like
her legendary great-aunt and adopted that persona whenever she
could.

Joseph's religious books with their elaborate decorations and
Hebrew script also fascinated little Lena. There were also news-
papers in Yiddish, a Germanic vernacular language that utilized
Hebrew letters. Lena started Hebrew school when she was about
five years old, but instruction focused on shaping letters instead of
thoughts: "I learned to write but I couldn't read it. . . . Visually I
loved it. I didn't know what it meant. What they're teaching, they
will say—they'll give you the alphabet, identify it—I could fol-
low that to a certain point. What I couldn't follow was actually
reading. I was slow there, if you will. So that visually I could stay
with it."[20]

At home her parents spoke Yiddish and Russian, but her older
siblings also spoke English, which she learned at school. She re-
called later that she also spoke "a bit of Yiddish, but if [her parents
and elder siblings] went off and spoke real fast [she] couldn't even
get that."[21] By her own admission, languages were not her forte,
and that kept her out of some of the family's interaction.

Through memorization, she learned to recite the daily morn-
ing prayer in Hebrew when she got up each day, though she never
understood what it meant until much later in life. "Well I didn't
know what I was saying; I had to say it or God would strike me
dead."[22] She later referred to this prayer as "my own shattering
experience," explaining that when she finally "read a translation of
the Prayer, which is indeed a beautiful prayer in every sense except

for the closing of it; it said, if you are a male you say, 'Thank You, O Lord, for creating me in Your image'; and if you are a woman you say, 'Thank You, O Lord, for creating me as You saw fit.'"[23]

In many ways, the Krasner family adhered to traditional Jewish mores. They shared their modest quarters at 373 Sackman Street in Brownsville, Brooklyn, with Anna's younger brother, William Weiss, who was still not married and who worked as an operator in a clothing factory.[24] The eldest sister, Edith, did the family cooking, kept the woodstove stoked, and took charge of the younger siblings. Anna dominated the household and enforced Jewish ritual observance. She never learned to read or write in English and remained fearful and superstitious.[25]

Esther later told her grandson stories of their arduous childhood.[26] Lee confirmed her sister's memories: "Yes, we were very poor. Everyone had to work. Every penny had to be dealt with," pointing out that her mother herself had been an orphan.[27] "I was brought up to be independent," she recalled.[28] Continuing the mores of the shtetl, the Krasner parents expected the children's obedience and respect, as declared in the fifth commandment, "Honor thy Father and thy Mother."[29] Yet Lee somehow managed to deviate from the family customs without causing too much friction.

Although many women of Anna's background did not read, she may have suffered from what is now called dyslexia and passed on this genetic trait to her next to youngest daughter. For Anna, modernity and secularism produced a kind of culture shock; like many other Jewish mothers, she favored her only son over her daughters.

Most of the Krasners' neighbors in Brownsville were like them—predominantly poor Jewish immigrants of East European origin, some relocated from Manhattan's congested Lower East Side. The Fulton Street El, the elevated railway's extension in 1889, had eased access to Manhattan, where Lena's uncle and many of their neighbors worked in the garment industry. The neighbor-

hood teemed with activity and Yiddish was usually the language heard in the shops and the open-air market where pushcarts filled the streets.

Sometimes the old world did not seem so far away because its ancient customs pervaded daily life. Many Orthodox synagogues drew the pious. One of the oldest, Beth Hamidrash Hagodal, founded in 1889, was also on Sackman Street, just a short walk down from the Krasners' first home. Young Jewish boys learned Orthodox traditions and rituals at *Cheders,* the schools where they went, but girls were not eligible to attend the same classes. Instead, they attended their own separate Hebrew school, where they were taught only enough mechanical reading skills to let them pray (even if they didn't understand what they were saying).[30] Lena liked the forms of the Hebrew letters: "When I was very young, I had to study Hebrew, and I had to learn to write in Hebrew."[31]

She was conscientious about religious practice: "I went to services at the synagogue, partly because it was expected of me. But there must have been something beyond, because I wasn't forced to go, and my younger sister did not."[32] Krasner later reflected that some part of her must have responded to her religion. "I fasted [on Yom Kippur, the Day of Atonement]. I didn't shortcut. I was religious. I observed."[33] That "something" might have been her strong identification with her adored father; yet she resented being told to go upstairs in the synagogue, which segregated the men from the women.

Her mother had little time to consider the merit of Jewish customs. At the age of thirty, in 1910, she gave birth to her seventh and last child—Lena's younger sister, Ruth (whose Yiddish name was Udel), when Lena was two years old. Lena soon found herself displaced from the role of the large family's beloved baby, and she began to distinguish herself from the more adorable Ruth by demonstrating strong intelligence and quick wit, attributes that were not especially admired in Jewish girls. An intense rivalry developed between Lena and Ruth, who shared a bed with their

older sister Rose, as they vied for attention from their parents and older siblings.

That her older siblings were European-born and spoke both Yiddish and Russian practically made the two youngest girls like a different family. Although Krasner later claimed that her family members also spoke Hebrew, this seems unlikely.[34] Some rabbis might even have objected to speaking Hebrew on ideological (religious) grounds because Hebrew was *lashon kodesh*—a holy language—only for prayer and study. Lena and Ruth were so eager to be American that they hardly bothered to speak Yiddish or Russian.

The two girls posed on their front stoop for a photograph when they were about seven and five, wearing identical coats and boots as well as short, cropped straight hair. In the photograph, Lena's arm is around Ruth's shoulder and she smiles; Ruth's hand is on Lena's knee, but she appears fearful and distrustful of the photographer.

By the time Lena entered elementary school at Brooklyn's P.S. 72, the family had moved about two miles away to a clapboard row house on Jerome Street in East New York, on central Brooklyn's eastern edge, adjacent to, yet different from, the much more crowded Brownsville.[35] East New York was originally called Oostwout by the Dutch.[36] This neighborhood became known as the New Lots, a part of the town of Flatbush. Laid out in 1835 to 1836, East New York was originally conceived as a rival to New York City. Nevertheless its development progressed rather slowly until the Williamsburg Bridge opened in 1903. Even so it continued to feel more rural than Brownsville.

Krasner recalled East New York as "rural. Not a city," and she quickly began to delight in the new natural surroundings: 'Where I lived there were beautiful flowers. I loved it. A backyard with irises. My fleurs-de-lis—my favorite flower. And wild daisies. Bridal veil. And lilac. And roses on the fences, and in all the back yards."[37] This love of nature would stay with Krasner her entire

life. She later commented: "There's nothing that I can think of, including spirit, that I conceive away from nature. How shall I sense it? This is the all-over, if you will, my God."[38]

Lena relished walking to school "through the lots filled with buttercups. There was a farm with a pail and cows. Smells. Warm milk in the bucket. I hated the taste, but for Mother and the family it was a treat. So I would go through the fields to get there."[39] At least some of the cows belonged to a neighbor, who housed them in his stable at the corner of New Lots Road and Hendrix Street, not far from Lena's home and school. Years earlier, the school's principal had protested about the cows to the New Lots Board of Trade organization, claiming that the cows clogged the sewers and threatened the schoolhouse's sanitation. But the cows' owner refused to move his cows, insisting that he had been there first, before real estate development spilled over from Brownsville.[40] To Lena's parents, this kind of rural bickering made the area feel more like the shtetl in the woods where they grew up. Looking back fondly on her neighborhood, Krasner recalled it having old clapboard houses, "traditional saltboxes." She remembered "a little wooden bridge," the neighbors' vegetable gardens, and chestnut trees, the blooms of which thrilled her.[41]

Lena's school was on New Lots Avenue between Schenck and Livonia Avenues, also close to her house.[42] Her father ran a fish, vegetable, and fruit stand at the Blake Avenue Market nearby. According to the United States Census for 1910, he owned a retail store and was classified as a "fish monger." That meant he had to get up at dawn and travel to Manhattan's wholesale market, buy fish—carp, pike, and whitefish—packed in heavy wooden crates chilled by ice, haul it by horse and wagon to the small stall at the market, and try to sell out by late afternoon before all the ice melted and the fish spoiled.[43] Managing the business left little time for the Krasner parents to attend to their children, and with time and money in short supply, Anna and Joseph struggled to provide their children with the basic necessities.

At school Krasner came into contact with new ideas and the ideal of personal goals and dreams. This differed from what she saw at home, where her mother was a model of stoicism and self-sacrifice for her family. Lena described her mother, exhausted from the family business, as "loving but not demonstrative. She would back what I wanted."[44] The contrast between her new values and those of her family would remain a source of inner tension for much of her life.

P.S. 72 had about 1,500 students in classes from kindergarten through eighth grade.[45] There were more girls than boys in Lena's class, presumably because so many of the boys attended private cheders. Though the school introduced Lena to the idea of art, she later said that she did not yet draw.[46] Her sister Ruth recalled, however, that Lena found and copied fashion advertisements in the newspaper: "She used to draw clothed women figures all the time. We were all aware of that—how marvelous it was to be able to put her pencil to paper and get a figure."[47] It was one of the few nice things Ruth ever recollected about Lee.

Lena also began going to the library to look at the art in books, such as the illustrations in her favorite fairy tales.[48] Krasner recalled that the only art in their home hung in the parlor. It was a print that depicted Columbus receiving jewels from Queen Isabella. The Brooklyn Museum, though already established, was too far for her to venture alone, and apparently no one in the family or at school took her there.

At the same time, East New York also offered a station on the Long Island Railroad's Manhattan Beach Branch, which ran from Long Island City in Queens to Manhattan Beach, the part of Coney Island east of Brighton Beach, in Brooklyn. The route had been built in the nineteenth century originally as one of several summer beach railways. There was, however, no subway service until 1922, miraculously finished just in time to fulfill Lena's desire to travel to Manhattan for high school.

Krasner enjoyed her neighborhood—there was still a village

atmosphere, even in Brooklyn. She knew all her neighbors and felt very much at home. Her friends were diverse, like the neighborhood: Sissy (Adelaide) Rhodes, who lived next door was a mulatto; Margaret Williams was French and Margaret Lehmann was German.[49]

As Lena was growing up, Brownsville welcomed radical social movements and philosophies including anarchism, socialism, and communism. There also were secularists and Zionists and leftist-oriented schools. Many different types of candidates ran for local elections. Some mounted wooden soapboxes on street corners or in the nearest park to deliver speeches against capitalism to whoever would listen. The district elected socialists to the New York State Assembly from 1915 to 1921.

During this time, women's activism became important and accepted in her immigrant community.[50] Women initiated protest movements, starting with the kosher meat boycott of 1902, in which 20,000 Jewish women on the Lower East Side broke into kosher butcher shops and rendered the meat inedible to protest rising prices. Many women led rent strikes and participated in the garment strike of 1909, which lasted for fourteen weeks and won for workers improved wages, working conditions, and hours.

Additionally the women's suffrage movement was growing, and it gained more support from Jewish immigrant groups than from any others in the state elections of 1915 and 1917.[51] Jewish women worked hard to get out the vote. Many of the immigrants had already been radicalized after fleeing oppression in Eastern Europe. Although the historian Daniel Bell has argued that "European enthusiasms were tempered" after immigrants accommodated to their new environment in America, it appears that the immigrants' American-born children often not only acquired an instinct for radical politics but also their parents' sense of social justice.[52]

Krasner was among those who developed a vigorous sense of social justice. The suffrage campaign must have been gripping for

Krasner. Unlike her older siblings, she was American-born, and when American women achieved the vote in 1920, she only had to wait to come of age to enjoy that right herself. It is unknown what Krasner's mother knew about the suffrage campaign, but her elder sisters must have been aware of it.

Though she received a typical indoctrination in religious ritual and belief at home, like many of her contemporaries, Krasner felt an even stronger pull to separate from the Old World ways of her parents, especially from the household and family burdens placed on her mother and her elder sisters. Like so many first-generation Americans and immigrants who arrived as small children, Lena began to question traditions that were identified with the old country. Krasner's inclination to independence was supported by popular culture, even Yiddish cinema, which featured rebellious "jazz babies," who renounced the backwardness of their parents, adopting instead dreams of being American and individual.[53]

Lena's role models at home were her father and brother, both of whom she favored over her sisters and her mother. Her brother Irving, who studied chemistry, introduced her to all kinds of cultural pursuits: he went to the library and brought home books by the great Russian authors, such as Dostoevsky, Gogol, Gorki, and Turgenev. Even though he could read in Russian, he probably read aloud to Lena from the English translations. There was also the Belgian francophone dramatist and poet Maeterlinck. And he listened to the music of Enrico Caruso, then the leading male singer at the Metropolitan Opera in New York City.[54] Irving liked the visual arts; he never married, and as an adult, he even collected art.[55]

When Irving read to Lena from the translations of Maeterlinck, she would have found encouragement for her love of nature. Maeterlinck's *News of Spring and Other Nature Studies,* including *The Intelligence of Flowers,* which was published in an American edition in 1913, could have reinforced the young Krasner's love of flowers.[56] Not only do the irises, roses, and daisies that she recalled

from her childhood all appear in this volume, but there is also an elaborate discussion of the lettuce leaf's remarkable ability to defend itself against slugs, recalling the unusual metaphor of a lettuce leaf, which she drew upon to explain her art in the statement for her first retrospective in 1965: "Painting, for me, when it really 'happens' is as miraculous as any natural phenomenon—as, say, a lettuce leaf. By 'happens,' I mean the painting in which the inner aspect of man and his outer aspect interlock."[57] In Maeterlinck, Krasner would also have been introduced to his use of symbols used to stand in for ideas and emotions.

In one of Maeterlinck's best-known plays, the fairy tale *The Blue Bird* (1908), the fairy Bérylune, a hunchbacked crone, sends the two children Tyltyl and Mytyl out to find the Blue Bird of Happiness for her sick daughter. She gives Tyltyl the visionary diamond: "One turn, you see the inside of things. . . . One more, and you behold the past. . . . Another, and you behold the future."[58] Tyltyl rotates the diamond, and the fairy becomes a princess of extraordinary beauty. The subsequent adventures take the children to the graveyard in search of the Blue Bird, to the Land of Memory, the Palace of Night, and the Kingdom of the Future. Years later Krasner would emphasize her interest in "time, in relation to past, present and future," recalling Maeterlinck's imagery, which appears to have contributed early on to the shape of her artistic imagination. She later affirmed: "All work has psychological content."[59]

In Gogol's novel *Dead Souls,* Irving and Lena could find analogies between Gogol's treatment of the inequities of an unjust social order and their own poverty in immigrant Brooklyn. Krasner would feel too, as with so many modern writers, the power of Dostoevsky's depictions of the human condition. Perhaps Irving read her both *Crime and Punishment* and *The Brothers Karamazov* and imparted ideas that anticipated psychoanalysis and existentialism. Turgenev's most widely read novel in America was *Fathers and Sons,* featuring themes of conflict and love between genera-

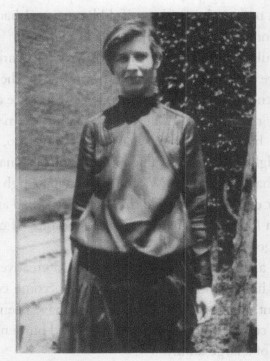

Lee Krasner's sister Rose, six years her senior, shared a bed with Lee and their youngest sister, Ruth. American born, the two youngest sisters vied for attention from their parents and older siblings, all of whom were immigrants.

tions.[60] This spoke powerfully to an American-born child growing up in a family of immigrants.

Lena's favorite teacher at P.S. 72 was male. She was probably about eleven or twelve when she had Mr. Philip L. Walrath as her teacher. She recounted that he was "eccentric enough" to believe that girls should be allowed to play baseball with the boys: "Togetherness like that was my kind of thing!"[61] While it is not clear what art instruction this school offered, Krasner recalled the craft aspect of making a map of the United States: "Every time I see a Jasper Johns map, I remember how crazy I was for doing that thing. We had to figure out what each state was known for. I got tiny empty capsules and filled them with wheat or whatever and

glued them onto a piece of beautiful blue paper. I had drawn the states in colored crayon. And I just loved that blue." [62]

Lena could never say why she chose art as a career. "I don't know where the word *A-R-T* came from; but by the time I was thirteen, I knew I wanted to be a painter." [63] She once commented, "All I can remember is that on graduation from elementary school, you had to designate what you chose to do, in order to select the right high school. The only school that majored in art which is what I wrote was Washington Irving High School. On applying for entrance I was told that they were filled and as I lived in Brooklyn I couldn't enter. It led to a good deal of complication as I had to go to a public high school." [64]

She had already envisioned a better life, a creative career outside of her home, and she also wanted to become economically self-sufficient. Dreams of a husband might have been part of the picture, but certainly not the responsibility and burden endured by the mother of a large family.

## TWO

# Breaking Away: Determined to Be an Artist, 1922–25

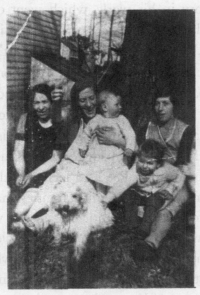

Lee Krasner (far right) at the age of sixteen with her mother, Anna Weiss Krasner (far left), and her sister Rose Krasner Stein, with Rose's two daughters, Muriel (held by Lee) and Bernice Stein, 1925.

WHEN LENA GRADUATED FROM P.S. 72 IN 1922, SHE BEGAN to see herself as "an independent girl" and started calling herself "Lenore."[1] It is also possible that Krasner was trying to move away from the more ethnically marked name Lena, which had been popular in her parents' Russia. "Lenore" was popular in America at the time, and Krasner later indicated that Edgar Allan Poe "had an enormous effect on me in my teens."[2] Since Poe used the name Lenore prominently in his poetry, his work may also have influenced her to adopt that name.

Krasner had been fascinated by the supernatural since her early childhood fixation on the monster that jumped at her across a banister in her home when she was about five years old.[3] Poe's use of fear and his evocative and stylized language meshed strongly with Krasner's lifelong preoccupation.[4] Krasner was most likely drawn to Poe's story "The Oval Portrait," which tells of an artist "who took glory in his work, which went on from hour to hour, and from day to day. And he was a passionate, and wild, and moody man." Poe also describes the artist's wife as suffering "withered" health and spirits by the behavior of her oblivious self-involved husband. Poe wrote: "Yet she smiled on and still on, uncomplainingly, because she saw that the painter (who had high renown) took a fervid and burning pleasure in his task."[5]

While it would be absurd to suggest that Krasner's future fate was determined by reading Poe as a teenager, this was the time in which she formed the values and fantasies that would help to shape her adult life. Such a romantic fantasy of a woman's devoted role as an artist's wife also echoed the kind of role that pious Jewish women assumed when they married men who devoted their lives to religious study, a common occupation among Jewish men in the Eastern Europe of Krasner's parents' generation. It is, after all, Krasner who, years later, volunteered that Poe resonated for her during these formative years. If she did not know then that she was destined not only to be an artist, but also to marry a self-destructive one, she certainly would make serious efforts to do both. Thus it is tempting to believe that she read and absorbed Poe's account of a crazed painter with his wife as a model, whose "deep love for her whom he depicted so surpassingly well. But at length, as the labor drew nearer to its conclusion, there were admitted none into the turret; for the painter had grown wild with the ardor of his work, and turned his eyes from the canvas rarely, even to regard the countenance of his wife. And he *would* not see that the tints which he spread upon the canvas were drawn from the cheeks of her who sat beside him." Poe told of a manic

self-absorbed painter who after he cried out at last "with a loud voice 'This is indeed *Life* itself!' turned suddenly to regard his beloved:—*She was dead.*"[5]

Lena might well have come across her new name while reading Poe's Gothic fantasy poem "Lenore" (1831), which also focuses on a woman's death:

> See! on yon drear and rigid bier low lies thy love, Lenore!
> Come! let the burial rite be read—the funeral song be
> sung!—

And, of course, the name also appears in Poe's "The Raven" (1845):

> From my books surcease of sorrow—sorrow for the lost
> Lenore—
> For the rare and radiant maiden whom the angels name
> Lenore—
> Nameless here for evermore.

Maurice Maeterlinck, who wrote in French, but whom she and her brother Irving read in translation, also probably had an effect on Krasner's other tastes in reading.[7] His book *On Emerson and Other Essays,* published in 1912, incorporated essays by Emerson, Ruysbroeck, and Novalis, three men "to whom the external event was nought beside the inner life."[8] Krasner was so engaged by Emerson's work that she later titled one of her major paintings after the first line in his essay "Circles." But both her new name and her memories of writers show that her interest in the mystical or inner nature of man began at an early age.

When it came time for high school, Lenore's first choice was Washington Irving High School in Manhattan: unique in the history of women's education in New York City, it described itself as "the only school in greater New York offering an industrial art

course for girls."[9] But Washington Irving rejected Krasner's first application. Her disappointment was all the more intense because she had seen high school as an opportunity to pursue a different kind of life from that of her parents and her elder sisters. As long as Krasner made no demands on her parents, they left her alone and did not try to dissuade her from her educational goals.[10] "I think my parents had their hands full acclimatizing themselves and putting their children through school. They didn't encourage me, but as long as I didn't present them with any particular problems, neither did they interfere. If I wanted to study art, it was all right with them."[11]

Anna's and Joseph's gradual openness resembled that of many Eastern European Jews who were now in America. The strain in Judaism that discouraged girls from obtaining all but the most basic literacy had been affected by the Jewish intellectual and literary movement known as *Haskalah* (or secular enlightenment), which had advanced the idea that Jewish emancipation and equality would come from the reconciliation of Judaism with modern Western ideas and customs. Already by 1844 a *Haskalah* writer broached the idea of a segregated education system for Jewish women, advocating "the establishment in various cities of special institutes of study, with a six-year program, for girls who are to obtain a strict moral education in these schools. The teachers and educators ought to be females only. In the entire course of the years of study and education, the girls must be strictly forbidden to see men and, especially, to speak with them."[12]

After Lenore was rejected by Washington Irving, she fell back on Brooklyn's Girls' High in Bedford-Stuyvesant. Established in 1886 as a free public high school for girls, the school was housed in a notable building designed in Victorian Gothic and French Second Empire styles. A descendant of the Central Grammar School, it was the first free secondary school in the city.[13]

Girls' High worked well for some of its students; among the successful graduates who preceded Lenore were the screenwriter

Helen Deutsch and the artist Gwendolyn Bennett, whose poster design won the school's art contest in 1921, and whose art and writing appeared in journals during the Harlem Renaissance.[14] But the experience at Girls' High was not what Lenore had in mind. She commented later: "Even at school as a kid, I knew I was an artist."[15] The school did not offer art as a major field of study, and she chose to study law.

Even Krasner's second choice of study, the law, attested to her desire to forge a new life, independent of that traditional model of her parents and older sisters. She never envisioned herself as a housewife. The message of suffrage and equal opportunity for women had somehow seized her imagination. She was determined to struggle for those rights.

It was also a time of rebellion. In class she refused to sing Christmas carols. "Much to my own astonishment, I got up in the classroom and said, 'I refuse to say "Jesus Christ is my Lord." He is not my Lord.' Now you can imagine this caused quite a commotion."[16] She had probably heard the legendary tale from 1913 when six boys from her own elementary school had protested the singing of Christian hymns. The boys had proclaimed themselves atheists and gone on a "silence strike," even getting attention in the local newspaper. The reporter noted that the six had "been reading up on science and evolution."[17] One teacher characterized the students as "free thinkers," commenting: "We have given up the practice of singing the hymns and are confining ourselves to Bible reading. The district seems to be a hot-bed of Socialism."

The teacher lamented that some of the school's girls had joined in the silence strike, forcing the end of the hymns. The next day Thomas D. Murphy, the school's principal, announced to the press that after consulting with the district superintendent, he had removed the objectionable hymns from the singing books and that only Bible readings would be required as "the religious part of the assembly exercises."[18]

With Irving's help, Lenore was also reading the German phi-

losophers Arthur Schopenhauer and Friedrich Nietzsche, which influenced her to turn away from Jewish tradition and belief. Both Nietzsche's dictum that "God is dead" and his insistence that humanity "take responsibility for setting its own moral standards" strongly affected her. Schopenhauer too influenced Lenore to leave behind religion: "The power of religious dogma, when inculcated early, is such as to stifle conscience, compassion, and finally every feeling of humanity."[19]

Lenore was miffed by Orthodox Judaism's inequitable beliefs about men and women, especially with regards to how women were excluded from significant religious involvement. "The beginnings were there in the synagogue, and I am told to go upstairs, I have never swallowed it to date," she insisted late in life. She was not alone in her disapproval. Rebekah Kohut, a Hungarian immigrant of Lenore's father's generation, married a rabbi and then became an activist, campaigning for Jewish women's right to fully participate in their religion. Kohut argued that "the denial of woman's ability to serve the synagogue in every part of its work is cruel and dangerous."[20] Though Kohut was in many ways successful in advancing Jewish women's rights in the synagogue, these successes came too late to prevent Lenore from becoming estranged from Jewish religious practice.

Krasner recalled arriving home one Shabbat (Sabbath) while her parents calmly entertained a friend over a cup of tea; she described herself as a young teenager coming in "like a charging banshee" and announcing that she was done with religion.[21] And that was that. She remained identified as Jewish but rejected all organized religion to lead a secular life, though gradually she would replace religious worship with devotion to art.

She recalled her changes of direction as abrupt: "I decided to be a lawyer and entered a high school in Brooklyn called Girls' High, I believe it was, flunked everything in the first six months I was there, and reapplied once more to Washington Irving. This time I was admitted and so I started my art career."[22] Either they kept

Krasner on a waiting list or had some students drop out, making room for her even though she lived in Brooklyn.

Washington Irving High School was just where Lenore wanted to be. Even its seven-story building on Irving Place suggested its special purpose. Completed in 1913, it was designed by C. B. J. Snyder in brick, limestone, and terra-cotta with an imposing arched entrance and paired round-arched Florentine Renaissance windows on the top. A deep cornice and a tiled hip roof completed the artful ensemble, echoed inside by elaborate interior mural decorations.[23] The school originated in 1902 as a branch of Wadleigh High School (at the time, the only girls' high school in Manhattan) called Girls' Technical High School. It was the concept of the progressive educator William McAndrew who sought to mingle girls training for vocational or technical trades with those pursuing an academic curriculum, figuring that they would learn from one another.

Washington Irving advertised a wide curriculum for women: drawing, illustrating, embroidery, picture hanging, printing, photography, costume designing, plain sewing, garment making, dancing, gardening, cooking, entertaining, sanitation, housekeeping, nursing, marketing, infant care, laundering, telephoning, typewriting, bookkeeping, stenography, salesmanship, office management, bookbinding, cataloguing, commercial filing, and newspaper writing, besides the usual high school subjects. Rather than promoting art for art's sake, the curriculum aimed at enabling its graduates to find work, including jobs in the thriving garment industry. For Lenore, determined to become an artist, the menu offered at least some of what she sought.

The all-female student body at Washington Irving was quite comfortable for Lenore. In 1921, the *New York Times* described the school as having "6000 pupils, almost wholly Jewish."[24] The school's industrial art department had been the project of the progressive Dr. James Parton Haney, secretary of the National Association for the Promotion of Industrial Education and the

first art director of New York City's high schools. Haney's singular achievement was praised in his obituary in March 1923.[25] The popular school was so overcrowded that in 1921 there were two sessions for academic classes and another two for students who elected commercial or industrial subjects.[26]

As a student Lenore certainly worked hard. Even years later, she was proud to state: "I earned my own car fare. . . . I had all kinds of jobs. I painted lamp shades. I put vertical stripes on felt hats."[27] These types of artistic odd jobs served as practice drills that prepared Lenore for technical labor later on, such as her work on the WPA during the 1930s. Many such tedious jobs depended on the labor of poorly paid young women. An immigrant she met a few years later described such subsistence-level factory jobs then available in New York, this one on the sixth floor of a large loft building just east of Washington Square. She was told to "fill in the 'modernistic' raised design on one of the parchment shades . . . they paid four cents a piece."[28]

Lenore preferred illustrating over needlework or other crafts identified with women's work and the Old World. Her early love of nature came in handy at Washington Irving. "We drew big charts of beetles, flies, butterflies, moths, insects, fish and so on. We would get models of a fly or butterflies in boxes with glass tops. Then it would be up to us to pick the size of sheet or composition board and the range of hard pencils and to decide how many to put on the page. And we would get anatomical assists from books. I loved doing those!"[29]

She recalled, however, that she did well in all her subjects, except art. "By the time one gets to the graduation class you're majoring in art a great deal, you're drawing from a live model and so forth," Krasner later recalled. She remembered taking "more and more periods of art."[30] Her determination and sense of purpose were not, however, enough to win her art teacher's praises. Her originality was still too roughly formed. She possessed neither the charm nor the beauty of some of the school's earlier success stories.

The French immigrant and future actor Claudette Colbert, for example, preceded her by only five years, moving on first to study fashion design at the Art Students League.[31] When Lenore decided in her senior year to go to a woman's art school, Cooper Union, she recalled that her high school art teacher "called me over and said very quietly and very definitely, 'The only reason I am passing you in art [sixty-five was the passing mark at that time] is because you've done so excellently in all your other subjects, I don't want to hold you back and so I am giving you a sixty-five and allowing you to graduate.' In other words, I didn't make the grade in art at all."[32]

Undaunted even by harsh criticism and confident in her own abilities, Lenore remained resolute. "You had to apply with work, so I picked the best, or what I thought was the best I'd done in Washington Irving and used that to get entrance into Cooper Union. I was admitted."[33] Her unflappable resolve and persistence would prove invaluable. She probably knew well the lesson of Rabbi Hillel, who was renowned for his concern for humanity. One of his most famous sayings, recorded in *Pirkei Avot* (Ethics of the Fathers, a tractate of the *Mishnah*), is: "If I am not for myself, then who will be for me? And if I am only for myself, then what am I? And if not now, when?"[34]

To study art, Lenore had to travel each day for about an hour each way to and from East New York. Manhattan must have seemed worlds apart from the provincial life she knew in Brooklyn. This was her first taste of real freedom—with galleries and museums to explore, including the Metropolitan Museum. There she saw the old masters and developed tastes that would last a lifetime, even after she rejected traditional art for modernism. She became particularly interested in paintings of the Italian renaissance, the Spanish masters, including Goya, and French painters such as Ingres.

With equal passion she learned to savor great art and to dance the latest steps. Unlike her older sisters, who married young, she

needed no further coaxing to move beyond her family's cramped life to one of individualism. Greenwich Village, with its lively bohemian scene, soon beckoned to her from Irving Place. It was the heyday of free love, the new woman, the Jazz Age, the fast-dancing flapper, and other thrilling new types.

While moralists attempted to prohibit "the shimmy" and other jazz dances during the early 1920s, a teenaged girl like Lenore was just getting her first taste of freedom. Drawn to the new and the chance to jettison her burdensome immigrant heritage, she was not encumbered by Victorian sexual mores. In her Jewish immigrant culture, sexuality in marriage, whether or not for procreation, was considered a positive value, not a necessary evil, as it was in Catholicism. As St. Augustine declared: "Intercourse even with one's legitimate wife is unlawful and wicked where the conception of offspring is prevented."[35] Though premarital sex was not permitted in strict Jewish culture, the religion did not associate the human body with guilt. Judaism assumed that a woman's sexual drive was at least equal to a man's and sex within marriage was sanctified—for both pleasure and procreation. In fact, the choice of a celibate life over a married life was condemned.[36]

As she graduated from high school in 1925, Lenore faced a world of new freedoms and possibilities in an economy that was robust.

# THREE

# Art School: Cooper Union, 1926–28

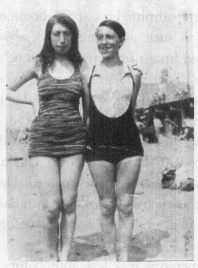

Lenore and Ruth Krasner at the beach, c. 1927.

I N FEBRUARY 1926, THE SEVENTEEN-YEAR-OLD "LENA KRASNER" entered the Cooper Union for the Advancement of Science and Art, a tuition-free college in Manhattan at the intersection of Fourth Avenue and East Eighth Street, known as Astor Place. Founded in 1859 by Peter Cooper, the school boasted that it had "a constant demand for the graduates in the commercial world."[1] The Woman's Art School was meant to enable "young women, who expect to be dependent on their exertions for gaining a livelihood, to obtain, free of cost, a training that will fit them for useful activity in art work of one form or another."[2]

The school's supporters, visible on the long list that constituted its "Ladies' Advisory Council," included such prominent names

as Miss Helen Frick (Henry Clay Frick's daughter), Mrs. Frederick W. Vanderbilt, and Her Highness, The Princess Viggo of Denmark (née Eleanor Green). Mrs. J. P. Morgan had also figured on the council until her recent death. The school had the attention of high society matrons, who contributed scholarship funds, money for student prizes, and even a summer art course in Paris.

Applicants were admitted as space became available, "with some preference to such as submit work showing preparatory training or decided fitness for artistic pursuits."[3] Lenore Krasner began in midyear. That academic year the Woman's Art School enrolled 293 girls for training in design and applied arts, including fashion, furniture, illustration, interior decoration, portrait and other painting, and the teaching of art. At the end of her life, Krasner reminisced: "I do recall Cooper Union having the most magnificent Cooper-Hewitt Museum available to us, just one flight below our classrooms—what an enormous treat."[4] The collection, now relocated, emphasized architecture and the decorative arts.

But another memory was less approbatory. "I also particularly remember the separation of the men and women, even with separate entrances. We never crossed paths!"[5] The Union's main men's division was an engineering school, although art classes for men were given during the evenings. Krasner never approved of separation by gender, yet, at the time, she had no other options. Typically only about two dozen women graduated in a given year.[6] The small number of graduates resulted from women dropping out because they could not produce acceptable work, as well as those who dropped out because they chose to get married, had to take a paying job, or wanted to pursue study at another school, as Krasner eventually did.

Cooper Union's emphasis on businesslike careers in the arts for women initially made it a good fit for the ambitious Krasner. The school stressed learning the craft and techniques of art, and the women's course of study was rather rigidly prescribed. Like her

classmates, Krasner began studying elementary drawing, which involved drawing from simple forms and from casts of ornaments, torsos, feet, and hands. She was also enrolled in General Drawing, which was an afternoon class open to all, and portrait painting.

Despite Krasner's previous training, her teacher for elementary drawing, sculptor and mural painter Charles Louis Hinton, still judged her work as "messy." Hinton had been a pupil of Will Hicok Low at the National Academy of Design in New York; he had also studied in Paris with Gérôme and Bouguereau, who were famous academicians in the 1890s. Hinton's course emphasized "drawing from simple forms and casts of ornaments, blocked hands, feet, etc. Also special elementary preparation for Decorative Design and Interior Decoration for students intending to study those branches."[7] Krasner, however, aimed to become a "fine artist," not a "decorative artist," and resisted this practical curriculum.

A muralist and an illustrator for children's books, Hinton was trying to maintain old-fashioned academic taste at a time when modern art was beginning to make its way into public consciousness.[8] He could not tolerate Krasner's independent spirit and casual attitudes. And for her part, this resistance came at significant risk. Students were subject to close supervision, and anyone not making fair progress was subject to dismissal. In order to advance from elementary drawing, the lowest class, a student had to advance—and that was subject to the teacher's judgment.[9]

Krasner later recounted how Hinton's course was divided into alcoves: "The first alcove, you did hands and feet of casts, the second the torso, and third, the full figure, and then you were promoted to life. Well I got stuck in the middle alcove somewhere in the torso and Mr. Hinton at one point, in utter despair and desperation, said more or less what the high school teacher had said, 'I'm going to promote you to life, not because you deserve it, but because I can't do anything with you.' And so I got into life."[10]

In May Cooper Union awarded Krasner a certificate stating

that she "has successfully completed the work prescribed for the class in Elementary Drawing." She had registered as "Lena Krasner" but managed to have them put on her certificate "Lenore," the first name that she had chosen for herself.[11]

Free from Hinton's strictures, Krasner began the fall term as one of 312 woman students.[12] Since almost all of the teachers at Cooper were men, role models for women were very scarce. Ethel Traphagen, who taught courses in fashion design, was a notable exception.[13] She had made an impact in the world of fashion and is said to have brought attention to the United States as a fashion center. She worked then on the staff of the *Ladies' Home Journal* and *Dress Magazine*. She also resurrected and depicted "costumes of Indian maidens" and collected nineteenth-century garments. Traphagen had started out at Cooper but eventually graduated from the National Academy of Design and also studied at the Art Students League and the Chase School. In 1923, she founded the Traphagen School of Design with her husband, William R. Leigh, a painter who fiercely opposed modernism.[14]

Traphagen's Costume Design and Illustration was a "two years course, designed to develop the taste of its students and to fit them for immediate practical work." The first year's focus was on "drawing and sketching the human figure in action, proportion and details; also from garments and drapery. Historic costume; color theory; dressmaker's sketches." By the second year, the focus was on "drawing for publication in pencil, pen-and-ink, wash, color, etc. Composition and grouping of figures. General preparation for practical work."[15] Students also began to sketch garments and drapery as well as historic costume. They studied color theory and made dressmaker's sketches. Krasner, who had enjoyed drawing fashions as a girl, came out of the course with a respect for clothing design and designers.

Krasner was interested in clothes and style. However, her own look must have appeared very relaxed to her classmates. In the February 4, 1927, issue of *The Pioneer,* the student newspaper,

the female columnist asked: Would the world come to an end if "Kitty Scholz quit believing she was the 'Princess'? Mickey Beyers favored long skirts? Betty Augonoa and Sadie Mulholland 'grew up'? Lee Krasner at last put her hair up?"[16]

This is also the first documented use of Krasner's nickname, "Lee," rather than Lena or Lenore. In a gossip column about women students, the school paper again identified her as "Lee Krasner" when it commented positively on her eyelashes.[17] Of Cooper Union, Krasner later said, "I'm surrounded by the women that are going to be artists so there's nothing unusual about women artists, it's a natural environment for me."[18] Changing names was commonplace among Krasner's immigrant siblings. Her name appears as "Lee" on the U.S. Federal Census for 1930, so she had definitely made the switch from Lenore by that time.[19] Though some have alleged that Krasner later took the androgynous name Lee so that it would seem that her art was made by a man, her earlier use of the name in her single-sex school casts doubt on that theory.[20]

At this time, Krasner was five feet five, with blue eyes, and she had developed a model's slender figure. Her hair was auburn and usually worn in a pageboy cut, just above the shoulders. Her smile was warm, though her facial features were far from classical. Greenwich Village was becoming home to women said to be sexually uninhibited, glamorous, and free. The feminists who fought for suffrage had been eclipsed by the flapper. The struggle of revolutionary women such as Emma Goldman and Crystal Eastman seemed over. With the economy booming and garrets in dilapidated buildings available at cheap rents, a bohemian existence at society's fringes became a viable option for many. Couples living freely together made traditional marriage and families look less like an inevitable destiny than a limiting choice.

Studies of the "New Woman" blossomed in the popular press. Carrie Chapman Catt, president of the National American Woman Suffrage Association, wrote that having gained the vote,

"woman is now learning how to use it intelligently so as to realize the ultimate aim of the movement—absolute equality between men and women."[21] Meanwhile reformers such as Charlotte Perkins Gilman discussed "companionate marriage" publicly, condemning it as "merely legal indulgence" of those "who deliberately prefer not to have children to interfere with their pleasures."[22] She excoriated those "who seek sex indulgence without marriage, and whose activities have long been recognized as so deleterious as to be called 'social evil,'" blaming much such behavior on "that new contingent who are infected by Freudian and sub-Freudian theories."[23]

Meanwhile the Reverend Henry Sloane Coffin, president of the Union Theological Seminary, exhorted married couples to hold "to marital vows and the keeping up of appearances even though the illusions and ideals of marriage have vanished." Coffin evoked a case in which "the wife realizes that she has married a mediocrity, or a weakling, or a scamp; the husband finds himself tied to a scold, or a bore, or a heartless worldling."[24] Such public discourse did little to make young women like Krasner long for matrimony just when they were beginning to test freedoms newly found.

Krasner's eventual decision to avoid motherhood should be viewed in the context of those who were then insisting that "the greatest social problem of the day" was excess population. Many in this camp, such as Harry Emerson Fosdick of the Park Avenue Baptist Church, argued publicly for "the general practice of scientific birth control."[25] This issue was closely related to the anti-immigration legislation that had passed in the early 1920s, which encouraged those who openly called for the use of eugenics to shape the population. Indeed, Fosdick described himself as "restrictionist in immigration."[26]

Krasner's own outlook was strongly cosmopolitan, having grown up in a neighborhood populated by a mix of old Dutch farmers and recent immigrants: Russian-Jewish, French, Irish, and German, and mixed-race.[27] Years later she spoke of despising

nationalistic attitudes and resented being narrowly categorized as an "American" artist—a point of view that must come from her early experiences with various cultures and her awareness of bias against minorities.

At Cooper Union, Krasner kept her eye on her professional goal. Soon after her introductory courses, she advanced to Drawing from the Antique and Fashion Design. Drawing from the Antique entailed working with plaster casts of Greek and Roman works. The students focused on drawing the human head and figure, and in the afternoons they drew in color. Lectures were required on anatomy, perspective, and the history of art.

The first term had been an awkward time for Lee, but then her prowess started being recorded not only on her transcript but also in the school paper, which listed some two dozen women who had their drawings "hung at the monthly exhibition," Krasner's among them.[28]

Given the school's vocational agenda, it is hardly surprising that Krasner quickly made a name for herself as a fine artist. By December she obtained admission to the life drawing class, for which one had to earn admission by submitting satisfactory drawings, usually in the third year. She was only in the second term of her first year. In the mornings the students drew from life, and in the afternoons they painted from life in oil. The course stressed posing, arrangement, and lighting. That December too the newspaper's women's column reported Krasner as one of the "girls who have had work on exhibition for December."[29] She also took Oil Painting—Portrait and art history, which was a required lecture course.

Krasner's work was among those chosen by a designer for the Famous Players–Lasky Corporation, who visited the costume class to select for an exhibition student work from a project that aimed "to change the styles for men," replacing tweeds with "light comfortable garments."[30]

Despite this success, Krasner was not like most of her class-

mates, who thought about jobs in industry after studying at Cooper. She was planning to be a painter. No doubt that she was already beginning to learn about the existence of modern art. In Cooper's weekly student newspaper, *The Pioneer,* there were discussions of modern painters and reviews of their works when shown at New York galleries. On February 17, 1928, a show of Cézanne's work at the Wildenstein Gallery was praised for his "cosmic truths," and his "warmth and sincerity." The same writer remarked, "In Matisse, in Derain and in Segonzac, no one can readily see the reflection of Cézanne, but in Cézanne, one sees all and more."[31]

Other shows reviewed in the Cooper newspaper that term included a show of Degas at Durand-Ruel, the Independent Artists held at the Waldorf Hotel, and the work of George Bellows, Ralph Blakelock, and Albert Ryder at the MacBeth Gallery. Even a Picasso still life in the latest "Surrealist" manner drew a student journalist's attention.[32] Thus, by the time Krasner left Cooper to enroll at the National Academy, it is likely that she already had some sense that there was more going on aesthetically than her instructors at Cooper had been willing to admit.

In spring 1928, Krasner continued to study portrait painting, life drawing, and art history. She also added courses in perspective and anatomy. By then she was in the third alcove, studying "in cast" the full figure with the French-born Victor Semon Perard. She got along very well with Perard, her lecturer for anatomy, who appreciated her abilities enough to pay her the first compensation she ever received for making art. Known as an etcher and a lithographer, Perard employed Krasner to make illustrations for his book, *Anatomy and Drawing* (1928)—"a page or two for his book of hands and feet, blocked hands and feet from a cast."[33] She recounted that she told herself: "This is easy!" She imagined that she could earn a living from selling her artwork. Years later, when Krasner was shown a copy of Perard's book, long since out of print and which she had not seen in fifty years, she proudly turned to

her sketch, "Studies of Hands Method of Blocking." The cubical forms, which do not resemble the book's other illustrations, perhaps hint at the modernist beginning to emerge.[34]

Perard's recognition was meaningful to Krasner. She did not, however, win any of the official prizes—110 in all—awarded that year to "Cooper Union girls." For those in their second year, the awards were given for recognition in drawing and sketching in black and white, for watercolor, mural painting, and even for drawing in crayon.[35]

Even though she was encouraged by Perard's response to her work, Krasner left after the spring term of 1928. "I decided I ought to do something more serious than Cooper Union."[36] She had already begun to share a studio at 96 Fifth Avenue (at Fifteenth Street) with some friends. Their rented quarters were near the Cooper Union Studio Club west of Union Square, where student members could work outside of school hours. Girls were known to go to Washington Square Park to sketch alfresco.

Krasner supported her share of the rent by modeling in the nude for Moses Weiner Dykaar, whose studio was located in the same building. Years later her friend the sculptor Ibram Lassaw recalled that he first met Krasner when she was working as a model.[37] Lassaw studied from 1931 to 1932 at the Beaux-Arts Institute of Design in Midtown, which held life modeling and other courses, where Krasner might also have modeled.

Although Dykaar liked to sculpt figures as well, he was known for his portrait busts, and had modeled one of Calvin Coolidge and other notables for the Senate Gallery in the United States Capitol.[38] Krasner might have been encouraged by Dykaar's success, since he had progressed from an impoverished young Jew in Vilnius (Lithuania, in the Russian empire) to studying art in Vilnius and in Paris at the Académie Julian. Nevertheless, she found him "bitter."[39]

Dykaar encouraged Krasner to enroll at the Arts Students League on West Fifty-seventh Street, which he considered less

structured than Cooper Union and more serious. In July she began study with Canadian-born George Brant Bridgman for a life drawing course. She studied five days a week in the mornings. Bridgman, like Hinton at Cooper Union, had studied in Paris with Gérôme and Bouguereau. In his teaching, Bridgman promoted a system of "wedging" to convey the twisting and turning of the human figure. Known to be "prim and meticulous," Bridgman was said to glower "at any student who wastes drawing paper or sits a few inches out of line from the other students. Occasionally he stops to drop a sardonic remark or to redraw, in heavy accurate lines, an improperly pitched shoulder or a badly proportioned leg." [40] Nor did he permit nude models in classes that mixed men and women. As might be expected, Krasner's determination to maintain her own emerging style conflicted with this French-Academic-trained teacher, as it had with Hinton, who was similarly trained. The Art Students League was not to Krasner's taste, and she decided to move on to the National Academy of Design.

Then suddenly Lee's older sister Rose died of appendicitis on July 9, 1928, leaving behind her husband, William Stein, and two small daughters, Muriel Pearl and Bernice.[41] According to Old World Jewish tradition, the next in line—Lee—the eldest of the two remaining unmarried sisters, was supposed to marry her brother-in-law and raise the children. But Lee refused. Though she doted on her nieces, she believed she had another destiny and would not even consider such a marriage. The responsibility fell to Lee's younger sister, Ruth, who, it seems, never forgave her sister.

## FOUR

# National Academy and
# First Love, 1928–32

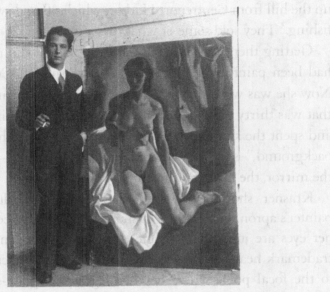

Igor Pantuhoff and his portrait of a nude model,
c. 1930. At the National Academy, Igor, a tall,
handsome, charming White Russian who boasted
of an aristocratic lineage, was easy to notice.
Younger than Krasner by three years, he often
won prizes for his work.

L ATE IN THE SUMMER OF 1928, LEE STARTED AN AMBITIOUS SELF-
portrait to qualify her for the life class at the National
Academy of Design. She set herself up outdoors at her par-
ents' new home in Greenlawn (Huntington Township) on Long
Island's north shore. They had purchased a modest rural house
with a separate garage (that might have been an old barn) in May
1926,[1] when Joseph was fifty-five and Anna was nearly forty-six.
(The 1930 census says that Lee's parents still lived in the Brooklyn

house they rented for $50 a month; Lee and Irving were also still living there.)[2] After nearly two decades of physical drudgery and economic uncertainty as fishmongers, Joseph and Anna longed for a country life like the one they'd had in Shpikov. The house, next to a small lake, was simple with no indoor plumbing, but they could grow vegetables, raise chickens, and sell eggs. It was also just up the hill from Centreport Harbor, which offered swimming and fishing.[3] They sold some of what they grew.

Getting there was easy via the Long Island Railroad. Krasner had been painting from life even before she left Cooper Union. Now she was working with confidence, producing an oil painting that was thirty by twenty-five inches. "I nailed a mirror to a tree, and spent the summer painting myself with trees showing in the background," she remembered. "It was difficult—the light in the mirror, the heat and the bugs."[4]

Krasner showed herself in a short-sleeved blue shirt and painter's apron. Her hair is cut short; her rouged cheeks stand out; her eyes are just intense white dots that glint from beneath her trademark heavy eyebrows. One full arm extends across her body to the focal point where her hand grasps a paint-spattered rag and three brushes tinted with color, while the other arm just vanishes at the canvas. By depicting herself in the act of painting, she thus asserts her identity as a painter. Yet the picture contains a puzzle: why does it show her clutching her tools in her right hand while working on the canvas with her left? She was right-handed and painted with her right hand.[5] Evidently her mind had not reckoned with the mirror's reversing effect, exhibiting left-right confusion that today is often considered a symptom of dyslexia.[6]

Though dyslexia is today known as a common disability caused by a defect in the brain's ability to process graphic symbols, it was not understood during Krasner's lifetime. Considered a learning disability, dyslexia does not reflect any lack of intelligence. Dyslexics might start math problems on the wrong side, or want to carry a number the wrong way. Similarly, Krasner habitually began her

paintings from right to left, working in a manner that was atypical in a culture that reads from left to right. A dyslexic's unique brain architecture and "unusual wiring" also make reading, writing, and spelling difficult. Many dyslexics, however, are gifted in areas that the brain's right hemisphere is said to control, among them artistic skill, vivid imagination, intuition, creative thinking, and curiosity—characteristics that could be used to describe Krasner.

Her lifelong propensity for asking people to read aloud to her as well as her frequent spelling errors and dislike of writing suggest that she suffered from a dyslexic's confused sense of direction, which often impedes reading and writing. However, as was the case with Krasner, comprehension through listening usually exceeds reading.

On September 17, 1928, nineteen-year-old "Lenore Krasner" formally applied to the National Academy of Design, then located "in an old wooden barn of a building" in Manhattan at 109th Street and Amsterdam Avenue, not far from the Cathedral of St. John the Divine.[7] A little more than a week later, she gained admission, with free tuition for the seven-month term. There were about six hundred students there, and for the first time since elementary school, she was with females and males.[8]

The academy's creed seemed to mesh with Krasner's ambition to become an artist: "Only students who intend to follow art as a profession will be admitted."[9] The academy advertised "a balanced system of art education, combining both practical study and theoretical knowledge."[10] Applicants had to practice drawing from casts of famous ancient sculptures until they could qualify for the life class by submitting an acceptable full-length figure or torso drawn from a cast.

Despite her new self-portraits, Krasner had to begin again by drawing from the antique. Even worse, she again faced her old nemesis from Cooper Union, Charles Hinton, who taught the traditional introduction at the academy. Neither the teacher nor the rebellious student wanted to repeat their previous clash. Kras-

ner remembered: "He looked at me and I looked at him, and this time there wasn't anything he could do about getting rid of me [by sending me to the next level] as it took a full committee at the Academy to promote you."[11]

Her opinion of Hinton was shared by her classmate and friend Esphyr (Esther) Slobodkina, who referred to him, with irony, as "our pretty Mr. Hinton" and as a "genteel mummy of a teacher." She complained that "if not for that dear, kindly Mr. [Arthur] Covey, our teacher in composition, and a few friends that I made, I surely would have gone out of my mind in that completely sterile atmosphere of permanently congealed mediocrity."[12]

Slobodkina was an immigrant on a student visa, so she had to sign in at the academy but was so disgusted with the school that she did little more than that. "When Mr. Hinton came to give me his 'criticism,'" she recalled, "I patiently waited for him to slick up a few spots on my far-from-inspired work while mumbling something about light and shade, and flowing line. The poor, old, doddering cherub knew no more what the real art of drawing was about than the school janitor. Yet he was there for years and years, ruining countless young, fresh, promising talents."[13]

Slobodkina was from Siberia, where her father managed a Rothschild-owned oil enterprise. Before arriving at the academy, she had trained in art and become familiar with modernism in Russia. Though she later won an Honorable Mention for Composition in 1932, Slobodkina quickly became disillusioned with the school's conservatism, as would some of the other more adventuresome students including Krasner, Herbert Ferber, Giorgio Cavallon, Byron Browne, and Ilya Bolotowsky—all destined to make names for themselves.

When Krasner was finally able to present her self-portrait to the appointed committee, they judged it so fine that they didn't believe it was done outdoors. "When you paint a picture inside, don't pretend it's done outside," they admonished her.[14] The committee chair, Raymond Perry Rodgers Neilson, a well-known

portrait artist, then forty-two, scolded, "That's a dirty trick you played." [15]

Nevertheless Krasner preferred him over Hinton. "It was no use my protesting, but he passed me anyway—on probation! At this time I had not seen any French painting; I had simply tried to paint what I saw. His reaction was very shocking to me. But now I suppose I must have seemed to him like some smart-aleck kid trying to imitate the French and show them all up. And I assume now they were all worried by the French." [16] In interviews years later, Krasner made much of being admitted on probation. But the catalogue stated: "All new students are admitted on probation" with advancement only by producing appropriate work.

Academy records document that Krasner was promoted to "Life in Full" for a one-month "trial" as of January 26, 1929. [17] "Life in Full" referred to leaving plaster casts behind to draw full-time from a live model. A related *Self-Portrait* survives in pencil and sepia watercolor on paper. To create the work, she glanced back over her shoulder into a mirror; her short haircut suggests that she created this work around the time of her outdoor oil self-portrait. Krasner explained that she had done a series of self-portraits, "not because I was fascinated with my image but because I was the one subject that would stand still at my convenience." [18] After her promotion, her record card for that first year reveals that someone drew a line through Hinton's name, as she dropped out of his dreaded class. Instead the name "Neilson," who taught the desired "Life Drawing and Painting" on Tuesday and Friday mornings, was written in. [19]

Krasner's outspokenness would keep getting her into trouble. A note on her record card states, "This student is always a bother—locker key paid—but no record of it on record—insists upon having own way despite School Rules." Krasner was very much a product of her Jewish immigrant culture. Growing up in a large impoverished family and having to fend for herself had made her into a fierce defender of her rights—as she saw them.

Furthermore, it had been necessary for her to look out for herself in the poverty-stricken immigrant communities in Brooklyn, where anti-Semitic gangs sometimes caused havoc—a precarious situation all too similar to the one her family had faced as Jews in Russia.

Of the 580 students (238 women, 342 men) who attended the academy that year, only 479 survived the entire school year. Krasner made friends with both men and women, but later mentioned only the men that she'd made friends with, most of whom later won recognition as artists: Byron Browne, Ilya Bolotowsky, Giorgio Cavallon, Boris Gorelick, Igor Pantuhoff, and Pan Theodor.[20] One classmate opined that two of the best-looking men were Browne, who was "tall, blond, strong and as radiantly handsome as a summer morning in a northern country," and Igor Pantuhoff.[21]

Although most students at the academy were Americans, there were also many international students, including some from Austria, China, France, Hungary, Canada, England, Italy, and Russia. Besides Esphyr Slobodkina, who was only there on a student visa because recently imposed quotas impeded her from immigrating legally, the "Russian" contingent included Eda Mirsky, her sister Kitty, Gorelick, Bolotowsky, and Pantuhoff.

Krasner became especially close to the Mirskys, Eda and her older sister Kitty. The sisters worked in contrasting styles: Eda painted flowers and children in "lavish colors, sensuous shapes," while Kitty preferred dark and brooding seascapes and kittens. Eda won the School Prizes of $15 for both the Still Life class and the Women's Night Class—Figure in 1932.

Their Russian-Jewish family had emigrated from Ukraine to England, where the girls were born, then to the United States, settling in the Bronx when the girls were still children. They eventually moved to Edgemere, Long Island. Their father, Samuel, was a self-taught portrait painter who earned a good living, working on commissions from his studio at Union Square. Kitty started study-

ing at the academy two years before Krasner. By the time Krasner encountered the Mirskys, they were living in Manhattan.

The Mirskys were conversant with their father's work as an artist, and this gave them a sophistication about art that Krasner lacked because she had no such role model at home. Yet the Mirsky daughters also had to deal with their father's judgment—both his criticism of their work and his high standards for what it took to be an artist. Nevertheless this did not deter them from pursuing art. Eda told her daughter, the author Erica Jong, that she "could have gone to college anywhere I chose—but since Kitty quit school and went to the National Academy of Design, and since she was always coming home with stories of how splendid it was, how many handsome boys there were, how much fun it was, I decided I wanted to leave school too. . . . Papa let me."[22]

Eda became a star at the academy, but with a bitter twist: "the teachers always twitted the boys: 'Better watch out for that Mirsky girl—she'll win the Prix de Rome,' which was the big traveling scholarship. But they never gave it to girls and I knew that. In fact, when I won two bronze medals, I was furious because I knew they were just tokens—not real money prizes. And that was because I was a girl. Why did they say 'Better watch out for that Mirsky girl!' if not to torment me?"[23] Eda was so frustrated by the sexism that years later she discouraged her daughter, Erica, from pursuing a career in the visual arts when Erica went to the High School of Music and Art and the Art Students League.[24]

Eda's granddaughter, the author Molly Jong-Fast, recalled her grandmother "screaming about socialism," a concern that would have interested her friend Lenore.[25] Lenore and Eda's friendship was so close that Lenore agreed to pose for at least two portraits. They capture Lenore's likeness and personality with extraordinary confidence. One shows her long, luxuriant hair, while in the later one, clad in a fashionable striped jacket, she sports the short haircut of a flapper. Lenore also gave Eda a self-portrait painted in the basement of her family's house in Brooklyn.

The basement portrait, a moody, wide-eyed image, resembles the style of Krasner's future teacher Leon Kroll, who would have appreciated Lenore's decision to pose before a mirror in half-shadow with the sunlight pouring through the basement window behind her, illuminating a potted plant and one side of her face. The portrait already shows remarkable sophistication and skill. Krasner's ability was not lost on Eda, who treasured the gift and finally, in 1988, gave it, along with her own two portraits of Krasner, to the Metropolitan Museum of Art.

Like Krasner, the Mirsky sisters studied with the despised Hinton and with Charles Courtney Curran. Curran, who was nearly seventy years old at the time, was equally old-fashioned in his style of teaching. Born in Kentucky, he had studied at the Académie Julian in Paris and exhibited at the Salon. Curran had won a number of prizes in the 1880s and 1890s in both Europe and the United States. At the time he taught Krasner he also held the prestigious position of the academy's corresponding secretary. His impressionistic style might have seemed like a breath of fresh air to Krasner had she not been attracted instead to the new Museum of Modern Art and its more radical program of showing Matisse, Picasso, and abstract art.

Krasner was attracted not only to modernism but also to a coterie of Russians who shared her enthusiasm. It was as if she felt at ease with people who shared the origin of her parents, older siblings, and mother's brother. On her registration card for the academy, the category "where born" correctly reads "New York City," but to the right on the same line is typed "Russia." The note reappears on cards for successive years, making it less likely that it's accidental. Some years, the word *Russia* follows the letters *M* and *F,* which seem to stand for the birthplace of "Mother" and "Father." Krasner may have been born in America, but she still spent her time with the Russians, most of whom were Jewish. But one of them who caught Krasner's eye definitely was not.[26]

A tall, handsome, charming White Russian, Igor Pantuhoff

was easy to notice. He was younger than Krasner by three years but boasted of an aristocratic lineage. Gossip about his background circulated among his fellow students and later among his contemporaries. Joop Sanders, a younger Dutch painter who settled in New York, recalled meeting Pantuhoff in the late 1940s through their mutual friend, the artist Willem de Kooning, and said that "Igor was very elegant and good looking with a smooth European manner."[27] Robert Jonas, another artist who befriended both de Kooning and Pantuhoff, later recalled that Pantuhoff's father was "a captain of the guard of the Kremlin."[28]

Oleg Ivanovich Pantuhoff was born in Kiev in 1882—the youngest son of a physician who had been a general in the Army Medical Corps—and had been an energetic young colonel, a commanding officer of the Russian Imperial Guard, and a staff member to Tsar Nicholas II. The tsar commissioned him to start a branch of the Boy Scouts in Russia (the National Organization of Russian Scouts, founded in St. Petersburg in 1909).[29] Colonel Pantuhoff became the first Chief Scout and the tsar's son, Alexei, was the first Russian Scout, placing Pantuhoff quite close to the imperial family.

When Colonel Pantuhoff named his second son Igor, he was expressing his ardent Russian nationalism, because the name recalls a twelfth-century Russian prince whose exploits were immortalized in an anonymous epic, *Song of Igor's Campaign*.[30] At the time of Igor's birth, the Pantuhoffs employed a children's nurse, a maid, a cook, and an orderly. Igor's mother, Nina Michailovna Dobrovolskaya, was ill for nearly a year after the boy's birth. At her doctor's suggestion, she left her family and resided in Davos, Switzerland, and then in a spa near Salzburg. She continued to suffer from asthma and was frequently absent while she visited various clinics in search of a cure.

As small children, Igor and his older brother, Oleg, Jr., lived with their parents in Tsarskoe Selo, the town devoted to the Imperial Palace and also where the last tsar officially resided.[31] During

spring and winter seasons, however, the two boys went to live with their grandmother in St. Petersburg, just sixteen miles away. They also stayed with their grandmother when their father went off to war.

The Russian Civil War began in 1918. Colonel Pantuhoff served with the White armies against the Bolshevik Red Army and "took part in the last defense of the Kremlin against the Bolsheviks."[32] As the fighting escalated, the Pantuhoffs fled first to Moscow and then to the Crimea on the Black Sea. Food became scarce. In his memoirs, Colonel Pantuhoff described how his family suffered from malnutrition. Both Igor and his brother developed jaundice; Oleg, Jr., became so weak that he could not walk. Their mother was also quite ill and weak, suffering from bouts of pneumonia.

Despite his family's suffering, Colonel Pantuhoff continued to work with the Boy Scouts, many of whom he later described as "sons or grandsons of men wounded or killed in the world war or the civil war. . . . Their recent experiences so confirmed them in loyalty to their country and to their church that, even after the Bolsheviks had outlawed scout activity, some persisted secretly in scout work."[33] He also wrote about "a large Jewish Boy Scout group in Sevastopol known as the Maccabees. Their leaders were good men and their boys looked very smart. On one occasion they invited me and other scoutmasters to inspect their unit and then asked to become part of the Russian Boy Scout organization." After conferring with his colleagues, Pantuhoff "decided that since they were not of our religion and carried a flag with the Star of David, our bylaws precluded their joining us."[34] Pantuhoff would later try to impose this same kind of exclusionary thinking on his sons in America.

During the height of the war, the brothers suffered from either changing schools or having no school at all. Colonel Pantuhoff wrote that Igor, who studied less well than Oleg, "lagged sadly behind in reading" but developed "unquestioned talents in drawing"

and "definite talent as an actor."[35] Igor's parents did what they could with homeschooling. After the Red Army recaptured Kiev on December 17, 1919, the major fighting ended, and the defeated Cossacks fled back toward the Black Sea. Colonel Pantuhoff finally decided to put his safety and that of his family first and joined more than a million Russian refugees from the Bolsheviks. The Pantuhoffs now had to cope with sudden poverty.

They sailed on a freighter from Sevastopol and landed on March 5, 1920, in Constantinople (now Istanbul), which was still under Allied control after World War I.[36] The boys were placed in two different boarding schools: Igor's, Yeni Kioi, had an English headmaster.

The Bolsheviks soon banned the scouts and, beginning in 1922, purged the scout leaders, who either perished or had already gone into exile along with other White Russians. Igor became a Cub Scout in Constantinople until early September of that year, when the Pantuhoffs sailed for the United States, arriving on the tenth of October.

Having moved about during most of Igor's childhood, the family finally settled down at 385 Central Park West—far in both distance and culture from the Brooklyn immigrant neighborhood of the Krasners. The Pantuhoffs' lifestyle, however, was not elegant. Like many other immigrants, the family could afford their apartment only by taking in four boarders.[37] Igor's brother modeled his life on their father's military career, joining the U.S. Army and distinguishing himself as a translator. Igor's mother had studied art in St. Petersburg at the art school of Ian F. Tzionglinsky, an ardent follower of Impressionism, and at the school of Technical Design of Baron Aleksander Stiglitze. Igor's father also enjoyed painting, so Igor took after both parents.[38]

Pantuhoff had already spent a full year at the academy when Krasner arrived there. In October 1928, Pantuhoff won an honorable mention in the required submission category, "A Corner of New York: Noon Hour," a theme that all competing had to

produce. The next spring, Krasner's second term, he won multiple prizes in the categories of painting from the nude, figure, still life, and composition.[39] Since he registered his name as "Igor Pantuckoff," it appears that he had not yet decided on how to anglicize it. Evidently names shifted among the emigrés; Ilya Bolotowsky was also "Elias" and Giorgio Cavallon also "George."[40] It would take still more time for "Lenore Krassner" to become Lee Krasner.

The new student at the academy caught the attention of the rising star. Just twenty-one, Krasner was outgoing and slender with a model's figure. She delighted in her first experience in a coed institution since elementary school. She was ambitious and determined to be an artist. To her, Pantuhoff embodied the sophistication of European culture. He exuded style, which was completely missing in her background.

The two soon became a couple. He began to style and present her to the world like a Pygmalion. She enjoyed the glamorous clothing and exotic jewelry he picked for her to purchase, even if her modest budget suffered. Whatever qualms Krasner might have had about Pantuhoff's attempts to transform her appearance faded in the context of Jazz Age New York, when the image of the flapper redefined modern womanhood. Rigid Victorian customs gave way, leaving young women to cope with sexual liberation. They now had new opportunities to dress in more revealing clothes and to wear makeup, once associated with prostitutes, but now fashionable in the Roaring Twenties.

Pantuhoff's attention to Krasner earned her some envy. Slobodkina grumbled, "Half the girls in school, including Kitty and Eda Mirsky, hung around him. His particular lady of the time was the extremely ugly, elegantly stylized Lee Krasner. She had a huge nose, pendulous lips, bleached hair in a long, slick bob, and a dazzlingly beautiful, luminously white body."[41] Slobodkina seems to have gotten a surprise from Igor when she first began to attend the academy morning sessions. She wrote in her memoir: "A dashing young man, the darling of the female student body, by the

name of Igor Pentukhov [*sic*] heard of the arrival of a new student a young lady not so bad to look at and a Russian at that. One late morning he rushed to our all female class, and finding me busily bent over the eternal drawing from the cast of Venus de Milo, unhesitatingly planted a gentle kiss in the temptingly low-cut décolleté of my back."[42] Slobodkina turned around and slapped his face. He protested that he just wanted to meet her and speak a little Russian. She snapped back that she was there to speak English and to learn to paint. "I must say he was not heartbroken."

Krasner was apparently less rejecting of Pantuhoff's flirtatious nature. Slobodkina's memoir documents that it was not unusual among the academy's students for them to form live-in relationships before marriage. In one case, however, Slobodkina commented that their classmate Gertrude "Peter" Greene was "indefatigable in her search for new partners. I suspect that she had a touch of nymphomania in her"; but she and others viewed Krasner as loving and faithful to Pantuhoff.[43] In fact many of their teachers and friends eventually believed the two were married.

In contrast with nineteenth-century precepts of womanly virtue, this era began to view sexual activity before marriage as no longer a grave moral breach. It was even commended by some books of advice. "The girl who makes use of the new opportunities for sex freedom is likely to find her experiences have been wholesome . . . she may be better prepared for marriage by her playful activities than if she had clung to a passive role of waiting for marriage before giving any expression to her sex impulses."[44]

Enchanted by Igor, Lee was relieved when her younger sister, Ruth, then only eighteen, stepped up to meet the family's responsibility of providing a wife for their sister's widower by marrying him on February 5, 1929. Ruth's new husband, Willie Stein, operated the projector at the Pearl Movie House in Brooklyn, then owned by his father, Morris Stein.[45] Ruth accepted the burden (or the opportunity) of raising Stein's two small daughters as her own. According to the 1930 federal census, Krasner apparently still

lived at home at 594 Jerome Street with her parents, along with her brother Irving.[46] Her sister Ruth and her husband, William Stein, along with Muriel and Bernice, his two daughters, also lived at the same address. Lee occupied the basement room and shared the kitchen and bathroom upstairs.

Pantuhoff often visited Krasner at her home. One of her nieces, Muriel, treasured her times with the couple. "I used to sit on [Igor's] lap and he would tell me stories and give me sips of wine."[47] Muriel remembers that Pantuhoff always had a glass of wine and that he smoked a lot. She also described her Aunt Lee as a frequent and beloved babysitter, who was much needed after Ruth's only child, Ronald Jay (Ronnie) Stein, was born in September 1930. For Muriel, Lee was "like a second mother"—very kind, helping her with her clothes, taking her out to eat, and teaching her "what the world was like."[48] Lee sometimes took Igor to visit her parents in Greenlawn, especially during the summers, where he would paint Muriel's portrait and landscapes. Krasner often took Muriel and Bernice to the circus and to shop for clothes, and "other such treats."[49] The sisters found Aunt Lee to be much warmer than their stepmother, Ruth. Aunt Lee often accompanied the girls to the movies at the Pearl, where their father worked until 1929. The theater, which was just north of East New York, had inspired Muriel's middle name.

The theater opened in 1914 and could draw about five hundred spectators for its second- and third-run films. Muriel recalls how thrilled she was to see Greta Garbo and Clark Gable and be with her Aunt Lee.[50] Muriel and her sister viewed their aunt as "a second mother," who was "kind and generous; she really wanted children and never had them." Conversely, Lee probably viewed her nieces as if they were her children—at least children whose lives she could enrich without taking primary responsibility for them. Later she would famously dote on their half brother, Ronnie Stein.

When the stock market crashed in October 1929, the academy's

adventuresome students didn't even seem to notice. No records have survived of any reaction from the students. Indeed it was not until 1930 that the grip of long-term economic depression took hold. Furthermore, for many of the students, especially those from immigrant families like Krasner, there had always been a worry over money.[51] Krasner's acquaintance and contemporary Lionel Abel, a playwright and critic, wrote that in November, "I did not even know that there had been a crash on Wall Street during the previous month. When I say I did not know about the crash, I do not mean that I had not read of it. I mean merely that it had no special significance to me."[52]

At the same time that Krasner gained admission to the Life Class at the beginning of 1929, she also enrolled in Charles Court-ney Curran's day class and the night class of Ivan Gregorewitch Olinsky, an affable Russian Jewish immigrant who was a highly successful portraitist who had work in major galleries. Olinsky was born in Elizabethgrad (Kirovohrad in the Ukraine) and emigrated with his family when he was twelve. Just after Alexan-der III ascended the throne, in April 1881, their town underwent two days of government-sanctioned pogroms. Many Jews were raped or murdered, and their property was destroyed. Olinsky and his family survived and managed to emigrate before an uprising in 1905 when many more Jews met their death. Given Olinsky's painful experience with anti-Semitism, it is not surprising that he often emphasized his Russian origins over his Jewish identity.[53]

Luckily for Olinsky, his family settled in New York, where he enrolled at the academy under the artists J. Alden Weir, George W. Maynard, and Robert Vonnoh. He also did a stint working for John La Farge, helping to make both murals and stained glass. Olinsky's portraits and figure paintings, while aca-demic in style, do show the influence of impressionism. He was purportedly so successful as a portraitist that he sometimes had no work for sale in his studio. He was represented by major New York art dealers such as the Macbeth and Grand Central galleries.

Middle-aged, established, and set in his ways, Olinsky nonetheless provided Krasner with a link to her family's ethnicity. His "Russian" profile at the academy may have represented a new possibility of assimilation and social acceptance for Krasner, whose own family was much more identified with Jewish insularity and isolation. Still, Olinsky offered no new aesthetic direction she could call her own.

That autumn Krasner added a fourth class that would occasion a significant turn in her artistic development—Still Life, taught with criticisms on Wednesday afternoons by the septuagenarian William S. Robinson. Robinson had studied at the Académie Julian in Paris, and the "extra" class that he taught was open to students "sufficiently advanced, whenever they desire to paint from the still life model." Attendance was required for three afternoons during the week.

Meanwhile Cézanne, Gauguin, Van Gogh, and Seurat were featured in the Museum of Modern Art's inaugural show on Friday, November 8, 1929. Throngs attended the opening, and the museum announced that it was open free to the public for the day.[54] The show's ninety-eight pictures were revelatory to many, who had to seek them out in the museum's first quarters, a few rented rooms on the twelfth floor of the Heckscher Building at 730 Fifth Avenue. The museum's director, Alfred H. Barr, Jr., told the press that "several art connoisseurs who had been known for their antipathy to modern painting were 'converted' after seeing the exhibition."[55]

Founded by three progressive and socially prominent women—Miss Lillie P. Bliss, Mrs. Cornelius J. (Mary Quinn) Sullivan, and Mrs. John D. (Abby Aldrich) Rockefeller, Jr.—the Modern challenged the conservative outlook of the National Academy. Curious and rebellious young artists like Krasner would naturally be attracted to the promise of a new aesthetic freedom.

Krasner went to the newly opened museum that Saturday with a group of classmates. "We disbanded after leaving the show, and

there was no time to compare notes. But on Monday morning we met again at the academy. Nothing was said, but the after-affects were automatic. We ripped down the red and green velvet curtains—they were always behind everything from the wall into the middle of the room. The model came in, he was a Negro, and wearing a brightly checked lumberjacket. He started to take it off, but we all shouted 'No! Keep your jacket on!'"[56] She often spoke of how encountering "live Matisses and Picassos" had an immediate effect on her and had inspired the students, who "decided to do what we saw in front of us."[57]

She delighted in telling how, when their portrait instructor, Sydney Edward Dickinson, showed up to give the next criticism, "he was so irritated with what he saw that . . . he picked up somebody's brushes and hurled them across the room, saying, 'I can't teach you people anything' and left."[58] Dickinson's angry response to the students' visual provocation was particularly startling. Krasner had described him as "a very charming, delightful man, who practically never raised his voice. He was extremely patient."[59] Having studied portrait and still life painting with the conservative William Merritt Chase and figure drawing with the traditionalist George Bridgman, Dickinson was a successful painter of society portraits, but he could not accept modernism.[60]

Krasner's work in her still life class suggests that she treasured MoMA's catalogue long after the show came down. She painted floral and fruit subjects including *Still Life with Apples* and *Easter Lillies,* both using a darker palette, though in the latter she daubed orange on the green cloth beneath the vase. However, both Krasner's modeling of her *Apples* and her decision to tilt the tabletop toward the picture plane suggest that she had been looking with care at both Cézanne and Gauguin. Krasner signed *Easter Lillies* as "L. Krassner" boldly on the bottom right.

At the Modern's inaugural show, Krasner would have seen at least six still life images of Cézanne's apples. Two of them probably had an impact on her. In Krasner's *Apples* still life, she depicts

apples piled on a plate seen from above. Her decision to place a single apple to the left, apart from the others on a cloth that does not lie flat, appears to echo a Cézanne then owned by Joseph Winterbotham and on loan for the show. Another Cézanne, from the Étienne Bignou Collection, has a similar arrangement of apples piled on a plate also repeating the visual emphasis on the table's back edge across the canvas. Krasner's decision to tip both the table and the plate forward, however, is actually closer to Gauguin's still life in his *Portrait of Meyer de Haan,* which was both in the show and reproduced in the catalogue.

"It was an upheaval for me," Krasner exclaimed, speaking of modern painting, "something like reading Nietzsche and Schopenhauer. A freeing . . . an opening of a door. I can't say what it was, exactly, that I recognized, any more than some years earlier I could have said why it was I wanted to have anything to do with art. But one thing, beyond the aesthetic impact: seeing those French paintings stirred my anger against any form of provincialism. When I hailed those masters I didn't care if they were French or what they were." [61]

Krasner also had problems with the academy beyond aesthetic differences. Even the rules that governed painting in still life made her angry. For example, she learned that anyone wanting to paint still life with fish had to do it in the basement, where it was cooler and the fish were slower to rot. The problem was that no women were allowed downstairs. "That was the first time I had experienced real separation as an artist, and it infuriated me. You're not being allowed to paint a . . . fish because you're a woman. It reminded me of being in the synagogue and being told to go up not downstairs. That kind of thing still riles me, and it still comes up." [62]

In protest, Krasner, the fishmonger's daughter, made the forbidden foray into the basement to paint fish with her pal Eda Mirsky, a star student. The faculty was so offended by the girls' rebellious gesture that it suspended them on December 7, 1929,

for "painting figures without permission." It took the signature of "CCC"—their teacher Charles Courtney Curran—to restore their student status after the suspension. In an interview with Eda Mirsky when she was ninety-nine years old, the artist beamed at the thought of her youthful act of defiance with Krasner. She insisted that it was the only time she got in trouble.[63] Surprisingly, Krasner later interpreted the experience differently, saying, "I had absolutely no consciousness of being discriminated against until abstract expressionism came into blossom."[64] This was one of her rare inconsistent moments, which may have sprung from her thinking in a different context.

If Krasner's rebellious attitude kept her from winning any prizes at the academy, it did not prevent Eda Mirsky's recognition there—at least the small prizes that they allowed for women. As for Krasner, by her second term in 1929, she was made a "monitor," which helped to pay for her materials and other expenses. According to Slobodkina, monitors were usually chosen by the students in a class.[65] But a teacher, if displeased, could surely replace the monitor.

Despite Krasner's problems with the academy, her fellow students seem to have recognized in Krasner the qualities of common sense, leadership, and a practical nature, since they made her secretary of the Students' Association even before she got into trouble. Careful minutes for November 11, 1929, remain on file: $327 profit, school dance; $227 taken out for "student's show," as well as $120, loaned to the students' supply store, leaving an active balance of $20.

Krasner continued to study during both day and night classes with Olinsky. As the academy required, he conducted separate life classes for men and women. Krasner's classmate Ilya Bolotowsky also liked Olinsky. He remarked years later that he thought that the National Academy: "was a very bad school. . . . The teachers were extremely academic, although Olinsky was not; he was sort of a modernist. I was considered a rebel and a bad example

because I was experimenting in color, rather modest experiments but for the Academy it was wild. We were warned not to follow people like Picasso, Cézanne . . . because Picasso never learned how to draw and Cézanne never learned how to paint, and other advice of this nature." [66]

The faculty that Bolotowsky described is also the one that continued to esteem Igor Pantuhoff, who also studied with both Neilson and Olinsky. They awarded him the Mooney Traveling Scholarship in spring 1930, enabling him to travel to study the old masters in Europe. The award meant a temporary separation for Pantuhoff and Krasner, who were already viewed as a couple according to May Tabak Rosenberg. [67] With Pantuhoff gone, Krasner could focus on advancing her own career, which he encouraged. [68]

According to the 1930 federal census, even though Krasner was registered as "Lenore" at the academy, she gave her name to the census taker as "Lee," having already adopted this nickname permanently during Cooper Union days; on April 11, she gave her age as twenty-one, which was correct, because she would not have her birthday until October. She had not yet begun her habit of lying about her age. She continued to include a second *s* in Krassner.

Though Krasner continued to serve as the monitor of the night class, she was not among the winners of bronze medals or honorable mentions that went to four of the female students in "Drawing from Life—Figure." In November 1930, Krasner was again taking Life in Full, continuing under Curran by day and Olinsky by night. Her work as the monitor for the night class suggests that she got along well with Olinsky. That year Krasner also attended lectures in art history, and lithography and took Chemistry of Color. In the spring of 1931, she attended lectures on the history of architecture, stained glass, and mosaics; the latter would prove particularly useful.

With Krasner in Curran's class in 1930 and 1931 was Joseph Vogel, a Polish-born Jewish immigrant, who lived with his fam-

ily in the Bronx. Vogel's family was also poor and struggling to make ends meet. By January 1931, the Depression hit hard, and his registration card noted: "Given time to pay; Entire family out of work." Vogel and Krasner took a class in the fall of 1931 with a new instructor named Leon Kroll.

Kroll had just arrived at the academy and was teaching Life in Full. He was gregarious, short, Jewish, and he painted portraits, figures, and landscapes. But most important, he was sophisticated enough to admire and talk about Cézanne, which caused the students to view him positively as a more progressive teacher. They did not know that Kroll's background included painting with the realist Edward Hopper in Gloucester in 1912, and, just before World War I, befriending the modernist artists Sonia and Robert Delaunay in Paris, who were already painting adventurous, colorful cubist-inspired abstractions. Vogel remembered Kroll as the "Bolshevik of the Academy," which, considering Vogel's politics, was a compliment.[69]

Krasner recalled that "when it was announced that Leon Kroll was coming to the National Academy, it was as if Picasso was coming." But she soon found him to be "very academic and hostile."[70] Kroll, once ensconced at the academy, seemed to have forgotten the modernist colors of the Delaunays. Krasner recalled that "one day this model came in and she was wild, her face was white, her hair was orange, she had purple eyelids and black round the eyes. I was the class monitor, and booked her right away, even though she wasn't exactly academy stock. Kroll came in and took one look at the model, and demanded loudly which one of us was the monitor. He came over, took one look at my painting and screamed, 'Young lady! Go home and take a mental bath.'"[71]

Krasner had just seen the Matisse retrospective at the Museum of Modern Art in the fall of 1931. Though her enthusiasm for Matisse would last a lifetime, not all the public was so positive. In his review of the show in *Art News,* Ralph Flint expressed real reservations about Matisse and his influence. "His sensation-seeking

brush has quickened many a brother artist into new flights of fancy. He has served as driving wedge to weaken those stubborn walls that stand in the way of all insurgent investigation. And yet, withal, he has remained a brilliant but signally uninspired master."[72]

Despite her newfound inspiration, disaster soon struck Krasner. A fire at her parents' home in Greenlawn destroyed the house and most of the work she had produced to date. One of the only surviving items was her small self-portrait on paper, which she always kept with her after that. In later years, she had it hanging in her parlor. The fire could have been ignited by her father's cigar, but the real cause is not known.

The fire and the economic loss it caused came at a time of great uncertainty for the Krasners and for Jews in America in general. With the house destroyed, Krasner's parents were reduced to living in their garage as they survived in a weakened national economy that fostered the growth of anti-Semitism, nationalism, anti-immigration sentiment, and local hate groups.[73] From afar, they witnessed the rise of Nazism in Europe.

In view of growing nationalism and its connections to anti-Semitism, it is not surprising that Krasner repeatedly said, "I could never support anything called 'American art.'"[74] She had no doubt seen the new Modern's second show, "Paintings by Nineteen Living Americans," and followed the discussion it elicited in the press. The critic Forbes Watson attacked the foreign-born (and Jewish) Max Weber for taking "no account of the American tradition" in his painting and for being tied to "European standards." Watson denounced "American laymen," for whom "the modernity of all art depends upon the degree of success with which it emulates painting in Paris."[75] At the same time, he defended Edward Hopper, John Sloan, Charles Burchfield, and Rockwell Kent against those who perceived "a disturbing conservative quality" in their work.

On a wave of cultural nationalism, the Whitney Museum of

American Art was founded in 1930 and opened on Eighth Street in 1931. It would feature what some saw as a more parochial choice of American artists than the Museum of Modern Art. The Whitney was aware of its problem, but it was not always sensitive to the identity issues it raised. One of the museum's earliest publications, a monograph on Edward Hopper by Guy Pène du Bois, described Hopper as "the most inherently Anglo-Saxon painter of all times." This was actually a distortion of Hopper's ancestry, which was half Dutch and part French.[76]

Krasner must have known that the artist Thomas Hart Benton and the critic Thomas Craven were not alone in denouncing immigrants, ethnics, leftists, and Jews, claiming that they were incapable of painting the "true American" experience.[77] To many eyes, the Jews were not the same race as Anglo-Saxons; they were not technically "white." They were still not allowed to join exclusive clubs, stay in restricted hotels, attend all schools, or live in certain areas. In her relationship with Pantuhoff, however, Krasner clearly hoped to transcend this inferior status.

Around this time the Depression was beginning to hit hard. This was the overwhelming issue that led Krasner's classmate Vogel to join the Unemployed Artists Group in the summer of 1933. Some of Vogel's fellow members, who already belonged to Krasner's circle of politically radical friends or would soon, were Balcomb Greene and his wife, Gertrude "Peter" Glass Greene, as well as Ibram Lassaw (all of whom would remain lifelong friends); Boris Gorelick, Michael Loew, and Max Spivak, with whom Krasner would work on the WPA and in the Artists Union. This group of activists was formed within the John Reed Club, which was the main institutional base for Communist and fellow-traveling artists before 1935.[78]

Unemployment became an even more significant issue when landlords began to throw these workers and their families onto the street. On February 4, 1932, more than 3,500 unemployed workers braved cold rain to gather at Union Square and march in

protest to City Hall. A group of Communist organizers told the board of alderman (city council): "Unless the city finds some way to prevent further evictions of the families of the unemployed, the Unemployed Councils of New York will use force to 'fight off the hired thugs of the landlords.' There are more than one million workers unemployed in New York City. The city is doing nothing to help them."[79]

A month later, on March 6, 1932, a large group of artists gathered in Union Square. They called themselves the Unemployment Council and, for the first time, called attention to unemployment and poverty among artists. Their efforts led to the founding of the Artists Union. Krasner's fellow student Boris Gorelick recalled: "It was not one of the first organizations, but it was the first amongst the cultural workers and subsequently played a very leading and very important role in, for one thing, bringing about recognition of the responsibility of government to the artist per se and also the need for unity amongst the artists for their own survival."[80]

Krasner had always suffered from her family's poverty, but at this time the harsh economy even impinged upon her ability to earn her own way through part-time jobs. Affected by the extreme poverty all around her and the bleak uncertainty for artists, Krasner left the academy in April 1932 and enrolled at the City College of New York on 139th Street and St. Nicholas Terrace in Manhattan, where tuition was free. Her purpose was to obtain a teaching certificate, which would allow her to teach art in high schools.[81] She took Teaching in Junior and Senior High and Problems in Secondary School Teaching. At this time, she gave her address as 2511 New Kirk Street in the Ditmas Park neighborhood of Flatbush in Brooklyn. It was a long commute to upper Manhattan, where she was spending time with Pantuhoff.

City College was intensely intellectual and ideological in the 1930s. At the college on May 23, 1932, three thousand students, organized by the leftist National Student League, protested a fee increase for evening students. Ten thousand students signed peti-

tions of protest, and the Board of Higher Education was forced to eliminate the fee. Although Krasner studied by day and worked at night, she can hardly have missed the night students' successful protest. Like most of her peers, she was struggling to survive. Among the other students that year was the future playwright Arthur Miller, who attended for only three weeks before he too had to give up. He was not able to make the commute from Brooklyn, hold down his job in a West Side warehouse, and complete his assignments.[82]

Krasner later recalled: "I decided to do something practical about livelihood, so I took my pedagogy, so I could qualify to teach art. I got through with it—I took it at CCNY—did waitressing in the afternoons or evenings, did this work in the daytime. I got my pedagogy and decided the last thing in the world that I wanted to do was to teach art so I tore that up."[83] She didn't finish the degree until 1935, so it was a considerable investment of time and effort that she eventually abandoned to pursue her long-held dreams of becoming an artist.

Krasner's decision to drop teaching might also have been a response to the times and the increasing difficulty of obtaining secure teaching positions. For example, Barnett Newman, a 1927 graduate of City College, tried unsuccessfully in 1931 to become an art teacher in the New York City public school system after his family's clothing business suffered from the stock market crash. Though he would later be famous as an abstract expressionist artist, he failed the exam for a regular teaching license and instead became a substitute art teacher, earning $7.50 a day, but only when work was available.

There was also Krasner's experience working at night as a cocktail waitress at Sam Johnson's, a bohemian nightclub and café, while attending college. Located on Third Street, between MacDougal and Thompson in Greenwich Village, Johnson's was a spot where artists and intellectuals liked to congregate and where poetry was read. The talk there was stimulating. Lionel

Abel once called Sam Johnson's "a sort of proletarianized version of the Jumble Shop," another Village eatery where Krasner spent time with other artists.[84]

Krasner reminisced, "They collected a great many bohemians who did special things like reading of poetry for discussions."[85] For her job, she wore the required work attire, Chinese silk "hostess" pajamas, and enjoyed socializing with the customers: "They would come in the evenings and discuss 'the higher things in life.' I was quietly in the background for a while and then I began to know them and I identified myself. But it was a short period while I was getting my pedagogy points at CCNY."[86]

The club was co-owned by the poet Eli Siegel, described as having "a saturnine expression and the bent bearing of a *yeshivah bocher,*" and Morton Deutsch, a "defrocked rabbi." Siegel, who once defined a poem as "A whirlwind with details," liked to recite Vachel Lindsay's poem "The Congo" as it was intended to be, read aloud, making a theatrical production out of its jazz-inspired rhythms. Siegel won *The Nation*'s poetry prize in 1926 and was the first American imitator of Gertrude Stein. According to Harold Rosenberg, Siegel "imitated Stein . . . quite well, too."[87]

At this period Krasner may have intensified her interest in Emerson's writings on the meaning of life and art.[88] His work as a poet, essayist, and philosopher could have caught her ear either in the talk about "higher things" at Sam Johnson's or it could have occurred during her classes at City College. The transcendentalism that Emerson expressed in his 1836 essay "Nature," stressing an ideal spiritual reality over empirical and scientific knowledge, would have suited some of Krasner's own sensibilities, which also relied upon intuition. Later, she titled a painting *The Eye Is the First Circle,* after the first line of Emerson's 1841 essay "Circles."

At Sam Johnson's, Krasner worked not only for tips but also for dinner on the nights she worked. (In her later years, she continued to complain about the art critic Harold Rosenberg, who never tipped.)[89] He later explained why he did not tip. "We didn't [have]

any dough, but we were more or less welcome because I suppose we provided local color or something. . . . The Sam Johnson was our hangout for quite a while. Lee [Krasner] Pollock used to be a waitress there."[90]

"You see, we knew Deutsch, and he ran the place really; Ei was just sort of a semisilent partner. He would read poetry there. That was his main function. So it was understood that we have everything on the house," rationalized Rosenberg, forgetting that Krasner still needed tips, even if he and his friends were feasting and drinking on the house. "So Lee would bring us sandwiches and coffee, or something. And once in a while we'd say to Deutsch, 'Why don't you get rid of these lousy bourgeois and go and get some booze, so we can have a real discussion here?'"[91]

The future art critic's wife, May Tabak (Rosenberg), believed that the club presented good opportunities for college girls. "The women of Bohemia found themselves given a better break than men. Even at some unskilled jobs. An educated girl tended to make more in waitress tips than an equally good-looking 'dumb' one. Male customers were more anxious to impress the smart girls. Bosses of restaurants believed that college dames added class to their joints."[92]

Krasner met a number of people who were also customers at Sam Johnson's. Among them were Rosenberg's brother, Dave, Lionel Abel, the film critic Parker Tyler, the writer and poet Maxwell Bodenheim, and Joe Gould, a Village character who is best known for the vernacular oral history of life around him that he claimed to chronicle.[93] *The Dial,* then a sophisticated arts magazine, published his short essay called "Civilization" in its April 1929 issue. A legend in his own time, Gould appears nude in his portrait painted in 1933 by the artist Alice Neel.

Maxwell Bodenheim was successful and well known as the editor of the avant-garde poetry magazine *Others,* and as the author of the 1925 novel *Replenishing Jessica,* then characterized by some critics as cynical and indecent. In 1928, when Bodenheim was

thirty-five and separated from his wife and child, he became no-
torious for his connection to twenty-four-year-old aspiring writer
Virginia Drew. Like Krasner, but just a few years older, Drew
had attended both Washington Irving High School and Cooper
Union. She had solicited Bodenheim for career advice. Desperate
after Bodenheim condemned her literary efforts, she committed
suicide in the Hudson River shortly after she left his MacDougal
Street apartment. A young woman who was her friend told de-
tectives that the two had made a suicide pact, which Bodenheim
denied.[94] Press accounts also reported Virginia Drew's complaint
"that her mother did not understand her ambitions."[95]

One newspaper also reported that, less than two weeks earlier,
"a nineteen-year-old girl was found unconscious in her apartment
in Greenwich Village. Gas was escaping from a stove, but the win-
dows were wide open."[96] Gladys Loeb, who had studied at New
York University, was rescued by her physician father, Dr. Martin J.
Loeb, and taken home to the Bronx, having tried to kill herself
after Bodenheim called her poetry "sentimental slush."[97] Even
after Drew's suicide hit the press, Gladys Loeb once again ap-
proached Bodenheim. By then he had fled to Provincetown, where
Loeb's father went in pursuit of his daughter, anxious that she too
might again try ending her life.

Krasner was not as fragile as the young women who pursued
Bodenheim. She always maintained that her parents were indif-
ferent to her career choice as long as she made no demands upon
them. Hence she was less vulnerable to judgments from powerful
or established men in the art world. She had a healthy sense of her
own ability and her work's value, even if others initially failed to
agree. She repeatedly brushed off her teachers' negative criticisms
and pushed ahead. Self-confidence and firm resolve were, in the
end, more valuable than talent alone. Sometimes, when asked how
she dealt with such issues, she would respond, "I guess that I'm
just a tough cookie."[98]

# Enduring the Great Depression,
# 1932–36

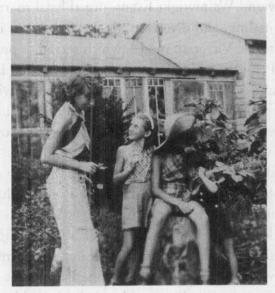

Lee Krasner with her nieces Muriel Stein and Bernice
Stein and her nephew (their half brother), Ronald Stein,
in her parents' garden in Huntington, Long Island,
c. 1934–36.

K RASNER "MOVED IN TOGETHER" WITH PANTUHOFF ON HIS RE-
turn from Europe, where he went in the spring of 1930 on
the traveling scholarship that the academy had awarded
him.[1] Their relationship would prove momentous and lasting.
Years later she described the relationship as "a togetherness."[2] And
many, including Krasner's parents, saw this togetherness as mar-
riage. At times even Krasner called herself "Mrs. Igor Pantuhoff,"
making it easy for acquaintances to assume something that wasn't
true. In the late 1940s, Pantuhoff would be introduced to Joop

Sanders as "the former husband of Lee Krasner" by either Willem de Kooning or Aristodimos Kaldis.[3]

Companionship without the legal ties of marriage was trendy at this time. New ideas about the relations of the sexes both within and outside of marriage generated a lot of discussion and controversy. In 1927 *The Companionate Marriage,* a book written by Ben Lindsey and Wainwright Evans, urged legal marriage, birth control, counseling, and divorce if all else failed, but it admitted alternatives to the Victorian model, which served to protect child-bearing and child rearing.[4] Krasner, having watched her mother struggle to support and care for a large family and having to cope with the Depression's economic hardships herself, did not appear to obsess over dreams of motherhood. She seemed suited to her relationship with Pantuhoff.

Krasner did take an active part in raising the Stein children— her nieces Muriel and Bernice and nephew Ronnie. Muriel recalls that her Aunt Lee sometimes brought Igor along to the family Passover seders. Muriel adored both her aunt and Igor, whom she described as "such a character, charming, so charming."[5] She remembers when her aunt took her to the Paramount Theatre at Times Square to see Ella Fitzgerald and Chick Webb, the orchestra leader who became Fitzgerald's mentor.[6] Muriel's father and her stepmother, Ruth, wondered about Lee: "Where did she come from?" They observed that Lee "dressed magnificently," wearing makeup and high heels. It was a flare for style that none in her family could match, but which owed much to her collaboration with Igor.[7]

Without their own children, there was nothing to tie Lee and Igor together. According to contemporary theorists, the woman had to keep "the flame of romance alive." A woman's "status must be won and rewon by personality and attractiveness if she is to get and keep a husband under the dissolving bans of modern marriage," wrote sociologist Robert S. Lynd, an observer of American customs during the 1920s.[8] To meet this challenge, Krasner

brought an outgoing personality, keen intelligence, and a dry wit. Though not blessed with a conventionally beautiful face or classic "Anglo-Saxon" features, she had a stunning slim figure. Her hair was auburn and luxuriant. Many friends remarked on her "animal energy," "voluptuousness," and "sex appeal," which is evident in some early photographs.[9]

Judging simply from a gouache sketch Igor did of her posing in a sultry profile, he felt the same way. In Krasner he must have also found the kind of physical abandon that satisfied his own often-expressed sexuality. "With Igor, Lee had a sparkle and gaiety," said Fritz Bultman, although he claimed to have heard Igor remark in her presence: "I like being with an ugly woman because it makes me feel more handsome."[10] It's hard to fathom why Pantuhoff felt so insecure as to make a comment like this— he was tall, slender, and some even said he was as handsome as a movie star. Pantuhoff clearly found in Krasner's self-assurance a quality he needed. He was invested in the relationship and made sure that Krasner exuded style. He helped her apply elaborate makeup and picked out her clothes, including colorful stockings to show off her legs.

But despite their relationship's sexual sparkle, it suffered from the economic challenges of the Depression. Things were already so bleak for artists in 1932 that a committee formed to raise money to see that artists and writers, "who were quite literally starving," could have "one square meal a day," recalled Krasner's academy classmate Balcomb Greene, the son of a Methodist minister, who became her colleague in several artists' groups. Eating in McFadden's restaurant, which had "an idea about the nutritional value of wheat germ," recalled the artist Bob Jonas, who met Krasner during the 1930s, meant "asking for hot water in a bowl," to which they would add "ketchup, salt, pepper, anything that was around."[11] "It was a period of great privation, hunger stalked the country, and that's not putting it dramatically, but that's a fact," said Boris Gorelick, who had been with Krasner at the academy.

"Millions of people were involved in very desperate circumstances, and the professions were down the drain because they were at the bottom of the economic ladder, especially the art profession."[12]

"After the '29 crash, there was a tremendous amount of unemployment in New York. There were a lot of people who were willing to do anything for a quarter. There were the usual apple sellers, and there were guys shoveling snow for the twenty-five cents or whatever it was they could get as a handout. There were people working in restaurants for just the room and board," recalled the artist Reuben Kadish.[13] At the time, he was close to the Dutch immigrant Willem de Kooning and to Jackson Pollock.

"None of us were established in any way," Kadish remembered. "De Kooning was a house painter, and Jackson was doing odd jobs and getting by. . . . There was a lot of bartering going on. People bartered with doctors and dentists, but not Jackson. Jack had such a highly developed sense of professionalism that even then there wasn't any question of him going to Washington Square and hanging a painting over the railing. He'd never go to the market with a painting and trade it for a bowl of soup. Others would."[14]

Artists were frequently evicted from their simple quarters. Some began to help others by returning their furniture, which had been placed out on the streets. With all the economic tension, art was the last thing that most people thought about. Artists needed work. In his acceptance speech before the Democratic National Convention on July 2, 1932, Franklin Delano Roosevelt promised to help, announcing "I pledge myself to a new deal for the American people. . . . Give me your help, not to win votes alone, but to win in this crusade to restore America to its own people."[15] As president he would eventually include visual artists among the recipients of federal help.

During this time, Krasner was still at City College with the ultimate goal of working toward her teaching certificate. She was waitressing, but she was also taking life classes with the painter

Job Goodman, a Russian-born Jew who had emigrated in 1905 at the age of eight. He had studied at the Art Students League and later taught there.[16] After returning from a Guggenheim grant to the Netherlands and Belgium, he became the director of art instruction at Greenwich House, which had been founded by social reformers in 1902, to improve living conditions among the immigrants who then populated Greenwich Village. From the start, Greenwich House held a strong commitment to the arts "as a dynamic stimulus for cultural enrichment and individual growth."[17]

Goodman stressed the "hollow and bump" method he had learned from the American artist Thomas Hart Benton at the Art Students League. It was a method adapted by Benton from the abstract painters known as Synchromists (whose name for themselves meant "with color," as *symphony* means "with sound") with whom he exhibited in New York during the 1910s.[18] The Synchromists Morgan Russell and Stanton Macdonald-Wright had painted abstractions based on figures by Michelangelo, whose work they studied attentively. Benton adapted their practice and later stressed Michelangelo's forms with his own students at the Art Students League, among whom in 1932 were Axel Horn and Pollock. In one exercise, Horn, recalled analyzing famous works of art, "stressing the interplay in the various forms by simplifying and accentuating changes in plane." Michelangelo was one of the "popular subjects."[19] Benton wrote of his "continued study of Michelangelo's sculptural structures, which soon was expanded to his paintings."[20]

In Goodman's class, Krasner produced a copy of one of Michelangelo's *ignudi* flanking the creation of Eve on the ceiling of the Sistine Chapel. While study of Michelangelo's forms was a standard assignment for a Benton disciple like Goodman, he might have noted the irony of Krasner's choice of subject and of the assignment itself. At the time, there was a slight controversy surrounding a number of rotogravure reproductions of Michelangelo's ceiling that had been held up by United States Customs,

which charged that the nudes were "obscene." What really mattered, according to a *New York Times* article covering the controversy, was that the art importer was "dumping" reproductions of a foreigner's art "on this country at a time when thousands of American artists are without a market for their work. We have talent enough in this country to produce a fair substitute for the Sistine paintings."[21]

Goodman's drawing classes also attracted Harold Rosenberg (whom Krasner had met at Sam Johnson's) to Greenwich House. "There was a fellow teaching there and they had a live model, so we'd go there in the afternoon and draw a bit, you know," Rosenberg later said. "I think it was just a matter of liking to do it, no particular aim in mind. I liked to draw. They had the model; all you had to do is register."[22]

Apart from Michelangelo, Krasner focused on drawing from life, working mainly in Conté crayon. She drew the male and female nude life models with candor and ease. Although Goodman taught courses also in murals and painting in oil and tempera, buying paint was also too costly at this time. Krasner's family was in no position to help her, so she depended on her own labors and wit, and was not able to hire her own model. When she later quipped about those customers at Sam Johnson's who were lousy tippers, she was talking about the difference between being able to pay for paint herself or having to borrow from her friends who had very little to lend.

Krasner gravitated toward others suffering poverty, and eventually they organized to address their plight. In 1932, the Society of Independent Artists made front-page news by deciding to barter work in exchange for some necessities of life. "Artists are always on the bread line, but this year they are in even worse straits than usual and we hope to make sales a special feature of the show. Dental services will be one of the most welcome media of exchange for works of art. Medical care and clothing will also

be acceptable. Best of all, however, will be the offer of rent for six months or a year," declared a spokesperson.[23]

In the summer of 1933 the John Reed Club, which had been founded in 1929 as a Communist organization of artists and writers and was named for the American journalist, poet, and Communist activist, whose firsthand account of the Bolshevik revolution is called *Ten Days That Shook the World,* gave birth to the Unemployed Artists Group. Creation of the group was perhaps prompted by the Cultural Committee of the Communist Party, to act as the "Emergency Work Bureau Artists Group, the bargaining unit for artists on government projects."[24] After holding meetings in various halls for a few months, it changed its name to the Artists Union in February 1934, when it rented a loft in Chelsea.[25] The founders argued "that in presenting resolutions to the State, numbers and organized strength counted."[26]

Boris Gorelick, who served as its president for three years, said that "it started in New York with possibly twenty-five or thirty people, but it quickly grew into an organization of about fifteen hundred to two thousand people with auxiliary groups which included women as separate sympathetic groups, students, young students in the art field who also became members of auxiliary groups."[27] Krasner favored the Artists Union because it looked out for artists' rights.

"The big meetings at the Artists Union . . . were held in a place called Germania Hall, on Third Avenue," recalled an artist named Irving Block. "That's an old parlor and beer hall, and they had a big meeting hall in the back, and they would have these meetings and they would go on interminably. They would begin by talking about the needs of the art project, about the artist role in society, and then they would just end up by general argument that the brushes were no damned good and the paints were no good."[28]

One issue raised at the Artists Union was that "easel" artists

were lending to shows that attracted crowds to be exploited by businesses. The union contended that these artists should receive direct payment for participation, as would commercial artists or mural painters for their work. Instead, as Max Spivak pointed out in an article he wrote for the union's journal, *Art Front,* sponsors like Wanamaker's Department Store or Rockefeller Center might support an art show at which "the easel painter is promised 'pie in the sky'" but instead receives nothing for taking part in "promotional schemes" of "big business."[29]

Meanwhile, a combination of forces from the art world and society persuaded the federal government to fund patronage programs for artists as part of the New Deal recovery effort. Established in late 1933 as part of the New Deal, the Public Works of Art Project (PWAP) would employ more than 3,700 artists to decorate federal and other public buildings, including post offices "now under construction throughout the country." "Artists to Adorn Nation's Buildings" read the headline in the *New York Times* for December 12, 1933. The article reported a meeting at the home of the painter Edward Bruce, "attended by Mrs. Franklin D. Roosevelt, leaders of American Art, and government officials."[30] Eleanor Roosevelt told the press, "I think this plan has tremendous possibilities for awakening the interest of the people as a whole in art and for developing artistic qualities which have not come to light in the past and for recognizing artists who already have made their names among their fellow-artists, but who have had little recognition from the public at large."[31]

Eventually, under various programs administered by the Treasury Department, the Works Progress Administration (WPA), and the Resettlement Administration (later the Farm Security Administration), more than 10,000 artists and support staff received commissions or salary jobs that rescued many of them from intense poverty. The WPA's Federal Art Project reflected President Roosevelt's belief that in order to retain human dignity, people needed jobs rather than direct relief. He later expressed

this in a radio address from the White House. "The Federal Art Project of the Works Progress Administration is a practical relief project which also emphasizes the best tradition of the democratic spirit. The WPA artist, in rendering his own impression of things, speaks also for the spirit of his fellow countrymen everywhere. I think the WPA artist exemplifies with great force the essential place which the arts have in a democratic society such as ours."[32]

"Once the WPA jobs were opened to the unemployed," Lionel Abel recalled, "real change came over the city. The breadlines disappeared, and that was very important because of the psycho-logical effect the lines had had. . . . The artists were helping the government by their work, saying, there can't possibly be a sea of blood here, for look, here are works of art!"[33] Yet all of the WPA artists, Krasner included, lived with the insecurity of not knowing when a government project would end.

Krasner recalled how she was chosen for her initial job doing illustrations for the Public Works of Art Project. While she was studying with Job Goodman a government official visited the class and announced that there were jobs for indigent artists. She immediately raised her hand and was told to report for an examination. Given her education, skills, and proven financial need, she was able to meet the criteria for acceptance.[34] Rosenberg described a similar experience at Greenwich House: "So I was there draw-ing one afternoon and a guy came rushing in like a messenger in an old-fashioned play, who announced that they were hiring art-ists up at the College Art Association . . . the agency appointed . . . to run the project in New York."[35]

In January 1934, Krasner attained a paid position at the Pub-lic Works of Art Project (PWAP). She worked through March, assisting a geology professor doing a book on rocks.[36] She was "drawing fossils," she recalled, "so that I was working [on] very detailed drawing. I don't remember how long it lasted as it was an extensive project with a loft full of artists working on these things."[37] The assignment brought back girlhood memories of

working from nature at Washington Irving High School. "There I was with a hard pencil, and what came to me was the memory of all those butterflies and beetles, only now in more abstract form. I was happy as a lark doing that stuff!"[38] She earned $23.65 per week, which was enough to survive, even thrive, compared to the dire straits of life without the Project.

Under the Temporary Emergency Relief Administration (TERA), which took over from the PWAP in April, Krasner began as a teacher, but was soon reassigned as an artist. Her salary was a weekly wage of $24.00 for "thirty to thirty-nine hours' work, that is, about $4.80 per day." The Artists Union raised the issue that only pressure from a strong union would give artists a chance to retain the union wage scale. An article in *Art Front* illustrated the meager artist's wage when compared to those of other skilled workers. "Union plumbers, for instance, receive $12.00 per day, house painters receive $11.20, plasterers, $12.00, stone carvers, $14.00. The Artists Union, after careful consideration of comparative wages, has determined on $2.00 per hour as a fair wage for artists, for a maximum 30-hour, and a minimum 12-hour week. Artists who now receive $24.00 for a 30-hour week will, under the new rate, receive the same sum for 12 hours of work."[39]

Krasner knew well many of those involved in the Union, including Balcomb Greene and his wife, Gertrude "Peter" Glass Greene, Ibram Lassaw, Michael Loew, Robert Jonas, Willem de Kooning, and the muralist Max Spivak, whom Krasner was assigned to assist at the WPA in 1935. Krasner also recalled that the Russian-emigré painter Anton Refregier was very active at the Union.[40] Having studied in Paris and then with Hofmann in Munich, Refregier was a friend of de Kooning's in New York, though he was much more politically active than his pragmatic Dutch friend.

De Kooning was four years older than Krasner, and they had first met at his loft on West Twenty-first Street in Manhattan's Chelsea neighborhood when he was living with the dancer Juliet

Browner. Krasner described Browner as "an exceptionally beautiful young girl [who] played the viola beautifully. . . . Many years later I learned that Julie became the wife of Man Ray."[41]

Since de Kooning did not move from Fifth Avenue and Eighth Street to his Chelsea loft until late that year, Krasner probably met de Kooning in late 1934 or early 1935. Krasner described the encounter many years later, making only a vague reference to the man who had been her lover before Pollock: "I do remember it was someone called Igor Pantuhoff, who . . . took me up to Bill's studio, a loft converted into a studio, on Twenty-second Street and introduced me to him. And it was quite a few years, maybe about three or four, before I met someone called Pollock."[42]

De Kooning, using income earned from working regularly as a commercial artist for A.S. Beck (a chain of shoe stores), had purchased a Capehart high-fidelity system with an automatic record changer.[43] The Capehart was advertised as "the finest gift it is possible to provide for a home and its family and friends. For the Capehart virtually brings the operatic stage, the symphonic festival, the theatre, the ballroom, the whole world of recorded and radio diversions, right to your living room."[44] De Kooning, like Krasner, liked to listen to classical music and to modernists like Stravinsky, as well as jazz, yet she was in no condition to acquire the best and most expensive record player available.[45]

Krasner recalled: "Bill had a beautiful recording machine and wonderful records, and he always encouraged the idea of people coming to his studio so that one rarely saw him alone, there would always be a kind of entourage, three or four people if one went there on a Sunday."[46] He also hosted informal loft parties, where artists brought their own liquor and danced.[47]

EVEN WITH THE HELP OF THE PWAP, KRASNER AND PANTUHOFF REmained anxious about getting by and being able to feed themselves. Leon Kroll, their former teacher at the academy, who was

now one of the confidential advisers at Yaddo, encouraged them to correspond with Elizabeth Ames at the artists colony in Saratoga Springs, New York. In a letter to Ames, Kroll recommended the couple as "desirable candidates for scholarships" and included "Igor Pantuckoff" on a list of the people he thought most important to go to Yaddo. Lee and Igor were invited to come between August and October 1934.[48]

The colony offered room, board, and studio space for two-month periods to those artists "who have achieved some measure of professional accomplishment."[49] In his rankings, Kroll placed Igor third, after artists Maurice Becker and Alix Stavenitz. He described Igor as "a talented young painter and an agreeable person. His wife not as good as he is. Both in the middle twenties. Pantukoff had won the Pulitzer Prize at the National Academy two or three years ago. His wife was one of his fellow students. They both studied under me and I thought they were of my best as students."[50]

By then, Igor and Lee were living in the Village at 56 West Eighth Street, and they signed their application to Yaddo as "Mr. and Mrs. Igor Pantuckoff." Even in their application letter, written in February, Igor referred to Lee as his wife. Both Kroll's letter and Pantuhoff's make clear that Lee and Igor pretended to be legally married. One note, saying that any time Yaddo accepts them would be "quite satisfactory," is signed "Igor and Lenore Pantukoff."[51] There is, however, no evidence that they ever did marry or that they ever went to Yaddo. The reason must be that by the time they were scheduled to go, they feared losing their federal employment.

KRASNER AND PANTUHOFF GREW TO ENJOY THE COMPANY OF HAROLD Rosenberg, whom she first met while waitressing at Sam Johnson's, and Rosenberg's wife, the writer May Natalie Tabak. Both couples were fascinated with politics and joined others in various

causes, occasionally attending political rallies together. They also talked about French poetry, Russian novels, Marxist literature, and "the eternal verities."[52] Tabak remembered, "Igor began to attend the newly opened Hans Hofmann art school. Other artists we all knew had gone to Europe to study with Hofmann; and, although familiar with much of his vocabulary (like 'push and pull,' which was interpreted by every artist in a personal way), the school in New York was an exciting curiosity. We were all fascinated by Igor's reports of what went on there."[53] Hofmann, a German modernist painter who had studied in Paris, opened his first school in America at 444 Madison Avenue in 1933.[54] Krasner too was curious about Pantuhoff's new venture.

The couple then moved to 213 West Fourteenth Street, just west of Seventh Avenue.[55] Their apartment building offered access to the roof, from which Krasner painted a typical city scene called *Fourteenth Street*.[56] Although the catalogue raisonné identifies this canvas as "one of Krasner's few attempts to paint in the Social Realist vein," it is not overtly political and is, in fact, much closer to the realist subject matter and the emphasis on painting light and shadow of an artist like Edward Hopper, who a few years earlier painted *City Roofs* (1932), a similar view from his own roof.[57] Hopper delivered *City Roofs* to the Rehn Gallery in New York in October 1932, so it's possible Krasner saw it there. Though Rehn is not a gallery she recalled frequenting, the entire art scene was then quite small, and eager artists looked everywhere for potential places to show their own work.

For another 1934 canvas, *Gansevoort I,* Krasner walked along the West Side of Manhattan, where she observed ships tied up at the docks. Gansevoort Street extends through its gritty riverfront neighborhood east to the point where both it and West Fourth end at West Thirteenth, a block south of West Fourteenth. The barren roughness of this meatpacking district, with its old cobblestone street and austere brick warehouses, seemed to have attracted her.

In her pencil sketch *Study for Gansevoort I,* Krasner included

on the sidewalk's right side a pair of figures sitting and reclining. Given the context of the Depression, the men are probably homeless.[58] The drawing also includes trash cans and assorted debris that she eliminated in her final painted composition; and she moved the fire hydrant from the street's left to its right side. Reducing the details, she sought to achieve an urban modernity worthy of the French painter Fernand Léger, who first visited New York in 1931. She nonetheless captured the neighborhood's exoticism, which long attracted artists to its cheap loft spaces located above ground-floor warehouses. Two years later, the prolific Berenice Abbott would photograph the same area that attracted Krasner.

Krasner and Pantuhoff enhanced their urban life by continuing to go to the beach on Long Island and to her parents' house. May Tabak recounted how, while Igor was driving Harold Rosenberg out to Jones Beach, a policeman stopped them for speeding.

" 'Where's the fire?,' he asked irritably.

"Igor, blond, young, startlingly handsome, with a heavy Russian accent, drew himself up with White-Russian-tsarist-officer disdain and snorted, 'I am Igor Pantuhoff, Great Artist!' 'Oh!' said the startled cop. 'OK, then,' said Igor and, shifting gears, drove off."[59] Igor's father had seen his promise as an actor.

At the beach Harold and Igor "had played handball, gone into the surf, played darts, gone swimming again. In and out, over and over again, hither and yon, from one sport to another. Finally, when they had just about seated themselves once more, Igor suggested they do something else. 'Sit still for a while and meditate,' Harold told him; 'Try it,' he told him. 'I've tried it,' said Igor. 'It's no good. As soon as I get set to meditate, I get a hard-on.' "[60]

Krasner seemed to have retained no inhibitions from the modesty of her observant Jewish home. She was so relaxed about her body that she posed for nude photos with Pantuhoff on the beach. In fact, the sexual electricity in their relationship caught the attention of their close circle. An estimate of their sexuality may be

encoded in a brightly colored crayon drawing of 1934 by Esphyr Slobodkina entitled *Lee Krasner Astride a Fighting Cock*. It shows three female figures, repeated as if in a cubist painting or film, mounted on a rooster's back. The faces on the three heads evoke Krasner, as do the three energetic bodies. The figure has hinged limbs, like those of paper dolls that Slobodkina remembered making as a child.[61] While a female doll astride a cock is an obvious sexual metaphor, whether Slobodkina meant to express envy or complaint is unclear.

Slobodkina and another friend from the academy, Ilya Bolotowsky, decided to marry in 1933; but lacking a sexual charge like Igor and Lee's, they were divorced by 1936, though they remained close friends for some time after. Esphyr later wrote that during "the Great Depression at its worst, every right-thinking artist's idea was to marry a good-looking, capable, young woman—preferably a teacher—thus acquiring in one fell swoop a model for his work and an economic anchor in what was usually a miserable bohemian existence."[62]

Krasner started working for the WPA at its inception in August 1935. Her experience was so satisfying that she rejected a career teaching. May Tabak recalled that Krasner and Pantuhoff "both got jobs on the WPA. For a while Igor continued to paint lovely landscapes and even lovelier portraits. On the Project he had immediately been assigned to the easel project, a 'sinecure' greatly coveted by the painters; for one thing, it meant working at home."[63] Being on the easel project also meant that Pantuhoff had more independence to work within his own aesthetic, while those on the mural project had to work on what the recipients wanted.

In contrast Krasner, who had not won acclaim at the academy, held firmly to her modernist vision. When a critic asked her years later whether her involvement with the WPA affected her aesthetic in any way, she responded, "To a degree it did, as the work that was called for didn't quite line up with what I was interested in. On the WPA an order for work—murals, easel paintings—

was to be placed in public buildings. Someone from the public buildings had to designate what kind of art they wanted. Needless to say it moved a little away from my own interests in art. Nevertheless, its validity I would never deny. It kept a group of painters alive through a very difficult period."[64]

Because the WPA was necessary for the survival of many artists, there was always the worry that the WPA would end. According to Harry Gottlieb, another artist on the Project in New York, "There were always problems. . . . Whenever they tried to get rid of the WPA we had picket lines set up."[65] On October 27, 1934, an artists' demonstration had marched on City Hall to protest the lack of jobs for artists and to demand "immediate relief for all artists."[66] The Artists Union insisted "only the artist can define the artist's needs and the conditions necessary for his maintenance as an artist."[67]

When asked if she was only concerned with art issues, Krasner answered: "Primarily, we were protecting our rights. However we did join some marches on social protest issues. For example, we marched [with] the workers picketing Ohrbach's. We carried signs with our names like 'I am Stuart Davis and I protest the firing of . . .' My sign said 'I am Lee Krasner and I protest the firing of . . .'"[68]

The picket line she recalled at Orhbach's department store on East Fourteenth Street formed in December 1934 when the workers demanded union recognition, a forty-hour week, and a ten-cent wage increase. The *New York Times* reported that the police broke up a line of 125 "snake dancing pickets in front of Orhbach's" and charged them with "disorderly conduct."[69] Those arrested were held until they paid $5 each in bail. The hearings took place the next day.

On the picket line, Krasner joined not just the store's workers, but also Office Workers Union members and others sympathetic to the cause—visual artists like herself, but also people such as the actor Dane Clark, who made his Broadway debut in Friedrich

Woolf's *Sailors of Catarro*. Though the protest was not advertised as Communist, the party probably organized it. And yet, even despite the arrests, the actors were somehow bailed out in time for the evening performance.[70]

Addressing the issue of women on the WPA, Krasner later reflected, "Of course there were many more men than women, but there were women. There was no pointed discrimination, but at that point there weren't many professional women artists. In the WPA you worked in your own studio and the timekeeper came to check you once a week to see that you were working. Once a week you reported to a meeting of all the mural artists. So you were necessarily with your fellow artists quite a bit. That meant you didn't feel totally isolated."[71]

Krasner and Pantuhoff were anything but lonely. During 1935 they moved yet again to share a railroad apartment in the East Village with artists Bob Jonas and Michael Loew. A close friend of Willem de Kooning, Jonas had studied commercial art in his native Newark, New Jersey. Jonas's father abandoned his family, and he worked to support his mother and siblings. He was feeling desperate. He had just left his family's home for the first time and later claimed: "I was into very advanced thinking. It used to frighten Lee Krasner."[72]

Krasner had worked with Loew on a WPA mural for the Straubenmuller Textile High School (now Charles Evans Hughes High School) on West Eighteenth Street. In addition to murals, Loew also worked on stained glass windows, but politics were his passion. He had come to the Artists Union from the John Reed Club and was very active.[73] In Loew's view, "Lee was an intense, serious person who didn't go for small talk or nonsense. Her work was semi-Surrealist, and she was seeking the most advanced ideas in art. Mature and strong, but by no means affectionate, she had warmth about art and she could be a good friend if you went along with her ideas."[74] On the other hand, Loew saw Pantuhoff as "a caricature of the White Russian, charming and suave—

who used to do portraits on ocean liners."[75] Loew also recalled Pantuhoff as "a real man of the world but wild, running around with women. I could hear them scrapping a lot."[76]

"They were all brilliant, talented," Jonas recalled of this group of friends. "Lee was better than Jackson Pollock in talent. Everything Mike Loew touched was beautiful. Igor was brilliant. He could draw like a wizard. . . . He had it in his hands, muscular, dashing, not sensitive. Lee was a Marxist of the Trotsky variety."[77]

Jonas also recounted that Pantuhoff "would say [to Krasner] as a put-down, 'you're common, like the rest of them.'"[78] Others directly cited Pantuhoff for anti-Semitism, which characterized his family's culture.[79] Igor's parents declined to meet Lee because she was Jewish, and this may have caused her to refuse to marry him. But he clearly embraced her family, who thought the two were married. In 1934, Igor had painted an affectionate portrait of Lee's father, showing him holding one of his Yiddish texts. Igor took the trouble to carefully reproduce the Hebrew letters. Krasner owned and treasured the painting, later giving it to her nephew Ronald Stein.

Some years later, Igor sent Lee a drawing of a figure in a landscape (with the setting sun and his name inscribed on a rock). The drawing was at the bottom of a note that he headed with the words, "But love . . . Igor." Above the drawing, he also inscribed: "Wonderful day . . . Full of Trust and confidance [sic]. Will be Sleeping Thursday with a friend there in Hospital . . . Hell with Christianity." The last three words survive to document the conflict that he felt about the prejudice his Russian (Orthodox) Christian family had against Jews.[80]

Pantuhoff and Krasner both worked on the WPA. She was working at the Temporary Emergency Relief Administration until admitted to work on the Mural Division of the Fine Arts Project of the Works Progress Administration, where she was assigned to assist Max Spivak on August 1, 1935. While working with Spivak, her pay was raised to $103.40 per month.[81] "To get

on the WPA," she recalled, "you had to qualify for relief first. You had to prove you had no visible means of support. Then your work was looked at, and if you were accepted you were put on either the mural or easel painting projects. I was part of the mural painting project, even though I had never worked on a mural."[82]

According to Krasner's old friend Esphyr Slobodkina, to meet the criteria to get on the federal payroll, it was necessary to endure "the bitter indignity of the Home Relief investigating, the demeaning visits to the local food distribution centers where they would supply you with a bag of half-rotten potatoes."[83]

Spivak, a Polish-born Jewish immigrant who was just two years older than Krasner, remembered that he had five assistants. "There was Lee Krasner who married Jackson Pollock. She was my research girl. Harold Rosenberg, who was my reader, a very good reader. And then we had a guy to wash the brushes and so forth. Another one did odd jobs."[84] Spivak preferred to have his assistants run errands for him, and he liked to engage them in discussions of Trotskyist politics.

Though Spivak was in charge, he did not have better training than Krasner. He had spent six months studying at Cooper Union, before studying for a year at the Grand Central Art School and two years at the Art Students League. He then spent three years in Europe, including some work at the Académie de la Grande Chaumière in Paris. A lot of his European training consisted of copying old masters in museums. Slobodkina recalled that Spivak stuttered.

And though Krasner was better spoken, Spivak was better connected politically. He had been a member of the John Reed Club, the Communist Party, and the four-man executive board that formed the Artists Union. "The WPA and Depression climate gave artists a sense of unity . . . ," he later reflected, "and the fact that they all shared the same experience of starvation, they weren't alone. . . . For the first time they were participating not as individuals but as a group."[85]

Spivak fondly recounted attending meetings, protests, picketing, and marching across Forty-fourth Street. "We used to have meetings. The meetings served as our social place." He described how painters of different styles began to talk about their common problems, "the trade union problems, what's doing on the project and who's the enemy."[86] Spivak, however, found himself labeled a "Trotskyite" because of infractions of party discipline. Disillusioned when told that artists had to give up everything to be revolutionary, he walked out of a meeting and quit the Communist Party.[87]

Though Spivak regarded Krasner as his "research girl," he did recognize (but did not acknowledge) her obvious intellectual abilities. This was probably why she didn't have to wash the paintbrushes. Spivak's art interests may have had a larger impact on Krasner than his politics. By the time she painted *Gansevoort II* in 1935, she seems to have responded to Spivak's style. She also seems to have discovered the work of the Italian modernist painter Giorgio de Chirico. "Some of the paintings had a slight touch of Surrealism," she admitted. "I saw paintings in reproduction and talked to fellow artists."[88]

Spivak recalled that, although Rosenberg was a writer, he had gotten into the artists' project by using someone else's painting. Even May Tabak admitted, "Harold and I never intended for him to get a regular job. He went on the art project because his friends went and no one really believed it would materialize."[89] Tabak recalled that some friends woke them up by knocking loudly on the door of their cold-water flat, exclaiming, "Harold, come on. Come on, come on. They're hiring artists." Telling him that it had to be done today, they implored him to "grab some paintings. . . . Grab anything you've got framed and come along."[90] This conflicted with Rosenberg's story of being picked out for the WPA at Greenwich House.

Tabak claimed that only a cursory glance was given to Rosenberg's sample works during his WPA interview. The applicants

could choose between teaching or being on the easel or mural projects. When Harold choose murals, they asked him, "Have you painted any murals?" to which he replied: "Nonsense. No one in this country has painted a mural yet."[91] Thus Rosenberg got himself into the WPA with almost no training as an artist, though he had amused himself in law school by sketching professors and students.[92]

Though layoffs were constant, Krasner saw one positive element. "There was no discrimination against women that I was aware of in the WPA. There were a lot of us working then—Alice Trumbull Mason, Suzy Frelinghuysen, Gertrude Greene and others. The head of the New York project was a woman, Audrey McMahon."[93] Another plus for Krasner was "the camaraderie, instead of isolation. . . . But basically, it was a living for us all."[94] Krasner received a pay adjustment on March 12, 1936, and her monthly salary was lowered to $95.44.

Since insecurity remained high and money was still in short supply, Krasner and Pantuhoff arranged to rent space for twenty-three dollars a month in an eight-room cold-water flat at 333 West Fourteenth Street.[95] "When I met them about the time the Art Project began, they were living together," Tabak recalled. "After a while they, we, and a bachelor friend [named Bobby Dolan][96] rented an eight-room top-floor apartment on Fourteenth Street, opposite a church. We divided the space so that we would not need to intrude on each other. We also shared the bathroom and the telephone.

"We had each kept a simple record of each telephone call we made, for example, and not once had the total varied by as much as one nickel," recalled Tabak. "It was possible for us to entertain without needing to invite the others; they did likewise. Sometimes we'd be joint hosts. When it proved impossible to find another shareable apartment, we moved into smaller quarters but continued our close friendship."[97]

Meanwhile, with the assistance of Krasner and Rosenberg,

Spivak was working on a series of murals on the theme of puppets for the downstairs playroom of the Astoria Branch of the public library in Long Island City. There were nine panels in all that took up 260 square feet. He made studies on paper and completed a model of the interior showing the murals in place. He exhibited these with one completed panel, in oil on canvas, in "New Horizons in American Art" in 1936, which opened on September 16, 1936, at the Museum of Modern Art after being shown at the Phillips Collection in Washington.[98]

In this same show, Pantuhoff exhibited *Ventilator # 2* of 1936, one of his canvases influenced by Surrealism during the mid-1930s—a time when he briefly shared Krasner's interest in the avant-garde. *Ventilator # 2* includes a Picassoesque head in profile, floating in space in the upper left of the composition. The central image, a metal construction mounted on a brick tower, distantly echoes both the Surrealist Giorgio de Chirico and Russian constructivism, including, strangely enough, Vladimir Tatlin's concept for the gigantic *Monument to the Third International* of 1920, designed at the time when Pantuhoff's family had been forced to flee Russia. Because Tatlin's *Monument* was re-created for the 1925 Exposition Internationale des Arts Décoratifs et Industriels Modernes in Paris, where it was awarded a gold medal, it certainly would have been known to Pantuhoff. Despite his recent study with Hans Hofmann, Pantuhoff lacked commitment to be avant-garde. Instead, encouraged by his parents, he seems to have wanted to break into the conservative establishment that he had known briefly as a prizewinner at the academy and to exploit his considerable skills as a portrait painter.

Krasner, however, kept her focus on the avant-garde. Surrealism affected her more profoundly than she later recalled, although her interest in the movement was fleeting. Her *Untitled (Surrealist Composition)* (1936–37) depicts a classical female figure floating in space, which indicates her continuing interest in de Chirico—she must have just seen the exhibition "Fantastic Art, Dada, and Sur-

realism," which Alfred H. Barr, Jr., opened to great fanfare for the Museum of Modern Art on December 7, 1936.[99] De Chirico's painting provided inspiration for her composition, which features two eyes floating in and above a landscape. For the motif of the eyes, she turned not to a Surrealist image, however, but to earlier fantastic art. For instance, she draws from two nineteenth-century French graphics: J. J. Grandville's *First dream—crime and expiation* and Odilon Redon's *The eye like a strange balloon mounts toward infinity,* both of which are reproduced in the show's catalogue.[100] In both artists' works, she found a similar horizon line defining a rather empty landscape. Krasner not only seized on these images of disembodied eyes, using the single round eyeball of Redon, but took a cue to multiply it from Grandville, as well as adopting the cross that he places in the landscape. She made pencil sketches on pages of notebook-size paper on which she began working out her own images.[101]

Surrealist films were also shown at the museum in conjunction with this show, and she certainly may have been affected by these films. Krasner's focusing again on eyes may reflect the notorious scene of a razor slicing a young woman's eye in Luis Buñuel's 1929 film, *Un Chien Andalou,* the script of which he wrote jointly with Salvador Dalí.[102]

Since discovering Matisse at the Modern, Krasner's passion for his work was also intensifying.[103] Her *Untitled (Still Life)* of 1935 closely resembles Matisse's *Gourds* of 1916, which the Museum of Modern Art acquired the same year she painted her homage. Her flat ground as well as the placement and shapes of the separate objects tilted toward the picture plane evoke this Matisse.

In *Bathroom Door,* painted in 1935, Krasner adapted Matisse's strategy of painting a still life in the foreground with a view into another space visible in the distance. In Krasner's case, this is through the bathroom door to an image of a female nude in the tub. Her composition brings to mind Matisse's 1924 canvas of an interior in Nice, which appears in Henry McBride's 1930 mono-

graph on Matisse and presents a similar spatial arrangement.[104] Krasner's figure in the tub, with her raised arm bent at the elbow, repeats the form of Matisse's sculpture of a reclining nude or of his painting *Blue Nude* of 1907. Krasner's nude seems like a self-portrait, and her treatment is intentionally erotic, signaled by the Cézannesque still life—the two ripe oranges in the foreground evoke the nude's round breasts. Were this a painting of the eighteenth century, one would interpret the broken pottery like the broken eggs in Jean-Baptiste Greuze's still life—as referring to the woman's lost virginity.[105] Krasner's subtle, yet teasing expression of sexuality suggests that she might have been momentarily interested in the erotic humor of Marcel Duchamp or the Surrealists, whose work she later discounted.

As Pantuhoff strayed, Krasner surely began to look around. In an unusually candid interview with Anne Bowen Parsons in 1967 or 1968, she acknowledged that she first met Jackson Pollock when he cut in on her dancing at an Artists Union party in December 1936. Parsons asked Krasner, "Did you feel that contacts initiated through working together on the project carried over into increased interaction, dialogue, ferment? Did you feel there was a lasting effect?"

"Of course," she responded, "in my own case, I met my husband as a result of the Project, and as a result of my involvement in the Artists Union, which was a related organization. There's no question that we continued to meet, to concern ourselves with one another and one another's work after the project was terminated."[106]

Krasner met Pollock at an Artists Union dance in 1936. Already suffering from alcoholism, Pollock was drunk when he approached Krasner. Nothing came of it, but she later repeated a version of the story in which she did not remember meeting Pollock in 1936 and did not get his name at that first meeting. Yet, in what she told Parsons, she seems to have known more about Pollock in 1936 than she later let on. In fact, B. H. Friedman recorded

in his journal how Krasner asked him to suppress the story of that first encounter (which he had heard about from their mutual friend, the painter Fritz Bultman), in which Pollock's only words to her were "Do you like to fuck?" [107]

Krasner also told Parsons about Pollock's work on a float for the May Day parade: "He worked with [David Alfaro] Siqueiros in his studio. At any rate, we felt a sense of community, of course for the rights of *all* artists. Stuart Davis was very active, for one." [108] Davis, who first marched in the 1935 May Day parade, remarked that it was "a necessity to be involved in what was going on, and since it had a specific artist section connected with it . . . the artists felt themselves part of everything else, general depression, the needs of money and food and everything else." [109]

At one May Day parade organized by the Artists Union, de Kooning helped the abstract expressionist painter Arshile Gorky build a float. "It was Gorky's idea," said Robert Jonas. The float took the form of an abstract tower, produced in painted cardboard.[110] Its immense size required six people to carry it. Gorky had emigrated from Armenia, where he was born Vosdanik Adoian in the village of Khorkom.

In fleeing the Turkish invasion, Gorky arrived in the United States in 1920 and shortly after changed his name to Arshile Gorky. From 1926 to 1931, he was a member of the faculty at the Grand Central School of Art in New York. Gorky was known to study the work of other modern artists intensely, especially Cézanne and Picasso. He became close friends with Stuart Davis, John Graham, and de Kooning. From 1935 to 1937 he worked on murals for Newark Airport under the Federal Art Program, although he painted in an abstract style. In a lecture at the Art Students League, rejecting Soviet orthodoxy, he disparaged the vogue of overtly political, proletarian art when he declared it "poor art for poor people." [111]

While Gorky, just four years older than Krasner, was already very prominent among their contemporaries, Pollock was virtually

unknown during the 1930s. Artists close to Gorky, from Stephen Greene to Willem de Kooning, later recalled that Pollock did not get along with Gorky, whom, according to Krasner, he did not actually meet until 1943.[112] The painter Milton Resnick allowed that Gorky "influenced Lee Krasner, who in turn influenced Pollock."[113]

Likewise, though Jackson Pollock worked with the activist David Alfaro Siqueiros, his politics have been described as "of the parlor and not of the activist variety. He was ultimately more interested in the revolution that would come from within, not one prescribed by sociopolitical agendas."[114] According to Harold Lehman in *Art Front,* the float Pollock worked on with the Siqueiros Experimental Workshop "crystallized practically all the outstanding ideas about which the shop had been organized. It was in the first place Art for the People, executed collaboratively; and into it went the dynamic idea, new painting media, mechanical construction and mechanical movement, polychrome structure, and the use of new tools. Certainly a message in such striking form had never been brought forward in a May Day parade before."[115]

Siqueiros began his Experimental Workshop on Fourteenth Street just after arriving back in New York in February 1936 as one of the official delegates from Mexico to the American Artists Congress. In 1932, he had been deported from New York for political reasons. His March 1934 show at Alma Reed's Delphic Studios in New York was reviewed for the *New Masses* that May by Charmion von Wiegand, who would become a disciple of the Dutch modernist painter Piet Mondrian. Von Wiegand stressed Siqueiros's commitment to revolution and viewed his art as "one form of revolutionary agitation."[116]

Siqueiros described the float as "an essay of polychromed monumental sculpture in motion," but he appears to have adapted the image from a poster for the Farmer-Labor Party, which was another one of his causes. His aim was to demonize Wall Street

and convey its fascistlike control of U.S. mainstream politics and encourage a backlash from the people. In order to do this, the workshop produced a huge figure with a swastika on its head and outstretched hands holding the symbols of the Democratic and Republican parties. At the same time, the float displayed a ticker tape machine from Wall Street being smashed by a gigantic hammer emblazoned with the hammer and sickle of the Communists, who were also supposed to represent united American resistance, shown triumphant as ticker tape spewed like blood over the figure of the capitalist.[117]

The 1936 May Day parade was said to have brought "the Communists and Left-wing Socialists together in a united demonstration for the first time in many years." News reports estimated that from 45,000 to 60,000 people paraded and attended rallies in Union Square and on the Polo Grounds.[118] The WPA's Dance Unit demonstrated with its slogan "Build Your Bodies But Not for War" and staged impromptu dances.[119] Krasner might well have participated in the parade and seen the float Pollock had worked on.

For Siqueiros's workshop, the artist Harold Lehman, who knew Pollock from Manual Arts High School in Los Angeles, had already worked with Siqueiros in Los Angeles. He recruited some of the Americans, including Pollock and his brother, Sande McCoy, while Siqueiros brought in artists from Mexico and South America. The stated aim of the workshop, held at 5 West Fourteenth Street, was "to raise the standard of a true revolutionary art program," and as such, it served as "a Laboratory of Modern Techniques in Art."[120] The workshop intended to explore making large-scale political art using modern technology (such as painting with spray guns) and new, inexpensive materials. Instead of oil paint or canvas, industrial paints such as automotive enamels and lacquers on wood panels were materials of choice at the Siqueiros workshop. The artistic technique of dripping industrial paint here preceded Pollock's later use of that technique.[121]

Given that in the late 1940s Krasner also dripped paint on horizontally placed canvases for her Little Image series, she too may have taken a cue either from Siqueiros or indirectly by way of Pollock. But it seems that her initial attention to Siqueiros in the 1930s was both for his artistry and for his leftist politics. Given her social networks at the time, she had obviously noticed his participation in the first American Artists Congress. The theme of the gathering was the struggle against war and fascism.

Though Krasner and the Communists shared a common interest in workers' rights, Krasner rejected the representational work of artists on the left, including social realism and such names as Raphael Soyer, William Gropper, or Philip Evergood. As Reuben Kadish once put it, "The social realists . . . produced art for the moment only. Think of the difference between Gropper and Daumier or Goya."[122] Krasner told an interviewer that the prominent leftist movements of the late 1930s "made me move as far away as possible, as they were emphasizing the most banal, provincial art. . . . French painting was the important thing at that point. Not the social realism that was going on here under our nose. Pictures of the Depression. Painting is not illustration."[123]

Krasner eventually served on the Artists Union's executive board, but even so, she and Jackson "never joined the party, proper," for the Communists were *the* party. Though a recent book-length exhibition catalogue in Switzerland calls Krasner "a committed Communist" (without citing any evidence),[124] this was not true. "We weren't organizational types, but we felt at that time that they fought for our interests. I feel that the degree of an artist's involvement can't possibly be measured by a literal representation of problem areas in his art. That is a naive position."[125] Another time she spoke of "a big power move" at the union: "The Communist Party had moved into the Artists Union and started to shove around very heavily and I said, bye, bye. I am about other things. Other things interest me. And I would like to restate that I felt the full validity of the WPA around which the so-called Art-

ists Union had organized. They did not meet to discuss any problems in painting. . . . Their full emphasis was a political move, a power move."[126]

Though Krasner never joined the Communists, Gerald Monroe, who interviewed her around 1970 about her participation in the Artists Union, still recognized that Krasner was "sympathetic." Monroe reported that she was occasionally invited to "the fraction meeting," which was the executive committee subject to party discipline. It was composed of those members of the union who were in the party or close to it, and they met secretly to get guidance from the party and work out the strategy for the meetings.[127] Krasner's friend B. H. Friedman wrote, "It would seem in retrospect that Lee on the Communist-dominated executive committee was a 'patsy' or dupe; although she was liberal in politics and committed to the rights of the artist, she was never a Communist."[128]

Monroe wrote that Krasner chaired many meetings and was "known to be very militant in union fights with government." Monroe's notes state that Krasner "headed committee to get fired (pink slip) artists back on WPA. By & large chairman ran an open meeting but when a crucial issue was on floor, discussion was controlled—through chairman ('via me') by selecting speakers from sea of hands on the floor. She was known not to be in party nor under strict control, never attended 'inner inner sanctum.'"[129]

Krasner recalled that after she had been relieved of her work with the WPA, she was on a committee of three or five people elected to meet with the WPA to get union members first priority in being rehired. When she found that her name had not made the list for reinstatement, she complained to an executive board member of the Artists Union that she was being overlooked. Her name was put on the list for reinstatement at the next meeting, where the director, Audrey McMahon, instructed her, "Miss Krasner this is something that you should discuss with your union, not me."[130] Then, weeks after being told that the union's policy was

that active members of the Artists Union, not Communist Party members, got preference, a board member told her, "[Communist] Party members are being reinstated first." Just before a meeting of the union was to begin, she told the board member, "What a dirty little trick! I am going to get up on the platform and inform membership what you just told me." He warned her not to do it, and she said, "Can't stop me." To which he replied, "OK you'll be on the job next week." He kept his word, and she was reinstated the following week.[131] That was a turning point for Krasner, who became less active in the union.

Years later, Krasner recalled a regular Wednesday-night meeting of the union in 1935 or 1936 when she questioned an issue on the floor only to hear several shouts of "Trotskyite." She didn't know much about politics, but the label so angered her that she actually began to read Trotsky. From the publication dates of books in her library—Leon Trotsky, *The History of the Russian Revolution* (1936), and Leon Trotsky, *The Revolution Betrayed: What Is the Soviet Union and Where Is It Going?* (1937)—this angry encounter at the union meeting may have come in late 1935 or in 1936.[132] The artist Bernarda Bryson recommended particular works of Trotsky to Krasner, who in turn urged them on Pantuhoff.[133] Krasner also kept two books by Karl Marx: *Class Struggle in France* (which is inscribed "Igor Pantuhoff") and *The 18th Brumaire of Louis Bonaparte* (Marxist Library v. 35), as well as Nikolai Bukharin's *Historical Materialism: A System of Sociology* (New York, 1934) and Lincoln Steffens's autobiography of 1931.

From Trotsky's *The Revolution Betrayed,* Krasner could understand his views on nationalism and culture:

> *The official formula reads: Culture should be socialist in content, national in form. As to the content of a socialist culture, however, only certain more or less happy guesses are possible. Nobody can grow that culture upon an inad-*

*equate economic foundation. Art is far less capable than*
*science of anticipating the future. In any case, such prescrip-*
*tions as, "portray the construction of the future," "indicate*
*the road to socialism," "make over mankind," give little*
*more to the creative imagination than does the price list of*
*a hardware store, or a railroad timetable.*[134]

Krasner made clear her attitude toward Trotsky and Siqueiros
in a 1975 videotaped interview with Christopher Crosman, then
on the staff of the Albright-Knox Art Gallery. He asked her di-
rectly about "unsubstantiated rumors floating around in Pollock's
name. . . . The Mexican muralist Siqueiros was being sought by
the American authorities, the FBI, I suppose, with regards to an
attempted assassination plot against Trotsky and that Pollock had
hid him out for maybe a day or two in his apartment. Have you
ever heard anything to that effect before?"

"I have and it's not true because I was already living with Pol-
lock at that point," she responded in good humor, but definitively.

"I guess that pretty well nails that rumor down," replied Cros-
man, as Krasner volunteered:

"It's a fact that Siqueiros was being sought and was accused
directly of being tied into the assassination. He was not— He
was not hidden out in Pollock's studio." She chuckled, adding, "I
wouldn't have allowed it if nothing else because I was a great ad-
mirer of Trotsky's." She closed her sentence with a smile, evidently
not particularly annoyed by the question.[135]

Unfortunately, Crosman missed the chance to point out to
Krasner that in fact she was not yet living with Pollock when
the unsuccessful attempt on Trotsky's life was made on May 24,
1940, nor by August 20, the day of Trotsky's assassination. An-
other curator says that Krasner "was particularly troubled that
Pollock had admitted aiding Siqueiros during the time he was
hiding from the police," and that she "brought this fact up sev-

eral times" during a visit in the summer of 1977. If so, then she reversed herself merely two years after denying this same story on camera.[136]

If Trotsky's ideas did not prompt her to reject nationalism in art along with socialist realism, they must at least have reinforced her convictions. Krasner did not value the accessible in art and instead favored the artist's personal expression. According to Trotsky, "The national form of an art is identical with its universal accessibility." He denies the ideological decree that what the public wants must be the inspiration for significant art, which is what the Soviet propaganda paper, *Pravda,* dictated to artists.[137]

Trotskyism in America dates back to October 27, 1928, when the party expelled three leaders who had criticized the leadership of Joseph Stalin and sought to return to Lenin's original ideas. By 1933, the Trotskyists began to influence American workers with their well-orchestrated campaign against the rise of fascism in Germany. Intellectuals, such as those involved in the journal *Partisan Review,* joined the Trotskyists, whose influence grew.

Krasner's acquaintance Lionel Abel recounted that "in the spiritual life of the city during the thirties, the most important question discussed was whether to defend the Stalin government against those who criticized it, or to join the critics of that government's policies, the most important of whom was Leon Trotsky. So the Trotsky-Stalin controversy became the most bitterly discussed and violently argued issue where ever radical politics were discussed, and they were discussed in the city streets and cafeterias, in the unions and at universities."[138] The Trotskyists had their largest impact in America between 1937 and 1940, before Trotsky was assassinated on August 20, 1940, in Mexico by a Comintern agent.[139]

"Artists and writers were very radical in that particular period," recalled Reuben Kadish. "I, for instance, was doing things for the Communist Party even though I wasn't a member. I wasn't alone. The party at that particular time was very forceful in bringing to-

gether the efforts of union people and artists. If you went through those areas that suffered fantastically and saw the bread lines and saw the things that nobody else was doing anything about, you might have been sympathetic to the party, too."[140]

Willem de Kooning recalled, "I was no Communist, no Stalinist. I was not so opposed to Russian art in principle, but all those other guys had made me a modern. . . . There were the ardent people like [William] Gropper, and they were so rigid, so doctrinaire. I remember their jeering at Gorky on the night when he stood up to speak at a union meeting."[141] Nonetheless, another friend recalled that Gorky was actively interested in the Spanish Civil War and took part in demonstrations.[142]

The Spanish Civil War (1936–39) motivated 2,800 Americans to voluntarily join the fight to defend the Spanish Republic against a military rebellion led by Francisco Franco, who was being assisted by the fascists Hitler and Mussolini. "In the Artists Union days, Spain was an issue," Krasner recalled. "Fellow artists went to Spain. You put things on the line."[143] Trotskyists in the Socialist Party quickly rallied to the Spanish workers' revolution and funded a military unit to join the battle in Spain.[144]

Joris Ivens's film *Spanish Earth*, which was shown in 1937, further raised awareness in America. On December 19, 1937, Picasso's statement about the Spanish Republican Government's struggle was read to the American Artists Congress in New York. As director of Madrid's Prado Museum, Picasso assured the artists that "the democratic government of the Spanish Republic has taken all the necessary measures to protect the artistic treasures of Spain during the cruel and unjust war. While rebel planes have dropped incendiary bombs on our museums, the people and the military at the risk of their lives, have rescued the works of art and placed them in security."

Picasso addressed artists directly when he said "artists who live and work with spiritual values cannot and should not remain indifferent to a conflict in which the highest values of humanity

and civilization are at stake."[145] Of the 2,800 Americans who went to Spain, many joined the Abraham Lincoln Brigade (Battalion), which fought from 1937 through 1938 against the rebel Nationalists. Others volunteered as doctors, nurses, medical technicians, and ambulance drivers.

Volunteers came from all walks of life and included visual artists such as Joseph Vogel from the National Academy and Emanuel Hochberg.[146] Krasner surely recalled that she and Vogel had both studied with Leon Kroll. Vogel recalled, "Out of a sense of sheer belief in social justice. . . . I found there were others with me and some of them lost their lives. Paul Block lost his life. A few other artists lost their lives there. . . . There were two others, a man by the name of Taylor. . . . There were others who never came back."[147]

The artists who responded to the Spanish Civil War and those who left for the front made a lasting impression on Krasner. The American Friends of Spanish Democracy, whose supporters included the influential critics Waldo Frank and Lewis Mumford and the philosopher John Dewey, donated an art award in 1937 to help focus public attention on the events in Spain. This was the same year that Joan Miró produced *The Reaper,* his famous mural for the Spanish Republican pavilion at the Paris International Exposition. He then produced a related poster of a raised clenched fist with the words "Aidez Espagne [Help Spain]." The image was also published by the journal *Cahiers d'Art.*

In the same pavilion Picasso showed his monumental black and white painting *Guernica* (1937), which depicts the Nazi bombing on market day in April 1937 of this Basque town. The Nazis bombed the town, which was not a military objective, in order to spread terror.

Though Krasner was politically active, her painting was not explicitly political. "There was the Spanish Civil War, the clash of fascism and communism. In theory, we were sympathetic to the Russian Revolution—the socialist idea as against the fascist idea,

naturally," she remarked. "Then came complications like Stalin-ism being the betrayal of the revolution. I, for one, didn't feel my art had to reflect my political point of view. I didn't feel like I was purifying the world at all. No, I was just going about my business and my business seemed to be in the direction of abstraction." [148]

Krasner's friend Balcomb Greene recalled, "We spent long evenings in arguing and discussing painting. A great many we-e opposed to social realism. I remember Gorky, in particular, was strongly of this opinion." Greene had written for *Art Front,* the union's magazine, and served as the union president for a year. [49] "Meetings grew very excited with discussions on art and politics," he reflected. "There was considerable difficulty in combating at-tempts of the Communist members to take over the union. It was hard to know exactly who they were at times, some but not all were openly Communists. You had to judge by a man's actions in the long run. It was this political rough stuff that put the artists off the Communist Party." [150]

*Art Front* magazine, the union's official publication, "was a broad cultural publication for which many very prominent people, international names from Man Ray to Léger, would write." [151] The journal did not promote art as propaganda but instead suggested that modernist forms themselves could be progressive, or even revolutionary. [152] Spivak recalled how the artist Hugo Gellert tried to make *Art Front* a completely proletarian magazine and that it was sold at the union parade on May Day. Circulation reached about three thousand.

The *Art Front* cover for March 1936 featured Igor Pantuhoff's painting *Ventilator No. 1,* which, according to the caption, he painted for the Federal Art Project. Pantuhoff's composition and subject matter, depicting the rooftop of an urban building with water towers and chimneys, were quite close to Krasner's painting *Fourteenth Street,* of 1934. Both Krasner and Pantuhoff exploit a worm's eye perspective, looking up at the water towers from the rooftop below. Although it is not known when Pantuhoff actually

painted the work, his composition with repeated arches and brick walls visible through them suggests that he had just seen the show featuring twenty-six of Giorgio de Chirico's paintings at the Pierre Matisse Gallery in New York, which was reviewed in *Art Front* for January 1936 by the artist Joe Solman. Solman had praised both de Chirico's "use of perspective" and his "fertile imagination."[153]

By January 1936, Harold Rosenberg had become a member of the *Art Front* editorial board alongside Solman, Joseph Gower, Murray Hantman, Jacob Kainen, Balcomb Greene, J. Yeargens, and Clarence Weinstock. Rosenberg had been added to the board by Spivak, who then resigned in February. Rosenberg became a regular contributor and wrote an essay, "The Wit of William Gropper," for the March issue with Pantuhoff's cover.[154]

In that same March issue, *Art Front* reported that on the WPA project in New York City, artists "are being paid $103.40 a month, supervisors of murals, $115.00, for a 24-hour week." The Artists Union was then pressing hard "for a $2.00 hour-rate, 15-hour minimum week."[155] Because private patronage had all but dried up, government patronage was the artists' only plausible salvation. Thus the union proposed that its funds be spent for "the benefit of the public, in the form of mural painting; decoration and sculpture in public buildings; the teaching of arts and crafts for children and adults; traveling exhibitions of paintings, drawings, small sculpture."[156]

Also featured in this March issue was Meyer Schapiro's article "Race, Nationality, and Art," in which he rejected nationalism. Schapiro condemned both the racialist theories of fascism that "call constantly on the traditions of art" and American critics who restricted what was "American" to those of "Anglo-Saxon blood." He warned against the perils of racial antagonism, used as a means to weaken the masses and leave "untouched the original relations of rich and poor."[157]

Schapiro's argument resonated with Krasner, who recalled these years not just as a time of austerity but also as a time of dis-

covery. "At that point, the center of art for Gorky, de Kooning and myself was the School of Paris. We used to go to shows at the Matisse and Valentine Dudensing galleries all the time."[15] Dudensing, which became known as the Valentine Gallery around the time it showed *Guernica,* had presented exhibitions of Matisse in 1927 and 1928 and also hired Pierre Matisse, the artist's son, then only in his twenties, to organize shows of contemporary French painting during the late 1920s. Then Pierre Matisse opened his own gallery in October 1931.[159]

While living with Pantuhoff, Krasner hung out with fellow vanguard artists such as Gorky and de Kooning at the Jumble Shop, the venerable Village eatery then at 28 West Eighth Street. Krasner once quipped, "You didn't get a seat at the table unless you thought Picasso was a god."[160] Of the 1930s, she recalled: "I knew de Kooning and I went to his studio so I knew about de Kooning's work. But only a little handful knew about it, you know. Maybe there were ten people who knew about it. That's a lot. There wasn't a movement. And Gorky one knew about and one went to his studio or sat and drank beer with him at the Jumble Shop and enthused about Picasso and the latest painting of Picasso's or Giotto, if that came up, or Ingres."[161]

Krasner does not say so, but she probably frequented the Jumble Shop with Pantuhoff: "We used to go there in the evening, settle down around the table, drink our beer, and have our big number on, say, Picasso. If Gorky was there, he dominated the conversation. And with Gorky, it was always Picasso."[162]

Another time, Krasner said of Gorky, "I had a great deal of fights with Arshile. Oh yes, it wasn't a relationship which always flowed in glowing terms. These arguments might, at some point, involve philosophies of art. At that point, the image of Picasso was dominating the art world very strongly and one might feel, well maybe Matisse is really a better painter."[163]

The Jumble Shop was a longtime bohemian resort with an old-fashioned bar and flowery tablecloths. A small private dining

room featured fanciful murals of nightlife, painted in 1934 by Guy Pène du Bois.[164] The shop was known for its "art-while-you-eat policy."[165] Other habitués ranged from the modernist Burgoyne Diller to the traditionalist Henry Varnum Poor.[166] Group shows of contemporary American artists were regularly held (and noted in the weekly art columns). One could nurse a cup of coffee over a long conversation. The artists on view were not avant-garde or abstractionists, and the shows repeatedly featured the same circle, usually chosen by the troika, Guy Pène du Bois, H. E. Schnakenberg, and Reginald Marsh, who were representational artists that showed at the conservative Whitney Museum of American Art just down the street.

An exception to usual representational fare happened only occasionally when, for example, the abstract painter I. Rice Pereira exhibited at a Jumble show. A Jewish woman who was just six years older than Krasner, Pereira used the initial *I* instead of *Irene* to avoid gender discrimination.[167] Krasner was aware of Pereira's work.[168] Jumble shows frequently included women, perhaps because both the stakes and the prices were low.[169]

The critic Lionel Abel also recalled the Jumble Shop in the 1930s, but the conversations focused on names like the socialist Morris Hillquit, the Communist Earl Browder, and Karl Marx, whom they dubbed "Charlie."[170] The more conservative, representational painters must have clustered at still another table. As the shop's name might seem to imply, its customers were politically and aesthetically diverse. Harold Rosenberg described it as "for a more respectable element who had enough dough to buy a beer or something, you know. Most of us didn't have very much money to spend, so we weren't likely to go to a place that had middle-class tastes. . . . But Stuart Davis used to hang around in the Jumble Shop, and a few other guys, you know, the older guys who already had some cash."[171]

# From Politics to Modernism, 1936–39

Lee Krasner in her New York studio, photographed by Maurice Berezov, c. 1939. At this time, under the influence of Mondrian's work, Krasner was producing thickly painted canvases with an emphasis on primary colors and bold black lines (CR 130 on her easel, CR 127 on wall, and CR 129 on the floor).

POVERTY AND PROTEST CHARACTERIZED KRASNER'S EXPERIENCE of the mid-1930s. Looking back, Krasner recounted how she was fired and rehired and jailed for illegal activities—meaning protests against the brutal "pink slips" of dismissal.[1] She said that she was arrested many times and was in "some of the best jails in New York."[2] "I was practically in every jail in New York City," she boasted. "Each time we were fired, or threatened with being fired, we'd go out and picket. On many occasions, we'd

be taken off in a Black Maria and locked in a cell. Fortunately, we never had to spend the night."[3]

The Black Maria paddy wagons actually evoked a certain nostalgia. Krasner was probably one of the eighty-three WPA artists and art teachers who picketed before the College Art Association on August 15, 1935, protesting wage cuts and demanding better pay, improved working conditions, and shorter hours.[4]

On December 1, 1936, Krasner was demonstrating in a sit-down strike with some four hundred artists and models against the impending dismissal of five hundred workers from the WPA. Organized by the Artists Union, their demonstration took place at 6 East Thirty-ninth Street, at the WPA Arts Projects Building. Paul Block, a sculptor and activist, urged the crowd to be nonviolent.[5] An eyewitness reported that Block was "slammed across the head with a club, dragged across the floor, stepped on, and thrown bleeding into the elevator." Months later he joined the Abraham Lincoln Brigade and was killed in the Spanish Civil War.[6] The *New York Daily Mirror* reported that more than 50 people were injured and some 231 protesters were arrested in a clash with the police that lasted more than two hours. The paper claimed that two policemen were bitten to the bone by "hysterical women," and that desks were smashed. Using a billy club, the police knocked unconscious the leader of the demonstration, a sixty-three-year-old mural painter and printmaker named Helen West Heller.[7]

Years later Krasner recalled that "special squads dragged out artists roughly," and she remembered "sedate elegant [Anne] Goldwaithe dragged on the floor while photographers coolly photographed the scene," calling it the "shock of my life." The police used clubs, she recalled, and the whole thing was "frightening."[8]

Another demonstrator, Serge Trubach, was a Ukrainian-born artist who studied at the National Academy and later worked with Krasner on the War Services project. Trubach recalled that when the artists refused to leave as the WPA offices were closing, "Mrs.

[Audrey] MacMahon called the police department and they came down to the entrance and the people wouldn't leave so they immediately called up ambulances and they beat the devil out of all the artists and some of them had to be taken to hospitals on stretchers."[9] He added, "The women were hit with rubber [truncheons] in the midriff because they didn't want to show any bruises, so there wouldn't be any public sentiment that they were also beaten. So they were hit in the midriff of their body so it wouldn't show in public, you know, when they went out of the building."

Trubach also recounted the protesters' harsh experiences in jail after the demonstration. "It turned out that all the artists arrested, all gave fictitious names and were sent up to night court." Often the names were of dead famous artists. "Everybody from Cézanne to Michelangelo was arrested. Rubens was there, and Bruegel, and, oh, Ryder, and let me see, Turner, everybody, you name them and they had them. After everybody was registered and their names taken. . . .

"They had two big pens. They put all the women in one pen and all the men in the other. And several women became hysterical. There was only a urinal on the floor where the men were. . . Nobody had eaten any dinner. It was just before dinnertime when the arrests were made. So they kept a vigil until about ten o'clock at night and they put all the men in . . . jail. . . . I don't know what happened to the women. I didn't know where they went," he explained, "but the men were all. . . . sleeping like sardines one over the other. And most of the artists just sat around and talked."

Krasner booked herself into prison as the painter Mary Cassatt.[10] "I didn't have a big selection, you know, it was either Rosa Bonheur or Mary Cassatt. . . . But when it came to trial, the court clerk reading some of these names, my dear; you know, you'd hear Picasso and everybody's head would turn around and see who had said Picasso."[11] She chuckled that the clerks were clueless as to their ruse.

Vito Marcantonio handled the case. Marcantonio was a radical

politician and protégé of Mayor Fiorello La Guardia, and he eventually got suspended sentences for all the artists arrested and convicted for "disorderly conduct" in exchange for not prosecuting the individual policemen that were brought up on charges of assault and brutality. Fifteen of the artists had needed emergency medical treatment.[12] Paul Block appeared in court as the main witness, Trubach recounted. "When he came to court he was bandaged from his shoulders up to his head. You could only see his eyes . . . it was obvious it was police brutality."

It was while jailed after this same protest that Krasner first met Jeanne (Mercedes) Cordoba Carles, who also got arrested. The daughter of the modernist painter Arthur B. Carles, Mercedes was a great beauty who easily attracted men in the art world— from the outspoken Gorky, with whom she was then involved, to Hans Hofmann, the much beloved teacher. Both women worked on the WPA mural project under Diller, and they became close friends. Their friendship, forged in such drastic circumstances in such desperate times, would be marked by both poignancy and significance.

In another protest against the WPA's periodic firings and rehirings, Krasner joined some seventy-eight artists in the group show *Pink Slips over Culture,* which was held at A.C.A. Gallery on Eighth Street from July 19 to 31, 1937, and organized by the Citizens Committee for Support of the WPA and the Artists Union, which by then was billing itself as a CIO affiliate. The Citizens Committee included writers Edna St. Vincent Millay, Lewis Mumford, Upton Sinclair, Van Wyck Brooks, John Dewey, Lillian Hellman, and Dr. Stephen S. Wise, along with artists Rockwell Kent, Edward Steichen, William Zorach, Yasuo Kuniyoshi, and the set designer Robert Edmund Jones.[13]

Most of the artists contributed work of their own, but it was announced that some of the exhibited works were ironically produced for and loaned by the Federal Art Project. The show's jury included artists Stuart Davis, Harry Gottlieb, Jacob

Kainen, Elizabeth Olds, and Nahum Tschacbasov. Some of the contributors—including Krasner, Joseph Stella, and Isaac Soyer—had already stood out among their contemporaries. Krasner's work joined sixty-eight paintings and ten sculptures.[14] The work Krasner submitted was ambiguously titled *Still Life*. This painting was possibly her still life on canvas from 1935, where flattened forms, in heavy black outlines against a solid ground of gray and blue, echo Matisse's influence.[15]

The show's catalogue reprinted a statement that the novelist Ford Madox Ford had delivered over WABC Radio: "In arranging this exhibition by artists dismissed from the FAP, the Artists Union feels that it is placing the very real question of the future of American art before the public. The public is to decide, in the long run, whether or not these artists and many others are to bring art to institutions and people hitherto unaware of the meaning of plastic beauty."[16] Ford also mentioned economic need, "with all its harrowing consequences for the artists and their families."[17]

The catalogue also included Lewis Mumford's open letter to President Roosevelt, which had originally appeared in the *New Republic*. Mumford urged the president to stop cutting off public support for the arts. "I wish to persuade you that indifference to the arts projects of the WPA would not merely be unjust to the artists themselves who have worked with a zeal and devotion of which we must all be proud, but it would be an outright betrayal of a unique opportunity. . . . It is time that art be taken for what it is, a realm like education which requires active and constant public support."[18]

Besides her work at the WPA and the political activism it triggered, Krasner continued to develop her artwork by enrolling in classes at the Hans Hofmann School of Art at 52 West Ninth Street:[19] "I joined the class because I wanted to work with a model again. This was close by to where I lived, it was available, and I was interested in what was happening there," she explained.[20] She had also heard a lot about Hofmann from Pantuhoff. Hofmann

considered that he taught "progressive art students" about "pictorial space." [21]

Krasner's arrival at the Hofmann School made a lasting impression on Lillian Olinsey (later Lillian Kiesler, married to the artist Frederick Kiesler), a student who volunteered as the school's registrar. Seeking to be admitted, Lee breezed into the school carrying a portfolio with her black-and-white figure drawings, which Olinsey judged "unusually dynamic." "Here was a very original talent," she recalled, "I was thoroughly convinced about Lee . . . this quality of energy, her power of articulation . . . so vital. She was just unique." [22] Also impressed by Krasner's appearance, Olinsey described her on that first encounter as dressed in a black blouse, a black tight skirt with black net stockings and high-heeled shoes. "She had an animal magnetism, an energy, a kind of arrogance that commands . . . an energy that makes the waves happen."

Olinsey rushed downstairs to see Hofmann in his small office, telling him about the new student, whom she considered "unique": "You must give her a scholarship." She had judged Krasner's work as superior to that of the other students. Hofmann took the advice of his trusted volunteer, and Krasner entered the school on a scholarship. All she had to do was buy the required Strathmore paper, charcoal, an eraser, and a board on which to work.

Despite Olinsey's enthusiastic initial evaluation, Hofmann felt that he had something to teach Krasner. Olinsey recalled that it was at Krasner's first Friday-morning "crit," after a life class, that Hofmann took Krasner's drawing and tore the lower part of it into pieces, reassembling them on the left to demonstrate how to achieve greater dynamism and "a distinct movement" in relationship to the picture plane. Olinsey too was stunned and spoke about this incident to Hofmann, who later explained that he was demonstrating what he saw as Krasner's need for the theories of modern art, that one could not just work from the center, but should consider all four sides of the composition. Krasner,

who had grown accustomed to receiving harsh criticism from her teachers, weathered the shock of having Hofmann rip up her drawing before her classmates.

Much later she would complain that she had a hard time understanding Hofmann's English at first. She recalled that he "would come in twice a week and move from student to student.[23] For the first six months I was there I couldn't understand a word the man was saying because he had such a heavy German accent. So I'd wait until he got through with the critique and there would be like thirty students—then when he left the room, I'd call George McNeil [the class monitor] over . . . and say 'What did he say to me?' so I really got George's version of what he thought Hofmann had said to me." Yet, given how many students were in the class, Krasner doubted that the monitor had really absorbed the master's words about her work. But "after a while," she added, "I could understand him directly."[24]

She remembered that Hofmann taught "the two-dimensional surface to be punctured and bring it back to the two-dimensional again; in effect he was teaching the principles of cubism."[25] Though cubism suggests showing multiple viewpoints simultaneously, this was her attempt at describing Hofmann's famous "push and pull" theory. He taught that the illusion of space, depth, and movement could be achieved on a flat canvas even in abstract art by using color principles and abstract shapes. At another time she described Hofmann as "one of the leading exponents in terms of explaining it [cubism] in this country. . . . I really didn't get . . . the full impact of [cubism] until I worked with Hofmann."[26] She concluded, however, "The most valid thing that came to me from Hofmann was his enthusiasm for painting and his seriousness and commitment to it."[27]

Hofmann brought extensive experience with modernism to his teaching. Born in 1880 in Bavaria, he grew up in Munich, then studied for a decade in Paris, beginning in 1904, where he met Braque and Picasso. He became a friend of Robert Delaunay, who

prompted him to focus on color through his own colorful abstract cubist style. The outbreak of World War I caused Hofmann to stay in Munich, and during this time he got to know Gabriele Münter, the former companion of Wassily Kandinsky, and read Kandinsky's book *On the Spiritual in Art*. Münter even persuaded Hofmann to store some of the art abandoned by Kandinsky when he fled to Russia as war broke out. Despite the fighting, Hofmann opened his own art school in 1915, and over the coming years it began to attract American students.

Eventually Hofmann was invited to be a visiting professor at the University of California at Berkeley, where he taught during the summer of 1930. He returned the next year, when he had a show of his work at the California Palace of the Legion of Honor in San Francisco. Not surprisingly, he closed his Munich school in 1932 and settled in the United States, and went on to run schools both winters in New York and summers in Provincetown.

"To avoid being academic" was Hofmann's byword. He said his philosophy was to be "a vital participant in contemporary aesthetics," insisting that "teaching which represents the Renaissance tradition has deteriorated to a method of mere visual representation, where perspective, anatomy, dynamic symmetry and other scientific formulas have been placed as obstacles to the natural creative process of painting."[28] He argued that the American reaction against the academic had resulted in "an exclusive interest in subject matter and neglect of aesthetic considerations."[29] He rejected the focus on representation of an Edward Hopper or a Raphael Soyer. He also rejected Surrealism and would not have liked either Krasner's *Gansevoort I* or *Gansevoort II,* despite the latter's abstracted shapes.

At the same time, Hofmann emphasized that "a student's talent should be estimated by his instinctive faculty of plastic sensitivity: the power, when applied to the experience of nature, to penetrate the relationships of its colors, forms, weights, textures, etc."[30] He emphasized life drawing and still life in the winter

classes in New York and added landscape in his summers on
Cape Cod, high above Provincetown overlooking the sea. He en-
couraged his students to work and rework their drawings before
moving on to paintings. The student would then reduce what was
observable to express only volumes that exist in nature through
planes of abstract color.

Krasner began making charcoal drawings of still life setups.
The students often worked on these in afternoon sessions: fruit,
objects, textiles on a tabletop. Some of the objects were bottles,
glasses, melons, or a bunch of grapes. From these, she quickly
moved into colors, letting planes and spots of color dominate her
composition. She didn't focus on edges but rather emphasized the
contrasts of colored shapes as they vibrated (pushing and pulling)
against one another in space. The hot colors like red seemed to
jump out at the viewer, while the cooler blues and violets appeared
to recede. Sometimes the objects almost seemed to dissolve into
the surrounding space, creating an abstract composition.

The mornings at the school were reserved for sketching in
charcoal from the human figure. Hofmann liked to set the model
in a space defined by the light and surrounding objects. Students
were to capture the push and pull, positive and negative space,
which articulated the figure. Krasner sketched seated female
models by employing bold lines and planes of paper left white
for contrast. Before long, she opened up the figure and depicted a
fragmented view, implying movement, as if exploring the dynam-
ics of how the limbs functioned.

Krasner depicted the figure in a shallow space with a contrast
of values that came out of cubism. Krasner acknowledged that she
was familiar with Picasso's 1910 drawing *Standing Figure,* which
the photographer and gallerist Alfred Stieglitz gave to the Metro-
politan Museum in 1949.[31] Krasner would have seen this drawing
in the Museum of Modern Art's 1936 show "Cubism and Abstract
Art," just in time to incorporate what she had observed in her
own work at the Hofmann School.[32] Some of the nude studies she

made in class repeat these axial lines of motion; they are a far cry from the figure drawing she had done at the National Academy or with Job Goodman, not even aiming at the subtle chiaroscuro of the old masters.

Her classmate Perle Fine recalled Krasner's distress when she arrived late one Monday morning after the class had been sketching from the same model for two or three weeks. Taking one look at her drawing, Krasner began to exclaim aloud, "It's all wrong. It's all wrong! It's all changed!"[33] The other students looked to Krasner and her drawing. She explained, "She's cut her hair," a deed that, while seemingly meaningless, changed the abstract planes Krasner was translating directly from what she observed.

Hofmann taught how colors interacted optically when juxtaposed. He had students try applying colored paper shapes to their drawings. Sometimes students felt that he went too far, especially when he seized a drawing and tore it in two pieces, hoping to show how to create vitality by shifting the paper to show a less rigid composition. His exuberant demonstrations might have unintentionally suggested the possibility of collage to Krasner. In connection with her Stable Gallery show of collages in 1955, Krasner reflected, "Back in the '30s, as a Hofmann student, I had cut and replaced portions of a painting."[34] "It was a result of the Hofmann classes that I painted my first abstract compositions. The physical break in my work occurred at the time I was attending Hofmann's class. I didn't go regularly, but I was there off and on for three years or so."[35]

Krasner also became interested in Piet Mondrian's work. Though Hofmann had not shown any of his students his own paintings, Krasner was influenced by one of Hofmann's classroom sessions on how Mondrian used space to compress nature into a few, stark horizontal and vertical lines and rectangles. Hofmann praised Mondrian as "the architect of modern painting"[36] and taught that "Mondrian brought plastic art to ultimate purity."[37]

Krasner sometimes worked in a palette limited to the primary

colors—red, yellow, and blue—plus black and white, like Mondrian's geometric *De Stijl* abstractions: "I might do a vertical or horizontal measurement of space; something when Mondrian was up front for me so it looked like a Mondrian but he [Hofmann] would want the negative elements to conform to what was absolutely in front of me; no leeway whatsoever. After a while this came to disturb me on quite a lot of levels."[38]

Eventually she turned out a painting that went beyond Mondrian, embodying the spatial concepts that Hofmann taught and creating planes that appeared to move in space. With this work, she anticipated Hofmann's own painting by about two decades—all without knowledge of how her teacher painted.[39] Olinsey recalled of Krasner: "She always made the fur fly."[40]

Later, when asked if she had liked Hofmann as a teacher, Krasner reflected, "I did at first, and then I really got very irritated with him at several levels. One was his rigidity of working within the given sphere; he didn't care how abstract you went—that is, there were many times when I reduced the model in front of me. You had to work rigidly from what was in front of you—still life or model. He insisted on it."[41] She complained that "he would come up to your drawing; pick up your charcoal and start working on top of the thing to make his corrections."[42]

Krasner was irritated with how Hofmann demonstrated what students should be doing by drawing on their sketches. Hofmann roamed through the classroom on the lookout for a work he considered unsuccessful. He was known to erase entire sections of a student's work or to add his own corrections, hoping to show how to activate space and his system of "push and pull."[43]

On balance, Krasner appreciated Hofmann. She told one interviewer that "Hofmann was the first person who said encouraging things to me about my work."[44] She liked the fact that he was teaching cubism. Reflecting, she concluded that it was analytical, not synthetic cubism, meaning that she viewed him as teaching how Picasso and Braque first analyzed and reduced observed

forms into geometric shapes on a two-dimensional picture surface rather than how they and others later (after 1912) constructed compositions and collages out of shapes often achieving more decorative effects.

Others seemed to be taking her seriously as well. Harold Rosenberg showed his respect when he introduced her to the art critic Clement Greenberg at a party, taking her aside and saying, "That guy wants to know about painting, talk to him about painting." Greenberg later admitted that he was in awe of Krasner's strength of character: "Just her presence. With this pure un-accented English. I learned a lot from that too. Her strict eye. And she was good [at] looking at art."[45] At the time, Krasner suggested that Greenberg attend Hofmann's Friday lectures, which were open to all.[46] Greenberg went and soon pronounced that no one in the United States understood cubism as well as Hofmann.[47]

Greenberg also signed up to take life drawing classes taught by Pantuhoff for the WPA.[48] Pantuhoff himself had already studied with Hofmann and moved on. He was not that open to Hofmann's engagement with abstraction and still held on to realistic representation. Painting portraits gave the opportunity to make good money, while there was no market yet for abstract art. Pantuhoff became particularly adept as a society portraitist, since his upper-class manners and good looks won him favor.

Greenberg saw a lot of Krasner, Pantuhoff, and other Hofmann students. Clement Greenberg also recalled that Krasner and Pantuhoff introduced him to Arshile Gorky somewhere on Eighth Street around 1937 or 1938,[49] and that Krasner first introduced him to Willem de Kooning. As for her relationship with Pantuhoff, Greenberg thought that Krasner had a "sick soul" and that she always chose weak men such as Pantuhoff, whom he called "a White Russian scamp." He remembered that she was with Pantuhoff when he first met her and that he had painted portraits. Greenberg liked Krasner's friend George Mercer even less, going so far as to question his masculinity.[50] Even though

Greenberg said that he viewed Krasner as "powerful," he blamed her attraction to such men on her having had a remote father, claiming that this was "the same story I've heard from other girls."[51]

Hofmann wielded an immense influence over Greenberg, Krasner, and many of his students. She viewed him as "swinging between Picasso and Matisse in terms of what he was saying. Because I'm aware of Picasso, I'm aware of Matisse, by the time I'm working with Hofmann."[52] Through Krasner, and by extension, through Hofmann, these artists became important for the future art critic Clement Greenberg too. On balance, Krasner credited Hofmann for her development as an artist. "His serious commitment to art supported my own."[53] He in turn remembered her as "one of the best students I ever had," although he once encouraged her by remarking, "This is so good you would not know it was by a woman."[54] A touch of sexism shows too in his view of her marriage to Pollock: "She gave in all the time. She was very feminine."[55]

At Hofmann's school, Krasner made many of her lifelong friends, such as George McNeil, George Mercer, Perle Fine, Fritz Bultman, Mercedes Carles [Matter], Lillian Olinsey [Kiesler], Ray "Buddha" Kaiser [Eames], and John Little. Just one year older than Lee, Little had come from the tiny town of Sanford, Alabama, near the Florida panhandle. "Often, Lee and I were assigned our working positions on the same side of the studio, and we were free to work on a drawing from the model for a week if need be,"[56] Little said later. His continuing respect for her devotion to art buttressed their close friendship. "At once I was attracted by Lee," Little recalled, "not only by her personality and natural beauty but by a real dedication to her work, by a quiet, smoldering inner rage that seemed to come through in her drawing, and by beautiful bright green stockings—all of which gave her a marked distinction and set her apart from the student body. Yes, she had style."[57]

As for McNeil, he had also worked on the Mural Project of the

WPA and was active in the Artists Union. He and Krasner both had the abstract painter Burgoyne Diller as their supervisor. Both Krasner and Diller were influenced by Mondrian. Diller was a sympathetic person in a powerful position. Krasner felt a large debt to Diller, whom she praised years later for his "enormous sensitivity to the needs of the painters. . . . I think he made it possible for more than one artist to continue painting. . . . He was in some supervisory capacity which made it possible for him to—he was fully aware of the needs of the artist and painting and dealing with something called high administrative jobs."[58] To other women on the project, Diller was known as "Killer-Diller" because, according to one woman, he was "extremely good-looking" and had "at least half of the project ladies running after him."[59]

Both Krasner and McNeil agreed that the shows at the Museum of Modern Art in the 1930s were very important, though he claimed Hofmann was his "most important influence."[60] Around this time McNeil shared a loft with Pantuhoff and Krasner at 38 East Ninth Street. By 1936, one of Krasner's assignments was to finish an abstract mural that Willem de Kooning had started for the WPA. Since she could not afford a space of her own, she was using part of the studio Pantuhoff and McNeil shared to work on de Kooning's design. "He had to leave [the employ of the WPA] because he was not a United States citizen," she recalled. "His sketch was about four by six feet. They took it and turned it over to me to blow it up. . . . I was already working abstractly and Diller would have known that."[61] Krasner probably viewed Diller's assignment to complete de Kooning's abstract mural as a more pleasant assignment than working on finishing other artists' representational schemes. De Kooning, she explained, would "come unofficially to my studio and see what I was doing. It was hard-edged for de Kooning and very abstract."[62] At least at that time they spoke the same basic aesthetic language.

While attending the Hofmann classes, Krasner remained active in the Artists Union, which she saw as "organized to protect

the rights of the artists on the WPA Art Project."[63] Although she worked abstractly, Krasner emphasized, "I as an abstract artist was active politically. And I know many others that were."[64]

Krasner's vivid memories of a meeting of artists in the late 1930s that took place in de Kooning's studio, a loft on Twenty-second Street, once again demonstrate that she was present during the formative experiences of the abstract expressionists, although most accounts of the movement usually exclude any mention of her or indeed of any other women. Though she was probably present accompanied by Pantuhoff, only she remained an abstract painter, while he became a portraitist.

Gorky called the meeting, and he got up and said, "We have to admit we are bankrupt."[65] Krasner explained, "Gorky felt that perhaps we could as a group do a painting, 'a composite.' And when we asked what he meant, he said, 'Well now, here we are about six or seven of us and there's one person who can draw better than the others, there's one who has better ideas than the others, there's one who is better at color than the others. Now what we have to do is sit and talk this over and come up with a thought and then we all go home and do our separate things and bring them back and then we'll decide who should draw it, who should paint it, who should color it.' . . . Well, we never got too far . . . I don't think there was a second meeting; or if there was, there was never a third meeting. The canvas never came about."[66]

Whether or not Krasner knew it, Gorky had been at the early meetings of the American Abstract Artists (AAA) in 1936, years before she joined. He tried to dominate the meetings, proposing similar "assignments" for the artists, but then not doing them himself. Already an art instructor, Gorky seemed bent on manipulating his colleagues, often through his theatrics and charisma. This time, as Ilya Bolotowsky reported, Gorky's act backfired. "Gorky used to talk a lot. Gorky told us that the whole idea [of AAA artists exhibiting together] was silly because in art progress is always achieved by the great personalities, and all the rest serve

as a kind of floorboard or floor mat for *the great men,* and our purpose should be to uphold and support and push one worthwhile personality who would survive in history, not waste ourselves on promoting useless careers like our own."[67]

It is worth noting that Gorky spoke only about "the great men," leaving no possibility for Krasner. When Gorky threatened to leave the meeting if the others did not follow his wish not to exhibit as a group, the painter Werner Drewes goaded him to make good on his threat, and he responded by walking out. His loyal friend, de Kooning, withdrew from the AAA in support of Gorky.[68] As for Krasner, she was apparently not offended either by Gorky's sexism or his need to be center stage; she later acknowledged that Gorky and his work "interested me enormously."[69] To the extent that she believed in Gorky's theory of "the great men," she might have concluded that if she could not be one, she could marry one.

Gorky, Krasner, Byron Browne, and the painter Mercedes Carles, whom Krasner knew well from the Artists Union activities, sometimes went together to Greek places. "The sailors used to come, and it was colorful and cheap," recalled Aristodimos Kaldis, a Greek artist and lecturer.[70] He remembered Gorky singing old Armenian songs, but he forgot about Pantuhoff, who surely went along.

Due to cutbacks in funding, Krasner received one of the infamous "pink slips" and was terminated by the WPA on July 16, 1937. No other jobs were readily available, so she was relieved to be rehired on August 19, 1937, at the same salary. On September 6, 1938, however, the government slapped on a "pay adjustment," cutting her wages to $91.10 per month.

After being rehired, Krasner was put on an assignment for a mural in "some high school in Brooklyn." The theme was history of ships. "It had been conceived and planned by another artist. He left in the middle for some reason. I supervised its completion." They received preliminary approval for this project on May 9, 1939.

Krasner explained, "The procedure was that an artist got a mural and then he would have anywhere from two to ten assistants, depending on the size of the mural and how many assistants he needed, or she needed. As the project lasted for a long time some of the artists whose sketchbooks had been approved, but the murals hadn't been executed, and for some reason or another they left the Project, the research had been done, everything had been done but the mural, the final execution of it."[71]

According to Krasner, there were five different mural projects hanging side by side in a shed above a pier, and all the artists worked alongside one another.[72] Municipal records document that she and Leonard Seweryn Jenkins worked on two large walls, each six by fifty feet. These were mural-sized oil paintings on canvas, which Krasner recalled as "108 feet long." They were destined not for a high school, but for a children's branch of the Brooklyn Public Library in Brownsville.[73]

"That mural seemed to be two or three miles wide. I worked from the original small sketch and blew it up. I had assistants and we worked on a pier over the river. Eleanor Roosevelt came to see us working there," she said years later, adding, "that whole experience introduced me to scale—none of the nonsense they call scale today. . . . Long before I met Pollock too, I had been working that large."[74]

Krasner recollected that she "got several of these dirty jobs to do—on the condition that they would give me an abstract mural of my own. To which they consented though there was very little request for abstract murals. You know there were mainly one or two places where they could be placed. This was some radio station I believe. . . . Unfortunately the public taste did not request abstract murals."[75] Krasner said she'd told Diller she would do the Brooklyn Public Library job "only if you give me a little mural of my own—something abstract—a small abstract panel. Well, he kept his word and gave me a small abstract panel, and I did the sketches and preliminary work, when wham the WPA was ended."[76]

Krasner and Pantuhoff continued to visit her parents' home in Huntington.[77] Her niece Rusty Kanokogi remembered seeing her Aunt Lee there with Igor when she was still a small child. She adored him, since he was handsome and charming and paid attention to her aunt. She recalls the unpleasant surprise of seeing her aunt arrive several years later with another guy, who, unlike Igor, was neither handsome nor outgoing.[78]

During the summer of 1938, Krasner and Pantuhoff, together with a group of friends, spent their vacation on Cape Cod, renting two rooms in Provincetown for $7 a week. Their group that summer included the artists Rosalind Bengelsdorf and Byron Browne, Arshile Gorky, and David Margolis. Bengelsdorf recalled how they played in the dunes, swam in the chilly waters, then sunbathed nude, trying to warm up. She recalled that Gorky picked up "a little girl" who did not take off her clothes, but instead "took photographs of all of us," which she never printed. Rosalind also remembered how Gorky directed all of this activity, but that "there was no eroticism, nobody touched anybody else. Everyone was with their own."[79] Gorky, she also recalled, made humorous remarks about everybody else's anatomy.

Krasner appears in a group photograph of Hofmann's class in Provincetown, which she apparently visited while on vacation. Though the published date is "c. 1939," it should be 1938, because Krasner did not travel to the Cape during 1939.[80] Among the others identified in this photograph, only Hofmann and Fritz Bultman are people who remained important for Krasner. Hofmann wrote that summer to his student Lillian Olinsey telling her of the escapades of Krasner and Pantuhoff in his flashy red convertible.

The escape to the relaxed environment of Provincetown helped to temper the frustrations of New York, which, as Krasner later noted, had "no atmosphere then, no ambiance. There was little support and few rewards. As an artist I felt like I was climbing a mountain made of porcelain. Paris was the center. We looked at

*Verve, Cahiers d'Art.* None of us had galleries. We saw European art—Miró, Matisse, Giacometti, Picasso—on Fifty-seventh Street. For instance, I saw the *Guernica* at the Valentine [Dudensing] Gallery." [81]

Picasso's mural *Guernica* showed there for three weeks in May 1939, when it went on view together with drawings and related studies at the Valentine Gallery under the auspices of the American Artists Congress as a benefit for the Spanish Refugee Relief Fund. The chairman of the exhibition committee was the New York businessman, author, art collector, and future gallerist Sidney Janis. *Guernica* inspired lively critical debate. "I'm afraid it knocked a lot of people flat," Krasner said of the painting. "I can only give you my response in that sense. It knocked me right out of the room, I circled the block four or five times, and then went back and took another look at it. I'm sure I was not alone in that kind of reaction." She explained that "the presence of a great work of art . . . does many things to you in one second. It wasn't that you consciously said, 'I want to do that.' You're overwhelmed in many directions when you're congenially confronted with, let's say, a painting like the *Guernica* for the first time. It disturbs so many elements in one given second you can't say 'I want to paint like that.' It isn't that simple." [82] To see it again she traveled up to the Boston Museum of Fine Arts. [83] Then, in November 1939, *Guernica* went on view once again in New York in the Picasso retrospective exhibition organized by Alfred H. Barr, Jr., for the Museum of Modern Art. At the time, many artists responded to how monumental and moving the painting was.

At the end of July 1939, friends of Krasner and Pantuhoff still considered them to be an item. While vacationing in Provincetown, George Mercer even sent them a postcard that read "Dear Lee Gor: How are you kids?" He encouraged them to join him and some of their friends attending the Hofmann summer school, including Bultman, Mercedes Carles, and Wilfrid Zogbaum. He included a hint of their aesthetic interests of the moment. "How is

'Can-Can' Kandinsky & Mother Miró?"[84] Mercer had managed to buy a Kandinsky, perhaps even from Hofmann.

Krasner had been attracted both to modernism and to Pantuhoff's keen interest in the avant-garde just after his return from his European tour in 1930. But as Igor's interest in modernism waned, her commitment strengthened, causing a growing tension in their relationship. Other troubling issues that divided them, as observed by friends like Michael Loew and Robert Jonas, were Pantuhoff's womanizing and the fact that his family refused to meet Krasner because she was Jewish.

Regardless, Igor gave Lee the book *Paintings and Drawings of Matisse* by Jean Cassou, which he inscribed: "To Lee with admiration from Igor, 1939, New York."[85] Beyond recognizing her passion for Matisse with this gift, Igor eventually gave or left other books to Krasner, including *Picasso* by Henri Mahaut, published in 1930 and inscribed "Igor Pantuhoff 1932," and *Raoul Dufy* by Jean René, published in Paris in 1931 and inscribed "Igor Pantuhoff 1931."[86]

Krasner ended her job on the WPA once again on August 31, 1939, under a ruling that discharged all who had been employed for more than eighteen months. She did not get rehired until November 29. The three months of virtual destitution further stressed her relationship with Pantuhoff, who friends recalled always lived beyond his means.[87]

Money was so scarce for them that she looked around to see what she could sell to raise some funds. On September 10, she ran an ad in the *New York Times* offering to sell a "Copehard Radio-Phonograph" with an automatic record changer for $100. The ad noted "Call between 5–7 o'clock. Lenore Krasner, 44 East 9th Street."[88] This ad obviously misspelled the "Capehart Radio-Phonograph," purchased by the often extravagant Pantuhoff, either in advance or in imitation of de Kooning's similar acquisition. Now with both of them broke, it had to be sacrificed to pay for basic living expenses.

Evidently Krasner informed Mercer that Igor was thinking of going to Florida. Mercer wrote her on September 18, 1939: "Glad to hear Ig'r still with. . . . Ask Ig'r who is going to Florida and g've the big br'ser a k'ck in the a's for me."[89] Perhaps pressured by his inability to support himself, Igor departed suddenly, leaving a note that said, "Dear Lee I'm going to Florida this morning. Will you take care of yourself. I will right [sic] as soon as I get there. Igor. My Florida adress [sic] is 811 Hunter St. W. Palm Beach Fla." On October 19, 1939, he sent a postcard from the Philco Race Track in Baltimore: "On the way Down South the Old bum. P.S. Say goodby to the gang."[90]

Desperate, discouraged, and hoping for better fortune, Partuhoff had gone to see his parents in Florida, from which he sent Krasner a letter on his second day. He illustrated his note with an elaborate sketch of himself reclining under the skimpy shade of a palm tree that he represented as an erect phallus with four fronds attached. He added a caption beneath the tree: "The large plant that you have does not lick [sic for like] sun. It must have shade to exist." He was clearly hard up for cash because he implored Krasner to "try to sell Jules portrait for anything you can get? My parents turned out to be much poorer than I expected." He reassured her, "I will give you 50% of the sum—I go to bed 8 p.m." He also wrote: "It seems to me that sun is shining especially for me," adding, "(The day before I araved [sic] hear [sic] three baby skunks came to my father's estate and nobody has a nurve [sic] to talk to them. Father promises 50 cents for me for each skunk I will persuade to go away.) P.S. But I am wise I will not talk to them."[91]

A week later, Igor sent Lee a note telling her, "I have a place to exibit [sic] Joans [sic] portrait so will you send it to me together with the strecher [sic]. When you roll it up, roll it with the fase [sic] outside. Send by American Express." He wanted it right away and asked that she also send him six black soft Conté sticks collec. He added: "I'm righting [sic] to Nat that if you need any money and if he has any to give to you. There is not very much to say

about this place it is raining and my parents are much purer [*sic* for *poorer*] then [*sic*] I expected. (father is crazy) Mother is sick."[92]

By then Krasner had moved from 44 East Ninth Street to a cheaper place a block away at 51 East Ninth—Mercer's former apartment. A few months later, Krasner had discovered the French symbolist poet Arthur Rimbaud's *A Season in Hell,* in a new translation by Delmore Schwartz that was published on November 5, 1939. She enlisted her friend Byron Browne to put the following lines on her studio wall because she liked his handwriting, which was bold and clear.[93]

> *To whom shall I hire myself out? What beast must one adore? What holy image attack? What hearts shall I break?* What lie must I maintain? *In what blood must I walk?*[94]

The words were entirely in black paint except for *"What lie must I maintain?"* in blue. Krasner would have been drawn to the title, *A Season in Hell,* at the moment that Schwartz's translation appeared, for it seemed to capture what she had been going through between unemployment and Pantuhoff's abrupt departure. In fact someone may have recommended Rimbaud's poem to her because it speaks about departure, suffering, and anger. Rimbaud even wrote denying a departure—just what Krasner did at first when trying to deal with Pantuhoff's absence.

Krasner's interest in these lines ran deep, as Eleanor Munro discovered when she asked Krasner about them in an interview. "She [Krasner] is not about to go back and expose those feelings now. But clearly there was a bond felt during those fraught and frustrating years with another artist [Pantuhoff] who had begun in full hopes only to find himself negating his gifts 'in the hell-fires of disgust and despair.'" Munro had stumbled upon pain Krasner suffered from Pantuhoff's self-destructive habits, espe-

cially his excessive drinking, but also his sudden abandonment of their relationship, their "togetherness."[95]

Krasner may also have been thinking about the consequences of choosing to live the artist's bohemian lifestyle with its copious consumption of alcohol. This might have been how she interpreted the line "What beast must one adore?" for herself. Certainly Pantuhoff's behavior at times qualified as that beast, beyond her control.

It is not certain where Krasner first encountered Rimbaud, but the poet is a logical extension for someone who admired the work of Poe. During this time art talk, exhibitions, and publications were discussing André Breton and his Surrealist colleagues, who believed that the unconscious mind was a source of inspiration and found examples in the work of earlier artists and poets, including Poe, Charles Baudelaire, and Rimbaud. Because we know that Krasner made art influenced by images in the 1936 MoMA show "Fantastic Art, Dada, and Surrealism," it is likely that she once had a copy of the show's catalogue, which discusses "the revolutionary aspects of Rimbaud."[96] That description alone was enough to provoke the curiosity of a woman who wanted to be part of what was new and revolutionary.

Harold Rosenberg, who shared her interest in Rimbaud, quoted the first two phrases of the same passage in a 1938 article for *Poetry* magazine entitled "The God in the Car," although his translation is not the one Krasner used, for she used more lines and did not know French.[97] At the time Delmore Schwartz's translation of Rimbaud's *A Season in Hell* was published, both he and Clement Greenberg were writing for *Partisan Review,* so Krasner could have met Schwartz through her friendship with Greenberg.[98]

The Rimbaud lines offered some solace, but Krasner was stunned by losing Igor, with whom she had made her life over the last decade. Other friends tried to cheer her up. That same fall,

Krasner accompanied John Little to an artists' costume ball given by the management of a new Viennese restaurant on East Seventy-ninth Street. As a publicity stunt, the restaurant invited all the students from the Hofmann School. "I invited a few students from the school to meet at my studio and go uptown together," recalled Little. "Lee was my date. She wore gray robes, a carrot-red wig made of yarn, and carried in her hand a real Madonna lily—the Raphael Madonna replete! I went as Mephistopheles [the name of the demon in the Faust legend]. As soon as all our friends arrived we had a few drinks and went off to the ball well prepared." For Little, it was "a memorable evening; and we danced until dawn."[99]

On November 23, 1939, just before the WPA hired Lee again, Igor wrote her from Miami Beach, telling her that he had received her air mail. "No I'm quite all right there is nothing rong [sic] I received your package for which I thank you very much. Sorry to hear you have not got your job back."[100] On February 26, 1940, he wrote again from West Palm Beach. "You ask me in the last letter if I'am [sic] coming back to New York? I dont think so I'am [sic] leaving for Texas soon where I hope to find work. About Nat and the money He rought [wrote me] and said that he did not have in mind paying me money but only building phonograp [sic]." He then asks her to send "C.O.D." all the things that he had left behind in New York: his leather jacket, shirts, and his sketch stool. If she doesn't want the large canvases he left behind, he requests that she give them to Hans Hofmann.[101]

This definitive break left Krasner bereft after living so long together and sharing so much. After all, they had given the impression that they were married, perhaps not only to others. Socially this was tantamount to a divorce. On March 7, 1940, Igor wrote again, noting that he had received her letters and the portrait that he had asked for. He requested her once again to send all of his things, enclosing a long list with such essentials as his "Burrbary coat [sic]," Mexican shoes, his blue raincoat, his underwear, and his "large palett [sic]." He concluded only "I hope you are well."

Apparently, when he had left for Florida, he had intended to return. Perhaps his family, who had refused to meet Krasner, had helped to convince him not to go back to her.

On March 19, Igor wrote again, acknowledging having received her letter about his things and "about Brodivish [sic]." He informed her that he wrote to Brodivish for information and tells her "the tools I imagine your father would lick [sic] to have. I hope you well Igor Will you do this as soon as possible? please." [102] On the back of the envelope, the word idiot is scrawled. The handwriting is Lee's.

By March 24, 1940, Pantuhoff had yet to move to Texas. Instead he was partying with the Social Register set and clearly using his parents' social connections in Russian high society in exile. The New York Times even reported his presence in Palm Beach at a Russian dinner given by Prince Mikhail A. Goundoroff for William C. Bullitt, the United States ambassador to France.[103] One can only imagine how Krasner must have felt if she read this notice or heard about it from friends. Earlier that month the Times had reported that "Mrs. Evelyn McL. Gray had a cocktail party at her [Palm Beach] home, where the portrait of her daughter, Miss Elise Phalen, by Igor Pantuhoff, was shown for the first time." [10-]

On March 28, Igor sent Lee a postcard from West Palm Beach to acknowledge that he had received hers. "I ges [sic] I did not explain that I need my things now. Will you please send them as soon as possible. Igor." [105] By this time, Pantuhoff had clearly decided to abandon hopes of a career in the New York art world. It seemed like he just wanted the easier lifestyle of a society portraitist.

Using his connection to Fritz Bultman, whom he knew from the Hofmann School, Igor went on to New Orleans. There, in 1940, he painted the portraits of Bultman's mother and, working from a photograph, his deceased grandfather, Tony Bultman. From New Orleans Igor moved on to high society in Natchez, Mississippi. He migrated from plantation to plantation, painting

as he went, sometimes "servicing" the southern ladies as well.[106] The young Dutch painter Joop Sanders recalled that by the late 1940s, Igor was known as "a walker," someone who escorted rich women.[107]

Fred Bultman, Fritz's father, helped Igor make connections in Natchez.[108] He hit it off with Leslie Carpenter, a banker who lived at Dunley Plantation. The two men began to "hunt, drink, and womanize" together until Igor had a hunting accident. He moved on then, "everybody's houseguest and bed mate," while the menfolk were otherwise engaged. He painted the dowager empress of the garden club, Catherine Grafton Miller. Attentive to both high style and telling detail, Igor endowed his female subjects with the same kind of flattering small waistline that John Singer Sargent had painted in his idealized portrait of Isabella Stewart Gardner in 1888.

Igor did not enjoy his own family's confidence. His father wrote to Igor's brother Oleg, Jr.: "one must be very careful in talking with Igor, as he gets everything mixed up. Right now he is in New Orleans, I hope painting."[109] Igor not only put a greater physical distance between himself and Lee, but he also moved light-years away from modern art and the New York scene. If Krasner had so far held on to hope that he would come back soon and that they would resume the life that they had shared, she finally had to see that he was not capable of either being the man or the artist she needed. The time had come to move on.

# SEVEN

# Solace in Abstraction, 1940–41

Lee Krasner working at the Hans Hofmann School
of Fine Arts, c. 1940; on the easel is an early state
of *Untitled, 1940–43* (CR 133).

W ITHOUT IGOR, KRASNER MAY WELL HAVE FOUND THAT
their old coterie of male artists treated her differently.
She liked Willem de Kooning and Arshile Gorky, but
it is not clear that they respected or recognized women artists as
more than sexual, if not life, partners. Around this time, Krasner
began taking an active interest in the American Abstract Artists
(AAA), an artist-run organization that included married artist
couples such as Krasner's friends Rosalind Bengelsdorf and Byron
Browne and Gertrude "Peter" Glass and Balcomb Greene. This
assured respect for women as artists and equals. Formed in 1936
exclusively for artists to show their work together, its founders

included a number of Krasner's other acquaintances and friends from her days at the academy, the WPA, and the Hofmann School—George McNeil, Burgoyne Diller, Harry Holtzman, and Ibram Lassaw.

The AAA supported "Peace," "Democracy," and "Cultural Progress," though according to George L. K. Morris, an abstract artist and ideological leftist, the organization opposed the social realist art supported by the American Artists Congress.[1] From 1937 to 1943, Morris wrote for *Partisan Review*, which he helped fund and edit and for which he was the first art critic; the *Review* became identified by many as espousing "Trotskyism," since, like Morris, it was anti-Stalinist.

Krasner took action with the AAA on April 15, 1940, when the organization picketed the Museum of Modern Art, which had rejected the AAA's request to show the group's abstract art. "We were picketing the Museum of Modern Art and were calling for a show of American paintings and George L. K. Morris and I, when we knew that there was a trustee meeting, were given the task of handing [each] one of them, as they left the building, a leaflet saying, 'Show American Paintings.'"[2]

The handouts, designed by fellow AAA member Ad Reinhardt, asked: "How Modern is the Museum of Modern Art?" It was a slogan that the *New York Times* called the "battle cry" of the "Avant Garde." The pamphlet proclaimed, "In 1939 the museum professed to show art in our time—whose time—Sargent, Homer, Lafarge and Harnett? Or Picasso, Braque, Léger and Mondrian? Which Time?"[3]

The *Times* reporter also described "a handbill passed out to about a thousand artists who, by invitation, entered the museum at 11 West Fifty-third Street for a preview. Even the curlicue type in which the challenge was set expressed the contempt of the rebels, for it conjured up the velvet antiquity and the theatrical posters of the Gay Nineties."[4] The show that set off the protest was called "P.M. Competition: The Artist as Reporter" and ran from April 15

to May 7, 1940. Organized by *P.M.,* "a projected afternoon tablod newspaper," the show was meant to attract publicity by searching for "new talent in the great tradition of Daumier, Cruikshank, Rowlandson, Winslow Homer, Nast, Luks, and Glackens."[5]

Many bystanders mistakenly thought that the museum's show of Italian Renaissance painting, which had been sent to the United States because of the war, had caused the artists' protest, but Morris explained the picketers' motive: "What they really were angry about was the show of drawings from the newspaper *P.M.;* Marshall Field [heir to the department store fortune and a trustee of the Museum of Modern Art] wanted them shown. American Abstract Artists felt that if the Museum of Modern Art had space for newspaper sketches it certainly wasn't true that they had no space for abstract American art."[6]

Field had hoped that the MoMA show would attract effective political art for the tabloid paper *P.M.,* which he financed. Starting in June 1940, Ralph Ingersoll published the tabloid in New York for eight years. It attracted radical journalists and feature photographers as notable as Weegee (Arthur Fellig) and Margaret Bourke-White, and illustrators such as Dr. Seuss (Theodor Seuss Geisel) and Crockett Johnson, both of whom became beloved for their children's book illustrations. At the time, Geisel was trying to drum up support for aiding Britain, especially because he believed war with Nazi Germany was inevitable.[7] The first issue of *P.M.* had not yet appeared when the protested show was held.

Krasner believed that an artist had to struggle against—and also depend on—the Museum of Modern Art. The museum was "like a feeding machine. You attack it for everything, but finally it's the source you have to make peace with. There are always problems between the artists and an institution. Maybe that's healthy. You need the dichotomy—artist/museums, individual/ society—for the individual to be able to breathe."[8] Even more important than the MoMA was the pantheon of French artists. "We acknowledged the School of French Painting—the Paris School

of painting as the leading force and vitality of the time. . . . One didn't miss a Léger show. . . . But the giants were unquestionably Matisse and Picasso."[9]

Krasner's ultimate evaluation of American Abstract Artists was somewhat critical: "I found them a little provincial after a bit in so far as they became exclusive; that is to say at one point—I was then working with Hofmann; I suggested that he be invited to lecture or do something and they turned that down. I wanted to know why they didn't include [Alexander] Calder, for instance, who was American, and so forth. And there was a no-no to that, so they were already ruling in and out certain things."[10]

This exclusivity was definitely a cause for irritation. "I can remember having some hair-splitting fights within my avant-garde group because I thought we were getting a little provincial and wanted to expand its dimension," she recalled. "Provincial in being a closed shop, as any group tends to become no matter what it is called."[11]

Despite her complaints, Krasner was happy meeting with the AAA once a week. "Their sole purpose was to put up a show once a year at the Riverside Museum and if you paid your dues and were a member you would put up two or three paintings depending on how much space one had. . . . You did submit work to be accepted [to AAA]. Once you were accepted that was it. You did your own selection of what went in."[12]

Krasner showed in AAA's Fourth Annual group show in June 1940, which was held at the Fine Arts Building at 215 West Fifty-seventh Street. Jerome Klein, writing in the *New York Post,* poked fun at the group. "American Abstract Artists, the national organization of adherents to squares, circles, and unchecked flourishes, are holding . . . their fourth exhibition." He listed Lenore Krasner as a participant, making this her first published notice as a professional.[13] In the *New York Times,* Edward Alden Jewell panned the show, declaring, "Most of this non-representational art is instinct with academicism of its own particular brand."[14]

The summer of 1940 was hot, and Krasner was stuck working in New York. She read Carl Jung's *Integration of Personality*, about which she later remarked, "I thought it was fabulous, and I thought how marvelous, you know, that he speaks in my language, even though it has nothing to do with art—until he gets to the point where he starts talking about painting, where he starts analyzing some of his patients' drawings. And that was for the birds; I lost interest in Jung instantly."[15]

While Lee was alone in the city, her old Hofmann School crowd was on their breezy hillside in Provincetown, wondering about Lee. George Mercer wrote that Mercedes Carles was asking about her, whether she would come up again; Hofmann and his wife, Miz, and Fritz Bultman also sent greetings.[16] Despite her friends' affection, Krasner seems to have told someone she had imagined ending her life, because it prompted Mercer to write to her from Brookline, Massachusetts, on November 24, 1940, referring to "her projected trip up the river" (presumably the river Styx). He proposed, breezily, "Why not wait for me? Maybe we'll get some publicity out of it and a couple of sweet-scented pine coffins!" Mercer's jocular vein shows that he trusted that she was too tough to let self-pity win out.

Mercer admitted that he had been wondering whether the month would bring Krasner to Provincetown and told her that he had sold his soul "to the bitch-goddess of success."[17] Mercer was referring to his recent commitment to work for a National Defense Project to do camouflage work. "I am the artist, or one of the artists who has been placed in the den of scientist lions and must not be devoured but must teach science the gentle way of art. It's the same old plot about which many stories have been told as perhaps you know."[18]

While Mercer compromised his artistic goals by working on camouflage, Krasner had to continue to work on finishing other artists' mural designs for the WPA. She was glad to have the income, but she longed to create her own abstract mural, more in

keeping with the abstract images she exhibited with the AAA. She had watched enviously as Gorky produced his abstract but metaphoric mural *Aviation* for the administration building at Newark airport in 1939–40. She also saw that some of the men in the AAA had been given the opportunity to design abstract murals, among them her old pal from the academy Ilya Bolotowsky, who had first designed one for the Williamsburg Housing Project in 1936–37 and then another for the Hall of Medical Science at the New York World's Fair in 1938–39, for which de Kooning also designed an abstract mural.

Finally, in 1940, Krasner was given a chance to design an abstract mural for the WPA, but she never got to paint it because the project ended just after she had produced the studies for it. All that remains of her designs is a photograph of a lost work and some small studies executed in gouache on paper. Her combination of red, yellow, and blue with black, white, and gray was inspired by Mondrian. Her shapes were hard-edged but biomorphic, suggesting the influence of Miró and Picasso. The forms are ambiguous—calling to mind both an artist's palette and musical notes or instrument parts.

In 1941, Krasner submitted a sketch for an abstract mural at the radio station WNYC, which they accepted and commissioned for Studio A, then located on the twenty-fifth floor of the Municipal Building in downtown Manhattan. Other early abstract murals at the station had been produced by Stuart Davis, John Von Wicht, Louis Schanker, and Byron Browne. Working at the Hofmann School, Krasner adapted her abstract study from a still life on a table, although only few original elements are easily recognizable. Once again, she utilized primary colors along with black, white, and gray. Before she could execute the mural, she was taken away from the project to join the war effort. Instead of abstractions for walls, the government needed propaganda posters and designs for camouflage.

The last days of the WPA were upon Krasner and her friends.

Gerome Kamrowski, an artist who was then working on the mural project with Byron Browne, Ilya Bolotowsky, and Krasner, recalled, "One time we went out to Flushing—it was the second year of the [1939–40] World's Fair.[19] The idea was that the murals were starting to fade and it was cheaper to use us than house painters. But nothing came of it. We just walked around looking at the place. On the way back [John] Graham was on the train carrying this large object like a baby—it was a beautiful piece of African sculpture that he had gotten from the Belgian pavilion. I was sitting next to Gorky and Graham opposite."[20]

Kamrowski did not make clear whether Krasner was on that particular excursion, though he mentioned her in the same interview. It's not likely that she was, because she only remembered meeting John Graham for the first time in late 1941. However, Krasner had already read Graham's book, *System and Dialectics of Art,* published in 1937, and had liked Graham's emphasis on Picasso, but also that he had introduced so-called primitive, non-Western tribal arts as a concept for artistic consideration.[21]

After the outbreak of war, a number of European modernists, and AAA favorites, fled wartime Europe for New York. Among them was Mondrian, who, at the age of sixty-eight, had been afraid to cross the Atlantic. He had left London on October 3, 1940, by convoy ship in the midst of the blitz. Not long after Hitler came to power, Mondrian discovered that he was on Hitler's list of those who made *entartete Kunst,* or so-called degenerate modern art. Having already had to abandon his paintings in Paris during World War I, Mondrian, who had been living in Paris since 1919, left for London in September 1938, when the Spanish Civil War was raging and wider conflict seemed inevitable. Only after a bomb exploded in the building next to his London studio did Mondrian urgently leave for New York.

Harry Holtzman had helped Mondrian make his way to the States. Holtzman was a member of AAA and was a former student of Hofmann. He had discovered Mondrian's paintings on

exhibition in the Gallatin Collection at New York University's Gallery of Living Art.[22] He felt so inspired that he went to meet Mondrian in Paris in 1934. The two men, four decades apart in age, developed a close friendship. Thus Holtzman, financed by his wife's money, was able and eager to help Mondrian immigrate to the United States. Holtzman took care of Mondrian, finding him a New York studio (near his own) where he could live and work.

Holtzman also introduced Mondrian to boogie-woogie music, which refers to a new form of jazz, which had become popular in the city, especially for dancing, after concerts in the late 1930s. It featured short melody lines broken by open rhythmical patterns.[23] Holtzman later recalled that Mondrian was "long an admirer of real jazz, but had never heard of Boogie-Woogie, which was fairly new. I had a fine High-Fi set and discs that had just appeared. He sat in complete absorption to the music, saying 'Enormous, enormous . . . ' After several months . . . we got him a player and a collection of his favorite discs—all Boogie-Woogie, and the real Blues."[24]

The AAA meeting in November 1940 opened with a discussion of the plight of refugee artists in France. Together with Werner Drewes, Gertrude Glass Greene, Bolotowsky, and Morris, Krasner formed "a committee to investigate and report any action by members to help particular artists."[25] As a result of their report, the AAA voted at that November meeting to invite both Mondrian and Fernand Léger, another artist who had fled Europe, to join the organization.

In a postcard dated to early January 1941, Mondrian accepted the invitation with pleasure and thanked Holtzman, his most loyal supporter and the organization's secretary.[26] Mondrian even volunteered to pay the annual dues of four dollars.[27] At the AAA meeting of January 24, 1941, it was announced that Léger had also accepted membership. The group immediately began to plan a reception to honor the two new distinguished members.

Krasner recalled first meeting Mondrian at the reception. It was hosted by fellow AAA members George L. K. Morris and his artist wife, Suzy Frelinghuysen, at their apartment on Sutton Place, the elegant lane adjacent to the East River in Midtown Manhattan—an address that reflected the hosts' background from wealthy and prominent American families. In fact, Morris's ancestors included diplomats and statesmen, as well as Lewis Morris III, one of the signers of the Declaration of Independence. George L. K. Morris had graduated from Groton and Yale, traveled to Paris in 1927, together with his cousin, the abstract artist and collector Albert E. Gallatin. Morris was well connected, and in Paris, he met Picasso, Braque, and Brancusi. Two years later, he returned to study with both Fernand Léger and Amédée Ozenfant.

Morris's wife came from the politically prominent New Jersey Frelinghuysens, who saw to it that she toured Europe and was privately tutored in art. Morris and Frelinghuysen had married in 1935. She was three years younger than Krasner, and he was three years older than Krasner. As an artist couple, their lives contrasted with that of Krasner and Pantuhoff, who at the time were struggling to get by with precarious and intermittent employment on the WPA. Morris encouraged Frelinghuysen to paint, and in 1938, she became the first woman to have work placed in the permanent collection of the Museum of Living Art, which had been founded by Gallatin, who was heir to a large banking fortune. His great-grandfather and namesake had served as secretary of the treasury under Presidents Jefferson and Madison. These urbane and elegant friends, known as the "Park Avenue Cubists," were not Krasner's usual social circle, but all the members of AAA were invited to celebrate the two immigrant guests.

Morris remembered that "Léger swept in with about five girls in tow, spoke only French, stayed just a few minutes, and swept out again."[28] Krasner recalled that she "met Léger; but he was not one of my gods as Mondrian was. Léger did not speak

English; I didn't speak French, but we worked out some way of communicating. Léger was . . . a delightful presence. I never missed one of his shows in New York, but he was not one of my heroes." [29]

Krasner's close friend Mercedes Carles was closer to Léger. She had got a job translating for Léger when he was working on murals for the French Lines Pier in 1935. The company had begun to suspect that Léger was a Communist and soon aborted the project. When this happened, Léger recommended that Mercedes work for Herbert Matter, a Swiss photographer and former student of his at the Académie Moderne in Paris. Matter shared a commission with his compatriot, the architect William Lescaze, for the Swiss Pavilion at the 1939 World's Fair.

Mondrian, who had just recovered from the risky journey across the Atlantic on a convoy ship during wartime, turned out to be "the life of the party." [30] He had such a good time he made a date for a few nights later to go dancing with about eight of the members, Krasner among them. [31] Meeting Mondrian thrilled her, and she no doubt relished the ambiance and posh setting provided by Morris and Frelinghuysen.

Krasner recalled that Mondrian "was very much here for me before I met him." [32] She meant that Mondrian had already made an impact on American artists interested in abstraction. His work had been on her mind during the previous two years, when she had been emulating his geometric abstractions.

Krasner had spoken of her admiration for Mondrian with Mercer, who wrote to her from Boston on December 12, 1940, following a spontaneous visit to see her in New York, only to discover that she was away for the weekend. He imagined a short dramatic skit between the two of them, adding an "Author's note: (Krasner is a highly flexible character. She can be a tiger but prefers humor and the making of fun of every situation.)" In the letter, Mercer referred to "Eleanor R. [Roosevelt] and Ooncle Piet [Mondrian]. And Leger. How does *Piet* look in bathrobe? What about

P.P. [Pablo Picasso]? Will he be here next?" Mercer described his own "dreamy dabbles" and confided: "I'm very much excited about the idea of working on a 'black' ground with the brilliant lights to relieve it. I hope to get a subject of this kind which I can paint . . . a sort of negative Mondrian." He concluded, "Carry on. I'll see you before long, I hope," and signed his name under a picture of a heart with an arrow through it, as if a child's valentine sketch.[33]

Mondrian and Léger joined Krasner and thirty-three AAA members in their fifth annual exhibition at the Riverside Museum from February 9 through 23, 1941. On February 11, 1941, Krasner received her second notice in the press, now in the *Times,* though she was merely listed as a participant. The article said it was "a relief to find that these particular canvases are by Léger and Mondrian themselves rather than by their admirers. Both artists have had, and continue to have, a by no means trifling influence hereabouts."[34] Henry McBride was also critical of the American artists, writing that Mondrian and Léger had "a crispness in idea and a force in presentation that the American 'comrades' do not rival."[35] A reviewer for *P.M.* commented that the two Europeans had added to the group's prestige, improving its "creative production."[36]

"Mondrian I saw on many occasions. We were both mad for jazz, and we used to go to jazz spots together," Krasner recalled.[37] For his part, Mondrian told Holtzman, "I have never enjoyed life so much as here."[38] He wrote AAA a thank-you note that was read aloud at the meeting of February 7, 1941.[39] Krasner recalled walking with Mondrian through this AAA exhibition. "He had a few comments about every painting. As we approached my work, I became very nervous. He said, 'You have a very strong inner rhythm. Never lose it.'"[40] At the time, Krasner was showing works that "were abstract, Picassoid, with heavy black lines, brilliant intense colors and thick impasto. But I wanted to do the maximum in color, and that lurked in the back of my mind."[41]

Meeting Mondrian helped to ease Krasner's worries about New

York's provinciality. "One couldn't have imagined in the '30s that the center of the art world would shift to New York," Krasner later commented. "One has to be alive enough to recognize when it *does* change otherwise it can lead to nationalism, chauvinism or provincialism."[42]

Krasner's continual anxiety about nationalism and provincialism can be understood within the context of her childhood. In becoming an artist, she dreamed of leaving behind both the poverty and the restricted, burdened role of the woman in her immigrant culture. She sought to fit into an America that was increasingly troubled by anti-Semitism both within and outside of its borders. The politics of the left offered a cosmopolitan ideal—a world that looked beyond ethnicities to a universalism that was quite distinct from the limited view of some of the critics then promoting representational American art.

In connection with the AAA show, a symposium took place on Sunday afternoon, February 16, with Balcomb Greene presiding and with Holtzman and, at long last, as Krasner had hoped, Hans Hofmann speaking. Holtzman, in his written statement for the "spring" 1941 show, expressed some ideas that connected well with some of Krasner's earlier points of view. He argued that "a clear differentiation between esthetic values and national values is essential. . . . Even after more than fifty years of its development, the habit is to allude to the advanced phases of modern art as merely European idioms and to fail to see that art is not merely the expression of nationality. . . . This is the consequence of the failure to perceive that the real expression of art is always and everywhere profoundly the same: universal."[43]

By stressing that "esthetic values do not change with latitude and longitude," Holtzman rejected the calls for an "American" national art that then resonated at the Whitney Museum and in the writings of conservative critics of the day such as Thomas Craven.[44] Earlier, the influential artist and teacher Robert Henri had also encouraged the search for a distinctive American art. Now

this goal grew even bolder in the words of critics who championed artists such as Edward Hopper and Thomas Hart Benton.[45]

Krasner's preference for European modernists was typical among her classmates from the Hofmann School, including George Mercer. In a letter dated January 4, 1941, Mercer had asked Krasner, "Why are so many women except yourself and a few others so dumb, so echoing? . . . Talk, talk, talk about nothing."[46] Mercer also shared his cynical opinions about success in art. "Are you a mural genius yet? Of course not. Why should you be? Realize before it is too late that geniushood belongs to the great— like Refégé [Anton Refregier], Ruth Reeves, etc., etc. and other adulterers of mankind. Even Brodovich [Alexey Brodovitch]; and Gorky, too, has a touch of genius. But I know a better one, that bloated genius called [Aristodimos] Caldis [Kaldis]. If ever there was a man with vision—with an eye for an opening. But let him go. He bores me."[47]

Mercer's grudging admission of the importance of the designers Ruth Reeves and Alexey Brodovitch must be aimed at Krasner's interest in the world of high fashion. Brodovitch shared the White Russian background of the Pantuhoff family. More than a decade older than Igor, Brodovitch had also left Russia in 1920. He began his career in Paris and immigrated to America in 1930. As art director of *Harper's Bazaar,* Brodovitch had a significant impact on American graphic design and photography. Krasner would later pose for photographs by some of his best students, including Hans Namuth and Irving Penn, but at this time she was modeling for Herbert Matter, who did assignments for Brodovitch.

Krasner knew Matter, an avant-garde photographer and innovative graphic designer, through his wife, Mercedes Carles, who had been her friend since the Hofmann School. She attended their 1941 wedding, to which Mercer jokingly referred as the marriage of "Kitty Carles" and "Hairbert."[48]

Matter often blurred the boundaries between commercial and fine art. Swiss born, he arrived in New York as a staff photogra-

pher for the touring Trudi Scoop dance troupe. When the tour ended, he went to work for Condé Nast publications taking photographs for *Fortune, Harper's Bazaar, House & Garden,* and *Vogue.* By early 1939, he was working on exhibition design for the Museum of Modern Art, assisting the curator James Johnson Sweeney. Matter got to know Sweeney through his friendship with the artist Alexander Calder, whose mobiles Matter photographed in motion. Sweeney was then writing about Calder and using Matter's photographs as illustrations.[49]

Around the time Krasner and Mercedes met, Mercedes was attempting to make money in the fashion industry.[50] She was encouraged by her aunt, Sara Johns, a rather successful fashion illustrator. Johns often employed both Carles and Krasner as models—an important source of income for Krasner in these lean years. While both Krasner and Carles were modeling for Herbert Matter by this time, Krasner's posing for Matter did not engage the same intimacy and passion.[51]

Krasner, who had lovely hands, modeled for Matter's photographs of Calder's jewelry and accessory designs. An excellent dancer and well coordinated, she also posed for a photograph Matter made as an advertisement for a client, Container Corporation, and the agency N. W. Ayer, which appeared in *Fortune* magazine in November 1941. Matter cropped his photograph to show Krasner's feet, clad in laced high-heeled shoes, and her legs below her knees; he recorded her mounting a staircase over and over again to put away a container of groceries for an avant-garde ad that recalls Marcel Duchamp's famous painting *Nude Descending the Staircase* or Fernand Léger's film, *Ballet Mécanique.* Matter's surviving notes and maquette document the identity of the model as Krasner.[52]

It was probably Herbert Matter who helped Lee get a brief stint at the Museum of Modern Art in 1940. The job was to take over from the Utah Federal Art Project a full-size painting reproducing a monumental pictograph from the sandstone walls of Barrier Canyon in Utah.[53] Measuring 12 by 60 feet, this painting was part

of an installation designed by curator René d'Harnoncourt, who sought to evoke the aura and ritualism of the Native Americans. Gerome Kamrowski recalled that "Lee . . . did the wall painting for the Indian show at the Modern, just a motif from pottery."[54] The show, "Indian Art of the United States," ran from January 22 to April 27, 1941.

News of the Indian exhibition prompted Mercer to write Krasner, asking if she had seen it and if it was as good as the Mexican one. He referred to two loan shows of non-European art held at the Modern, including the influential "Twenty Centuries of Mexican Art" from 1940. She had in fact done a lot more than visit the Indian exhibition. Mercer also asked about the "Greco show," which was at the Metropolitan Museum and featured El Greco, who was much beloved by modernists.[55] Mercer's interest in these three shows hints at their impact on Krasner and her contemporaries who were then searching for new ways to expand their imaginative range.

Ominously for Krasner, Mercer complained about having to usher at a friend's wedding. He had planned to "get roaring, boreing [sic] drunk" at the ushers' dinner and at the wedding the next week. He asked Krasner and himself, "Why can't I shake myself free of my past? Answer that one." The question was about a problem that would haunt her and the men in her life.[56]

By March 10, 1941, Krasner heard from Mercer that he had been drafted and had become a private in the army. He had moved to Fort Belvoir, Virginia, and was in the 84th Engineer Battalion.[57] He expected to be there for three years, working in camouflage. He told her that he hoped to get a weekend off to visit her in New York, and apologized for not being able to "get down that night. It was impossible." He wrote: "Krasner, I both like and dislike your voice on the telephone. You sound so blasé. I like you better when I see you."[58]

After describing the army routine, Mercer reported, "The fellows down here are surprisingly nice. One is a 'modern' artist,

likes Picasso, Kandinsky, Miró and all! What a surprise for me."
He wrote also about his Kandinsky, which he was preparing to
sell. He signed the letter "Love toots, Private Mercer."[59] Enthu-
siasm for Kandinsky, which reflected Hofmann's influence, also
affected Krasner, who had admired Kandinsky's early pictures
from around 1913–14 in the Museum of Non-Objective Painting
(the future Solomon R. Guggenheim Museum Collection), then
housed at the Plaza Hotel.[60]

In a letter a month later, Mercer wrote from Washington,
D.C., about "an interesting friend who was on the stage before he
entered the army. His outlook is both interesting and somewhat
amusing to me. He is essentially a person of a good deal of integ-
rity and determination but has that peculiar communist leaning so
accessible to those who are looking for it. I think he will outgrow
it. He reminds me of many New York Villagers."[61] By writing to
Krasner of "that peculiar communist leaning," Mercer suggests
that he knows that she too disdains communism. He complained
that "the officers are passive. They have not faced the issue of war
by a long shot. . . . The underlying outlook is very British—before
Dunkirk. There are no Nietzchians [sic]. We do work hard but
there is no yen amongst us to fight a war."[62]

He then confided: "Another thing (probably peculiar to our
group) is an underlying dormant bisexuality. Certainly this is out-
side the mind intent on war—or is it? Female company is scarce
and much sought after. There is not enough of it to encourage a
completely natural life. Strange thing this war business."[63] Mercer
sent his greetings to Carles and Herbert [Matter] and "good old
Hans," signing himself "love, George."[64] Krasner's response to
Mercer's comment about "dormant bisexuality" was to send him
a photograph of Joan Bennett, the femme fatale of film noir mov-
ies such as Fritz Lang's *Man Hunt* of 1941. It was an interesting
choice, considering all the photographs she had of herself, some of
them intentionally seductive.

Krasner felt close enough to Mercer that when she had a health

crisis and was broke she appealed to him for help. Unfortunately Mercer did not get her message in time. On March 25, 1941, he wrote, "I'm terribly disappointed that I didn't help. I *was* in the infirmary when I got your telegram. I managed to get a blank check on another bank and sent you $50 in a Special Delivery envelope the same day (Tuesday). I suppose it just wasn't mailed, damn those ward-boys and nurses."[65] He told her that she could cash the check or tear it up. In his note dated two weeks later, he thanked her for her "nice letter" and noted that she sounded better. "You do sound in a bit of a blue funk but I felt an undercurrent of optimism ready to bubble forth—your typical self."

Not hearing from Mercer and feeling desperate, Krasner had sought aid from Igor. Not knowing how to contact him, she tried through his parents. On March 20, 1941, his mother, Nina, wrote from Florida, "My dear Miss Krasner: I received your letter today and I am sorry about your circumstances, but I made up my mind not to forward your message to Igor. I know quite definitively that he is not able to help you out and it would only disturb him, without doing you any good. I hope that your relatives will assist you and that you will get well soon."[66]

Somehow or another, Krasner did manage to contact Pantuhoff, because nearly a week later, he sent her a note postmarked Palm Beach, Florida: "Dear Lee I'm sorry not to be able to send you more than this."[67] He evidently wanted or felt that he should try to help.

Eventually the WPA temporarily rehired and promoted Krasner to the rank of "Senior Artist," but her salary was reduced once again to $87.60 per month. On April 16, 1941, Mercer wrote to confirm that she was "off the Project." He asked if she had cashed the check that he sent.[68] Termination from the WPA came about almost a week after. (She was, however, reinstated a few weeks afterward. Her last assignment came when she had to work with aviation sheet metal from January 4, 1943, through April 3, 1943. Her salary was reduced even further, to $52.80 per month.)

By April 28, Mercer wrote again to explain that he had sent her some checks meant to be for "when the Project fell from under you. Has it yet? Let me know and I'll send another '$25er' along." [69] From his comfortable existence and his military salary, Mercer was able to help out. Not only was he generous, but he also had few needs while in the army. Mercer wrote that "the painters here are all half-ass. . . . Hofmann . . . looks so very good from this place." [70] He liked, he wrote, her story of Carles's wedding to Herbert Matter. He missed speaking with Lee.

Though Krasner's letters to Mercer have not yet come to light, his letters to her represent more than just the complaints of an artist unhappily enlisted in the army. They reveal how closely Krasner experienced the problems of those artists forced to be soldiers in the months leading up to Pearl Harbor and during the war itself. Mercer complained that in the army "the ruthless have the best chance of survival. And that ruthlessness seems outside of me. So I try to capture it only to find I am outside of it. Try to be that way in outlook? If I do, I'm afraid that I'll never regain enough sensitivity to paint—which I really want to do. Be a painter—sensitive—thoughtful. That is badly out of place in a world like today's. I want to continue to live—for some reason. That doesn't seem to be in line with Army policy." [71]

Mercer's letters to Krasner show both her empathy and intellect. She was sympathetic and receptive to the Harvard-educated Mercer, who wrote discussing everything from Nietzsche and T. S. Eliot to his own passion to paint. [72] While Krasner too had her own struggle to paint, her struggle was economic and social—she was a single woman struggling with poverty and loneliness, when most eligible men were serving in the armed forces. She consoled Mercer, and he replied that her letter was just what he needed and he had reread it and would "use it again as a booster at the time of decision-making. Your saying that sensitivity minus survival isn't much use to anyone is rather true. I hadn't thought as bluntly and as clearly as you on that point. And then, you speak

of the 'cultured intellectuals' one unavoidably must spend time with."[73]

Krasner's equanimity was invaluable to Mercer at a time when he felt alienated and threatened by the prospect of war. Having had his budding artistic career completely interrupted by circumstances beyond his control, he had to decide whether to give in to his fate or protest it.

She recommended that he read Henry Miller's *The Cosmological Eye,* where she found a worldview that was similar to the one they now faced: "The times are permanently bad. . . . To imagine a way of life that could be patched up is to think of the cosmos as a vast plumbing affair. To expect others to do what we are unable to do ourselves is truly to believe in miracles."[74] Miller shared her dislike of nationalism: "I should hate to be a French or a German or a Russian or an American writer. It must be hell. I am a cosmological writer, and when I open my trap I broadcast to the whole word [*sic,* world] at once."[75] Krasner might also have recommended the book to Mercer because of Miller's antiwar sentiments: "A real man has no need of governments, of laws, of moral or ethical codes, to say nothing of battleships, police clubs, high-powered bombers and such things."[76]

Mercer clearly wanted the exchange with her to continue. "I don't like the idea of my being in a war," he wrote. "Not at all. I can hardly believe it. It isn't I that's going to war. I have no desire to. I want to paint a picture."[77] He wrote on July 7, 1941, that "I like Henry Miller. He seems a little contradictory at times, but I will be able to judge him better at a later date. I'll let you know. Sometimes he hits the nail on the head with perfect precision and I laugh with delight."[78] By this time Mercer had begun to sign his letters "Love, George."

Some weeks after, he wrote, "The day ahead looked very glum and your words saved me from gloom (two words). Honey you're my inspiration. There's so much rot around here that I think writing about it will save me from death. It's impossible to know

where to begin. (Remember Prufrock, hon). . . . This Goddamn situation just makes things worse again. I was beginning to get out of the Prufrock snarl through painting but now I'm thrown with this normal, so called, world again and protest quite naturally."[79] Mercer questioned why he couldn't "have my paroxysms of pain in relation to painting? That would be bad enough—trying to face making a living and painting, too." He expands his reference to T. S. Eliot's "The Love Song of J. Alfred Prufrock":

*Shall I part my hair behind? Do I dare to eat a peach?*
*I shall wear white flannel trousers, and walk upon the beach.*
*I have heard the mermaids singing, each to each.*
*I do not think that they will sing to me.*[80]

"God how I'd like to tell a few people around here 'off.' But I'm never destined to do it. I just don't dare to eat that God Damn peach that Eliot urges me to swallow. Well, the old son-of-a bitch couldn't swallow it himself."[81] Mercer may obliquely refer to Prufrock's peach as a much-discussed metaphor for his own anxiety about sexual inadequacy with women, his worry that his advances will be scorned.

On August 11, Mercer wrote to Krasner and told her, "I like you."[82] His feelings for her intensified. Five days later, he wrote her twice. The first short note reported, "I had a good time in N.Y. with you but forgot to buy you the flower. Next time!"[83] He added, "Why are all but a handful of woman (and males) so God Damn Dumb? (Please answer) Much love and best of luck, George."[84]

On September 26, Mercer wrote that once again he had been passed over for promotion to corporal, based, according to him, on a popular vote by the noncommissioned officers. His camou-flage "company" was living in pup tents about a mile outside of town and were having enactments of the enemy capturing their camp.[85] "To be 'popular' is difficult for me," he told her, adding, "Well, remember the words of Krasner's Rimbaud 'What lie must

I maintain?' "[86] His reference to the lines that were written on her studio wall confirms that she had had them there at least since his last visit in August 1941.

When Mercer finally made corporal in October and got a raise to $54 a month, he told Krasner he was pleased and he would not "need the $20 which you mentioned and which I had completely forgotten about. Take your time and more."[87] He lifts himself out of his self-pity for a moment to respond to her report of music "The Brahms piano concerto with Horowitz and Toscanini sounds wonderful. And Tristan und Isolde. We shall enjoy them together some day."[88] Mercer addressed her worries from the third person "Don't get too down on Krasner. She's a pretty good fighter, you know. *And* I am sure that it is those few who are willing to be critical of themselves; to subject themselves to self-torture, are the material nature uses to mould great character and understanding."[89]

Krasner's struggle was with both finding income enough to survive and coping with loneliness. Her $10 rent was modest, but her income was unsteady and minimal. She lived sparingly and occasionally borrowed from friends, such as "Sarah," Mercedes Matter's aunt Sara Johns, the commercial fashion artist for whom Krasner sometimes worked as a model.

On the back of Mercer's last envelope, Krasner has made notes about her budget:

5 dia —
5 canvas—
3 coat
2 Carles [debt?]
1 Sarah [debt]
———
16
10 rent
———
26

Without Igor to keep her company, Krasner remained preoccupied with the AAA, but she continued to see Gorky and de Kooning, who shunned that group. Before long she met an acquaintance of theirs, John Graham, who was also an immigrant, through Aristodimos Kaldis, whom she knew from the WPA.[90] Kaldis may have had more than a passing interest in Krasner. On January 1, 1941, he sent her a picture postcard of an Aztec Goddess of Flowing Water with the note: "I hope that during the coming year you'll descend from the ethereal cosmos to our prosaic world. Aristo." His choice of image reflects contemporary artists' enthusiasm for the MoMA show "Twenty Centuries of Mexican Art" of the previous year, but his references to both a goddess and her place in "the ethereal cosmos" suggest that he was attracted to her but found her too aloof.

One day, while Krasner was walking near her apartment on Ninth Street, she ran into Kaldis, and he introduced her to Graham, who at once commented, "You're a painter."[91]

She remembered thinking, "My God, that man has magical insight." She asked him how he knew, and he pointed to her legs, which had specks of paint on them.[92] He then asked to see her work, and she agreed.

Graham had come to New York from Paris, but he was born Ivan Gratianovitch Dombrowski in 1886 of Polish parents in Kiev, Ukraine (then in the Russian empire). Like Pantuhoff's father, he had fled the Bolsheviks in 1920 after fighting in the civil war on the side of the tsar. Graham enrolled at the Art Students League in 1923, where he worked as assistant to the realist painter John Sloan before getting his first solo museum show in 1929. During this time, Graham traveled between New York and Paris, dealing in African art and bringing the ideas of European modernism to America.

Graham's immense influence on American artists derived from the sophisticated perspective he conveyed in his articles and his book, *System and Dialectics of Art* (1937), which many read with

intense interest and respect. "He was in touch with artists," Krasner recalled. "He knew European painters. He had an awareness of what was happening. He moved around. And in that sense one knew that John Graham was one of the people—there were so few then—who was interested in the painting that interested us."[93] Krasner also said that she responded to Graham because of his "fascinating personality. He had this marvelous little museum where he lived. . . . It opened up a whole new world in that sense."[94]

On November 12, 1941, following his impromptu visit to her studio, Graham sent Krasner a postcard: "Dear Lenore—I am arranging at an uptown gallery a show of French and American paintings with excellent publicity etc. I have Braque, Picasso, Derain, Segonzac, S. [Stuart] Davis, and others. I want to have your last large painting. I will drop at your place Friday afternoon with the manager of the gallery. Telephone me if you can. Ever GRAHAM."[95]

Graham's invitation gave Krasner an unimagined opportunity: "I was delighted to be in the exhibition because the French names were Matisse, Braque, Picasso."[96] The Americans in the show, besides her, were Stuart Davis, Walt Kuhn, Virginia Diaz, H. Levitt Purdy, Pat Collins, Willem de Kooning, David Burliuk, and Jackson Pollock. The Europeans, beyond Graham and those named by her and on his postcard to Krasner, were Bonnard, Modigliani, Rouault, and de Chirico.

Later Krasner often told the story about how she wondered who the "unknown Americans" in Graham's show would be and that she was surprised to find only one who was unknown to her—Jackson Pollock. By the time Graham's show was announced, she knew de Kooning well, and he had known Graham since the spring of 1929, when he had seen Graham's solo show at Valentine Dudensing Gallery in Manhattan, a gallery frequented by Krasner as well.

Through her friendship with de Kooning, Krasner also knew

Virginia Diaz, and perhaps through her had met Pat Collins, an Irish-born former circus performer and boxer. Collins had also studied in New York at both the National Academy and the Art Students League, so Krasner could have run into him at the academy or when he worked on the WPA.[97] Kuhn, famous for his role in organizing the Armory Show in 1913, made many portraits of circus and vaudeville performers, so he might also be a link among Graham, Collins, and Diaz. Krasner knew Stuart Davis from both the Artists Union and *Art Front* magazine. She either knew David Burliuk, or could have considered him European, since he arrived in the United States in 1922 and was already a fully trained artist. If, however, H. Levitt Purdy was ever known to Krasner, his or her identity has been erased from history.

Krasner's story that she failed to recognize only Pollock's name does not fully convince; after all, she thought she knew most of the art world. She explained that she began asking around before the show but found no one who knew him. Then she attended an opening at Edith Halpert's Downtown Gallery.[98] She surely knew the exhibiting cartoonist William Steig from the academy, but even so, there is a good chance she wasn't even going to see the artwork so much as to hang out, make connections, and trade art talk. Steig's "amusing drawings of metropolitan types" were hanging in the Downtown Gallery's group show. For a few years, he had been making "symbolic drawings," pen-and-ink works that tried to convey states of mind. Most of the others on view were rather established American artists and gallery regulars, all much older than Krasner.

At the gallery, Krasner ran into Lou Bunce (Louis Demott Bunce), whom she knew from the WPA mural project. As they chatted, he asked, "By the way, do you know this painter Pollock? He's a good painter; he's going to be in a show that John Graham is doing."[99] "Good painter" then meant to them a modernist who was painting abstractly. Bunce had met Pollock in his third year at the Art Students League in 1930.[100]

Bunce was making abstract paintings at the time, and he later recalled hearing Léger speak one evening at the Artists Union.[101] Bunce recalled too that he "was running around a little bit with Jack [Pollock] then. And he was excited as well as I was about the Surrealists. And I remember we went to see a big, beautiful Miró show at the modern museum in '41. It was a dinger, I'll tell you. And a lot of those people were in New York at that time. Seligman, and Ernst came, and Tanguy."[102]

Krasner learned from Bunce that Pollock lived just around the corner from her on Eighth Street between Broadway and University Place, so she soon dropped by to "make his acquaintance." Uncertain of his apartment, she climbed to the top floor and ran into Pollock's brother Sande McCoy, who, when asked, directed her to Pollock's door.[103] A balding fellow a few years her junior answered the knock. She recognized him as someone she had danced with some years earlier at an Artists Union party. His studio seemed strange because there were no books anywhere.[104]

When she got to know Pollock a little better, she once asked him, "Don't you ever read anything?"

He said, "Of course I do."

"Why don't I ever see a book?"

He then showed her his back closet and various drawers which he kept "packed with books." She exclaimed, "Well Jackson, this is mad! Why have you got these books pushed away, locked up?"

He said, "Look, when someone comes into my place, I don't want them to just take a look and know what I'm all about."[105]

Yet his work impressed her enormously. She later described it as "wild enthusiasm."[106] Another time she said that her reaction was "the same sort of thing that I responded to in Matisse, in Picasso, in Mondrian."[107] She recalled that one particular canvas "just about stunned me. I saw a whole batch of early work there, finished paintings, not drawings. He had already moved to that point. I was confronted with something ahead of me. I felt elation. *My God, there it is.*"[108] In the account Krasner gave to *Time* in

1958, she said, "I lunged right over and when I saw his paintings I almost died. They bowled me over. Then I met him, and that was it."[109]

The writer B. H. Friedman, who was a young collector still in his twenties when he first encountered Pollock and befriended the couple in the spring of 1955, described what Krasner first found artistically significant in the new man: "Jackson had cubism. He had already assimilated the two-dimensionality of the canvas. What interested him most, in addition to Picasso's early master-piece, *Les Demoiselles d'Avignon,* was the emotional content of that artist's later work in such paintings as *Guernica* and the studies for it."[110] Friedman also recognized that though Pollock was not a big fan of Surrealist painting, he believed in many of the "Surrealist intuitions," especially the subconscious as a basis for art and the use of accident. He understood that Krasner saw Pollock as at-tacking the "holy images" of cubism and Surrealism through his ability to assimilate both styles.

Krasner was particularly impressed with Pollock's canvas *The Magic Mirror* of 1941. She saw beyond the influence of Picasso and felt that Pollock was destined to make a place in art history.[111] "When I saw his work," she later recalled, "I felt an immediate response. I was completely moved. It took me about three years to digest it for myself."[112]

Krasner later told Lawrence Campbell that Pollock had said at the time that he did not know if *The Magic Mirror* was finished, provoking her to "consternation" and eventually close associa-tion.[113] Mercedes Carles Matter, Betsy Zogbaum (wife of sculptor Wilfrid Zogbaum), and others later liked to claim that they had first recognized Pollock's talent, while Lee was simply taken with him as a man; but it seems clear that Lee was really attracted to the entire package.[114]

Moreover, her belief in Pollock's genius never wavered. This kind of conviction evidently irked the art critic Clement Green-berg, who recalled, "Lee was a master of self-centeredness, a

prodigy of self-centeredness. She introduced me to Jackson on the street, saying in her uncouth way, 'This guy is a great painter.' He looked bourgeois in a gray felt hat—the only time I ever saw Jackson in a hat—and affable but silent, with a reluctant smile. It was a hard face, having to do with alcoholism and with his needing help—with his always being in danger because he felt helpless."[15]

Krasner may have been interested in Pollock's obvious artistic talent, but she was also attracted to the shy, introverted man himself. Born January 28, 1912, Jackson was just over three years younger than Lee, a near contemporary, and unattached. Though not nearly as handsome as Igor, Jackson was rugged and available—that is, he was neither in the army nor in the bed of some southern belle. The previous April, Pollock had been in treatment for alcoholism and other mental problems with the Jungian analyst Violet Staub de Laszlo, who had classified him as 4-F, meaning that he was unqualified to be drafted for military service.[116]

Krasner probably did not yet know it, but Pollock was similar to Pantuhoff in that his childhood had been marked by his family's hardships and frequent dislocation. In Pollock's case, the cause was not war but economic misfortune. Also, his parents' failed marriage affected his emotional development.

Unlike Pantuhoff, Pollock was born in America—in Cody, Wyoming—to American-born parents of Scotch-Irish extraction. Both his mother, Stella May McClure, and his father, LeRoy McCoy Pollock, were born and raised in Tingley, Iowa. Jackson was not even a year old when the entire family, including his four older brothers, moved to California. His childhood was marred by the family's frequent moves from town to town in search of better fortune, which ultimately proved elusive. Jackson suffered from his parents' dysfunctional marriage and his father's depression and failure to provide adequately for the family.

Already troubled in high school, Jackson was expelled. Finally he attended Manual Arts High School in Los Angeles, where an

art teacher, Frederick John de St. Vrain Schwankovsky, introduced Jackson to Theosophy and the teachings of Krishnamurti. Theosophy is a system of beliefs of religious philosophy and mysticism holding that all religions are attempts by the "Spiritual Hierarchy" to help humanity and that each religion therefore has a portion of the truth. Madame Helena Petrovna Blavatsky cofounded the Theosophical Society in New York in 1875 and then moved it to India in 1882. There in a small town in the south of India in 1895, Krishnamurti was born. He was adopted in his youth by Dr. Annie Besant, then president of the Theosophical Society, who announced that he was to be a world teacher whose arrival the Theosophists had predicted. In 1929, however, Krishnamurti renounced the role that he was chosen to play, rejected the organization that had formed to support him, and gave back all the money and property that had been raised for this work. Instead he became an independent itinerant voice urging meditation and changing the world for the better.

Krishnamurti may well have appealed to Pollock after growing up in a family that did not attend church and with parents who professed no spiritual beliefs. In contrast, Krasner had grown up in a religious family and rejected most of the ritual of Orthodox Judaism along with the patriarchy that she felt oppressed women. But she remained intellectually curious about religious practices and retained some of the fears associated with folk beliefs imported by her mother from the shtetl.

In 1930 Jackson followed the example of his eldest brother, Charles, who had chosen to study art. Like Charles, who moved to New York in 1926 and enrolled in the Art Students League in the class of the muralist Thomas Hart Benton, Jackson too joined Benton's class. Though Pollock studied with Benton, who painted representational images that came to be called "regionalist," and Krasner studied with Hofmann and painted modernist abstractions, the two had had some similar aesthetic experiences. Like Krasner, Pollock had worked on WPA murals, though he

soon transferred to the easel division. Pollock had worked on a mural for Grover Cleveland High School under Job Goodman, the same former Benton student with whom Krasner had studed drawing.[117] So it must have seemed to Krasner as if they had much in common despite their divergent ethnic backgrounds.

The summer before Krasner met Pollock, his brother Sande (Sanford), with whom he had been living in New York, had written to their oldest brother, Charles, then in Michigan working on murals and graphic art for the WPA, and said that Jackson's maladjustment had proven to be much more than "the usual stress and strain of a sensitive persons [*sic*] transition from adolescence to manhood, a thing he would out-grow. . . . One requiring the help of Doctors. In the summer of 39 [1938] he was hospitalized for six months in a psychiatric institution. This was done at his own request for help and upon the advice of Doctors."[118]

Sande lamented that though Jackson had shown improvement upon release, it did not last, and they had had to seek medical attention again. He worried about Pollock's alcoholism and his self-destructive nature and warned that "part of his trouble (perhaps a large part) lies in his childhood relationships with his Mother in particular and family in general." Sande reported to Charles on Jackson's condition, referring to one of his symptoms as "depressive mania (Dad)."[119]

Despite his brother's psychiatric problems, Sande had also studied art, and he asserted that Jackson's art "if he allows [it] to grow, will . . . come to great importance." Sande believed Pollock was "doing work which is creative in the most genuine sense of the word. Here again, although I 'feel' its meaning and implication, I am not qualified to present it in terms of words. His thinking is, I think, related to that of men like Beckmann, Orozco, and Picasso. We are sure that if he is able to hold himself together his work will become of real significance."[120]

But Krasner was still unaware of most of Pollock's problematic history. Only later did she learn that Pollock was in analysis,

which she recalled, "I was very shocked to learn, because I was very prejudiced, couldn't have been more against it, so that I had a conflict in response, that is, there was full response to the painting, later learning he is in analysis I was very unsympathetic to that."[121] But for now, she needed a man in her life again; it was wartime, and Pollock seemed to fit the bill. She immediately began to consider the possibilities.

Had Krasner known all of what the family knew, perhaps she would have backed away from Pollock. B. H. Friedman wrote in 1965, "The answers to some of Rimbaud's questions were there in this rangy handsome tough-tender rebellious Westerner. Lee had met someone to whom she could 'hire herself out,' a beast whom she could adore."[122] Had she asked her friend George McNeil, she might have gotten a more realistic impression. "Jackson was very macho from the beginning, drinking being the big thing," McNeil reported. "Behavior at the [Art Students] League could be pretty far out; you could be drunk in the lunchroom, loud, all kinds of things; and there were Saturday night bouts at 125th Street in Harlem. I remember the folds in his face and the way he *felt* big—strong and tough. He came on like a big guy, and his walk seemed a kind of shuffle—a wobbling walk, not direct."[123] But Krasner did not ask her friends what they thought of him. Nor would she have been dissuaded by knowing that, according to McNeil, Pollock was "shy, hated crowds, would go to the rooms with no one in them at shows and didn't like openings."[124]

Pollock soon visited Krasner's Ninth Street studio, and she felt that his initial response was "very sympathetic."[125] What he saw were the paintings inspired by Picasso, work of the late 1920s, forms with heavy black outlines derived from still life setups and intense primary colors that recalled the work of Mondrian. Her paintings were also reminiscent of Gorky's adaptations of Picasso's work. Since by then Pollock too was also deeply engaged with Picasso, the two found common ground.

Mercedes Carles Matter recalled, "Lee dropped in one day to

tell me she had met someone she liked very much. They were to have their first date that afternoon, to go to the Frick Collection together."[126] Krasner was smitten. She soon brought Pollock to meet Mercedes and Herbert, who later recalled: "From the first time I met him—in 1941 . . . from that very first evening Jackson and I felt a deep rapport."[127] Both introverts, Matter and Pollock seemed to have hit if off without much conversation; they felt no need for small talk. De Kooning recalled that Matter and Pollock "were taken with each other—they had a nice feeling between them. They didn't have to talk."[128]

Krasner was also the one who introduced Pollock to de Kooning. She told Pollock about another artist who would also be in the show with them and took him over to meet de Kooning at his loft. She later recalled: "De Kooning had a loft at that time because he was something."[129] The fact that Krasner chose to take Pollock to meet de Kooning suggests that she believed that the Dutch painter respected her and her work. She was part of "the gang" during the 1930s. According to Emilie Kilgore, who was close to de Kooning in the 1970s, he remarked that Krasner "was no slouch as a painter."[130]

Krasner had already lived with Pantuhoff's excessive drinking, which may have misled her to suppose she could handle Pollock's. But she could hardly have foreseen Pollock's tendency to "be violent when he was drunk," as his sister-in-law Arloie McCoy would later describe it. The artist Mervin Jules concurred that Pollock "got mean when he was drunk," but no one warned Krasner.[131] Alma, the wife of Pollock's brother Jay, saw that Pollock "wanted his life to be free to paint. In order to do that, others had to do everything else. And he didn't want to be helped; he wanted to be taken care of."[132] Taking care of a man, especially one she viewed as destined to make art history, did not strike Krasner as too steep a price.

Regardless, some of Krasner's contemporaries believed the price was too steep, and that it affected Krasner. For example,

Fritz Bultman incorrectly claimed that Rimbaud's words first appeared on Krasner's wall only after she met Pollock. "Lee was quite excited about Jackson, having written in great big blue script on her wall as a way of anticipating their life together, a part of Rimbaud's *Season in Hell* about worshipping the beast and so forth, and Jackson was certainly an 'infernal bridegroom.' But he was very lonesome and warm underneath his not knowing how to make contact with people. The alcoholic macho thing was a mask; he needed a breakout from time to time."[133]

One of Mercer's letters from September 22, 1941, refers to the Rimbaud words on the wall, so Bultman cannot have accurately remembered when Krasner put the writing on her wall. Krasner also recalled clearly on separate occasions to Friedman, Munro, and others that the words were written in black with only one phrase, "What lie must I maintain?," written in blue.[134] Krasner told Friedman in 1965 that the words by Rimbaud were there on her studio wall "through the late thirties and early forties"[135]

There was even a notable instance involving Bultman and the wall before Krasner met Pollock. When Bultman brought the playwright Tennessee Williams to Krasner's New York studio, the Rimbaud quotation on the wall proved provocative. According to Krasner, Williams "pulled apart" the Rimbaud quotation in such an offensive manner that she asked him to leave.[136] This probably took place a year or so before Krasner encountered Pollock.

Even if, as Bultman claimed, Rimbaud's words had not appeared on Krasner's walls until after she started seeing Pollock, it is fair to say that they also characterized her relationship with Igor, who had both his own internal demons and his sense of inadequacy that he could not seem to measure up to his parents' high expectations. The Pantuhoffs desperately wanted their sons to regain some semblance of their own lost position in society—to marry up—certainly not to the daughter of poor Jewish immigrants from Russia.

In this portrait of Lee Krasner by Igor Pan-
tuhoff, he seems to have captured how she
responded to the stress of the Depression,
his infidelities, and the general insecurity of
their lives. Private collection; photograph
courtesy of the Pantuhoff Family Collection.

With regard to the new couple, Bultman commented, "He and
Lee complemented each other, but it was almost like an antago-
nism."[137] This contrasts with the experience of John Little, who
later recalled that in late 1941, "Lee was in charge of the Works
Progress Administration. One evening she invited me to her studio
to meet and take a look at the work of a young painter who was
also on the WPA by the name of Jackson Pollock." Little remem-
bered that she was "very enthusiastic about" Jackson and that he
too thought the pictures were "very exciting and beautiful. Later
that week we met Jackson [Pollock] himself at her studio. On that
occasion he was very silent and shy: once in a while a smile would
light up his face but no words came."[138]

Balcomb Greene, who was also on the Federal Art Project with
Krasner, Pollock, and Little, when asked with whom he worked,
said, "Lee Krasner is about the only one I can recall."[139] For

Greene as for many others, Krasner stood out. Like her, Greene had also joined the Artists Union and the American Abstract Artists. He worked on abstract murals for the World's Fair in 1939 and for the Williamsburg Housing Project. Krasner recalled Greene too, but with a host of other colleagues from the WPA.[140]

By early December 1941, Krasner's friends all noticed something new. Even from afar, Mercer wrote to Krasner, anticipating a visit with her in New York. After he had not heard from her, he wrote again, asking, "Why so silent? . . . I believe something is up with you. Out with it!" His visit had been postponed, and he would see her after his family at the end of his leave. "Krasner, I must talk with you even if you are married to someone else."[141] He looked forward to dancing with her too.[142]

# EIGHT

# A New Attachment:
# Life with Pollock, 1942–43

Lee and Jackson in what may be the first photograph of the couple together. Taken at the home of Tillie Shahn, in Truro, Massachusetts, 1944, during a summer spent in Provincetown, where they socialized with many friends, including those there with the Hofmann School. Photographed by the artist Bernard Schardt, whose wife, Nene, was, like Krasner, a student of Hofmann's.

K RASNER SAW GEORGE MERCER AGAIN IN NEW YORK IN EARLY
January 1942, and afterward he wrote to her: "Miró with
you was great fun for me. Then I liked that crazy evening
or rather-whacky dine and dance hall we went to up top."[1] This
was the Lafayette Hotel on University Place in the Village, where
French food, drinks, and the atmosphere encouraged guests to

linger, as if in a Parisian café. He praised Krasner's dancing and thanked her too "for being such a willing and devoted listener."[2] For Krasner, however, Mercer, frustrated about art and stuck in the army, could not compete with the excitement Pollock generated with his amazing paintings, rugged sex appeal, and immediate availability.

What had first sparked Krasner's interest in Pollock, their impending joint appearance in John Graham's show "American and French Paintings," turned out to be all that she had hoped for. It was advertised in the *New York Times* for January 18, 1942, and ran from January 20 through February 6. Graham had chosen to show her *Abstraction,* a canvas from 1941 that was forty by thirty-six inches, in which a still life subject is still intelligible. Distinguished by its bold Picassoid forms, impasto surface, and Mondrian-like heavy black outlines, the painting resembles an approach to Picasso's work already explored by her friend Gorky. "My own excitement around it was overwhelming," Krasner recalled. "I found myself flanked by a Matisse on one side and a Braque on the other."[3]

Among the other works on view was Pollock's *Birth,* which stood out for its bold forms, colors, and original composition, though Picasso's impact was still apparent. De Kooning showed *Standing Man,* which Krasner said depicted "a young boy, very well dressed, very nostalgic, the image very clear, not abstract at all."[4] There were also works by Picasso, including *Portrait of Dora Maar, Roses, Femme aux Deux Profils,* and *Femme au Fauteuil.* Matisse's *La Jeune Femme en Rose* was in the show as well, along with works by other Europeans, including Bonnard, de Chirico, Rouault, Modigliani, Segonzac, Braque, and Derain.

*Art Digest* wrote about the show: "Most of the Americans . . . have French leanings, or being primitives, have a naive approach often typical of the School of Paris."[5] The magazine went on to say, "A strange painter is William Kooning [*sic*] who does ana-

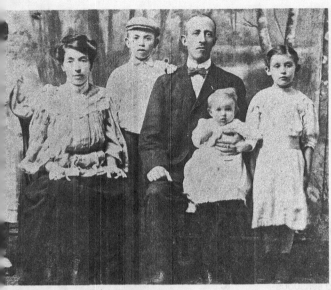

Krasner family photograph before their emigration in Shpikov, the Russian Empire, c. 1905, three years before Lena's birth. In this photograph, the edge of the imaginary painted landscape is visible, which must be one of the first painted scenes that Lee Krasner ever saw.

Joseph and Anna Krasner, Huntington Station, Long Island, c. 1936. After nearly two decades of physical drudgery and economic uncertainty as fishmongers in Brooklyn, Joseph and Anna had moved to Huntington, Long Island, which afforded a small-town life like the one they had in Shpikov.

Lena Krasner (front row, sixth from left) at her graduation from Brooklyn's P.S. 72, 1921. She walked to this public school from the family's rented house on Jerome Street in East New York, on central Brooklyn's eastern edge, where she recalled that it was "Rural. Not a city."

Irving Krasner, Lee's only brother, introduced her to culture: he went to the library and brought home books by the great Russian authors, and probably read aloud to Lena from the English translations.

At the National Academy, Krasner became especially close to the Mirsky sisters. Kitty, the older sister, painted dark and brooding seascapes and kittens, while her sister Eda preferred flowers and children in warmer colors and sensuous shapes.

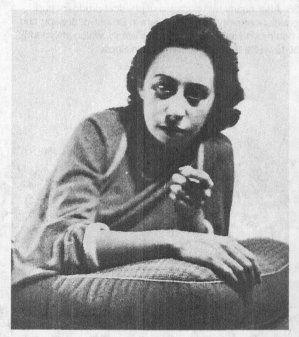

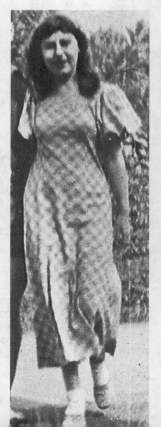

Eda Mirsky (Mann), Krasner's classmate at the National Academy, was so frustrated by the sexism that years later she discouraged her daughter Erica Jong from pursuing a career in the visual arts.

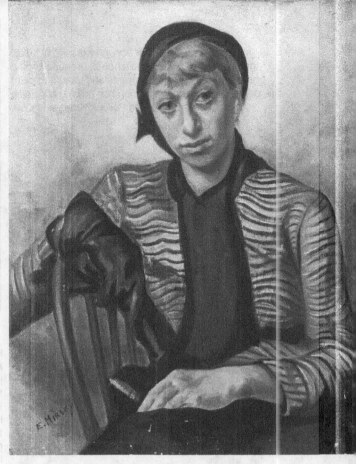

Eda Mirsky (Mann), *Portrait of Lee Krasner*, c. 1929–30, oil on canvas, 24 x 30 in., The Metropolitan Museum of Art. Krasner's classmate portrayed her as a stylish flapper. The two women were briefly suspended from the Academy after they went to the school's basement to paint a still life of a fish, which was forbidden for women. Gift of Eda Mirsky Mann, 1988.

Esphyr Slobodkina, *Lee Krasner Astride a Fighting Cock*, 1934, Crayon sketch on manila paper for a large cartoon to decorate the artist and model's costume ball. Using the obvious sexual metaphor of a female paper doll astride a cock, this sketch caught the sexual electricity in Lee Krasner's relationship with Igor Pantuhoff. It shows Krasner as a triple threat—as three female figures, repeated as if in a cubist painting or film, mounted on a rooster's back. Courtesy of the Slobodkina Foundations, Glen Head, New York. Photograph by Karen Cantor.

Igor Pantuhoff, *Portrait of Joseph Krasner*, c. 1936, Igor, who often visited Lee's home, probably took a photograph of Krasner's parents and used it to paint this portrait of her father, showing him holding a Yiddish book. Collection of the Pollock-Krasner House.

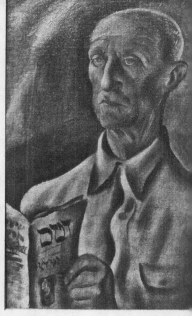

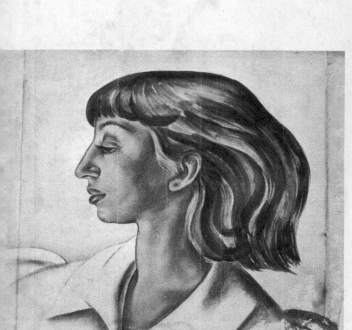

Igor Pantuhoff, *Portrait of Lee Krasner*, c. 1932, gouache on paper, 22 x 25. Judging simply from this sketch Pantuhoff did of Krasner posing in a sultry profile, he responded to the sex appeal that some of her contemporaries remarked upon. "With Igor, Lee had a sparkle and gaiety," said Fritz Bultman. Collection of the Pollock-Krasner House.

Igor Pantuhoff, *Ventilator #1*, reproduced on the cover of *Art Front*, March 1936. Painted for the Federal Art Project, Pantuhoff's composition and subject matter, depicting the rooftop of an urban building with water towers and chimneys, were quite close to Krasner's painting *Fourteenth Street* of 1934.

MARCH, 1936
10c.

**ART FRONT**

11

IN THIS ISSUE:
PAINTING IN FASCIST ITALY BY MARGARET DUROC · THE GROPPER EXHIBITION · RACE, NATIONALITY AND ART BY MEYER SCHAPIRO · PAINTINGS AND DRAWINGS BY KOPMAN, SCHANKER, CASSANDRE

Lee Krasner posing as a bohemian, c. 1938, photographer is possibly Igor Pantuhoff. Krasner liked the form of this antique cast-iron garden bench, which remained with her until the end of her life.

Perle Fine, George Mercer, Lee Krasner, and Igor Pantuhoff in Provincetown, Massachusetts, 1938, photographed by Maurice Berezov. Fine remained one of Krasner's most supportive female friends.

Lee Krasner and Igor Pantuhoff on the beach, during the summer of 1938, when they and other friends spent their vacation in Provincetown on Cape Cod. As they sunbathed in the nude trying to warm up from the chilly waters, an unknown woman took their photograph, but, one friend recalled "there was no eroticism, nobody touched anybody else. Everyone was with their own."

Letter from Igor Pantuhoff to Lee Krasner, October 24, 1939, Desperate, discouraged, and hoping for better fortune, Igor had gone to see his parents in Florida. He sent Krasner this letter illustrated by an elaborate sketch of himself reclining under the skimpy shade of a palm tree that he represented as an erect phallus. Collection of the Pollock-Krasner House.

Lee Krasner photographed by Maurice Berezov, c. 1940. Krasner, who worked as a model, developed a taste for elegant furniture and house plants, already evident here, even though she struggled to earn enough money on which to live.

George Mercer in his army uniform during World War II, when he and Lee Krasner (friends from the Hofmann School) corresponded at length and saw each other when he could get a leave. She was sympathetic and receptive to the Harvard-educated Mercer, who wrote discussing everything from Nietzsche and T.S. Eliot to his own frustrated passion to paint.

Lee Krasner before one of her abstract paintings, now lost, c. 1939–40. Photograph by Maurice Berezov.

Krasner supervised the production of nineteen store window displays meant to publicize courses offered in New York area schools to help the war effort. These courses were offered in the municipal colleges to prepare students for "service in the armed forces and in strategic war industries." CR 200, *Spherical Trigonometry*, War Services Project Window, 1942, photomontage and collage, dimensions unknown, destroyed.

Jackson Pollock, Lee Krasner, Anna Krasner, Ruth Stein, William Stein stand in the back row, with Muriel Stein and her half-brother Ronald Stein in the front row with Pollock and Krasner's dog Gyp, Springs, summer 1946.

Jackson, Lee, Gyp, and Caw-Caw (Jackson's tamed crow) on Lee's head, Springs, July 10, 1947. With their move to Springs, nature was a source of shared pleasure. Photograph by Ronald Stein.

Krasner and Pollock photographed in their Springs garden by Wilfrid Zogbaum, c. 1949.

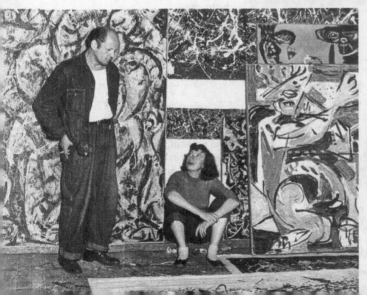

Krasner and Pollock in his studio, 1950. Pollock stands in front of his painting *Gothic*; his canvas *The Key* (1946) is visible on the right side of this photograph by Larry Larkin, a portraitist and collector.

Lee Krasner, Stella Pollock, and Jackson Pollock in the Springs kitchen, Thanksgiving, 1950.

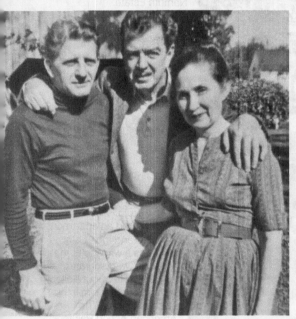

Jackson's brother, Sande McCoy, and his wife, Arloie, posing with the artist James Brooks. Brooks took over the Eighth Street studio when Pollock and Krasner moved to East Hampton.

Lee Krasner and Jackson Pollock hold Raphael Gribetz, summer 1952. Joel Gribetz, M.D., and his wife, Helen, rented the house next door for the summer. She recalls Krasner as "most gracious." Photograph by Willard B. Golovin. Courtesy of the Archives of American Art.

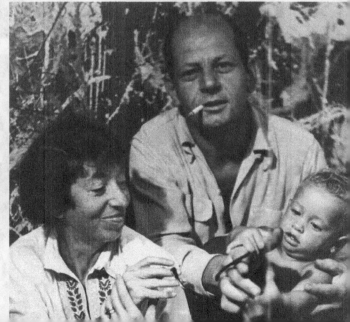

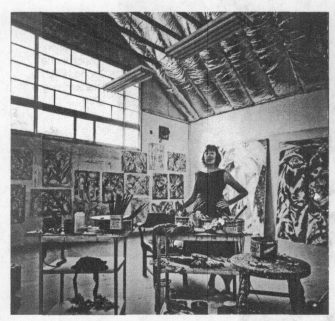

Lee Krasner in her Springs Studio in 1962. A series of drawings on paper in watercolor, crayon, pastel and oilstick from that time are visible on the windowed studio wall. Her canvas, *Earth Green* of 1957, is visible on the right wall. Photograph by Hans Namuth, Courtesy of the Center for Creative Photography, University of Arizona © 1991 Hans Namuth Estate.

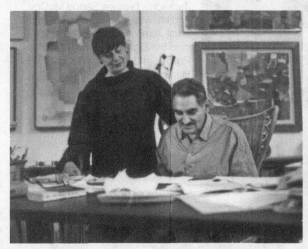

The writer May Natalie Tabak and her husband, art critic Harold Rosenberg, both once shared an apartment with Lee and Igor. Later, May was a witness at the Pollocks' wedding and Harold wrote about Pollock without naming him in his famous article, "The American Action Painters," published in December 1952. Photograph by Maurice Berezov.

In the Spring of 1954, Patsy Southgate was a mother with two young children when she saw that Krasner was trapped in the house. She offered to give her driving lessons in return for painting instruction, so Krasner finally learned to drive. Photograph by Robert Beverly Hale, Springs, 1956.

Lee Krasner, the painter and critic Paul Brach, and Jackson Pollock on the beach in East Hampton, New York, c. 1955, photographed by Miriam Schapiro.

Lee Krasner, Abby and Bob Friedman, Annalee and Barnett Newman (in cap), and Sheridan Lord standing in the back next to Newman, Thanksgiving 1957, probably photographed by Cile Lord. Courtesy of B.H. Friedman.

Ruth Kligman, Willem de Kooning, and Perle Fine, summer 1958. It is not known if Krasner knew that Fine, whom she had convinced to move to East Hampton, was spending time with de Kooning, but because she lived in the small town, she surely heard that Kligman had moved on after Pollock's death to have an affair with de Kooning, who was seen as Pollock's chief rival. Photograph by Fine's husband, Maurice Berezov.

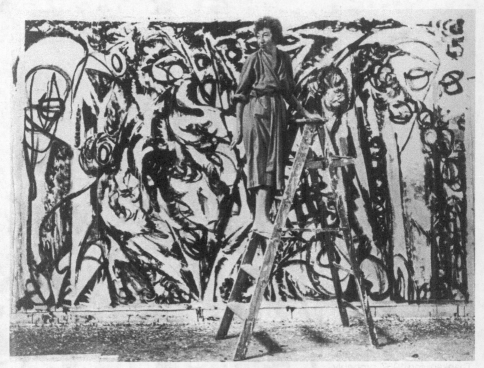

Krasner standing on a ladder in front of an early state of *The Gate* (CR 342), July or August 1959. Photograph by Hallie Erskine.

Lee Krasner with Fritz Bultman (and Alfonso Ossorio in the background) at a party at the New York home of Martha Jackson, autumn 1959. After Jackson's death, Lee spent several months living with Fritz and Jeanne Bultman in their townhouse on East Ninety-fifth street. This photograph was taken the year after Krasner showed with Martha Jackson.

Frank Lloyd, photographed by Donald McKinney. Krasner's near contemporary and a tough businessman who had landed with the British army during the Normandy invasion, Lloyd was said to have twinkling blue eyes that helped to conceal his toughness. Krasner, however, probably recognized and respected his pugnacity because it mirrored her own.

Donald McKinney, the director of the Marlborough-Gerson Gallery in New York, often traveled with Krasner. In February 1967, they took a week's trip to Tuscaloosa, Alabama, where she had a show at the university's new gallery there. Photograph courtesy of Donald McKinney.

The art dealer and critic John Bernard Myers, was a close friend of Krasner's. Photograph by Donald McKinney.

Lee Krasner with her friends the artist Terence Netter and the *New York Times* art critic John Russell at an art opening, c. 1977. Photograph courtesy of Terence Netter.

Lee Krasner with her painting *Sundial* with students Laurel Daunis and Cynthia Hall, along with the Fine Arts Department chairman Jack C. Davis, at the Atwood Gallery, Beaver College, April 4, 1974.

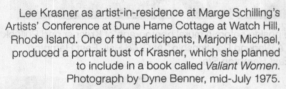

Lee Krasner as artist-in-residence at Marge Schilling's Artists' Conference at Dune Hame Cottage at Watch Hill, Rhode Island. One of the participants, Marjorie Michael, produced a portrait bust of Krasner, which she planned to include in a book called *Valiant Women*. Photograph by Dyne Benner, mid-July 1975.

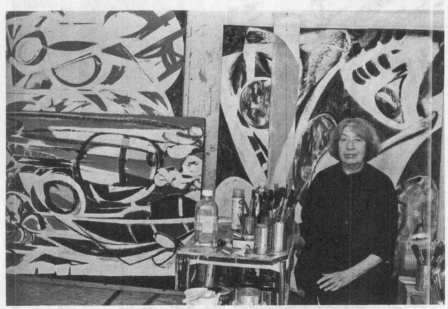

Lee Krasner in her studio in front of an early state of *Crisis Moment*, c. 1972–80, oil and paper collage on canvas; *Butterfly Weed*, 1957–81, oil on canvas, is visible on its side on the left; photographed by Lilo Raymond.

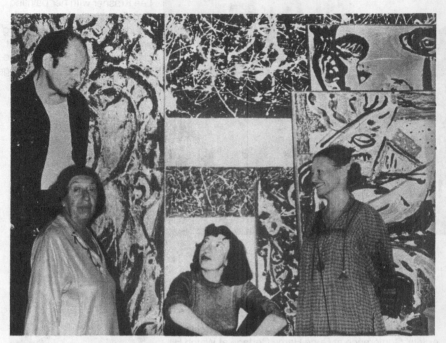

Lee Krasner and Barbara Rose posing before a mural photograph of Krasner and Pollock for the show "Pollock-Krasner: A Working Relationship," at Guild Hall, East Hampton, August 1981. Courtesy of the *East Hampton Star*.

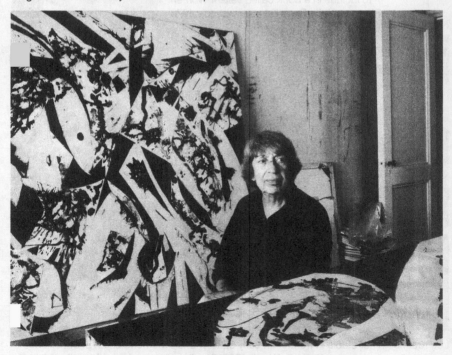

Lee Krasner with *To the North* (CR 585), 1980, oil and paper on canvas, photographed by Arthur Mones, 1981.

tomical men with one visible eye, but whose work reveals a rather interesting feeling for paint surfaces and color."[6]

The magazine did not mention Krasner's painting in the show, but her friends from the Hofmann School took a close look at it, especially Perle Fine, who wrote to say how much she liked it: "It was so much more spatial and the color looked so much richer than anything I had seen of yours previously (and you know how much I liked your other work). It had some real competition, I think, but stood up, Maurice [her husband, the photographer Maurice Berezov] & I agreed, very admirably. We're proud of you."[7]

Despite her excitement about Pollock, Krasner did not immediately cancel all of the connections that she had been building to focus on him alone. She was there when Mondrian's first (and only during his lifetime) solo show opened that January at the Valentine Gallery (run by F. Valentine Dudensing) on Fifty-seventh Street; however, Mondrian stayed away because he had heard somewhere that artists do not attend the openings of their own shows.[8] This disappointed some of his followers who had come to pay homage to him. Nonetheless, his work earned praise in the press.[9]

"After the terrible experience Mondrian had in the London blitz he was quite sick," John Little recalled. Only after Mondrian felt that he had recovered did the Valentine Dudensing Gallery give him his show in January 1942 and invite a few artists "to meet Mondrian and attend a lecture on his theories."[10] Mondrian's lecture, which Little remembered as having been called "Toward the True Vision of Reality," took place on Friday, January 23, 1942, and appeared in the newspaper as "The Liberation of Oppression in Plastic Art and Life."[11] Huge crowds, including Krasner, Little, and many of her other friends from the Hofmann School and the American Abstract Artists, jammed in to hear what Mondrian had to tell them.[12]

This lecture was the second in a series of informal meetings

sponsored by the American Abstract Artists.[13] Actually it was a member of the group, Balcomb Greene, who read Mondrian's contribution, in which he reflected on abstract art and how different the intuitive power of adults was from the instinctive capacities of primitives and children. He also explained his theories of composition and how he determined space in his pictures.[14] Mondrian's lecture was later published as an essay entitled "A New Realism" by the American Abstract Artists in their yearbook.[15]

Mondrian's art and theories had become known as "Neoplasticism" after he published a manifesto of that name in 1920. His work had been known as part of the Dutch *De Stijl* movement founded in 1917 by Theo van Doesburg. It stressed pure abstraction and universality, reducing subject matter to the essentials of form and primary colors—red, blue, and yellow—or the noncolors of black, gray, and white. Those in the movement favored asymmetry, while Mondrian liked to limit himself to vertical and horizontal lines. In Paris, Mondrian had joined a broader association of abstract artists (including Kandinsky, Jean Arp, and hundreds of others) founded in 1931 and called the Abstraction-Création movement.

After the lecture, John Little and Krasner went to a party to welcome Mondrian to America at Café Society Uptown, which at that time "was the *in* place in New York and featured the latest music form, boogie-woogie, with Louis Armstrong at the piano and Hazel Scott, the exciting young singer [and pianist]. Mondrian was delighted, and we danced through the night."[16]

Café Society Uptown, the second branch of a successful downtown nightclub, was established in October 1940. The first Café Society, in downtown Manhattan, was written about in *Time* magazine as "a subterranean nightclub" that attracted connoisseurs of jazz. Its founder, Barney Josephson, was said to be "a mild-mannered shoe store owner" from Trenton, New Jersey. Josephson recalled that his aim was to create the "first truly integrated nightclub in this country."[17]

Krasner's friend from the WPA Lou Bunce recalled, "Going and listening a lot . . . I had known some jazz people, particularly two-beat jazz in those years. . . . We went to the opening of Café Society. There was a friend of mine by the name of Anton Refregier, who did decorations, and . . . he managed to invite us there and it was our night out on the "town there. . . . It was kind of a neat place. It was beautiful. And I remember there was a jazz pianist by the name of Hazel Scott. And she was just absolutely great. That was the opening gun. It was quite an experience."[18]

Krasner's admiration for Mondrian was such that she must have relished the opportunity to mingle with him once again. For her friend John Little, and for other Americans already influenced by Mondrian's work, meeting him was sensational, an event they, like Krasner, recollected for the rest of their lives. Many of the Americans, including Krasner and Little, among many others, had experimented with the master's Neoplasticism, trying out variations of his structure, forms, color, space, and content.[19]

But they were also impressed with Mondrian's engaging personality. His enjoyment of boogie-woogie music and dancing also added to the fun. Krasner recalled that they "liked to listen to jazz, and we used to go to a Café Uptown or Café Downtown . . . and dance."[20] She considered Mondrian one of her most outstanding partners for dancing. "I was a fairly good dancer, that is to say I can follow easily, but the complexity of Mondrian's rhythm was not simple in any sense."[21] "I nearly went mad trying to follow this man's rhythm."[22]

Krasner remembered a particular evening with Mondrian at the Café Uptown or Café Downtown. "First, he waited through several numbers for a particular piece that he wanted to dance to," she recalled. "Then he said, 'Now!' and we went around in what I would describe as one of the strangest rhythms I've ever had to deal with. In other words, I had to do major concentration to follow this man. . . . I noticed lots of heads looking at us and

I thought, 'Of course, they're looking at us, because I'm dancing with Mondrian.' Then we swung around a corner and I could see the couple behind us, and it was some movie actor and a divine-looking woman, and that's who were being watched!"[23]

American Abstract Artists member Charmion von Wiegand described Mondrian as "a perfect dancer [who] danced in a way so perfect that it was almost too perfect . . . it was alive." Another recalled that Mondrian "danced stiffly, with his head thrown back."[24] Mondrian apparently liked women and once gave this explanation for why he never married: "I have not come so far. I have been too occupied with my work."[25] Though he had purportedly been in love several times, it was rumored that he had not married because he lacked adequate money and security to support both his work and a wife. Described by some as a "passionate, virile man," Mondrian, according to von Wiegand, liked to dance to the accompaniment of boogie-woogie, not the melody.[26]

Harriet Janis (Sidney's wife) recalled that Mondrian's favorite haunt was "Café Society, Downtown, where he went especially to hear Albert Ammons, Mead Lux Lewis, and Pete Johnson, the Negro boogie-woogie pianists."[27] Boogie-woogie was considered the least melodic form of jazz and the most technical, and for Mondrian, it related to music in the same way that abstract art related to traditional representational art: "Boogie-Woogie was to jazz what Neoplasticism was to Cubism,"[28] he said. He loved the rhythm.

According to Little, Mondrian's patron (probably Holtzman) invited them for breakfast at Child's restaurant, not far from Mondrian's Fifty-sixth Street studio. From there Krasner and Little headed back to the Village, tired but invigorated by the memorable night out.

Inspired, Mondrian would go on to begin work that summer on his famous canvas *Broadway Boogie-Woogie* (1942–43), which the Museum of Modern Art rushed to acquire in May 1943 and exhibit the following summer. "I especially like the metropolitan

life of New York," exclaimed Mondrian. "Very noisy, but that doesn't hinder me. I think that in America there is much more general appreciation for the new things than in France and in London. I don't know the reason but it may be that Americans see freer—a very good quality."[29] For the unfinished *Victory Boogie-Woogie* of 1943–44, where he added some secondary colors, Mondrian relied on both bits of colored paper and small bits of Dennison adhesive tape, which were then produced in primary colors.[30]

For one of Krasner's works called *Mosaic Collage* (estimated in the catalogue raisonné to have been produced sometime in 1939–40), she appears to have seized on a jazz rhythm like Mondrian's. She too experimented with mostly primary colors and small bits of colored paper to achieve an optical effect that also vibrates. Though Mondrian rejected curves in his classic abstractions, Krasner employed curves and circles both here and in her other Mondrian-inspired works while emphasizing primary colors, such as in her *Red, Yellow, Blue* of 1939–40.[31] Her single collage of this period is a unique work in her oeuvre and seems unlikely to be related to anything but Mondrian's work.

Mondrian's place in Krasner's thinking is even more evident in Mercer's reply to a letter she sent him in February 1942. "You are right," he wrote to her about Mondrian. "Piet is wrong. He's cloistered. 'Good' and 'Bad,' pure and impure are equally valid. But then, if we will be ourselves, what can Piet do? His purity makes for impure in painting—or doesn't it? (One can still like him)."[32]

From Fort Bragg, North Carolina, where Mercer was running a camouflage school, he confided his anxiety that America might not win the impending war. Krasner's friendship with Mercer resulted in her close exposure to a reluctant and frustrated soldier's view of the war. Not long after the bombing of Pearl Harbor on December 7, 1941, he reflected his frustration that the United States had allowed Japan to open hostilities and complained that we had been "so blind to the moral condition of Germany."[33]

Mercer also inquired about Krasner: "What about you? And your co-exhibitor friend that you think you like? Write and let me know."[34] Their friendship was such that she had confided in Mercer, indeed shared, the excitement she felt upon meeting Pollock.

On March 16, 1942, Mercer wrote to Krasner, asking about the AAA show.[35] He referred to the Sixth Annual Exhibition of the American Abstract Artists held at the Fine Arts Galleries, 215 West Fifty-seventh Street, and described by *Art News* as "the best show of abstract painting seen in some time."[36] Among the artists were both Krasner and her hero, Mondrian. Unlike Harry Holtzman, she was not, thankfully, singled out in the press for "slavishly" imitating the Dutch master. Though there were no published comments about Krasner's heavily impastoed work, the *New York Times* critic Edward Alden Jewell did list "Leonore [*sic*] Krasner" as one of the forty-six participants.[37]

Some, however, received more prominent notice. The reviewer for *Art Digest* singled out Bolotowsky, Slobodkina, Glarner, Holty, Xceron, and, of course, Mondrian and Léger—not so much for their aesthetics, but rather for their foreign birth, viewing these artists as Russian, Swiss, German, Greek, Dutch, and French.[38] Krasner, of course, was American.

By April 1942, Mercer reported that he had been chosen for officers school. "How is Monsieur Pollack [*sic*]? You like him, yes," he wrote to her, then: "Krasner, I have spring fever. Tonight I wish we were walking together down along the docks, walking and talking until dawn broke, physically exhausted. How does that old song go . . . You are my favorite star."[39] A month later, he asked again, "What about Mr. Pollack [*sic*]?"

Mercer rattled on: "I met Fritz [Bultman]'s sister [Muriel Francis]. She is a MONSTER. Krasner, you have the life—giving touch. You are WONDERBAR as the Germans say—only they don't say it that way. (By the way, I should like to see you.)"[40] After dismissing Miss Bultman, then active as an art collector, Mercer tells Krasner that he "was interviewed last night and asked a lot

of interesting and peculiar questions. I was asked to tell *just* where I had been in Europe, especially Germany, Austria, Italy, and France. When they saw from my classification card that I was a painter—landscape & still life variety, they wanted to know if I could paint and draw coastlines! Good bye, honey. I'm off for a commando outfit or something like that. Jesus how I wish I could get into something terribly exciting, thrilling and dangerous. Only to kill this christ-awful dragging on and on."[41]

After the end of officers' training and his promotion to lieutenant, Mercer reflected, "I can almost see now why I liked painting. Every now and then I find some phenomenon I would like to paint or draw but the chance and the will are fading. I know that painting is impossible. Even this writing demonstrates that I give it some thought but for now it is on the wane. I guess the death, for a time?, of the painter was a beautifully painful experience. And I can even summon that feeling again, as I have said. I am hardly mad about it any more."[42] When Barbara Rose asked her years later, "Were people affected by the war?" Krasner answered: "People were very affected by the war. But it didn't mean you stopped painting unless you were called into the army; then you just couldn't paint. But otherwise one continued."[43]

Ever more mindful that most of the eligible men had been drafted by the armed forces, Krasner had set her eye on Pollock, conveniently classified 4-F or unfit for military service because of his psychological problems, but still ambitious enough to paint. "We had a helluva lot in common—our interests, our goal. Art was the thing, for both of us. We focused on it, zeroed in on it, because our backgrounds, though different, were not so different as all that. Cody . . . Brooklyn. Not so different."[44] Indeed, compared to Pantuhoff, Krasner and Pollock were not from such dissimilar social classes.

She and Pollock shared a "mutual interest in painting which was the Paris School of Painting. . . . We'd either be talking about Picasso, or arguing about Matisse but . . . it was always French

painting. I knew of his early interest in Orozco and Siqueiros, but we were past that stage."[45] Krasner recalled that Pollock had "the last publication of the then Picasso (whether it was *Cahiers d'Art* or what, I don't know), thumbing through it, and going into a total rage about it, and saying, 'That bastard, he misses *nothing*!,' which meant, like, he was with it, in that sense . . . so that his eye was very much directed towards what was happening in the so-called Paris School of painting."[46]

Pollock was close to John Graham, whose ideas and art also informed Krasner's work in 1942. She seriously considered Graham's emphasis on an artist's need to unite thought, feeling, and a record of physical gesture, which he called *automatic writing,* or *"écriture."*[47] He meant a combination of training and "improvisation." Krasner took a close look at Graham's own drawing and experimented with some pen-and-ink sketches in which she played around with line and rhythm, searching perhaps for what Graham termed a child's "direct response to space."[48] In this sense, she could depart from Hofmann's attachment to nature and allow line to have a life of its own.

Graham also respected Mondrian's "Neoplasticism," and wrote that "Mondrian had the vision and heart to start anew. Maybe he did not go far enough, but he had the courage at least to say a new 'a.'"[49]

Graham began inviting Krasner and Pollock to elaborate Russian-style teas at his place, and soon enough, the three of them were spending a lot of time together. Krasner recalled: "He had already written his book which I had read prior to having met him . . . the book affected us and . . . he had these fabulous oceanic and African pieces."[50] Pollock was closer to Graham than Krasner because he had participated in a drawing group Graham held in his Greenwich Street studio.

Pollock had taken what was for him a rare initiative in order to meet Graham, writing to him after being impressed by Graham's article on Picasso and the unconscious.[51] The abstract painter Carl

Holty recalled getting to know "Pollock slightly" at Graham's studio. "We used to draw down there at night, he had models and we have this a good deal today in New York. You know, you get a model and a group of fellows will practice drawing."[52]

One wintry night in early 1942, Krasner and Pollock were walking Graham back to his studio, when they ran into "a little man with a long overcoat," whom Graham introduced: Frederick Kiesler, the architect and designer. Graham presented Pollock as "the greatest painter in America," to which Kiesler, with his elegant European manners, bowed deeply and asked, "North or South America?"[53]

Krasner was also busy visiting the downtown location of the Café Society.[54] Among her acquaintances, Reuben Kadish later recalled going to "Cafe Society Downtown on Sheridan Square. I saw the Mills Brothers there, Billie Holiday, and Lena Horne. It was worth dropping five dollars or so to see them."[55] Many of the patrons and even those who worked there had no idea that the Café Society was originally founded to raise funds for the American Communist Party and to guard against the spread of fascist ideas in the United States.[56] Indeed, the radical periodical *New Masses* had been involved with the café's foundation.

Café Society also served as the locale for benefits for the Abraham Lincoln Brigade.[57] It attracted radicals and intellectuals critical of American society. Even the name of the club was an attempt to put down the wealthy Upper East Side café society.[58] The decor, produced by leftist artists such as William Gropper or Anton Refregier, reflected the same ideology, sending up the lifestyle of the rich. Café Society advertised that it was "the wrong place for the Right people" and appropriate for "Celebs, Debs, and Plebs."[59]

The appearance there of boogie-woogie pianists Albert Ammons, Pete Johnson, and Meade Lux Lewis helped to create the craze for this music.[60] Having enjoyed "dives" in Harlem, Krasner loved to go to Café Society, where those reported to have taken part in the racially mixed audience include Paul Robeson,

Nelson Rockefeller, Charlie Chaplin, Lillian Hellman, and Eleanor Roosevelt.[61] In his letter to Krasner of December 12, 1940, Mercer had jokingly referred to "Eleanor R." in the same sentence as Piet Mondrian, suggesting that Krasner had either encountered Roosevelt at Café Society or at least had heard that she had once been seen there.

In between her Café Society visits, Krasner and Pollock began seeing each other more frequently, during which time, she insisted, "we didn't do art talk!"[62] Most of her own engagements in the art world did not involve Pollock. Nevertheless, Krasner began to share with Pollock her enthusiasm for European modernism. Soon she was making efforts to have him go with her to look at work by modern masters. She later recalled that "while Pollock had Miró as a god, I favored Mondrian and Matisse."[63] Pollock also favored Picasso, but they both liked "early Kandinsky, the ones in the [collection of Solomon] Guggenheim . . . the 1913, '14, magnificent, beautiful, beautiful things. Those we saw I think at the Plaza hotel, which is where the Guggenheim, the Baronness Rebay prior to her opening, that's where the collection was."[64] She recalled seeing the Kandinsky paintings in what was then called the Museum of Non-Objective Painting, before it became the Guggenheim Museum.

Krasner also introduced Pollock to Hans Hofmann by taking him to Pollock's messy studio, even though she knew that Hofmann, like Mondrian, favored cleanliness and order. Because he saw no evidence of still lifes or models in Pollock's studio, Hofmann asked Pollock, "Do you work from nature?" Pollock responded: "I am nature." Hofmann then warned, "You don't work from nature, you work by heart. That's no good. You will repeat yourself."[65] Pollock then bellowed at Hofmann that his theories did not interest him, telling him to "put up or shut up! Where's your work?"[66]

"Hans had a marvelous way of being deaf to Jackson's aggressive/defensive manner," recalled Bultman. "Hans was quite aware of

the hostility. Later when the Pollocks were in their worst financial straits, he bought a couple of pictures."[67] Lee's friends Mercedes Carles and Herbert Matter were also very supportive of Pollock. Herbert tried to bring Alexander Calder over to see Jackson's work. However, the sculptor, some of whose work can be described as drawing with wire in real space, found Pollock's work too "dense." Herbert Matter then encouraged James Johnson Sweeney of the Museum of Modern Art to become an enthusiastic supporter of Pollock's.[68]

In May 1942, Krasner and Pollock both signed a petition to President Franklin Roosevelt in protest of the deterioration of creative activity on the WPA easel project in New York. At that same time, Krasner was working for the United States government on the War Services Project, the last hurrah of the WPA. She served as supervisor for the production of nineteen store window displays meant to publicize courses offered in New York–area schools to help the war effort. These courses were offered in the municipal colleges to prepare students for "service in the armed forces and in strategic war industries."[69] Krasner recalled that some of the displays were for the windows of Gimbels department store in Herald Square.[70]

In May Krasner went to observe a number of classes from various schools, "looking for the one spot that could be dramatized."[71] These visits included a class on explosives with Professor Burtell of City College, who showed her "interesting and displayable items," which she recorded and described. She focused on "a weird looking device like some alchemist's dream based on a series of glass jars and retorts connected by rubber tubes, which is used to test the amount of hydrogen in an explosive."[72] She made more "Notes on Ideas and Materials Available for Window Displays in Stores of the War Courses Given in the Colleges." Additional course topics included cryptography, chemistry, civil defense, mechanical drawing, metallurgy, optics, military topography, radio, and spherical trigonometry.[73]

The montages that Krasner's team produced were accompanied by one designed by Herbert Bayer. This montage was supposed to be at Pennsylvania Station and in the store windows as "a unifying key or symbol."[74] The Austrian-born Bayer was already a famous Bauhaus-trained graphic designer whose montage displayed marching soldiers and students at courses in four different colleges. The caption for his montage read "50,000 Young People Prepare to Serve Their County."

But the designs from Krasner's workshop were even more adventuresome than Bayer's. Documentary photographs survive from Krasner's group effort, although it is not possible to know who produced what part of most of the displays.[75] There were strange juxtapositions of objects and scale, floating letters, lots of diagonal axes, and bold tonal contrasts. These works were all spatially complex and implied several levels of reality.

Krasner managed to get Pollock assigned to her team that summer. By the spring, he often stayed at Krasner's place on Ninth Street. In describing their "courting period," Krasner said, "I resisted at first, but I must admit, I didn't resist very long. I was terribly drawn to Jackson, and I fell in love with him—physically, mentally—in every sense of the word. I had a conviction when I met Jackson that he had something important to say. When we began going together, my own work became irrelevant. *He* was the important thing. I couldn't do enough for him. He was not easy. But at the very beginning he was accepting of my encouragement, attention, and love."[76] Perhaps the self-sufficient Krasner was not so much drawn to weak, dependent, alcoholic men but was just capable, after a decade of living with Igor, of dealing with one.

The anticipation of a visit from his mother that May propelled Pollock into a binge of drinking that ended with his admittance to Bellevue Hospital, a New York City public hospital well known for its psychiatric facilities—the hospital had established a dedicated unit for alcoholics as early as 1892. (In fact, by 1936, 40 percent of Bellevue's 25,000 annual admissions were alcoholics.)[77]

Krasner recalled the spring morning when Pollock's brother Sande knocked on her door, asking, "Did Jackson spend the night here last night?" When she asked why, he replied, "Because he is in Bellevue Hospital and our mother has arrived in New York. Will you go with me and get him?" Krasner later told how she had gone with Sande to the Bellevue ward: "He looked awful. He had been drinking for days. I said to him, 'Is this the best hotel you can find?' At Sande's suggestion I took him back to my place and fed him milk and eggs to be in shape for dinner that night with Mother. We went together. It was my first meeting with Mother. I was overpowered by her cooking."[78] Krasner was caught off guard: "I had never seen such a spread as she put on." Seeing that Stella Pollock had prepared the abundant home-cooked dinner and even baked the bread, Krasner's first response was to be impressed. She told Jackson, "You're off your rocker, she's sweet, nice." It took Krasner time to appreciate why there was a problem between Jackson and his mother, how she dominated her youngest son.[79]

To understand how Krasner dealt with Pollock's drinking problem at the time, it is necessary to consider how the interpretation of alcoholism was then evolving. At the time of Pollock's hospitalization, alcoholism was generally regarded as "a self-induced condition that was more a reflection of moral weakness than medical illness."[80]

By 1943, when Pollock was admitted to Bellevue, the old cultural paradigm saw alcohol and drunkenness as "sin and moral degeneracy." However, this interpretation was giving way to the new "metaphor of alcoholism as a disease."[81] Krasner never would have subscribed to the old notion of alcohol as "sinful"—after all, she was too hip, too rebellious, too much a part of a social milieu that accepted drinking. Instead, she accepted medical authority that invoked the problem of alcoholism as a disease, as it had been viewed in the nineteenth century, well before Prohibition.[82]

If alcoholism was a disease, then treatment was possible if

one could only find the right cure. Awestruck by Pollock's extraordinary talent and other redeeming qualities, Krasner was determined to try to help him. Her experience dealing with Igor's problems with alcohol made Pollock's more severe problems seem at once familiar and more manageable. But as Krasner searched for treatments not only for Pollock's alcoholism but also for other maladies of her own, she was exposed to a great deal of medical quackery.

Early twentieth-century addiction specialists had argued that putting alcoholics in medically supervised settings was necessary to treat them effectively. Of course, neither Pollock nor other alcoholics could easily be persuaded to remain in a mental hospital such as Bellevue long enough for treatment to succeed. During the postwar years, drinking was heavy in the art community, and that made Krasner's efforts more difficult. Bars were the hangouts of choice, where one went to make the necessary connections, while entertaining at home also included copious amounts of alcohol.

Thus Krasner became a part of Sande's efforts to conceal Jackson's drinking from their mother and get him into a better state to welcome her.[83] In doing so, Krasner gradually became aware of the depth of Pollock's problems, which began to take up more and more of her time.

During Stella Pollock's visit that May, she stayed with Sande and his wife, Arloie, whom he had known since high school, in the fourth-floor walk-up apartment on Eighth Street that they shared with Jackson. Stella wrote to their brother Charles that it was "almost ten o'clock" and Jack "has just left for his girls [sic] home."[84] She appears to have been pleased.

As long as she hid Pollock's problems from his mother, from herself, and from others, Krasner was not alone in her positive assessment of Pollock and his talent. Finally, George Mercer met Pollock while visiting Krasner in New York in August 1942. After he returned to North Carolina, he wrote, "I have been meaning to write and tell you what a good time I had in New York with you

and Pollack [*sic*]. What a change it was from the life here. I was a little disappointed that New York wasn't all lighted up for my arrival but then one must put up with the war, you know."[85] Mercer was supportive of his friend's new companion, telling her, "I not only liked Pollack [*sic*] but approved of him as well. You may tell him so if you wish. His quiet intelligence is particularly admirable. Few people are able to give the impression of intelligence without noisy reminder. He is one of the few."[86]

Mercer also liked Krasner's canvas in progress. "The painting was and is very beautiful. Don't change it. Or have you done so already? Next time I will have to see it in the daytime. I too would like to delve into the matter of color. I am about on the verge of buying some colored pencils. What a splurge. I'd sort of like to sneak off and put some colors on paper."[87]

That fall, Jackson's brother Sande left New York City to take a defense industry job in Connecticut, which allowed him to avoid military service. He must have felt relieved to be able to leave Jackson in Lee's hands. Only at that point did Krasner give up her own place.[88] Charles Pollock, their elder brother, later reflected, "Lee and I never had much to say to each other and I had no real impression of her work. Lee had strength, which Jack needed, and ways of opening up avenues for him. If he hadn't met her, he might have gotten tied up with a lethal woman."[89]

Charles's wife, Elizabeth Pollock, added, "Jackson was narcissistic, totally in love with Jackson; that's why he had to be mothered. Lee struck me as extremely capable and domineering; I knew immediately why Jackson was with her. He had found a 'mummy.'"[90]

With Pollock's family gone, Krasner moved in with him at 46 East Eighth Street, around the corner from her previous apartment, taking the place of his brother Sande and Sande's wife, Arloie, who had looked after Jackson. Krasner was able to paint, working at the other end of Pollock's studio. But still their relationship was not an easy one.

"I was out one afternoon and I came in," she recalled, "and I found that the painting I had on the easel, that I was working, you know, and I said, 'That's not my painting,' and then the second reaction was, he had worked on it. And in a total rage, I slashed the canvas. . . . I wished to hell I had never done it, but . . . And I guess I didn't speak to him for some two months, and then we got through that."[91]

It was bad enough that Hofmann had made corrections on her drawings, but this intrusion and interference by Pollock was totally unbearable. Those who claim that Krasner did not continue to show her own work because she did not want to appear competitive should take into account her anger at his attempt to improve upon her painting.

By October 1, 1942, Krasner had taken charge of the City War Services Project and had eight artists under her supervision, including Pollock.[92] Of Krasner's group, the artists John [later, Jean] Xceron and Serge Trubach were fellow members of the American Abstract Artists. In a letter to Audrey McMahon, who was the general supervisor of the City War Services Project, Pearl Bernstein wrote of "the difficulties" Krasner "encountered in coordinating all of the work in spite of academic and other temperaments. The fact that all those who worked on the displays still seem happy about them, is not the least of the things to Miss Krasner's credit."[93] It is notable that Krasner reported to McMahon, because in December 1936, it was McMahon who had called the police in against the Artists Union demonstrators, some of whom they brutalized; both Trubach and Krasner were among them.[94]

Several of the artists who worked with Krasner on this project were deeply engaged with modernism. Ben Benn, who had studied at the National Academy of Design from 1904 to 1908, had participated in "The Forum Exhibition of Modern American Painters" held in 1916 at the Anderson Galleries in New York, along with Thomas Hart Benton, who had been Pollock's

teacher. Early on, Benn felt the influence of Matisse, Picasso, and Kandinsky.

Xceron, who had first gone to Paris in 1927, was another enthusiastic advocate of modernism in the group. He had worked in Paris as a syndicated art columnist for the European editions of the *Chicago Herald Tribune,* the *Boston Evening Transcript,* and the *New York Herald Tribune,* newspapers with high circulations Imbued with modern sensibilities, he was a strong advocate for non-objective painting.

In October 1942, Igor returned to New York for a short time. Jeanne Lawson Bultman, who was involved with Igor after Lee and before her marriage to Fritz, recalled Igor telling her that he had wanted to see Lee but that he upset Jackson so much that Jackson began throwing things at him to hasten his departure.[95] Apparently Krasner no longer wanted Igor back and had to force him to leave her in peace. Now that he had had a change of heart, he was the rejected one.

Krasner wrote to Mercer about it; he responded, "I think that I would like to have witnessed the splash of plates. At any rate it amused me. It sounds as tho Igor is gone for good now. The last shower of crockery symbolizes something. I like the way you were forced to stop to be honest by the way."[96]

Krasner's catalogue raisonné dated a canvas called *Igor* to circa 1943, but it probably was completed in late 1942 in response to the unexpected return of the man who had deserted her. The central motif of *Igor* (which has too often been reproduced upside down) looks like an abstract head of a rooster. Though it is not clear that Esphyr Slobodkina had shown Krasner the 1934 caricature that she had made of her friend astride a cock, the sexual metaphor of the cock was well known to their generation.

Yet the catalogue raisonné suggests the impetus for this picture rests in the princes that Krasner would have known from the Russian fairy tales that her father read to her. It is much more likely

that Krasner's *Igor* refers not to literary lore or to Borodin's opera *Prince Igor* but to her own experience, first growing up in rural East New York with its farms, where she recalled going to fetch buckets of fresh milk for her family, and then at her parents' farm in Greenlawn, where they raised chickens. Like any farm girl, she would have known that though the cock was not monogamous, he would attack other roosters who entered his territory, where his hens were nesting. Likewise, Krasner knew that Igor had wandered into the arms of other women, often the society women he depicted in commissioned portraits, but that he had returned to her, wanting to reclaim his territory. Thus, this canvas is a self-declaration that she had moved on.

As Pantuhoff's fortunes diminished, Krasner saw Pollock's potential. Unlike Igor, whose work had become increasingly conservative and out of step with their contemporaries, Jackson was moving in avant-garde directions, challenging tradition, even contemporary leaders like Matisse and Picasso, whose influence can be seen in her canvas *Igor*. While the suave Igor charmed society women, Jackson maintained a bad-boy persona, but that could be regarded as linked to the antics of Dada artists like Duchamp and the Surrealists, who were then making their mark in New York.

# Coping with Peggy Guggenheim, 1943–45

Jackson Pollock with Peggy Guggenheim in front of *Mural*, a 1943 painting that she commissioned from him for the entrance hall of her town house at 155 East 61st Street. Lee recalled that Guggenheim had sent a copy of her book inscribed, " 'To Jackson.' . . . She had not included me in the inscription. . . . I must not have realized that she probably resented my attachment to Jackson." Photographed by George Karger.

THE SURREALISTS TRULY BEGAN TO MAKE HEADWAY IN NEW York when the heiress Peggy Guggenheim opened her gallery, Art of This Century, at 30 West Fifty-Seventh Street on October 20, 1942. She was the niece of Solomon Guggenheim, the founder of the Museum of Non-Objective Painting, then at 24 East Fifty-Fourth Street. She had previously run her own com-

mercial gallery in London, which she named Guggenheim Jeune, at once hitching her star to her uncle's fame and giving the appearance that she was his daughter, instead of his niece.

Peggy's wealthy parents, Benjamin Guggenheim and Florette Seligman, were one of the most socially influential Jewish families in New York, but in 1912, when Peggy was only fourteen years old, her father perished in the sinking of *Titanic.* As a young woman, she discovered the avant-garde while working at the Sunwise Turn, a radical bookstore in Greenwich Village run by her cousin Harold Loeb. She forged friendships not only with artists but also with others on the cutting edge of change.

In connection with the opening of her gallery in New York, Guggenheim published a catalogue, *Art of This Century,* which included prefaces by Mondrian, André Breton, and Jean Arp, demonstrating her connections with those in both abstract and Surrealist art. She wanted her gallery to be noticed, so she commissioned an unusual interior design by Frederick J. Kiesler, a European-born and -trained experimental artist, theoretician, and architect.

Guggenheim opened with a show of her collection of modern paintings and sculpture. Many of the paintings were shown without frames to avoid the look of tradition; sculpture was suspended in the air, walls were curved, and special biomorphically shaped chairs were flipped over to become sculpture pedestals. "We, the inheritors of chaos," said Kiesler, "must be the architects of a new unity. These galleries are a demonstration of a changing world, in which the artist's work stands forth as a vital entity in a spatial whole and art stands forth as a vital link in the structure of a new myth."[1]

Peggy's uncle's museum, the Museum of Non-Objective Painting, had hired Pollock as a custodian in May, just months after the WPA ended his employment. He worked on making frames and counting attendance and did other odd jobs. Later on, when an interviewer asked her what she had been doing, Krasner replied

that she stayed home and was "very busy keeping house."[2] In fact, she was focused on taking care of Jackson, wanting this relation-ship to last.

Pollock would soon come to Peggy Guggenheim's attention through a series of connections. Previously he had worked on the WPA easel project, where he had met William Baziotes, an art-ist Krasner knew in the WPA, who hung out with the Chilean painter Matta.[3] Krasner recalled that in early 1942, Matta sug-gested that Baziotes introduce Pollock to Robert Motherwell, a young painter from a relatively well-to-do family, who invited Pol-lock to show in a group exhibition of Surrealists. He explained the concept of "psychic automatism," only to find that Jackson already embraced the role of the subconscious in art. Still, Pollock disliked group activities and so declined to join the projected show.

Despite Krasner's own previous experiments with Surrealist imagery, she was turned off by the men's chauvinism. "I was there, too, but that was irrelevant," she remembered about male artists whom she thought never paid her much respect.[4] Krasner liked to rail against the way the Surrealists treated their wives and how this way of treating women influenced the American male artists who looked up to the Surrealists. "There were the artists and then there were the 'dames,'" she explained. "I was considered a 'dame' even if I was a painter too. And they had this terrible custom, the artists we knew. It was something they'd picked up from the Sur-realists. I think—they used to dress up their wives to go out to parties. Very elaborate costumes, and hairdos and everything."[5] A much younger Krasner had once liked having Pantuhoff manipu-late her style, but after him, though she enjoyed fashion, she had no tolerance for this sort of behavior, which she just saw as men treating women like dolls to be adorned.

Krasner was not alone in her reaction against the Surreal-ists' behavior. Even though her old friend Gorky became close to André Breton, Matta, and a number of the Surrealists in New York, his close friend, the painter Saul Schary, insisted, "Gorky

was not a Surrealist. He never was a Surrealist, because the Surrealists believed that by taking reality and putting it together in strange and unusual juxtapositions, they made it sur-real. 'You know, Schary,'... Gorky said to me, 'I made a terrible mistake getting in with these Surrealist people. They're terrible people. The husbands sleep with each other's wives and they're terrible people.'"[6] Gorky was referring to his own wife's affair with Matta, one of several torments that contributed to his suicide.[7]

Krasner also recalled the "little social engagements" that she and Pollock had with Matta, Baziotes, and Motherwell, during which they played the after-dinner Surrealist game Exquisite Corpse. She described this as: "It was to draw a figure, and you do the head, and then fold the paper and then give it to me, so that I'd start the upper part of the torso, and then I'd fold it up, and so on; it isn't a literary concept."[8] Jackson and Lee also began to experiment with writing automatic poetry, emphasizing one's stream of consciousness with Motherwell, Baziotes, and their wives—but merely as an after-dinner game.

Through Motherwell, Pollock received an invitation to take part in Peggy Guggenheim's show of collages that was held from April 16 to May 15, 1943. The two men worked together on their collages in Pollock's studio. Pollock was also invited to submit his work to the jury for the Spring Salon for Young Artists (under the age of thirty-five) at Art of This Century. Krasner, who would not turn thirty-five until October, did not submit anything, though she continued to work on her own art.

Guggenheim asked the English art and literary critic Herbert Read to help her choose the artists for her salon, and they worked together with her new employee, Howard Putzel, to organize the show. Putzel knew and supported Pollock. He visited Pollock's studio in advance and told Pollock to send in his painting *Stenographic Figure* for this juried show.

Jimmy Ernst, Guggenheim's assistant and the son of the famous artist Max Ernst, who was then briefly married to Guggenheim,

was present when Mondrian and the other members of the jury—the French artist Marcel Duchamp, the critics James Johnson Sweeney and James Soby, Putzel, and Guggenheim—considered Pollock's painting. Jimmy reported overhearing Mondrian comment that he found Pollock's work "exciting and unusual," though not easily understood. There was something new going on there, Mondrian noted, which might mean that Pollock was one of the most original American artists that he had ever seen. Guggenheim, who had not previously paid attention to Pollock's work, soon made a date to visit his studio.

On June 23, Peggy arrived, but Lee and Jackson were a bit late, and when they arrived, they ran into her exiting their building. "Anticipating that we might be late we left the doors open for her," Krasner recounted. "My paintings were up as well as Jackson's. . . . [Peggy] started to bawl Jackson out for not being there on time, saying, 'I came into the place, the doors were open, and I see a lot of paintings, L.K., L.K. I didn't come to look at L.K.'s paintings. Who is L.K.?' And she damn well knew at that point who L.K. was."[9] Eventually, they prevailed upon the irate Peggy to climb back up the stairs for a proper studio visit in Jackson's presence. There, as they continued to mollify her, she warmed to his work.

It was Peggy's friend Jean Connolly who wrote the review of the spring salon for *The Nation,* which Krasner liked to quote, for it said that Pollock's canvas left the exhibition jury "starry-eyed."[10] This really made an impression on Krasner because Mondrian was one of the jurors. She might have been aware that at the time, Connolly was the lover of her old friend, the critic Clement Greenberg, who was then serving in the U.S. Army Air Force.[11] Krasner must have also liked what Robert M. Coates in *The New Yorker* had to say about Pollock's work—"a real discovery."[12] Others were now seeing what she had seen in Pollock a few years earlier. The future, for once, looked rosy.

By July 15, Pollock proudly wrote to Lee on Long Island, where she was visiting her aging and ailing parents, that he had signed

a contract from Peggy Guggenheim. Like Krasner, Guggenheim seemed fortunate to have found in Pollock a talented young male American artist who wasn't in military service. Guggenheim scheduled a solo show for him in November, commissioned a mural-size painting for the entrance hall of her town house at 155 East Sixty-first Street, and agreed to pay him $150 a month for a year with a settlement at the end of the year. If more than $2,700 worth of art were sold (less one-third commission for the gallery), he would receive further payment, and if less, he would make up the difference in paintings turned over to Guggenheim.[13] Her patronage seemed fantastic. It immediately enabled him to quit the custodial job that he held at the Museum of Non-Objective Painting, where, like many of the artists-employees, he felt threatened by the dogmatic director, the Baroness Hilla Rebay.

That same summer, Krasner wrote to Jackson's mother, Stella Pollock: "I'm really ashamed for not having written sooner but life in N.Y. is complicated and in spite of the fact that I'm not working (except for the posing I do for Sara) and I seem to be kept busy every minute. It was nice seeing Frank and in uniform, much to everyone's surprise and Sande (who's getting fatter every day)."[14] She exulted about the wonderful things that were beginning to happen to Jackson: Peggy Guggenheim's visit to his studio, her purchase of a drawing, and her promise of a solo show for him in November. "She is really very excited about his work; in fact she said one of the large canvases was the most beautiful painting done in America. She wants to handle his work and can do a lot for him," she enthused.[15] She also told how James Johnson Sweeney had offered Jackson a teaching job in Buffalo, New York. It was not tempting, but it was flattering, and it suggested that he was destined for success.[16] And there was more: "some woman who came in from the coast to arrange some shows for the San Francisco Museum offered him an exhibition of his drawings and I can't remember what else is happening but it's all very wonderful."[17]

Lee also wrote to Stella: "Please be sure and send me the in-formation about your shoes so I can get them quickly—are you thinking about coming East soon? I'll write soon." She signed her letter to Jackson's mother "Love, Lee."[18] Though not yet married, she was clearly behaving like an ingratiating daughter-in-law.

On April 6, 1943, Krasner applied to the City of New York to correct her birth certificate, which had been issued incorrectly as "Lena Kreisner." She petitioned to have it changed to "Lenore Krasner," not using the "Lee" from either Cooper Union days or the 1930 U.S. census. She reported that her parents Anna (not Annie, as had been recorded on the original certificate) and Jo-seph were aged seventy and eighty and were living at Delaware Avenue and Winfield Place in Huntington Station, Long Island, New York. She also noted that Joseph had "operated a fish store," not worked as a "Fisher."[19] The reason Krasner elected to file this official paper could be related to her desire to marry. Though Jackson had problems, things seemed to be falling into place.

While Krasner's relationship with Pollock was developing, Hans Hofmann was helping to promote her work. Eventually Sidney Janis, who had helped arrange the New York showing of Picasso's *Guernica,* noticed her. Janis even selected work by Lee, Mercedes Carles, and their pal Ray Eames, all former Hof-mann students, to include in his book, *Abstract & Surrealist Art in America,* which would be published in November 1944. The three women were featured along with Hofmann as well as Stu-art Davis, John D. Graham, Byron Browne, Willem de Kooning, Robert Motherwell, and others who worked under the rubric "American Abstract Painters." Krasner's unsigned contribution, which Herbert Matter photographed, was called *Composition* (1943) and reproduced across the gutter from John Graham's *Studio.* Though Krasner employed various colors, her palette, emphasizing red, yellow, and blue, still attests to her adulation of Mondrian at the time. She listed her date of birth as 1911, inten-tionally shaving three years off her age, as so many women did in

those days of intense gender discrimination.[20] It is not clear if she lied about her age to Pollock, but in retrospect, it seems unlikely that he would have paid much attention to such a detail at the time they were first attracted to each other.

Ray Eames's *For C in Limited Palette* (1943), a small oil, just ten by thirteen and a half inches, was even more hard-edged than Krasner's larger *Composition,* measuring thirty by twenty-four inches. Eames delved into "the recovery of form through movement and balance and depth and light."[21] Whereas Krasner employed heavy black outlines and mainly geometric shapes, Eames's shapes included several that were clearly biomorphic, closer to de Kooning's *The Wave* (1942–43), which was much more ambitious in scale at forty-eight inches square. Mercedes Carles's *Still Life in Red and Green* (1935) reveals a thick application of paint, but forms that depend upon color do not read well in a small black-and-white reproduction of an original only sixteen by twenty inches.

It was Krasner who got Janis to look at Pollock's work, which he had never seen.[22] Janis recalled, "While I was working on the book, I was interested in meeting some of Hans Hofmann's pupils. One of them was Lee Krasner. During the course of my visit, she asked me if I knew an artist by the name of Jackson Pollock. I said no. She then said that he was completely unknown and would I like to see his work? I said, by all means—especially if you recommend him. I did not know at the time that she was interested in Pollock in any way except artistically." Janis told how Krasner took him to Pollock's Eighth Street studio, where he saw the artist, whom he recalled as "a dour-looking fellow, who didn't say one word during my entire visit. He was quiet and stood in a corner of his studio. He let Lee do all of the talking. Jackson just listened. He was that way, until he got to know you. A very reticent man, he was. And of course, he was cold sober. When not so sober, he did quite a lot of talking."[23]

In his book, Janis categorized Pollock as one of the "American

Surrealist Painters," along with artists such as Arshile Gorky, Mark Tobey, William Baziotes, Jimmy Ernst, Mark Rothko, Adolph Gottlieb, among others. Janis featured Pollock's forty-two-and-a-half-by-sixty-seven-inch painting *The She-Wolf* (1943) with a color plate, an honor Janis had also bestowed upon Hans Hofmann's *Painting* (1944) in an earlier section of the book. Pollock, unlike Krasner, who was uncharacteristically silent, offered the following statement to Janis for his book: "[*The*] *She-Wolf* came into existence because I had to paint it. Any attempt on my part to say something about it, to attempt explanation of the inexplicable, could only destroy it."[24]

Janis was so impressed by Pollock's work that he recommended *The She-Wolf* for purchase by the Museum of Modern Art, where he served on the Advisory Committee, which bought the painting for $600. He wrote to Pollock about how impressed he was and told Pollock that "L.K. is to phone when you feel like visiting me. Best to you both."[25]

But with Pollock's success came frustration for Krasner. Mercedes had just moved to Santa Monica, California, and Krasner wrote to her to say, "I'm painting and nothing happens its [*sic*] maddening."[26] She complained, "I showed Janis my last three paintings—He said they were to [*sic*] much Pollocks. It's completely idiotic but I have a feeling from now on that's going to be the story."[27]

The Matters had gone to California so that Herbert, still a Swiss citizen, could remain in the United States during World War II. He was allowed to work in the office of the designers Charles and Ray "Buddha" Eames, who had married in 1941 and were designing furniture and doing government work as part of the war effort.[28] Krasner assured her chum how much she missed them and how it seemed like they were just on a long vacation. "Your shack sounds wonderful and I really wish I was there. However don't start getting ideas—I just don't like the sound of California—but the waves and the aloneness that kind of alone-

ness seems wonderful—the fact that you can think about painting again and be away from the hysteria of the city—all that I envy."[29]

"I'm posing for Sara [Johns] now—They've asked her to try some covers and of course she gets more vague every day—But I'm sure she'll get it done in her own strange way," Lee wrote to Mercedes about their mutual friend and classmate, Buddha.

Ray Eames was born as Bernice Alexandra Kaiser in Sacramento, California, where she developed an interest in new forms of art, design, dance, and film. Later, short and squat, she seemed to have earned her nickname, though it probably reflected her serene personality. She studied at Sacramento Junior College before moving with her widowed mother to New York in 1932, in order to be closer to her brother, who was at West Point. She landed in the German emigré Hans Hofmann's class at the Art Students League and followed him when he set up his own school later that year. She attended the Hofmann School in both New York and Provincetown, joined and exhibited with the American Abstract Artists, and also studied modern dance with Martha Graham and Hanya Holm. In the autumn of 1940, Kaiser left the Hofmann School to study modern design at the Cranbrook Academy in Michigan, where she met the designer Charles Eames, whom she married and with whom she would successfully collaborate. Buddha's productive work relationship with Charles was in great contrast to Lee's struggle to support Jackson's career in the face of his alcoholism, while sometimes neglecting her own.

Lee probably first met Buddha Eames through Mercedes—in the early 1930s, both had attended the May Friend Bennett School in Millbrook, New York, where they studied art with the sculptor Lu Duble.[30] Also Buddha, Mercedes, and Lee then studied together at the Hofmann School. Lee also noted that she was amazed "you still speak to each other at all. I warned you not to break up a life long friendship."[31]

Lee told Mercedes about a dinner party she gave a week earlier, where the guests included Hans and Miz Hofmann, Janet Hauke

(a fellow student from the Hofmann School) and her husband, the artist Frederick Hauke (who had been on Krasner's War Services Project), Peggy Guggenheim, and Howard Putzel. She pronounced the dinner "a complete success—food superb (Quote a line from Mr. Putzel to Mr. Pollock the following day 'My Very Best regards to your Cordon Bleu chef") Yes I'm cooking these days—seriously. As I was saying after a most charming dinner we all went up [to] Hans' place to show Peggy his work—now mind—this business of casually walking down four flights at 46 E. 8th & walking up 3 flights at 44 E. 8th took all winter to plot—nothing must go wrong."[32] Cooking "seriously" meant that she was using her "womanly" skills to promote the art of Pollock and her former teacher—even as she struggled with her own painting.

Krasner complained that Janet Hauke "didn't shut her mouth for one second & we were there for hours. . . . How ever the gods had destined a successful evening and Peggy was terribly excited about the work & asked if she couldn't come up & see them quitely [sic] & to sum up she's giving Hans a show this March—I think that [Sidney] Janis is in Calif. now & if you see him be sure to tell him about it. I think he'll be quite surprised."[33]

Sometime in July 1943, on their Eighth Street rooftop, Krasner took a snapshot of Pollock, Morris Kadish, an unidentified friend (who appears to be George Mercer), and the artist Reuben Kadish, who, having headed the mural division for the Federal Art Project in San Francisco, was then serving in the army's Artist Unit to document wartime life.[34] Krasner was probably using Kadish's camera because he also photographed Pollock in the Eighth Street studio he shared with Krasner in front of his unfinished painting *Guardians of the Secret,* with her painting visible in the distance.[35]

By August 1943, with Lee's help, Jackson had ended Jungian analysis, which he entered in 1939 with Joseph Henderson and then, when the therapist moved to California in September

of 1940, continued with Violet Staub de Laszlo. Instead, Pollock began treatment with Elizabeth Wright Hubbard, M.D., a homeopathic physician in New York. Hubbard practiced "holistic" medicine, characterized by exploring the psychological as well as the physical. Today Hubbard is considered to have been one of the foremost homeopaths, whose extensive writings are still influential. Hubbard was one of the first six women to graduate from the College of Physicians and Surgeons at Columbia University, and was a pioneer in the field of holistic medicine before her death in 1967.[36] One of the first to understand the significance of the mind-body connection, Hubbard treated a number of culturally prominent patients, including Alexander Calder, Darius Milhaud, and Marlene Dietrich.[37] Years later, Krasner recalled that Dr. Hubbard was a Theosophist.[38] Though Krasner only had a passing interest in such esoteric ideas, the spiritual leader Krishnamurti, who had himself been connected to Theosophy in his youth, had attracted Pollock's attention during his high school days in California. After Pollock entered treatment with Dr. Hubbard, Krasner felt freer to focus on other goals.

By now it was clear that Krasner was Pollock's facilitator in the world. She saw him as "riddled with doubt," but believed that "no one knew as much about himself as Jackson did. He knew what he was about."[39] She was also his cheerleader, guardian, and secretary. On November 1, Peggy Guggenheim's assistant, Putzel, wrote to Krasner, asking her, "Lee, if you have time Tuesday can (or will) you help fold 1200 catalogues?"[40] He also invited them to join him at a concert by the classical guitarist Segovia.

Pollock's first solo show opened at Art of This Century on November 8, 1943. "Sweeney is very pleased with Jackson & Jackson is very pleased with Sweeney," Krasner noted of James Johnson Sweeney, the curator who had penned the catalogue's brief note, which declared: "Pollock's talent is volcanic. It has fire. It is unpredictable. It is undisciplined," and it also praised him for painting "from inner impulsion without an ear to what the critic or specta-

tor may feel."[41] Sweeney had been curator of the department of painting and sculpture at the Museum of Modern Art since 1935. The son of a rich importer of lace and textiles whose family had come from Donegal, Ireland, Sweeney had studied literature at Cambridge University and, among other work, assisted James Joyce in editing a manuscript. Well heeled and well educated, Sweeney probably had little in common with Krasner and Pollock, and they seem to have sensed that.

In addition to the activity at Guggenheim's gallery, Sidney Janis had organized an exhibition called "Abstract and Surrealist Art in America," which featured the artists from his book, including Krasner and Pollock. It began at the Cincinnati Art Museum, in February 1944, billed as organized by the San Francisco Museum of Art and selected by Sidney Janis. The show then traveled to four museums across the country before it hit New York at the Mortimer Brandt Gallery from November 29 through December 30.[42]

After Pollock's show with Guggenheim closed on November 29, Krasner wrote to Mercedes (whom she addressed as "Carles Darling"), "We're just settling down to a normal existence. The show is over. Jackson says he isn't going to paint until Peggy sells all his paintings. No use painting new ones. The Museum of Modern Art is going to buy one when they can decide which of two canvases they like best (I hope they make up their minds some time this year). Three gouaches were sold and that's all—He got revues [sic] in the New Yorker, Art News, Art Digest—and the Nation—and one fan letter."[43]

For Jackson and Lee, life was particularly fine. She later reflected, "Jackson had a delightful sense of humor, and when I'd rant and rave about someone being a son of a bitch, et cetera, he'd calm me down considerably. When I bellyached about my work, he'd say 'Stay with it.' We had a continuing dialogue about our work and he always wanted me to see what he was doing; he was always asking my reaction."[44]

In her letter to Mercedes, Krasner demanded news of Buddha and whether the Matters' young son, nicknamed "Pundit," realized that he was in California: "I hope not—might have a bad psychological effect on him."[45] She also recounted a bit of gossip: "Sande [Alexander 'Sandy' Calder] is *making* a bed for Peggy. Can't get metal so its [*sic*] going to be in silver. And I've heard plenty of wise cracks about all three Sande—Peggy—and the Bed."[46] Jackson too was taken with the bed project and later wrote about it to Herbert Matter: "Sande [*sic*] did an interesting end decoration for Peggy's bed, a sort of enlarged ear-ring that hangs on the wall. We seldom ever see him."[47]

Pollock, thrilled with his "amazing success for my first year of showing," wrote in 1944 to his mother and his brother Charles to recount the details of the magazine features. He was also relieved about having the security of a "contract set for next year" from Guggenheim.[48] He was still getting $150 a month, which he quickly realized "just about doesn't meet the bills."[49] When he asked for an increase to meet minimal living expenses, Guggenheim replied, "Tell Lee to go out and get a job." Recalling the moment, Krasner explained, "Pollock wouldn't accept that solution and she never dared mention it again."[50]

During this period Krasner was busy corresponding with her closest friends. After Hans Hofmann's show at Art of This Century from March 7 to 31, 1944, Lee wrote about Guggenheim again to Mercedes. "To begin with 'Peggy' after that visit to Hans' studio, had a severe change of heart—I couldn't track down who was responsible for it—to some extent those fucking sur-real-ist[s] around her—at any rate she got more & more impossible as the time for the opening approached. How ever the show was finally hung—(I stayed away.) Jackson was there—& it naturally looked very exciting and she seemed to relax some what—She hates his large oils—loves his gouaches."[51] Krasner reported that Hans's wife, Meetz, "Miz," was "behaving beautifully around this busi-

ness," but that she preferred that the show feature the large oils. Peggy took the opposite view and, naturally, got her way.

Regardless, Krasner liked the outcome. "The show is really very very beautiful & alive and exciting. . . . The 'Times' reviewed the show. . . . The opening was mobbed—But none of your snobbish friends—and Hans was aware of it—not even Sandy [Calder]— Sweeney hasn't seen the show yet but he will."[52] Krasner felt that Howard Putzel had been "wonderful throughout—He really likes Hans' work—& he helped & plotted with us—Hans feels a great deal will depend on whether Sweeney approves or not—and to a great extent He's right. If he does—it may break up that taboo which exists in that small but useful little groupe [sic]—Of course I'd prefer to use a bomb. The results would be much more to my liking—Yes you certainly picked the right winter to be away from N.Y."[53]

Krasner wanted her close friend to return to New York— what she called "this nice nest of snakes in the east." She also confided: "Jackson censors my letters so He says I can't tell you that Dr. Hubbards little pills are showing results—'on him.' He's amazed that those silly little pills lessen the desire to drink—I'm keeping my fingers crossed—Remember How we poopooed Herbert when he suggested Hubbard?" Lee informed Mercedes. "By the way I gave her a good talking to about her ignorance of painting (modern). Did you know Cezanne used Homeopathy? That's what started it—I mean my lecture—Also probably modern art."[54] Though Krasner believed in Hubbard and was grateful to Herbert Matter for recommending him, she felt that she had to enlighten the doctor about art.

Lee also wrote that Jackson's mother had just come east and stayed with them for two weeks. "We had a wonderful time eating a new cake every day—each one better than the one before." Though she also asked how Herbert's show had gone in Chicago, she was preoccupied by anxiety about Jackson's relationship with

Art of This Century and Peggy's contract with Jackson that guaranteed him a minimal monthly income. This concern held her focus: "July 15th draws near & Peggy is not renewing the contract—She's still as interested as ever in his paintings but she can't stand 'ties'—She's been uncomfortable about it since the day she signed it. That's why she's probably had 4 husbands & is getting ready for a 5th. Strangely enough I can understand it—Maybe that's why I don't get married."[55]

Lee boasted that Jackson had "just finished the largest & possibly his best canvas to date—56 x 96"—Peggy is coming to dinner Sunday to see it—My painting stinks but I won't give up—The horrible thing is that I'm painting every day (much more painting time than Jackson) but it still stinks."[56] She was writing about *Pasiphae,* a canvas Pollock had not finished in time for his solo show in November 1943. She also reminded the Matters not to miss buying the April issue of *Harper's Bazaar,* which featured Sweeney's article "Five American Painters" and included a color reproduction of Pollock's canvas *The She-Wolf* (1943).[57] The others featured were Gorky, Morris Graves, Milton Avery, and Matta.

Though Krasner did not save Mercedes's letters to her, she did retain George Mercer's letters. After Mercer visited Lee and Jackson in New York in the spring of 1944, he wrote on April 17, 1944, to tell them he had enjoyed seeing them and the "victory" dinner that they had shared. Pollock was celebrating getting a contract for another year after all. "I should have told you of my faith in order that the pressure could have been eased," Mercer wrote to them. "But then, that might have removed the necessity or desire for an excursion with Bacchus. Those things can be fun."[58] Clearly Mercer did not grasp the danger of alcohol for Pollock. He probably appreciated, even envied, that Pollock was free from military duty and able to paint. Another visitor was her friend and Hofmann School chum Ray "Buddha" Eames, who was visiting New York with her husband.

In June 1944, Lee wrote to Mercedes, this time from Cape

Cod, where she and Jackson, having sublet their place in the city, planned to spend the summer: "Now we are settled in P-town—15 Cottage St. and things seem a little more settled—I suppose you've seen Buddha by now." Lee complained that her time with Buddha in New York had seemed like "two seconds" because they could not really talk in the presence of Jackson and Charles Eames. "At the moment we are living most happily and I am truly gratified—P-T. is beautiful as you know and we are one block from the farm so we can stay off of the muck around center of town—We came up with Hans and Meetz [Miz]—Hans left from the hospital directly on to the Cape Coder."

She reported how well Hofmann was doing after his hernia operation, though expressed concern that his recovery was a bit slow. Fritz and Jeanne Bultman were among those whose presence she noted, while going on to gossip about another Hofmann student, the jewelry, furniture, and interior designer Ward Bennett, who was staying at the Hofmann house, asking if he had been "'Elsa K.'s' l'amour—yes?" Krasner asked about how things were with "Herbert & Pundit": "Do you think you'll be out west much longer now that the end of the war is so close? I heard about Herbert's show in Chicago & someone told me He is or has shown in Los Angeles. Tell me about it," she implored.

Krasner also noted, "Howard Putzel is coming up in a few days and I understand he quit his job (with Peggy). Sounds serious but I won't know anything until I see him." She also wrote that she had seen a show of work by Mercedes's father—Arthur E. Carles—and found his paintings "very wonderful."[59]

For his part, Jackson wrote to his mother and his brother Sande, and his wife, Arloie, "Provincetown looks much better to me now—we are at the west end of town and within walking distance of the beach. We get in for a dip at least once a day. . . . Haven't gotten into work yet. Howard Putzel came up last nite [sic] for [a] two week stay—we had dinner with the Hofmanns. Hans still has to take it pretty easy."[60]

By September 7, 1944, Pollock had changed his mood again, writing to Herbert Matter in Los Angeles: "I have definitely decided I don't like P-town. Perhaps Truro or Wellfleet is more sympathetic to painting," he opined. The small town of Truro, where the much more politically conservative Edward Hopper painted realistic views of the landscape, was, however, an unlikely place for Pollock.

"Neither Lee nor I have touched a brush since we are here. Am anxious to get back to 46 E. 8th and down to work. I have a brother at 901 E Hyde Park, Inglewood. If you're able to get around look him up and I'll tell him to do the same—he's a swell guy and politically left—I feel he supports me in that direction."[61]

Hofmann also wrote about that summer to Mercedes Matter, observing, "neither Lee nor Jackson worked. They have been every day on the beach—well—who can blame them—he worked so hard throughout a long time and Lee was exhausted I think from being the wife of him."[62] Hofmann already thought of the couple as married, although they were not then.

Krasner had to leave suddenly to tend to her ailing father in Huntington, Long Island. With no one to answer to, Pollock got arrested for being drunk and disturbing the peace. Hofmann explained that Jackson's behavior suffered when he drank excessively: "he offends everyone in his surroundings—the end is always a collapse."[63] This episode perhaps exemplifies Pollock's pathologies and why his letters to the Matters differ from Krasner's cheery accounts.

For his part, Hofmann admired Krasner and recognized Pollock's talent, but, as he wrote to Mercedes Matter in October 1944, he feared the change that came over Pollock when he drank to the point of collapsing: "I feel sorry for such a constitution because in the end it must be of tragic consequences. Jackson is highly sensitive, he is a wonderful artist, he is in reality good-natured, but his companionship is hard to stand when he is off the normal. Lee

will have a hard time with him, but she stays with him and I respect her for this."[64]

KRASNER'S FATHER DIED ON NOVEMBER 17, 1944. GEORGE MERCER, who had recently visited with Krasner and Pollock in New York, sent his sympathy for her "unhappiness and discomfort" before discussing his own efforts at painting.[65] "This is the first painting that hasn't been tortured into a Hans Hofmann format. It is delightful to be free of the restraints of the 'old school.' I'm sure it has its bad features and its good ones. The parts of this painting do not have to answer the question 'Is it plastic' but rather 'Is it right?, Does it work?' I'm sure Hofmann's [sic] would be in agony if he saw the painting but I am excited because I have found things and colors (in paint, of course.)."[66] Inspired by Persian miniatures, Mercer explained, he had to paint small. The army kept him from having both enough free time and a studio in which to produce larger works.

Mercer reported that "it was nice to see Jackson. We had a short talk but didn't quite get our hooks entangled. I was too self conscious about my wisdom tooth which had been taken out the week before. I like his new paintings. I 'saw' them for the first time and should like to be painting what he is—but of course that is impossible. I think they are very important and sound—if that has any meaning as criticism of painting."[67]

Toward the end of December, Lee wrote to Mercedes, "It seems as if you've been away 10 years—It (California) couldn't be that bad or you wouldn't have stayed that long—I hate N.Y. and everybody in it—Sorry to splash ice water on your firey [sic] dreams of N.Y. We're isolated ourselves in a sense—No openings no cocktail parties as little of 57th St and all its shit as possible—Even at that some creeps through and the stench is terrific."[68]

Krasner's desire not to mingle represents a change for her that

most likely had to do with her desire to protect Pollock from too many opportunities to drink. When she was with Pantuhoff she had often gone to art openings and hung out at the Jumble Shop.

Krasner also complained about James Johnson Sweeney, "whom I must still be respectful of (at least publicly) because of his continued interest in Jackson . . . I might add slightly cooled interest, from time to time [he] commits outrages [sic] acts—and I must keep my mouth shut—Your Sande [sic] Calder just had a show of his recent works—And in all honesty they are dull."[69]

Krasner had an even lower opinion of "*Jackson's* Peggy Guggenheim," who, she said, "is still part of our life. But oh my isn't she a rest less ladie [sic]—Here to-day but then there's to-morrow—A new star loomed on the 57th St—sky—Howard Putzel—formerly with P.G. has his own Gallery—67 East 57th St—Its backed by McPherson [sic]—Remember him? He's the man (I mean be careful how you use that word) that shares Peggy's house and has more money than Peggy (be careful what you say about him he buys Pollocks)."[70] Kenneth Macpherson, an openly bisexual and debonair Scotsman, poet, and novelist moved into his own apartment in Peggy's town house on East Sixty-first Street and comforted her during her divorce from Max Ernst.[71]

Krasner could be somewhat caustic, especially when defending Pollock. She told Mercedes, "*Our* Hans is painting and exhibiting all over the place—Some good some not so good—Our relationship Pollocks Mr. & Mrs. & Hofmanns Mr. & Mrs.—is a little touchy right now—It's silly and not worth going into except to say that it was produced mainly by Meetz's [Miz, Mrs. Hofmann] stupid tongue. She however is so much better now as a person that it seems unfair to mention it at all. Particularly don't you mention it."[72] It's notable that Krasner referred to herself as "Mrs. Pollock" though not yet married.

The reference to Mrs. Hofmann's troubling tongue may have come from an incident that Robert Motherwell recounted years later. Motherwell described a visit he and Pollock made "to Hof-

mann's studio, hung with works by Léger, Miró, Braque, etc. . . . We were drinking from a jug of wine when there was a phenomenon like changing gears in a car; Pollock's whole expression changed, literally in seconds, and his eyes became glazed—a real Jekyll and Hyde." He became either too drunk or too belligerent to walk. Motherwell complained: "Jackson and Hofmann both lived on the top floors of their buildings, so Hofmann, in his sixties, and I had to drag him down five or six flights, then along 8th Street to his building's foyer. We buzzed his apartment but no answer."

The drunken Pollock teased them, refusing to give them his key so that they could help him upstairs. In the midst of his antics, Pollock fell, hitting his head against a marble surface, which knocked him out cold. At first they were frantic, thinking that he was dead. When they realized that Pollock was still alive, they retrieved the key and struggled to drag his limp body up the stairs. "We were trying to open the apartment door when Lee opened it; she'd been there all the time but wasn't answering. I was so enraged by that, we just dropped him. And to this day I have no idea what was going on in her mind." [73]

Then only in his twenties, Motherwell seems to have assumed that Lee actually heard the buzzer. In the heat of the moment, he did not stop to consider that she might have been in the bath, listening to loud music, or sound asleep—or that the buzzer was not even working. Much better off economically than Lee or Jackson, Motherwell might not have imagined living in a walk-up apartment on the top floor without a working buzzer. Nor did he show the least bit of concern for a woman confronting her live-in companion's inert body dumped on the floor in front of her.

This incident may also shed some light on his dislike of Krasner. Perhaps Motherwell resented Krasner's closeness to Pollock—the energy she expended on promoting him, or her resentment of being viewed by Motherwell and other male artists as just one of the "wives." [74] Ironically, given their long mutual antipathy, Kras-

ner and Motherwell were both enthusiasts of Matisse, Rimbaud, Poe, Meyer Schapiro, medieval manuscripts, and international-ism.[75] Though both searched for universal modern principles in art, perhaps gender bias, rivalry over Pollock, and personality kept them against each other.

Though she claimed not to hear who was sleeping with whom, Lee shared some gossip with Mercedes, covering the tales of Peggy Guggenheim's daughter, Pegeen, and the French modernist painter Jean Hélion, whom Pegeen would marry, and of Matta, the Chilean Surrealist who had run off and left his wife and two small children. Krasner had heard these stories from Laura Swee-ney, the curator's wife.

Lee also told Mercedes about a dinner she had given for Peggy and the critic Clem Greenberg and noted that he reviewed paint-ing for *The Nation,* an influential position that he had assumed in early 1942. Having heard that Mercedes had run into Arshile Gorky's ex-lover reminded Lee to comment on what she had heard about Gorky: that there had been "this terrific change that took place in his work. Sweeney in his Harper's Bazaar article & much talk here & there. I had the opportunity to see a gigantic canvas & I mean huge even in relation to Jacksons [sic] paintings. It is at the Janis show. . . . He has unquestionably opened up in his painting but the main change is that its [sic] now Kandinsky in-stead of Matta, Miro, Picasso, etc. Still not enough Gorky."[76]

Among other news, Lee told Mercedes that she had not seen Sara Johns more than a couple of times since she had returned from Provincetown, which she regretted, because she considered Sara "so wonderful." Upbeat about Jackson, Lee noted that he was still working with Dr. Hubbard and wrote, "Some wonderful painting has come into existence since you & Herbert left N.Y. He is having a show in a month or so at the San Francisco Museum & Dr. Morley—is going to send it from there to several other places in California. Don't know where yet. Try & See it."[77] She still ex-uded optimism.

On March 19, 1945, Pollock's solo show opened to a large crowd at Art of This Century. Guggenheim later wrote that she had "acute infectious mononucleosis . . . during the annual Pollock show and had to stay in bed. This distressed Lee Krasner very much, as she said no one could sell anything in the gallery except me, and Putzel had left to set up his gallery in New York. Poor man, this proved to be a great tragedy, as it ended in his suicide."[78]

Mercer, then stationed in Los Angeles, wrote to Krasner on April 24, 1945, telling her, "I have the note you wrote. You refer to the Miro show and to the paintings—'each painting is a little miracle.' That is a wonderful description. I have stored it and remembered it. I shant forget it."[79] He proudly reported doing "a terrific analytic cubist painting for the picture and was fun—a tank covered with rubble-like boards and plaster and burned wood and only the slim line of the grain and one of the caterpillar tracks showing. No one knew what I was doing but I suppose I was almost having a camouflaged orgasm due to the fact I haven't painted for so long and because I told them that . . . the way to camouflage a tank is burned-out ruins and it is."[80] He promised to show her a photograph of this work.

Mercer was happy to receive an invitation to Jackson's show, which he wanted to see, though it was impossible. He said he hoped to visit them on a leave in either July or August. He wrote that his sister and her husband, Elizabeth and Whit, "wrote that they saw Jackson's show and were tempted to buy. That is a great conversion! Kandinsky has had his effect on them since he has been hanging in their living room. Dad mentioned the favorable review in the New Republic—which impressed him. Krasner—are you painting?"[81]

The question was a sore point. This was a frustrating period for Krasner. Nothing seemed to work. Unlike her friend, she did not have the army to blame for her inability to realize paintings that just seemed to turn into gray slabs. She later attributed this period of transition to the impact of Pollock on her work. "I went

through a kind of black-out period or a painting of nothing but gray building up, because the big transition there is that up to that point, and including Hofmann, I had worked from nature. . . . as I had worked so-called, from nature, that is, I am here and Nature is out there, whether it be in the form of a woman or an apple or anything else, the concept was broken."[82]

She discussed the trauma of facing a blank canvas "with the knowledge that I am nature and try to make something happen on that canvas, now this is the real transition that took place. And it took me some three years."[83] Krasner explained the change in her way of working: "If Hofmann broke up the Academy, then Pollock broke up Hofmann, and by Hofmann, I mean working from the cubist, bearing in mind that Hofmann was teaching the principles of cubism. And Pollock once more broke that up."[84]

Regardless of her frustration, Krasner described Pollock's attitude toward her own artwork as "very supportive . . . I don't know how I would have felt if he'd said 'I don't want you to paint,' or acted it out in some way. The issue, of course, never arose; but it's inconceivable to me that I would have stopped painting if my husband hadn't approved. Since Pollock was a turbulent man, life with him was never very calm. But the question—should I paint, shouldn't I paint—never arose. I didn't hide my paintings in a closet; they hung on the wall next to his."[85]

On May 14, 1945, Howard Putzel's first show—"A Problem for Critics"—at his new Gallery 67 opened in New York, and it included work by both Lee and Jackson. Putzel maintained close ties to the couple after leaving Peggy Guggenheim's employ. They were in excellent company, since Putzel had included work by Jean Arp, Miró, and Picasso, whom he considered forerunners of the new movement. Besides Lee and Jackson, the other artists included Hans Hofmann, André Masson, Mark Rothko, Charles Seliger, Rufino Tamayo, R. W. [Richard] Pousette-Dart, Arshile Gorky, and Adolph Gottlieb. Although "Lenore Krasner" was the only woman in the show, the critic for the *New York Times,* Edward

Alden Jewell, did not comment on her work, nor did he identify her ties to Jackson Pollock, whom he called "a vigorous new talent that could advantageously bend its wild will to a lot more discipline."[86] Jewell understood that the title of the show referred to the need "to supply the first syllable for a new 'ism,' which, Mr. Putzel believes, has been developing since around 1940."[87]

At this time, Krasner went to work in studio space rented from Reuben Kadish. He recalled that she and Jackson needed to be apart: "They were so competitive then, so much so that Lee couldn't work in the same space as Jackson, and I rented her a room in my studio."[88] Krasner produced a few works such as *Image Surfacing*, where forms were beginning to emerge from her thick gray foundation that had previously threatened to absorb all her imagery as she sought to escape cubism. The shapes, though familiar, appeared to be more crudely rendered than usual, which attests to the powerful impact of Pollock on her work. Likewise, a primitive figure suggests both Krasner's and Pollock's mutual appreciation of the work of Miró. A small palettelike shape on the right side may represent a studio still life setup, which hearkens back to her time with Hofmann. She has drawn marks in wet paint with the handle of her brush instead of painting the clean black outlines that she had used while under the influence of Mondrian. Her continuing interest in the idea of the "primitive" reflects the influence of both Graham and Pollock.

Among the books Krasner owned is the American edition of G. Baldwin Brown's *The Art of the Cave Dweller*, which features schematic drawings of animals from cave paintings that relate to *Image Surfacing*, particularly in its evocation of a large eye.[39] Brown wrote: "The earliest stages in the evolution of representative art have been already traced—the casual finger mark, the accidental resemblance, the resemblance worked out, the mental image materialized till the original is re-created as a thing of life."[90] Krasner may have meant to call upon just such an accidental process in her title *Image Surfacing*.

Mercer wrote to Krasner on June 24, 1945, "There have been many times since 1940 that I have thought of our talks and have relied on them as one of the few things I could trust and wanted to renew. (I might as well shear myself of formality and say that I have sometimes wondered what I would do if I couldn't look forward to talking with you again and benefiting from your sound logic.)" [91] He told of his "regeneration after college" but admitted that "the bubble burst, with a weak, ridiculous little noise. . . . That left no one except Krasner and I thanked someone (not God I'm afraid) for Krasner. I thanked her, too, for 'The Cosmological Eye'—which I have been reading." [92]

Mercer, who never saw actual battle, lamented that "the war has carried me away from the things which were important to me in 1940. . . . After three years of telling lies and playing a weak game of politics, I wonder whether I'll be able to get 'back.' . . . What painting I have done seems to me to be a very feeble protest against Army routine. It is so different an undertaking that it requires a different mind and a different attitude." He was not able to achieve the separation from the army that he needed in order to paint. "Besides, the painting must be turned off and on—like water," he explained. "Thereby it becomes a hobby and Christ knows painting is no hobby." [93]

Whatever Krasner wrote to Mercer about her spiritual struggle provoked a response that suggests what Krasner had been writing to him: "Your admission that you need religion is one that I have never made. I salute your courage. Of course, it can be difficult to find once the admission is made. That's in the way of warning but not discouragement. You also speak of a /\/\/\ 'fever chart' existence—from ecstasy to horrible despair. It ain't good, I know. But I'm afraid the despair is the price you pay for the ecstasy." [94] The search for something to replace the beliefs that she had jettisoned as a teenager would continue for Krasner, who would later befriend a number of Catholic priests. [95]

Mercer tried to console her: "I don't believe that everyone ex-

periences ecstasy as strongly as the artist or poet. And perhaps he creates the desperation in his mind at times when he is struggling unsuccessfully to reach a pinnacle of great excitement, love and insight. Those few people who are able to reach the pinnacle should regard it as a gift—because the ability is certainly not acquired, although a struggle is required for them to reach it—even occasionally." From his point of view, "the struggle is worth it except when you hit the bottom of the barrel with a bang—and wonder.' That was the painful place Krasner's own painting had reached as she sought to respond to Pollock's new kind of painting.

Mercer brought up "the gray mass," referring to her unresolved paintings: "Can you imagine living the part of the gray mass (or straight horizontal line) and at the same time realizing that you have voluntarily and irrevocably given up an attempt to reach the heights of great inspiration? No, that would be the worst miserable condition in existence."[96] He attempted to encourage her as she struggled to deal with the huge impact of Pollock's new way of painting and to free herself from the constraints of cubism.

It was Mercer's turn in their reciprocal exchange. Her efforts to pull him up when he had been depressed had helped. By now he had adapted to the constraints imposed by the army. Mercer told how he painted in his room, taking care to hide it from others. He wanted to blend into the army and did not want to mix that life up with what he called "the real life." He asked Krasner if he was wrong to take such an attitude and, if so, what a good solution would be. Clearly he valued what he viewed as her clearheaded logic. He looked forward to his next visit with her. Mercer also wrote that he was delighted with the print that she sent of Martin Schöngauer's *Temptation of St. Anthony,* which, he said, gave him a "good solid belly laugh to realize that Saint 'Tony' went through Hell, too."[97]

Renouncing all worldly pleasures, Anthony, the Egyptian, went off to live as a hermit in the desert. In the midst of his prayers, Anthony often saw visions of Satan. The appeal to Krasner of both

the devil theme and of Schöngauer's imaginative portrayal, must have been the powerfully rendered collection of devils, demons, and winged monsters that spoke to her own fear of the dark and the supernatural.

Krasner's decision to send Mercer a reproduction of Schöngauer's *Temptation of St. Anthony* suggests that the image appealed to her as well. It is a very interesting selection because the theme of supernatural temptation occurs in old masters such as Schöngauer, Hieronymus Bosch, and Matthias Grünwald, and also in the work of modern artists, especially Surrealists like Max Ernst, who produced a painting on the theme in 1945.

Krasner had probably heard about Hollywood's Loew-Lewin motion picture productions that had just held a contest among twelve well-known modern artists to paint what St. Anthony saw. That the producers paid each invited contestant $500 and that the announced prize (which ultimately went to Ernst) was $3,000 would have caught Krasner's attention. The judges were Alfred H. Barr, Jr., Marcel Duchamp, and Sidney Janis, in whose book Krasner's own work had appeared.[98] Besides Max Ernst, with whom Krasner was familiar through both Peggy Guggenheim and Max's son Jimmy, the invited artists included such notables as the Surrealists Paul Delvaux, Salvador Dalí, Dorothea Tanning, and Leonora Carrington, and the Americans Abraham Rattner, Louis Guglielmi, and Ivan Le Lorraine Albright.[99]

Krasner's own struggle to change her mode of painting may explain why she declined to take part in a June 1945 group show titled "The Women," held at Art of This Century. Jewell reported in the *New York Times,* "Although Gypsy Rose Lee, Loren McIver [*sic*] and Lenore Krasner are listed as participants in this vehement June gambado, work by them could not be secured, so their names must, with regret, be crossed off."[100] The show also featured a number of women artists, who, like Krasner, were closely associated with male artists, including Kay Sage, the French Surrealist

Yves Tanguy's American wife; Hedda Sterne, wife of the artist-illustrator Saul Steinberg; and Jacqueline Lamba, who divorced the Surrealist André Breton and married the American sculptor David Hare. Krasner no doubt resented being segregated into a show of only women and already disliked Peggy intensely. She admitted years later that she "hated her attitude toward women. I didn't want to show. She wasn't friendly to women. She didn't like women."[101]

Because Guggenheim was constantly supporting needy friends, it seems less likely that she resented Krasner merely for asking her to renew Pollock's contract or to raise his stipend enough so that they could live on it. In retrospect, the antipathy between Krasner and Guggenheim seems inevitable. Guggenheim, the descendant of an earlier migration of Swiss and German Jews, came from inherited wealth. Many German Jews viewed Russian Jews like Krasner with condescension and considered themselves respectable in contrast to the "uncouth, unwashed Russians," creating much resentment.[102] Peggy had descended from two well-established families—the Guggenheims, but also the Seligmans on her mother's side—and she must have viewed Krasner as true to stereotype: irksome, loud, pushy, and aggressive. Indeed, she was forceful and intense in her promotion of Pollock's art.

Guggenheim's supposed prejudices do not account for her friendship with the anarchist Emma Goldman, whom she knew well in France during the late 1920s and early 1930s. Peggy financially supported Emma, who helped her separate from her abusive husband, the artist Laurence Vail, which allowed her to regain her "lost self-respect."[103] Eventually, however, Peggy turned on Emma (who declined to mention Peggy's support in her memoir) after deciding she was an "awful fake."[104]

In the case of Krasner, it is also possible that Guggenheim was jealous of Pollock's wife. After all, she was aging and was twice divorced. Guggenheim wrote, "My relationship with Pollock was

purely that of artist and patron, and Lee was the intermediary. Pollock himself was rather difficult; he drank too much and became so unpleasant, one might say devilish, on these occasions."[105]

Despite her personal feelings about Guggenheim, Krasner always made sure to credit her accomplishments: "Art of This Century was of the utmost importance as the first place where the New York School could be seen. That can never be minimized, and Peggy's achievement should not be underestimated; she did major things for the so-called Abstract Expressionist group. Her gallery was the foundation, it's where it all started to happen. . . . Peggy was invaluable. . . . That must be kept in history."[106]

And even though the couple met such art world luminaries as Duchamp, Matta, Sweeney, Soby, and Barr at Peggy's parties at her home, these events were taxing for Krasner—she always had to keep her eye on Pollock, his drinking, and the resulting behavior.[107] It was a time when he should have been making contacts to help promote his work and she did as much as she could to help him.

Even Krasner needed a break from her constant efforts to promote Pollock. In August 1945, she and Pollock joined Barbara and Reuben Kadish, who were looking to purchase a house in Amagansett, in eastern Long Island. They were able to use a small shack at Louse Point on the bay in Springs, a small hamlet, about three miles outside of East Hampton village.[108] The printmaker Stanley William Hayter, who knew Pollock, had originally rented the shack, but he found it too remote to bike to the train in town. Hayter needed to make regular trips to the city to supervise Atelier 17, his graphic workshop, so he and his wife, the sculptor Helen Phillips, preferred to live in Amagansett, which was more of a village, less isolated than Louse Point, and had its own train station for easy access to the city.

The sculptor David Slivka, just released from the Merchant Marines, was another link among the Kadishes, Krasner and Pollock, and Hayter. He had gone to school with Phillips in San

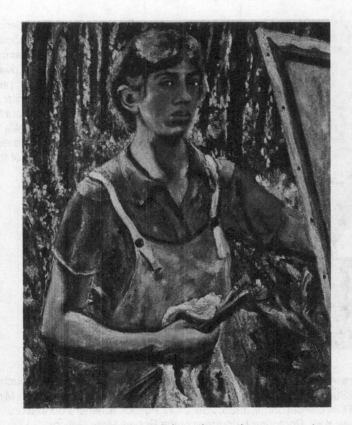

Krasner submitted this work from the previous summer to the committee at the National Academy of Design in order to be allowed to work from life models instead of casts. She was promoted in January 1929. CR 3 *Self-portrait*, 1928, the Jewish Museum, New York.

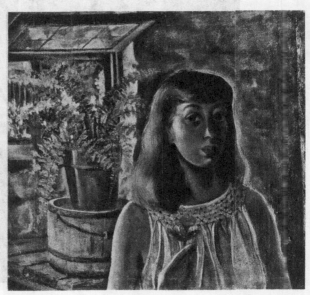

his self-portrait, Krasner depicted herself in half-light, posing in the ooklyn basement where she lived. r friend, Eda Mirsky, acquired the nting and later presented it to the Metropolitan Museum of Art. CR 1 *Self-portrait*, c. 1929, oil on canvas, 30½ x 32½ in. The Metropolitan Museum of Art, New k; Gift of Eda Mirsky Mann, 1988.

From 213 West Fourteenth Street, a building that offered access to the roof, Krasner briefly painted in a realist style close to that of Edward Hopper, who, two years earlier, painted *City Roofs*, depicting a similar view from his own roof. CR 17 *Fourteenth Street*, 1934, oil on canvas, 24¾ x 21¾ in. Pollock-Krasner Foundation, New York. Photograph courtesy of the Robert Miller Gallery.

Krasner admitted that some of her early paintings had "a slight touch of Surrealism." Here she has already discovered the work of Joan Miró. CR 24 *Gansevoort II*, 1935, 25 x 27 in. Pollock-Krasner Foundation, New York. Photograph courtesy of the Robert Miller Gallery.

Krasner's aim is intentionally erotic, signaled by the Cézannesque still life—two ripe oranges in the foreground evoke the nude's round breasts and the broken pottery, like the broken eggs in Greuze's still life, the woman's lost virginity. CR 32 *Bathroom Door*, 1935, oil on linen, 20 x 22 in. Pollock-Krasner Foundation, New York. Photograph courtesy of the Robert Miller Gallery.

Her flat ground, as well as the placement and shapes of the separate objects tilted toward the picture plane, evoke Matisse's *Gourds* of 1916, acquired by the Museum of Modern Art the same year she painted this homage. CR 33 *Untitled (Still Life)*, 1935, oil on canvas, 20 x 28 in. Pollock-Krasner Foundation, New York. Photograph courtesy of the Robert Miller Gallery.

Krasner borrowed the motif of eyes from examples of fantastic art by Grandville and Redon, both featured in the MoMA exhibition "Fantastic Art, Dada, and Surrealism" that opened in 1936. CR 31 *Untitled (Surrealist Composition)*, c. 1936–38, mixed media on blue paper, 12 x 9 in. Pollock-Krasner Foundation, New York. Photograph courtesy of the Robert Miller Gallery.

Working from a still-life set-up at the Hofmann school, Krasner allowed the objects to dissolve into the surrounding space, creating an abstract composition animated by vibrations of colored shapes pushing and pulling against one another. CR 39 *Untitled (Still Life)*, 1938, oil on paper, 19 x 25 in. Pollock-Krasner Foundation, New York. Photograph courtesy of the Robert Miller Gallery.

Mondrian's geometric abstractions appealed to Krasner, who sometimes worked in a similar palette limited to the primary colors—red, yellow, and blue—plus black and white. CR 95 *Red, White, Blue, Yellow, Black*, 1939, oil on paper with collage, 25 x 19⅛ in. Thyssen-Bornemìsza Collections.

With its jazz rhythm, emphasis on primary colors, and use of bits of colored paper to achieve an optical effect that vibrates, this seems unlikely to be related to anything but Mondrian's work. CR 97 *Mosaic Collage*, c. 1942, paper collage on paper, 18 x 19½ in. Private collection. Photograph courtesy of the Robert Miller Gallery.

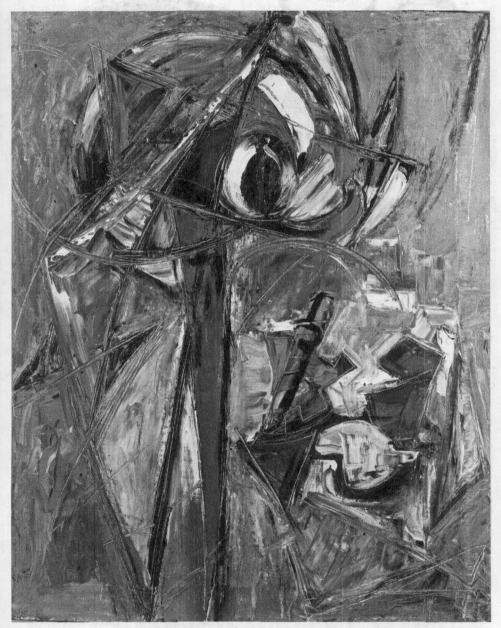

Forms were beginning to emerge from Krasner's thick gray foundation that had previously threatened to absorb all her imagery as she sought to escape cubism. Pollock, Miró, or cave paintings influenced this primitive figure. CR 202 *Image Surfacing*, c. 1945, oil on linen, 27 x 21½ in. Pollock-Krasner Foundation, New York. Photograph courtesy of the Robert Miller Gallery.

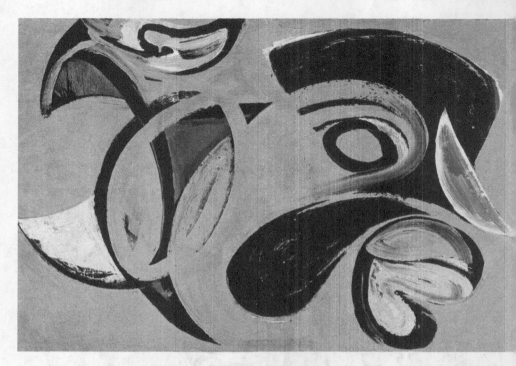

The head of a rooster suggests the sexual metaphor of the cock who would attack other roosters where his hens were nesting. Igor had returned, hoping to reclaim Krasner, but with this work, she declared that she had moved on. CR 180 *Igor*, 1943, 18 x 24⅞ in. Private collection.

Inspired by Pollock, Krasner now worked more from instinct than she had before. She also tried to be more at one with nature and developed her own all-over patterns of strokes with her palette knife and brush handle. CR 208 *Untitled*, 1946, oil on linen, 27¾ x 30¼ in. Pollock-Krasner Foundation, New York. Photograph courtesy of the Robert Miller Gallery.

One of Krasner's 'Little Image" paintings, which she said she produced horizontally and represented the only instances where she dripped paint. CF 212 *Abstract No. 2*, 1946–48, oil on canvas, 20½ x 23¼ in. IVAM, Institut Valencià d'Art Modern, Generalitat, Valencia, Spain.

Krasner's originality led her to improvise with shells, pebbles, broken glass, keys, coins, and bits of costume jewelry. For the table's frames, Krasner used an old iron wagon wheel. CR 218 *Mosaic Table*, 1947, mosaic and mixed media on wood, 46 in. diameter. Courtesy of Jason McCoy, Inc.

This is one of her largest "Little Image" series. It features dripped enamel paint, used by Pollock, who was inspired by the workshop of Siqueiros. CR 236 *Continuum*, 1947–49, oil and enamel on canvas, 53 x 42 in. Private collection.

This is one of the few surviving works from Krasner's first solo show, held the same year at Betty Parson's gallery. The vibrating geometric shapes recall her admiration of Mondrian's work and her association with American Abstract Artists. CR 252 *Number 2*, 1951, oil on canvas, 92½ x 132 in. Pollock-Krasner Foundation, New York. Photograph courtesy of the Robert Miller Gallery.

In her show at the Stable Gallery, this and other dynamic collages won Krasner praise. CR 284 *Burning Candles*, 1955, oil, paper, cloth, and canvas collage on linen, 58 x 39 in. Collection of Neuberger Museum, State University of New York at Purchase; gift of Roy R. Neuberger.

Krasner, Pollock, and others considered this painting "scary." It remained on her easel when she left for Europe in 1956, and she later acknowledged its figurative content. CR 302 *Prophecy*, 1956, oil on cotton duck, 58½ x 34 in. Private collection.

This painting, which recalls Matisse's *Bathers by a River* of 1909–1910, may refer to Pollock's earlier canvas, *Two*, of 1945. The third figure inserted between the male and female may refer to Ruth Kligman, who had intervened and threatened to split up Pollock and Krasner's relationship. CR 305 *Three in Two*, 1956, oil on canvas, 75 x 58 in. Mr. and Mrs. Robert I. MacDonnell. Photograph courtesy of the Robert Miller Gallery.

The title *Birth* echoes that of Pollock's painting, which Krasner admired in the January 1942 show at McMillan Gallery, where she too participated. Her return to this theme could suggest either her rebirth after Pollock's death or her awareness that he had longed to have a child. CR 304 *Birth*, 1956, oil on canvas, 82½ x 48 in. Collection of Barbara B. Millhouse.

Krasner recalled that "tears were literally pouring down" when she painted these bright colors and biomorphic forms. They evoke a figure in a garden, an activity that she shared with Pollock after they first moved to Springs. CR 311 *Listen*, 1957, oil on cotton duck, 63¼ x 58½ in. Private collection. Photograph courtesy of the Robert Miller Gallery.

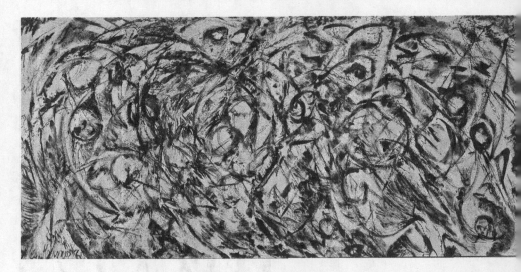

To name her picture, Krasner drew upon the opening lines of Emerson's "Circles," which had impressed her years before and appealed to her appreciation of nature and patterns. She had focused on disembodied eyes as early as the 1930s, under the influence of Surrealism. CR 350 *The Eye Is the First Circle*, 1960, oil on canvas, 92¾ x 191⅛ in. Private collection. Photograph courtesy of the Robert Miller Gallery.

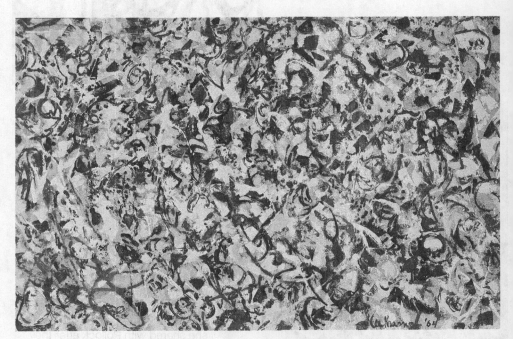

*The Springs* pays homage to the hamlet in East Hampton where Krasner and Pollock made their home in 1945. The all-over pattern suggests reference to local flora and to Pollock's 1946 series, "Sounds in the Grass." CR 401 *The Springs*, 1964, oil on canvas, 43⅛ x 66⅛ in. The National Museum of Women in the Arts, Washington, D.C., gift of Wallace and Wilhelmina Holladay.

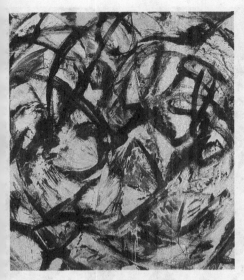

Krasner began to warm up the canvases of her umber series by adding warm reddish tones. These are among her most gestural paintings. CR 357 *Double Helix*, 1961, oil on canvas, 70½ x 62½ in. Private collection.

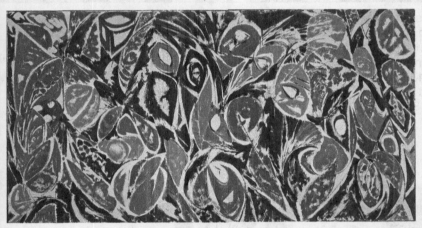

Among the colorful biomorphic shapes repeated across the wide canvas, it is possible to see what could be a bird form, however abstract, on the left side of the painting, which appears to allude to her difficulty in telling right from left. CR 431 *Right Bird Left*, 1965, oil on canvas, 70 x 135 in. Collection of Ball State University Museum of Art, Muncie, Indiana, gift of David T. Owsley.

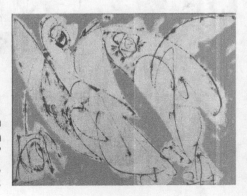

Krasner named this painting *Courtship*, which was most likely an allusion to David Gibbs, whom one of her friends called "a charming cad." CR 438 *Courtship*, 1966, oil on canvas, 51 x 71 in. Private collection.

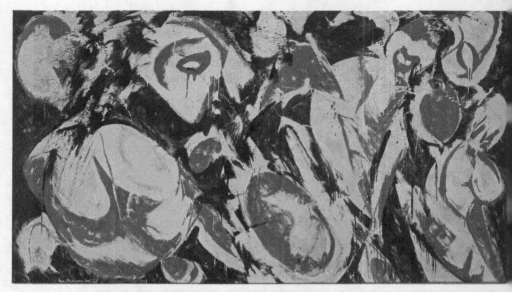

This title recalls a myth: primordial Earth gave virgin birth to Sky (Uranos), who promptly cohabited with his mother to produce offspring called Titans. When Sky blocked his mother, Gaea, from giving birth to monsters, she conspired with their son, Kronos, who castrated his father. The painting's agitated biomorphic forms in bright magenta suggested the violence of the title. CR 440 *Gaea*, 1966, oil on canvas, 69 x 120 in. The Museum of Modern Art, New York (Licensed by SCALA / Art Resource, NY and © 2010 The Pollock-Krasner Foundation), Artist's Rights Society (ARS), New York. Kay Sage Tanguy Fund.

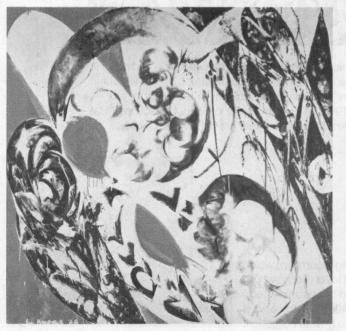

Krasner commented, "I can remember walking across vacant lots on my way to scho and my enchantment at seein and picking clover, buttercups and dandelions. I'm sure that this memory among other things is in *Pollination* . . ." CR 449 *Pollination*, 1968, oil on canvas, 81¼ x 83 in. Dallas Museum of Art, gift of Mr. and Mrs. Algur H. Meadows and the Meadows Foundation, Incorporated.

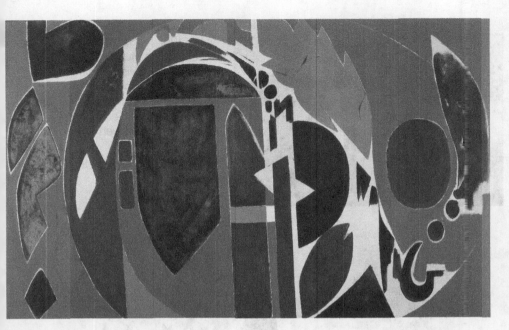

The title, which refers to embryonic development that reproduces the ancestral features of the species, suggests Krasner's deep engagement with nature, which remained of utmost importance to her throughout her life. The intense colors and crisp edges recall Matisse's late work. CR 540 *Palingenesis*, 1971, oil on canvas, 82 x 134 in. Pollock-Krasner Foundation, New York. Photograph courtesy of the Robert Miller Gallery.

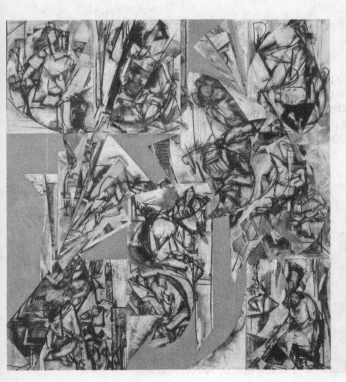

This work contains a number of rejected figurative drawings from her time at the Hofmann School. The title of the series reflects her fascination with time and the verb "to see"; here she chose "Were you seeing?" CR 565 *Imperfect Indicative*, 1976, collage on canvas, 78 x 72 in. Pollock-Krasner Foundation, New York. Photograph courtesy of the Robert Miller Gallery.

Lee Krasner with Bill Lieberman at the 1967 retrospective of Jackson Pollock at the Museum of Modern Art, New York. Visible from left to right are Pollock's *Pasiphae* (c. 1943), *The She-Wolf* (1943), and *Guardians of the Secret* (1943). Photograph by Steven Paley.

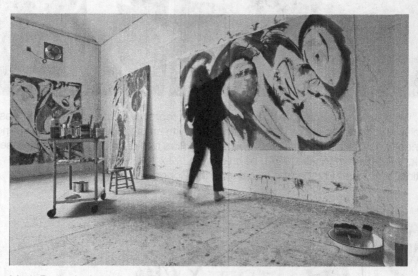

Mark Patiky is the only person to photograph Krasner while she painted. Patiky watched as she became very focused, standing back some fifteen feet with her arms folded, then running up and making "these slashing strokes," a very active process, applied to unstretched canvas tacked to the wall. She is painting *Portrait in Green* (CR434), 1969.

Here, Krasner in front of her latest painting, which she had made for "Poets and Artists," an invitational show of forty-two artist-poet collaborations scheduled for Guild Hall that July. Krasner had teamed up with poet Howard Moss, whom she knew well through their mutual friend, Edward Albee. Lee Krasner standing in front of *Morning Glory*, 1982, oil on canvas, 84 x 60 in. Photograph by Ann Chwatsky.

Francisco before the war and had been invited by Phillips and Hayter to Amagansett as their guest. Since Slivka also knew Kadish from their WPA days in San Francisco, he brought out his bicycle on the train and biked back and forth between Louse Point and Amagansett, visiting both sets of friends. Slivka recalled that when he arrived at Louse Point, he did not yet know Krasner was an artist. He remembered her as "an attractive, Eastern-European-Jewish type." [109]

For Lee and Jackson, the time at Louse Point was just a splendid vacation, though she was always anxious that his drinking would turn excessive. Pollock found instead less temptation and a lot of distraction in the bicycle trips, clamming expeditions, and relaxed atmosphere. The beaches were spectacular and the experience was surprisingly therapeutic.

On August 3, 1945, Mercer wrote to Krasner in East Hampton, telling her how he longed for the days of Provincetown and painting "those beautiful broad beaches" and "that perfectly clear sky, clear water and the vast stretches of sand." Mercer's glowing description must have helped Krasner realize that Eastern Long Island equaled the Cape in beauty but was much closer to the art scene in New York City. "I remember liking the 'vie boheme,'" Mercer noted, "and finding it quite a natural expression. But now, I'm afraid I would look on it differently, wondering if it wasn't all right for youth but not for adulthood. The great thing that I have lost is my optimism. I am even pessimistic about the possibilities of being a painter." [110] Mercer told how he longed to talk with her and Jackson and anticipated his return to the East.

Nevertheless, by September 18, 1945, Mercer had been east and had missed Krasner and Pollock, who were then still on Long Island. In a letter, Mercer expressed his anxiety about life after the army, when he hoped to paint again: "I have a hunch that 4 years away from the brush don't leave me in no good shape to become the American Picasso overnight. I got dough, but I got a little laziness too and the old question—Will I succeed if I take your

course, Mr Hofmann? I.E. I am seriously thinking of painting before my money runs out." [111] "I am directing some of my questions to you, Madam, because the parents suggested it when I saw them in New York and because I have always considered you my technical advisor." [112]

Mercer talked about studying with a teacher again to get "back into the groove and save some time" and mentioned the possibility of "Arthur Carles, particularly if he is still alive. I saw a painting of his at the Chicago Art Institute on my way to Calif. and thought it was a good painting. Not a Picasso, but a Redon, perhaps or perhaps better. . . . I trust Carles, so is he living, so should I let him teach me?" [113]

He also expressed his existential fear about the state of the world. "And what do you think of the atomic bomb, my little ones. (It's the fastest-acting bedtime story ever told.) I am a little less concerned about it than I was at first. Perhaps it is another poison gas and the protection against it will be easy to find. We can always burrow under the ground, even if it has to be hundreds of feet. That will protect us at present, as far as I can see." [114]

Now a seasoned pessimist, Mercer maintained that the bomb had "answered quite to the point that question that Lewis Mumford asked when he titled one of his books, 'Can The City Survive?' I never did take much stock in those literary characters who proposed colossal questions and solved them by wagging the finger." [115] "This is the way the world ends," he concluded, "not with a bang but with an atomic bomb. (I always knew that T. S. Eliot was fighting a losing game, but was surprised to see the score announced so early)." [116]

Despite Mercer's cynicism, Krasner and Pollock enjoyed their time at the beach. There were artists showing that summer in East Hampton's Guild Hall, a local museum and theater in the center of town. According to Francis Newton, who had worked with the illustrator Howard Pyle, it was "often difficult to locate all the artists living in the community." [117] Among those groups of

Lee Krasner holding brushes and cigarette, c. 1941, photographed by Maurice Berezov. She recommended to George Mercer that he read Henry Miller's *The Cosmological Eye*, where she found a similar world view: "The times are permanently bad," but she made the best of the hand that she was dealt.

artists showing at Guild Hall that summer was the conservative American Watercolor Society. Pollock and Krasner would have no part of such an academic tradition.[118]

It is curious that Newton had so much trouble finding artists in the community. Remarkably he seemed to have no awareness that so many artists interested in Surrealism were then summering on the East End of Long Island. One wonders how he missed some of the tiny, hand-woven bikinis that some of the women wore on the beach, those who went nude in violation of local codes, or the bare feet pattering down Main Street.[119]

Many artists Krasner knew from New York were staying on the East End of Long Island that summer—Max Ernst, his son Jimmy, Dorothea Tanning (who would marry Max Ernst the following year), and Jean Hélion and his wife, Pegeen Vail (Peggy

Guggenheim's daughter), were also staying at the Ernsts' rented summer home in Amagansett, when he was not in his own studio in nearby Hampton Bays. Léger had come out with the painter Lucia Christofanetti, and Robert Motherwell was renting nearby, since his new East Hampton house was being designed by French émigré and architect Pierre Chareau. The sculptor Isamu Noguchi, and Chilean Surrealist Matta, whom Pollock had met in New York in 1942, also frequented the area.

Many in the area were shocked by the news of Howard Putzel's death from a heart attack at the age of just forty-six, on August 7, 1945. Peggy Guggenheim insisted his death was a suicide. Putzel, whom Macpherson had backed, had not been able to manage finances well and had been reduced to living in his gallery, where he died.[120] For Krasner, Putzel had been an enthusiastic supporter, gallerist, and friend—unusual because he did not overlook or trivialize artists because they happened to be women or wives. There weren't many out there like him.

## Coming Together:
## Marriage and Springs, 1945–47

Lee Krasner and Jackson Pollock, Springs, c. 1946, photographed by her nephew Ronald Stein. Their quiet life in the country was "a beautiful new experience," Krasner recalled, saying how much the house meant to Pollock: "He loved the grounds, he loved gardening . . ."

L EE AND JACKSON'S TIME IN EAST HAMPTON HAD BEEN SO GOOD for Pollock she proposed that they get a rental for the winter. At first Pollock refused, but then after a week back in New York, he felt overwhelmed by the city's heat and noise. He abruptly declared they should move to Long Island year-round. Their friends Harold and May Rosenberg had just purchased an old house on Neck Path in Springs, which inspired them to think they could too. "I wanted to get away from the wear and tear,"

Pollock recalled. "Besides, I had an underneath confidence that I could begin to live on my painting."[1] They stayed with the Rosenbergs while looking for a house of their own.

The idea of moving to a small town coincided with Krasner's desire to be married. She later attributed this to the loss of her father. "Jackson and I had been living together for three years, and I gave him an ultimatum—either we get married or we split."[2] Pollock agreed but rejected going to City Hall and insisted on a church wedding, claiming, "I'm not a dog; I won't go get a license."[3] It was left for Krasner to arrange the church. After encountering refusals to marry a mixed couple—unbaptized Christian and Jew—she found a minister reputed to be liberal at Marble Collegiate Church on Fifth Avenue and Twenty-ninth Street.

Lee asked May Tabak Rosenberg and Peggy Guggenheim to stand as witnesses, but the latter demurred with a query that reflects her own checkered matrimonial history: "Aren't you already married enough?" The church janitor stepped up to take her place. Krasner, when asked if she recalled what she wore, told an interviewer years later, "No, oh, what a question! I'm sure I must have thought 'what shall I wear.' But, now I can't remember." She did, however, claim to remember the service and that "Pollock liked ritual. . . . I think he always had the need for ritual and the family background had none of it and had total contempt for it, in fact."[4]

The one willing witness, however, May Rosenberg, did remember that they "ran around looking for a hat" for Lee to wear. "It was a beautiful ceremony," said May. "The minister spoke about . . . beauties in faith. . . . It was a lovely simple ceremony. Quite wonderful. Then we left, and I took them to breakfast or brunch. We were ecstatic."[5]

The newlyweds set out to look for a place that fall and found an empty farmhouse in Springs on Fireplace Road with a view out over Accabonac Creek. The price, $5,000, though not high, was more than they could muster. They rented for $40 a month with

an option to buy.[6] At the time East Hampton was experiencing a boom in housing sales and rentals. The village was just three hours out of New York City, where returning GIs had caused a housing crisis. The local paper in East Hampton noted, "The possibility of serious inflation has made people eager to own something tangible, and living under one's own roof is particularly attractive after the renting difficulties of [the] war years."[7]

Krasner warned Herbert and Mercedes, who were planning to return to New York, about the postwar housing shortage. She hoped they might consider the Springs–East Hampton alternative. After warning Mercedes that she no longer had any New York gossip, she added an afterthought, "I forgot to mention that I am now legally Mrs. Jackson Pollock—also the fact that this house we have rented with an option to buy—which gives me about three months to raise $2,000. Its [sic] 5,000 but they'll carry a 3,000 mortgage which we can pay off in a sort of monthly rental. I have three of Jackson's paintings which I'm able to sell outside of his contract & hope to be able to raise the 2000 that way."[8]

Krasner told Mercedes that Hofmann was trying to find someone to buy one of the paintings they had to sell. "Of course all three are gigantic paintings and since I had choice I took the best—I don't suppose you got to see Jackson's show in San Francisco? The museum purchased 'Guardians of the Secret' & he may have a show in Paris this winter."[9]

Despite Peggy's stance on their marriage, Lee set about getting her to lend them $2000 as a down payment on the Springs house. Peggy wrote years later, "Lee was so dedicated to Pollock that when I was sick in bed, she came every morning to try to persuade me to lend them two thousand dollars to buy a home on Long Island. She thought that if Pollock got out of New York, he would stop drinking. Though I did not see how I could produce any extra funds, I finally agreed to do so as it was the only way to get rid of Lee."[10]

Peggy and Lee worked out a new two-year contract for

Pollock, raising his stipend to $300 a month, minus a deduction to pay off the loan. In exchange, Pollock was to give her virtually his total output of finished work. The Pollocks moved in the autumn of 1945, loading books, canvases—everything they owned—into a truck they borrowed from a butcher who was May Rosenberg's brother.[11] "We arrived in Springs in November during a Northeaster—what an entrance. We knew no one. I wondered what we were doing there," recalled Krasner.[12] For their first three days it rained solid, which was no small matter—at first they had no inside toilet, tub, or hot water—just a hand pump and a small basin for drawing water to wash.[13] Wartime rationing still prevailed, and they could get just one bucket of coal at a time, not enough for warmth. The house was dead cold during the night.[14]

"We had given up the New York place and burned all our bridges. When we arrived, the house was stuffed from floor to ceiling with the belongings of the people who had lived there. The macanaw [Mackinaw] of the man who had lived there was still hanging on the rocker in the kitchen. It was a rough scene we walked into. The barn was packed solid with cast iron farm tools."[15]

They found the interior covered with layers of wallpaper, which they started to peel away. The three kinds of gold leaf paper that survived in the front parlor, along with the old carpet and a chandelier, appealed to Krasner enough that she kept that room intact for years.[16] She recalled that Pollock "broke down the walls to create spaces to hang paintings. . . . He loved having the house. He loved the grounds, he loved gardening."[17] "We were so busy for about two years tearing off wall paper and burning up the contents of the house (which we finally had to buy because the owners wouldn't clean it out) that we didn't have time to do much else."[18]

Their life in the country was "most conservative, quiet."[19] Krasner recalled that "in the early days it wasn't an art colony. . . . A lot of our friends then were writers, very few artists. Ashawagh Hall, the little building down the road, was the community cen-

ter."[20] She reminisced that they "cooked, canned, gardened; it was all a beautiful new experience."[21] Jackson "did the baking in our family. . . . If he wanted apple pie, he baked it. I didn't know how to bake. I cooked—but he cooked too. He also cut the lawn (I couldn't run the machine). He more than pitched in. Perhaps if we'd had more money, we would have hired people to do things. But we didn't, so we had to do everything ourselves, and we shared the work to be done."[22] They acquired both a boat and a goat, which might have helped keep the grass trimmed.

Krasner reflected, "One thing Jackson and I had in common was experience on the same level . . . feeling the same things about landscape, for instance, or about the moon. He did a series around the moon. He had mysterious involvement with it. I had my own way of using that material. Very often I would get up at two or three and come out on the porch and just sit in the light here."[23] Away from the city's electric lights, the moon came into its own.

Not long after their move, Krasner wrote to Mercedes: "Well here we be in Springs East Hampton—3 hours from N.Y. and it might as well be 300 or 3000 miles. We've been here in this funny old Victorian bastard house & I begin to recall some of your early letters with all the trials & tribulations of trying to get settled."[24]

There was a gigantic coal stove in the living room, but no coal yet, so that their only heat came from the kitchen. "I think it will be very comfortable when we do get it. A wood stove in the kitchen—running water (cold) and no bath—tub—otherwise all the comforts of our 8th St apt—Its [sic] very beautiful out here—the back of the house leads to a pond (inlet from the bay & with the house amongst other things is an old leaky row-boat)."[25]

Often the couple went clamming, and Jackson dug up clams with his bare toes.[26] Bicycles were their sole means of transport: "so long as the weather permits we ride our sturdy steeds—I know you and Herbert will love the place."[27] "We had one bike for two years, and then we had two bikes," Krasner later remembered, perhaps exaggerating their poverty to a journalist.[28]

Krasner wasn't sure if they were the first artists to move to Springs. "When we moved out, Motherwell was here," Krasner recalled. He was "renting a house, but I believe he was here for about one season and we didn't see very much of him. We saw a little of him and then he went elsewhere and slowly the first artists came here. I think John Little came out first, followed by Wilfrid Zogbaum, and so the colony started."[29] She told how "when Zog and John were buying their houses, both Jackson and I were very involved with it and you know, went and saw the house they were getting, watched it getting in shape, saw each other closely, and so forth."[30]

Another time she recalled that Motherwell was then "married to his first wife, a Mexican girl, Maria. And they had rented a guest house and were living there for a short time and then he left . . . and I think that was the end of East Hampton for him."[31] Motherwell considered buying a piece of property across the road from the Pollocks. One evening at their place, after plenty of drinks, he remarked, "I'm going to be the best-known artist in America." Lee replied, "I'd be very lucky to live opposite the best-known artist in America and be married to the best."[32]

A studio space had to be found at once for Jackson, the potential star and breadwinner, so that he could prepare for his next solo show the following April.[33] Krasner reported that his working space took priority over hers. "It was a matter of cleaning everything out before we could move in or work. So the first year was really about reclaiming the house. In the meantime, Jackson took one of the bedrooms to try to paint in."[34] He produced eleven oils and eight temperas for the show.

Many of Pollock's titles for his 1946 show had figurative references: *Circumcision, Water Figure, Troubled Queen, The Little King, The Child Proceeds, The White Angel,* and *High Priestess.* One source may have been the popular comic character the Little King, a King Features Sunday strip, created by Otto Soglow, who

narrated through pantomime with almost no words, just as some maintained Pollock communicated.[35] Curves similar to those in Soglow's cartoons are visible in photographs of Pollock's painting *The Little King* before he painted over the canvas the following year and retitled it *Galaxy*.[36] Perhaps Pollock worried that his self-reflexive reference to the strip was too transparent, especially because it depicted a king who, like Pollock, just did not fit into society or his role in it. If he self-identified with the *Little King*, he must have seen Lee as the *Troubled Queen*, a sly acknowledgment of the trials he put her through.

The couple mainly struggled not with each other, but rather with Pollock's drinking bouts and the torments that drove him to drink. Krasner's hope that moving to East Hampton would stop Pollock from drinking had not panned out. He still drank to excess from time to time. She became preoccupied with keeping him from drinking, using distractions such as working on the house and in the garden.

After June 1946, the Pollocks had the small barn that came with the property moved from behind the house to the north side of the property. Not only could they now clearly see Accabonac Creek, but Jackson was able to use the barn as his studio, which in turn allowed him to enlarge the size of his paintings. Lee took a little upstairs bedroom as her work space, keeping another larger one free to accommodate guests. They began inviting more friends out to visit.[37] "Exhibitions would bring us into the city and there were visits from people connected with the art world," Lee remembered. "We were away from the city but we felt in touch."[38] "The people we wanted to see we invited out," she explained.[39]

Krasner's primary purpose was to make sure Pollock could focus on painting. She insisted, "Even if I hadn't been married to him, I would have been influenced by his work as would any painter who is interested in the development of painting. Pollock and I had a mutual respect for each others' work. He

worked in his studio and I had mine. He didn't verbalize and we didn't exchange ideas on art. The whole exchange existed in the painting[s], which spoke for themselves."[40]

Clearly at this moment Krasner deferred her pride to Pollock. His work represented their best chance at sales. Though she admitted that her "'mud' period had abated," and that "an image began to come through those gray slabs,"[41] her work went nowhere. Yet "I wasn't saying 'Why are you getting ahead and I'm not?'" she reflected years later. "For me, it was quite enough to continue working, and his success, once he began to sell, gave us an income of sorts and made me ever so grateful because, unlike wives of other artists who had to go out and support them, I could continue painting myself."[42] She insisted, "Jackson was totally determined to live from the sale of his paintings. He made a real issue of it. Other painters in his circle—Tony Smith, Barney Newman, Adolph Gottlieb—were all supported by their wives, but he couldn't take that. His attitude was macho; he didn't want me to go out and work and support him. When his work began to sell a tiny little bit, we lived off that. I was able to keep painting that way, so I tried very hard to help him sell."[43] Though Krasner admitted that she suffered from being reliant on Pollock, she "wasn't conscious of it. And to the degree that I became aware of it, I felt the problem in a very large sense and that it wasn't localized. It wasn't Pollock and me."[44]

Krasner explained that after meeting Pollock, she had been trying "to undo my Cubist orientation and produced very little work in a rather anxious situation."[45] Before the move, she had scraped down many of her thickly painted canvases to salvage material for future work.[46] Yet despite her private struggle, as she worked through a major change in her art, she had already achieved a measure of recognition among her peers. This is evident by her inclusion in fellow Abstract American Artists member Ad Reinhardt's cartoon, *How to Look at Modern Art in America,* published in *P.M.* on June 2, 1946. It was captioned: "Here's a guide to the

galleries—the art world in a nutshell—a tree of contemporary art from pure (abstract) 'paintings' (on your left) to pure (illustrative) 'pictures' (down on your right). If you know what you like but don't know anything about art, you'll find the artists on your left hardest to understand, and the names on the right easiest and most familiar (famous)."

Reinhardt put the names of the American artists on leaves of their own and grouped the leaves on branches according to his perception of their aesthetic. He placed Krasner near some of the women with whom she had shown in the American Abstract Artists group shows—Slobodkina, Alice Trumbull Mason, Ray Eames, and Suzy Frelinghuysen. But he also placed Krasner close to "de Kooning," presumably Willem not Elaine, as well as men such as Werner Drewes, John Ferren, Charles Shaw, Carl Holty, and Stuart Davis. Pollock, misspelled "Pollack," was on another branch along with such names as Arthur B. Carles, George McNeil, Hans Hofmann, and Arthur Dove. From Reinhardt's perspective, both Krasner and Pollock were clearly avant-garde.

Soon they were settled enough to invite Pollock's family for Thanksgiving dinner. They had no coal yet, and Jackson complained that "wood burns like paper at $21 a cord."[47] They found local shopping convenient, thanks to the opening in mid-November of Dan T. Miller's new general store in Springs. He sold both hardware and groceries and once took a painting in trade.

Before Pollock's show with her in April 1946, Guggenheim came out from the city to visit the newlyweds. She must have wanted to see something of what Pollock would be showing at her gallery that spring. It was "so cold there was ice in the toilet." Krasner recalled. "We gave her an oil stove for warmth and she carried it around with her. She came down in one of her negligees with the oil stove and said, 'This reminds me of the castles in England.'"[48] Careful to keep Peggy's support, Pollock designed the dust jacket for her book of memoirs, Out of This Century. For the

front-cover motifs, he recycled a black-and-red serigraph Christmas card that he had designed in 1944.[49]

Krasner later said that Guggenheim had sent them a copy of the book inscribed " 'To Jackson.' . . . She had not included me in the inscription and I remembered being quite hurt by this. I genuinely liked Peggy. I must not have realized that she probably resented my attachment to Jackson, and that, basically, she had very little use for women."[50]

Krasner understood that the prejudice she had to deal with was not in her home. "It wasn't [Jackson] who was stopping me, but the whole milieu in which we lived, and the way things were, which I accepted. Because as long as I could keep working, I was perfectly willing to go along with it, with irritation, with impatience. But it didn't interfere with my work, and that was the main thing." She insisted: "My irritation, anger and rage was with the entire situation, not with the family."[51] "Painting is revelation, an act of love. There is no competitiveness in it," she explained. "As a painter I can't experience it any other way."[52]

Pollock's third show opened at Art of This Century in early April 1946. He and Krasner arranged to stay for two weeks at their old place at 46 East Eighth Street, which Pollock's brother Jay and his wife, Alma, now shared with James Brooks, a painter both he and Krasner knew from the WPA.[53] They would continue to stay here when visiting the city over the next several years.

Back in Springs, Pollock painted his last big canvas on the floor of his bedroom studio. *The Key,* a brightly colored canvas nearly five by seven feet, "took up the whole space on the floor," Krasner recalled. "He could barely walk around it."[54] *The Key* was part of a series he named "Accabonac Creek," after the body of water behind their home. *The Key* would be one of sixteen oils in his last solo show for Guggenheim's Art of This Century in January 1947.

Among the weekend visitors in the summer of 1946 was Lee's old friend Clement Greenberg, who by the time he came out to visit Lee and Jackson at the end of July 1946 was the art critic

at *The Nation*.[55] Krasner and Pollock treated him with kid gloves. They stayed up late as the critic usually did, sitting at the kitchen table and talking until the early hours of the morning. Greenberg, who recognized Krasner's keen intelligence, later reflected: "Without her Jackson wouldn't have made it the way he did. She did everything. She had a great eye."[56]

Pollock listened carefully to what Greenberg had to say about his pictures and later advised Fritz Bultman to "be nice to Clem . . . if he likes your work he'll help you."[57] Bultman was in Provincetown that summer with George Mercer, who wrote on August 11, 1946, to say that Hans and Miz Hofmann were asking about her. Though he felt that Provincetown was the place for him, he yearned for "a day or so of pure talk" with Krasner. He had just sent a gift of a necklace and bracelets.[58]

MOVING INTO HER OWN STUDIO UPSTAIRS PROBABLY ENABLED KRASner to make a definitive break with her past. "All I know is that is where my Little Image paintings began, when I started painting in the bedroom," she recounted. "The grayness of the streets finally began to open up in the Little Image paintings. It was a great change."[59] She described the Little Images as taking her "some three years and what began to emerge in the first of these, which was around '46, were very small canvases, these things around here, what I refer to as the little image, were the first as I gained confidence and strength, it expanded—it grew bolder in time."[60] While some are larger, several of these canvases measure only from about twenty to thirty inches on each side. The paintings are known for their abstract, allover patterns and thick textures forged by layers of paint.

In 1965 Krasner told B. H. Friedman that she called this group her "hieroglyphs."[61] She described herself as "waiting for something to happen." She also knew she had to deal with "pigment and canvas, which was the only thing I knew. . . . I was

pretty confident something would happen, I guess, because I can remember Benton calling on Pollock [while they were still in the city]—which was the only time I ever met Benton—and he came up and Jackson introduced me and Benton said to me, 'I hear you're a painter.' And I said, 'Yes.' And he said, 'Can I see what you're painting?' And I just said, 'Certainly,' and walked him in front of this blank gray thing I had up there."[62]

She described the silence that followed as "astounding."[63] Krasner allowed Pollock to change the subject, and they walked out of her studio, making her reflect, "I must have felt pretty hostile to Benton or confident in myself to show him what I knew was in the studio."[64]

Krasner later clarified that her Little Image paintings were not painted on an easel and were "not easel in concept."[65] "The canvas is down on a floor or on a table and I am working out of a tiny can. In other words, I have to hold the paint so I can move it. But [contrasting her method with Pollock's] I wouldn't have been using Duco. My paint would always have been oil and I could get the consistency of a thick pouring quality in it by squeezing it into a can and cutting it with turp."[66] She thought the early Little Image pictures were the only time she ever dripped paint. "There's what I would describe as a controlled dripping situation, very controlled and sustained, as it took many sessions to do one. . . . I have an awareness of that, of that kind of control."[67]

"I couldn't do those right on the wall," she elaborated. "Those want to be—only group of my things and some watercolors—and some washes where I saturated the washes where I saturated the paper, dipped it in the bathtub and then had to hold it horizontally until the image fixed where I wanted it to be. And the Little Image I had to work in horizontal looking down. Otherwise everything else I do is on the wall."[68] Another time, she explained the process of making the Little Images to a different interviewer: "I stayed with them until they built up surface. Until I got what I wanted."[69]

Inspired by Pollock, Krasner now worked more from instinct than she had previously. She also tried to be more at one with nature, rather than standing back to depict it as she once had. She developed her own allover patterns of strokes with her palette knife, small squirts or blobs of paint direct from the tube, or controlled drips right out of a can of paint or off the tip of a stiff brush. Since her Little Images were on smaller canvases than Pollock's, she did not need the kind of stepping motion of being in the painting as Pollock was. She simply stood over her canvases.

Specific interpretations of the meaning of Krasner's Little Image paintings have sometimes seemed too limiting. An abstract painting like *Night Life* (1947) has been compared to "the buildup of seaweed, shells, stones, etc. at Louse Point, a bay beach" where Krasner and Pollock swam, but this abstract image might just as well have been inspired by the night sky and the fireflies that illuminate a Long Island summer night—just what Krasner liked to view from their back porch.[70]

*Night Life* could also refer to stepping out for entertainment, evoked by the recorded music that Pollock was constantly playing. Krasner recalled that Pollock "would get into grooves of listening to his jazz records—not just for days, day and night, [but] day and night for three days running, until you thought you would climb the roof! . . . Jazz? He thought it was the only other really creative thing happening in this country."[71]

When Krasner worked, she did so in careful control, raising and lowering the source of the paint to change the amount of paint she allowed to flow onto her canvas. Other artists besides Pollock had been experimenting with dripping paint—for instance, the immigrant "housewife," Janet Sobel, who had a solo show at Peggy Guggenheim's in January 1946 and attracted Pollock's (and probably Krasner's) attention, or Mark Tobey, who showed canvases with his calligraphy-inspired "white writing" at the Willard Gallery in New York in 1944. Even Hans Hofmann and Max Ernst experimented.

The feminist art critic Cindy Nemser told Krasner that she thought of the Little Image paintings as "controlled chaos," prompting Krasner to comment: "I love that. . . . This work is a key turning point."[72] Nemser once asked Krasner why she had not fought to have her achievement of this body of work acknowledged along with Pollock's. The reply was unambiguous and blunt. "I couldn't run out and do a one-woman job on the sexist aspects of the art world, continue my painting and stay in the role I was in as Mrs. Pollock. I just couldn't do that much. What I considered important was that I was able to work and other things would have to take their turn. Now rightly or wrongly, I made my decisions."[73]

Nemser had a clear understanding of the dilemma a woman artist faced. "It is important to remember before Krasner is blamed for not standing up more strongly for herself that it is very unlikely in those macho days of the later '40s, the days of the returning GIs and the heavy reassertion of the feminine mystique, if any amount of protest or any amount of self promotion would have done Krasner much good."[74]

"If I hadn't been a woman, I'd have had a different situation," Krasner explained. Asked about the few women among the abstract expressionists, she commented, "I was conscious of it and settled for the idea that I could continue working." She also admitted that she "was willing to let everything else go aside, I was feeling pretty good because I was able to work."[75]

Krasner was not able to show the Little Image paintings as a group to the public at the time she produced them. She had to rely on comments from friends or visitors. She recalled, "John [Bernard] Myers admired them and I can remember Clement Greenberg saying about an early one, 'That's hot; It's cooking.' I considered it a compliment."[76]

The men's opinions were the ones that seemed to matter. "Bradley Walker Tomlin admired a great many of my Little Image paintings. He saw them hanging in our guest bedroom

as he was our house guest a good deal. He used to tell me how beautiful they were and his warm response to these paintings of mine I remember very well."[77] Tomlin, who was nearly a decade older than Krasner, had painted in a cubist style until he encountered Adolph Gottlieb, who introduced him to Motherwell, Philip Guston, Pollock, and Krasner. Once exposed to their abstract and expressive styles, Tomlin began to experiment and switched to a more spontaneous and abstract style of his own.

Years later the curator Marcia Tucker pointed out to Krasner that she painted from right to left, just as one would write Hebrew lettering, which Krasner had studied as a child. Though she had never thought about this, it turned out that Krasner indeed did work a canvas from right to left, so this theory made sense to her.[78] At the time, no one considered that Krasner might have been dyslexic. This now common term for a reading disability that is caused by a quirk in the brain's ability to process graphic symbols was not then current. Before research in the 1980s, dyslexia was not well understood. Now scientists describe "a neurologically-based, often familial, disorder which interferes with the acquisition and processing of language. Varying in degrees of severity, it is manifested by difficulties in receptive and expressive language."[79] People with dyslexia are known "to have a larger right-hemisphere in their brains than those of normal readers. That may be one reason people with dyslexia often have significant strengths in areas controlled by the right-side of the brain, such as artistic, athletic, and mechanical gifts."

Krasner was fascinated with writing systems throughout her life. As a girl, Krasner had learned to write Hebrew but not to read it. As a child, she enjoyed writing messages in a secret language that she invented. This may have been an attempt to substitute a language that others could not decipher in reciprocity for her own trouble reading the letters that her family and society imposed on her—both English and Hebrew. Later on, Krasner became enamored of the visual art of creating symbols for language,

and she explored calligraphy and explored the forms of Hebrew, Arabic, Persian, Celtic, and Chinese characters.

POLLOCK HAD HIS LAST SOLO SHOW AT GUGGENHEIM'S ART OF THIS Century from January 14 through February 1, 1947. Many of the titles reflected his new environment and the new barn studio: *Croaking Movement, Shimmering Substance, Eyes in the Heat, Earthworms, The Blue Unconscious, Something of the Past, The Dancers, The Water Bull, Yellow Triangle, Bird Effort, Grey Center, The Key, Constellation, The Teacup, Magic Light,* and *Mural.* The last was the twenty-foot mural Guggenheim commissioned for her New York home and that Pollock painted in 1943.

The spring following this show, Guggenheim closed her gallery and moved to Venice. She found Betty Parsons to show Pollock until his contract with her ran out in early 1948. Unlike Guggenheim, Parsons was not only a dealer and a collector, but also an artist. Growing up in New York City in an upper-class family, Betty, at the age of thirteen, had attended the International Exhibition of Modern Art known as the Armory Show and absorbed the "New Spirit" of what she saw. She had attended the New York City private school Miss Chapin's School, where she made friends who would support her throughout her life.[80]

After her brief marriage of convenience to Schuyler Livingston Parsons ended in divorce, she found herself in Paris in the 1920s, where she studied both painting and sculpture and began to live as a lesbian. When her ex-husband could no longer afford alimony during the Depression, Betty returned to America and began to work for galleries in New York, including one owned by Mrs. Cornelius J. (Mary J. Quinn) Sullivan, one of the founders of the Museum of Modern Art. In September 1946, Parsons opened her own gallery at 15 East 57th Street with a show of Northwest Coast Indian art. She obtained an essay for the catalogue from her friend the artist Barnett Newman, whom she knew from working with

him at the Wakefield Bookshop Gallery, where she was director from 1940 to 1944.

Until the end of Pollock's contract, all of his new work, with the exception of one painting per year, was to go to Guggenheim. Parsons agreed to continue paying Guggenheim the proceeds from Pollock's paintings that Guggenheim already owned, and she agreed to continue paying him his monthly allowance. Parsons also committed to give Pollock a solo show the following winter.

AROUND THIS TIME MORE AND MORE RESEARCH WAS COMING OUT about alcoholism. Medical interpretations of alcoholism acquired increasing authority, fostered by the new antibiotics that were saving lives. A Johns Hopkins psychiatrist, Robert V. Seliger, wrote *Alcoholics Are Sick People,* a book published in 1945, arguing that "physicians, psychiatrists, psychotherapists, nurses, social workers, clergymen, educators, patients, and relatives" all had to work together to rehabilitate the alcoholic.[81]

At this point, Pollock's drinking was episodic, which meant that he and Krasner were able to have a social life. Their friendship with George Mercer continued, and in early June 1947, he spent a week with them in East Hampton, writing, "The good effects of my stay with you have not disappeared yet. . . . Being with you enabled me to start on a gouache which seems to be progressing fairly well. I was shocked by its superiority over a painting which I completed three years ago—the one which includes the ruins of the church. That kind of shock is encouraging."

David Slivka and a new acquaintance drove out to East Hampton one Sunday in the latter's Jaguar, and dropped in unannounced on Pollock and Krasner. They found the couple having a backyard picnic with artists and future spouses Jim Brooks and Charlotte Park. Rather than continuing to visit with his guests, Pollock immediately wanted to drive the sports car. Krasner, Slivka remembered, was always "gracious," "very intelligent," but

said she had an "ironic kind of humor—she could destroy some
one with a couple of phrases."[82]

With a circle of local friends, Pollock and Krasner were thriv-
ing in Springs and profited from being in the country. That
summer, they had a "swell garden," proclaimed Stella Pollock
as she praised her son's cantaloupes and their "wonderful fla-
vor." Mrs. Pollock sent Lee an apron, hoping to encourage her
daughter-in-law's efforts at cooking.[83] Years later, Krasner re-
flected, "There was this side to the marriage that was cozy, do-
mestic and very fulfilling."[84]

# ELEVEN

# Triumphs and Challenges, 1948–50

Lee Krasner in Jackson Pollock's studio, April 1949, photographed by Harry Bowden. Pollock renewed his contract with Betty Parsons at the end of June 1949 to run through January 1, 1952. They told Pollock's mother that the sales from his show had been "very good" and that they wanted to make a trip to the West Coast.

I N DECEMBER 1947 POLLOCK SIGNED A CONTRACT WITH BETTY Parsons, effective through June 1949, and began to focus on preparing for his first show at her gallery. Stella Pollock noted her son and daughter-in-law's happiness after a Thanksgiving visit, attributing this improvement to their move out of the city. She reported that Lee was also painting.[1]

With the chill of winter, since they had only enough money to heat one floor of their house at a time, Krasner began working on mosaic tables downstairs in the back parlor, through which

everyone who entered the house had to walk, making privacy to paint impossible. She tried her hand at making a piece of furniture, which they really needed. Pollock had already moved his work into the barn, eventually heating it with a kerosene stove.

Some have tried to attribute Krasner's two mosaic tables to Pollock, who suggested she "try a mosaic" and provided her with some glass tesserae left over from his work with the WPA.[2] Yet Krasner had already attended lectures on mosaics while at the National Academy and had worked on preparing Harry Bowden's design for a mosaic while on the WPA. Thus she hardly needed Pollock's WPA mosaic design to get ideas about the technique. Indeed, her originality went far beyond his tesserae, improvising with shells, pebbles, broken glass, keys, coins, and bits of costume jewelry. For the tables' frames, Krasner used two old iron rims of wagon wheels they found abandoned in the barn. As the child of impoverished immigrants, she hardly needed to find precedents for making do with what was on hand.

When Pollock's show opened at Betty Parsons Gallery on January 5, 1948, the event gave Krasner reasons for hope. It prompted responses from younger artists such as Harry Jackson and Grace Hartigan, who recalled, "We had just seen the first drip show of Pollock. We were fascinated. I'd seen it, I think, fifteen times." When they told this to Sonja Sekula, another of the gallery's artists, she said, "Why don't you call him and tell him? He's moved to the country and Peggy Guggenheim's gone back to Europe and he's lonely, broke, and no younger people have said they liked his work."[3] Harry phoned and Pollock invited the couple out to Springs for a visit. Harry did not want Grace, to whom he was not yet married, to let it be known that she was also a painter. "It was only when Harry and Pollock went out to a bar and I was alone with Lee," Hartigan, who was fourteen years younger than Krasner, recounted, "and she said, 'Confess. You're a painter, aren't you?' So we two women painters sat and talked about my work."[4]

Hartigan remembered: "Lee had a beautiful body with a per-

fect hour-glass figure. She wore Rider jeans that looked as though they had been made for her."[5] Hartigan recalled that Pollock was terribly shy—like "a clam without a shell," while Harry has often been quoted as saying that Jackson put Lee down by calling her "the little woman," or "you goddamn cunt."[6] But Grace disagreed with her former husband and insisted that "Jackson had a great love for Lee. He was never cruel to her."[7] Grace's insistence is supported by the fact that Harry Jackson inveterately mythologized himself.[8] Born Harry Aaron Shapiro, Jr., he goes by his mother's maiden name after his father deserted the family. Much later on, he fulfilled his artistic fantasies and his desire to be a cowboy by settling in Cody, Wyoming, to make bronze sculptures with western themes in the tradition of Frederic Remington. Telling colorful yarns, he has captivated a coterie of male biographers and scholars, who still flock to Wyoming eager to hear about his connections to Pollock.

Despite visits from enthusiastic young people and other positive responses to Jackson's work, by April 1948 the Pollocks were again facing trouble covering their expenses. Parsons wrote to Guggenheim in Venice, telling her of the "terrible financial condition of the Pollocks."[9] Evidently others noted the problem. MoMA curator James Johnson Sweeney tried to secure financial assistance for Pollock by getting him $1,500 from the Eben Demarest Trust Fund for the advancement of art and archaeology. The money was to be paid out in quarterly installments from July 1948 through July 1949.

During the summer, the Pollocks invited Elaine and Willem de Kooning to the house. Lee was scornful that the painter Elaine Fried had taken her husband's surname, while Krasner had refused to change hers.[10] (Elaine, who was a decade younger than Lee, remained married to de Kooning through decades of his infidelity, including his fathering a child with another woman.) Like so many guests, Elaine and Bill eventually also moved to the area.[11]

Mercedes Carles Matter and Herbert Matter had returned from California, and that summer they and a German couple, named Vita and Gustave "Peter" Petersen, who had arrived in New York before the war, shared a rented house near Pollock and Krasner. Vita, an artist, had also studied with Hofmann.[12] For the duration of the rental, the Matters, the Petersens, and the Pollocks saw a lot of each other, although Herbert and Peter came out only for weekends because they had to work in the city during the week. When the two women drove into town to shop, they passed by the Pollocks' home and picked up Lee, who still did not know how to drive.

Vita Petersen recalled her friend Mercedes's extraordinary beauty, as well as her intensity, and said that Mercedes only had intimate relationships with artists if she "admired" their work—then "it became personal, intense 100%."[13] Mercedes, whom many men found irresistible, had earlier had affairs with Zogbaum, Gorky, and Hofmann, among others.

Petersen also recalled that Mercedes was attracted to Pollock and admired his work. They may have gone to bed once or twice, but she is doubtful they had an affair. Like Krasner, Petersen thought Pollock was "adorable, gentle, poetic, a nice and kind person when not drinking."[14]

For Krasner, however, the attention Pollock paid to these two attractive and slightly younger women (five and seven years Krasner's junior) had to have been painful, especially because Mercedes had long been one of her closest friends. Even harmless teasing might have seemed sexually suggestive.

Pollock kept copies of at least two photographs of Mercedes that Herbert had taken on the beach in Provincetown in 1940. One is overtly erotic, showing Mercedes nude on the beach, her head, shoulders, and one breast visible, framed with driftwood, a cliché typical of the times. The photographs probably came from Mercedes, instead of Herbert, who was hurt by his wife's affairs but tolerated her behavior.[15] Although Krasner too had once de-

lighted in such exhibitionism on the beach in Provincetown, by 1948 she was thinking about exhibiting her art, not her body.

Perhaps provoked by jealousy over Pollock's flirtation with these two women, Krasner allowed Igor Pantuhoff to stay as a houseguest in Springs. As Vita Petersen recalled, he was on his way to somewhere else and was only there for a day or two.[16] To Petersen, Pantuhoff seemed "sort of chic," but his presence was disturbing for the insecure Pollock, who began drinking again.[17] At one point, Jackson, Peter, Vita, and Igor went for a walk while Lee stayed at home. Jackson and Igor began to fight and had to be pulled apart by Peter, who saved Igor from anything worse than a cut lip.

IN THE AUTUMN OF 1948, MRS. JACKSON POLLOCK BEGAN TO BE PUB-licly and professionally called "Lee Krasner"—for the first time spelled with only one s.[18] As recently as the show at Putzel's 67 Gallery in July 1945, the press had identified her as "Leonore Krassner," perhaps adding the o in error. Surely she did not want to be confused with the British Surrealist artist Leonora Car-rington or the Argentine Surrealist painter Leonor Fini, both of whom exhibited at Art of This Century. Krasner's classmates at Cooper Union in the late 1920s, however, had already dropped Lena and Lenore for Lee. Now that she was facing turning forty, she inevitably thought about the significance of her life so far. She had lied about her age to the press, so she was unable to cel-ebrate her fortieth year publicly. Nonetheless she began to focus once again on her own identity as an artist.

As "Lee Krasner," she took part in an exhibition at the Bertha Schaefer Gallery. The show, September 20 through October 16, 1948, was billed as a collaboration between "architect, interior-designer, and artist to make the modern house come alive."[19] Schaefer showed two model living room schemes built around unique coffee tables by Krasner that Schaefer saw as meant for

houses designed by contemporary architects such as Edward Durell Stone and Carl F. Brauer.

A reporter described one of Krasner's tables as "a large round table, its metal rim taken from a wagon wheel. The center is filled with a mosaic pattern and worked into concrete by Lee Krasner. Pieces of rich blue glass plus such trivia as keys and coins form a varied pattern and give color clues for the fabrics."[20] This was the first of the two tables Krasner made in the back parlor of the Springs house, begun during the winter of 1947, when money was lacking to heat the upstairs bedroom during the day.

For the first time, the press singled out Krasner's work for praise without reservation: Ann Pringle, writing in the *New York Herald Tribune,* called the total effect "magnificent." Aline B. Louchheim, the critic for the *New York Times,* pronounced Bertha Schaefer's "use of abstract designs for table tops . . . noteworthy," and then singled out Krasner's work: "a mosaic table made inside a thirty-eight-inch-diameter wagon wheel. . . . The pinwheel bright blues and reds and the irregular shapes are arranged in a satisfying abstract pattern. The other table consists of an oil painting with a wide black frame raised several inches above the surface of the canvas and a piece of glass at this level over the whole. As this design of thickly encrusted pigment is conceived as an all-over pattern, it looks as well from one angle or direction as another."[21]

Ann Pringle reported in the *New York Herald Tribune* that Bertha Schaefer was "especially proud" of a "black wood coffee table in the Brauer house [that] has an oil painting by Lee Krasner as its top, and not the least of the table's charms is that the painting succeeds in looking at home there."[22] The *New York Times* reported that this was "a rectangular wood coffee table with a canvas painted by Lee Krasner set into the center and glass covered."[23] The work is one of Krasner's Little Image paintings, which she said she produced horizontally. This one, known as *Composition,* measures just twenty-one and a half by thirty-one

and a half inches.[24] Another of Krasner's Little Images, *Abstract No. 2* (1946–48), also appeared in the show. On the canvas several numbers can be read, especially 4 and 6, which may refer to the number of the apartment she shared with Pollock at 46 East Eighth Street.[25]

If Krasner minded having her art shown as part of a decorative ensemble, she never protested to Schaefer; nor did she actively pursue this as a marketing angle for her work. A reproduction of Krasner's mosaic table, probably the first ever to be published of any of her work, was featured in the *New York Herald Tribune;* it showed her table standing on the floor beneath an oil painting of Dogtown by the late Marsden Hartley.[26]

At Pollock's suggestion, Krasner gave the second of her two mosaic tables to Happy and Valentine Macy, who had admired it. The couple had just sold a home, and they gave Krasner and Pollock some furniture they no longer needed—a heavy pre-Jacobean court cupboard and two long tables. When Krasner hesitated about giving away her table and asked Pollock to give one of his paintings instead, he asked, "Did you ever hear them admire it?" Admitting that she had not, she parted with one of her two tables, never to make another.[27]

After the exhibit Krasner realized a connection between her mosaic tables and her paintings. Ever frugal, she reused the round piece of pressed wood that she had used as a base while making the two mosaic tables to create a tondo for *Stop and Go* (1949–50). It was a format that she chose only this once, covering the surface with hieroglyphic-like symbols that were reminiscent of some of the rhythmic forms on the tables. Like the mosaics, the images in some of her paintings would soon contain more repeated shapes, which were what she referred to as "hieroglyphics." Because Krasner maintained her allover patterning by rhythmically repeating similar shapes from edge to edge instead of emphasizing any particular sequence of symbols, the viewer perceives the totality of the shapes working together rather than the individual shapes.

Like Krasner's, Pollock's artwork was getting attention from different sources. Specifically, his style of allover patterning attracted Alfonso Ossorio, heir to a Philippine sugar fortune, who bought Pollock's *Number 5* (1948) from Betty Parsons in January 1949. Ossorio saw in Pollock "a man who had gone beyond Picasso" and in whose work there was "a meeting of East and West."[28] But when Parsons shipped the painting, it arrived damaged. In April, Parsons took Pollock and Krasner to have a look at it at Ossorio's new place in Greenwich Village. Pollock offered to repair the painting in his Springs studio. The next month, Ossorio and his companion, Ted Dragon, a dancer with the New York City Ballet, drove out with the canvas, staying over with the Pollocks, and in the process becoming friends. The visit affirmed Ossorio's high esteem for Pollock's work. He also became interested in Krasner's work, which he saw at the house for the first time. Like so many others, Ossorio decided to rent a place and spend the summer of 1949 living in East Hampton.

"I saw a good deal of Lee and Jackson," Ossorio recalled. "I met him just after he had stopped drinking and so I knew him for two years as a teetotaler.[29] . . . With Jackson one didn't sit and have a long connected conversation. He would show the work, he would make very perceptive comments. His vocabulary was psychoanalytical in the sense that he had been in analysis and his intellectual vocabulary was based on that rather than on aesthetics or art history or philosophy."[30]

Ossorio was stimulated by the Pollocks and was also a sophisticated influence on them. He was able to respond to and support Pollock's work because of his grasp of modernism in the context of international art, philosophy, and culture. By this time, Ossorio had already lived in the Philippines, England, and the United States, having gone to boarding schools in England and Rhode Island, before studying art history at Harvard for both undergraduate and graduate studies. At Harvard, Ossorio had developed a deep interest in Asian as well as European and American art. He

knew such scholars of Asian art as Benjamin Rowland and the important Ceylonese philosopher and art historian Ananda K. Coomaraswamy. At Harvard's Peabody Museum, Ossorio had studied objects from the Pacific Islands as well as exhibits about the history of indigenous peoples of North America, whose art had long interested both Krasner and Pollock. He became a friend and a patron to the couple, whose work influenced Ossorio's own paintings and abstract sculpture.

Pollock was then seeing Dr. Edwin H. Heller, a local general practitioner in East Hampton, who had managed to get him to stop drinking. Heller told Pollock that he had to forgo all alcohol, because even a small amount would provoke him to drink to excess. He also understood the role of alcohol to numb threatening feelings and anxieties. Krasner, perhaps unwilling to accept the idea that Pollock's psyche was damaged, said she never understood what Heller did that others could not. She only heard from Pollock that Heller was "an honest man; I can believe in him."[31] While in Heller's care, Pollock was able to remain "on the wagon."

In January 1949, Stella Pollock wrote to Charles Pollock from her son Sande's house in Deep River, Connecticut: "Jack and Lee were here and we had a very nice Christmas . . . and there was no drinking. We were all so happy. Jack has been going to a Dr. in Hampton and hadn't drunk anything for over three weeks at Christmas. Hope he will stay with it. He says he wants to quit and went to the Dr. on his own. The Dr. told him he would have to leave it alone. Everything wine to beer for they were poison to him."[32]

Pollock's second solo show with Betty Parsons opened on January 24, 1949. Among those present were Grace Hartigan and Harry Jackson, who would marry in March. Lee and Jackson agreed to act as hosts, matron of honor, and best man; they were also the only two witnesses for an intimate ceremony conducted by their neighbor Judge William Schellinger.

During this time Krasner made a breakthrough in the imagery

of her painting. "I have to go with it," she explained of the change of direction, "so in that sense I find it a little off-beat compared to a great many of my contemporaries."[33] She referred to artists such as Rothko, Motherwell, or Gottlieb, who developed themes or signature images that they continued to explore over and over again. Her new direction employed a thinner paint application, a much larger scale, and, as she described it, "a vertical and horizontal distribution."[34]

In mid-April, Stella Pollock visited Jackson and Lee again. She reported to Charles how happy she had been to find that Jackson was still not drinking and was getting ready to put in a garden. "They have good soil. Lee loves to dig in the dirt and she has green fingers. Jack is going to shingle his studio. Prices have dropped enough that he feels he can he will do it himself."[35]

Pollock renewed his contract with Betty Parsons at the end of June 1949 to run through January 1, 1952. They told Pollock's mother that the sales from his show had been "very good" and that they wanted to make a trip to the West Coast.[36]

That July Krasner and Pollock were both in a show called "17 Eastern Long Island Artists," held at East Hampton's Guild Hall. John Little, Lee's old chum from the Hofmann School, who was now living in Springs, organized the show, and the potter Rose-anne Larkin and Enez Whipple, the cultural center's director, sponsored it against the protests of the conservative coterie of traditional artists who had been patronized by the Maidstone, a posh exclusive country club on the Atlantic Ocean in the village of East Hampton. These artists had dominated the local scene with their timid watercolors of seascapes and still lifes.

Little put himself in the show alongside a number of Krasner's and Pollock's friends, including James Brooks, Wilfrid Zogbaum, and Balcomb Greene, who were working abstractly, as well as more traditional figurative painters such as Alexander Brook and Raphael Soyer[37]. The *New York Times* critic Stuart Preston reviewed the show, describing it as a balance "between conserva-

tive and advanced art." He made a special note of "Jackson Pollock's chromatic explosions, those free of instinct" and wrote that "Lee Krasner's rigidly patterned abstracts sound a call to order."[38] Preston's opinion held little weight for East Hampton's uptight, "white-gloved hostesses pouring tea and serving punch" who found abstract art in general and Pollock's work in particular shocking.[39]

Unlike the Guild Hall show, which didn't acknowledge Pollock and Krasner's marriage, Lee and Jackson showed in the Sidney Janis Gallery's exhibition "Husband and Wife" that September. The show also included eight other artist-couples, such as the de Koonings, Max Ernst and Dorothea Tanning, and Picasso and Françoise Gilot.[40] Stuart Preston covered this show too and wrote, "On the whole the husbands are the more adventurous, giving ideas their heads, whereas the wives are apt to hold them back by the short reins of the particular scheme of design or color on which they are based. This is noticeably true of the Jackson Pollock as opposed to Lee Krasner's conglomeration of little forms that are both fastened and divided by a honeycomb of white line. In exactly the same relationship are Willem and Elaine de Kooning."[41]

Krasner reflected later that she thought the "title of the show is rather gimmicky, but for some reason Mr. Janis wanted to put on a show of husbands and wives who painted. And as a matter of fact, he had a curious accumulation there. I don't know whatever motive there was. It was sort of a catchy thing, I think."[42] She later told a reporter for *Time,* "I respected and understood his [Pollock's] painting as he did mine. There was never any cause for rivalry."[43]

A third solo show for Pollock opened at Betty Parsons on November 21, 1949. Afterward Lee and Jackson again spent Christmas in Deep River, Connecticut, with Stella, who reported to Frank that the couple was "so tired from being in the City just worn out. Had the best show he has ever had and sold well eigh-

teen paintings and prospects of others. They both are fine and he is still on the wagon."[44]

During the winter of 1950, Lee and Jackson went to stay in Alfonso Ossorio's house at 9 MacDougal Alley while he and Dragon were abroad. As Lee wrote them, the couple took advantage of their time in the city to visit lots of artists' exhibitions. She liked the ones of Gorky and Buffie Johnson, found acceptable those of Pousette-Dart and Jim Brooks, and rejected those of Herbert Ferber and Mary Callery.[45]

That winter a group of artists, including de Kooning, Franz Kline, and the sculptor Philip Pavia, rented a loft and held meetings at 39 East Eighth Street. They called themselves the Club and later the Artists Club. Pavia recalled that Pollock "would come and stand in the back—later sometimes drunk—then Bill and Franz would take care of him." Pavia's comments about women artists, however, are especially revealing: "The women's movement was born in the Club. They would get up there and tell us off—aggressive, and the joke was that we'd make monsters out of these women and got even the wives to talk. They did, too—like Lee, wanting to compete against Jackson."[46]

Clearly the level of sexism at the Club had grown since the more egalitarian days of the WPA and the Artists Union, where Lee was able to speak out and be respected. Hedda Sterne recalled: "I went to the Club only once or twice. People were incredibly hostile to each other. Insults would fly. . . . But the Club changed my image of Pollock. I was influenced by those stories of his violence at parties, etc., and to see this gentle, quiet, moving person was such a contrast. He was even proud of being inarticulate. . . . Jackson was a social outsider and his gestures were that, defending himself against people. He needed affection—who doesn't?—but didn't know how to find it."[47]

The Pollocks returned to East Hampton in the early spring. As the weather warmed, their friends began appearing. It was clearly a time when they enjoyed socializing in the local community.

Krasner was one of the thirty-three artists, along with Pollock and Bradley Walker Tomlin, whom Betty Parsons included in her review show of painters and sculptors in June 1950. In the *New York Times,* Stuart Preston reviewed the show, asking, "What meaning or value beyond themselves do these contrivances possess?" He also referred to the "impetuously handled, rather turgid colored forms of the painting of Lee Krasner," noting that "of course Jackson Pollock's seething canvas, the furious shaking of a lion's mane of color, is the climax of this direction."[48]

Around this time Krasner's work began to evolve away from the Little Image series. "I cannot make any connection why this happens," she insisted over and over again.[49] Krasner and Pollock both appeared in another show at Guild Hall of "Ten East Hampton Abstractionists" that opened on July 1. Among the other artists were friends and local acquaintances, including Motherwell, Linda Lindeberg, John Little, Wilfrid Zogbaum, James Brooks, and Buffie Johnson.[50] The local newspaper reported that "Pollock, a prominent figure in American modern art, was one of the seven American painters chosen to represent this country in the world-renowned Biennale, which opened recently in Venice."[51]

Like Buffie Johnson, who was identified as "Mrs. George [actually Gerald] Sykes," Lee Krasner was identified as "Mrs. Jackson Pollock." The practice of linking women's identities to their husbands' was common at this time in East Hampton society. Again Preston praised Pollock's big canvas, writing that it "dominates the North Gallery." He was less harsh about Krasner's work than previously, noting that she drew from Pollock's influence.

At the opening of the East Hampton show, Pollock met Hans Namuth, a young German-born photographer whose teacher Alexey Brodovitch had told him that Pollock was preeminent among contemporary artists. Namuth was spending the summer in Water Mill, not far from East Hampton, and asked Pollock if he could photograph him while he was painting. Pollock agreed, offering to start a new picture for the session. Namuth spent many

hours taking photographs of Pollock that summer, a project Krasner thought would benefit Pollock's stature.

While at their house Namuth also photographed Krasner in her studio. She posed with two large paintings (now destroyed) that depicted large stick figures, painted light on dark grounds. These presumably were in her studio when Betty Parsons visited and agreed to give her a show. These canvases are a far cry from Krasner's Little Image paintings, but they also appear to be unrelated to the geometric pictures she eventually put in her show at Parsons. Instead Krasner's stick figures recall those in Miró's work as well as in Pollock's mural for Peggy Guggenheim and his *Guardians of the Secret,* both of 1943. Krasner appeared to be playing catch-up to Pollock's invention, and when she realized this, she destroyed the new work and went off in a geometric direction that veered sharply away from her husband's work.[52]

Many factors suggest that Pollock's star was on the rise, though he lacked the confidence to comprehend that. Pollock got a taste of widespread fame in August 1949 when *Life* magazine featured an article titled "Jackson Pollock: Is He the Greatest Living Painter in the United States?"[53] The newfound celebrity, however, soon became difficult for Jackson to digest. His friend Jim Brooks recalled how the *Life* issue made Jackson "self-conscious." Brooks continued to observe: "You know you're expected to do a hell of a lot, being famous, and it made him self-conscious. . . . I think right then Jackson saw what was coming and was scared to death."[54]

In May 1950, Barnett Newman phoned to invite Pollock to sign an open letter of protest to the president of the Metropolitan Museum of Art alongside other vanguard painters. The protest was over the museum's director, Francis Henry Taylor, publicly declaring "his contempt for modern painting." The letter, published in both the *New York Times* and the *Herald Tribune,* said that the protestors refused to participate in the museum's national juried exhibition of contemporary American painting because the

"choice of jurors . . . does not warrant any hope that a just proportion of advanced art will be included."[55]

Lee had answered Newman's phone call, only to have him ignore her and ask to speak to Jackson, who agreed to lend his name. Hedda Sterne became the only woman to participate in the protest and in the now-notorious publicity photograph of the group, which was published in *Life* magazine on January 15, 1951, as "The Irascibles."[56] Krasner believed that the only reason one woman—Hedda Sterne—made the list is that Betty Parsons saw to it that she was. "She was [showing] in Betty's gallery and Betty said, 'you've got to put Hedda Sterne in,' and so they put Hedda Sterne in."[57] The photograph was shot for *Life* by Nina Leen on November 24, 1950, in a room rented for the occasion.

On August 5, 1950, *The New Yorker*'s "Talk of the Town" featured an interview with Jackson and Lee that some critics have interpreted as pushing a sexist stereotype.[58] Pollock is described as "watching his wife, the former Lee Krasner, a slim auburn-haired young woman who also is an artist, as she bent over a hot stove, making currant jelly." In all likelihood, however, Krasner was putting on a show of domestic creative activity for the *New Yorker* writer. Perhaps she wanted to make their home life seem idyllic and justify their residence far from the center of New York's art world. In fact she had already bragged to Mercedes of having developed cooking skills worthy of "Cordon Bleu," which she had been using to promote Pollock.[59]

Pollock told the writer that "I've got the old Eighth Street habit of sleeping all day and working all night pretty well licked. So has Lee. We had to, or lose the respect of the neighbors. I can't deny, though, that it's taken a little while. . . . It's marvelous the way Lee's adjusted herself. . . . She's a native New Yorker, but she's turned into a hell of a good gardener, and she's always up by nine. Ten at the latest. I'm way behind her in orientation."[60]

Jackson spoke of his childhood on his father's farm near Cody,

Wyoming, to which Krasner added, "Jackson's work is full of the West. That's what gives it that feeling of spaciousness. It's what makes it so American." From someone like Krasner, who repeatedly decried nationalism, this was a ploy at creating a niche for Pollock and eliciting good press.

Pollock recounted his journey from study with Benton to patronage from Peggy Guggenheim to the move out to Springs. "Somebody had bought one of my pictures. We lived for a year on that picture and a few clams I dug out of the bay with my toes. Since then things have been a little easier." The writer noted that "Mrs. Pollock smiled. 'Quite a little,' she said. 'Jackson showed thirty pictures last fall and sold all but five. And his collectors are nibbling at those.' Pollock grunted. 'Be nice if it lasts,' he said."[61] The writer then asked to see Pollock's work. On the wall of the living room was *Number Two,* 1949. The writer noted that he had forgotten the title and Krasner piped up, "Jackson used to give his pictures conventional titles—'Eyes in the Heat' and 'The Blue Unconscious' and so on—but now he simply numbers them. Numbers are neutral. They make people look at a picture for what it is—pure painting." Pollock averred, "I decided to stop adding to the confusion. Abstract painting is abstract. It confronts you. There was a reviewer a while back who wrote that my pictures didn't have any beginning or any end. He didn't mean it as a compliment, but it was. Only he didn't know it." Looking for another public relations angle, Krasner redoubled, "That's exactly what Jackson's work is . . . sort of unframed space."[62]

Even though Krasner did enjoy cooking, she understood that by presenting herself to the *New Yorker* reporter in the stereotypical role of homemaker, she would appear less threatening and Pollock would appear more conventional. The low status of women at this time is also behind Barnett Newman's failure to invite Krasner to join the men in making their protest to the Metropolitan Museum and to be in the photograph known as "The Irascibles." Naturally, male artists were reluctant to share their privileged

status with women in a profession where success was already so elusive.

It was Krasner's threat that Charles-Édouard Jeanneret-Gris, the well-known architect and painter known as Le Corbusier, saw that summer when he paid a visit to the Pollocks with their friend and Springs neighbor, the sculptor Costantino Nivola. "I took Le Corbusier to see Jackson—he was suspicious of Abstract Expressionists, calling them noisy and trying to get away from discipline—but he was pleased Jackson had his book," recalled Nivola. Le Corbusier, he reported, said of Jackson's work, "This man is like a hunter who shoots without aiming. But his wife, she has talent—women always have too much talent."[63]

In the fall, Pollock's works were on view in Venice in both the XXV Biennale and as part of Peggy Guggenheim's collection at the Museo Correr. On November 20, *Time* published an article, "Chaos, Damn It!," which claimed that Pollock had "followed his canvases to Italy." Yet *Time* took remarks made by the Italian critic Bruno Alfieri in *L'Arte Moderna* (and reprinted in Guggenheim's catalogue) out of context, and Pollock became distressed over the emphasis on "chaos" in the *Time* article. In response, Krasner helped Pollock draft a telegram to *Time:* "NO CHAOS DAMN IT. DAMNED BUSY PAINTING AS YOU CAN SEE BY MY SHOW COMING UP NOV. 28 I'VE NEVER BEEN TO EUROPE. THINK YOU LEFT OUT MOST EXCITING PART OF MR. ALFIERI'S PIECE."[64]

"What they want is to stop modern art," Pollock exclaimed to his friend Jeffrey Potter. "It's not just me they're after, but taking me as a symbol sure works."[65] When the painter Gina Knee ran into Pollock on the street in Amagansett, she sensed that he was "very upset" about the piece in *Time:* "I didn't try to console him but reasoned with him; how good he was and how wonderful that he was in that show. He brightened a bit but I thought, 'Oh—there's more than that churning inside of him.'"[66] Sensing a storm brewing in Jackson, she decided to decline the Pollocks' invitation to a dinner the Saturday after Thanksgiving. Years later,

she claimed that her husband, Alexander Brook, the academic portraitist, was not fond of Lee, implying that he preferred prettier women, since he was always looking for new subjects to paint.

Soon after Knee's encounter with Pollock, Hans Namuth filmed him painting on glass. He shot from below, catching the action through the glass surface of Jackson laying down the paint. What was usually the act of painting privately in one's studio suddenly was recorded for all to see. In a sense this was a psychic violation. Yet Pollock had not only acceded in advance, but also actually performed by painting while being filmed for the first time. The film was finished late on the cold and windy Saturday following Thanksgiving. Pollock and Namuth came into the house just as Lee had finished preparing an elaborate dinner party. The other guests included the photographer's wife, Carmen, Alfonso Ossorio and Ted Dragon, Josephine and John Little, Penny and Jeffrey Potter, Betsy and Wilfrid Zogbaum, and the architect and critic, Peter Blake.[67]

But Lee had made a mistake in not removing all alcohol from the house, and soon she was stunned to see Pollock pull a bottle of whiskey from under the sink and fill two large glasses as he said to Namuth: "This is the first drink I've had in two years. Dammit, we need it!"[68] Lee was horrified at the tragedy of Pollock's act. In fact, Pollock got so drunk that he turned the dinner table over onto the laps of their guests, destroying both the food and the evening. Pollock didn't even try to justify himself. A few days later, he told a concerned Jeffrey Potter: "Shit, I wasn't upset! The table was."[69]

And Pollock's doctor, Edwin H. Heller, had been killed in a car crash six months earlier. The death was devastating, and sudden. He had been the only doctor who succeeded in keeping Pollock away from alcohol. The nasty comment published in *Time* and the disturbance Namuth caused by filming the insecure artist in the process of painting combined to wear away Pollock's resolve to stay on the wagon.

Pollock's fourth solo show with Betty Parsons opened on the evening of November 28 and remained on view through December 16, 1950. Among the thirty-two works were several now considered his best: *Autumn Rhythm, Lavender Mist,* and *One,* which, ironically, given the show's failure to sell, are now in the collections of the Metropolitan Museum of Art, the National Gallery of Art, and the Museum of Modern Art.[70] Only *Lavender Mist* did sell, to Ossorio for $1,500.[71]

Parsons had crammed Pollock's monumental paintings into an inadequate space that didn't do them justice. "The show was a disaster," Parsons recalled. "For me it was heartbreaking, those big paintings at a mere $1200. For Jackson it was ghastly; here was beauty, but instead of admiration it brought contempt."[72]

Pollock's brother Marvin Jay wrote from New York to their brother Frank in Los Angeles: "The big thing right now is Jack's show. Alma and I were there and it was bigger than ever this year and many important people in the art world were present. Lee seemed very happy and greeted every one with a big smile."[73] Among those whom she could not have been pleased to see was Elaine de Kooning, still married to (though estranged from) Willem de Kooning. According to Clement Greenberg, "This was Jackson's best show, and up came Elaine de Kooning, who said the show was no good except for one painting—the only weak picture in the show, the one he painted [on glass] when they were working on the movie. The show was so good, it's unbelievable."[74] Elaine de Kooning's comment can only have irritated Krasner. She must have noted that Ossorio purchased not only the Pollock but also three oils on paper from de Kooning's women series.

Even the reviews for the show were mixed. The critic for the *New York Times,* Howard Devree, called Pollock one of two (with Mark Tobey) of "the most controversial figures in the field" and declared that the "content" in Pollock's work was "almost negligible." He trivialized the artist by asking, "But isn't all this rather in the nature of day-dreaming we have all done while staring at a

wallpaper pattern and ourselves investing it with ideas?"[75] Robert
Coates of *The New Yorker* also professed doubt about the work,
asking, "Does personal comment ever come through to us?"[76]

Even though more positive notices appeared in *Art News*
and *Art Digest,* they were not enough to boost Pollock's sinking
spirits.[77] *Art News* chose Pollock's show as one of the three best
one-man shows of the year, ranking it ahead of the Swiss sculptor
Alberto Giacometti's, but behind the early American modernist
John Marin's.[78] When the sales that Pollock had hoped for did not
materialize, it compounded his letdown.[79] His serious lack of self-
esteem made things worse. Krasner had her hands full.

# TWELVE

## First Solo Show, 1951–52

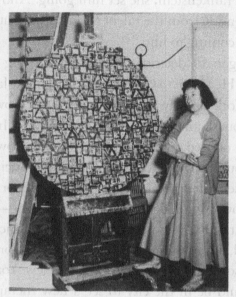

Lee Krasner with her painting *Stop and Go*, c. 1950, photographer unknown. Ever frugal, she created this tondo of 1949–50 by reusing the round wooden base that had served her while making the two mosaic tables. She invented repeated hieroglyphic-like symbols that were reminiscent of some of the rhythmic forms on the tables.

P OLLOCK'S RELAPSE SUBJECTED KRASNER TO INCREASED STRESS. "As Jackson's fame grew, he became more and more tortured," she reflected. "My help, assistance, and encouragement seemed insufficient. His feelings towards me became somewhat ambiguous. Of course, he had many other supporters. Tony Smith, then an architect (later a sculptor), was among the strongest, as was [the abstract painter] Clyfford Still, whose letters and comments meant a great deal to Jackson. He adored Franz

Kline [another abstract painter]—whom he could talk to. And of course there was Clement Greenberg, who from the very first was one of his most avid supporters."[1] Fritz Bultman blamed Lee for Jackson's problems, claiming, "In a way Jackson was Lee's creation, her Frankenstein; she set him going. And she saw *where* he was going, aside from the talent and all that, but he was devastated by fame coming to him."[2]

Pollock began to deteriorate rapidly. Nothing seemed to go right for him. He wrote to Ossorio and Dragon in January 1951, "I found New York terribly depressing after my show—and nearly impossible—but I am coming out of it now."[3] In late January 1951, Ossorio offered Pollock $200 a month "towards the next painting of yours that we acquire." Yet other anticipated sales did not materialize. A few weeks later, he wrote Ossorio, "I really hit an all time low—with depression and drinking—NYC is brutal."[4] Pollock tried seeing his regular homeopathic doctor, Elizabeth Hubbard, but nothing mitigated his depression.

Ossorio also lent Jackson and Lee his New York town house so Jackson could be in the city to see a new therapist, Ruth Fox, M.D., beginning in March 1951. Fox served as president of the New York City Medical Society on Alcoholism and vice president of the National Committee on Alcoholism. Lee had learned about the doctor through Elizabeth Hubbard. Fox treated alcoholism through psychoanalytic therapy combined with participation in Alcoholics Anonymous, which meant that Jackson had to adhere to total abstinence.[5] Fox prescribed a drug called Antabuse, which makes the patient sick if he or she drinks alcohol. In 1948 Fox had helped bring the drug to the United States from Denmark, where it was developed.[6] Pollock resisted both taking Antabuse and going to meetings of Alcoholics Anonymous in Southampton, which he did not like, perhaps because of its group interaction and its religious invocations.

Fox also insisted that alcoholics realize how much their families suffered. Sober partners had to deal with an alcoholic's mood

changes and their demands for "exclusive attention," and they became exposed to ostracism and shame in the community.[7] For Krasner, Pollock's behavior when drunk was so outrageous that their marriage and their social life withered. Their friends were amazed at the extent of Krasner's devotion under such trying circumstances. Linda Lindeberg, a painter who had been a Hofmann student, recalled that Lee "was like his left hand and though she lived with an alcoholic, never, never did I hear her say anything against Jackson."[8]

In an essay, "The Alcoholic Spouse," published in 1956, Fox wrote: "The wives of alcoholic men . . . will make almost any sacrifice to help their husbands once they have learned to look upon them as sick individuals. This is partly because of their greater tendency to mother and sympathize with the husband, sensing that he cannot help himself."[9] Fox also defined three types of alcoholics, of which she would have placed Pollock among the "primary addicts . . . persons who have been psychoneurotic throughout their lives, with alcoholism starting at an early age, often in their teens. These individuals were obviously maladjusted on an emotional level prior to their compulsive drinking. They might have been introverted or insecure with respect to interpersonal relations, or excessively dependent."[10]

Years later Krasner told a journalist who inquired about Pollock's drinking, "Who knows why people drink? With all that's been written about alcoholism, we still don't know what really causes it. In all the years I knew him, he drank off and on except for one two-year period. He tried every known way to stop, except for AA, which for some reason he couldn't accept, and I still have all the bills to prove it. He never drank when he was working; it was two different cycles of his life."[11] Another time she commented that Pollock's heavy drinking related to the macho image that "originated as far back as [his teacher] Benton, where it was he-man stuff to do."[12]

On March 9, 1951, Pollock signed a will, leaving everything

to Krasner. In the event she predeceased him, he left everything to his brother Sande McCoy. In the event that neither survived him, he arranged to have his estate divided among his other three brothers, Frank, Jay, and Charles. Alternative executors included Sande McCoy, Clement Greenberg, and Alfonso Ossorio, in that order. In a separate letter that accompanied the will, Pollock wrote, "Lee—if you are the Executrix lend some of the paintings to my brothers then living. Remember those paintings will belong to you alone and you alone can decide which paintings are to be borrowed and for how long. This is a request which I have purposely omitted from my will because of its complicating nature." [13]

Krasner and Pollock showed together with many other abstract artists in the Artists Club's 9th Street Show. The show was curated by Leo Castelli and opened on May 21, 1951. The announcement for the show still spelled her name with the double *s*. The few other women artists in the large show included Elaine de Kooning and Grace Hartigan. [14]

On June 7 the Pollocks were back in Springs, and Jackson wrote to Ossorio that Krasner was preparing for her first solo exhibition in New York City. [15] Pollock had persuaded his dealer, Betty Parsons, to show her work. Parsons later explained that she "didn't believe in having husband and wife in the same gallery. Jackson knew this—he said they shouldn't be with the same analyst either—but for Lee he could be persistent. And I felt if I didn't show her, there would be problems." [16] So Parsons agreed to give Krasner a show to satisfy Pollock.

Though some deny that Pollock supported Krasner as an artist, Parson's statement corroborates Krasner's claims that he did. Certainly Pollock might have pretended otherwise on occasion, especially to please his male colleagues, but in the letter he wrote to Ossorio and Dragon and in the efforts he made with Parsons, his actions confirm Krasner's sense of the matter.

Krasner always said that Parsons gave her a show because

"Jackson asked Betty . . . to come and look at my work with regard to giving me a show. And so she came, and she looked, and scheduled a show. But the show was like nine months away or something. And right after she left . . . my image so-called broke. . . . A whole new thing happened and that became my first show with Betty Parsons."[17]

Krasner tried to explain the concept of her art changing as "going for a certain length of time" before "the image breaks again."[18] From the time Parsons saw her work and agreed to a show, Krasner admitted, "it was a far cry from what is now known as the 'Little Image.'"[19] Krasner's show "Paintings 1951, Lee Krasner" presented canvases that were larger than she had been making. "You could say they maybe started to blow up. For me it was only holding the vertical, though some of them move horizontally as well." After making this comment to the critic Cindy Nemser in an interview in 1972, Krasner proudly quoted Pollock's 1951 letter to Ossorio: "'Lee is doing some of her best painting. It has a freshness and bigness that she didn't get before. I think she will have a handsome show.'"[20] This was Krasner's first solo show ever, and it ran for a month, starting on October 15.

Among the fourteen canvases she showed at Parsons, Krasner kept only two in their original state. She either reused the old canvases as backgrounds for the collages she made for a show in 1955 or cut them up.[21] She later described one of the fourteen as "a vertical-horizontal measurement of space in soft color."[22] She was probably referring to the canvas known as *Number 2* which survived rolled up as late as 1967, and measures 92.5 by 132 inches.[23] The geometric shapes and overlapping forms relate to Mondrian, but the more innovative palette is composed mainly of earth tones.

Along with Krasner, Parsons also showed Anne Ryan, who had been active as a writer in Greenwich Village during the 1920s. Ryan was married, the mother of three children, and a poet. In 1941 she took up painting and then joined Atelier 17, Stanley Hayter's printmaking studio. Subsequently she produced prints

and collages, the latter after being inspired by a show of Kurt Schwitters's work.[24] Ryan also designed scenery for the theater and costumes for the ballet. A generation older than Krasner, Ryan must have made an impression on Krasner. When interviewed later in life about women artists, Krasner named Ryan as one who had come to her attention.[25]

Both Ryan's small collages and Krasner's paintings were reviewed together, like their shows, by Stuart Preston in the *New York Times*. About Krasner, he wrote: "By means of their placid rectangular forms, by their discreet, limpid color and their unobtrusive handling, these paintings, large and small, emanate feelings of calm and restraint. Roughly, here is the Mondrian formula worked out with feminine acuteness and a searching for formal and chromatic harmonies rather than a delivery of water-tight solutions. Here designs are occasionally awkward, but they are ever clear and it is to her credit that the more complex they get the better they come off." He even wrote of one work's "majestic and thoughtful construction."[26] How, one wonders, did he define "feminine acuteness," and was it intended as a compliment?

Krasner must have longed for the more effusive enthusiasm Preston reserved for Ryan's collages, which he described as "abstracts made with bits of colored paper and cloth. Nothing new in the way of praise can be said about these fragments of delicacy that has not appeared in this column before. Their taste is as refined as it is unvarying and she seems to have a power of self-criticism that some of her more flamboyant colleagues lack. Free from ostentation, she stands in relation to them rather as Boudin to the great Impressionists."[27]

Regardless of how Krasner judged herself in relation to Ryan, the more interesting question to ask is: what had influenced Krasner's shift in style before she showed with Ryan? One answer might be geometric abstractions by I. Rice Pereira, who was one of only three women in the Museum of Modern Art's 1946 show "Fourteen Americans." Then, along with Ryan, she was

one of only seven women in that museum's 1951 traveling survey, "Abstract Painting and Sculpture in America." Opinion remains divided as to whether the geometric work Krasner showed at Parsons owed a debt to Mondrian, whom she acknowledged, or Rice Pereira, whom she did not.[28]

The artist Robert Goodnough reviewed Krasner's show in *Art News,* noting: "One comes away with the feeling of having been journeying through a vast uninhabited land of quiet color."[29] Reviewing the show in *Art Digest,* the critic Dore Ashton also focused on her "love for delicate, closely related color tonalities," remarking that she used "right-angle tensions related to Mondrian in structure, if more sensuous in color."[30]

Another review, also clipped and saved by Krasner, which appears to be written by Emily Genauer, the chief art critic at the *New York Herald Tribune,* linked Krasner to "a purification of Mondrian, whose rigid formalism has been purged of all harshness."[31] Given Krasner's strong interest in nature, she must have cringed when this same review stated: "This art seems to demand no identification with nature, nor does it command a vital illusion." Still, this reviewer admitted to being "touched" by Krasner's "painted surfaces . . . beautifully smoothed into quietly innocuous patterns of arresting, sweetly cultivated tonal composition."[32] It was not a bad set of reviews for a solo debut in New York, but Parsons did not arrange much in the way of either sales or publicity, leading to Krasner's disappointment. Most likely the huge fuss made over Pollock's shows had raised her expectations beyond what was typical or likely, especially for a woman artist in 1951.

When Krasner and Pollock learned in 1951 that a seventy-acre estate on beautiful Georgica Pond in East Hampton that had once been owned by the late painter/designers Albert and Adele Herter was on the market, they recommended that Ossorio buy it and move out from the city.[33] Ossorio drove out in August, saw the mansion and its sprawling grounds, called The Creeks, and took their advice. Soon he was acting as host for many who came out to

visit, among them Parsons and abstract expressionist painters like Clyfford Still and Grace Hartigan.[34]

Pollock's fifth show at Parsons followed later that fall, opening on November 26, 1951. Greenberg, having resigned from *The Nation,* wrote in *Partisan Review* of "achieved and monumental works of art, beyond accomplishedness, facility or taste." He concluded, "If Pollock were a Frenchman, people would already be calling him 'maitre' and speculating in his pictures." At this moment, Greenberg identified Pollock as "the best painter of a whole generation."[35]

Greenberg didn't write a word about Krasner's show, which was odd, because the three of them were close friends. Greenberg admitted that he really only conversed with Krasner, and not Pollock, about art. "Lee and I and Jackson would sit at the kitchen table and talk for hours—all day sometimes. Jackson usually wouldn't say much—we'd drink a lot of coffee. I know that this sounds like part of a myth. We would sit for hours and go to bed at three or four in the morning."[36] Krasner cannot have missed the irony in this situation. She had first introduced Greenberg to avant-garde art, to Hofmann, and continued to provide articulate intelligent art talk for him, and yet he wrote only about Pollock's work.

At this same time, Pollock, still seeing Dr. Ruth Fox, was going for intensive "biochemical" treatment for alcoholism that he had begun in September 1951, some six months after beginning with Fox. Discouraged by Pollock's refusal to go to Alcoholics Anonymous and to take Antabuse, she eventually objected to these concurrent treatments, causing Pollock to cease seeing her in June 1952. For these "biochemical" treatments that continued through the fall of 1953, Pollock traveled to Park Avenue in New York to see Grant Mark, who was not a physician but had been recommended by Pollock and Krasner's homeopathic doctor, Elizabeth Hubbard, who worked with Mark for a time. One of Pollock's friends later characterized Mark as "a biochemist with a Svengali

air," likening his excessive control over Pollock to the villainous hypnotist in George du Maurier's 1894 novel, *Trilby*.[37] Krasner, who was herself prey to medical charlatanism, also received treatments from Mark, who accepted two of her paintings for his fees.[38]

Mark prescribed for Pollock a regimen of salt baths, a highly restricted diet, injections of copper and zinc, followed by analysis of his urine and blood samples. Against Mark's instructions, Pollock continued to drink alcohol, but he also consumed Mark's own soy-based emulsion at a cost of $200 a month.[39] Pollock responded badly to these treatments, exclaiming: "It's like being skinned alive. And instead of putting lead in my pencil, he must have taken some out."[40]

From the beginning of their relationship, Krasner had filled in for Pollock's brother Sande as Jackson's caretaker and protector. Yet in dealing with Pollock's emotional problems, she gradually slipped into behavior that is now often termed "codependency." Though initially their needs had seemed compatible, as Pollock put her under growing pressure, her health began to break. She suffered from colitis and other painful digestive problems that stress exacerbated. She had become so enmeshed in his addiction that everything he did affected her. As he turned increasingly to greater and greater amounts of alcohol, her life became more and more about trying to stop his drinking. As his caregiver, she was constantly tied into his destructive behavior. His needs, which may have initially appealed to her wish to be maternal, had by now become suffocating.

In the early-morning hours on December 29, 1951, after a night of drinking, Pollock was driving home alone in his Cadillac, going down the dark roads toward his house in Springs. At the Louse Point intersection on Old Stone Highway, he lost control of the big car and veered off the road, catching several mailboxes and continuing onto the other side, hitting a utility pole and a tree. The accident destroyed the car, but Pollock was able to walk away from the wreckage.[41] Now his drinking was compromising his safety.

On March 30, 1952, Pollock wrote to Ossorio, "My experience with Dr. Mark which got more involved each weak [sic] until a crisis last week—I'm still a little dazed by the whole experience."[42]

Ossorio recalled Pollock telling him that Mark said "he should eat no fowl that can't take off at fifty miles an hour, such as wild duck, and his range of understanding was enough to see the humor in it."[43] In Paris Ossorio had befriended the avant-garde painter and sculptor Jean Dubuffet and amassed a collection of his work. Meanwhile he was actively pursuing his interest in Asian culture, including Japanese art and Zen, and it's possible he discussed Zen concepts of "action" with Pollock.

Among the books Ossorio acquired that year was Langdon Warner's new The Enduring Art of Japan.[44] Warner was a Harvard professor, Asian art expert, and onetime student of Okakura Tenshin, a Japanese scholar who became the first head of the Boston Museum of Fine Arts' Asian art division in 1910.[45] Warner was a raconteur, and he taught art history at Harvard when Ossorio was a student.[46] Ossorio found Warner's book and his teachings very valuable because they introduced him to Zen and to Daisetz T. Suzuki's 1934 book, Introduction to Zen Buddhism, a book much read in art circles in New York during the 1950s.[47] In his book Warner wrote, "In the practice of putting down their paintings in ink on paper Zen artists discovered that the principle of muga (it is not I that am doing this) opens the gate for the necessary essential truth to flow in. When the self does not control the drawing, meaning must. The principle runs all through Zen teachings especially where action is involved."[48]

The concept of action also surfaces in Harold Rosenberg's article "The American Action Painters," which appeared in Art News in December 1952. Rosenberg wrote, "At a certain moment the canvas began to appear to one American painter after another as an arena in which to act—rather than as a space in which to reproduce, re-design, analyze, or 'express' an object, actual or imagined."[49] Rosenberg's work on this landmark article, in which

he first coined the term "action painting," appears to coincide with the publication of Warner's new book.

Around the time Rosenberg was writing his article, Pollock decided to leave Parsons's gallery as soon as his contract expired at the end of 1951. He had become disappointed by her failure to sell his paintings. Nonetheless, Parsons asked Pollock to remain until May 1952 so that she could try to get some business from his last show. That spring he moved to Sidney Janis's gallery, which was planning to give Pollock a solo show. Janis wrote Pollock that Greenberg had "reacted very nicely to your new things."[50]

Pollock's move to Janis proved traumatic for Krasner, who lost Parsons as her dealer. Parsons recollected, "I know that Lee . . . was upset when I decided not to continue showing her work. But, as I told Lee, it had nothing to do with thinking she wasn't a very fine painter, it was that the association was too painful."[51] As for Krasner, she later reported that these words from Parsons "put me into such as state of shock. I couldn't paint for nine months."[52] This loss for Krasner cannot have helped her relations with her troubled husband.

Pollock's conflicts, his disappointment with his dealer, and his frustrated desire to have a child, despite his total disregard for the responsibilities involved in parenthood, fueled his anger at Krasner, who seemed to deny him his wishes. Hence he displaced some of his resentment by flirting in public with other women in their circle, especially those younger and more attractive, such as Mercedes Carles Matter. Often this behavior, then escalating, occurred in front of Lee.

Mercedes was a woman so desired that sleeping with her conveyed status among New York artists. Mercedes was no ingénue—she liked to drink with the boys at the Cedar Bar (aka the Cedar Tavern) and to flirt with them at the Club, where liquor flowed freely and dancing was wild.[53] Cynthia Navaretta, who also frequented the Club, recalled Mercedes as very striking, self-confident, and "a pirate with everyone's husband."[54] Though

Krasner chose to avoid the Club and the Cedar, she could not keep Pollock away from either place.

The possibility that Jackson not only had flirted but had become sexually involved with Mercedes has been dismissed along with the indiscreet boasts he made about his sexual escapades. Though discounted as mere bravado, some of Pollock's claims appear to have been true. Rita Benton, the wife of Pollock's favorite teacher, Thomas Hart Benton, told Gene Thaw (coauthor of the Pollock catalogue raisonné) that she gave the young Pollock "his baptism of fire in bed."[55]

By 1951, Mercedes was having an intense affair with Harold Rosenberg. Both Mercedes and Rosenberg had histories of multiple lovers and were married to long-suffering partners. She had already had well-known liaisons with Gorky, Hofmann, George McNeil, and Philip Guston. Though Mercedes usually went for a man because she admired his art, Harold was an exception.[56] Rosenberg, for his part, usually had affairs with women art writers, but he was not opposed to propositioning young women artists.[57]

Harold and Mercedes, both dexterous and experienced at deceiving their paramours, had met each other's match. Mercedes was able to tease Rosenberg with her other liaisons in the art world, but none would have had the same impact on him as her admiration for and public flirtation with Pollock, whom *Life* magazine had already turned into a celebrity and who was on his way to becoming a cultural icon.

In surviving fragments of Rosenberg's journal for May 1951, he wrote about his affair with Mercedes, while fending off her "rage": "She believes that I do not love her and cannot be cured of the pain of having read in my notebook that an affair is the conquest of the strange & that one wills to return to his wife as to himself."[58] In these same pages, he remarks how much he admired the fiction his wife was then writing; he repeatedly documents his own heavy drinking and the resulting hangovers; he comments on his friendship with Bill de Kooning, which was then so close that Rosen-

berg could stop by unannounced at all times of the day and night, inviting himself to join Bill and Elaine at parties to which he had not been invited.[59]

At the time of the journal, Rosenberg was about to depart for Paris, where his wife, May, had taken their daughter, Patia, to get away from his too-conspicuous affair with Mercedes. In June Rosenberg noted that he "had felt disturbed after leaving M [Mercedes] but today I hardly thought of her except very distantly. May's letters are very cheerful & discerning."

On June 16, Rosenberg reported that Herbert Matter was uttering nonsense when he said that Clement Greenberg "had a high opinion of me, liked me, etc." Though Herbert Matter described Greenberg as "pathological" and attributed his problems to alcoholism, Rosenberg still concluded "that C [Clement] never had an idea under any condition & is essentially empty & rattle-brained."[60]

Greenberg and Rosenberg were competing with each other to be the greatest art critic of their time. Because Greenberg had premised his own authority on discovering and promoting Pollock, Rosenberg saw that he could take Greenberg down a peg by denigrating Pollock. Whether or not Lee believed that Mercedes's flirtation with Jackson had concluded in a sexual encounter, she must have felt betrayed by her friend's intimate involvement with Rosenberg, whom she saw as trying to subvert Pollock's status. In any case, the two former friends had become estranged.

Rosenberg was also able to build his own authority by promoting Bill de Kooning over Pollock. After all, Rosenberg had already been sleeping with de Kooning's wife before he got together with Mercedes. Though she loyally promoted Bill, Elaine de Kooning was as spirited and as sexually active as Mercedes. And Bill paid no attention, because he was preoccupied with loves of his own.

Ultimately for Rosenberg, his weapon against Greenberg was his pen. His agenda did not escape the young artist and critic Paul Brach, who accused him of trying to bring Jackson down. Rosenberg implicitly confirmed Brach's accusation, replying, "You're a

smart kid."[61] What escaped Brach and Pollock's biographers alike was that Rosenberg's strike at Pollock was inevitably colored by his emotions over his affairs with both Mercedes and Elaine.

Mercedes was jealous of Elaine. Rosenberg noted in his journal, "I was quite drunk & reluctant to go to bed tho she [Mercedes] was hoping I would not go to the Club, since Elaine was there."[62] He went instead to the Cedar Bar and the next day reported, "M [Mercedes] was in a terrifying state this morning because I had 'gone to E [Elaine de Kooning]' at the Cedar."[63] Mercedes, venting her jealousy of Elaine to Harold, had to have realized that her own high regard for Pollock, as well as her history with both Pollock and Krasner, provoked Rosenberg, even while he tried to undermine Greenberg. It is not clear if Mercedes saw Rosenberg's swipe at Pollock as collateral damage in her affair, or as something that added value to the power of her own conquests.

In the meantime, as Krasner and many others were well aware, Elaine had begun a long-term affair with Thomas Hess, the powerful critic and editor of Art News, though she continued to see Rosenberg long into the late 1950s and 1960s.[64] In their biography of de Kooning, Mark Stevens and Annalyn Swan state: "Many, in fact, believed that [Elaine] chose to sleep with the two critics in order to promote her husband's career. That act of devotion was, however, unnecessary; they were already committed to de Kooning."[65] It should be noted that these biographers fail to account for the fickleness of critics, whose loyalties do not necessarily last forever.

Krasner was among those who believed that Elaine slept with the two powerful critics as part of her strategy to promote her husband's work.[66] Krasner not only disapproved of the kind of marriage Elaine and Bill had, in which both partners pursued sexual relations with others, but she was especially offended by Elaine's sexual liaisons with the two critics because they came to favor Bill's work over Jackson's.[67]

If the gossip about all these infidelities was not enough for Krasner to bear, she also had to be hospitable to another beautiful and much younger woman painter—Helen Frankenthaler, who was Clement Greenberg's new girlfriend. The couple arrived as the Pollocks' houseguests in the summer of 1952. At the time, Frankenthaler was in her early twenties, literally a generation younger than Krasner and Greenberg. She was the daughter of a New York superior court judge from a well-established German-Jewish family, the kind that often looked down on poor Russian-Jewish immigrants like Krasner's parents and older siblings or, for that matter, Greenberg's parents. A photograph of the foursome on the beach in East Hampton documents the visit and shows a slender Krasner looking tiny next to Frankenthaler's more buxom figure.[68] Frankenthaler's threat to Krasner, however, was not as a glamorous younger woman artist who might try to take her famous husband away from her, but as one who would respond to Pollock's example and method, then enjoy the status afforded by her brief acquaintance with him. Frankenthaler became linked to Pollock's celebrity and style, but Greenberg, not Pollock, was her ticket to fame. By 1961, the artist Morris Louis, a Greenberg disciple, remarked that Frankenthaler served as "a bridge between Pollock and what was possible."[69]

Krasner, however, took these challenges in stride and kept her focus on helping Pollock get ahead. She was responsible for arranging his first solo show at the Janis Gallery (located across the hall from Betty Parsons at 15 East Fifty-seventh Street) from November 10 to 29, 1952. Janis, who had known Krasner since before he published his 1944 book, *Abstract and Surrealist Art,* recalled that Pollock had dropped by his new gallery in 1948. "At the time he was showing with Betty Parsons, so I didn't say anything. Finally he left. Then, almost five years later, Lee Krasner came to us and said that Jackson was no longer with Betty Parsons and he was looking for a new gallery."

Knowing that in recent years Pollock had had a show every year, Janis asked her, "Don't you think, Lee, that the market is rather saturated with Pollock's work?"

She responded, "Sidney, the surface hasn't even been scratched."

"And how right she was!" he recalled. "Anyway, we got together, Lee and I, and we had a verbal contract, and we gave Jackson his first show . . . a magnificent show. He had changed from his 'drip' image to a kind of impasto, pigment surface, and it was more figurative, but still had the Jackson Pollock bite. The show wasn't too successful."[70]

Janis did point out that later he was able to sell some of these same paintings to museums. Greenberg, who by now felt Pollock's "inspiration was flagging," declined to review the show at Janis.[71] In the *New York Times*, however, Howard Devree was more positive about Pollock than he had ever been before, comparing some of his new work to that of Kandinsky. He saw what he called a "source of inspiration with a use of deep space instead of obsession with mere surface."[72] Devree's opinion meant much less to Pollock and Krasner than Greenberg's silence, which really pained both of them.

A week after the Janis exhibition, Pollock's "first retrospective show" took place at Bennington College in Vermont, organized by Greenberg, who had handpicked eight paintings for the show. He had also written a note for the catalogue (a folder). His belief in Pollock is clear, though he had his own idea of Pollock's strengths: "Most of the paintings on view are major works, major in a way that very little American art has been up to now. That is, they determine the main tradition of painting at their point in time."[73]

Krasner and Pollock borrowed Ossorio's station wagon to drive up to Bennington for the opening, accompanied in the car by Greenberg and Frankenthaler. They planned to make an unhurried trip, stopping at the home of the sculptor David Smith and Jean Freas in Bolton's Landing, New York, on Lake George. Greenberg later told a biographer that Krasner had a "tantrum"

after he, Pollock, Smith, and Frankenthaler spent a long time in Smith's studio having drinks and looking at his new work.[74] Krasner must have panicked, fearing that Pollock would be too drunk to show up at his own opening. She insisted that they leave at once for Bennington without touching the carefully prepared supper.[75]

According to Freas, the Pollocks stopped in Bolton's Landing because a reporter for "the March of Time was coming" and expected to film both artists. Freas also described Krasner's arrival "wearing a fur coat—because by then they were getting some recognition—and I had made this really nice meal and so forth. And she said, 'Oh, we couldn't possibly eat here.' Pollock was—if you even spoke to him he'd turn red. He just—and he looked thoroughly miserable, he was sober."[76] If, however, as Greenberg recalled, Pollock had already been drinking, Freas might have been wrong.

Krasner's insistence that Pollock stop drinking in Bolton's Landing offended Freas, who in retrospect appears to have been naive: "At this point they were like—she was calling every shot, and he stayed wherever Mama said. She was very ambitious, which I don't—I'm not rebuking her for that—but she was very nasty, to me—and I know why she was nasty: because I was young and pretty, and she was—I think she may have been the ugliest woman I've ever seen. The god that made her was not kind to her. She was behind the door when the looks—she had this quivering upper lip, like this, and—I don't know what she became later on, but I know she had this trembling, thick upper lip."[77]

Freas said that Krasner was "very tough. You talk about tough. Whoa! She was *the* toughest woman in the art world. No question about that."[78] A generation younger than Krasner, Freas had just graduated from Sarah Lawrence two years earlier. Freas married Smith, bore him two daughters, and then divorced.[79] As "Jean Smith," she later became a TV journalist and writer, but she never competed as an artist with David Smith, even working in the same arena, as Krasner did with Pollock.

Interviewed years later, Freas was critical of Krasner, whom she believed ordered Pollock around. She had little sympathy for being the wife of a troubled alcoholic: "He had to pay for every time he'd ever misbehaved, by her. And she was uncouth, she was mean—that's the only side of her—she may have had wonderful sides to her, I never saw them." [80] Freas recalled that Pollock was the most diffident person she'd ever met when he was sober. "But when he was drunk he was horrible. He was like a gargoyle. He was very handsome, you know, until he drank, and then his whole face underwent change. Ugh! I've never known an alcoholic to change so entirely as he did." [81] According to Freas, she and Smith saw Pollock mainly at the Cedar Bar, "usually not with her [Krasner], because they would have these fights, and they wouldn't be together." [82] She seems not to have understood that Krasner detested the Cedar Bar. Thus Krasner not only had to deal with Pollock's alcoholic unraveling before his show opened, but she also had to struggle to extricate him from their "friends" who were indifferent, even hostile, to her trials.

In Bennington, the painter Paul Feeley and his wife, Helen, hosted a party following the show's opening. Feeley was the chair of the art department where Frankenthaler had studied. Krasner, still anxious, volunteered to tend the bar so that she could monitor what Pollock drank. As the party wound down, someone unaware of the situation offered Pollock a drink—in earshot of Greenberg, who told him, "Lay off," to no avail. "Fool," Pollock retorted as he bolted down the drink. [83] Nothing more needed to be said.

After breakfast the next morning, Pollock drove Greenberg and Frankenthaler to their train for New York while he and Krasner headed back to Springs. "When he called me a fool," said Greenberg years later, "I was furious and I was off him for a couple of years. I didn't say it but Jackson sensed it. . . . Besides, he had become, if not famous, at least notorious, and I suppose the battle had been won." [84] Another time, Greenberg said that he was "dissatisfied" with most of Pollock's work after 1952. [85]

Immediately following the Bennington fiasco and Pollock's show at Janis, gossip circuits buzzed when Rosenberg's "The American Action Painters" appeared in the December *Art News*. The article created a stir that pained Pollock, who felt personally attacked by Rosenberg's thesis on "action painting," even though Rosenberg did not identify him by name. Pollock claimed that in conversation with Rosenberg, he had referred to his canvas as an "arena"; he did not approve of the subsequent use Rosenberg made of the term.[86] Lee made notes on the article in her copy of *Art News* and carefully examined Rosenberg's main point.[87] She commented on the attitudes of other artists she knew who read the piece, noting that Clyfford Still stopped by and "had a fit about it"; then de Kooning and Philip Pavia stopped by and said that they liked the piece. "So there was a good deal of screaming on the subject," she recounted.[88]

When Rosenberg poked fun at an unnamed artist who claimed that another was not modern because "he works from sketches," he was describing an attitude held by both Krasner and Pollock, neither of whom worked from sketches in making paintings.[89] Rosenberg wrote, "A painting that is an act is inseparable from the biography of the artist. The painting itself is a 'moment' in the adulterated mixture of his life. . . . The new painting has broken down every distinction between art and life."[90] This statement implicitly attacked Pollock, whose public behavior was too often dysfunctional, while his paintings had gained him both admiring and derisive attention. Rosenberg argued that "what gives the canvas its meaning" is "the way the artist organizes his emotional and intellectual energy as if he were in a living situation."[91]

Rosenberg taunted Pollock even more directly by discussing artists who, "lacking verbal flexibility . . . speak in a jargon"; among the examples he gave of an artist describing his work was "It doesn't reproduce Nature; it is Nature," which was Pollock's notorious retort to Hofmann's advice.[92] Rosenberg may have revealed more than he intended when he stated "a piece of wood

found on the beach becomes Art. . . . Modern Art does not have to be actually new; it only has to be new to *somebody*—to the last lady who found out about the driftwood."[93]

Driftwood would have been on his mind if he had seen Herbert Matter's photograph of Mercedes nude on the beach. Matter had used driftwood to frame Mercedes's breast. Pollock had a copy of the photo in his studio. In this regard, Rosenberg's apparently dismissive reference "to the last lady" may be an erotic wink to his mistress.

Hurt by gossip, Pollock told Jeffrey Potter, "The corner they got me in is more like what Harold Rosenberg wrote about Action Painters. . . . How does it go? Vanguard painters have a zero audience; the work gets used and traded but not wanted."[94] Rosenberg later wrote: "Art in the service of politics declined after the war, but ideology has by no means relaxed its hold on American painting. Zen, psychoanalysis, Action art, purism, anti-art—and their dogmas and programs—have replaced the Marxism and regionalism of the thirties. It is still the rare artist who trusts his work to the intuitions that arise in the course of creating it."[95]

Yet Clement Greenberg wrote that Pollock mocked the very notion of "Action Painting," which he understood, when sober, to be "a purely rhetorical fabrication." Greenberg viewed Pollock as "the most intelligent painter" that he had ever known, "one of the most learned & truly sophisticated; without his intelligence, he would not have become the artist he was."[96]

# Coming Apart, 1953–56

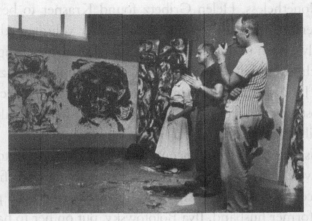

Jackson Pollock and Lee Krasner in his barn studio with their Springs neighbor Sam Duboff, August 1953. Pollock's *Portrait and a Dream* is visible.

URING THE SPRING OF 1953, IN THE MIDST OF HIS DRINKING binges, Jackson Pollock drove his Model A into the wrong lane of traffic on Main Street in East Hampton, forcing a motorist coming toward him off the road.[1] During this period, he had been preoccupied with trying to shingle and winterize his barn studio so that he could work comfortably during the winter, making a considerable financial stretch to achieve this goal. That summer he devoted himself to painting, managing to produce major canvases despite his growing self-doubt.

In the summer of 1953, Pollock posed for photographs with Raphael Gribetz, the adorable infant son of Joel and Helen Gribetz, a doctor and his wife, who rented the house next door for the summer. Though Pollock was just forty-one, he grinned like a proud grandfather. He had been longing to have a child of his own. Lee was then nearly forty-five and no more interested in hav-

ing a child than when they had married almost eight years earlier. For her, as she later made clear, Pollock was enough of a child.[2] Both psychologically and economically, Krasner had felt that she did not have enough to share with yet another helpless human being. Nonetheless, Helen Gribetz found Krasner to be "a very giving person." She still recalls how Krasner volunteered to take her family's wash to the Laundromat, since she was taking care of her five children that summer. The Gribetz couple socialized with Lee and Jackson that summer, so much so that Helen recalls Lee as "a most gracious hostess."[3] Jackson too was helpful, taking the older Gribetz children to the beach.

At this time, it was not uncommon for women artists to choose not to have children, especially those women living in difficult circumstances. Krasner's friend, Slobodkina, described the pressure that her former husband, Ilya Bolotowsky, put on her to have children: "My NO was clear and firm. I had enough to do with one child in the family; and besides I married him to become an artist, not a mother."[4] In Krasner's case, she had already become an artist and married Pollock just two days before her thirty-seventh birthday, prepared to take care of his intensive needs, not those of a child.

Almost miraculously Krasner's instinct for self-preservation emerged out of the chaos of Pollock's self-destructive binges. She finally got her own separate studio, after they bought an acre adjoining their house on the north side and moved onto it a little shack, which had once been a smokehouse, for her to work in. Perhaps finally realizing what she was up against, and finding herself less and less able to help Pollock, she lost herself in her own work and made a new set of collages, recycling older work. She later said, "These were inspired by earlier drawings that I had torn, feeling somewhat depressed. The studio was hung solidly with drawings I couldn't stand. 1953 was the deluge in this spurt of collage. It led to the exhibit at the Stable Gallery in 1955."[5]

In many ways, Krasner's work was a continuation of her

studies. "Back in the '30s as a Hofmann student, I had cut and replaced portions of a painting. I had also transposed a painting thinking I would put it into a mosaic form. There is a challenge in reshaping and re-adhering imagery from the earlier periods. . . . Well, there is a recycling of the self in some form."

In East Hampton, Guild Hall held a summer group show of seventeen local artists. Though the organization had claimed eight years earlier that it was difficult to identify the artists in its community, New York Times journalist Stuart Preston commented, "It must have required considerable tact to choose such a comparatively small number from the large and energetic picture-producing community there, but those who made the grade should be well satisfied."[6] The artists, most of whom were now working abstractly, included both Krasner and Pollock, as well as James Brooks, Balcomb Greene, Alfonso Ossorio, Willem de Kooning, Elaine de Kooning, Wilfrid Zogbaum, and the realist Alexander Brook, who showed a romantic landscape.

Never a supporter of abstraction, Preston singled out "[Willem] de Kooning's blithe and violent figures of women. As a pure sensationalist this artist has no equal here. There is much the same degree of energy in Jackson Pollock's single canvas on which swirling tides of sullen paint encircle pockets of bright color." Again, he criticized Krasner, saying that her "propeller and ribbon shapes in two contrasted colors are too sluggishly drawn to come off as they should." She cannot have appreciated his comment, but at least he did manage to spell her name correctly.[7]

By mid-October, Pollock had become more and more dysfunctional as his binge drinking continued and his life spun out of control. Unable to paint and prepare for his next show on time, he had to ask Janis for "another advance" against sales. "Why the hell I let myself get in this position I don't know—took off too big a bite on shingling the house I guess."[8] Janis had to postpone until the following February the show he had originally scheduled for November, because Pollock did not have a new body of work ready

for it. The promised show, consisting of ten works, finally ran from February 1 to 27, 1954. Although Clement Greenberg did not review it, he was not silent. When he did express himself in 1955, he was pointedly negative: "Few of [Pollock's] fellow artists can yet tell the difference between his good and his bad work—or at least not in New York. His most recent show, in 1954, was the first to contain pictures that were forced, pumped, dressed up, but it got more acceptance than any of his previous exhibitions."[9]

In the spring of 1954, a troubled Pollock traded the art dealer Martha Jackson two of his black and white paintings for her green 1950 Oldsmobile convertible. He told Jeffrey Potter that he was thinking about letting Lee learn to drive on the Model A, "the clutch being almost gone, anyway."[10] Patsy Southgate, a newcomer to the region, had stepped in: "I took Lee's side strongly from the point of view that 'This Woman Is Not Being Treated Fairly.' I mean literally. Lee had two pairs of britches to her name, was trapped in the house, and didn't know how to drive. Jackson didn't want her to, but he had mobility. He would go off, had this large studio, this person making delicious food, and pretty much what he wanted."[11]

Southgate was a mother with two young children. She and her husband, the writer Peter Matthiessen, had only just arrived on Long Island the year before from Paris, where he had founded the *Paris Review*. Krasner and Southgate quickly became close friends. Krasner was attracted not so much to the younger woman's legendary beauty as to her intelligence and the sophistication she had acquired in France. Southgate also understood what it meant to go through a difficult time. She offered to give Krasner driving lessons in return for painting instruction, though she quickly realized that she could not paint. And Krasner was having trouble learning to drive, which Southgate attributed to a lack of self-confidence: "She had to take her license test a couple of times, but she did get her license finally. Then she was liberated: She could go shopping, see friends, be on her own. Jackson didn't like my

teaching her at all; if you give people a car and a license, they have independence. I don't think he wanted that."[12]

The importance of driving to boost women's confidence and as a remedy for inferiority complexes had been promoted at least since 1939, when an article in the magazine *Independent Woman* stated, "This consciousness and power that come with successful handling of an automobile might even prove an important antidote for personality quirks. . . . It can make us feel infinitely more important than managing an egg beater."[13] The notion that women who could master driving an automobile might achieve biological and psychological equality with men had pervaded popular culture. The thought of Lee driving fueled some of Pollock's fears, exacerbating his deep insecurities as a man, as a driver, and as a painter.

Since her show at Parsons, Krasner had begun to work in black and white, using ink, gouache, and collage on paper, canvas, or canvas board. Her forms were biomorphic, yet the titles give nothing away. She showed with other women in "Eight Painters, Two Sculptors" that summer at the Hampton Gallery and Workshop in Amagansett.

Krasner also had a solo show of her Little Image paintings and some recent collages for only one day in August at the House of Books and Music, an East Hampton shop where her friend Patsy Southgate worked. The owners of the shop, Donald and Carol Braider, stored some of their stock in a place known as the "red house" in the nearby town of Bridgehampton, which that summer a group of artists including the de Koonings rented. Pollock drove over one June day, hoping to visit with Franz Kline and de Kooning. They were all drinking and horsing around, when suddenly Pollock was on the ground with a broken ankle.

"He was absolutely indignant," Elaine de Kooning said.

"He said: 'I've never broken a bone.'"

The accident forced Pollock to abandon "that ridiculous little car of his there."[14]

Pollock painted little during this year. He was filled with doubt. Matthiessen, who saw him during this period, described Pollock as "wonderful in many ways" and "calm if not plastered," but recalled that he appeared to have "a hand grenade in his pocket" that could go off at any time.[15] Even though the Solomon R. Guggenheim Museum (formerly the Museum of Non-Objective Painting, founded by Peggy's uncle) acquired Pollock's 1953 painting *Ocean Greyness* in November 1954, the sale to a museum did little to assuage his deep-seated doubts about himself. His drinking continued to increase.

Meanwhile Clement Greenberg definitively ended his relationship with Helen Frankenthaler in April 1955. Though he had written negatively about Pollock's last show, Krasner still welcomed him in Springs several times. Greenberg came because he hoped to see his new psychotherapist, Ralph Klein, who was vacationing with his colleagues nearby at Barnes Landing, an East Hampton community that bordered Springs on the east.

While at Springs, Greenberg sided with Krasner against Pollock's worsening alcoholism. "That summer they were fighting all the time and I'd be there. . . . Well, I thought, 'Why don't you get out?' . . . She had this drunkard on her hands. I don't like calling Jackson a drunkard, but that's what he was. He was the most radical alcoholic I ever met, and I met plenty."[16]

Krasner was still recovering from a severe attack of colitis from a year before. According to Greenberg, the illness changed her: "Before Lee got sick she was pretty intense; always talking about art. What do we think of this? What do we think of that? . . . Now Lee, I'd always had respect for. She was formidable; made of steel. And so competent at everything, except not the business head she was reputed to be. . . . Then when she was soft after her colitis, she didn't give a shit anymore, for a while. It was delightful that she didn't give a shit about what she thought about art. That was all off, she thought about life. . . . Jackson couldn't stand it. I'll

go on record here. That's when he began to turn on her. It wasn't so much attacking her as rejecting something."[17]

When Greenberg saw Pollock drinking and in a rage at Krasner, he suggested that she see either Ralph Klein or the psychiatrist Jane Pearce, who was Klein's colleague. Both were still associated with the William Alanson White Institute, which continued the teachings of Harry Stack Sullivan after his death in 1949. Sullivan, an American follower of Freud, had emphasized the importance of parent-child relationships. His so-called followers, known as "Sullivanians," were led by Pearce's husband, Saul Newton.[18] The group has been labeled "blasphemous" for invoking Sullivan's name and for encouraging the severing of all family ties.[19] In Newton and Pearce's 1963 book, *Conditions of Human Growth,* they argued that the nuclear family prevented individual growth and creativity and they advocated breaking such ties.[20] Their activist form of therapy advocated new "growth experiences." It must be noted that Newton only had a B.A. degree.

The day after talking to Greenberg, Krasner took his advice and was referred to Leonard Israel Siegel, another Sullivanian colleague. Unlike Saul Newton, Siegel actually had professional training, including a degree in medicine from Johns Hopkins University and a residency in psychiatry at Bellevue Hospital in New York. He purported to be a disciple of Sullivan, but his close association with Pearce and Newton suggests that his therapy then diverged from Sullivan's teachings as theirs did.

In one published paper, Siegel wrote: "The role of successful psychotherapy is to enlarge the scope of the self, as previously dissociated and selectively unattended aspects of self can be reintegrated."[21] He contended that "for Sullivan, anxiety and its avoidance are central motivating forces. . . . There is a drive toward relatedness with other people and toward seeking their approval and avoiding their disapproval. . . . Mental illness is seen as an attempt to solve interpersonal problems, especially those created by

pathology in parents and in the larger social surround."[22] This latter reference to pathology in parents recalls the "Sullivanian" cult's attempt to get their followers to cut off from their families and close friends. Siegel's therapy might later have motivated Krasner to break off completely with close friends such as Fritz Bultman and B. H. Friedman.

Not enough is known about how long Siegel stayed affiliated with the Sullivanians; however, his widow confirms that he was affiliated with both the Sullivanians and, earlier, with the William Alanson White Institute in New York.[23] Without knowing the extent of Siegel's involvement with the Sullivanians, it is impossible to reconstruct his therapy for Krasner and its effect. What is known is that Siegel's own analyst was Clara M. Thompson, who was a cofounder of the William Alanson White Institute and a close friend of Harry Stack Sullivan. Thompson wrote papers on the role of women, including "Some Effects of the Derogatory Attitude toward Female Sexuality" (1950), the latter around the time that Siegel was training with her.

Siegel developed a deep interest in the arts "as a vehicle to the unconscious and encouraged his patients to paint, draw, compose, etc." He also got some of his patients to paint with him. It is not certain how long Krasner stayed in therapy, since Bob Friedman says her therapy with Siegel ended in July 1958.[24] Yet her nephew's ex-wife, Frances Patiky Stein, recalled that Lee was still seeing "that maniac doctor" Siegel in the early 1960s.[25] Stein said that Siegel was "insane, off the wall."[26]

Krasner's friend Cile Downs remembered going over to Len Siegel's place at Barnes Landing with Krasner for a cookout. She observed that "Siegel, like Jackson, wanted Lee to coddle him." She also remarked that he was one of the Sullivanians who "believed that therapists slept with their patients."[27] Clement Greenberg commented that Siegel became so dependent on Krasner that he came to see her to be comforted, a fact that caused her to give up on him as her therapist.[28] Greenberg asserted that the Sulliva-

nians, the followers of Saul Newton, also gave up on Siegel as a result, but added that he understood how someone could "succumb" to Krasner's strength.[29]

Krasner was at least partially aware that what she got was not just the orthodox teachings of Harry Stack Sullivan: "I had one year of analysis at the time I painted *Prophecy*. It was a splinter group from the Sullivan school and if one must separate Jung and Freud, this would be in the direction of Freud."[30]

Not to be left out, Pollock entered weekly analysis with Ralph Klein in New York City in the fall. He tried to get three sessions into two days, and while in the city, he stopped regularly by the Cedar Bar.[31] He was stuck in a period of heavy drinking and artistic inactivity. Klein later spoke about having Pollock as his patient, telling how the artist came blustering in and said that therapy was all "a bunch of shit," and how he had to tell Pollock to shut up and be seated. He admitted that he usually found Pollock drunk, and, although he was unable to stop Pollock's destructive behavior, he did not seek other help for him.[32]

Ben Heller, a young businessman and art collector who had befriended Pollock, recalls that Pollock would often telephone him on Tuesdays, when he was recovering from a binge the night before, after his appointment with Klein. Heller became so concerned that Pollock was not getting enough nutrition that he telephoned Klein, who reassured him that beer was very nutritious.[33]

Klein's treatment of Pollock's problems ignored his alcoholism and was otherwise quite unorthodox. Klein left the William Alanson White Institute at the time the American Psychiatric Association refused to sanction training of nonmedical psychoanalysts, joining Newton in the Sullivanian Institute for Research in Psychoanalysis, which was founded in 1957. As a follower of Pearce and Newton, Klein became one of four leaders in their new radical therapeutic community on Manhattan's Upper West Side. They moved on from Sullivan's idea about the critical significance of interpersonal relationships to declare them harmful.

even encouraging patients to break all close ties. The founders of the new group believed that they were the germ of a new society that would permit freedom from repression and obligation that kept people from personal fulfillment and creativity. The group eventually turned coercive and totalitarian, with the therapists wielding enormous power over the lives of patients and group members.[34]

Klein's circle did not consider monogamy acceptable—anyone could choose to have a child and might get permission to do so with anyone, not necessarily a spouse. Klein encouraged Pollock to have an extramarital affair. This would at least allow him to fulfill his desire to have a child. Pollock was completely under Klein's spell. Patsy Southgate often took the train with Pollock to or from New York when he was going to his appointments.

"He never wept on the train going in—he was always frightened then—but coming out there would be tears, and I felt it was genuine when he wasn't drunk," Southgate recalled. "The therapy situation was very frustrating for him, the not being understood or thinking he wasn't. He had a complete transference with Klein and as with all transferences, a sort of godlike quality was attributed to him. I would think, 'Lord I hope this guy realizes what he's doing and what's brewing inside Jackson's head.'"[35]

Another one of Klein's patients, the singer Judy Collins, wrote about her therapy with Klein several years later: "I told Ralph that I thought I had a problem with alcohol. Ralph, to my relief at the time and horror later on, did not agree. He said that we would work on the underlying trouble and not to worry about my drinking. . . . Ralph was quite comfortable recommending alcohol for anxiety."[36] The Sullivanians were not up-to-date in their treatment of alcoholism, which required abstinence. Instead they focused on interpersonal relationships. Along with the other Sullivanians, Klein "did not think people should be in monogamous relationships or live with anyone exclusively," recalled Collins, who explained their interest in encouraging creative individuals "to

break down the isolation they thought people acquire in a one-on-one relationship in which each partner becomes dependent on the other for everything."[37]

Klein was clearly not up to the task of treating Pollock, who was already struggling with so much pain, and must have only confused him. "Dr. Klein had said it was all right for Jackson to drink and drive," Krasner later told a stunned Jeffrey Potter.[38] It was a treatment that proved fatal—as Patsy Southgate later said, "I think Ralph Klein killed Jackson."[39] What Krasner probably failed to grasp was that Klein pushed Pollock to break his bond with her.

Decades later, the New York State Board of Regents forced Klein to surrender his license. Many considered the Sullivanian Institute to be a cult because it was said to permit sexual relationships between licensed psychologists and their patients, to foster the use of controlled substances, to promote the destruction of family relationships, and to commit other violations of professional standards.[40] It may be that Siegel, Krasner's therapist, wanted to escape this coterie, since he eventually moved all the way to Australia.

Krasner kept papers on which she wrote down one of her dreams for her therapist. She noted, "J. [Jackson] better but still very disturbed—went to bed and he tried to talk to me about getting closer—said he appreciated my staying with him."[41] The next day she notes, "Friday. J. almost out of state." Clearly she was struggling to deal with her deeply troubled spouse and it was taking its toll. Later she spoke of being in a perpetual state of crisis with Pollock.[42]

Their friends were also concerned. Sheridan Lord, the painter, and his wife, Cile (Downs), had met Krasner and Pollock at the home of Peter Matthiessen and Patsy Southgate, when Pollock's alcoholism was acute. Although Krasner had begun to rely on the Lords to help keep track of Pollock, they were not able to prevent him from drinking or to prevail upon him to go home with

them.[43] Cile recalled that if tea was given to Pollock, he would pour whiskey into it. She said that Krasner was always calm and permissive, and that "she hadn't had any therapy about drawing the line yet."[44] At the time, she said Lee was "cute and lively" with a "poodle haircut."[45]

But according to Cile, once Krasner entered therapy, her behavior toward Pollock changed. She no longer functioned as his enabler, having learned about what we would now call "tough love"—and that put Pollock in a rage. Once Pollock bought roses, Cile remembered, and gave each one of them to various women in East Hampton, including Cile. Lee's nephew Ronnie Stein, who saw a lot of his aunt and uncle, commented, "Lee had loved Jackson intensely, the way a young girl would love a hero: as a man, as an artist, as an image. The difficulty began when her physical and mental strength began to break down, and she became less and less capable. Then deadly alcohol changed love to drudgery: Jackson left boyish pranks and carryings-on—that polarity from being mystical to being boyish—for going down. There was an unholy alliance! He might have been a genius, but he was also a common drunk."[46]

Krasner kept papers on which she wrote down one of her dreams for her therapist. She noted, "[Jackson] better, but still

BY 1955, KRASNER HAD TO LOOK TO HER OWN WORK FOR SOLACE. She must have determined not to let Pollock pull her down with him into the abyss. The critic Eleanor Munro has characterized some of her collages of 1955 as "fiercely vertical compositions with titles expressive of a will not to lie down: *Milkweed . . . Burning Candles.*"[47] Krasner remarked, "The fact that he drank and was extraordinarily difficult to live with was another side. . . . But the thing that made it possible for me to hold my equilibrium were these intervals when we had so much."[48] That her love for Pollock had become self-destructive was difficult for her to accept.

Krasner had a solo show at Eleanor Ward's Stable Gallery from

September 26 through October 15, 1955. The gallery took its name from its first home, a former livery stable on Seventh Avenue at West Fifty-eighth Street in Manhattan. On view were a group of collages of paper and cloth attached to painted supports of pressed wood, stretched linen, or cotton duck, at least some of which were unsold works from her 1951 show at Parsons.

STUART PRESTON FINALLY WROTE A FAVORABLE REVIEW FOR THE *New York Times:* "In Lee Krasner's collages at The Stable Gallery, we find ourselves in the midst of a dense jungle of exotic shape and color. The eye is fenced in by the myriad scraps of paper, burlap and canvas swabbed with color that she pastes up so energetically. She is a good noisy colorist, and some of the larger pictures would agreeably animate many an antiseptic modern interior. For their principle is verticality which they both exemplify and communicate."[49]

The painter and art critic Fairfield Porter wrote in *Art News* that some of her largest collages "with titles like *Stretched Yellow, Milkweed* and *Blue Level,* are like nature photographs magnified. . . . Krasner's art, which seems to be about nature, instead of making the spectator aware of a grand design, makes him aware of a subtle disorder greater than he might otherwise have thought possible."[50]

In *Arts,* the critic and art historian Martica Sawin worried that "the assets of making paintings with paper and cloth instead of, or in combination with pigment, are not clear since the immediacy of touch and stroke are lacking and only the decorative effects remain."[51]

The gallerist Eleanor Ward was the same age as Pollock and was a person of "taste and flair." She had come to art from the world of fashion, having worked for the designer Christian Dior in Paris. She came from an "Episcopalian social-register back-

ground," recalled Alan Groh, who worked as her gallery assistant from 1956 to 1970—she once told him, "I would not have hired you if I'd known you were a Jew."[52]

Thus she probably considered Krasner provincial, ill mannered, and downright pushy. "This very strong woman was not easy to work with," Ward said of Krasner. "I told her that I thought it was a good time for me to select her show. She said 'You select my show? I am selecting my show and I am hanging it on both floors.' So I answered, 'Lee, then there will be no show, unless it is on one floor and I select it.' That's the way it ended because she wanted a show. And I realized that if I once let her gain control over me, I would just be putty."[53] But Ward, who was said to be proud of her "eye," never allowed artists to be present while she installed their work on her gallery walls.[54]

Ward later wrote to the sculptor Wilfrid Zogbaum, whom she also represented, to complain about Krasner's "high temperament" and that she had left the Stable Gallery for Martha Jackson's.[55] Krasner can hardly be blamed for rejecting Ward's controlling nature and limited enthusiasm to find a better dealer. Yet Zogbaum replied bluntly and sympathetically toward Ward: "Was sorry to hear about your difficulties with Lee Krasner but it did not come as a great surprise. Although she has been a friend of mine for twenty years there is that extreme ambition in her that is at times a bit frightening. One doesn't know whether to admire or despise it."[56] Zogbaum was certainly not the first man to react against Krasner's remarkable enterprise, but one can hardly imagine that Zogbaum would have been so frightened if Krasner had been a man.

One night Krasner had invited Ward to dinner at her house. Ward recalled, "The relationship [between Jackson and Lee] was very, very curious. Once at dinner there was a bowl of peaches Lee had made, which Jackson wouldn't touch. She said, 'Now Jackson, they're good for you. Eat them.' He picked up a spoon like a child being told what to do."[57] Ossorio also commented about the "ma-

ternal aspect" in their relationship, "the way she treated him like a child and he hating it." [58]

The younger artist Nicolas Carone, who shared with Krasner the experience of having studied with both Leon Kroll and Hans Hofmann, felt he understood what their relationship was about: "She took care of him; you don't let go of a Jackson. You have to watch him every minute, and more; a woman taking care of such a man is not just feeding him and darning his socks; she's living with a man who might flip any minute. Think of the tensions she lived under! Lee knew she was dealing with a powder keg." [59]

Dan T. Miller, the proprietor of the General Store in Springs, not far from the Pollocks' home, recalled: "I've seen him drive up here to these gas pumps for gas and get in and drive away with Mrs. Pollock sitting beside him, and I wouldn't have sat beside him in that condition he was in but she did. There was a quality of love or however you want to put it. But the point I wanted to make is that she didn't just get up and run when things got a little bit rugged. She sure didn't. I thought to myself more than once 'Well Lee I wouldn't drive with that son-of-a-gun—I'd get up and walk off' but she didn't." [60]

Pollock's mother, Stella, suffered a series of heart attacks in late November 1954. Soon after, Lee went with Jackson to see Stella at Sande and Arloie's home in Deep River, Connecticut. At Christmas they returned. Lee offered to have Stella come and live with them in Springs, thinking that Stella might help save Jackson, but Arloie refused, citing Stella's age and condition: "Jack didn't have anything to help her with. He and Lee were not in a very happy situation and she [Stella] didn't need that aggravation; the strain would have been huge." [61]

Pollock became more and more desperate as he became less able to paint. In 1955 he told his homeopath, Dr. Hubbard, that he had not painted for a year and a half because he wondered if he was saying anything. [62] In the middle of February, he broke his ankle again, this time wrestling with Sheridan Lord. Jackson had

challenged Sheridan on his own living room floor. Sheridan's wife, Cile, recalled that "Lee had been trying to get him not to, and he knew his bones were brittle. . . . It was such a dumb thing to do, I wasn't even sorry for him."[63] But Cile was sorry for Lee. "It was hell. I thought that we were going to lose Lee. She got thinner and thinner."[64]

Things got slightly better in 1956. Pollock told Dr. Hubbard that he felt better even though he couldn't "stand reality."[65] In the early spring of 1956, the painter Paul Jenkins saw Pollock at Clement Greenberg's on Bank Street and encouraged him to come to Paris. Pollock protested, saying, "It's too late for that."[66] He was just forty-four.

In April Greenberg arranged for Jenkins and two other abstract painters, the German-born Friedel Dzubas and Alan Davie (then visiting from Scotland for his show in New York), to stay in The Creeks and meet Pollock. Krasner cooked lunch for them. Jenkins said her cooking was "extraordinary." He recalled that Pollock was sober, and that he drove the two of them out to Montauk Point, the scenic spot at the end of Long Island.[67] Jenkins knew that Pollock's work was admired in Paris, and he invited Pollock and Krasner to come there and see him and his wife. Jenkins had no trouble interesting Krasner, but he had trouble with Pollock. Nevertheless he applied for a passport, and then never used it. Perhaps he only got the passport to appease Lee.

One day Krasner recounted to Jenkins how she had gone to her therapist to talk about "one of the most terrifying nightmares anyone has ever told." After the session, when she returned to Jackson, "he turned white when he saw her. He walked up to her and clasped both of her hands and they sat down together. 'What happened Lee?' 'Jackson, please, I am all right.' 'Please tell me. You are completely different!' Lee went on to explain Jackson's astonishment, and how she could not get over it."[68] Jenkins explained that what took place in Krasner's therapy session could be "compared to a kind of exorcism. A kind of monster that had

dwelt in her childhood had dissolved, vanished—and Jackson knew it, he did not just sense it. In Lee's dream, a frightening total monster lived in her cellar when she was a child, and it was real in her psyche, not her imagination."[69]

At one point during his stay Jenkins witnessed Jackson shoot an arrow into the wall of the kitchen in his Springs house. After leaving the house, Jenkins sent Jackson and Lee a gift of *Zen in the Art of Archery,* a book written by the philosopher Eugen Herrigel in German and first translated into English in 1953. Jenkins wrote, "Again many good thoughts for the weekend spent with you both. Here is the archery book and Esther & I hope you enjoy reading it. Before returning to Paris I hope we will [have] another chance to talk—if we don't however it has been a real joy to have visited and will remember always your generosity."[70]

After receiving the book, Krasner wrote herself a note: "I want to talk about my self destruction my disgust & stupidity—(waiting—paralysis) waiting—& trapped by . . . Zen & the mastery of Archery . . . began to breathe more easily & dove in—point I made about painting—let it come to me."[71] In her desperate search for inner peace in the face of Pollock's turmoil, Lee had been thinking about Zen concepts.

Krasner's fear was surely related to the disquieting presence in the painting she was working on in the summer of 1956: "The painting disturbed me enormously and I called Jackson to look at it. He assured me it was a good painting, and said not to think about it, just continue—do another one. Not tie into what my reaction to it was, the way I was doing."[72]

Krasner ignored Pollock's suggestion that she remove the disembodied eye scratched onto the dark upper right corner of the composition. The painting, which she later titled *Prophecy,* always chilled her: "In that sense the painting becomes an element of the unconscious—as one might bring forth a dream."[73] Even Eleanor Ward, upon seeing the painting before it was ready, commented, "God, that's scary."[74] Krasner described this canvas as "a break in

color as well as imagery" and said, "I think I felt when I did the painting, it was *Prophecy,* as it was a new theme."[75] Alfonso Ossorio recognized how significant this canvas was and purchased it.

Meanwhile Pollock's reputation was carrying him along, even though he was no longer productive. In May, the Museum of Modern Art told Pollock that he would be featured in a solo midcareer show of twenty-five works, the first of a series of shows of "Work in Progress." That June Pollock said in an interview, "I don't care for 'abstract expressionism' . . . and it's certainly not 'nonobjective,' and not 'nonrepresentational' either. I'm very representational some of the time, and a little all of the time. But when you're painting out of your unconscious, figures are bound to emerge. We're all of us influenced by Freud, I guess. I've been a Jungian for a long time. . . . Painting is a state of being. . . . Painting is self-discovery. Every good artist paints what he is."[76] By this time, however, Pollock had serious doubts as to what he was.

Hoping to cheer up Pollock, Krasner invited Charlotte Park and Jim Brooks for dinner on June 18, 1956. Charlotte wrote in her journal, "Went to Pollocks for dinner last night. Had invited them here but Jackson's going through another bad spell. . . . Jackson is in bad shape but went to bed about a half-hour and when he got up was much more coherent."[77]

Back in New York, at the Cedar Bar, Pollock ran into Audrey Flack, an ambitious young painter then just twenty-five, who recalls seeing him earlier at the Artists Club on Ninth Street. Flack recalls that she went to the Cedar alone, hoping to meet her heroes, including Pollock, de Kooning, and Kline. When Pollock approached her at the bar, however, she describes how he tried "to grab me, physically grab me—pulled my behind—and burped in my face. . . . He was so sick, the idea of kissing him—it would be like kissing a derelict on the Bowery."[78] She was so appalled that she never again visited the Cedar.

Shortly after her encounter with Pollock, Flack met Ruth Kligman, a stunningly beautiful young woman who had just moved to

the city from New Jersey and was working for $25 a week as an assistant at the obscure Collector's Gallery. When Kligman asked her for the names of important artists she should meet, Flack replied, "Jackson Pollock, Franz Kline, or Bill de Kooning." "She asked which one was the most important," Flack recalled, "and I said Pollock; that's why she started with him. She went right to the bar and made a beeline for Pollock. Ruth had a desperation and a need."[79] She was a "star-fucker," commented Flack, using the word "star" as a noun and object of the verb.[80]

Accounts have variously described Kligman as endowed with "an Elizabeth Taylor aspect" and as "coquettish" during the time she ensnared Pollock at the Cedar.[81] Patsy Southgate said that she and Jackson "talked a lot about Ruth and we talked a lot about Lee; he was very excited about Ruth and terribly afraid of Lee, desperately afraid of Lee. . . . He viewed the whole thing as an amazing adventure; he wondered if he could pull it off with Lee, keep Ruth going along. Like a little boy, his dream was to have both."[82]

Ruth was "an art bobby-soxer," said Carol Braider, who had showed Krasner's work at her House of Books and Music. "As for the 'Lee doesn't understand me' line he handed out, most of us would say, 'Oh fuck off, Jackson!'"[83] B. H. Friedman, who met with both Krasner and Kligman during this period, described Lee as "lively, talkative, gregarious" and Kligman as someone who told Pollock in his dissipation that he was "still alive."[84] Ossorio considered Pollock's relationship with Ruth to be "pathetic . . . a young girl throwing herself at his feet."[85]

Kligman sensationalized and capitalized on her time with Pollock in a 1974 memoir called *Love Affair*.[86] She wrote that she would tell him that he was married and that she had to "make a life" for herself and that Pollock would argue against this by insisting, "My analyst says the opposite. That we're good for each other. I told him all about you, and he encouraged me."[87] She claimed more than once that Pollock told her of his analyst's support for

their relationship. Kligman also asserted that Jackson questioned her about her grandparents—the kind of stock she came from—telling her that he planned to marry her and suggesting by this interest that he fantasized about having a child with her. Not surprisingly, these reports are consistent with Ralph Klein's reputation—one that led to his losing his license to practice.

The affair became intolerable for Lee when Jackson got Ruth to spend the night in his studio with Lee not far away in their house. She gave him an ultimatum to stop seeing Ruth and announced that she was going to take the anticipated trip to visit the Jenkinses in Europe in three days and would return in three weeks. Both of them would have time and space to consider their future.

Krasner's bold actions forced Pollock to reconsider his impetuous affair. According to the Pollocks' neighbor, the painter Nicolas Carone, "He went through the act of getting rid of Lee to bring in Ruth with the romantic notion of filling in a moment in his life, an interlude and then realized it was shit. Also, he realized that he needed his wife, so he'd staked all on a move that didn't have any substance. Lee understood the psychotic problems and knew he was miserable. And she knew that the real value of his work was more important to her than it was to him."[88]

Pollock's realization perhaps caused him to then turn against Ruth. A number of friends later noted that Pollock misbehaved with Ruth as he had with Lee. Charlotte Brooks commented that "Jackson was pretty tough with Ruth," and Cile Downs reflected that she couldn't "imagine Jackson and Ruth being a couple for long, and he was hostile to her—really rude, mean to her—although I never saw any physical violence."[89]

When Krasner left for Europe in July, it was intended to be a trial separation, but it upset them both. "While she was in Paris," Jenkins recalled, "[Lee and I] saw painters, met old friends like John Graham at the Deux Magots. . . . Maybe if Jackson had gone to Paris, it might have turned him around."[90]

In a Paris café, Krasner chanced upon Charles Gimpel, an art dealer whom she had hoped to see in London. He invited her to visit his home in Provence in the south of France, expanding her plans.[91] Gimpel had been hoping to arrange a show of Pollock's black-and-white work at his London gallery. Lee wrote to Jackson from Paris on July 21:

> *I'm staying at the Hotel Quai Voltaire, Paris, until Sat*
> *the 28 then going to the South of France to visit with the*
> *Gimpel's [sic] and I hope to get to Venice about the early*
> *part of August—It all seems like a dream. The Jenkins,*
> *Paul & Esther, were very kind, in fact I don't think I'd*
> *have had a chance without them. Thursday nite ended*
> *up in a Latin quarter dive, with Betty Parsons, David*
> *[Howard], who works at Sidney's, Helen Frankenthaler,*
> *the Jenkins, Sidney Geist & I don't remember who else, all*
> *dancing like mad. Went to the flea market with John Gra-*
> *ham yesterday—saw all the left-bank galleries, met Druin*
> *and several other dealers (Tapié, Stadler etc.) Am going to*
> *do the right-bank galleries next week. I entered the Louvre*
> *which is just across the Seine outside my balcony which*
> *opens on it. About the Louvre I can say anything. It is*
> *overwhelming—beyond belief. I miss you and wish*
> *you were sharing this with me. The roses [that he sent to*
> *her] were the most beautiful deep red. Kiss Gype [sic] &*
> *Ahab [their dogs] for me. It would be wonderful to get a*
> *note from you. Love Lee—The painting here is unbeliev-*
> *ably bad. (How are you Jackson?)* [92]

Krasner later recalled the impact of seeing Chartres Cathedral and the old masters in the Louvre, which interested her much more than the contemporary art scene in Paris: "three paintings that stopped me dead in my tracks, and that startled me more than anything else because I didn't expect these would be the

paintings that would knock me off my track, so to speak. They were not what I expected them to be."[93] She recalled that the paintings were Uccello's *The Battle of San Romano* (c. 1435–40), Andrea Mantegna's *St. Sebastian* (c. 1480), and Goya's *La comtesse del Carpio, marquise de La Solana* (1794–95).[94] She was in awe over the latter. "The Goya is all spirit; you know, it simply leaves the earth."[95] Krasner also told how much she was interested by Ingres, whose style had captivated Browne, Gorky, Graham, and de Kooning during the 1930s.

From the old masters in the Louvre, she traveled to the narrow streets and medieval houses of Ménerbes, a lovely village in the Vaucluse. At the home of Charles and Kay Gimpel, Krasner found the artist Helen Frankenthaler.[96] Krasner also visited the art historian Douglas Cooper in Menton on the Côte d'Azur, near the Italian border.

On July 26, Kay Gimpel wrote to Peggy Guggenheim, telling her that Lee was staying with her and that she wanted to go to Venice at the end of July or the beginning of August, before she sailed home on the twenty-third of August. Lee wanted to see Peggy in Venice and she was requesting Peggy's help in booking a hotel.[97]

Krasner sent a postcard from Ménerbes back to Paul and Esther Jenkins in Paris: "The house is unbelievably 11th century perched on the top of a hill with views quite out of this world— Taking motor trips out to Arles, Aix, Marseilles, St. Remy etc. We'll be here until about the 6th and then on to see Peggy—and back to you. Hope your time is moving pleasantly. Love, Lee."[98]

When Krasner followed up on Kay's letter, and called Peggy from the south of France to ask about reserving a hotel room, Peggy replied that she was too busy to see Lee and could not recommend a place for her to stay.[99] This confirmed Krasner's feeling that Peggy disliked women. Krasner thus decided to return to Paris. Her hotel was no longer available, so she decided to stay

with Paul and Esther Jenkins at their place on the rue Decrès on the Left Bank.

Just after Lee returned to Paris, on Sunday, August 12, Paul Jenkins received a frantic phone call from Clement Greenberg in New York, who was trying to locate Lee. The news was bad. On August 11, at 10:15 P.M., while speeding north on Fireplace Road toward home, Pollock crashed his car into a clump of trees and flipped over. Of the car's three occupants Ruth Kligman was injured, but a friend of hers, Edith Metzger, and Pollock were killed. Pollock suffered a compound fracture of the skull, laceration of the brain and both lungs, hemothorax, and shock. He was forty-four years old. Krasner was now, at forty-seven, a widow.

Krasner processed the news for a moment and then "she got up from the couch and screamed, 'Jackson's dead!'" recalled Jenkins.[100] "We were living on the sixth floor, and she headed toward an open balcony; I reached out and grasped her. I placed her to the wall and didn't let her go until she calmed down." Jenkins contacted Darthea Speyer, the U.S. cultural attaché, who arranged for Lee to fly to New York that same night, where she would be met at the airport by the artist Barnett Newman and his wife, Annalee.

Before flight time, Esther Jenkins packed Krasner's bags, and Paul drove Lee around Paris, even recruiting the assistance of Helen Frankenthaler, who also had come back to Paris.[101] They stopped at the Bois de Boulogne and the Luxembourg Gardens to help pass the time.

The front page of the *New York Times* reported: "Mr. Pollock's convertible turned over three miles north of East Hampton, according to witnesses. The accident occurred shortly after 10 P.M. on Fireplace Road. A woman riding in the car was killed and another woman, identified by Southampton hospital authorities as Ruth Kligman, was injured. The police were unable to determine the cause of the accident, but said the automobile had smashed

into an embankment."[102] This article continued with a discussion of who Pollock was and what he was known for, before explaining, "Mr. Pollock was married to Lee Krasner, an established painter in her own right. Acquaintances here said that she was now in Europe."[103]

The funeral took place on Wednesday, August 15, at the Springs Chapel, down the road from their house. Barnett and Annalee Newman paid for Pollock's funeral, since Krasner had only $200 in the bank at that moment.[104] Peter Matthiessen said that Lee asked him to take care of their dogs at the funeral. Pollock was then buried in Green River Cemetery, nearby in Springs. Jackson's mother and brothers attended the funeral. Lee's nephew and her sister also came, as did friends such as John Little, Reuben Kadish, Gina Knee, and Jim Brooks.

Krasner asked Clement Greenberg to speak at the funeral, but he refused, because of Pollock's role in the death of Edith Metzger, though he did go to the funeral. Years later, Greenberg commented about the impact of Pollock's death on him personally, saying that he thought more of him "as a man at the end and as a friend, even more than as an artist. I minded that girl getting killed with him and I wasn't going to get up and speak about Jackson. Lee had hysterics over the phone. I wasn't going to get up there and lie. I thought Jackson went out in a shabby way."[105]

Another time, Greenberg said: "Lee was the one who really got to him and she was right. He could talk about art only with her—well, he could with me *mostly when Lee was there to join in.* . . . Art was his justification as a human being, because he felt inadequate in other respects. But Lee was his victim in the end, *and* a better painter than before."[106]

A few nights after the funeral, the Sullivanian therapist Saul Newton, who spent summers with his disciples at nearby Barnes Landing, called on Krasner in Springs and recounted that "Lee was carrying on like an old-fashioned mourner. Franz Kline was there and she was blubbering 'Help, help' at him. About midnight

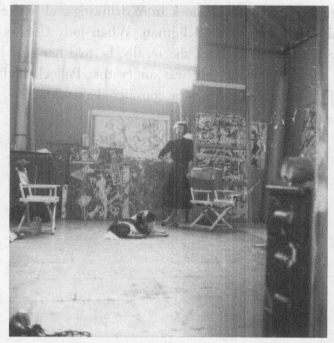

Lee Krasner with their dog, Gyp, in Jackson Pollock's studio, two days after his burial, August 1956, photographed by Maurice Berezov. One of Krasner's first preoccupations as a widow was supporting Pollock's scheduled exhibition at MoMA, which turned into a memorial retrospective. Having lost him, she was determined not to let his legacy get away from her.

she *had* to visit the cemetery, so I took her and Patsy [Southgate] there. It was a dark night and I told Lee she would have just one minute. Then I told her when her time was up, got them back, and left her in Patsy's hands as a nightwatch. She slept off her grief and in the morning was in okay shape."[107]

It was an ironic and tragic twist of fate that Greenberg—Pollock's most important critical supporter—introduced Pollock and Krasner to people like Newton, Klein, and Pearce. Though these practitioners aimed to heal their patients, sometimes, instead of cures for conditions like alcoholism, which they did not understand, they offered misguided therapy, coercive and destructive advice that ended up doing harm. It was Klein, after all, who

postponed trying to stop Pollock from drinking and who encouraged his relationship with Kligman. When Judy Collins began therapy with Klein in 1963, she recalls, he told her that he had treated Jackson Pollock. He was angry that Pollock had killed himself in the accident, which he considered a suicide.[108]

# Dual Identities:
# Artist and Widow, 1956–59

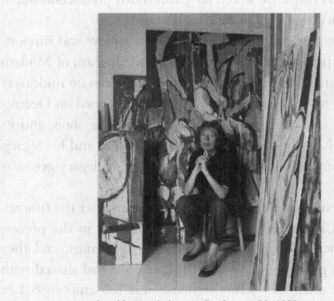

Lee Krasner in her studio, August 30, 1956, two weeks after Jackson Pollock's death. Visible are her *Prophecy* (CR 302, right) and *Cauldron* (CR 300, unfinished, behind), photographed by Waintrob-Budd.

Y OU FELT THAT IT WAS PART OF HER DESTINY TO BE SUPPORTIVE of this person with a recognizable continuity. But then his death gave her freedom to become a creative being," wrote John Cole, a journalist who knew Jackson and Lee in East Hampton.[1] "The marriage couldn't have been more rough," Krasner admitted. "Sure it was rough. Big deal. I was in love with Pollock and he was in love with me. He gave an enormous amount, Pollock. Of course, he took too."[2] Stanley William Hayter, who had worked with Pollock in his printmaking studio on Eighth Street,

and who, together with his artist wife, Helen Phillips, had partied with Pollock, Krasner, and the Kadishes in East Hampton in the summer of 1945, understood Krasner's role well: "Most men are dependent on some women to support them, one way or another. This idea of being hairy-chested men and superior to women—bugger! I don't think we would have had much production out of Jack if it hadn't been for Lee, or even survival."[3]

One of Krasner's first preoccupations as a widow was supporting Pollock's projected 1956 exhibition at the Museum of Modern Art. Once planned as the inaugural show in a series on midcareer artists, it was now a memorial retrospective. It opened on December 19, 1956, and closed on February 3, 1957. The show and its reviews kept Krasner focused on her late husband and his legacy. Having lost him, she was determined not to let the legacy get away from her.

Krasner remained in Springs for the autumn after the funeral. In October, Charlotte Park and Jim Brooks were in the process of moving their Montauk house by barge to Springs, and they stayed with a grieving Krasner in the house she had shared with Pollock.[4] But after they left, the house was too empty, so Lee spent several months with Fritz and Jeanne Bultman in their town house on East Ninety-fifth Street and several more months living with Bob (B. H.) and Abby Friedman.[5] Lee stayed there through New Year's, shared with Helen Frankenthaler, Betty and Bob Motherwell, and Musa and Philip Guston. "Jackson's ghost was more real,"[6] Bob Friedman wrote in his journal on New Year's Day 1957. They had all been at a party where two of Krasner's least favorite people, Motherwell and Frankenthaler, met, evidently for the first time.[7] Later that year, Motherwell divorced Betty Little, with whom he had two daughters, and in 1958 married Frankenthaler.

After staying with friends through the winter, Krasner then tried living on in Springs, but she disliked being alone in the

house. "It was hard at first, damned hard. I'm not the country type. And the loneliness," she complained.[8] "After Pollock's death I came back to New York, rented an apartment and then abandoned it after two years. I couldn't stand it. So I went back out to Springs. The second attempt was very beautiful. I wasn't depressed at all. Then, at a point during that time [the two years], I took over the barn. There was no point in letting it stand empty. I had difficulty trying to reestablish myself in New York."[9]

But Krasner soon realized that she couldn't spend all her time in Springs alone, so she also tried to get back into New York. She rented an apartment in 1957 at 147 East Seventy-second Street in Manhattan, signing a two-year lease. That summer she had tried out painting in the barn that had been Pollock's studio. She had been able to tolerate staying in the old Springs house, however, only when she had been able to get someone to stay there with her. She depended on hired assistants, friends, and, if they lived nearby, even their teenaged children.[10]

As a widow, Krasner was not just moving into her late husband's studio to paint, but rather she was also focused on how best to place Pollock's work in museums and important private collections. At first she kept Pollock's work with his last dealer, Sidney Janis, but she did need to raise a certain amount of money to pay estate taxes. In the year before Pollock's death, Janis had offered Pollock's *Autumn Rhythm* to the Museum of Modern Art for $8,000, but the museum rejected the price as too high. Now Alfred Barr, on behalf of the museum, made another inquiry about the painting. This time Janis, after speaking with Krasner, asked for $30,000.[11] Evidently Barr was so stunned by the increase that he never even responded. Janis sold the picture to the Metropolitan Museum instead—a success for Krasner, even though the deal for $20,000 included an agreement that she would buy back another one of Pollock's canvases (*Number 17,* 1951) for $10,000.[12] Nonetheless, she had now set a new record for Pollock's prices. Her

skill in marketing Pollock's work slowly and judiciously would also help to set much higher prices for other abstract expressionist works.

Janis later commented: "After the second [Pollock] exhibition following his death [in 1958], Lee was a little discouraged by our selling quite a few at low prices and decided not to deal here. He died a little too soon, but other artists were immediately affected—began selling and raising their prices after that romantic death—like Van Gogh's."[13]

Krasner's marketing strategy was bound to affect the way her own paintings were seen and shown and how she was perceived. "After Jackson died the load was far heavier on me than when he was alive," she maintained. "He was painter number one and the whole art world turned on me. It was like I wasn't there. It was very rocky."[14]

"She didn't get anywhere, until her husband died," the painter Buffie Johnson told an interviewer. "We were good friends for a while, and then I showed one of my old realistic paintings in the East Hampton Guild Hall, because they'd asked me to put something in a realistic show. She stopped on the street in front of the post office and harangued at me for doing this. I said, 'Well, I don't deny my early work. If Picasso shows his realistic things and his abstract things side by side, I don't know why [I shouldn't].' [Lee] said, 'We've spent years trying to get the Guild Hall to accept abstract work, and you come along and undo all our work.' She's a very emphatic woman. . . . I felt very injured."[15]

WITH POLLOCK'S DEATH, KRASNER HAD TO PICK UP THE PIECES AND put her life back together. What she had left was her art, and she soon returned to it. When she was asked how she managed to do this so quickly, she responded, "I don't think I thought about it. And I don't feel I had a choice. It was just extremely difficult to get to do it. 'I had to' is the only way I can put it, and it was not

easy. . . . I was not in a position to say I will not continue painting or I will continue painting."[16] She explained her motivation this way: "I am preoccupied with trying to know myself in order to communicate with others. Painting is not separate from life. It is one. It is like asking—do I want to live? My answer is yes—and I paint."[17]

Though Krasner's abstract paintings were not usually very representational, a canvas such as *Three in Two* painted in 1956 begs a biographical reading. The catalogue raisonné refers to *Three in Two* as having a "cryptic title," which "probably relates in some way to Pollock's equally ambiguous *There Were Seven in Eight* of c. 1945." Yet Krasner's enigmatic canvas might be read as three vertical panels of fragments of figures inspired by her favorite painter, Matisse. His *Bathers by a River* of 1909–1910 was well known to her from the 1951 Matisse retrospective at the Museum of Modern Art as well as from Greenberg's 1953 book on Matisse.[18]

Taking a hint from Matisse, Krasner could have painted *Three in Two* in order to reference Pollock's earlier canvas, *Two,* of 1945, a painting that has already been compared to *Bathers.*[19] Following this, Krasner may have inserted a third figure between the male and female figures that critics have identified in Pollock's *Two.* Chances are this third figure represents Ruth Kligman, who had intervened and split up Pollock and Krasner's relationship in the same year that Krasner produced this painting. In a very literal sense, Kligman inserted herself between the pair—a third figure wedged into two.[20]

Another blow to Krasner came on May 1957, when *Life* magazine ran an article called "Women Artists in Ascendancy" featuring five women artists—"none over 35." Naturally it omitted Krasner, who was nearly fifty. The article featured Grace Hartigan, Joan Mitchell, Jane Wilson, Helen Frankenthaler, and Nell Blaine, touted as a "Young Group [that] Reflects Lively Virtues of U.S. Painting." With glamour in mind, *Life* stressed both the youth

and the physical attractiveness of these younger women artists and even exulted that Jane Wilson "works as a New York fashion model."[21] It made good copy, but it already relegated to the dustbin of history the older women who had labored among the male abstract expressionists of the first generation, such as Krasner, Perle Fine, and even the somewhat younger Elaine de Kooning.

The critical dismissal was premature. Krasner was now painting in Pollock's barn studio, enjoying for the first time its excellent light and ample space. Her work's scale soon expanded. Though her paintings appear to mirror her emotions, sometimes they are the opposite of this. For example, after Pollock's sudden death, she painted bold and upbeat works in a series she called *Earth Green*. Her impulse was to reach out and boldly embrace life, which had so swiftly left Pollock. Her frequent preoccupations include an emphasis on nature, and she sometimes hints of birth, destruction, and regeneration.

At the same time, one must take into account the possibility that Krasner was actually relieved to be free of Pollock's debilitating behavior and the constant anxiety it created not only in her but also in many others who came into contact with him. Years later, she reflected: "Look, it was a mixed blessing—our relationship. It had many, many pluses and several minuses. His drinking, for instance, was very rough on me, to put it mildly."[22]

Krasner perhaps expressed the burden Pollock represented in a memorable dream: "Jackson and I were standing on top of the world. The earth was a sphere with a pole going through the center. I was holding the pole with my left hand. Suddenly, I let go of the pole, but I kept holding on to Jackson, and we both went floating off into outer space. We were not earthbound."[23] She had supported Pollock as long as she could, but eventually his drinking and the emotional pain that caused him to drink produced a situation that was too difficult to endure. Krasner had never, however, intended to let go of Pollock.

Though Krasner was still working, she needed to be able to

show her paintings—being able to do so meant continuing to exist in the world. But she, and many of her contemporaries, were concerned about the lack of opportunity to show their work. The artists John Little and Elizabeth Parker, both of whom had also studied with Hofmann, joined with Alfonso Ossorio to open the Signa Gallery in 1957 at 53 Main Street in East Hampton in a space that was formerly a small market. Financed by Ossorio, this was the first commercial gallery in the area devoted to contemporary vanguard work. The gallery's profile was high, and its openings became popular social events, often attracting up to five hundred people.[24]

Signa Gallery lasted for four years. Krasner showed her painting *Spring Beat* (1957) in a group show from August 11 to 24, 1957, along with Paul Brach, David Hare, Franz Kline, Costantino Nivola, Charlotte Park, Elizabeth Parker, and Theodoros Stamos.[25] She showed fewer works than the others, but her canvas (at 98 by 124 inches) was the largest object on view. Krasner also participated in "A Review of the Season," Signa's September show that same year.

August 1957 marked a year since Pollock's death. Krasner's friends Giorgio Cavallon and Linda Lindeberg wrote, telling her that she was in their thoughts and how wonderful she had been in the past year, "always making something positive and clear out of the tragedy of Jackson's death." They said how they admired her positive attitude, her courage, and her new paintings.[26] Krasner spent Thanksgiving that year with Bob and Abby Friedman, Barnett and Annalee Newman, and Sheridan and Cile Lord, recorded in a snapshot probably taken by Cile.

In 1949, U.S. Representative George Dondero had denounced "the link between the Communist art of the 'isms' and the so-called modern art of America."[27] Now, at the height of the cold war, the Federal Bureau of Investigation investigated Krasner under the names "Mrs. Jackson Pollock" and "Lee Pollock" for espionage.[28] Most of her FBI file, which is only two pages long,

has been blacked out, but the following is visible: "Mrs. Pollock is an artist of the modern school." The FBI continued looking into her case until December 16, 1957. It appears that someone had reported her. One explanation is that the person did it out of anger. Another possibility is that Krasner, when she was in Europe at the time of Pollock's death, had some innocent contact with someone who had political connections that raised suspicion about her activities. One must note that the FBI also investigated a number of her contemporaries, for example, Mark Rothko and Adolph Gottlieb, to name just two. Like Krasner, both were Jewish. It has been suggested that at this time "sectors of the U.S. government were openly racist" and anti-Semitic.[29]

Krasner was not nearly as politically engaged during the 1950s as she had been during the 1930s, when the FBI seems to have ignored her. Nothing incriminating was ever found, and it appears that Krasner never knew she was being investigated. It is difficult to imagine Krasner operating as a spy, particularly since she had no access to any secret information that anyone would want. She certainly was preoccupied during this period with marketing Pollock's work, taking full advantage of the capitalist system.

Oblivious of the FBI, Krasner focused on exhibiting her *Earth Green* series at the Martha Jackson Gallery from February 24 through March 22, 1958. Located on the Upper East Side at 32 East Sixty-ninth Street, the gallery was relatively new, having opened a few blocks away in 1953. Nearly Krasner's contemporary, Martha Kellogg Jackson was born in Buffalo, New York, where she grew up interested in art. She graduated from Smith College and attended Moore College of Art in Philadelphia.[30] She was said to be quite sympathetic to her artists, who, among Americans, also included Willem de Kooning, Paul Jenkins, and Louise Nevelson. She introduced some important European artists to the American public, including Antoni Tàpies from Spain and Karel Appel from the Netherlands.

Krasner's seventeen oil paintings at Martha Jackson were large, ranging from six to about seventeen feet in length. The longest, *The Seasons,* she had painted in the barn studio that had been Pollock's. Ben Heller recalls that Krasner enlisted him to help stretch her paintings at the gallery, causing his hands to be "sore." He never bought any of her work.[31] The show occupied two floors of the gallery. According to the gallery's press release, "All the canvases are closely related and actually form a series along a central theme. A deeply felt personal experience is suggested by such paintings as *Listen, Earth Green, Spring Beat, Upstream, Sun Woman, The Seasons,* and others such as *Embrace* and *Birth*."[32] Krasner chose B. H. Friedman to write an introduction in the catalogue for her show. After discussing why she had not yet received the recognition she deserved and discussing her devotion to Pollock, he concluded, "In looking at these paintings, listening to them, feeling them, I know this work—Lee Krasner's most mature and personal, as well as most joyous and positive, to date—was done entirely during the past year and a half, a period of profound sorrow for the artist. The paintings are a stunning affirmation of life."[33]

Among the telegrams and notes of congratulations Krasner saved was a card of the type that usually arrives with flowers. It was inscribed "To Lee—The Best and the Most—Len Siegel," a warm greeting from her therapist. The following July, according to Bob Friedman's journal, Krasner's therapist "'dismissed' (her word)" her. Friedman commented cynically, "In this case dismissal means that he has gotten as much help from her as he can."[34] She had at least begun to work through her grief.

Nearly two decades later, Krasner spoke about the paintings in this series: "I can remember when I was painting *Listen,* which is so highly keyed in color—I've seen it many times since and it looks like such a happy painting—I can remember that while I was painting it I almost didn't see it, because tears were literally

pouring down."[35] The bright colors and biomorphic forms evoke a figure in a garden, an activity that she shared with Pollock after they first moved to Springs.

In 1979 Krasner wrote about the work *April,* which she related to *Listen, Sun Woman,* and *The Seasons.* "The title wouldn't necessarily mean that I painted this work *in* April. I might have, but it's too far away from me now. I think I felt the painting *was* April, whether the month was April or not. I paint a picture and the title follows, so there must have been something in either the color or the iconography to indicate why I chose *April* as this title. I'd say that this painting would be typical of the color in that show."[36]

Once thinking about her palette, she reflected, "I have no idea as to why I sometimes go from no color to a very high keyed color. I have no way of explaining this to myself—what makes this happen—and so I've ceased to try to explore it, and simply go with it. I either feel color, or I don't, and when it doesn't happen, I don't feel the need to explain it to myself now, as strongly as I did in the past when I was more preoccupied with this question."[37]

Finally, at what the press release announced as "her third one-man show," Krasner won over the critics. In the *New York Times,* Stuart Preston opened his article with: "The bravado of Lee Krasner's recent and huge abstract paintings at the Martha Jackson Gallery presents a raw challenge to the eye whether or not we accept the symbolic intentions of her sequences of whirling shapes. What impresses the spectator is the sheer energy that Miss Krasner manages to generate on her picture surfaces. We feel that somewhere behind each picture is a spring that sets off the killing pace of her shapes like an alarm clock."[38] *Time* magazine devoted an entire article to "Mrs. Jackson Pollock," chronicling her early history back to the months leading up to the McMillan show of 1942. Though the article got a few details wrong, including the date, it noted the important fact that "Blue-eyed Lee Krasner, 49," had met Pollock and "In the years that followed, the pair made art

history; one with commotion—Jackson Pollock; the other with devotion—Lee Krasner, who became his wife."[39]

*Time* quoted Krasner about her work in the show: "These are special paintings to me. They come from a very trying time, a time of life and death." The writer went on to say: "[The paintings] have haunting titles; e.g., *Visitation, Listen.* They mostly seem to explore death-haunted themes that, Lee Krasner says, make it 'hard enough for me just to accept my own paintings.' But they also strike a lonely note of hope: one of them is entitled *Birth.*"[40]

Even women, such as the critic Anita Ventura, who reviewed Krasner's show in *Arts Magazine,* felt compelled to see this art through the lens of Pollock's work: "Her paintings stand in a relationship to Jackson Pollock's that is similar to that of Juan Gris's Cubist works to Picasso's or Braque's, or of Dufy's Fauve paintings to Matisse's. This is particularly true of her successes: *Earth Green* and *Listen* (related to Pollock's totem series and *Ocean Greyness*—to my mind his best paintings), in which she moves his energetic forms toward a rose-beige-brown, emerald-green and fuchsia delicate beauty."[41] Ventura qualified her praise by writing, "Her less successful works, in which the energy is dissipated rather than transformed, become unintentional caricatures."

Ventura viewed Krasner as one of the earliest to assimilate Pollock's innovation: "It isn't that the second [Krasner] lacks spirit; it has its own sensibility."[42] She then recalled how the Arensbergs, Los Angeles collectors of cubism and Dada, had cared for "the first harsh moment when something not quite comprehensible was got hold of, when nobody knew whether the work was ugly or not until somebody else came along and made it beautiful."[43]

Parker Tyler, writing in *Art News,* came to a similar conclusion, declaring though one "saw clearly, sex and the woman," Pollock's "motifs of flesh and fecundity are repeated by his wife in a palette that oddly suggests off-pink cosmetic and fuchsia lipstick as well as flower petal, plant leaf and the void. The scale is audacious, the derivation as legitimate as a painter might wish."[44]

Krasner readily acknowledged the importance of Pollock on her artistic development, saying, "He would have influenced me even if I hadn't married him. So did Picasso and Matisse and Mondrian. But I think I've held my own identity right through." At the same time, the influence was inevitable by virtue of their marriage: "How can you live with someone without that happening, too? We never sat down and had a big art talk together. He'd come in and say, 'Want to look at what I've done?' And I'd invite him into my studio. Maybe I'd say, 'Want to look at what I've done?' But we never talked about, say, whether the edges should go inside or out, that sort of thing."[45] When Krasner was asked if she had an influence on Pollock, she was only willing to say, "I daresay that the only possible influence that I might have had was to bring Pollock an awareness of Matisse."[46]

At the time of Krasner's show at Martha Jackson, the International Council of the Museum of Modern Art had, with her help and her approval, organized a circulating show of sixty of Pollock's paintings that would travel around Europe, going from the Galleria Nazionale in Rome to museums in Basel, Amsterdam, Hamburg, and London.[47]

Krasner's own work got international attention in April 1958, when it was included in "International Art of a New Era," an art exhibition arranged by the French curator and critic Michel Tapié at the Gallery of Takashimaya for Japan's Osaka Art Festival. Krasner was represented by *Rose Red* (1958) and her monumental canvas *The Seasons* (1957), which features forms that make allusions to human anatomy, suggesting sexuality and regenerative life forces. Krasner feared flying, so she chose not to travel with her art to Japan and missed an opportunity to promote her work in Asia.

Krasner continued to see friends in East Hampton, including Patsy Southgate, then divorced, who met her future husband, the artist Michael Goldberg at Krasner's home over Memorial Day weekend, which opened the 1958 season.[48] During that summer, Krasner again showed her work at the Signa Gallery in East

Hampton. She participated in the second year's first show called "The Artists' Vision—1948–1958," which featured the work of Hans Hofmann, who was "among the artists from outside this area who have been invited to participate." Krasner showed *Continuum* (1949, a canvas on loan from Ossorio and not for sale), a collage called *The City* (1953, not for sale), and *Four,* a canvas from 1957, for which she asked one thousand dollars. Krasner's price was small compared to Hofmann's; his works were priced at three to six thousand dollars.[49] Some of Krasner's old friends showed, including Perle Fine, Balcomb Greene, Ibram Lassaw, and the gallery's three founders.[50]

Krasner's friendship with Perle Fine was beginning to blossom again after their days together in Hofmann's class. Four years earlier, Krasner had convinced Fine to give up her Tenth Street studio and move out to Springs. "It was through Lee that we decided to come out here on the East End," Fine explained. "Lee was always talking about how wonderful it was, how much she and Jackson enjoyed it."[51] That same summer Fine posed for a photograph taken by her husband, Maurice Berezov. The photo depicts de Kooning grinning in the center, flanked by Fine and, on the other side, a smiling Ruth Kligman, who had moved on after Pollock's death to have an affair with de Kooning. Though still technically married to Elaine, he had also fathered a daughter with Joan Ward just a few years before.[52] It is not known if Krasner knew that Fine was spending time with de Kooning; but living in the small town, she did hear about Kligman's relationship with the artist who was still seen as Pollock's chief rival.

David Slivka recalled that Krasner invited him and his wife, Rose, to come out from the city for a weekend. Early in the morning, while the women were still asleep, Slivka went for a walk and ran right into de Kooning pushing Kligman on a bicycle. Bill invited him over for coffee. While there Slivka saw some of Ruth's paintings and thought it bizarre that she was trying to imitate de Kooning's style. When he returned to Krasner's, Rose asked where

he had been, and he said he'd been having coffee. But when he asked indiscreetly what Lee thought of Kligman and de Kooning renting Conrad Marca-Relli's cottage next door to her, she replied, "She's suing me!"[53] Indeed Kligman had sued Krasner to force her insurance to pay her medical expenses from the crash that killed Pollock.

The gossip and posturing around Krasner must have made things difficult for her. She was not one to cower in a corner, however, and so she just kept trying to be Lee Krasner, the artist, which meant participating in a third show that season, called "The Human Image." Thanks to Ossorio, the show projected an international perspective, including, among others, Dubuffet and Karel Appel, as well as sculpture by David Smith and James Rosati. Additionally there was the work of Pollock and Grace Hartigan, Willem and Elaine de Kooning, and the gallery's founders.

Krasner showed *Prophecy,* which was the canvas that had remained on her easel when she left for Europe in 1956. Ossorio had reserved it, so it was not for sale, but Krasner's agreement to have it in this particular show marks her public acknowledgment of its "human" or figurative image. "I got back from Europe and this painting—once more I had to look at it and deal with it; *Prophecy* still frightened me enormously. I couldn't read why it frightened me so, and even now would be hard put to do so. And so in that sense the painting becomes an element of the unconscious—as one might bring forth a dream."[54] Ossorio paid $720 to Martha Jackson Gallery for *Prophecy,* of which $120 went to Signa Gallery for its commission.[55]

That summer Lee had two young men live in what was little more than a shed on the Fireplace Road property—Bob Friedman's brother, Sanford (Sandy), a novelist, and his partner, Richard Howard, a poet. Krasner became close to the men, who returned to live in the little house for the next two summers as well. Krasner and Pollock had acquired the building to serve as her studio, but since she began to work in the barn that had been

Pollock's studio, she later gave this one to her nephew Ronald Stein and his wife to use as a house, surely hoping that their presence would allay her fears of living alone.

Howard recalled, "If there was no houseguest, if Sanford or I were unavailable, then a neighbor's daughter, a child would do, but there had to be someone there. And if she could not sleep, even less could she concentrate on a book."[56] Richard and Sandy not only read aloud to Krasner, but they also helped her name her paintings. Their friendship with Krasner lasted until her death.

In autumn 1958, *It is,* the avant-garde journal, reproduced seventeen signature plates of work by contemporary artists, including Krasner's and Perle Fine's. Many of the others were much younger.[57] That same year Bob Friedman, then vice president of Uris Brothers, a real estate company, commissioned Krasner to create two large mosaic panels for the exterior of their corporate headquarters, a thirty-story building at 2 Broadway, near the southern tip of Manhattan.[58] The architects for this building, Emery Roth & Sons, had suggested, in the preliminary renderings, that a mural, made of durable glass mosaic set in cement, be placed between the second and third floors at the main Broadway entrance. The larger of the two murals was to be eighty-six feet long and twelve feet high, and a second, smaller mural was commissioned for the building's facade on Broad Street.

Bob Friedman had long admired Krasner's mosaic table in her house.[59] She had also worked on immense murals while on the WPA, so she felt up to the challenge for the Uris Brothers project. "By the time I came to do a mosaic in the Uris Brothers building in downtown Manhattan, eighty-six feet long, that scale was nothing new to me. Long before I met Pollock, too, I had been working that large."[60]

Krasner also saw this commission as an opportunity to help her nephew's career. It was a poignant decision. When her mother died in 1959, Krasner's siblings and nieces and nephews were the only family she had left. Among all her relatives that she had

taken under her wing, Ronald Stein, the son of her sister Ruth, became an artist. Having influenced him, she felt responsible for his future.

The artist Will Barnet still recalls that Krasner sent Stein to study with him at Cooper Union, where she had begun her own education, and that Stein had talent but "kept getting into fights in bars."[61] After his study at Cooper, Stein earned an MFA at Yale. Stein, then in his late twenties, had already done some mosaics of his own, including a commission for a series of panels representing the Stations of the Cross.[62] For the Uris Brothers mural, the aunt and nephew team produced both a scaled study in collage format and studies of the mural's details.

Bob Friedman was both the impresario commissioning the project and the mural's promoter. He wrote about it for *Craft Horizon* and compared Krasner and Stein's efforts to those of Gaudí in Spain.[63] The two artists, in an attempt to avoid "rigidity," elected to have the glass plates of the mural broken into free-form or random shapes, rather than have the Italian glass cut into the typical "tesserae" pattern. Rules of union labor in New York City prohibited the artists from doing the physical work themselves, and they were not even able to touch the materials without fear of provoking a strike. Instead Krasner and Stein closely supervised the work, even to the mixing of the cement, so they achieved the dark color they envisioned. Even being allowed to watch while the craftsmen worked was itself a concession on the part of the union.

Krasner accepted the union's control, but she believed it made it impossible to produce inventive mosaics in New York.[64] Union workers expected to work with a sketch and evenly spaced tesserae and ordered directional patterns. The union workers ignored the idea, understood during antiquity and the Middle Ages, that mosaic could modulate light. They couldn't understand murals as abstract as Krasner's.

Krasner's loss of her mother, following closely on Pollock's death, disturbed her so much that she was not able to sleep. Years later she told an interviewer, "I wasn't allowed to mourn at my own tempo—which might have seemed sluggish to some people."[65]

Krasner had also stopped living in East Hampton year-round, and the move to Manhattan was a major change. She finally acknowledged to herself that she was suffering from chronic insomnia and took to painting at night in the city. Because she had to work under artificial light, she reduced her palette to umber and white. The poet Richard Howard recalled how startled he and Sandy Friedman were "that all the new paintings were coming out, as we used to say, Ahab-colored." Ahab was the brown poodle Ossorio and Dragon had given Krasner and Pollock.

Howard asked Krasner if this color "represented a descent into a new crucible of emotions . . . a specific registration of grief. Were these not mourning paintings."[66] Krasner demurred, "I was going down deep into something which wasn't easy or pleasant. . . . Well, there was so much taking place. My mother dies at this time. A lot happens aside from my grief for Jackson. There are many elements. I cancel my show with Greenberg—a show scheduled at French and Co. And these paintings are already under way."[67] It was as if some deep-seated depression had finally caught up with her, and she turned to making large, somber canvases that cried out with emotional chaos. She renounced color, explaining, "I like daylight. Those were the only paintings done by artificial light. Those paintings [were] done in deep turmoil."[68]

One of the first paintings of this type is *The Gate,* a monumental canvas that she was working on during the summer of 1959 after her move into the barn studio. During its creation, Halley Erskine photographed Krasner while she worked. With *The Gate,* "There was a demand to abstract it to this point. The imagery is much clearer in the early version, however you're going to read it.

The title *The Gate* is much connected with my mother's death, at least on a conscious level when it was painted."[69] In its early stages, *The Gate* had many recognizable shapes, but in its final version, it was filled with energetic lines and splashes of white paint. Describing this canvas and its series, she explained, "These are physical paintings. The gesture is a thrust—I don't generally do that."[70] In fact her gesture makes one think of Pollock.

Krasner's depression was exacerbated by an upsetting falling-out with Clement Greenberg, which aborted plans for her show at the gallery French & Company in 1959. Greenberg had recently started working for the gallery, and accounts differ over what happened between him and Krasner. At the time of the clash, Greenberg was still in therapy with Ralph Klein, who by then had joined with Saul Newton and Jane Pearce in the Sullivanian Institute for Research in Psychoanalysis. Greenberg, who was not normally an early riser, was reporting for 9:30 A.M. appointments with Klein several days a week. He was reputed to be taking prescription sleep medication and drinking martinis in the afternoon.[71] Klein notoriously was not wont to help his patients control their intake of alcohol and drugs.

When Greenberg began his association with the contemporary art gallery French & Company in March 1959, it was already experiencing serious financial problems, though he didn't know it at the time. He was expected to turn a profit. In a letter dated August 1, 1959, to "Mrs. Lee Pollock," Spencer Samuels, whose family owned the gallery, thanked Lee for her warm hospitality during a delightful weekend in Springs and mentioned that he had also thanked Alfonso [Ossorio] with whom he enjoyed a provocative conversation. He told Krasner that her show was excellent and that he felt certain that "Clem will go along with the idea of a 'semi-retrospective' show unless he has something particular in mind in regard to your work."[72] He also assured Krasner that he was making an effort to "rough out" an agreement about some of the issues that they had covered during the weekend.

Greenberg's most recent biographer claims that the critic wanted to show Pollock's work, but that Krasner "insisted that he also give her a show. Greenberg agreed, but his evident reluctance so angered her that she canceled both her and Pollock's shows."[73]

On May 20, 1973, Greenberg wrote an angry response to the editor of *Arts Magazine* regarding a published conversation between Cindy Nemser and Krasner. Greenberg's letter, which was published in the November issue, claimed that Krasner erred in describing him as French & Company's director, stating that all he did was serve as "adviser" to its contemporary art department.[74] In the letter, Greenberg had crossed out nearly two lines from his original typescript that can still be deciphered. Perhaps his anger no longer allowed him to express his early regard for Krasner's work.

In his effort to contradict Krasner, Greenberg wrote, "When in the spring of 1959, Miss Krasner proposed to me, out of the blue, that she have a show at French & Co. I agreed immediately." He then stated that Krasner also asked for a show of Pollock's black and white paintings. "To this I didn't agree so readily; I was afraid it would look like a tie-in. But Miss Krasner overcame my qualms, & in the end I agreed to the Pollock show too."[75] Greenberg agreed that Krasner had canceled her show because of his negative "response" to her new work. He claimed, however, that he had scheduled the show "out of my personal & professional regard for her," rather than out of admiration for her work.[76]

He followed this amended passage by asserting that after he had visited Krasner's studio, discussion about the Pollock show ceased. Not having access to the Pollock estate was a source of great bitterness for Greenberg, who saw himself as having promoted Pollock from the beginning.

It is difficult to know whether or not Greenberg's account above is legitimate, because he later contradicted himself about Krasner in a lengthy interview with Florence Rubenfeld, his first biographer:

*When I became an advisor to French and Co., '59...
[Krasner] wanted me to tell French to put on a show of
Jackson's black and white pictures from before '51 (when
he'd done a whole series of black and whites that had been
exhibited). These were antecedent to those. And I said sure
that'd be great. And then she said, "and a show for me."
And I said—I was being so pure and I was showing off
to myself which I've done in the past—and I said no. It
looks too much like a tie [in]. A show for you but not for
Pollock. This in front of Porter [Macray of MoMA] and
Jenny [Greenberg's wife].... And finally I said, OK I'm
being too pure. A show for both of you. I'll tell French. And
that was that. And then we went to Europe. And when
we came back we went out to see Lee and her studio and
socially.*[77]

When Greenberg and his wife went to Springs as Lee's house-
guests, her show was still on his mind. Lee's friend Patsy South-
gate was there. "So after this woman left, and the moment the
door shut. What came first I don't know, but I'd gone to see Lee's
studio and I'd seen the pictures and I didn't like them. Lee was
not a good painter. [Greenberg struck this line out of the tran-
script sent to him by Rubenfeld.] She was so accomplished but it
was hollow. And first Lee got mad at Jenny because Jenny had
[said] something critical about the lady who *had been* there....
I [had] seen her pictures and I had and I didn't like them."[78] In
her biography, Rubenfeld highlighted the fact that the Greenbergs
were staying with Lee. In her interview, she asked Greenberg,
"God, and you had to tell her you didn't like her paintings?"
Greenberg responded:

*Yah. And Lee wasn't large-souled. She wasn't magnani-
mous. And Jenny said to me, let's go. Let's go. And I—with
my newly found analytic piety [his handwritten correction*

*of* views] *said no, we can't leave angry. We'll sweat this out. Don't leave angry. We're friends and all that. And so, somehow we got thru dinner and I got up the next morning and Lee's face was swollen. You know there are people, and I've noticed this before who when they sleep on their rage when they get up their faces are swollen. And she drove us to the train station [twenty minutes away] and I said some pious thing like we're still friends and so forth. No, she was angry, angry, angry. With her swollen face. And so we told her, don't wait for the train with us. We didn't want her to wait.*[79]

Later in the same interview—held nearly six years after Krasner's death—Rubenfeld skillfully questioned Greenberg about his estimate of Krasner's painting, asking if he had seen her painting since this last acrimonious encounter. He admitted:

*I hadn't paid enough attention to it. It was better when I saw it in the Museum of Modern Art retrospective [held after Krasner's death]. And some of the allover things— I thought they had come straight out of Jackson. I didn't pay enough attention. She was a better painter back then—she was a better painter before she met Jackson. Not that he hurt her paintings. It was just another one of my mistakes. She wasn't that good but she was a good painter. I remember at the retrospective there was only one really good picture. Incandescent. Smallish one.*

To Rubenfeld, Greenberg also complained about "Lee's self-centeredness. . . . Lee had a lot of character but she didn't have the essence of character. . . . She's so self-centered. And Jackson was so self-centered too. The two of them." [80] He also admitted, "I still admire Lee. How she intimidated me, that's what I admired." Greenberg acknowledged that Krasner was the only one who

could always intimidate him. For Greenberg, it was her "force of character . . . and boy she had it." [81] In Greenberg's view, he let Lee know that he did not like her work and she canceled both her show and Pollock's show scheduled for French & Company.

Krasner told her friend the critic and art historian Barbara Rose that "we had words and he exited." Rose commented, "I imagine the words and the exit. I also realize it was her last chance to become part of the official avant-garde and that she deliberately refuses to conform." [82] But Krasner explained more than once that Greenberg canceled the show that he had promised her at French & Company because she refused to give him access to the Pollock estate and let him show it there. [83]

In 1981 Krasner told another interviewer, "People treated me as Pollock's wife, not as a painter. . . . Someone like Greenberg, because I didn't hand over to him the Pollock estate, did his job well to make sure I didn't come through as a painter. He had power." [84] It is clear that at this particular moment Greenberg was under pressure to produce sales for French & Company, and Pollock was then, after his death, a very "hot" artist with escalating prices.

Instead of the prestigious show she had anticipated at French & Company, Krasner had a solo show, "Lee Krasner, Paintings 1947–59," in East Hampton with the Signa Gallery from July 24 to August 20, 1959. The show ranged from her Little Images to recent works like *Cornucopia* (1958) or *Breath* (1959). There were a total of fifteen pictures, of which two canvases, *Noon* and *Yes & No,* were not for sale. The prices went from $600 for the collage, *Forest I* (1954), to $1,800 for the canvases, *Birth* (1956), *The Bull* (1958), and *Cornucopia.*

Meanwhile, helped by her relationship with the French critic Michel Tapié, Krasner managed to take part in several group shows in Europe, such as the "Arte Nuova" show that took place at the Circolo degli Artisti at Palazzo Granieri della Roccia in Turin, Italy, during the spring of 1959. Both *Spring Memory* (1959), an

oil on canvas, and *Broken Gray*, an oil and collage on Masonite, were shown, though the latter was misdated as 1958, when it was actually from 1955.[85] As when she had work on view in Japan, Krasner made no effort to travel to Turin for the opening. Had she done so, her international recognition would surely have expanded.

Krasner's association with Tapié came from her long and close friendship with Ossorio and his companion, Ted Dragon. In February 1959, the East Hampton police apprehended Dragon while he was burglarizing a house and carrying a chair out of a second-floor bedroom window. For four years, while he was left to guard The Creeks house, Dragon had been "rescuing" antiques and art from homes and estates left vacant over the winter.[86] He never sold anything but, without Ossorio's knowledge, stored most of his booty in their attic, telling Ossorio that he got these things from his relatives in Northampton, Massachusetts.

After he was caught, Dragon's only explanation was that he "just loved beautiful things so much, and sometimes I was appalled at how badly the furniture was being kept."[87] In fact Dragon restored and reupholstered some of the furniture he took, even eliciting thank-you notes from a few of the victims when they got their antiques back in better condition. Among Dragon's targets was the art dealer Leo Castelli, whose home Ossorio and Dragon had visited together on several occasions. Instead of prison, Dragon was sent for two years to West Hill, a private sanitarium in Connecticut, where he produced needlepoint and taught the other patients ballet. While there, he received a note from Grace Hartigan, saying, "Thank God we have a Robin Hood out on Long Island."[88]

Some rejected Dragon for his criminal activity and referred to The Creeks as "the Creeps."[89] To the contrary, Krasner loyally stood by Dragon, saying she thought his rescues were "terrific." She enjoyed his tales of acquisition and his taste for antiques. As

she began to have more disposable income, Dragon began to help her shop for antiques to redecorate. Krasner's stance also helped to cement her relationship with Ossorio.

Dragon later commented that, except for Lee Krasner, "most of the people who passed in and out of the house weren't interested in me in the least."[90] Krasner instead empathized with anyone who had to play the role of spouse to a famous artist. Despite her compassion, Dragon could be critical of Krasner: "Lee knew how to manipulate. From the moment I met that woman, her mind had one channel: Art, the making of Pollock, and the making of herself."[91] Dragon recalled Krasner's sessions of calculating who in the art world could do what she needed for her. She even spread out small papers with their names on a table to study: "It was stepping stone after stepping stone. And if they didn't come through, the relationship ended—like opening a trap door."

# FIFTEEN

# A New Alliance, 1959–64

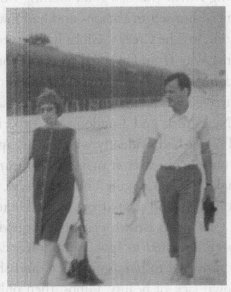

Lee Krasner and David Gibbs walking on the beach in East Hampton, July 1960. Krasner was so taken with the handsome Englishman that she gave him the choice assignment of finding a gallery to represent the Pollock estate. Courtesy of the Pollock-Krasner House and Study Center, East Hampton, New York.

LFONSO OSSORIO WAS "DEVOTED TO LEE" AND SEVERAL TIMES asked her to marry him, but always when he was "very drunk," according to Richard Howard.[1] Cile said that Alfonso was sort of "appealing," but Lee said that she found him "revolting"[2] and refused to marry him. Ossorio had been married once, in 1940, to Bridget Hubrecht, though they divorced the next year. Krasner often saw Ossorio socially and, for a time, frequently. Through Ossorio she first met Dubuffet and saw more of

Clyfford Still, with whom she stayed friendly long after Pollock's death.

During the summer of 1959, Ossorio asked Krasner over for a Saturday-evening dinner. Betty Parsons was there as well and had brought along David Gibbs, a good-looking Englishman who had just introduced himself to Parsons and had managed to get a weekend invitation to The Creeks. Gibbs had served in the Welsh Guards in World War II and worked as a stockbroker but now was a self-proclaimed "art dealer" who dreamed of becoming a painter. His marriage was disintegrating as he began dividing his time between New York and London. His experience working in the financial sector had evidently whetted his appetite for rich women. To an outside observer, it may have appeared as if Gibbs was "on the make," professionally and otherwise, as if he were planning to settle down and start afresh in the United States.

Krasner fell for Gibbs's British charm and good looks, just as she had once been attracted to Igor Pantuhoff's European style. She was clearly attracted to handsome men, and she was not inhibited by her own lack of beauty. Gibbs, then only thirty-three, was seventeen years younger than Krasner at fifty; but this didn't deter her.[3] Gibbs was "tall, gray-haired and urbane even for this most urbane of professions," according to a British newspaper's description just a year later.[4]

At The Creeks, Gibbs spent Friday night in a room with works by Dubuffet, Pollock, and Krasner on the walls. He claimed to like Krasner's small painting "enormously" and told her so at dinner the next evening, while requesting to see more of her work.[5] She invited him to drop by on Sunday, when, without missing a beat, he purchased one of her new large canvases, *Cool White* (1959). It was one of her first large pictures to sell, and Gibbs later resold it for a handsome profit.[6]

The purchase was the ultimate flattery, and Krasner was disarmed. He later claimed that he and other Brits were seen by New Yorkers as invigorating because they were not felt to be tainted by

the art world. He may have been thinking of the British critic and curator Bryan Robertson, who served as curator of the first Pollock retrospective in Europe.[7] However, Robertson was openly gay and did not tease Krasner with a romantic entanglement. A year later, in May 1960, the *Sunday Times* of London included Gibbs in a feature story called "Atticus among the Art Dealers," about a "handful of dealers who still manage to keep London at the head of the art-dealing centres of Europe."[8] The headline's classical reference is to Roman times, when Atticus, a friend of Cicero's, was an Epicurean who collected art.

Gibbs's treatment of Krasner was more than just professional. In a letter postmarked December 21, 1959, he addressed her as "Dearest Lee" and told her how he thought of her frequently, longed for her, and missed hearing from her, which, he claimed, left him unable to sleep. He said that he worried about the dangerous steering wheel on her car and urged her to take care of herself. Gibbs praised her gift to him of jazz record albums, especially the ones by Ornette Coleman and Miles Davis. He also implored her to come see him in England early in the new year. He told her how close he still felt to New York and fondly referred to her painting that he had picked out, though he had yet to pay.

In his letter Gibbs encouraged Krasner to break from her past and begin anew without the weight of old memories. He cheered her on, telling her what a terrific person she was, which was just what he thought she wanted to hear. He pledged to help her manage the Pollock estate with all of his energy, declaring that it was just the challenge he truly wanted to take on and that he would soon return to New York. He urged her to keep painting and encouraged her to write to him. The effusions concluded with his wishing her a happy new year and sending his love.[9]

Gibbs wrote this last letter on stationery imprinted with "David Gibbs & Co. Ltd c/o Louis Poirer & Co. LTD. Wine Shippers, 15 Old Bond Street, London."[10] He shared an office with a Bond Street wine merchant and, according to a London reporter,

"believes that a good dealer should be a cross between a psycho-analyst and a stockbroker. He has been a soldier, biscuit manu-facturer and stockbroker but prefers selling pictures to anything else. He believes that most galleries are far too forbidding to the new potential picture-buying public, and does most of his business from his commodious flat in Chesham Place."[11] Gibbs proudly sent this article to Krasner.

Krasner fell hard for Gibbs. In a letter of April 6, 1960, he again addressed her as "Dearest" and said that he was thrilled she had called him earlier. It's clear that Gibbs was after Pollock's estate. But how he ended up getting ahold of it so efficiently is somewhat complicated. From a letter that he wrote to Clement Greenberg on May 6, 1960, it appears that Gibbs carefully calcu-lated and arranged meetings with Parsons and Ossorio—all along he was working toward getting to Krasner, his ultimate target. A year earlier, he had met Greenberg at the opening of an exhibition of Barnett Newman's work, organized by Greenberg for French & Company before Krasner's show had been canceled.[12] Gibbs had done his homework.

In the letter, Gibbs described having had an immediate insight when he first met Greenberg at Newman's exhibition. He then recalled how he had followed up the meeting by paying a call the following Sunday morning, when Greenberg was at home with the flu. He avowed that he had liked Greenberg. If the feeling hadn't been mutual, Gibbs would have let the matter drop. Instead the two men got together during the critic's visit to London and became friendly.[13] Gibbs wrote that he presumed that Greenberg could teach him about American paintings, which he did. He also assumed that Greenberg benefited from their friendship because such relationships (he described them metaphorically as "traffic") are always mutual and reciprocal.

Gibbs pretended to be amazed by the turn of events over the previous few weeks—he had been asked by Krasner to help handle Pollock's estate—and he attributed his success to Green-

berg and his wife, Jenny, who he claimed gave him his start in America. He stated that the purpose of his letter was to protect their friendship against a possible breach.

At the letter's climax, Gibbs exposed his underlying purpose—traveling to East Hampton and meeting Krasner. Artfully, he asserted that she made him feel the immediate sensation of mutual understanding—the same feeling that he had felt with Greenberg some ten months before. Thus because Greenberg and Krasner were no longer on good terms, when he came to New York, Gibbs claimed that he faced divided loyalties. He did not want to choose one new friend over the other.[14]

He described an extraordinary dinner with Krasner at the elegant New York restaurant "21," at which he agreed to go back to London and promote a small number of American paintings. Afterward Krasner called him to ask if he would help her decide where she should show her work. In particular, should she accept the overtures of Howard Wise, the latest dealer pursuing her painting? Then, dropping the bomb on Greenberg, he wrote that she had asked him if he would be interested in assisting her to place the Pollock estate.

It was disingenuous of Gibbs to feign surprise to Greenberg. After all, he had been working to obtain Pollock's estate even before he first set eyes on Krasner. He clearly knew that the news of his success would be devastating to Greenberg. After Greenberg's long years of promoting Pollock's work, a Johnny-come-lately from abroad had snatched the right to work with Krasner on the Pollock estate right from Greenberg's grasp.

Gibbs told Greenberg that he lost no time in flying to New York. Krasner telephoned on the Thursday before Easter, and he left the following Friday. He wrote about the previous two weeks in detail and feigned modesty by claiming that he had never before written a letter like this and that he would love to exchange letters with Greenberg over the matter. He also mentioned that he told Sidney Janis to forward all inquiries about Pollock on to him.

He ended the letter by asking how everything struck Greenberg. If Greenberg wrote a response, it hasn't been found; but Gibbs sent Krasner a copy of his typed letter that she kept, hence he clearly meant it also for her eyes.

Krasner was so taken with Gibbs that she gave him the choice assignment of finding a gallery to represent the Pollock estate, at once enhancing his income and his status. He managed not only to get the job, but he billed Krasner $1,000 ($100 a day for ten days) for his time, plus another $1,086 for his airfare, hotel, and sundry expenses. Payment was all handled by her attorney, Gerald Dickler. By October 26, 1960, he was about to visit her again and signed his business letter "with my fondest love." [15]

Krasner's friend Cile (Lord) Downs perceived Gibbs as "very personable, tall, and reedy," and as "one of those borderline guys—gay—AC-DC so clever at handling Lee." [16] Richard Howard recalled that Gibbs was "attractive in a way that was alien and new to Lee . . . a different model of man." [17] Sanford Friedman, who was close to Krasner at this time, believed that Krasner and Gibbs were "lovers," but admitted that Gibbs was "an ambitious careerist." [18] Friedman later remarked, "I think that Lee was really in love with him, which if we look at all that precedes Gibbs in her life—how she fell for that—I don't know, but she did. How she would put aside her defiance, opposition, and toughness to surrender." [19] Friedman was struck by how "out of character" Krasner's behavior was: "She was smitten. He played it for all it was worth." The British critic Bryan Robertson was less harsh, perceiving Gibbs as not quite "a gigolo. A bit of a fancy boy, but not a villain, or cruel. He'd be nice to the woman he was with." [20]

Gibbs knew Krasner wanted a large sum of money from a gallery up front, so his assignment was not as easy as it now sounds. Typical Pollocks were then selling for just three or four thousand dollars. When Gibbs sent Krasner the copy of his letter, he also wrote her that he had felt anxious about Greenberg and thus

wrote the letter to explain recent events and to bring Greenberg, whom he viewed as "deranged," back to reality. He added with melodramatic hyperbole that if his letter failed, he would have no choice but to destroy this threat.[21]

Gibbs didn't explain why Greenberg was a threat or why he thought he was disturbed. In the rest of the letter, Gibbs gushed about how marvelous the past two weeks had been and how he expected to go to Paris to see Alfonso Ossorio. He signed the letter, blessing her and wishing her well, adding a drawing of a flower emerging from a bulb while a bird pulls a worm from the earth. It's an ironic juxtaposition—the image of burgeoning love blended with the early grasp of prey.

The London *Sunday Times* wrote about Gibbs just a month later: "His chief task is acting as consultant to anyone who wishes to buy a modern painting but does not know how to go about it. His own taste is for modern American abstracts. He has just been appointed art advisor to the new foundation formed to promote the work of the late Jackson Pollock, the greatest of American action painters."[22] Gibbs was proud of this article, which he showed Krasner.

Greenberg had decided to write a book about Pollock. On September 1, 1960, he wrote Paul Jenkins to say that it was not going well because he wanted to express things that just did not belong in his text.[23] The book never appeared, though the letter shows Greenberg's awareness of what was taking place in the market for Pollock. He also noted that David Gibbs spent two weeks in July in East Hampton, but that he had not seen him.

Despite Gibbs's early calculation and choreography with Krasner, he seems to have developed a genuine affection for her. Naturally this is understandable, given that she boosted his career and his income. Besides, he saw Krasner as a source of inspiration for becoming an artist because she was directly connected to the great Jackson Pollock. Evidently in his own ambition to become a painter, he felt enormous self-doubt, seeking advice and

encouragement from Krasner as a mentor, if not a muse. For her, Gibbs offered excitement, diversion, and an opening into a new world of European artists, galleries, and exhibitions. She believed that Pollock's higher prices "took European approval," which happened when a "show went to Europe through the sponsorship of the Museum of Modern Art."[24]

In hindsight it is easy to see the opportunist in Gibbs. In 1993, long after Krasner's death, he was exhibiting his own artwork in Connecticut, where he elicited this write-up: "The third artist, David Gibbs, was born in England and saw service in World War II before becoming a banker and an art dealer. Upon settling in the United States, in the early 1960s, Mr. Gibbs met Lee Krasner, who appointed him executor of Jackson Pollock's estate. She also turned over to him the studio in which she and her husband had painted. But seemingly Mr. Gibbs osmosed nothing from the atmosphere there."[25] Though Krasner may have allowed Gibbs to paint in the studio when she was in one of her so-called dry periods, the notion of her turning Pollock's studio over to anyone seems like the kind of exaggeration that Gibbs could have made only after her death.

To some extent, Krasner got what she bargained for with Gibbs. Seeking to market Pollock's work, Gibbs thought of Frank Lloyd, the head of the prominent London gallery Marlborough Fine Art Limited, which was then looking to open an American outpost. Though it is not known when Gibbs and Lloyd met, they were both players in the small world of upscale London art dealers. They were both among the handful of dealers featured by the London *Sunday Times* in May 1960 in the article "Atticus among the Art Dealers." The piece described Marlborough Fine Art as "a good example of what can still be done in the art world with a knowledge of painting and business flair."[26]

Lloyd, a diminutive but dashing Jew, was born Franz Kurt Levai in 1911 in Austria, where his parents and one set of grandparents were well-known antique dealers. Krasner's near contem-

porary, he was married and a tough businessman who had landed with the British Army during the Normandy invasion. He had a taste for collecting art and was said to have twinkling blue eyes that helped to conceal his toughness. Krasner, however, probably recognized and respected his pugnacity because it mirrored her own. Evidently she liked his Viennese charm—as a former oil importer, he was much more interested in money than art.

After all, money saved his life in 1938. He had been able to trade his Vienna apartment and its contents (including art by Picasso and the Fauves) for a visa to escape the Nazis. He escaped to Paris, where he joined his brother. In 1939, Germany was poised to invade France, so Lloyd and his brother fled Paris for Biarritz. French authorities put Lloyd and his brother in an intern camp as Jewish refugees. After being released, Lloyd escaped to London, taking a Polish boat from St.-Jean-de-Luz.[27]

Lloyd founded the Marlborough gallery in London in 1946 together with Harry Fisher, a fellow Austrian Jew.[28] The name was meant to evoke British aristocracy, and at first they focused on impressionist and post-impressionist art and early-twentieth-century French modernists. Two years later, David Somerset, who later became the Duke of Beaufort, joined their enterprise and helped them make overtures to cash-strapped aristocrats with art to sell. Not one to accept limitations, Lloyd soon began to sell contemporary art, which he knew would never be in short supply.

By late November 1960, Gibbs had negotiated a deal between Lloyd and Krasner. She agreed to show sixty works by Pollock in March 1961 at his proposed gallery in New York, half of which would be made available for purchase. On December 13, Gibbs wrote to the New York collector Ben Heller, thanking him for allowing him to bring Lloyd to see his collection, which included Pollock's *Blue Poles* and other works, and telling him the terms of the new arrangement.

Months before Gibbs placed Pollock's work with Lloyd, Krasner signed an exclusive contract with the Howard Wise Gallery

for her own work. Wise had just opened a new place at 50 West Fifty-seventh Street, and he had written to Krasner to invite her to the opening party to "make yourself known to me."[29] His overture worked, and Wise became Krasner's "exclusive sales agent."

During the summer of 1960, Krasner gave Wise the courtesy of asking his advice before agreeing to lend one or two pictures to the Angeleski Gallery on Madison Avenue for a group show called "Leading Women Painters and Sculptors of the U.S." Wise replied, "I really don't see the point in a show of work by lady painters. Who cares about the sex the painter belongs to, when it is the painting that counts? And I doubt that you are ambitious to be known as a lady painter, even the best lady painter. There are so many of them, and as such they are not held in particularly high esteem. My inclination would be to suggest that you not participate in this exhibition, or indeed in any other exhibition of works by lady painters."

He suggested that she wait to participate until a woman's show would be organized by "some very important organization such as the Museum of Modern Art."[30] (Of course, this didn't happen in her lifetime.) Wise offered to write the Angeleski Gallery a polite letter of refusal for Krasner.

Wise grew up in Cleveland, Ohio, and then studied at Cambridge in England and at the Louvre. His father forced him to go into his paint company, but he finally started a gallery in Cleveland, where he mainly sold prints.[31] For his opening show in New York, he chose the abstract expressionist painter Milton Resnick. Russian-born, Resnick had arrived in New York at age five in 1922, when his family settled in Brooklyn. If Krasner had not met Resnick during their days on the WPA, she would have known him during the 1940s, when he was de Kooning's friend.

Whether Wise approved or not, Krasner exhibited in three group shows at the Signa Gallery in East Hampton during the summer of 1960 and for the last received a mention in *The New Yorker*.[32] Also that summer Krasner gave what she said was her

first interview ever to Louise Elliott Rago, a high school teacher who was writing for *School Arts* about "Why People Create." Asked if she really believed that there have been no great women painters since Mary Cassatt, Krasner responded, "I do not think it is a question of Mary Cassatt's greatness. It's like asking when were women permitted to give up their veils? I believe this is a problem for the sociologist and anthropologist. We are discussing a living problem and painting is one of the most complex phenomena today. There is undoubtedly prejudice. When I am painting, and this is a heroic task, the question of male or female is irrelevant. Naturally I am a woman. I do not conceive of painting in a fragmented sense."[33]

When asked if she had responded to the "explosion of color painting of the sixties," she remarked, "I have a perverse streak. When all that color painting was going on, I did my umber paintings. But I think one is affected by many things, consciously and unconsciously. My pull towards Matisse dates way back, and if I had to point to a colorist today, he would still be the one, whether the sixties acted as a catalyst or not, I can't really say."[34]

"The impact of the first Matisses I saw is still within me. It was always part of the background of my work," Krasner explained years later.[35] She had seen her first Matisses in person when the Museum of Modern Art was still new and she still a student at the National Academy. Asked what she liked about Matisse, Krasner replied, "It's the air-borne quality of it. . . . It doesn't grind you down to the earth, it allows you to move into space, infinite space."[36]

Another time she reflected that color-field painting was becoming prominent in the early 1960s and it was "a very different form of painting from what is happening with me. . . . It seems to me that I'm dealing with the whole alphabet, while color-field goes from A to B. Well, why put that kind of restriction on painting? I don't understand it."[37] By "A to B" Krasner referred to color-field painting's flat color on a flat picture plane, often stained into the

canvas, as championed by Clement Greenberg, who argued that some of the abstract expressionists such as Rothko and Newman made work that utilized vast areas of flat, solid color instead of gesture and brushstrokes. Greenberg also promoted color-field painters such as Helen Frankenthaler, Morris Louis, and Kenneth Noland.

The end of that summer was marked by a holiday gathering over Labor Day weekend, which included Bob Friedman and his wife, Abby, his brother Sandy, Richard Howard, Len Siegel (Lee's therapist), and Lee—discussing the meaning of "complexity."[38] Thus we know that Krasner continued to see Siegel, but it is unclear whether she was still his patient.

Despite, or perhaps because of, the excitement of her friendship with Gibbs, Krasner had a productive year during 1960, painting *Night Watch, Triple Goddess, Uncaged, Entrance, The Guardian, Fecundity, Charred Landscape, The Eye Is the First Circle, Seeded, Vigil, Celebration,* and *Polar Stampede.* She continued to paint during sleepless nights, working in umber and white under artificial lights. She explained, "I don't like to deal with color in artificial light."[39]

Krasner discussed some of her work from this period in an interview with Richard Howard. "Well *The Eye Is the First Circle.* . . . That was painted in East Hampton—its title was the first line of Emerson's essay on circles . . . ," to which Howard responds: "Yes, the *literary* titles were both yours, one from Emerson and the other from Rimbaud"; and she rejoins: *"What Beast Must I Adore."*[40] Howard emphasized to Krasner that she seemed "exultant about these paintings," and she concurred: "I remember how excited I was when I finished *The Eye Is the First Circle.* I was hardly depressed." She described the painting as being "as though you were descending once more, bringing forth from the unconscious, subconscious, or whatever area you bring forth from, as one does in a dream."[41] In this case, to name her picture, she recalled

that she drew upon Emerson's words, which had "preoccupied [her] many years before."[42]

The opening lines of Emerson's "Circles" appealed to Krasner's deep appreciation of nature and patterns: "The eye is the first circle; the horizon which it forms is the second; and throughout nature this primary figure is repeated without end."[43] Of course Krasner had focused on disembodied eyes as early as the 1930s, when she was briefly under the influence of Surrealism. Krasner said that she titled the painting after she finished it and saw those eyes.[44]

Krasner's fourth solo show took place at the Howard Wise Gallery from November 15 through December 10, 1960. Wise offered Krasner's recent paintings for sale at prices from $1,800 for *Breath,* $3,750 for *Seeded,* and $7,500 for *The Eye Is the First Circle,* a work that was nearly eight by sixteen feet. *Cool White,* which David Gibbs had purchased, was included in the show but not offered for sale. Prices were mutually agreed upon, and the gallery's commission was one-third of the sales price.

Krasner received a number of reviews for this show. "Miss Krasner whips up her severely colored shapes into a wild whirlpool-like dance. They beat with a powerful, even pulse and can be imagined as being accompanied by a tom-tom. She sees to it, as well, that they do not get out of hand," wrote Stuart Preston in the *New York Times.*[45] Emily Genauer, reviewing for the *New York Herald Tribune,* described "huge abstract-expressionist canvases . . . vast, highly complex networks of tortured line (all but one limited to shades of brown and white) through which peer countless agonized eyes, never relaxing their watch despite imprisoning labyrinths and swirling vortices."[46]

The critic for *Arts Magazine,* Vivien Raynor, was less enthusiastic, even baffled. "One felt physically thumped by Miss Krasner's very severe, monochromatic work. . . . It is perhaps some measure of their power that they did not permit scrutiny and analysis;

indeed it would be easier to analyze a breaking wave than *The Gate*.[47] ... If the ideal painting of our time should be an exterior, threatening force, then these are it. It was as if some Norse god had taken a sabbatical from tossing anvils and had painted for a stretch of time and canvas—each square foot of fabric carried an equal share of pressure. Miss Krasner denies us a sensual experience from her work."[48] Raynor did acknowledge that Krasner had "the power both to disturb and compress."[49]

More terse, but more positive, was Irving H. Sandler in *Art News,* noting that her "mural-size canvases have been influenced by the works of her late husband, Jackson Pollock, but arrive at personal images." Disagreeing with Raynor, he wrote, "Miss Krasner dramatizes a mythological content. *Celebration,* an abandoned bacchanal of orange belly shapes, whirls the viewer into its vigorous all-over action. Other, brown and white, paintings are less orgiastic, more brooding and ominous. The spectator is allowed to trace his way through labyrinths of whipped lines in which are encountered fetichistic eyes. These might be the eye of God, Cyclops or Medusa, the evil eye, the inner eye, the artist's eye or the eye of the hurricane."[50] In contrast to Raynor, Sandler elaborated, "In *The Gate,* Miss Krasner compresses her totemic imagery into staccato stabs and showers of sparks. One senses the struggle she had with this dense picture."[51]

And Krasner did struggle. She titled a painting she made in 1961 *Assault on the Solar Plexus,* saying that "for me it was an embarrassingly realistic title. I experienced it."[52] The solar plexus, another name for the *Celiac plexus,* is often used to refer to the site of a blow to the stomach or the general region where it is located. Such a blow can cause the diaphragm to spasm, resulting in difficulty in breathing. "Getting the wind knocked out of you" is the idiomatic expression, which is often used to express the kind of painful emotional trauma that Krasner had experienced around Pollock's death. Krasner also related the pain of this period to her

blowup with Greenberg and to the death of her mother. She had also just pulled the Pollock estate out of the Sidney Janis Gallery.

"I didn't know how to deal with Pollock," she reflected. "It was a rough life."[53]

This was the context in which she painted the canvas called *What Beast Must I Adore?,* calling from memory the old words from Rimbaud's *A Season in Hell* that she had had painted on her studio wall. Delmore Schwartz's translation of 1939, which must have been her source for these lines, reads "What beast must one adore?"[54] Krasner probably misremembered the line when she recalled it to name her painting.[55] Krasner told an interviewer in 1967, "So this painting was finished. I looked at it and suddenly *What Beast Must I Adore* came to me from something that meant a great deal to me many years back. And again, it was not there in a conscious sense, but it automatically suggested that to me. . . . The beast is peering at me."[56]

In this case, the beast might have been David Gibbs. She had shipped him some of her paintings, and when they arrived, in pure Gibbs style, he sent her a telegram on March 23, 1961, telling her that he had received the paintings in good condition and that they looked great. He signed his telegram with the word "love."[57] Though it seems she had begun to see through his charm, she was astute to trust Gibbs to promote her work in Britain, because he was able to make headway in associating her with other important American artists in several group exhibitions.

Along with Pollock's work and artists such as Al Held, Paul Jenkins, Helen Frankenthaler, Shirley Jaffee, and Norman Bluhm, Krasner participated in another group show abroad in spring 1961. Called "Modern American Painting," this one took place at the Laing Art Gallery in Newcastle-upon-Tyne, England. Her 1956 paintings *Embrace* and *Birth* merited reproductions, and the latter was mentioned in the *Guardian* review of the show by W. E. Johnson: "Lee Krasner—Pollock's widow—also comes

close to figuration in her two canvases that are sensuous not only in their boldly flowing, all encompassing line, but also in the fleshy pink that she has chosen as her principal pigment."[58] David Gibbs & Co. loaned *Embrace* to the show, suggesting that he might have chosen it from Krasner to make an allusion to their own intimate relationship.

The first major monograph on Pollock, written by Bryan Robertson, then only thirty-five, appeared dedicated by the author to "Lee Krasner Pollock." Harold Rosenberg, then fifty-four, attacked the younger critic in a review of the book in *Art News,* writing that Robertson "knows nothing about the United States" and "knows next to nothing about Pollock."[59] This scorn, however, was merely a preamble to the rest of Rosenberg's assault. Robertson had written that "during a conversation in 1949 with Harold Rosenberg, Pollock talked of the supremacy of *the act of painting* as in itself a source of magic. An observer with extreme intelligence, Rosenberg immediately coined the new phrase: action painting."[60] In response, Rosenberg argued, "The aim of this statement is, obviously, to present Pollock as the originator of Action Painting in theory and in practice, if not in name." Rosenberg said the claim that Pollock originated action painting was false, but he did admit to a conversation he had had with Pollock in 1952, when Pollock "attacked a fellow artist for working with sketches, which in Pollock's opinion made that artist 'Renaissance.'" Thus Rosenberg essentially acknowledged that he had been discussing Pollock in that particular veiled reference he had made in his article on action painting: "'B. is not modern,' one of the leaders of this mode said to me the other day. 'He works from sketches. That makes him Renaissance.'"[61] Despite this admission, Rosenberg went on to say that he had told Pollock "that the article was not 'about' him, even if he had played a part in it." Pollock and Krasner had thought otherwise, and Krasner had felt the pain of betrayal by her old friend.

Shortly after Rosenberg's review of Robertson appeared, Kras-

ner asked Richard Howard to write a reply for her to Harold Rosenberg. However, according to Bob Friedman, who recorded one such discussion in his journal, Richard protested that Krasner "would be at a disadvantage trying to match wits with Harold," while Friedman's brother, Sandy, felt that Rosenberg's "historical inaccuracies" deserved a response.[62] Bob Friedman noted that Krasner had supplied Robertson with the idea that Pollock was responsible for the phrase "action painting."

What Friedman attributed to Rosenberg's wounded "pride of authorship" was actually, given the critic's tangled web of personal relations, much more complex.[63] It is easy to see how his rivalry with Greenberg and his loyal support for Willem de Kooning comes out in his denigration of Pollock. He also seems to have wanted to weaken Pollock's reputation, putting him in direct opposition to Krasner, who had found support for Pollock's preeminence among the abstract expressionists with Robertson and others in the English art world. In fact while Rosenberg was promoting de Kooning, Robertson's monograph argued that Pollock was "second only to Picasso in the hierarchy of twentieth century art."[64]

In May 1961, Krasner was preparing to travel to London for the opening at Marlborough Fine Art of a show of works by Pollock selected from her collection. It would be only her second trip overseas, and her first to England. She would also reunite with David Gibbs while there. At fifty-three, "the idiosyncrasies of her figure loom (surely the right word) problematically for any dressmaker,"[65] remarked her friend the poet Richard Howard. To create a suitable wardrobe for the trip, Fritz Bultman suggested she consider using the designer Charles James, "once famous for his romantic 'architectural' clothes." James asked "how she wanted to confront the English art world—Do you want to charm them? To astonish them?" She replied that she wanted to "look invisible," to which James retorted, "That, Mrs. Pollock, is one thing I cannot do for you."[66]

In the end she commissioned three outfits, recalled by Howard as "a stiff white-silk evening gown, a green woolen suit, a brocade cocktail dress. The clothes emphasized all the apparent defects of Lee's body rather than attempting to conceal or compensate for them. . . . And lo! by some structural law unknown to 'Mode,' these clothes were a marvel; they made Lee look not invisible but invulnerable, not at all in fashion but beyond, entirely attractive and secure; and like no one else."[67]

Howard was amazed that Krasner submitted cheerfully to so many fittings, enduring delay and tolerating the entire process. He did not know that Krasner had adored drawing fashions when she was a child and that she had studied fashion design at Cooper Union. Nor did he realize that Igor Pantuhoff had once dressed Krasner like a model. Charles James had a lot of cachet in the art world, including patrons such as Dominique de Menil and Millicent Rogers (both of whom founded their own museums, the former in Houston and the latter in Taos, New Mexico).[68] Krasner's decision was applauded by Fritz Bultman's wife, Jeanne, who had actually worked for James and admired his designs. For Krasner this was the opportunity of a lifetime. As the fashion photojournalist Bill Cunningham once pointed out, James "presented women with a shape that was not their own. You went in to Charles James deformed, and you came out a *Venus de Milo*."[69]

Krasner enjoyed London, where she stayed at the Ritz and met such notables as the art historian Sir Kenneth Clark and Sir John Rothenstein, then the director of the Tate Gallery, who, according to Richard Howard, "made much of her company."[70] Professionally the London connection would continue to be productive for her.

Krasner's relationship with Gibbs continued to thrive enough that they traveled that June on a whirlwind trip to Paris, Zurich, Bern, Turin, and Milan, the better to create an international market for Pollock's work. Gibbs made the arrangements, billed her, and she picked up the tab. Five nights were devoted to Paris, cre-

ating a better memory than her first trip there, which had ended with the news of Pollock's death. They spent the tenth of June at the Excelsior Hotel Gallia in Milan, where "Sig. David Gibbs" was accompanied by "Mrs. Pollock," added by hand to the printed bill.[71] Gibbs billed Krasner three thousand dollars for his consultant's fees from May 1, 1961, to October 31, 1961, but he also billed her that December for an "Agreed bonus" of five thousand dollars for the same period.

The following autumn, Marlborough Fine Art Limited in London staged "The New New York Scene," an exhibition of abstract American art that included, among others, Krasner, Ellsworth Kelly, Raymond Parker, Helen Frankenthaler, and Lee Bontecou. Representing Krasner were *Cool White* (1959, 72 by 114 inches) and *Triple Goddess* (1960, 86 by 58 inches).[72] The future novelist, then art historian at the University of Reading, Anita Brookner, reviewed the show for *Burlington Magazine*. Clearly not well informed as a critic of contemporary art, she wrote that she wanted to append a subtitle to the show: "Painting to be viewed through dark glasses" and commented "Lee Krasner paints rather more spontaneously [than the minimalist art of Kelly or Parker]: the man [*sic*] is clearly a romantic."[73] Brookner's failure to discern or to research Krasner's gender is a testament to her objectivity as a critic, who reported only how she responded to what she saw. Krasner might have been pleased to be mistaken for a male artist, at a time when men still monopolized power and prestige. It was important to Krasner that her work be appreciated on its own terms, without regard to her history and role as Pollock's spouse. This mistake was more likely to happen abroad, because she was virtually unknown outside of the circle of New York artists with whom she had long been affiliated.

Pollock's art was growing in attention and in price. These factors, along with a lingering antipathy toward Krasner, may have provoked Peggy Guggenheim to sue Pollock's estate in federal court, charging that Pollock had defrauded her when he was

under contract to give her all of his works (except for one each year) in exchange for an allowance of $300 a month for two years, starting on March 15, 1946. Guggenheim had become aware that in 1960 the American Friends of the Tate Gallery in London had paid $100,000 for a painting by Pollock, and she wanted $122,000 from Krasner.[74] Guggenheim charged that Krasner had been fraudulently holding on to some of Pollock's paintings that belonged to her. Since there was as yet no catalogue raisonné, the exact number of works Pollock had produced in that particular two-year period was then unknown and not easy to ascertain. The case did not close until 1965.

Krasner didn't want to spend the summer alone again, and she looked for someone to live at the Springs house. Her nephew had been teaching at Rutgers in New Jersey, where Robert Miller and Betsy Wittenborn had just graduated. When Krasner met them at the opening of a show, she invited Bob to work as her studio assistant. He subsequently worked for her in East Hampton, taking the place of Richard Howard and Sandy Friedman, who stayed friends but wanted to move on. By the time Bob and Betsy got married in 1964, Krasner had discovered that she and Betsy both were born on October 27, which helped to forge a bond.[75]

That summer *Newsday* ran a feature on Krasner—"Pollock's Widow Paints in His Old Studio." Calling her "a serious and talented abstract expressionist in her own right," Lois Tenke reported that the artist told her, "All my time now is devoted to my work and handling my husband's exhibits. I don't have time for anything else."[76] At the time, Krasner claimed to have "just one small painting of his in my bedroom." When Tenke asked Krasner about the material success of her own work or lack of it, she responded, "I know that a lot of my fellow artists have realized far more success than I have, but it doesn't bother me. The fact that my work isn't financially successful has less effect on me now than it did in the past, because of my own assurance in what

I am doing."[77] Krasner was now confident that she would never be financially needy again, as she had been with both Pantuhoff and Pollock. Pollock's rising fame and her large collection of his work guaranteed her security. She no longer had to answer to anyone. In fact, Pollock's prices had so escalated that Krasner became afraid to have even his one small painting on view in her bedroom, lest it be stolen.

By February 12, 1962, Krasner had grown displeased with her arrangement with Gibbs and had Dickler, her attorney, write to him explaining her concerns about "the triangular relationship" between him, Krasner, and the Marlborough Gallery.[78] Dickler summed up why she had gone with him: she wanted to move Pollock's work to Europe from New York to escape the burden of duties involved. With the planned opening of Marlborough in New York, Krasner saw that Gibbs would have to serve their interest in his new role as its New York representative. She also feared upsetting the New York art market by helping to set up a British competitor on their turf.

From March 6 to 30, 1962, Howard Wise Gallery gave Krasner another solo show, which was generally well received. Also, her prices went up. *The Seasons* at $8,500; *Fragments from a Crucifixion* at $6,000; and *White Rage* at $5,000. Her work once again attracted Irving Sandler, who reviewed the show for *Art News*. Sandler thought she had produced two groups of action paintings. He viewed one group as "composed of impulsive, curvilinear sweeps on bare canvas" similar to those of her previous show a year earlier. He thought that paintings in "the other series relate to a denser and more complex canvas, *The Gate,* which was in her last show. They consist of splashed and spattered whites and off-whites varied with staccato dark brown stabs which open up light brown backgrounds. In an explosive *White Rage,* Miss Krasner attempts a fusion of the two ways of working. This picture, the most impressive in the show, avoids the tendency to thinness in the linear works and to decoration in the more painterly ones."

Sandler found her work more abstract and noted "the works are as abandoned and expansive as before, but Miss Krasner now celebrates the act of painting—a new delight in the manipulation of space—rather than a mythological content."[79] While the critic for the *New York Times* praised her "rhythms" and "subjugation of color," Vivien Raynor, reviewing for *Arts Magazine,* concurred about the "strong rhythm," but warned "the paintings occasionally veer close to textile design."[80]

BY THE END OF THE SUMMER OF 1962, KRASNER WAS DISTRESSED THAT sales of Pollock's work were disappointing despite Marlborough Gallery's international efforts. Pressured by Gibbs and Lloyd to cut prices, she declined in almost every case, preferring, she insisted, to withdraw them from the market. On September 14, Dickler even wrote to Gibbs inquiring whether the expenses he billed were "solely on her behalf."[81] Through her attorney, Krasner kept a close watch on the Pollocks she had consigned or loaned to Marlborough.

On Christmas night 1962, while at a dinner party in East Hampton with Ronald and Frances Stein, Krasner suffered a brain hemorrhage. She insisted on telephoning Dr. Elizabeth Hubbard, who treated the incident as if it were a migraine headache. Realizing the seriousness of his aunt's condition, Stein interceded and called a nearby doctor and the police. Krasner was then rushed to Southampton Hospital. When tests disclosed a bleeding on the brain, she was transferred to Saint Luke's Hospital in New York, where she underwent surgery to remove an aneurysm in the artery that encircles the brain. Afterward she chose to convalesce at the Hotel Adams on the Upper East Side.

Sandy Friedman wrote to David Gibbs, telling him about Krasner's ordeal and its effect on her: "There has been a marked change in Lee. Before all this happened, I think she had reached a point where she was soured and fed up with the Art World.

She had devoted her life's blood to art, to Pollock; and had lived through Pollock's tragedy and its disturbing aftermath; the feuds, the jealousies, the petty politics and grasping." He attributed her turnabout to a "flood of notes and flowers and messages of concern from almost everyone—even unexpected sources like Harold and May Rosenberg."

In some ways the ordeal made Krasner easier to deal with, even if for a short time. According to Friedman, "Something inside her—her hostility, defensiveness (dare I call it paranoia?) has relented, relaxed. For the first time since I've known her, she is filled with tolerance, sympathy, even tenderness for her fellow artists and the art world in general." [82] A week later, after seeing Lee, Fritz Bultman quipped, "Not only didn't she lose any wheels, she seems to have added a few." [83] By February 3, Sandy was more pessimistic about Krasner, who was resting at the Hotel Adams. "Once again here with Lee—feeling so different now: troubled by her isolation, her disconnection, the imposition of her convalescence. Everything I said in my last letter seems reversed—it's all so ephemeral—tomorrow may be entirely different—who knows?" [84] He added, "She doesn't know yet what has happened to her. Like an infant she feels she must start all over again from scratch. Like an infant, she must learn to walk, to relate, to be in the world. Like an infant, she knows nothing about ART, but must familiarize herself with her own bone, body, her tongue and speech, people and the world." [85]

More than two weeks passed, and Sandy, visiting Lee at the Adams, transcribed for her a letter to David Gibbs: "Once my fury against ART relented it began to waiver [sic] between Elizabeth Hubbard and David Gibbs—though at the moment it seems to favor Elizabeth—No telling how I'll come out with you David." [86]

Gibbs also heard from Ronald Stein, who wrote to him on April 19, 1963, asking for his help in getting Frank Lloyd to take an interest in showing his work in his New York gallery. Lloyd had just purchased the Otto Gerson Gallery in Manhattan and

was planning to open the following fall as Marlborough-Gerson Gallery, which would feature Jackson Pollock's work. Krasner essentially withdrew her work from the Howard Wise Gallery at this time.[87] Stein described himself as "despondent" because he was "galleryless." Krasner had already persuaded Lloyd to visit Stein's studio, from which he purchased a small sculpture. Stein reported to Gibbs that "Lee was overjoyed with [Lloyd's] response" and that he was also "delighted with his reaction and proceeded to get smashed for three days afterward."[88] Given his aunt's experience with Pollock's alcoholism, this was a slightly ominous note.

For the summer of 1963, Krasner again settled in the Springs house, which by now, according to William K. Zinsser, writing for *Horizon,* was assuming mythic dimensions: "Jackson Pollock, fleeing the hostile New York art world, came to this isolated spot in 1946 [1945], and gradually other painters followed. As Pollock's work at last caught on, and especially after his death in 1956, the colony became almost a shrine, and so did the Pollock house where his widow, Lee Krasner, still lives and paints. Today the abstract expressionists in The Springs form a sizable clique, and they do not lack for admirers—East Hampton is full of wealthy patrons and hangers-on."[89]

This article featured a photograph of Krasner among a diverse group of luminaries who then spent their summers on the East End of Long Island, including the actors Eli Wallach and Anne Jackson, Gwen Verdon and her husband, the choreographer-director Bob Fosse, architects Gordon Bunshaft and Peter Blake (who had collaborated with Pollock), and writers such as Jean Stafford, Helen MacInnes, and Gilbert Highet. Krasner, identified as "the widow of Jackson Pollock," was described as "anything but Bohemian, Miss Krasner has her clothes made by America's most cerebral couturier, Charles James, and her house is tasteful and feminine. It is filled with her own paintings, but there are no longer any Pollocks—they have become too precious and costly for

a summer house."[90] The feature allowed that "although her style was undoubtedly influenced by her late husband's innovations and theories, it is quite distinctly her own."[91]

That summer Krasner hired a young graduate student in American history, James T. Valliere, who had written a paper on El Greco's influence on Pollock's early work. He lived and worked in a small building behind her home for the next two summers, assuring that she was not there alone. She had him begin putting together material for what she envisioned as a complete catalogue of Pollock's art. Valliere made a catalogue of all the books that had been in the Springs home before Pollock's death and conducted some interviews about Pollock with some of the people who knew him.[92]

Krasner began experiencing dizzy spells, and once she tripped and fell while walking down Main Street in East Hampton and broke her right arm. She had to wear a cast, which left only her fingertips free. Undaunted, she devised a way to move her left hand around with her right fingertips, enabling her to paint. Using paint directly from the tube with a technique of spots sometimes called stippling, she managed to produce pictures such as *Eyes in the Weeds, Happy Lady, Flowering Limb,* and *August Petals.*[93] In 1964, she explained: "This broken right hand which was done a year ago last summer, made me start painting with the left hand."[94]

Despite her spunk in handling impediments to her health, Krasner could not deal with male colleagues, including de Kooning, Mark Rothko, Robert Motherwell, and Barnett Newman, who treated her as less than equal. Of these, Newman was closest to Krasner. He and his wife had met her at the airport when she returned from Europe for Pollock's funeral, so they recognized her as a widow, but often not as an artist in her own right. It was Newman who had failed to invite Krasner to join with Pollock and the other men in the protest that led to the infamous "Irascibles" photograph.

Newman's attitudes as a Jewish man in particular reflected those Krasner had encountered when at the age of thirteen she discovered that she could not sit with her father in the synagogue. "At that point I begin to realize the differences where they separate; in the synagogue the women have to sit upstairs and the men downstairs. That was the beginning of it."[95] Krasner never forgot the struggles she experienced trying to achieve parity as a woman and remained bitter about the morning prayer for women that she had recited daily in Hebrew in her Orthodox Jewish home, claiming, "That started up a revolution that I have not recovered from."[96]

Krasner often spoke of her "running argument with Barnett Newman" over "the role of the female in Judea . . . we never settled that argument."[97] In a subsequent interview, she discussed how she had fought this ideological battle with Newman, who told her that she had missed the whole point. "I said I didn't think I missed it, I thought I had it and I objected too. But the Christian concept is basically the same—it's Judeo-Christian; and the Moslem concept is not much better. It will take time to iron the whole thing out," she said, using a metaphor of domesticity. "It's not just the fault of the Surrealists."[98]

Of her bout with Newman, she recalled, "We battled till he died; he said I misunderstood and I said I understood loud and clear but I objected. Then one time he asked me whether I had seen the plans for his synagogue. I asked why I should see them." He claimed that his design would settle the argument. " 'Well, where are the women in your synagogue,' I asked. 'You'll see! You'll understand!' he said. 'Right on the altar!' And I said, 'Never. *You* can sit on the altar and get yourself slaughtered. I want the first empty seat on the aisle.' "[99]

This exchange must have taken place in 1963, when Newman first presented his synagogue model in the exhibition "Recent American Synagogue Architecture." Apparently he drew upon Jewish mysticism and baseball for his design—in the synagogue the men sat together in a dugout. For the traditional raised plat-

form (bimah), Newman substituted a raised pitcher's mound in the center of the room. "The synagogue is more than just a House of Prayer," Newman explained. "It is a place, Makom, where each man can be called up to stand before the Torah to read his portion. . . . Here in this synagogue, each man sits, private and secluded in the dugouts, waiting to be called, not to ascend a stage, but to go up on the mound where . . . he can experience a total sense of his own personality before the Torah and His Name." [100]

While Krasner might have found the baseball metaphor acceptable, Newman's focus on the men's role in the synagogue was just the kind of thinking that had alienated Krasner in the first place. She had enthused instead over Mr. Walrath, her elementary school teacher, who allowed the boys and girls to play baseball together. Krasner always wanted to be "a player."

Around this time, Krasner met the art critic Barbara Rose, who recalled that the critic and dealer John Bernard Myers and his partner, the theater director Herbert Machiz, brought Lee over to meet her. Rose, then still in her twenties, remembered how Krasner adored her young daughter Rachel and made paper bag puppets for her. The two women began to meet each other over lunch. Rose recalled that Krasner was then "very isolated," very "Depression-oriented," and often served her leftovers. [101] The two enjoyed sharing gossip, and an enduring friendship was forged. Rose admired Krasner's work and had seen her shows at the Howard Wise Gallery. She heard Krasner's bitter and colorful stories about the men who ran the art world, and before long, she began to write about Krasner, including her in a book, *American Art Since 1900,* and in such popular publications as *Vogue* and *New York* magazine, raising Krasner's public profile and eventually winning her trust for larger projects. [102]

During the summer of 1964, Terence Netter, a handsome Jesuit priest then in his thirties, arrived in East Hampton with his teacher Alex Russo and some younger students to study painting. They were part of a master's in fine arts program at the Corcoran.

The group made studio visits to John Little, Conrad Marca-Relli, and then Lee Krasner. She took them into her house, where *The Eye Is the First Circle,* nearly sixteen feet wide, was hanging in the large open dining room. Netter recalls that he looked at it and said to her, "That's your painting. What does it make you feel?" "It scares the shit out of me," she replied. Netter was enchanted and responded, "I like you. Can we have dinner tonight?" Krasner accepted. It was "friendship at first sight," [103] the beginning of a strong bond that would endure through major changes in his life and until the end of hers.

Krasner found Netter fascinating. His father was Jewish and his mother was Catholic, and he had put away his desires to become an artist at the age of eighteen to join the priesthood. He was sent to study theology in Austria and France, where he became fluent in German and French. Krasner, who had already found Catholicism of interest in her conversations with Alfonso Ossorio, found that Netter understood the spiritual side of creativity. For him, Krasner "had a very fine mind" and was "absolutely authentic." [104] He explained, "Lee was almost like a nun—so single-minded and obsessed with the art world that she really didn't live in this world. . . . I'm certain Lee believed in God, but she wasn't someone who thinks a 'religious' painting is one which has religious imagery. Rather, she was interested in the whole notion of art as a sublime statement—Man trying to get beyond this world to reach some transcendental reality." [105]

# Recognition, 1965–69

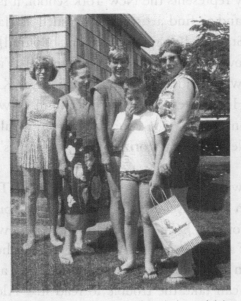

Lee Krasner with her sister-in-law, Arloie McCoy; her nephew Jason McCoy; her great-nephew, Christopher Stewart; and his mother, Krasner's niece Rena Glickman Stewart (later Rusty Kanokogi), 1965, Springs. She invited her visitors into the barn studio to see new work and asked ten-year-old Chris what he would call her latest painting. He burst out, "Combat," and she accepted the name at once.

K RASNER MUST HAVE BEEN SURPRISED WHEN BARNETT NEW-man took up her cause in September 1965. He objected to a large exhibition called "New York School, First Generation: Paintings of the 1940s and 1950s," which had been organized for the Los Angeles County Museum by its modern art curator, Maurice Tuchman, whom many came to dislike because of his repeated failure to include women or minority artists in

the shows he organized.[1] Newman criticized both the use of the term "New York School" and the inclusion of Clyfford Still and Ad Reinhardt in the show. Newman argued that both men were "on record more than once as being anti–New York school. . . . If this show truly represents the New York school, it is surprising to find them in and to find artists missing such as [James] Brooks, [Theodoros] Stamos, [Giorgio] Cavallon, [Conrad] Marca-Relli, [Jack] Tworkov, [Alfonso] Ossorio, [Esteban] Vicente, [Fritz] Glarner, [Ludwig] Sander, etc. and the ladies Lee Krasner, Elaine de Kooning, Hedda Sterne. All were active in New York during those important years."[2] Of course, Krasner would have taken exception to Newman's categorization of "the ladies" as a separate group.

As for "New York school," Newman declared, "This was never a movement in the conventional sense of a 'style,' but a collection of individual voices. . . . The only common ground we all had is in the creation of a new, free, plastic language."[3] For her part, Krasner insisted on individuality: "My painting is so autobiographical, if anyone can take the trouble to read it."[4] Along the same lines, she penned in 1965 a dismissal of "problems in aesthetic, having only to do with the outer man. But the painting I have in mind, painting in which inner & outer are inseparable, transcends technique, transcends subject and moves into the realm of the inevitable."[5]

Given her aesthetic ideal of moving into the realm of the inevitable, Krasner relished the directness of children, who often seemed to understand her art. When, during the summer of 1965, she invited into the barn studio to see new work Christopher Stewart, her ten-year-old great-nephew, and his mother (her niece Rusty Kanokogi), she asked the boy what he would call her latest painting (70 by 161 inches). When he burst out, *"Combat,"* she accepted it at once.[6] It was the last painting she finished before her first show in London opened in the fall.

To name her pictures, Krasner often preferred the intuition of

children, poets, and novelists over that of dealers or critics. When Krasner's Detroit dealer, Frank Siden, supplied her with names for the new work, all gouache on paper, that she was including in her solo show at his gallery there in 1965, she rejected almost all of them, even though his choices alluded to forms in nature. For example, Siden's *Pertaining to Fauna* became her *Ahab*.[7] Krasner and Pollock had named their brown poodle Ahab after Captain Ahab in Herman Melville's 1851 novel *Moby-Dick*—the book was read by many of their abstract expressionist acquaintances.[8] (Ahab's mission to get even with Moby Dick, the ferocious white whale that bit off his leg, must have appealed to Krasner's sense of tragic strife.) One of Siden's titles that she kept was *Night Creatures*. However, she did reject titles like *Bathsheba's Garden,* now known as *Summer Play,* and *First Step into Eden,* now known as *Autumnal*.[9] Either Krasner rejected these latter two names because of their references to the Hebrew Bible and her long discomfort with the attitude toward the female in traditional Jewish culture or she just found them too pretentious.

According to Sanford Friedman, Krasner once rejected *Entering Jerusalem* as a title for a painting that evoked a palm. "What are you crazy?" he exclaimed. "She didn't want anything Christian [Christ's entry into Jerusalem on Palm Sunday]; not that she had so much love for the Jews' Old Testament."[10]

Terry Netter remembers the time when Krasner came with Josephine Little to hear Netter preach at the Catholic church in East Hampton, then known as St. Philomena, even wearing a hat for the occasion.[11] When Netter decided in 1968 to leave the Jesuits and marry Therese Franzese, "the pretty sister of one of his students," Krasner was supportive.[12] Apparently, "Therese loved her."[13]

Despite her skepticism about organized Judaism, Krasner saw herself as Jewish. "She made a point of making everybody know she was Jewish," Netter recalls. And she remained fascinated with the appearance of Hebrew and other exotic writing. She continued

her interest in the visual form of writing systems in a painting of 1965 that she called *Kufic,* which is an ancient form of Arabic. Though painted on an ochre background, this large canvas continues the themes of her more hieroglyphic Little Image paintings during the late 1940s.

Krasner's interest in the forms of letters and the looks of different languages led her to attend lectures at the Morgan Library by the art historian Meyer Schapiro about the Book of Kells, a manuscript she revered.[14] In 1967, Krasner painted *Uncial,* a canvas named for the Latin term for the hooked medieval handwriting that she admired when she visited the Morgan Library to look at illuminated manuscripts.

Krasner's love of illuminated books and her admiration for the poet and critic Frank O'Hara led her to accept the Museum of Modern Art's invitation to participate in their publication *In Memory of My Feelings: A Selection of Poems by Frank O'Hara,* for which she produced a two-part drawing. O'Hara had written the first monograph about Pollock, which was published in 1959 by George Braziller. Krasner had been very positive about this book, preferring a poet's impressions over those of art critics.[15]

On September 21, Krasner's first ever retrospective opened at London's Whitechapel Gallery. The organizer and gallery's director, Bryan Robertson, had already achieved what he had wanted with Pollock seven years earlier, so he clearly chose to organize Krasner's first retrospective with no hidden agenda. Whitechapel Gallery exhibited but did not collect art. From 1952 to 1968, when Robertson was in charge, he staged many other important shows, from the major American artists such as Mark Rothko and Robert Rauschenberg, to many emerging British artists, including Anthony Caro, David Hockney, and Bridget Riley.

In a brief preface for the show's catalogue, Robertson wrote, "[Krasner's] contribution to American painting has yet to be properly recorded or assessed: the present large exhibition rep-

resents a fraction only of the total work."[16] He also wrote, "In 1955 Lee Krasner held an exhibition of collages in New York which Clement Greenberg has described as a major addition to the American art scene of that era."[17] Robertson's report seems likely to be accurate, because it was never repudiated by Greenberg, who notoriously wrote caustic letters denouncing material he considered false. In fact in a 1975 interview, Greenberg told Ruth Appelhof, then a graduate student, "I have always considered Lee's best period to have been in 1955. She developed a quality of humanness, an expansiveness, which could be seen not only in her personality but in her paintings as well."[18]

The catalogue also featured a much more substantial introduction by B. H. Friedman, who had earlier commissioned her mosaic murals for his company's building: "First, it must be said that Lee Krasner is a woman—in a field which still, even now in 1965, barely tolerates women, condescends to them with the phrase 'woman painter,' as odious and pejorative as 'woman writer' or 'woman driver.' In her work, Lee Krasner wants to be judged—or, better, experienced—as a painter. She wants no special categories. It may even be, whether consciously or unconsciously, that this is why she took the sexually anonymous name 'Lee.'"[19] Friedman showed cultural sensitivity in noting the androgynous character of the name, which others too have remarked on. Ironically, the nickname was used, if not coined, by her classmates at the Woman's Art School at Cooper Union and appeared in the student newspaper in the 1920s—at that time and in that place she surely had no reason to pretend to be male.

Robertson's young assistant, Tejas Englesmith, described the show at Whitechapel as "quite beautiful" and said that he "loved Lee."[20] He remembered that "the Snowdons" (Princess Margaret and her husband, the photographer Antony Armstrong-Jones, who was created Earl of Snowdon by the queen) came to see the show. Sir Kenneth Clark, whom she had met when she visited

London for the Pollock show in 1961, was supposed to take her to dinner but "rang the gallery to say that he had to cancel because Lady Clark drank a bit too much."

Englesmith recalled that Krasner said to him, "I'm free. Are you free? So let's do something." Krasner then changed a hundred dollars for pounds, which was "a lot of money in those days," especially for a poorly paid assistant curator. Krasner handed him the money to take charge of and said, "Let's have a good time." They went to dinner and then to see the Beatles' new film, *Help!,* with very good seats. For Krasner the film must have epitomized the youthful energy she felt in London, liberated from the constraints on her career that she had felt in New York. With her interest in primitive art, she must have loved the film's scene of exotic sacrifice. The evening ended with drinks at her hotel and her giving Englesmith money and urging him to take a cab home. He accepted her invitation to stay with her in New York. It was the beginning of a beautiful friendship.

The show attracted a good deal of attention in the British press, but it was not initially about Krasner as an artist. Instead Krasner was heralded as "the widow of probably the most important artist that America has produced, Jackson Pollock." Krasner told one reporter: "Things have been loaded against me in New York. Here I should get a fighting chance of some unprejudiced criticism."[21] She exulted in the fact that she had arrived on the *Queen Elizabeth,* and that she was staying at the Ritz, which was a much fancier address than the apartment she then rented in New York at 70 East End Avenue. It was a remarkable contrast to the poverty she and Pollock had suffered. "In the 1930s and in New York, there were no galleries, no audience and nobody buying abstract paintings. We were pioneers. It was like trying to get up a mountain made of porcelain. There were just no finger holds."[22]

The reporter for the London *Sunday Times* mentioned that a good painting by Pollock "could fetch £100,000," but that Pollock never got more than £1,000 for any of his paintings.[23]

Krasner even told how she had quickly and unsuccessfully tried to resolve the Pollock estate: "I looked around for somebody to give the collection to, but nobody would take them unless I paid for the upkeep."[24] When the reporter asked if it was not particularly tragic that Pollock was not around to reap the financial benefit of his work, she replied, "He had a high awareness of his own talent. The money would not have made much difference. It's just the way things are. When somebody comes along and opens a door, you can't expect everyone to see it. The next genius that comes along is not likely to be recognized in his own time."[25] She claimed that despite the money, "she would still consider giving all her husband's paintings away, if they were properly housed."[26] However, she reflected: "I know that having them [Pollock's paintings] means I am very rich. I can stay at the Ritz. That's the fun thing. But I could give it up. Caring for the paintings is a lot of worry."[27]

When a reporter asked Krasner how the exhibition happened, she responded: "I cannot say I chose to come here, as I was invited. But had I been able to choose, this is where I would have wanted to come."[28] It was a good strategy. The reporter pronounced her "an important figure in American abstract painting" and noted that "a strong independent streak runs throughout her work. . . . Her own talents as a painter, which are considerable as anyone who goes to the Whitechapel Gallery can see, have been overlooked."[29]

The London *Times* reviewer declared that "while participating in a general trend which places her in relation with other American abstract painters, Miss Krasner, it can be appreciated, has preserved an individuality of her own. A strong, decorative rhythm, very attractive in its expansion on a large scale, a sense of colour, sometimes employed with a deliberate restraint but on occasion rich and intricate and a capacity for bold design, exemplified in a number of collages, are the qualities that appear."[30] Writing in the *Observer,* Nigel Gosling declared, "I doubt whether anybody would guess from the paintings that they are by a woman. On the

other hand, they are unmistakably American. The free, confident handling, the relaxed bigness of scale, and the driving vigour which runs through the largest composition like sap, are enviable birthmarks of her time and place." [31]

John Russell, in the *Sunday Times,* pronounced the show "exhilarating." [32] Sheldon Williams, writing for the Paris edition of the *Herald Tribune,* declared Krasner "a prime mover in the abstract-expressionist revolution that fired the first shot in the battle to put U.S. modern artists into the front line of world appreciation." [33] At least three of Krasner's London reviewers saw the influence of Mark Tobey on her work, especially the last of her Little Images. This was an inaccurate judgment based on the journalists' greater and earlier familiarity with Tobey's work from his living, teaching, and exhibiting in England. [34] Norbert Lynton, writing in *Art International,* made the boldest claim by stating that "Tobey's influence appears to have been disastrous and dominates her work round about 1948–9." Nevertheless, Lynton still viewed Krasner as "a considerable and enjoyable follower, synthesizer, adapter and recreator of elements that have been presented by others. This is more than I should say of a great many artists who are more widely admired than she." [35] Despite such quibbles, most of the press was very positive, and Krasner was no doubt quite pleased.

When asked by Andrew Forge about the stylistic break from brown earth tones, which she had painted under artificial light, to the bold forms and bright colors in her recent work, Krasner admitted, "It used to frighten me, you know, work and then this break would happen and I would have to be the first to deal with the break and accept it." She then commented that her show at Whitechapel was "the first opportunity I have to see a period of work from about '46 and the rewarding thing to see for me is that the break isn't quite so violent as it seems at the time it's taking place, and in that sense I think every painter should have an op-

portunity to put up a ten-year period of work some place so that the painter can see what's taking place." [36]

Included in the Whitechapel show was *Right Bird Left,* a canvas of 1965, painted in bright rich colors with biomorphic shapes repeated across the wide canvas. It is possible to see what could be a bird form, however abstract, on the left side of the painting. The title is noteworthy, though it is not known whether Krasner chose it herself or accepted a suggestion from one of her friends. This is the only painting in which she alludes to her difficulty in telling right from left.

During the festivities in London, Krasner did not see David Gibbs, who had been so central to her first London visit in 1961. The very week her show was opening in London, Gibbs, at age forty-three, had divorced his wife and was in New York marrying Geraldine Stutz, forty-one, described as "a 5'6", 110-pound, perfect size 6." She was president of Henri Bendel, the chic Manhattan shop. The wedding notice identified him as an "abstract painter." [37]

Before Gibbs's marriage to Stutz ended in 1976, *New York* featured them as a couple, stating, "Her elegant and erudite English husband discarded his lucrative career as a London art dealer when he decided he wanted to paint." [38] His decision was no doubt helped by Stutz's success, which was so great that she eventually bought Henri Bendel for a reputed eight million dollars.

Gibbs's actions may have affected Lee's work over the next year, 1966. Much is discernible from the titles of her paintings then— *Memory of Love, Courtship,* and *Siren. Siren* refers to the female Sirens in Homer's *Odyssey* who promise to sing of all history and nature to seafarers passing by their island. However, those who approach the Sirens die at their feet. Another title besides *Siren* was *Gaea* ("Earth"), which recalls another layered myth: primordial Earth gave virgin birth to Sky (Uranos), who promptly cohabited with his mother to produce offspring called Titans. When Sky blocked his mother, Gaea, from giving birth to monsters, she con-

spired with their son, Kronos, who castrated his father. The painting's agitated biomorphic forms in bright magenta suggested the violence of the title.

Krasner defended her nomenclature, stating, "I wouldn't call it monstrous or underworld. You use the word monstrous as though it were relegated to a realm other than man. I would call it basic, insofar as I am drawing from sources that are basic."[39] Krasner herself named *Courtship,* which was most likely an allusion to David Gibbs. To Krasner, Gibbs was "a charming cad," in the words of her friend the art dealer Nancy Schwartz.[40] Yet Krasner had not lost out. Gibbs had given Krasner what she wanted—access to an international market for Pollock's work and a chance for her to exhibit in Europe—and she remained on friendly terms with him, even inviting him and his new wife to her events.

News of Krasner's success prompted her old beau Igor Pantuhoff to write to her in the late spring of 1965: "I want to congratulate you for making a jerk out of Peggy. . . . Good for you! Igor."[41] He alluded to press reports that Krasner had prevailed against Guggenheim's lawsuit claiming that she contractually owned more of the works in the Pollock estate from the years 1946 and 1947. Guggenheim had been forced to drop her claim for damages of more than $122,000, "retract all charges of wrongdoing on the part of the defendant," and settle for only two small works by Pollock then said to be worth only $400.[42] It has been said that Guggenheim lost her case because of a sentence she wrote in her book *Confessions of an Art Addict,* describing the unsold pictures in the aftermath of Pollock's first show with Parsons: "All the rest were sent to me, according to the contract, at Venice, where I had gone to live."[43]

Krasner had won out over Guggenheim in another sense—here was Krasner's revenge against someone who had asked Pollock, "Who is this L.K.? I didn't come to see work by LK," at his studio in New York. Now Krasner was having a retrospective in London, where Guggenheim had opened her first art gallery.

By January 1966, Krasner was again thinking about getting an apartment in the city and had taken a room at the Elysée Hotel.[44] By the summer, she was back in Springs, where she was the most prominent of six artists featured in a show at East Hampton's Guild Hall called "Artists of the Region."[45] The *East Hampton Star* wrote effusively that her Whitechapel Gallery show had been chosen by the British Arts Council to tour museums of the British Isles, then the Israel Museum in Jerusalem and the Stedelijk Museum in Amsterdam.

That same summer, Francis V. O'Connor, a thirty-year-old art historian, visited Krasner after sending her his recently completed doctoral dissertation on Jackson Pollock. She arranged for Alfonso Ossorio to pick up O'Connor at the East Hampton train station. O'Connor learned from Ossorio that Krasner had asked him to read the dissertation aloud to her and that the two of them had wept at learning so much about Pollock's young life.[46] The dissertation research became the basis of O'Connor's work in the catalogue of the 1967 Pollock show at the Museum of Modern Art.

In 1967 Krasner moved to 180 East Seventy-ninth Street, a building with a twenty-four-hour doorman. She took a spacious apartment with a large master bedroom that she used as her studio, because, as she said, "the light is magnificent."[47] She slept in the smaller bedroom and used the tiny maid's room off the kitchen for guests. This arrangement was ideal for someone who lived alone and had wanted to have twenty-four-hour access to her studio, enabling her to go in at night if her insomnia returned. She rented secure storage for her paintings just one block away. The apartment studio, though atypical, fit her need to feel safe and complemented her use of the barn studio in Springs for the summers.

In February 1967, a solo show of twenty paintings by Krasner opened as the first show ever at the University of Alabama's new Garland Hall Gallery. Donald McKinney of Marlborough-Gerson Gallery accompanied her to Tuscaloosa for the week.[48]

Though she did not lecture, she did visit several art classes, spoke informally with students, and was the sole juror of a student art show. She spoke to a reporter there about how she had "succeeded in combining my career with the role of wife. It can certainly be done," she explained, "if a woman wants to work hard enough."[49] She insisted: "There is absolutely no truth in the rumor that our painting interests clashed; he offered me a lot of encouragement about my paintings."[50]

Krasner sounded more like a feminist with a female reporter at the University News Bureau. "It can never be said that painting is a man's field; traditionally women have not produced great art, but this is because of social views rather than any in-born ability. A woman must face prejudice in this field, and must be perhaps one and a half times as good as her male counterpart to gain recognition."[51] Theodore Klitze, the head of the university's art department, told Krasner about a new cooperative of African American women who made remarkable patchwork quilts. She insisted that she and McKinney visit these women in Gee's Bend, the small town where they worked. Krasner was deeply moved by the work and arranged to purchase some of the quilts, encouraging the women by her comments and actions.

She later recalled the experience: "Finally, we arrived at someone's house and went in. I shall never forget it. We went into this room where there was a stretcher [quilt frame] the full space of the room. The women were seated against the walls of the room, working on a quilt. It was quite a sight to behold: to have the door opened and to be confronted with I don't know how many women sitting around and working on this quilt. . . . I was very taken with what I had seen. I asked about this and that and ordered three quilts. . . . Gee's Bend is very implanted in my mind."[52]

Back in New York, the second Pollock retrospective opened on April 5, 1967, at the Museum of Modern Art, and Krasner was interviewed extensively about it. The show caught the attention of critics, the general public, and many prominent contemporary

artists, among them Donald Judd, Robert Morris, Jasper Johns, and Richard Lindner, who were moved to praise Pollock's work.[53] The art historian William Rubin (who later became the museum's director of painting and sculpture) also began publishing his serial essay on Pollock and European modernism in *Artforum*. Clement Greenberg joined the outpouring with an article in *Vogue*, in which he wrote that Pollock "saw more in art and knew more of it than almost anybody (with the exception of his wife, the painter Lenore Krasner) who talked to him about it."[54]

Harold Rosenberg weighed in on the show with an essay, "The Mythic Act," in *The New Yorker* in which he referred to Krasner, but not by name: "Pollock's wife quotes him as saying in reply to an observation about working from nature, 'I *am* Nature.'" Rosenberg then conflated Krasner's intellect with Pollock's, claiming that Rimbaud was among his favorite reading and, again without identifying her, noted "a quotation from (if my memory is correct) *A Season in Hell* appeared in large letters on the wall of his wife's studio in the early forties."[55]

Despite her irritation at Rosenberg's repeated attempts to obscure her identity as an artist, she was no doubt pleased to see the attention he paid Pollock. Krasner's continuing success in promoting Pollock's work was satisfying to her. Her dedication to taking care of him both in life and after his death was indicative of both the love she felt for him and of the awe and respect that she had for his art. Painful memories of Pollock's affair with a younger woman and Krasner's failed relationship with David Gibbs seem to have convinced her neither to seek nor to accept any more attention from heterosexual men. She must have realized that she had lost her previous asset of a fabulous figure and that her facial features matched nobody's idea of beauty. Despite her abundant humor and her quick wit (which often threatened men of her generation), it seems she decided that she no longer wanted to compete with younger women.

In one sense, Krasner could not focus on another heterosexual

man, for she remained "Mrs. Jackson Pollock." Her devotion to Pollock in their married life continued, even though he was dead. In fact she could work more efficiently to promote his work because she no longer had to deal with his dysfunctional behavior. When she traveled to the West Coast opening of the Museum of Modern Art's Pollock retrospective, the *Los Angeles Times* featured her as "The Artist Leading a Double Life." She told the female reporter that she was preparing for a spring show in New York City, "which is why I can't stay in Los Angeles. I have to return home to paint pictures,"[56] adding with regard to the constant demands about Pollock's work: "Nonetheless, I've learned to deal with it, even though it means being separated from my own work at times. Being Lee Krasner Pollock is a full-time job."[57]

Instead of vying to attract straight men, Krasner was drawn to openly gay men or to one, like Terry Netter, who was a Catholic priest when they first met, which precluded any sexual issues. She cultivated gay male friends. They satisfied her interest in handsome, often younger men, and could be bright, attentive, unthreatening, and loyal, sometimes serving, in Donald McKinney's account of his role, as "her walker."[58] Those to whom she was closest included McKinney, John Bernard Myers, Bill Lieberman, Richard Howard, Sanford Friedman, Bryan Robertson, Alfonso Ossorio, Ted Dragon, and Edward Albee.

William Slattery Lieberman, known as "Bill," began at the Modern in 1945 as assistant to its founding director, Alfred H. Barr, Jr. After a thirty-five-year curatorial career at the Modern, he left to direct twentieth-century art in a new wing at the Metropolitan, where the director, Philippe de Montebello, praised "his absolute professionalism and his ability to attract the best, together with the immense esteem and affection in which he's held here."[59] Lieberman, a self-described workaholic and a gay man identified in public as "single," admitted that he considered the constant dinner parties he attended to be an important part of his job. Among the substantial donations for the Metropolitan Museum that he

successfully wooed was a gift of forty drawings by Jackson Pollock, given by Krasner.[60]

It is often written that Krasner did not get along with other women and especially with other women artists, including the painter Grace Hartigan, whose friendship survived decades, back to the time she showed up with Harry Jackson to visit the Pollocks. In the fall of 1979, Hartigan wrote to Krasner, thanking her for writing and asking if she could come down to speak with her graduate students at the Maryland Institute College of Art the following January. She offered to adjust her schedule to suit her old friend. Offered a modest honorarium of $300 plus expenses, Krasner, who never gave formal lectures, accepted the invitation and asked Hartigan to show the film made about her by Barbara Rose and then schedule an informal discussion for her with the students afterward.[61]

Additionally Krasner often wrote affectionately to "Buddha," her close friend, the designer Ray Kaiser Eames, whom she continued to see whenever they were both in New York.[62] Krasner's other friendships with women artists at this period ranged from her contemporary Perle Fine to the younger Nancy Graves.

On August 30, 1967, Krasner's friend Ad Reinhardt died of a heart attack. She held a wake for him at her home, and he was buried in the same Springs cemetery as Pollock. Krasner had known Reinhardt while on the WPA and as a fellow member of American Abstract Artists. She no doubt appreciated that in 1946 Reinhardt, when illustrating for *P.M.*, included her on a "tree" of artists in one of his cartoons in his now famous "How to Look at Art" series. This was especially important because it took place when so many other men in the art world found it more convenient to ignore her painting and treat her as Pollock's wife.

This problem continued for decades after she became a widow. In a review of a show at the Jewish Museum called "Large Scale American Paintings," Harold Rosenberg referred to her in terms of Pollock: "At the Jewish Museum, panoramic abstraction is represented by Lee Krasner, Pollock's widow, by Milton Resnick,

and, in a restricted sense, by the pencil-marked canvas of Cy Twombley. . . . The replacement of action by activity, or process, also manifest in Miss Krasner's 'Combat,' marks the passage from Action Painting to 'environmental' art." [63] Nearly two years earlier, writing in *Esquire,* Rosenberg had lambasted the role of the artist's widow in general for controlling prices and sabotaging shows and publications. He noted in particular that "Mrs. Jackson Pollock, besides being a painter in her own right, is often credited with having almost singlehandedly forced up prices for contemporary American abstract art after the death of her husband." [64]

Eventually Krasner began to publicly protest her situation. "I was put together with the wives, and when Rosenberg wrote his article ["The Art Establishment" in *Esquire* in January 1965] many years ago . . . the widow has become the most powerful influence . . . [or at least the most] powerful something in the art world. To date, a lot of the widows are acting it out. [Rosenberg] never acknowledged me as a painter, but as a widow, I was acknowledged. And, in fact, whenever he mentioned me at all following Pollock's death, he would always say Lee Krasner, widow of Jackson Pollock, as if I needed that handle." [65]

As she was facing her sixtieth year, Krasner expressed her continuing openness to the new and unexpected: "Some things in time do clarify themselves. You do have an individual who, you know, appears on the horizon, and opens a door, *wide;* we all live on it, for a long time to come, 'till the next one (individual) arrives, and opens another door. In that sense, with regard to the young painter, whoever she or he may be, it's inevitable that something will come along." [66] Krasner made clear however that no one had yet appeared to displace for her the two greatest influences on her work—Matisse and Pollock.

Krasner finally arranged to have Lloyd's New York gallery represent her. In March 1968, her first solo show at Marlborough-Gerson Gallery garnered significant articles. *Artforum* published

Emily Wasserman's "Lee Krasner in Mid-Career"; *Art News* brought out Lawrence Campbell's "Of Lilith and Lettuce"; and Grace Glueck wrote a feature for the *New York Times.* The cover of *Artforum* for March 1968 featured Krasner's canvas *Pollination,* about which she once commented, "I can remember walking across vacant lots, on my way to school and my enchantment at seeing and picking clover, buttercups, and dandelions. I'm sure that this memory among other things is in *Pollination.* . . . Yellow has always been a difficult color for me."[67]

Emily Wasserman insightfully acknowledged the albatross in Krasner's connection to Pollock. "That Lee Krasner was the wife of Jackson Pollock has been at once the greatest single advantage and the greatest handicap to her career as an independent painter: an advantage, because the experience of living and working intimately with Pollock served as a crucial catalyst to her own work— a disadvantage, especially since his death in 1956, because in one sense, she has had to labor against her relationship to Pollock."[68]

Campbell took the title for his article in part from Krasner's statement in the catalogue of her Whitechapel retrospective: "Painting, for me, when it really 'happens' is as miraculous as, say, a lettuce leaf. By 'happens,' I mean the painting in which the inner aspect of man and his outer aspect interlock."[69] Evidently mindful that Lee Krasner was Jewish, Campbell added the reference to Lilith, a night demon in Jewish lore, appearing in the Bible as a screech owl or "night monster" (Isaiah 34:14). Campbell wrote, "The daimons are there, and also Lilith who, it will be recalled, chose to leave Eden of her own free will."[70]

Around the time of Campbell's article, feminists had taken up an interest in Lilith, as she appeared in an anonymous medieval text, "The Alphabet of Ben Sira," which describes her as Adam's first wife. After Adam rejected her demand for equality in sexual positions, she deserted him and went on to mate and procreate with demons.[71] The parallels between this fable and Krasner's life

are uncanny—Campbell could have very well been referencing Krasner's intimate relationship with Pollock before he left her to have sex with "demons."

Campbell was clearly on Krasner's side when he concluded: "It is not always realized by those who see her work today that she was already a formed painter when she met Pollock and that her work remained quite independent of his through much of their married life. Her influence on him, however, seems to have been important. . . . Lee Krasner is a strong woman. She sails bravely into the teeth of whatever gale is blowing, and the handsome paintings in this current show demonstrate her continued strength and vitality."[72]

For the *New York Times,* the caption to Grace Glueck's piece read "And Mr. Kenneth Does Her Hair," in the slightly condescending manner that too often characterized Glueck's observations about women artists in the early years of the second wave of the feminist movement.[73] Glueck quoted Krasner as saying, "I'm bad fashion, but I think there are signs that the tastemakers' rule in the art world is breaking up. Maybe my work will be visible again."

When Glueck interviewed Krasner for the article, it's clear she asked her about Campbell's interpretation of the Lilith myth in relation to Krasner. " 'Lilith!' [Krasner] snorts, objecting to a current characterization of her by a leading art magazine. 'I want you to know that *this* Lilith's furs are by Ritter Brothers and Mr. Kenneth does her hair.' " Lee's hairstyle, cut with Mamie Eisenhower bangs, was visible in an accompanying photograph. The caption and the article's placement typified a long tradition at the *Times* of reducing women artists to fashion.

Among the other large canvases in the Marlborough show were *Kufic* (1965), *Siren* (1966), *Gaea* (1966), *Jungle Lattice* (1967), *Uncial* (1967), *The Green Fuse* (1968), *Towards One* (1967). As a result, the installation was quite colorful. Yet Glueck dismissed the work as "very superficial," with the exception of *Kufic,* described

as the "one notable painting" with its "improvised shapes (with a distinct echo of Matisse) . . . drawn in ocher against the brownish raw canvas surface. No other color obtrudes; no forms are filled in; the close-valued resonance of the ocher drawing and the brown canvas carries the entire picture."[74]

Other reviews were more positive. In *The Nation,* Max Kozloff quibbled and criticized Krasner's earlier work from 1962 but concluded that "the burgeoning of a mature artist has resulted in an incredibly bright and calamitous vision as well."[75] Cindy Nemser wrote for *Arts Magazine,* "Between 1963 and 1968, the basic elements of Lee Krasner's paintings have burst their original tight bounds, and they are now boldly headed beyond the confines of the canvas."[76]

While she commanded attention in the city, Krasner continued to show in East Hampton. She participated with a large group of artists who joined in a group show at Ashawagh Hall in Springs in August 1968, along with such friends as Perle Fine, Esteban Vicente, Ibram Lassaw, John Little, James Brooks, Tino Nivola, Alfonso Ossorio, and her nephew Ronald Stein. This was the first annual exhibition of what would become a series called "Artists of the Springs."

A year later Krasner participated in a panel discussion on the topic "Is American Art Chauvinistic?" at Guild Hall on August 24, 1969, along with Adolph Gottlieb, Jimmy Ernst, John Little, Warren Brandt, and Hedda Sterne. Harold Rosenberg was the moderator. Krasner had never even approved of the category "American art"—she found it too nationalistic—so it is not surprising that she applauded the efforts of those who playfully demonstrated outside Guild Hall as the speakers and the audience arrived. As for the demonstrators, they questioned whether a discussion of the supposed superior attitude of American art was even worth having in a time when they opposed the Vietnam War. By demonstrating, they emulated the student radicals of the era.

One of the ringleaders, the sculptor Bill King, poked fun at the panel. "It was such an idiotic subject and panels are a blight! [The pacifist writer] Dwight and Gloria [Mcdonald], my wife, Annie, and I got all dressed up. I wore my Greek silk suit and the girls wore evening gowns. I went to Dreesen's and got a whole bologna and a knife. Then I printed up paper napkins in red that said, 'This is the real boloney.' So we stood outside Guild Hall and, as the people were filing in, we'd put the bologna on a napkin and hand it to them, saying 'This is just a sample of what you're gonna get inside, folks.'"[77]

As expected, people laughed at their protest, but King noted with surprise, "Lee Krasner ate hers like a real [trouper]."[78] King was unaware either that Krasner had a history of demonstrating during her formative years or that she bristled at the notion of "American art." To him, she seemed like a forbidding widow of a powerful artist.[79]

That same summer of 1969, Krasner needed a poster for an upcoming show in San Francisco. She asked Mark Patiky, the younger brother of Frances Stein, to come out to Springs and take her photograph. Already experienced in the world of fashion and advertising, Patiky, then just twenty-five, looked around for places for take the photograph. When Krasner took him out to the studio, he photographed her. Then she commented that she felt like painting, and he asked to photograph her as she worked. She readily agreed, and he captured her painting what became *Portrait in Green*.[80]

Patiky watched as Krasner became very focused, standing back some fifteen feet with her arms folded, then running up and making "these slashing strokes," a very active process. She worked on unstretched canvas tacked to the studio wall. As he watched her attack the canvas, he kept shooting until she said, "It's finished."

"How can you tell?" he asked.

"I know," she said, though he says that she reworked it a couple of years later.[81]

When Krasner's show of works on paper traveled
from New York to Reese Palley Gallery in San
Francisco, the local critic, Alfred Frankenstein,
observed that her work resembled Pollock's, "but
it has such force, richness, and individuality as to
set one wondering just who, in this instance, influ-
enced whom." The poster featured Mark Patiky's
photograph of her.

Krasner told Patiky that he was the first person to photograph
her in the process of painting. He stayed for the weekend and en-
joyed the dinner Krasner made, especially the fettucini with fresh
dill and cottage cheese, and the chocolate nut sundae for dessert.

What Patiky observed was Krasner's avowed preference for
having her canvas "within my physical scope including jumping
up to hit the top of the canvas": "What I don't want to do is get up
on a ladder and hit the top. I want it to be within my body experi-
ence. I don't want assistants working for me. I don't experience it
that way. I want to be in contact with my body and the work."[82]

Krasner had another New York solo show at Marlborough in
October 1969. John Gruen reviewed the work, praising her series

of small abstract gouaches as echoing her monumental oils, "but whose reduced scale produces a singular delicacy of design. There is all manner of invention and all manner of sensitivity at work here."[83] The reviewer for *Art News* was less clear, writing that "each work is its own adventure."[84]

The following month Krasner's show of works on paper traveled from New York to Reese Palley Gallery in San Francisco, advertised there by a poster with Patiky's photograph of her. The local critic, Alfred Frankenstein, opined, "Her work strongly resembles Pollock's, but it has such force, richness and individuality as to set one wondering just who, in this instance, influenced whom."[85]

# SEVENTEEN

# The Feminist Decade, 1970–79

Gail Levin, then curator at the Whitney Museum of American Art, with Lee Krasner, Springs, summer 1977.

THE POSITIVE RECEPTION IN LONDON FOR KRASNER'S 1965 RETrospective at the Whitechapel Gallery led Barbara Rose to complain in 1972, "It remains, however, for America to acknowledge that Lee Krasner's works share the same esthetic, the same content, the same history and are the same quality as those of her male colleagues, the 'first generation' New York painters.[1]

"Perhaps because these painters called themselves 'heroic,' and because we as a people are slower to honor our heroines than our heroes, this recognition has been unnecessarily delayed. But, throughout our history, we have had brave, self-reliant American women who struck out on unknown paths. Lee Krasner is one of them."[2]

Krasner was outspoken about the discrimination she experienced as an artist. Though she hadn't been discriminated against at the Woman's Art School at Cooper Union and on the WPA, once "the scene moves from Paris, which was the center, and shifts to New York" problems became apparent. Krasner attributed these problems to "a group of Surrealists who treated their women like well-groomed poodles and then the abstract expressionists— where we now have galleries, prices, money, attention. Up to then it's a pretty quiet scene. That's when I am first aware of being a woman and a situation is there."[3] That she had been insulted at the National Academy of Design, where as a female she was forbidden to paint a fish still life in the basement, now seemed less significant.

Krasner's deeply held beliefs led her to reject the work of many artists in the feminist movement. During the second half of the 1950s, Krasner met the artists Miriam Schapiro and her husband, Paul Brach, who had purchased a barn in East Hampton as their summer home. Both Schapiro and Brach were then working in an abstract expressionist style. Later Schapiro moved to California, following her husband's new job as dean in the new California Institute of the Arts, funded by the Walt Disney Company. There Schapiro got to know another artist, Judy Chicago, who was sixteen years younger than Schapiro and who pioneered new ways of educating women as artists.

The two worked together to move Chicago's innovative education plan for women artists from California State College at Fresno to Cal Arts in Valencia, where it became known as the Feminist Art Program. During the fall of 1971, they took over an abandoned house in Los Angeles. With the help of their students, they produced *Womanhouse* (1972), a temporary installation and performance space that examined the role of women and creativity in the setting of a house. These two feminist art pioneers were among those featured in the spring of 1972 at the Corcoran Conference for Women in the Arts in Washington, D.C.[4]

Lee Krasner's absence from the conference was notable. When asked about women "banding together, forming an old-girl network," she demurred, "I wouldn't become a part of that. I'm an artist not a woman artist. The pendulum is swinging to the other side. It comes a little late for me."[5]

The feminist art that Chicago and Schapiro made was anathema to some women, among them Krasner. She recognized the need for a feminist movement, but she had no affinity for feminist art, or anything with labels for that matter. In 1972 she commented to Barbara Rose: "I don't suppose I know what's meant by 'feminine' subject matter, any more than I understand what's meant by 'masculine' subject matter. I'm sympathetic to the women's movement, but I could never support anything called 'American art.'"[6] On another occasion she declared, "When I see those big labels, 'American,' I know someone is selling something. I get very uncomfortable with any kind of chauvinism—male, French or American."[7] The link that Krasner felt between chauvinism and nationalism began when as a girl she first became aware that not everyone could qualify as "American," certainly not recent immigrants. Fanatical patriotism and the prejudiced belief in the superiority of one group over another often excluded Jews and the newly arrived. In 1929, some critics had protested that artists such as Max Weber, Jules Pascin, and Yasuo Kuniyoshi should not have been considered American for inclusion in the MoMA show "Nineteen Living Americans." Rose published in 1972 a *Vogue* article, "American Great: Lee Krasner." Beneath the title she quoted Krasner: "I'm an artist—not a 'woman artist'; not an 'American artist.'"[8]

Some of Krasner's hesitation about categorizing art came from her own struggles to deal simultaneously with both anti-Semitism and antifemale prejudice. In a 1972 interview, Krasner pointed out that an article (in *Art in America* from August 1965) about the abstract expressionist movement included only four women—Marisol, Hedda Sterne, Alice Mason, and Louise Nevelson—out of seventy-

three artists. The article had appeared the very same year as Krasner's first retrospective—in London, not New York. When asked who else might have been named, Krasner immediately reeled off "female artists dating possibly from late 1935 to the mid-1940s that I was aware of: Loren MacIver, I. Rice Pereira, Louise Bourgeois, Jeanne Reynal, Anne Ryan, Sonia Sekula, Louise Nevelson, Alice Mason, Peter (Gertrude) Greene, [Suzy] Frelinghuysen, Leonor Fini, Dorothea Tanning, [Maria Helena] Vieira de Silva, Barbara Hepworth, and lastly but hardly least, Miss Georgia O'Keeffe." She allowed that "when you restrict it to abstract expressionism, some of the names would have to be removed."[9]

Despite her uneasiness about feminist art, Krasner benefited enormously from the feminist movement, and she embraced it without accepting the art that carried the name. "I'm glad I'm alive, now that women's lib has brought a new consciousness," Lee Krasner admitted to an interviewer in 1973. "Thank you, women's lib. In that sense, [life now] is better than forty plus."[10]

In 1980 she reiterated to another journalist, "Women's liberation helped me enormously—if they have to have someone, I'm not so bad as an artist—and I've benefited from the opportunity."[11]

Later Cindy Nemser interviewed Krasner and wrote several articles about her work, including one for *Artforum*. Commenting from the perspective of a woman artist, Krasner noted, "It's too bad that women's liberation didn't occur thirty years earlier in my life. It would have been of enormous assistance at that time."[12]

DURING THE 1970S, THE FEMINIST MOVEMENT ENCOURAGED FEMALE critics, curators, and historians to focus on the achievements of women artists, and Krasner welcomed the increasing attention. She had once been reluctant, but now she joined calls on art museums to show more women, and she accepted many requests to lend work to all-female exhibitions and to make personal appearances. On April 14, 1972, Krasner joined demonstrators organized

by Women in the Arts to dramatize "inequities against women pervading galleries, universities, and museums."[13] The group of some three hundred demanded an exhibition of women artists chosen by their own membership that would take place simultaneously at the Brooklyn, Metropolitan, Whitney, Modern, and Guggenheim museums. Among the other demonstrators who are now well known were Louise Bourgeois and Chryssa. Another demonstrator, the feminist critic Cindy Nemser, spoke to Grace Glueck, who was covering the event for the *New York Times:* "The demonstration also has to do with the corrupt and decadent structure of the art world. Women are leading the way to a new art world that is open and inclusive. We want a diversity of styles, not just fashion shows of this year's trends."[14] Glueck reported that the demonstrators wore signs with statements such as MOMA PREFERS PAPA and SIGMUND, THIS IS WHAT WE WANT, AN END TO DISCRIMINATION.

The demonstrators at MoMA handed out pink leaflets that detailed discriminatory practices by museums and galleries. One claim was that MoMA had held one thousand one-artist shows in forty-three years, but only five times had the artist been a woman. Another charge was "that in ten leading New York galleries, 94.6 percent of the artists represented were men." According to the *New York Times,* MoMA countered by claiming that it "had staged only 293 one-artist shows since 1929 and twenty-seven, or approximately 9 percent, were devoted to women artists." The museum admitted that in the painting and sculpture department's permanent collection, women represented "slightly less than 10 percent."[15] The percentages were still very low, so it's difficult to know why the museum bothered to quibble.

Later on the Museum of Modern Art tried to play catchup and organized a show of new acquisitions of drawings in the summer of 1977 called "Extraordinary Women," which included Krasner along with such historical artists as Hannah Höch, Sonia Delaunay, Sophie Taeuber-Arp, Natalia Goncharova, and Suzanne Valadon.[16] The following fall Krasner reflected that "the

Modern was like a feeding machine. You attack it for everything, but finally it's the source you have to make peace with. There are always problems between artists and an institution. Maybe that's healthy. You need the dichotomy—artist/museum, individual/society—for the individual to be able to breathe." [17]

Krasner saw both the positive and the negative aspects of the local community in East Hampton. She had not forgiven Harold Rosenberg's support for de Kooning instead of Pollock, yet she was not that angry, because when asked in 1972 if she still saw her old friends, she answered, "Not too many of them are alive. I see Giorgio Cavallon, whom I've known since the academy and Pat and Clyfford Still when they visit New York. When I'm in Springs, sometimes I see Gottlieb or de Kooning, although not often, and Harold and May Rosenberg." [18] From the Hofmann School days, she could have also named Ray Kaiser and John Little, two friends with whom she stayed in touch.

Though she was genuinely grateful for Clement Greenberg's early support of Pollock's work, she was clear that his chauvinism bothered her. "Greenberg is very hung up on the subject of women, but he wasn't alone, his whole generation. . . . In my opinion, [Harold] Rosenberg as well as Greenberg, as well as most of my fellow artists." [19] She qualified this point by conceding, "Well, it wasn't just Greenberg and Rosenberg. . . . Galleries were very uncomfortable with a woman in the art world. That would go for museums. To date, look at the record of the Museum of Modern Art with regard to showing women. They don't. Or the Guggenheim. So like, that's New York, the center of it all, where all the pow-wow goes on, and once you leave New York, it gets worse, not better." [20]

Krasner continued to say negative things about the chauvinist attitudes of some of her male contemporaries, especially Newman and de Kooning. De Kooning painted a series of abstract women with violent, expressionist brushstrokes that many saw as misogynistic and Krasner rejected "them one hundred percent; I find

them offensive in every possible sense; they offend every aspect of me as a woman, as a female. . . . It's the hatred and hostility toward the female."[21] She went on to say: "And as for de Kooning, I think his problem with women is so complex and difficult that we nod to each other, we say hello and good-bye after about forty-five years, but that's our full contact."[22]

Simultaneously Krasner attacked de Kooning's aggressive images of women, maintained her antipathy toward feminist art, and voiced her sympathy with, and need for, the feminist movement.

Among the all-women shows Krasner participated in was "Woman as a Creator," held in early 1973 at the University of North Dakota in Grand Forks as part of the 4th Annual Writer's Conference. The conference's theme for the year was "Women in the Arts." Among the conference speakers were the novelist, critic, and memoirist Mary McCarthy, the poets Gwendolyn Brooks, Carolyn Kizer, and Diane Wakoski, and the playwright Myrna Lamb. Krasner's work was featured together with fourteen artists, including Judy Chicago, Miriam Schapiro, Diane Arbus, and Jeanne Reynal.[23]

Although Krasner did not travel to North Dakota, Judy Chicago did go and spoke during the group show. She recorded in her journal that she found the women to be passive, repressed, apathetic, isolated, and ignorant.[24] Perhaps Krasner would have been more understanding, but by early 1973, she was busy preparing for her next solo show on West Fifty-seventh Street at Marlborough.

Regardless, the North Dakota show was well reviewed in the college newspaper. "It's hard to keep politics out of art when an exhibition is arranged around a political motif like blackness, or femaleness. These artists were chosen because of their art and incidentally, since it was the nature of this conference, because they were women," wrote Jackie MacElroy in the campus newspaper, the *Dakota Student*. She was impressed that Krasner had "favored the University Art Gallery by sending three works, two of which are commonly reproduced and indeed are among her

best canvases," noting that Krasner "was and remains an abstract-expressionist and successful despite the odds. There are many things in the Gallery which represent a more innovative approach than Krasner's work but few if any exceed the sureness and fluidity of her mature style."[25]

For Krasner's next show at Marlborough, she showed twelve paintings from the last two years, all monumental in size, including *Palingenesis* (1971), *Majuscule* (1971), and *Rising Green* (1972). The show opened on April 21 to rave reviews. In the *New York Times,* Hilton Kramer pronounced that the show was "by far the finest exhibition of Miss Krasner's work I have seen. Something of the sweep and the rhythm of her former expressionist style has been retained—in the bolder, flatter, hard-edged forms of the new paintings, which are lyrical celebrations of color. There is a good deal of late Matisse in these new paintings, and a happy influence it proves to be, prompting the artist to a great boldness of design and a more eloquent simplicity of form."[26]

Barbara Rose also applauded Krasner, writing, "In her newest paintings, however, she seems to have come to what used to be termed a 'breakthrough' in terms of arriving at uniquely personal statements. And significantly enough this departure from her past works has been in the direction of pure color. . . . It took nearly twenty years to realize the direction the collage paintings pointed to."[27]

At Guild Hall again in the summer of 1973, Krasner took part in a show called "Twenty-One Over Sixty." She was sixty-four. She had suggested the idea, but by the time the show took place, she was regretful: "Now I wish I never got the idea to begin with. It's just that one gets a little bored with the American youth image. It's suburbia and Hollywood all in one. It started in the '60s, which I call the Sterile '60s. If you haven't had a major show by the time you're thirty-five, you're nothing."[28] Other artists in the show included current and past friends: Perle Fine, Ilya Bolotowsky,

James Brooks, Costantino Nivola, Willem de Kooning, Adolph Gottlieb, Ibram Lassaw, and Esteban Vicente.

Krasner refused to allow her age to be printed in catalogues, and she once told a journalist, "Call me sixty plus." Age was very important for an artist's success in America. "If you're an artist, you have to have a lot of mileage. You have to do a lot of painting. You can't get by with a youth image. In Europe, artists live to be eighty or ninety. In this country, we kill them off younger."[29] Krasner, a heavy smoker and a drinker, as was common in her generation, took no responsibility for her own health.

That summer the artist Hermine Freed videotaped Krasner in the Springs house for her "Herstory" project, which raised a number of topics, including stereotypes and inequity that women artists still had to endure. Krasner fiercely attacked her old friend and patron B. H. Friedman—she said she disliked his biography of Pollock because of "his Gucci-Pucci attitude towards life," "his warped idea" of masculinity, and asked, "What chance do I have to get an objective view?" Angry at Friedman's depictions of both herself and Pollock, Krasner rails on the video at Friedman's inherited wealth. Her remark about his idea of masculinity probably referred to his account of Pollock's affair with Ruth Kligman. He wrote, "how dead Pollock felt at the time, how much he needed to be told he was alive. . . . Perhaps Ruth Kligman told him physically—and verbally."[30] At the same time, Krasner probably felt he had not paid enough attention to her as an artist. Krasner explained that in the beginning, she was less conscious of prejudice against women, but that she was annoyed with "the prejudice today, the intolerance today."[31]

Krasner pointed Freed toward Barbara Rose's review of the biography. Rose had branded the book as "closer to a fantasy re-creation of the artist's personality, motivations, psychology and behavior. . . . The feat of transforming Pollock's life into a novel that begs for a Hollywood translation is considerable."[32] Rose took

Friedman to task for viewing Krasner as "simply the great man's wife" and treating her that way, making her into a stereotype throughout the book, seeing her as "anything but being a creative equal as complicated and tormented as Pollock himself."

On November 13, 1973, "Lee Krasner: Large Paintings" opened in New York at the Whitney Museum but did not go on tour. While the Whitney had continued to support the realism of artists such as Edward Hopper or Andrew Wyeth during the 1950s and 1960s, it also gave shows to vanguard abstract artists, though most of them were male. Krasner's solo show, organized by Marcia Tucker, a dynamic thirty-three-year-old curator who had been working there since 1969, included eighteen large-scale canvases dating from 1953 to 1973. It was her first one-person show in a New York museum. Most of the work was still in Krasner's possession and was lent courtesy of Marlborough Gallery.

One major canvas in her show, *Pollination,* was lent by the Dallas Museum of Art. According to Donald McKinney, then president of Marlborough, Krasner did not want to sell major works by Pollock to anyone but museums, and then only reluctantly. She did so more readily when museums also acquired her work.[33] In the case of the Dallas Museum, however, the museum purchased her *Pollination* the year after it bought *Portrait and a Dream,* Pollock's major canvas of 1953.[34] If this was her strategy, it seems to have worked and benefited both the museum and the artist.

Even *Time* magazine covered her show, and the writer A. T. Baker defended Krasner against an earlier attack from Harold Rosenberg. "Critic Harold Rosenberg once credited her with 'almost singlehandedly forcing up the prices for contemporary American Art.' She lives comfortably now on Manhattan's East Side, but beyond a weakness for fur coats, she takes little interest in her latter-day wealth. What occupies her is the determination to reassert her artistic individuality."[35] Such a relic of the old

journalist vice of setting woman artists apart by discussing them in the context of fashion would never have been inflicted on a male.

Baker was not wrong in asserting that Krasner wanted individuality. In *Newsday* art critic Amei Wallach captioned her article: "Lee Krasner, Angry Artist." She quoted Krasner saying, "I happen to be Mrs. Jackson Pollock, and that's a mouthful. The only thing I haven't had against me was being black. I was a woman, Jewish, a widow, a damn good painter, thank you, and a little too independent."[36]

In his review for the *New York Times*, Hilton Kramer acknowledged that Krasner brought her own power to the abstract expressionist style that Pollock had pioneered. Kramer noted that Krasner's work was "a less desperate and more lyrical affirmation, and there is no suggestion of anything secondhand or merely appropriated in these pictures."[37] He did question why this show was such "a fragmentary view" of a career that "has remained far too obscure." Barbara Rose reiterated Kramer's point about Krasner's career in *New York*, writing that Lee Krasner's "show is impressive and coherent, but overlooks her historic importance as one of the seminal forces among the Abstract Expressionists."[38]

The curator, Marcia Tucker, wrote the show's catalogue essay, and Pamela Adler compiled the chronology, which reflected Krasner's direct confrontational style. For 1959, we find: "November, Clement Greenberg schedules a solo exhibition for her at French & Company. Krasner cancels show because of Greenberg's attitude."[39] The chronology also featured, for the first time, Krasner's real birth date, a notable change from "all the other ones I've given in the past, on licenses and things." Krasner reflected that she "was in analysis a long time and couldn't handle [aging]."[40]

Tucker pronounced that Krasner's paintings were "rich, authoritative, impetuous and vibrant," and declared, "The artist's role as participant and contributor to what is the major, seminal

art movement in the country has yet to be fully documented." She explained that "Krasner matured in an artistic milieu to which women were admitted reluctantly, if at all. Many were the wives of other artists and played a secondary role in relation to their husbands."[41]

As Tucker worked with Krasner on the exhibit, she got a feeling for Krasner's stubbornness about art. "Even though Lee Krasner had a reputation as a tough old bird, we got along well. . . . When I told her she couldn't watch while I installed the work, she reacted as though I'd stabbed her with a pitchfork."[42] Tucker complained about "spending weekends alone with Lee in East Hampton, never leaving the house, while she reviewed every single aspect of her life, obsessively cataloguing the ideas that she said her husband, Jackson Pollock, had borrowed from her. . . . I was always hungry when we worked: either Lee couldn't cook or she didn't like to eat."[43]

Krasner may have sensed that Tucker arrived with a bias based on having heard tales about her "reputation as a tough old bird," for Krasner seems to have offered less hospitality to her than to others. Many friends and visitors recall eating well and even some delicious home-cooked food, like her famous clam chowder or fresh local fish. Krasner's close friend Eugene V. Thaw, who co-authored the Pollock catalogue raisonné, recalled having lavish food and drinks at her home.[44] The young photographer Mark Patiky recalled her delicious cooking. Tucker must have confused Krasner's comments about Pollock borrowing ideas from her with statements made by another woman artist, since through her many documented interviews and encounters Krasner barely claimed to have influenced Pollock at all.

In March 1974, Miriam Schapiro's students in the Feminist Art Program at California Institute of the Arts reached out to Krasner, requesting that she write a "Letter to a Young Woman Artist." The letter could have been "about your experiences, or advice, or whatever feelings you might wish to express." She responded by

having Donald McKinney, Marlborough's president, send in a quotation by her for the students' publication:

> On a questioning of my newer work being more organic
> and close to nature images, I think for every level you go
> higher, you slip down one or two levels and then come back
> up again. When I say slip back, I don't mean that detrimen-
> tally. I think it is like the swing of a pendulum rather than
> better or back, assuming that back means going down. If
> you think of it in terms of time, in relation to past, present
> and future, and think of them all as a oneness, you will find
> that you swing the pendulum constantly to be with now.
> Part of it becomes past and the other is projection but it has
> got to become one to be right now. I think there is an order,
> but it isn't better, better, best. I don't believe in that kind of
> scaling.[45]

For her statement, Krasner adapted her own response to a ques-
tion Cindy Nemser had posed in an interview. Her long-standing
preoccupation with time, past, present, and future would become
a theme of a show of her work held in 1977.

With the help of feminists, more attention was focused on
Krasner's work. Cindy Nemser interviewed Krasner and wrote
several articles about her work, including one for *Artforum* fo-
cused on paintings from the late 1940s. The Alumni Association
of Cooper Union took notice and awarded Krasner its Augustus
Saint-Gaudens Medal (named for the sculptor who studied there
in 1861) for "her accomplishments as a painter and her influence
on the art world." Unfortunately that influence was a thinly veiled
reference to her having been Jackson Pollock's wife. No other
women from her time as a student at Cooper Union made names
for themselves.

At this time, Krasner accepted shows in obscure places in order
to build her reputation. In March 1974, she sent a small show

of work from the years 1946 to 1972 to the Teaching Gallery of Miami-Dade Community College. The art critic of the *Miami Herald,* Griffin Smith, wrote that the show offered evidence that "not only is a re-evaluation of her painting in terms of its impact on other pioneer first-generation New York abstract expressionists long over due, but that Krasner herself, far from being merely 'Jackson Pollock's widow who paints,' is a major artist in her own right."[46] In May, Smith's review was reprinted in *Art News* magazine. The exposure was paying off.

The *Miami Herald* also sent a staff writer to interview Krasner for a feature story about the show. The writer asked Krasner about Ruth Kligman's memoir, which was about to be published. "Pollock had many affairs that I knew about," Krasner replied. It was a rare moment of candor. "That this pathetic and petty person should exploit him like this is. . . . Well, the exploitation of him has been indescribable, painful for me. . . . The affairs irritated the hell out of me, of course they did," she added. "This Ruth Kligman . . . All right, she may have slept with him, and if she wants to make a mountain out of a molehill, that's her problem not mine."[47]

The next month, Krasner was on the road again—this time in the Atwood Gallery at Beaver College in suburban Philadelphia. A show in a one-room gallery at a small college was a far cry from her dream—a retrospective at the Museum of Modern Art in New York. Yet she went. Her appearance, at the age of sixty-five, before undergraduate students prompted the following: "Lee Krasner is just herself: Dull gray hair in a Dutch-boy style, pale—if any—color on her full lips, unstylish brown plastic glasses, shapeless black and white polka-dot dress, flat shoes."[48] A photograph of Krasner talking to a student in front of her 1972 painting *Sundial* was staged in the gallery. Laurel Daunis, a freshman who just happened to pass through the gallery, remembered Krasner seeming "very sweet, personable."[49]

Krasner answered questions from the audience. She described

her work schedule as "a very neurotic rhythm of painting. I have a high discipline of keeping my time open to work. If I'm in a real work cycle, I'll pretty much isolate myself and paint straight through, avoiding social engagements. After not painting for two months due to lecturing in Miami, I'm getting restless, nervous, irritable."[50]

In January 1975, "Lee Krasner: Collages and Works on Paper, 1933–1974" opened at the Corcoran Gallery of Art in Washington, D.C., organized by Gene Baro, a freelance critic. It surveyed her art from a 1933 Conté crayon nude drawn from the model through recent abstract gouaches. The list of lenders to this show offers a view of those with whom the artist had been closely associated, including her therapist Dr. Leonard Siegel, her friends Edward Albee, Hans Namuth, Alfonso Ossorio, and Edward F. Dragon, and Krasner's old flame David Gibbs and his wife, Geraldine Stutz. B. H. Friedman was represented by his company, Uris Buildings Corporation.

Baro called Krasner "an artist of natural sensations, of elemental attributes and appearances of things. Her interest isn't to describe an experience but to reorder or reinvent it as visual feeling."[51] Paul Richard wrote for the *Washington Post:* "Lee Krasner is a famous artist whose fame has hurt, not helped her." After rehearsing her life with Pollock, he concluded, "Lee Krasner is no mere imitative artist."[52] Additionally the reviewer Benjamin Forgey noted, in the *Washington Star-News,* that "Krasner is obviously a talented artist" but lamented not being able to consider her recent, large, oil-on-canvas paintings.[53]

The Corcoran show traveled to both the Pennsylvania State University Museum of Art and the Rose Art Museum at Brandeis University.[54] Reviewing the show in the *Boston Globe,* Robert Taylor began by pointing out that Krasner was "victimized by our inability to distinguish between the relevant aspects of an artist's biography and an artist's work; but then so was her husband, Jackson Pollock. He was a drunk, with all a drunk's self-hatred, yet

the least relevant aspect of his career was the boisterous romanticism that made him such a wretched custodian of his talent."[55] He continued, however, to note: "Of course, Brandeis's show not only indicates that she can stand on her own, but that she is a serious and highly significant American painter."[56]

In a related article, Lucille Bandes noted that Krasner was finally beginning to gain recognition "as a major figure in contemporary art," while noting how devoted she was to her husband's needs. "Those who knew them both well report that in addition to the necessity to earn money and to guard Pollock from the effects of his heavy drinking, she found it difficult to paint because he resented it. She herself insists that her husband encouraged her art, but she does say, 'I would give anything to have someone giving me what I was able to give Pollock.'"[57]

In 1975, Krasner produced *Free Space,* a serigraph on paper, for a print and sculpture portfolio and a traveling exhibition project called "An American Portrait," timed to coincide with the bicentennial. The exhibition was produced by Alex Rosenberg under the name Transworld Art Corporation, and it featured thirty-two other artists, including Alex Katz, André Masson, Romare Bearden, and Karel Appel. Rosenberg said that working with Krasner was easy because "she was a pro, an absolute pro."[58] Rosenberg found Krasner to be very friendly and "not as tough as she was made out to be."

When he asked her, "What was a nice Jewish girl from Brooklyn doing with Jackson Pollock?" she responded, "Who said I was a nice girl?"[59]

There was a brief statement about the project that read: "Krasner, who risked a depth of exploration of the psyche, gained by it; 'We shall not cease from exploration' is a T. S. Eliot line that Krasner likes to quote."[60]

That summer Ruth Appelhof, then a graduate student at Syracuse University, arranged to spend time with Krasner in Springs. She drove Krasner out from the city—Lee no longer

drove anywhere herself. While Appelhof served Krasner's need not to be alone in the house, she got to conduct research for her master's thesis. Appelhof recalled an excursion to swim at Louse Point, the bay beach after which de Kooning named one of his canvases. There, they ran into Harold and May Rosenberg, who had a cordial exchange with Krasner. Appelhof observed that Krasner "had a sexual demeanor about her. She was very aware of her body and apt to show it off."[61] The young scholar could hardly have known of those long past sensual scenes with Pantuhoff on the beach.

In July 1975, Krasner accepted an invitation to be artist in residence at Marge Schilling's artists' conference at Dune Hame Cottage in Watch Hill, Rhode Island. The invitation offered a pleasant setting and a chance for a change of pace.[62] Marge Schilling was a New York portrait painter who worked on commissions, mainly of children. She also supported herself organizing this annual conference for women artists at her Rhode Island summer home. None of the women who attended were famous, but they were thrilled to have Krasner present.[63]

One of the artists who attended the conference was Majorie Michael, whose sculpture was the subject of a book, *A Woman's Journey,* published the previous year.[64] She found Krasner to be "a remarkable woman" and considered her an "excellent painter"; the two got along well.[65] Michael made many sketches and took photographs of Krasner during the week at Watch Hill so that she could start making a portrait bust. Krasner liked the project enough that she traveled that October to the suburbs north of New York City to sit for Michael in her Chappaqua, New York, studio.[66] Krasner inspired Michael, who wrote in her journal in 1977, "Like Lee Krasner says, 'It is a big wide canvas but I can reach it all with a little jump!'"[67] Michael kept in touch with Krasner, visiting her in East Hampton in 1981.

Schilling hired Dyne Benner to be the cook at the conference. Benner had studied painting at the Art Students League with

Morris Kantor and Theodoros Stamos, and she photographed some of the group in Rhode Island, including Krasner, who was wearing a fashionable brown strapless bra under a see-through brown tunic of Indian muslin.

That fall Krasner invited Benner to Long Island for a couple of days, but Benner found Krasner too bossy and felt uneasy, so she departed. When Krasner asked Benner, "What do you want from me?,"[68] Benner was unable to respond. Others, like Ronald Stein, Clement Greenberg, or David Gibbs, usually wanted something from her.

Later that summer Krasner turned down an invitation to take part in a group show at Ashawagh Hall, just down the road from her home, where she had often been in the annual exhibitions. This time, however, the organizers, Joan Semmel and Joyce Kozloff, had just arrived on the scene and proposed a new theme for the familiar venue: "Women Artists Here and Now."[69] It's possible that Krasner didn't want to associate with feminist artists. She knew that Semmel and Kozloff made feminist art, as did some of the artists in the show—Miriam Schapiro, Audrey Flack, and Carolee Schneemann. And though Krasner curtly refused, Perle Fine, Elaine de Kooning, Betty Parsons, and Hedda Sterne all accepted, and none of them made feminist art. During the show on August 29, 1975, Schneemann staged a now-legendary performance nude before the audience, in which she read from a script on a scroll that she slowly pulled out of her vagina.[70] Perhaps Krasner's posing for nude photographs on the beach had faded from memory, but she could not conceive of the new feminist performance as art.

In June 1976, Krasner left Marlborough for Pace Gallery, which was on the same street. She would be the third woman at Pace, joining Louise Nevelson and Agnes Martin. Denying that the move had anything to do with Marlborough's notorious abuse of the Mark Rothko estate, the *New York Times* quoted Krasner: "All good things come to an end. It's the longest time I've been

with any dealer, and it's time for a change."[71] She also removed Pollock's work from Marlborough, perhaps to protect his estate from a fate similar to Rothko's, although that motive was not acknowledged.

As she aged, Krasner began to take up some of the activities of her youth. She joined a political protest against the French government's release of the suspected Palestinian terrorist Abu Daoud, who was the alleged mastermind of the 1972 Munich Olympic massacre. Krasner lent her name to an advertisement in the *New York Times* that announced that the petition's signers were boycotting the opening of the government-sponsored museum le Centre national d'art et de culture Georges Pompidou (also known as le Centre Beaubourg). The campaign was organized by her dealer, Arnold Glimcher of Pace Gallery, and her fellow gallery artist Louise Nevelson. Many artists joined the list of protesters, including Willem de Kooning, Robert Motherwell, James Rosenquist, and Lucas Samaras, as well as critics Dore Ashton, Barbara Rose, and Robert Hughes.[72]

At the end of the year, she told *Newsday* that the best thing that happened to her during 1976 was that she "started to dance again. . . . John Bernard Meyers [an art dealer] asked me to dance at a party. At first I refused, but then I said, 'If you go very, very easy or very slowly,' because I hadn't danced for years. I used to be mad for it. Well, after a few numbers, it was he who had to be walked away."[73]

When Gaby Rodgers, an interviewer for the *Women Artists Newsletter*, asked Krasner in 1977 if she felt the women's movement had made errors, she responded, "Every revolution makes errors. The women's movement is the major revolution of our time; it's natural for them to make errors. I don't kid myself. Women are not yet equal—we are still second-class citizens."[74] Rodgers, editorialized, "I am sure glad [Krasner] is around. Today, when the feminist movement looks for role models and young people flock to gurus for wisdom, we would do well to pay attention

to the wise women amongst us, to keep a dialogue with the accomplished women of Lee Krasner's generation. Aside from her extraordinary gifts as an artist, she can tell us what it was like out there during a lifetime of struggle and dedication."[75] Krasner told art historian Cassandra Langer in 1981 that she realized the recognition she had received recently was "entirely due to the women's movement," repeating her oft-spoken pronouncement: "The raising of women's consciousness is one of the major revolutions of our time."[76]

Krasner always maintained that she had benefited from the efforts of some men, especially John Graham and Jackson Pollock. But she loved to repeat the story of her teacher, Hans Hofmann, who in examining her work in class, had commented, "This is so good you would not believe it was done by a woman." When an interviewer commented that this was "a kind of a mixed compliment," Krasner responded, "Well, yes. You know, you get a cold shower before you've had a chance to receive the warmth of the compliment."[77]

Krasner's intensity could be intimidating to male artists. Bill King, who was seeing Cile Downs in the late 1970s, recalled parties at which the guests were drinking heavily, where he felt "chilled" by "a certain kind of women's laughter" that made him think of "maenads that tore Orpheus apart. My hair stood on end. I was scared of Krasner, especially when she laughed."[78] In a time of feminist activism, such perceptions and their consequences cannot be discounted.

In January 1977, the exhibition "Women Artists: 1550–1950," organized by feminist art historians Linda Nochlin and Ann Sutherland Harris, which had just opened at the Los Angeles County Museum of Art, was reviewed by Robert Hughes in *Time*. He asserted that "an area of great consequence for art history has now been opened up" and argued that "the last section, spanning about 1900 to 1950 makes the contribution of women to modern art seem less than it actually was. Painters of large

and unquestionable talent, like Lee Krasner, are not seen at their best." [79]

That fall the show opened at the Brooklyn Museum. Among those who came to see it was Joan Mondale, the wife of Vice President Walter Mondale. She stayed to meet with twenty-five women artists and art historians, including three living artists who were in the show: Krasner, and the representational painters Isabel Bishop and Alice Neel.

Mondale spoke to the select audience: "The present administration is interested in discrimination against women." She had brought along Midge Costanza, the director of the Office of Public Liaison in the White House, who read a letter she had sent to the General Services Administration, the National Endowment for the Arts, and the Smithsonian Institution advising them "to initiate remedial procedures" to correct discrimination against women artists. [80] The letter was written in response to a protest the previous March by the New York group called Women in the Arts against President Carter's choice of ten artists—all male—for a series of prints connected to his inauguration. Krasner had picketed MoMA with the group five years earlier.

When asked in 1977 if she felt that women artists have an easier time being an artist than in the past, she exclaimed that "the next generation, [Grace] Hartigan, [Joan] Mitchell, [Helen] Frankenthaler had an easier time of it. Galleries existed, dealers. We didn't have that. We had to create all this. The next generation had an open door. This has all happened in a short passage of time." [81]

"But you see," Krasner reflected, "I can rattle off right away three names of women artists without stopping to think. During other periods in history, you couldn't think right away of women painters. That's a little bit of progress." [82]

In February 1977, in *Arts Magazine,* Barbara Rose published "Lee Krasner and the Origins of Abstract Expressionism," seeking to expand the perception of Krasner to "a broader historical

perspective, to acknowledge her importance not as the wife and greatest supporter of Jackson Pollock, but as a modernist painter of the first rank, whose name belongs on any list of first-generation Abstract Expressionists. . . . It is particularly ironic that Krasner is excluded from standard histories of the New York School such as Irving Sandler's *The Triumph of American Painting,* since she and she alone had contact with *all* of the major forces that shaped its evolution." [83] Rose concluded, "Her ability to embody conceptual ideas within a concrete work of art exposes the vacuity of current abstraction devoid of mental content. Ignored by the canonizers of the pantheon of Abstract Expressionism, Krasner emerges as a survivor with history now on her side." [84]

The insult of being omitted from standard histories of the New York School only strengthened Krasner's determination. " 'Survivor,' she called herself. 'Yes, I think that's what counts in the end. If you can live long enough. . . . I say, Betty Friedan—great. But I didn't need *The Feminine Mystique* to get me off the ground. . . . Let me say the women's revolution is the only real revolution of our time,' " proclaimed Krasner to Jerry Tallmer, a genial male reporter from the *New York Post.* [85]

Friedan's *The Feminine Mystique,* published in 1963, had helped to ignite a renewed interest in feminism that came to be called the "second wave," taking up where the suffrage campaigns of the previous century had left off. Friedan had brought attention to the limited career prospects for women and to the myth that the suburban housewife had found fulfillment. [86] But Krasner never envisioned being a housewife or accepted the restraint society imposed on women.

The art critic David Bourdon noted that Krasner said, "As a painter, I never thought of myself as anything but LEE KRASNER," with a certain satisfaction. "I'm always going to be Mrs. Jackson Pollock—that's a matter of fact—but I've never used the name Pollock in connection with my work. I painted before Pollock, during Pollock, after Pollock." Bourdon found Krasner

"unpretentious" and "uncommonly openminded. . . . Krasner belongs chronologically and contextually to the Abstract Expressionist generation—and is usually ignored in annals of the New York School. Some contemporary critics, mainly women, now assert that Krasner is 'a modernist painter of the first rank' whose achievement is on a par with other 'first generation' Abstract Expressionists. I agree that Krasner, at her best, is a first-rate painter, but I question whether she needs to be elevated to this particular pantheon," argued Bourdon.[87] He tried to support this position by claiming that Krasner was "an atypical modernist insofar as she is not eager to relinquish the past. She is by no means a reductive artist who steadily eliminates everything inessential. To the contrary, she is a synthesizer."[88]

Her collages made with cut fragments of charcoal drawings from her Hofmann School days in the late 1930s were then on view in a solo show at Pace Gallery. "She audaciously recycles her own past to concoct new works that seemingly summarize modern art from Cubism to Abstract Expressionism," concluded Bourdon.[89] Regardless of Bourdon's categorizations, the fact that Krasner's aesthetic had begun to reach beyond her earlier abstract expressionist work anticipated the definition of her later work as part of postmodernism.[90]

The title of Krasner's 1977 show at Pace was "11 Ways to Use the Words 'To See.'" She had created a series of collages the year before from her old figure drawings and the rubbed-off ghost images that the charcoal sketches made while forgotten in storage. Krasner had only discovered the portfolios of her old drawings during a visit from Bryan Robertson years after he organized her 1965 Whitechapel show. He spotted the portfolios in the barn and inquired what was in them. He "pulled them out and saw there was no fixative on them, so the charcoal had blurred and even made some mirror images. He said, 'Get them into New York and get fixative on them.' I did that, and brought them to this apartment. The first time I'd looked at them in almost 30 years."[91] She

went through her old drawings and picked out some to be framed, while setting others aside to be discarded.

The rejected drawings languished in her New York studio, only to be rediscovered in 1975, when they inspired her to collage once again. "At first I did have some nostalgia about the drawings," she reflected. "But then I began to look at them as if they weren't done by me—simply pieces of material for making new work. Of course I had shaky moments after I'd started—I thought, what the hell's happening here? What am I doing? Is it valid? Whenever work breaks or changes I go through that process. But the idea that I'd done the drawings 30 years ago and could use them now, excites me." [92]

Krasner compared her use of her own earlier work to her collages of the 1950s. The difference between the two sets of work was that with the first set, she had torn up her canvases. Now she cut her early drawings with scissors: "I wanted precise incision, no torn edges." [93] When asked if she would call the new collaged works "an extension of cubism," she replied, "Oh no. God no. It's like taking Cubism and carrying it to a totally new dimension. I think it's called Conceptualism. *I* don't call it that, but I think *they* do. I hate those titles." [94] What she was referring to was an aesthetic, propounded by artists like Sol LeWitt: "In conceptual art the idea or concept is the most important aspect of the work. When an artist uses a conceptual form of art, it means that all of the planning and decisions are made beforehand and the execution is a perfunctory affair. The idea becomes a machine that makes the art." [95]

One of the visitors to the Pace show that winter was the young artist Deborah Kass, who ran into Krasner going in the building on West Fifty-seventh Street. Kass was only twenty-four and she thought Krasner "looked exactly like Maureen Stapleton in *Bye Bye Birdie*," since she was wearing a long fur coat, sensible, perhaps orthopedic, shoes, and was carrying shopping bags from Bergdorf's in each hand. Kass recalled that Krasner "looked just

as formidable as one would imagine she would, but I gathered my wits and stepped into the elevator with her. As the doors opened and we both stepped out I screwed up my courage and asked, 'This is your show, isn't it?'

"And she looked me up and down and said, 'Are you a painter?'

"'Am I leaking?' I replied. 'Yes, I love your work. You are a hero.' I couldn't believe I spoke to Lee Krasner. In that moment I so loved New York and I loved my life." [96]

Krasner disappeared into the office, and Kass spent time looking at Krasner's work. Afterward Krasner came out and gave her own show "a good long look." Kass, who once again followed Krasner into the elevator, asked if she could walk with her a bit. Kass recalled that she and Krasner "discussed her new work literally cut from the old, which brought up time and history, women and painting, Pollock, New York. I was in heaven. At one point looking south there was a reflection in a high-rise glass building of other buildings and glass that looked exactly like her collages. Pointing to the reflections in the gridded glass, I said, 'Look at that! That's amazing!' I didn't have to say why it was so obvious.

"'It is!' said she as we both stood still looking at the Krasner in the sky."

Kass was only one of many young artists and critics who flocked to Krasner's show. The press also took notice. The *New York Times* critic Hilton Kramer called Krasner's show at Pace "a cold-blooded act of self-criticism that is also a bizarre form of artistic self-cannibalization." He saw the new works as "late Matisse-type pictures of a sort that she has excelled at in recent years. As the drawings themselves owe much to Picasso, this 'new work' puts Miss Krasner in the position of conducting a kind of visual dialogue between the two great masters of the School of Paris." [97] He also saw the work as a commentary on the relationship of the "young, aspiring artist Miss Krasner then was to the mature, more knowledgeable artist she is now." [98]

Another critic, for the *SoHo Weekly News,* concluded, "These

are heroic paintings. The artist is working through her heritage to establish an identity which has up to now been eclipsed by Pollock's legend. And it has a decidedly feminist bent: she is working 'through the flower.'"[99] In referring to Krasner's forms as "like those petals made with a compass," the critic William Zimmer, alluded to the feminist artist Judy Chicago's 1975 memoir, *Through the Flower: My Struggle as a Woman Artist,* and to her series of paintings by that name. Chicago described these as "an image of a cunt/flower/formal structure, which is opening up on to a vista of blue sky and open space."[100] Chicago's metaphor appeared in *The Second Sex* by Simone de Beauvoir, who wrote, "We speak of 'taking' a girl's virginity, her flower, or 'breaking' her maidenhead . . . as an abrupt rupture with the past."[101] With this body of work, Krasner had not only broken out from Pollock's shadow, but she had also reclaimed her independent identity as an artist from the years before she and Pollock became a couple.

The Women in the Arts Foundation published a newsletter in which the artist Jenny Tango clearly agreed with Zimmer. "I find this work very much a feminist work. It is biographical and uses oneself out of which to create the work. It has all the strength and passion usually attributed to women." Tango went on to argue perceptively that "the kinetic quality of action painting animates under the surface but there is no macho, no self-destruct, no philosophizing—only the movement of relationships and the daring in restructuring these relationships. Collage, legitimized by feminist art, made it possible for Krasner to piece herself together in an exciting way."[102] Krasner had exhibited a body of collages at the Stable Gallery in 1955, long before the existence of feminist art, but collage became popular among feminist artists during the 1970s, in part because of its relationship to traditional women's crafts such as quilts and Victorian collages made out of memorabilia. Miriam Schapiro even dubbed her feminist collage "femmage," hoping to distinguish them from the great men who made collages such as Picasso and Kurt Schwitters.

The collaged works at Pace generated an enormous amount of positive press. It also gave Krasner a chance to protest repeatedly the relative lack of attention that American museums paid to her work: "But do you realize," she asked Amei Wallach, then the *Newsday* critic, who described Krasner's "arms flying as she slouched in a velvet chair in her Manhattan apartment," "to date as you are writing this piece, no museum in New York, where I have been born and bred and am part of history—*where I fought the battle*—no museum has given me a retrospective. When I think of it I go into a rage!"[103] Five days later, Grace Glueck reported Krasner made the same rant to the *New York Times:* "Do you realize I've never had a retrospective here in the city where I was born, studied, and helped produce a revolution in art? But at least now they compare my work with Matisse's rather than Pollock's. That feels more objective. I've never been married to Matisse."[104]

IN 1977 I WAS WORKING AS A CURATOR AT THE WHITNEY AND WAS collaborating with Robert Hobbs from the Herbert F. Johnson Museum at Cornell on a show to be called "Abstract Expressionism: The Formative Years." I had been interested in the abstract work on paper that Krasner produced under Matisse's influence while she was in Hans Hofmann's class during the late 1930s. That summer Hobbs and I went to East Hampton to meet with Krasner, whom I had first met and interviewed in 1971 as a graduate student. For the forthcoming show, I was determined to include some of Krasner's abstract works on paper from her days at the Hofmann School, as well as some of her Little Image paintings from the 1940s. Krasner was puzzled that I wanted to include what she considered "student work."

"Trust me," I answered. "They are important. I want to show that you were painting abstractly before you were with Pollock."[105]

While we were visiting Krasner at her home, Barbara Rose phoned about filming a documentary on Krasner. Rose asked us

to stay over another day to interview Krasner on camera, which we did.

Rose's film *Lee Krasner: The Long View,* a half-hour documentary, was screened during the exhibition at the Whitney Museum from November 14 through December 2, 1978.[106] Asked what she thought of the film, Krasner admitted, "I'm pleased with it," then she added, "But if I did it again, I think I'd gripe a lot more."[107] In the film, the viewer sees Krasner in her studio, at home in Springs, and at her posh New York hairdresser, Kenneth. She blames the arrival of the Surrealists in New York as the start of when women in the arts were degraded.

Commenting on the film in *Women Artists News,* Diana Morris wrote, "She is shown unflatteringly getting a haircut at Kenneth's, the salon of the beautiful people; she looks awful. When Rose asks her, rather tactlessly, why she cares how she looks, Krasner laughs: 'Why do I care? Well, I am a member of civilized society, even if I do make pictures!' No one who wants to become an art world myth would allow herself to be filmed with her hair in rollers, especially at Kenneth's."[108]

In an interview with Barbaralee Diamonstein in 1977, Krasner remarked, "The show that is being worked on now, which I think will be enormously interesting, is being done by Cornell and the Whitney, and it's called 'Abstract Expressionism: The Formative Years,' and it ought to be damn interesting."[109] Krasner, who understood that she was finally being considered with male colleagues of her generation, had a hunch this show would be significant for her career.

That hunch was right. The show opened to praise, especially for Krasner, who was finally recognized as a pioneer and first-generation abstract expressionist. Barbara Cavaliere wrote that "the recent 'Abstract Expressionism: The Formative Years' was the first time a number of Krasner's Little Image series of 1945–50 were seen in relationship with her peers' work of the period. They are among her most powerful works, the achievements of

a mature artist who had internalized the ideas behind Abstract Expressionism."[110] Hilton Kramer praised Krasner in the *New York Times,* noting the revision of the early history of Abstract Expressionism: "The exhibition, called 'Abstract Expressionism: The Formative Years,' which opened last fall, was one of the first surveys of the subject to accord her an honored place in its history."[111]

Just as her own work was beginning to win public acclaim, Krasner realized a longtime goal when Yale University Press published in October 1978 a four-volume catalogue raisonné for all of Pollock's authentic works. Krasner had required the project in her contracts with both Sidney Janis and Marlborough galleries, but although Marlborough did make a substantial financial contribution, the complicated project never got off the ground. It needed the help of Eugene V. Thaw, the New York dealer and also her friend. Thaw took over the demanding and complex project and established a committee to determine the authenticity of the works going into it. He hired the scholar Francis V. O'Connor to be his coauthor and paid for the rest of the costs himself. The committee consisted of Thaw, O'Connor, Krasner, William Lieberman (then director of the Museum of Modern Art's department of drawings), and Donald McKinney, the former president of Marlborough, with whom Krasner had developed a close relationship.

Krasner said she had demanded the creation of a catalogue because "there were so many fakes that . . . I began to feel the pressure."[112] She was prescient, since controversies over fake Pollocks have continued with greater frequency and audacity as prices for his work have soared.[113] At the time, there were few such definitive catalogues of American painters, and Krasner was very proud of having pushed this one into being.

The publication of the Pollock catalogue raisonné was celebrated with an exhibition of his "New-Found Works," which opened at the Yale University Art Gallery and then traveled to other towns. A week before the show opened at the National Collection of Fine Arts in Washington (NCFA; now called the

Smithsonian Museum of American Art), the curator Harry Rand (who had just run into Krasner at the Whitney) wrote to her that he admired her work and would like to organize "a project of significant historical scope and depth." He never called it what she longed for—a retrospective.[114]

Rand indicated that he and Ellen Landau, then a research fellow at the museum who was preparing a dissertation on Krasner's early work, had been discussing this project. Landau recalled that Krasner asked her to propose an exhibition, which she did through Rand, who was the sponsor for her fellowship at the museum.[115] On the same day that Rand wrote his letter, Landau wrote to Krasner as well, mentioning her discussions with Rand about a show that would be focused on her art before and including the Little Images of the 1940s—the exact topic of her dissertation. She indicated that the decision to focus on her earlier work was made based on her success in the show "Abstract Expressionism: The Formative Years," which Landau cited as demonstrating that Krasner was on a par with her peers. Despite the focus, Landau noted that she and Rand would be open to considering a show of broader scope.[116]

At the opening of the Pollock show in Washington, Rand told Krasner that he would like to organize a retrospective exhibition for which Landau would write most of the catalogue.[117] Krasner replied that she would agree only if the show could go to the Museum of Modern Art in New York. By February 16, 1979, Landau wrote to Krasner that the NCFA had placed her retrospective exhibition on its schedule of proposed future shows and that she would be writing the catalogue, with the exception of a forward by Rand and a preface by the museum's director, Joshua Taylor.[118] Krasner soon telephoned Rand to insist that Barbara Rose write an essay in the catalogue.[119] This was hardly surprising, given Rose's extraordinary long-term commitment to promoting Krasner's work and the friendship between the two that went back to the early 1960s. Not only had Rose made a documentary film

about Krasner, but she had also included Krasner in her book on American art in 1967, when few in America paid Krasner serious attention.

The Sarah Campbell Blaffer Foundation in Houston, which had purchased Krasner's 1957 canvas *April,* asked her for a statement for a catalogue it planned to publish. In a rare gesture, Krasner produced two pages. She began, "I certainly was there through the formative years of Abstract Expressionism, and I have been treated like I wasn't. So, I'd say the fact that this is being brought to light today by Barbara Rose, Gail Levin and others makes me feel pretty good. The fact that I was Mrs. Jackson Pollock has complicated matters. I want to be very clear about this. Because Jackson Pollock was in the forefront, a difficult light was thrown on the role that I had." [120] She included an asterisk by Rose's name to indicate both Rose's February 1977 article in *Arts Magazine* and her film. The double asterisk by my name referred to my essay in the catalogue *Abstract Expressionism: The Formative Years.* She continued, "I have never denied that Pollock had an influence on my work. But then, so did Mondrian, Picasso, and Matisse. I never dripped that I was aware of and I never worked on the floor as Pollock worked. I always used brushes, which Pollock sometimes did and sometimes didn't. We are all influenced by other artists. Art brings about art." [121] She did not consider the very controlled dripping that she did do in some of her Little Images as the same process that Pollock employed.

Krasner continued to speak out about the attitudes of some of her male peers, noting that "Jackson always treated me as an artist. His ego was so colossal. I didn't threaten him. He always acknowledged what I was doing. I was working, and that was that. I couldn't have lived with him for one minute if this weren't so. Franz Kline spoke about my work, but quietly, just he and I in the room. Bradley Walker Tomlin would talk to me. But egos like Newman, Rothko, Motherwell . . . Baziotes was angelic; he didn't say no and he didn't say yes." [122] Krasner reserved her scorn for

de Kooning, whom she often accused of having a difficult "problem with women." She recalled fighting with Gorky, "but at least, I had a level to fight on. It was more than I was given later on."[123]

On February 3, 1979, the Pace Gallery opened "Lee Krasner Paintings 1959–1962," featuring her umber and white work, which had been shown twice in the early 1960s by the Howard Wise Gallery. Hilton Kramer lamented the lack of color in these canvases and attributed this to an "act of homage to Pollock's memory."[124] Eleanor Munro found these works to be "full of tragedy and storm."[125] Barbara Cavaliere asserted that these works were "autobiographical," and that Krasner was repeating themes Richard Howard had written about after interviewing Krasner for the catalogue. Howard's article cited Greenberg's dislike of her work, which led her to cancel her show at French & Company; her mother's death; and her grief over Pollock's death.[126]

In November 1979, Daniel Wildenstein of the New York gallery Wildenstein & Company wrote to Krasner to request the honor of inaugurating his gallery's new program with a show of both her work and Pollock's. Wildenstein suggested that he would borrow work from European museums and produce a scholarly catalogue that would get rid of the "American pejorative," allowing her work and Pollock's to be ranked with Rembrandt, Velázquez, and Cézanne.[127] He was already discussing a merger with Krasner's dealer, Arnold Glimcher. (This merger did not materialize until much later, in October 1993, when Wildenstein & Company purchased 49 percent of the Pace Gallery.) Wildenstein had hoped to add the Pollock estate to its roster, but Krasner, as always, did not want to cede control of it and trusted few dealers with it. By now she had an aversion to dealers who used showing her work as a means of getting hold of the Pollock estate. Since this is what she sensed, she declined the offer.

On November 28, 1979, Lee Anne Miller, the president of the Women's Caucus for Art, wrote to Krasner to tell her that the

Awards Selection Committee had named her as "a recipient of the 2nd Annual Awards for Outstanding Achievement in the Visual Arts" for her "extraordinary contributions as a painter."[128] The other recipients that year were the graphic artist Caroline Durieux; the painter Ida Kohlmeyer, who, like Krasner, had studied with Hofmann; weaver and designer Anni Albers; and the sculptor Louise Bourgeois. The selection committee was composed of Ann Sutherland Harris (the chair, then an art historian working at the Metropolitan Museum of Art), Lucy R. Lippard (art critic), Linda Nochlin (art historian, then teaching at Vassar College), Athena Tacha (artist and art historian, then teaching at Oberlin College), Eleanor Tufts (art historian, then teaching at Southern Methodist University), and Ruth Weisberg (artist, then teaching at the University of Southern California). All of the committee members were known as strong feminists. The award was going to be presented at the annual meeting of the College Art Association, which was in New Orleans that year.

Krasner agreed to receive the award but asked me to accept it for her because I was already planning to go to the meeting. She dictated an acceptance speech to me, which, after saying a few words of my own, I read at the ceremony in New Orleans: "I am really very pleased—honored—to receive this award from the Women's Caucus for Art. However, I hope for the day when such an award could be a joint acknowledgment from men and women. The belated recognition that I have recently received is largely due to consciousness raising by the feminist movement, which I consider the major revolution of our time. Thank you."[129]

Wendy Slatkin echoed Krasner's speech in 1993, writing, "Feminist revisionism has helped us reevaluate the art of this major creator."[130] Slatkin noted that "Krasner's restoration into the pantheon of Abstract Expressionists began in 1978 with her inclusion in an exhibition curated by Gail Levin and Robert Hobbs for the Whitney Museum's 'Abstract Expressionism: The Formative

Years' (1978). Her reputation so consistently overshadowed by her position as the wife of Jackson Pollock, began to emerge independently when the artist was over 70."

Krasner declared, "Some part of me must have had an enormous confidence. No matter how hard the thing was, I sustained and kept going. . . . Tough position, tough place, and a hell of a lot of resentment. . . . A suicide I'm not. So, that's that. You know, you stay with it. You keep going. I might say thank God, thank women's lib." [131]

Much of Krasner's resentment about sexism stemmed from the problem women faced with religion. "All Christian, Judaic and, for that matter, Moslem and Eastern civilization has a male image as God. So you're going to have to eliminate all of history if you're going to break it down. At what point do you stop? Now that's a fact, and culturally, we are a part of this civilization. You can't eliminate five thousand years even if you're a women's libber." [132]

In 1979 Krasner told an interviewer who asked about feminism that she had "very little patience with clubby attitudes towards it and I can't devote time towards that kind of thing." [133] Another time, while recounting a story of discrimination early in her life, she said: "Well you don't just have a few feminist meetings and resolve the issue. It takes slow patient years. It's not a political revolution fought once and then it's over. I think it will take a long time for woman to find her proper place." [134]

Lee frequently spoke with me and others about what it meant to be a woman artist. "There is discrimination against women artists, and it's going to take quite a while before it gets ironed out. Western culture is old, and the role of women has always had a specific place in it. That's changing now, but these things don't happen overnight. I agree that in a sense we older artists paved the way for the younger women. It's better now than it was ten or twenty years ago, but that doesn't mean that the problem doesn't still exist." [135]

At the same time, Krasner felt her case had become compli-

cated because she also functioned as the widow: "In my case it's doubly complicated by being the wife and now the widow of Jackson Pollock. Thinking about it, I wonder whether the situation is discriminatory because I'm Pollock's widow or because I'm a woman. In both roles I'm a woman, but *who* I am makes it a little more difficult." [136]

Krasner continued to await a retrospective of her work at an American museum. She wanted that museum to be the Museum of Modern Art in New York. Harry Rand wrote to Bill Rubin on August 23, 1979, telling him that the National Collection of Fine Arts had committed to organizing a retrospective for Krasner, and that she had committed to working with them. He informed Rubin that Ellen Landau would be working on the project. [137]

In October 1979, Krasner traveled to the University of Virginia to attend a symposium entitled "Abstract Expressionism: Idea and Symbol," organized by the art historian Elizabeth Langhorne. Although I was a participant, I was not there to talk about Krasner, but instead to speak about Richard Pousette-Dart, another of the lesser-known artists in "Abstract Expressionism: The Formative Years." [138]

At the time Ellen Landau was working on her doctoral dissertation, and Barbara Rose had just finished her film on Krasner. [139] Because I was quite busy with work on my upcoming show (1980) and catalogue raisonné of Edward Hopper, I was content to keep Krasner as a friend and mentor. She and I saw a lot of each other, but our friendship made writing about her much more complicated, so I was not contemplating any project about her at that time.

For the symposium in Virginia, Krasner, accompanied by Barbara Rose and Bill Rubin, the director of painting and sculpture at the Museum of Modern Art, traveled by train to Washington, where they had arranged for Landau to drive them to Charlottesville. Rand had already written to Rubin to say that he and

Landau had met with Krasner in New York and discussed the possibility of the retrospective organized by the NCFA. Rubin, however, had not responded to the letter Rand had sent about having MoMA share the Krasner retrospective. Not only did Krasner have an intense desire to have a retrospective in the United States, but she also strongly preferred having it at a museum with a more cosmopolitan, global perspective, like the Museum of Modern Art, rather than in a parochial museum limited to American art. And she wanted Barbara Rose to be the curator.

Landau recalls a scheme that would go into effect on the drive to Charlottesville. The car would stop at a restaurant en route, and Krasner and Rose would go to the ladies' room, giving Landau an opportunity to propose that Rubin give Krasner a retrospective at the Museum of Modern Art to mark her seventy-fifth birthday in 1983.[140]

At the two-day symposium, Krasner, along with Richard Pousette-Dart, participated in an artists' panel, which was supposed to respond to the scholars' papers. A third participant, Robert Motherwell, had been announced but dropped out at the last minute and did not attend. A reporter for the local paper found that Krasner "managed to say more with a raised eyebrow and a gesture of the hand than some of the more bombastic orators. Somewhat dazed by all the rhetoric that read psychological meaning into every brushstroke, she announced, 'After a session like this today, I wonder if I'll be able to paint another picture.'"[141]

A week after this encounter, Landau sent Rubin a copy of Rand's letter from August 23, 1979, asking him to reply to Rand directly.[142] A while later, Landau sent Krasner a letter stating that Rubin said in the restaurant that he would be interested in holding the retrospective. It is remarkable that such intrigue was employed to obtain a retrospective exhibition for an artist with unquestionable merits. However, it's not unusual, since women artists were so neglected in museums at that time and scheduling a major show often involves powerful players and large egos.

The sculptor Marjorie Michael sketched and took photographs of Krasner so that she could start making a portrait bust of her after they returned from the artists' conference where they met at Watch Hill, Rhode Island, in July 1975.

Though women artists still struggle, they experience and often appreciate the small improvements since the days when Krasner worked. The artist and feminist Helene Aylon recounted a chance encounter she had with Krasner in 1972, at the Museum of Modern Art cafeteria when she was with her sixteen-year-old nephew: "There was Lee Krasner sitting at the next table. My nephew was already an art lover, and had related to her work and he was in awe at being so close. He said hello. They got to speaking about art, and she told him to go to Marlborough [just four blocks away] and ask the gallery dealer to give him a poster of hers, which she would then sign. He still has it in his house."[143]

"Krasner in life and death was put into the inferior position,"

complained Aylon. "Like the biblical quote to Eve: 'Thy desire shall be for thy husband but he shall rule over thee.' The treatment at Betty Parsons alone could have made her a feminist. In life, she talked about her inner rhythm, an inner voice she listened to closely. And Pollock was about an outward gesture that he threw around flamboyantly, even allowing his cigarettes to drop down in the torrent. In death, he has the larger stone in the Cemetery." [144] Aylon concluded, "[Krasner's] influence on me, as she had been [like me] in the [Betty Parsons] gallery and was a role model for sure, was her speaking about how she wanted to be surprised. How she wanted the work to breathe and become alive." [145]

# Retrospective, 1980–84

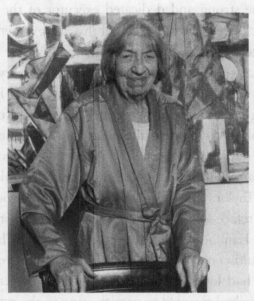

Bernard Gotfryd's photograph of Lee Krasner, December 1983. Krasner got up out of her sickbed to pose in her bathrobe in her New York City apartment. She is standing in front of her 1983 *Untitled* collage on canvas (CR 599), the last work she completed. She held it back from her retrospective, saying: "I wanted to keep the one I just finished because I need to have my work to look at. Even when I'm just looking, I am working."

ON MARCH 27, 1980, THE STONY BROOK FOUNDATION RECOGnized Lee Krasner's lifelong "dedication to the arts" by giving her one of its Awards for Distinguished Contributions to Higher Education. Her fellow recipients were Sir Rudolf Bing, the Austrian-born opera impresario who served as the general manager of the Metropolitan Opera in New York from 1950 to 1972; and John Houseman, the noted actor and pro-

ducer of both theater and film. The citation read in part: "Scores of prominent lay artists have learned from you. The critics here finally caught up to you. And now, Lee Krasner, the painter, is established as a prestigious and original artist in her own right as well as the strong and dedicated executor of the estate of the late, great Jackson Pollock. . . . All of this achievement called for a single-minded devotion to art."[1]

Earlier that year Bill Rubin had written to Harry Rand about the Krasner retrospective, telling him how excited he was about it and saying he was sure it would be "very beautiful."[2] On May 20, Rand replied, confirming the plans for the Krasner retrospective to open in Washington before going on tour to the MoMA at a time that would fit into the museum's schedule. Rand said that Joshua Taylor, the director of his museum, would write the catalogue's preface and that he and Rubin would contribute short essays. Ellen Landau would write a "biography." The substantial criticism would come from Barbara Rose.[3] Rubin replied, telling him that he had long been "a great admirer" of Krasner's work and that he looked forward to participating in the retrospective.[4]

In the summer of 1980, Krasner showed some of her work on paper from 1962 to 1970 at the Tower Gallery in Southampton, New York. Evelyn Bennett, writing for the *Southampton Press,* reported that Willem de Kooning was also supposed to show but pulled out at the last moment "by doubling the prices of his work (thereby making it impossible for the gallery to insure his paintings)." Krasner thought de Kooning was unprofessional. "You don't pull out of a show at the last minute, and leave the gallery high and dry."[5] It's possible that her resentment stemmed from regret at missing the chance to have her work compared to Pollock's most significant rival instead of being compared to Pollock, as usual.

On view at the Tower Gallery were pieces from Krasner's *Water* series: "This was a series using Douglass Howell [hand-made] papers. It took courage to take gouache and bathe it. They

were experiments in color, and a tough paper was needed for what I wanted to try. The monotone is something I tend to do a lot. With the water dipping techniques, I could get great varieties— and effects that would hold my interest and that of an observer too. You might say I was pushing, with the fixed points just the gouache and the paper."[6] She also said she had tried acrylics (first commercially available in the 1950s) and had not liked them at all.

Krasner explained to Bennett that an underlying philosophy of her work for the series related to the totality of life—what she considered "nature."

"There are 'elements of nature' in my work," she said, "but not in the sense of birds and trees and water. When I say nature I might mean energy, motion, everything that's happening in and around me. That's what I mean by nature."

"So you're really talking about everything living, really?" Bennett rejoined.

"Yes and death too," Krasner replied, "things that are dead, everything."

When told, "There's something very religious about that," Krasner returned, "Of course—art *is* religious; it has to be. That's what I think, anyway. These people who do paintings of trivia—it's a waste of my time."[7] What she meant by paintings of trivia was subject matter found in Pop Art such as soup cans, comics, and other such themes taken from popular culture.

Despite favorable press attention, Krasner still longed for a retrospective of her work in America and remained anxious about her reputation and her legacy. But a September 10, 1980, letter from Landau to Rubin indicated that the Washington part of the retrospective was set.[8]

Krasner met with Landau, still a graduate student when she traveled to New York. She took Krasner to lunch and began to go over a list of questions pertaining to her dissertation. Something rubbed Krasner the wrong way; for, according to Landau, Krasner started to scream at her and two days later telephoned to

inform Landau that she was no longer involved with her retrospective. Krasner had decided to cut off Landau and would now entrust her legacy to Barbara Rose, in whom she had much more confidence, based on their years of friendship and Rose's constant advocacy on her behalf.

Rose had been talking with Krasner for years about organizing her first American retrospective and now she was in a position to make it happen. Though Rose did not officially become the chief curator of the Museum of Fine Arts in Houston until March 1981, she had already been offered the position by the time that Krasner decided to ditch Landau. Krasner knew Rose's writing and her high profile in the art world as well as her record organizing major shows for the Museum of Modern Art—one on Claes Oldenburg in 1969 and another on Patrick Henry Bruce in 1979. Over the years, Rose had spoken with Rubin about organizing a retrospective for Krasner and knew he respected her work.[9]

On February 19, 1981, just a week before Rose began her new job, Landau wrote to Krasner. She was about to receive her doctorate that June. In her letter, she apologized for the anger she had expressed in their last telephone conversation. Yet there was also a certain bitterness to the letter. She had been annoyed that Krasner seemed to question her expertise, especially after Landau had devoted three years to researching Krasner's work for her dissertation. She felt she knew much more about Krasner's early work than just about any other person. Landau wrote that she hoped Krasner would cease "holding up Gail Levin to me." Landau was responding in part to Krasner's earlier suggestion that she should consider making me the second reader of her dissertation.[10] Landau claimed that my work on Krasner was insignificant. In turn, Krasner sent a copy of Landau's letter to me on March 15. She enclosed her own letter telling me, "I'd like your reaction to the enclosed letter from Ellen Landau. I find it so arrogant, hostile and disgusting. Please read it and send your response to me."[11] I chose to stay out of their conflict and did not reply.

In the same letter, Landau also expressed resentment that Krasner preferred Barbara Rose as the curator of her retrospective, objecting that she should have made that preference clear at their first meeting. Landau also protested that Krasner had used her as a "pawn" to obtain the retrospective in New York. Rand claims to have suggested the retrospective to Krasner at the opening of the Pollock show at NCFA, but Landau says she was the one who first proposed Krasner's retrospective to the Washington museum.[12]

What Landau failed to realize was how much Krasner had riding on the first American retrospective of her work. Except for the 1965 London show, this would be her only retrospective in her lifetime. Krasner knew Landau had not spent much time looking at her paintings because (as Landau stated in her letter) she had permitted Landau to look at the ones in storage only once. Gene Thaw, who believes Krasner was a smart woman when it came to analyzing people, recalled that Krasner feared that Landau was really only interested in Pollock.[13] Rose shared this same concern with Krasner.[14] In fact Landau's dissertation covered Krasner's career only up through 1949, and she often compared Krasner's early work to that of Pollock, even before the two artists met. Krasner saw Landau as lacking both curatorial experience and the familiarity with her later work necessary to organize her retrospective. These perceived faults quickly turned into distrust.

The questions Landau posed to Krasner that day at lunch may have provoked some kind of alarm. Landau may have been diligent and capable, but to Krasner she was an untested student. Their dispute reflects the reciprocal insecurity of a woman artist who felt unjustly overlooked and an art historian who felt inadequately appreciated.

Krasner wrote to Professor William I. Homer, Landau's faculty adviser at the University of Delaware, telling him how she had trusted Landau and had given her "free access" to her files of unpublished material for her dissertation research. Now, to Krasner's

consternation, she complained that Landau refused "to allow me to check her use of this material." Then in a state of panic over what she termed a "very distressing problem," she insisted, "She does not have my permission to publish any of the unpublished material without my checking and approving it."[15] Because Krasner had carefully saved many documents about her career with an eye to posterity, it is difficult to know what inaccuracies she feared, but it is clear that she was not about to leave the matter to chance.

Landau says that during this period, she attempted to call Krasner, but Krasner refused to speak with her. Landau also attempted to resolve the complaint to her faculty adviser by offering to show her dissertation to Krasner just before it was published.

Krasner's frantic letter to Homer was dated the day before "Lee Krasner/Solstice" opened at Pace Gallery in March 1981. The exhibition was a show of her new collages, produced from rejected lithographs and paintings. The reviews were positive and noted that "Krasner has been painting for over a half-century now."[16] Barbara Cavaliere saw that the "internal movements in Krasner's art signify the correspondences which link the present with the past and future," singling out *Vernal Yellow* (1980) for its "vibrating movement."[17] In the *New York Times,* John Russell called the show "a heady mixture," noting "the recurrent and unmistakable rhythm of her images."[18]

Krasner, dressed in a perky felt hat and colorful scarf, was in an upbeat mood when she dropped in at the gallery for an interview with Jerry Tallmer, a critic at the *New York Post:* "Looks pretty good. . . . If you want my reaction to it, not bad at all."[19] There was a big difference between her collages of 1977 and those showing in the Pace Gallery. While the 1977 collages utilized her old charcoal drawings from classes with Hofmann, these were filled with what Tallmer termed a "new flaming burst of color."

About the show, she said: "The last time I did high-key color was nineteen seventy-something. So I must go into that from time to time. This time, because of the color, I wanted to call this series

*The Rites of Spring.* Stravinsky, you know. . . . But then I thought, well, that's a little heavy, let's just call it *Solstice.* Which was also keeping with my picture *The Seasons.*"

She had exhibited this piece the previous month in a show titled "Abstract Expressionists and Their Precursors" at the Nassau County Museum. Though she painted *The Seasons* from 1957 to 1958, it still interested her.

In his article Tallmer said he told Krasner, "You know . . . when the record of this era is written 50 years from now, you're going to stand pretty high in it."

"'You think so?' She held up two crossed fingers. 'Maybe. I have to say that when I saw my work beside all those others at Gail Levin's 1978 Whitney show ["Abstract Expressionism: The Formative Years"] I was flabbergasted.'"

"So were a lot of other people. Knocked out," Tallmer responded.

She reflected, "Yeah, but I'm the artist. In a way there's been this slow recognition of me. At one point I resented it. But now, in hindsight, it was a protection, a coating. I had to go into my studio and keep myself painting my own pictures, because the outside world wasn't dealing with it anyway."

Tallmer reported that "Krasner from Brooklyn crossed herself in the air" before she added, "My concern has been to align myself with my contemporaries and to stay alive. As a painter, I don't mean just physically, but to have this work stay alive."

That same spring John Post Lee, an art history major at Vassar College in his junior year, heard from a friend that Krasner was looking for someone to work for her during the summer. He didn't want to return home to Philadelphia, so he set about making a quick study of Krasner and her work, memorizing the names and dates of many of her paintings. He met with her in her New York apartment and was able to identify *Kufic* (1966) as the painting hanging on the wall. The job was his.

That day Krasner told him to "stick around. Tom Armstrong,

the director of the Whitney, is coming over to ask for a loan of a Pollock."

The young man from Vassar watched the bow-tied director try to charm Krasner. But when Armstrong bent over to pull the Pollock catalogue raisonné off the shelf, "Krasner made a grotesque body motion toward him that he could not see, making clear that she just didn't like Tom Armstrong."[20] What the student did not realize was Krasner's long disdain for the Whitney for defining itself as a museum of "American art," which she felt embraced nationalism. There were also rumors of Armstrong's anti-Semitism (though denied by his supporters), which would also have put her off.[21] It is not clear if it was because she had qualms about Armstrong, but Krasner only donated one minor ink drawing by Pollock to the Whitney, presumably in appreciation of her "Large Paintings" show. However, she donated many works by Pollock to both the Metropolitan and the Museum of Modern Art.

Krasner paid John Post Lee fifty dollars a week, plus room and board, with no days off. He served as her driver in his own car, for which she paid for the gas. He recalled her "Gestalt as very Depression-oriented."[22] She had no idea how much a young man could eat, so he would often sneak over to the neighborhood pizzeria. He would mix her favorite drink, a "sunrise," consisting of cranberry and grapefruit juices with a splash of vodka and Campari. He discovered that when she drank, she became less guarded in her conversation.

John Post Lee thought Krasner was "very generous" and recalled that they talked "about everything." Her politics were clearly liberal. Krasner often had him read aloud to her in the sitting room. Often this meant the newspaper. She expressed extreme irritation at President Reagan's firing of the air traffic controllers.[23] He also thought she was very intelligent and also "street smart." He accompanied her everywhere that summer—to Terence Netter's show at Stony Brook, to the homes of Ibram and Ernestine Lassaw, Jimmy and Dallas Ernst, James and Charlotte Brooks, Jo-

sephine and John Little, Patsy Southgate, and Edward Albee. He met her nephews Jason McCoy and Ronald Stein. Stein was then living next door and working as a pilot, flying out of East Hampton airport. As John worked with Krasner, he began to notice that she was quite infirm, already suffering from rheumatoid arthritis.

John Post Lee was with Krasner in August 1981, when the show "Krasner/Pollock: A Working Relationship," organized by Barbara Rose, opened at Guild Hall. That fall the show traveled to the Grey Art Gallery at New York University. Interviewed about the prospect of seeing her work next to Pollock's chronologically, Krasner responded gruffly: "It could be a terrible pitfall for me as an artist. I'm aware of that. I've been around. But I couldn't give two hoots about that. I want to see it with my eye for myself—because I've never seen it visually, and until I see it visually, I don't know what they're talking about. And because I have an endless curiosity above and beyond the mob, I couldn't care less about what their reaction is."[24] Krasner was upset that those male colleagues who had been influenced by Pollock were never compared directly to Pollock.

"Look," Krasner said. "They don't take de Kooning and put him up that way. And if de Kooning or Motherwell takes from Pollock, nobody even breathes a word about it. But with Lee Krasner, wow. It's been a heavy, heavy number. It's hard for them to separate me from Pollock in that sense."[25]

Despite Krasner's frustrations, at least one reviewer at Guild Hall understood her plight—the artist William Pellicone sought to reverse the common conception of Krasner's position being beneath Pollock's in the pantheon of great artists. "Krasner is identified as Jackson Pollock's widow, an artist in her [own] right. It should read: Jackson Pollock, husband of Lee Krasner. . . . The revelation exposed is the fact that Lee Krasner gave Pollock everything because of her superior talent and he eventually destroys her true path with his superior barbaric, macho strength. . . . The Guild Hall show calls for a completely new evaluation of the Krasner-Pollock link."[26]

Krasner was clear about dealing with Pollock's reputation so many years after his death: "I may have resented being in the shadow of Jackson Pollock, but the resentment was never so sharp a thing to deal with that it interfered with my work."[27] On the other hand, Krasner admitted, "I stepped on a lot of toes because you know Pollock remains the magic name, and they had to deal with me to get to his works and I can say no very harshly. As a result, people in the art world acted out against me as a painter."[28]

When a journalist described Krasner as "slowed a bit by arthritis, still actively painting" at the age of seventy-three, she was clear about her decision to devote so much energy to Pollock and stated emphatically: "I don't feel I sacrificed myself And if I had it to do all over again from the very beginning, I'd do the same thing."[29]

Barbara Rose maintained that had Krasner and Pollock lived during the days of feminism, Krasner might not have "played so wifely a role with Pollock" and might have even "dumped the genius." Interestingly Krasner disagreed with Rose's speculation. "I think I would do the same, identical thing all over again in the presence of talent like that, but it takes that kind of talent to move me. Anything else is for the birds."[30]

Nevertheless, in the show's catalogue, Rose argued that "of the many things Krasner and Pollock did for each other as artists, including criticize and support each other's works, the greatest thing they did was to free each other from the dogma of their respective teachers."[31] Rose also asserted, "Jackson helped her to be free and spontaneous, and she helped him to be organized and refined."[32] Krasner seemed to appreciate Rose's thoughtful advocacy.

John Post Lee read Rose's manuscript aloud to Krasner sentence by sentence. He recalled that she would occasionally say, "That's not true." He also remembered that she paid particular attention to the mention of Pollock's drinking, giving it emphasis.[33] At another point, Krasner objected: "How come I'm the only one that is held accountable for being influenced by Pollock? Robert Motherwell pretends that he splatters paint because he was looking at a wave

splashing on the beach. Oh, come on."[34] She also expressed disdain for de Kooning: "He's interested in two things—women and real estate, so he buys a house and puts a woman in it."[35]

Impressed by Krasner's strong beliefs and good sense of humor, John Post Lee returned to Vassar at the end of the summer and wrote his senior thesis on Krasner's collages, *Eleven Ways to Use the Words to See*.[36]

Among Krasner's friends that she saw frequently in this period were the playwright Edward Albee, Sanford Friedman, and Richard Howard. Albee, who got along well with Krasner, surmised that, like her gay male friends, she considered herself "an outsider." "She had a good anger. I admired it. She was a survivor."[37] He also admired her honesty but was puzzled at her dislike of Louise Nevelson, a close friend of his. Because both women came from poor Jewish immigrant families and had to struggle as women artists, Albee believed they were fighting similar battles. It's more likely that Krasner was not thrilled to play the number two spot in the heart of Arnold Glimcher, their shared art dealer, who built his career promoting Nevelson's work.

In late 1981, Krasner left Glimcher's Pace Gallery, where she had been since 1977. The departure from Pace was described as "amicable" by both sides. Krasner commented, "We never had a fight. We are still friends. But I remember the dealer Pierre Matisse saying, 'It's the artists who've made my gallery.' Arne, on the other hand, feels his gallery made his artists, and this is a serious disturbance. I wasn't comfortable there."[38]

On the other side, Glimcher maintained, "She wants a closer connection with her dealer, and I think she has made the right decision, although she certainly had the greatest success of her life in my gallery. I think she's a wonderful artist, and I wish her the best."[39]

In August 1981, a journalist reported that Krasner's works commanded "as much as $30,000 and are in the collections" of major museums, including the Guggenheim Museum, the Na-

tional Gallery, London's Tate Gallery, and the Cologne Museum. If the journalist's statements are true, then a sale to the Tate Gallery must already have been in the works when Krasner left Pace.[40] In fact the Tate's purchase of Krasner's *Gothic Landscape* of 1961 was not announced in the press until March 1982. At that time, Tim Hilton, in the *Observer* in London, identified Krasner as "Jackson Pollock's widow, long overshadowed and now in the odd position of being famous for being neglected," while praising the new acquisition as "a marvelous picture." He insisted, "This is better painting than the Gottliebs that hang next to it. I dare say that it's better painting than the new Barnett Newman."[41] These words must have been music to Krasner's ears. Glimcher sent her the clipping, which he inscribed, "Dear Lee—Thought that you'd like to have this—Arne." Given Glimcher's successes in placing Krasner's pictures, it's very possible that the unspoken point of difference between the dealer and the artist might have revolved around his desire to gain access to the estate of Jackson Pollock, which Krasner continued to hold close.

From the Pace Gallery, Krasner moved to the Robert Miller Gallery, then founded five years earlier. She was fond of Miller and his wife, Betsy, with whom Lee shared a birthday. Before they married in 1964, the Millers had both studied art at Rutgers, where they met Krasner's nephew Ronald Stein, then teaching there. He had introduced them to Krasner and, as a result, Bob had become her studio assistant in 1963.[42] Soon he moved on to work for the New York dealer André Emmerich during the same period that Pollock's nephew Jason McCoy also worked there. Krasner's long and affectionate association with Miller helps to explain her departure from Pace.

Nathan Kernan, who was then a young man working at the Robert Miller Gallery, recalls that he and his colleague John Cheim "loved especially the rather terrifying way she once said, in speaking of her annoyance with her former dealer, 'I made it *cry-stal clear* to him . . . !' She always pronounced the word *collage*

with the accent on the first syllable, 'COLL-age' and 'retrospective' became, with perhaps an undertone of irony, 'The RETro-spect.'" Kernan remembers that when they called Krasner from the gallery, "she would answer the phone suspiciously, 'What's up?' immediately on alert for a problem and ready to pounce on any ambiguity or inanity we might have the misfortune to utter. We lived in terror of having something made 'crystal clear' to us."[43]

Her first show there took place in October 1982 and was called "Lee Krasner: Paintings from the Late Fifties." Grace Glueck described her work on view as "high-key abstractions that derive from figuration," which "reinforces our astonishment that recognition was so late in coming to an artist of such gifts."[44]

For Krasner's efforts on behalf of Pollock's art, she was named Chevalier de l'Ordre des Arts et des Lettres by the French government. Jack Lang, the French minister of culture, presented the award to her on January 11, 1982, just before the opening of a major Pollock retrospective at the Musée national d'art moderne at the Centre Georges Pompidou in Paris. Krasner had made the show possible with her loans to the museum. She enjoyed receiving the award and getting attention at the opening, but she fell and injured her arm. The accident prevented her from making a planned visit to the caves of Lascaux.[45] She had long been interested in prehistoric art, so it was quite a disappointment to forgo the visit. Krasner returned alone to New York, traveling on RMS *Queen Elizabeth 2* (known as the *QE2*) from Southampton.

After Krasner's return, the photographer Ann Chwatsky got an assignment to photograph her as one of five Hamptons artists for *Long Island Magazine*. She arranged for the shoot to take place in midmorning at Krasner's apartment on East Seventy-ninth Street. When she arrived, Krasner was dressed in a "navy house smock," looking "like the wrath of God." When Chwatsky told Krasner that she wanted her to look as strong as her paintings, Krasner, who was then suffering from her arthritis, commented how

hard it was for her to get ready without any help. Chwatsky had brought along makeup, which she applied, and a long magenta shawl, which she draped around the ailing artist for the shoot. The result was pleasing to both the photographer and her subject.

For several of Chwatsky's shots, she posed Krasner in front of her latest painting, which she had made for "Poets and Artists," an invitational show of forty-two artist-poet collaborations scheduled for Guild Hall that July. Although some of the artists and poets were paired by the show's organizers, Krasner had teamed up with poet Howard Moss, whom she knew well through their mutual friend, Edward Albee.[46] The idea for the show had come from the painter Jimmy Ernst, Krasner's friend since the days when he worked for Peggy Guggenheim at Art of This Century. Taking the title of Moss's poem "Morning Glory" as the title of her painting, Krasner inscribed in the upper-left-hand corner of her abstract canvas "How blue is blue," the opening words of the poem.

That same summer Krasner called Chwatsky and invited her for lunch in the Springs house. Chwatsky sensed Krasner's loneliness and invited her to go to a movie. They saw *Diner,* a 1982 film about the 1960s that Krasner loved. While they stood in line, many people recognized Krasner. Chwatsky observed that Krasner, who seemed aged and tired, was cranky as a result of dealing with her illness but extremely nice. Krasner spoke not about Pollock but of her concerns about conserving his paintings.[47]

Krasner's nephew Ronald Stein was dismayed by her choices of medical treatment: "Lee was not into medical doctors. . . . If she had been properly dealt with medically, she wouldn't later have refused to take cortisone for her arthritis because it might be bad for her health; yet here was a woman dying because she couldn't move. And her colitis—that's in the family and probably psychosomatic, only they would go to doctors who prescribe corrective medication and it would disappear. But Lee? She would go to witch doctors."[48]

Krasner definitely preferred alternative medicine. Her last assistant, Darby Cardonsky, remembers that she went for acupuncture treatments.[49] I recall that she wore copper bracelets, which she said were supposed "to help her arthritis." Wearing copper for arthritis pain relief is an old folk remedy, based on the belief that copper is absorbed by the skin to relieve joint pain. The idea remains controversial. Out of desperation to find cures, Krasner had long turned to ideas from alternative and folk medicine, including some that were definite dead ends.

In August a frail Krasner joined John Little at Guild Hall, which held a retrospective of his work. Krasner held on to his arm as they posed for a photograph before one of his colorful abstract canvases—two old friends who once danced together to boogie-woogie music in the days when they met Mondrian more than forty years earlier.[50]

Almost a year later, in June 1983, Krasner received a letter from Steven W. Naifeh requesting an interview for a book he said he was writing on the history of the art world from the 1940s to the 1960s.[51] This book was eventually published as a biography of Jackson Pollock, coauthored by Naifeh and Gregory White Smith. Krasner's assistant, Darby Cardonsky, replied to the letter in June, suggesting that Naifeh contact her after the first of July, when Krasner expected to be in East Hampton. A bit earlier Krasner made appointments to be interviewed by Deborah Solomon, the author of a biography of Pollock, which appeared two years earlier than Naifeh and Smith's, but she canceled them, the last time for February 28, 1984.[52] Krasner was still bristling over Friedman's biography of Pollock and was wary of biographers and, indeed, of all who wrote about her and Pollock, especially people she did not know well. Barbara Rose and Gene Thaw both recall how Krasner was at this time completely focused on her first American retrospective, even while daunted by her failing health.[53]

"During Lee's last summer," Carol Braider recounted, "when I was sort of her sitter, she was consumed by rage. She was afraid

that if she couldn't find a way to take out her hate on the world, she wouldn't be able to go on painting or even exist. Those weeks were a nightmare. It was as if rage were all she had. Of a Bill de Kooning work going for $2 million, Lee said, 'If Bill thinks that's something, wait until he hears the latest in Jackson's sales.'"[54]

Krasner was preoccupied with Barbara Rose's text in the catalogue for the retrospective. The show was to open at the Museum of Fine Arts in Houston on October 27, 1983, Krasner's seventy-fifth birthday. Krasner enlisted Terry Netter to come out and help her edit it. He spent a week in the Springs house reading every word aloud to her. She would stop him and call Rose to ask for changes, which she could trust that Rose would make. Netter remarked, "Lee loved to think. She liked intellectuals. She was very bright. I don't think that she read very much."[55] He suspected she was dyslexic.

As the opening neared, the press's interest grew. Krasner told Michael Kernan at the *Washington Post* that she wished that museums would give artists retrospectives "every ten years or so, for the artists' sake, so they can see the cycle of their own work. . . . Really, it shouldn't be a once-in-a-lifetime thing."[56] Still, she said she would miss having her paintings around—"It'll be two years before I get them back."[57]

Before the show opened, Krasner admitted that she hadn't let Rose see all of her work. She had kept one finished painting that Rose would have wanted—just to hang it on her wall. "I wanted to keep the one I just finished because I need to have my work to look at. Even when I'm just looking; I am working."[58] This was probably her *Untitled* collage on canvas (dated 1984 in the catalogue raisonné, but actually finished in 1983) before which she would pose in December 1983 for a photograph by Bernard Gotfryd.[59]

Krasner flew to Houston accompanied by Bob Miller and John Cheim and Nathan Kernan, who worked for the gallery. She was now in a wheelchair and had to spend much of the time in her room at the Warwick Hotel across the street from the museum.

Among the dignitaries there to greet her was her friend James Mollison, director of the Australian National Gallery, who became notorious in 1973 for paying $2 million for Jackson Pollock's *Blue Poles,* setting a new record price not only for Pollock but also for American painting. The money went not to Krasner but to the New York businessman and art collector Ben Heller, who had paid only $32,000 in 1956, when he had purchased the large 1952 painting once sold by Sidney Janis for only $6,000.[60] When Krasner had told Janis that Pollock's work was underpriced, she was correct. Now she could take satisfaction in what she had achieved in creating an international market for Pollock's art. In 1978, Mollison purchased for his museum Krasner's *Cool White,* a major canvas from 1959, once owned by David Gibbs, and then he followed that by acquiring several of her works on paper.

The large installation in Houston featured 152 paintings and drawings, including a biographical section, "Lee Krasner: The Education of an American Artist," emphasizing the artist's thorough training in the use of line. The exhibition was reduced in size in the show's subsequent venues at the San Francisco Museum of Modern Art and the MoMA in New York.

Krasner was delighted by the Houston opening. "The show looks terrific! Of course, I didn't exactly have a chance to take a leisurely look [during the opening]; people were wishing me happy birthday and talking to me, but I found it a bit overwhelming— overpowering."[61] Terry Netter recalls that Krasner entertained a few close friends in her hotel suite, among them "Buddha" Eames from Krasner's time at the Hofmann School. Krasner returned to look at the show again without the crowds.

In *Time,* the critic Robert Hughes, who attended the opening of the show in Houston, wrote that Krasner was a major American artist and wondered aloud what kept her from earlier recognition. He provided his audience with an answer that also gave voice to some of Krasner's frustrations: "Women artists through the '40s and into the '50s in New York City were the victims of a sort of

cultural apartheid, and the ruling assumptions about the inherent
weakness, derivativeness and silly femininity of women painters
were almost unbelievably phallocentric. . . . Add this to Krasner's
prickly contempt for diplomacy with critics, and one can see why
for most of her life her work was scanted as 'minor,' an appendage
to Pollock's."[62]

Hughes thought that "her dislike of groups always stopped her
from presenting herself as a 'feminist' artist. Hence by the '70s
there was no lack of denigrators on both sides of the sex war tacitly
writing her off as an art widow first, a painter second."[63] Though
a feminist artist such as Judy Chicago scorned Krasner as "male
identified," Krasner's ambivalence about feminist art is much
more complicated than just not liking groups.[64] Yes, she may have
identified herself in relation to males, but her devotion to a man
like Pollock stemmed not from an aversion to feminist groups, but
rather from her love and admiration for him. Her choices were
also affected by the cultural matrix of her immigrant childhood.
She saw how women were treated in the world, and risked her
own future by hitching onto the coattails of a man whom she saw
as a genius and whom she believed she could nurture to success.

Hughes praised Krasner's artistic "formal instinct," noting that
"she wanted to combine Picassoan drawing, gestural and probing,
with Matissean color. . . . Is there a less 'feminine' woman artist
of her generation? Probably not. Even Krasner's favorite pink, a
domineering fuchsia that raps hotly on the eyeball at 50 paces, is
aggressive, confrontational . . . her line evokes eros. . . . This is an
intensely moving exhibition, and it will suggest to all but the most
doctrinaire how many revisions of postwar American art history
are still waiting to be made."[65]

In reviewing the retrospective for *Artweek*, Susie Kalil repeated
Rose's argument and supported Hughes's criticism: "Of all the ab-
stract expressionists, only Krasner had contact with virtually every
major force that shaped its evolution. . . . Why hasn't Krasner
been accorded her due as a painter? The inequity can be directly

attributed to the sexist attitudes rampant among critics and artists alike during the 1940s and 1950s. Krasner matured in an artistic environment to which few women, if any, were admitted."[66]

*Los Angeles Times* critic William Wilson, who had rejected the feminist art movement during the 1970s, wrote that Krasner "may not be quite the peer of the great Action Painting innovators Pollock and de Kooning, but she certainly can be thought of in the same breath with Hans Hofmann, Robert Motherwell, and Franz Kline. She is arguably a better painter than such lesser lights as Adolph Gottlieb or William Baziotes."[67] At the time he wrote, this was a radical statement.

In San Francisco, Thomas Albright, a local newspaper critic beloved in the Bay Area for his promotion of local artists, reviewed Krasner's traveling retrospective. He accused Rose of writing the catalogue essay in a "relentlessly uncritical, Horatio Alger style that has become the norm for this generally lamentable literary genre."[68] He also questioned "whether this hard-won reputation is wholly justified by the work itself, or whether it is more a product of feminist advocacy and/or the insatiable craving of art historians for disinterring new 'masters' from the Potters' Field of the past."[69]

Other critics also took issue with Rose. A Houston-based husband-and-wife team of artists, Ed Hill and Suzanne Bloom, argued in *Artforum:* "We should make no mistake in our reading of this innocent art play: Rose was writing history here, or, rather, correcting it to her image. Krasner would appear to have been the beneficiary of Rose's historicism, but in truth she may have been simply the occasion for it. As a curator Rose has no light touch. She overdraws her case."[70]

In *Art in America,* Marcia Vetrocq made an argument similar to the one made by the Blooms. Vetrocq claimed that Rose was preoccupied "with most art historians' omission of Krasner from the first generation of Abstract Expressionism . . . as it has come to be petrified in art historical accounts. . . . [Krasner] will prob-

ably never be judged an innovator of the magnitude to satisfy a [Irving] Sandler or a [Henry] Geldzahler."[71] Vetrocq was correct that Sandler's mind was too closed to be able to see Krasner as one of the founding members of abstract expressionism, which would have forced him to revise his own narrative.[72]

Though Vetrocq praised Krasner's work and acknowledged that it had been "so little shown or reproduced," she also asserted, "Krasner need not be proved the first or the only or the earliest in anything for her work to reward our attention and assume a position of dignity and significance in the history of postwar art. She has earned it."[73]

In her own defense, Krasner reiterated in 1984, "It's quite clear that I didn't fit in, although I never felt I didn't. I was not accepted, let me put it that way. . . . With relation to the group, if you are going to call them a group, there was not room for a woman."[74]

Krasner returned from Houston exhausted but elated at the acclaim. Though she had been in a wheelchair, she had nonetheless spent hours looking at her works on view.[75] She was now crippled by rheumatoid arthritis—she could barely stand, and it was impossible for her to walk. She "took to bed" and was too weak to return to painting. Darby Cardonsky, her assistant, would read her reviews to her.

Krasner was also suffering discomfort from intestinal problems such as diverticulitis (weak spots in the colon wall) and what may have been the complications of Crohn's disease.[76] Krasner had no choice but to write to Henry Hopkins, the director of the San Francisco Museum of Modern Art, that "health concerns" would not allow her to make the trip to see her retrospective installed there.[77]

Edward Albee admired Lee's strength and recalled that she was in so much pain from arthritis that she remained confined to New York City, where she was taking gold injections.[78] They were supposed to relieve joint pain and stiffness, reduce swelling and

bone damage, and lower the chance of joint deformity and disability. But the injections didn't help Krasner.

Assigned by *Newsweek* to go and photograph Krasner at her New York apartment, Bernard Gotfryd arrived to find that the ailing artist had not even gotten out of bed yet. He offered to return another time, but, not wanting to postpone the shoot, she asked him to wait for her to get ready. She wanted to know whom else he had photographed and he replied, "The list is so long, I'll be here forever."

"Then you photographed a lot of painters?" Krasner wanted reassurance. "Georgia O'Keeffe, Salvador Dalí, Andy Warhol, Barnett Newman," he replied. When she responded to Barnett Newman's name, he told her a story of taking Newman's photograph during the installation of his show at the Guggenheim in the spring of 1966. Naturally the installation took place on a day when the museum was closed to visitors. Newman had gone downstairs to use the men's room and not returned, so after a while Gotfryd went in search of him, finding the artist locked in the restroom, banging on the door, trying to summon someone to rescue him. Newman screamed, "What do they want me to do, have a heart attack?" Gotfryd forced the door open, got Newman out, but the artist was "in a rage," even as he posed for the rest of the photographs. Krasner loved hearing the story about her old friend, who, in fact, had died of a heart attack in 1970, and, even in her pain, she smiled for Gotfryd and posed in front of her 1983 collage.[79]

Krasner also received a positive review in *Newsweek* from Mark Stevens, a future biographer of Willem de Kooning, who asserted, "Krasner fully deserves to be counted as one of the handful of important abstract expressionists."[80] Gotfryd's photograph accompanied the review.

Krasner finished this collage and reworked a painting on New Year's Eve 1983, even though she was suffering unbearable pain.[81] By March she had lost a lot of weight, and her health had deterio-

rated to the extent that she began going to New York Hospital for treatment.[82] Deborah Solomon, then writing a biography of Pollock, spoke to her briefly by phone as Krasner lay in her hospital bed on March 20, 1984, but by then Krasner was in no condition to give an interview. She was far too weak and too thin. Barbara Rose believes that Krasner was in so much pain that she stopped eating.

Krasner nonetheless agreed to be present in order to accept an honorary doctor of fine arts degree from the State University of New York at Stony Brook on May 20, 1984. John H. Marburger, the university's president, wrote to her: "I am sorry to hear from Terry Netter that your arthritis is giving you worse trouble."

Unfortunately Krasner was too ill to attend the ceremony at Stony Brook. Special permission was obtained to award the degree to her in absentia. This was the only honorary degree she ever received. The distractions of her failing health and her retrospective meant she worked very little during the last year: "I'm just poking along these days. Not working at full intensity," she told a visiting critic.[83] She knew she would not be able to make it to the Springs studio that summer.

LEE KRASNER DIED UNEXPECTEDLY AT THE AGE OF SEVENTY-FIVE ON June 19, 1984, at New York Hospital in Manhattan. She had been taken there for a transfusion in an effort to stop her weight loss, which had reduced her to ninety-four pounds. She had not survived long enough to see her long-anticipated retrospective at the Museum of Modern Art, though she was at least assured that it was taking place.

Krasner was survived by two of her sisters, Esther Gersing and Ruth Stein. Because she left no instructions, the law designated that Krasner's next of kin was Ruth Stein. She arranged for a funeral that took place on June 25 in Sag Harbor, conducted by Rabbi David Greenberg. Afterward she was buried in Green

River Cemetery in Springs, next to Jackson Pollock's grave. Gene Thaw is sure Krasner would have abhorred the Orthodox Jewish rites.[84]

Patsy Southgate recalled, "When I saw her three weeks earlier she was still being wheeled to the park, but she was very weak—and very low. She gave me the feeling of wanting to go, so it's good that she did. But she wouldn't have thought the funeral was so great—you can't get the art world to come to Sag Harbor on a Monday."[85]

Among the others who did come were Krasner's nephews Ronald Stein and Jason McCoy and his wife, Diana Burroughs, and Krasner's niece Rusty Glickman Kanokogi. At the service, Gene and Clare Thaw sat together with Gerald Dickler, Krasner's longtime attorney, of whom she was quite fond. Among her Long Island friends were Jim and Charlotte Brooks, Ibram and Ernestine Lassaw, John and Josephine Little, Alfonso Ossorio and Ted Dragon, Terence and Therese Netter, Jeffrey Potter, the artist Esteban Vicente and his wife, Harriet, and Enez Whipple, the director of Guild Hall.

Krasner's obituary in the *New York Times* stated, "In the last decade, Miss Krasner has begun to get her due, in part because of the effects of the women's movement."[86] Barbara Rose offered words, saying, "Like Mondrian, she was a beacon of integrity. She had an absolute inability to compromise with anything."

In accordance with Jewish tradition, Krasner's gravestone was unveiled a year after her death, on June 23, 1985. Krasner's grave is marked by a small stone that sits in front of Pollock's larger stone. Many have observed that the stone appears to be located at Jackson Pollock's feet and that his much larger stone grave marker overshadows hers. Others, however, have insisted that the smaller gravestone was what Krasner wanted: a place by Pollock's side, but not to overshadow the man who she believed was the greater artist.

Her friend Ted Dragon later opined that Ronald Stein was responsible for the awkward arrangement in the cemetery and that

he did it because he was angry at his aunt's will. Krasner left Stein only $20,000, while she left several other family members, including her niece Rusty Kanokogi and her nephews Jason McCoy and Seymour Glickman, twice that sum. She appears to have based her decision on what she thought each relative needed at the time she signed her will in January 1979. She reserved most of her $10 million estate to fund the Pollock-Krasner Foundation.[87]

· By leaving most of her fortune to endow the Pollock-Krasner Foundation, whose mission was to support "needy and worthy" artists, Krasner embraced the Jewish concept of *Tikuun Olam,* going out to repair the world. Terry Netter also believed that Krasner's decision was a part of "the Judaic tradition of anonymous philanthropy," because people can't thank you personally when you're dead. She had not forgotten the many years when she struggled to survive and the many artists who had never found adequate support. Among the needy artists that she helped after she had money was Igor Pantuhoff, her first love, who had fallen on hard times. He had died in 1972.

Krasner had been concerned about what would happen to the treasured home and studio, where she and Pollock had made art history. For help, she had turned to Netter, who had been the founding director of the Fine Art Center at the State University of New York at Stony Brook since 1979. Because she left the bulk of her estate to support artists in need, Krasner's will stated that her home should become a museum only if an appropriate institution could be found to run the Springs house.

Netter spoke with John Marburger, the university's president and a distinguished scientist, who agreed to run the house as a museum and study center. The house is now open as a museum, the Pollock-Krasner House and Study Center. It is designated by the secretary of the interior as a National Historic Landmark because it has exceptional value or quality in illustrating or interpreting the heritage of the United States. Visitors can tour the house and the studio in which both Pollock and Krasner worked.

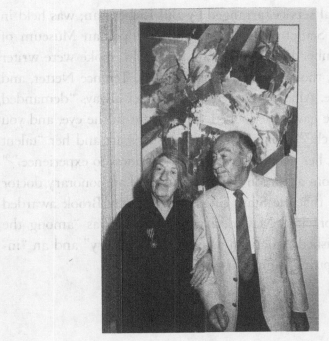

In August 1982, Lee Krasner joined John Little at Guild Hall in East Hampton, which held a retrospective of his work, and they posed before one of his colorful abstract canvases. Krasner and Little were two old friends who once danced together to boogie-woogie music forty years earlier, in the days when they were acquainted with Piet Mondrian. Photograph by Rameshwar Das, courtesy of the *East Hampton Star.*

Bill Lieberman, a former curator at MoMA and then at the Metropolitan Museum of Art, said that Krasner "painted in the modern idiom when Jackson was still in the regional style. . . . She should be remembered for the strength of her decorative sense and as an excellent draftsman."[88] Krasner's friend Eugene Thaw, who coauthored and helped to fund the definitive catalogue of Jackson Pollock's art, commented, "We are coming to the end of an era and she was a significant part of it. But because she was a woman and because she was overshadowed by Pollock, her due was late in coming."[89]

A memorial service, arranged by Bill Lieberman, was held in the Medieval Sculpture Court at the Metropolitan Museum of Art on September 17, 1984. Among those who spoke were writer Susan Sontag, the art critic Robert Hughes, Terence Netter, and Edward Albee. Albee remarked that Krasner always "demanded the quality she gave. She looked you straight in the eye, and you dared not flinch."[90] Sontag praised Krasner's art and her "talent for friendship, her genuine vitality and openness to experience."[91] Netter read from a citation that accompanied an honorary doctor of arts degree that the State University at Stony Brook awarded Krasner the previous May, declaring that she was "among the most distinguished American artists of the century" and an "inspiration to aspiring women artists."[92]

# ACKNOWLEDGMENTS

I AM GRATEFUL TO THE POLLOCK-KRASNER FOUNDATION AND THE Pollock-Krasner House and Study Center for supporting this project with a fellowship that not only enabled me to take a year off from teaching but also provided, for the academic year, a research assistant, Karen Cantor. Her able assistance proved valuable, including when I organized a related symposium, "The Art and Life of Lee Krasner: Recollections, Cultural Context and New Perspectives," which took place over two days in April 2007 at the Manhattan center of Stony Brook University. I am grateful to all who participated and to the *Woman's Art Journal,* which published a special issue featuring some of the presentations from the program.

I was then fortunate enough to be able to write full-time for a second year, while holding the Distinguished Fulbright Chair in American Studies at the Roosevelt Study Center, in Middelburg, the Netherlands. There I wish to thank the director, Kees van Minnen, and his staff, as well as Janpeter Muilwijk and Guido Lippens, two of the town's resident artists, and their families, whose friendship made my stay so far from home much more enjoyable. Several months spent at the University of Milan followed, where hospitality at the library and especially from colleagues

such as Luigi Lehnus, Francesca Orestano, and Massimo Gioseffi was greatly appreciated. In addition, my research at the Peggy Guggenheim Collection in Venice was facilitated by its director, Philip Rylands, and by Venetian friends Mario Geymonat and Anna Lombardo, who offered hospitality in Italy, as did Blaise and Aniko Pasztory and Margherita Azzi-Visentini, who also welcomed me to Switzerland. In Paris, Evelyn Alcaude and Jeannine and Georges Richards were welcoming and encouraging.

This book was also supported by grants from the Hadassah-Brandeis Institute at Brandeis University, the Getty Research Center, and the Research Foundation of the City University of New York. I am also grateful to the City University of New York for granting me fellowship leave from teaching responsibilities during which time I worked on this book. I appreciate the help of Louisa Moy and Lisa Ellis at the Baruch College Library.

For permission to reproduce Krasner's art works, and quote from her writing and that of Jackson Pollock, and for other help, I wish to thank the Pollock-Krasner Foundation, especially Kerrie Buitrago. I also wish to acknowledge the help of Maria Fernanda Meza at the Artists Rights Society.

Helen A. Harrison, director of the Pollock-Krasner House and Study Center, deserves special thanks for sharing with me her expertise on Pollock and Krasner and the East Hampton scene, for helping me find some of my interview subjects, and for reading and commenting on an early stage of this book. She has made the Pollock-Krasner House and Study Center into an exceptional resource that would have pleased Lee Krasner. For helping me there and for her enthusiasm, I would also like to thank Ruby Jackson.

Among the other writers who have worked on either Lee Krasner or Jackson Pollock, some generously shared their unpublished recorded interviews and deserve particular thanks: Jeffrey Potter, whose interviews for his oral biography of Pollock proved an essential resource; also Cassandra Langer, Elizabeth Langhorne,

Andrea Gabor, Barbara Rose, and Deborah Solomon. I am also grateful to Michael Brenson, who made available to me an interview from his unpublished research for his biography of David Smith, still in progress, and to David Craven, who first obtained Krasner's FBI file in 1992, and shared it with me. Eugene V. Thaw, coauthor of the Pollock catalogue raisonné was also particularly helpful. Speaking with each of these writers has enriched this project.

Anyone writing an artist's biography is fortunate if there is a catalogue raisonné to consult, so I thank Ellen G. Landau and Jeffrey Grove, who served as her assistant, for having had the dedication to complete Krasner's. When my findings have clearly contradicted theirs, I have sometimes reported this, usually in the endnotes. When my chronology disagrees with theirs or that of other authors, however, it does not reflect any oversight on my part, but reflects new evidence previously overlooked or undiscovered. I also wish to acknowledge writing on Krasner: by B. H. Friedman, including his catalogue essay for Krasner's 1965 retrospective; extensive work by Barbara Rose, including the catalogue for Krasner's 1983 retrospective and her 1978 film, *Lee Krasner: The Long View;* and work by Robert Hobbs, particularly the retrospective that he organized in 1999, making much of Krasner's art accessible once again. Many other writers on Krasner too numerous to name here are listed in the selected bibliography. Limitations of space in this volume do not permit a discussion of how my conclusions differ from those of other scholars. However, the conclusions of this book represent my own point of view.

I am grateful to all those who had conversations with me about Krasner, especially to her extended family members: Diana Burroughs, Jack Dressler, Leslie Dressler, Muriel Dressler, James S. Gersing, Charles Glickman, Rusty (Rena Glickman) Kanokogi, Jason McCoy, Cindy Shapiro Munson, Sylvia Pollock, and Frances Patiky Stein; and to her closest friends: Edward Albee, Cile

Downs, Sanford Friedman, Eda Mirsky Mann, Terence Netter, Therese Netter, Barbara Rose, Eugene Victor Thaw, and Clare Thaw.

I also learned from speaking about Krasner to Pamela Adler, Ruth Appelhof, Dore Ashton, Helene Aylon, Will Barnet, Nancy Miller Batty, Dyne Benner, Patricia Bowden, Paul Brach, Phyllis Braff, Rachel Brownstein, Arlene Bujese, Jeanne Bultman, Darby Cardonsky, John Cheim, Ann Chwatsky, Christopher Crosman, Laurel Daunis-Allen, Barbaralee Diamonstein, Ruth Dickler, Elizabeth Epstein DuBoff, Tejas Englesmith, Dallas Ernst, Audrey Flack, B. H. Friedman, Arnold Glimcher, Grace Glueck, Edward Goldman, Elaine Goldman, Bernard Gotfryd, Janice Van Horne (Jenny Greenberg), Helen Gribetz, Raphael Gribetz, John Gruen, Grace Hartigan, Ben Heller, Robert C. Hobbs, Richard Howard, Robert Hughes, Jill Jakes, Lana Jankel, Carroll Janis, Paul Jenkins, Luise Kaish, Morton Kaish, Howard Kanowitz, Deborah Kass, Diane Kelder, Nathan Kernan, Bill King, Joyce Kozloff, Max Kozloff, Ellen G. Landau, Elizabeth Langhorne, Denise Lassaw, Ernestine Lassaw, John Post Lee, Donald McKinney, Peter Matthiessen, Betsy Wittenborn Miller, Gerald Monroe, Eleanor Munro, Cynthia Navaretta, Cindy Nemser, Ruth Nivola, Francis V. O'Connor, Mark Patiky, Vita Petersen, Norman Podhoretz, Jeffrey Potter, Harry Rand, Virginia Pitts Rembert, Alex Rosenberg, Patia Rosenberg, Joop Sanders, Irving Sandler, Martica Sawin, Miriam Schapiro, Grace Schulman, Constance Schwartz, Joyce Pomeroy Schwartz, Nancy Schwartz, Charles Seliger, Joan Semmel, David Slivka, Kiki Smith, Harry Striebel, Elizabeth Strong-Cuevas, Jerry Tallmer, Arlene Talmadge, Abigail Little Tooker, Marcia Tucker, Helen Weinberg, Tony Vaccaro, Judith Wolfe, Virginia Zabriskie, Athos Zacharias, and Barbara Zucker.

I sometimes wished that I had started this book sooner, since I was fortunate enough to meet and (in some cases interview) numerous others who figure in this biography but who were

already deceased by the time I envisioned this writing, among them: Krasner's teacher Leon Kroll, her nephew Ronald Stein, her friends and acquaintances including Louise Bourgeois, Fritz Bultman, Ray Kaiser Eames, Jimmy Ernst, Clement Greenberg, Peggy Guggenheim, Harry Holtzman, Sidney Janis, Buffie Johnson, Lillian Olinsey Kiesler, Ibram Lassaw, William Lieberman, John Little, Josephine Little, Howard Moss, Robert Motherwell, John Bernard Myers, Annalee Newman, Alfonso Ossorio, Betty Parsons, David Porter, Richard Pousette-Dart, Bryan Robertson, Harold Rosenberg, William S. Rubin, Rose Slivka, and Sidney Waintrob. Likewise, I was fortunate to discuss Krasner, contemporary art, and women artists with the late critics David Bourdon, Emily Genauer, Hilton Kramer, and John Russell, as well as with the artist Hermine Freed, who made a video of Krasner as a part of her series on "Herstory." Though I also met Robert Miller and Helen Frankenthaler, neither was able to be interviewed for this book.

I benefited from communications with the following, who, though they did not know Krasner, helped to illuminate other figures and events in her life story: Bonnie Bernstein, Diane Harris Brown, Judy Collins, Judy Chicago, Jack Drescher, Angela Gibbs, Emilie S. Kilgore, Patrick Michael, Celia Siegel Newman, Leigh Olshan, Mimi Pantuhova, Irene Pappas, Val Schaffner, Joan Ulman Schwartz, Melissa Michael Sheldon, Christina Strassfield, and Karole Vail.

Especially helpful to me in my research were Charles Duncan and Darcy Tell at the Archives of American Art; the Archives at the Armenian Church of North America Eastern Diocese; Joy Holland, Brooklyn Collection, Brooklyn Public Library; the Brooklyn Museum Archives; Carol Salomon, archivist, Cooper Union; Hillary Bober, archivist, and Jeffrey Grove, curator, at the Dallas Museum of Art; Tom Branigar, archivist at the Dwight D. Eisenhower Library; the Long Island Collection at the East Hampton Library; Jeannette Clough, Sally McKay, and Sarah Sherman of the Getty Research Institute Library; Philip

Rylands of the Guggenheim Museum in Venice; Julie Greene and Marcia Mitrowski of the Hampton Library, Bridgehampton; Gwen David and Daniel Starr of the Thomas J. Watson Library, curators Lisa Messinger and Samantha Rippner, and Image Licensing at the Metropolitan Museum of Art; Jenny Tobias at the Museum of Modern Art Library and Archives; Marshall Price, curator at the National Academy of Design; Quinn Marshall at New Directions Press; Sipora Matatov, New York City archivist; Dan Sharon of the Spertus Institute Library in Chicago; Nina Yiakoumaki, archivist at Whitechapel Gallery, London; and the staff at YIVO Institute in New York.

I wish to thank the following who contributed in diverse ways to my research for this book: James Atlas, Debra Bricker Balken, Greta Berman, Judy Brodsky, Michele Cohen, Blanche Wiesen Cook, Cezar Del Valle, Tina Dickey, Jack Drescher, MD, Ann E. Gibson, Jeff Kisseloff, Brad Gooch, Kathleen L. Housley, Suzanne Jenkins, Erica Jong, Connie Kaplan, Pepe Karmel, Sandra Kraskin, Tom McCormick, Joan Marter, Irene Pappas, Claudia Oberweger, Elizabeth A. Sackler, Hope Sandrow, Martica Sawin, Amy B. Siskind, David W. Stowe, Vita Susak, Jacquelin Bograd Weld, and Barbara Wolanin.

I wish to thank Anne Abeles, who wrote her dissertation on James Brooks, and Tetsuya Oshima, who wrote his dissertation on Jackson Pollock, both under my supervision at the Graduate Center of the City University of New York. Both encouraged me to resume my studies in this field.

For helping with photographs of Krasner, her friends, and her art, I wish to thank George R. Allen, Dyne Benner, David and Maddy Berezov, Ann Chwatsky, Rameshwar Das, Leslie Dressler, Tracy Fitzpatrick and the Neuberger Museum in Purchase, New York, B. H. Friedman, James S. Gersing, Bernard Gotfryd, Ripley Golovin Hathaway, Rusty Kanokogi, Whitman E. Knapp, Laura Kruger, Donald McKinney, George T. Mercer, Barbara B. Millhouse, the National Museum of Women in the Arts, Stephan

Paley, Mark Patiky, Helen Rattray at the *East Hampton Star,* the Pollock-Krasner House and Study Center, Miriam Schapiro, David Stekert, and Tony Vaccaro. For helping me locate reproductions of Krasner's art, I thank the Robert Miller Gallery, as well as Jason McCoy Inc. and Pace Gallery, all in New York. I have tried to locate, request permission of, and credit each of the photographers whose work I have included. I hope that anyone whom I have failed to find will forgive my unintentional oversight and accept my sincere thanks.

I thank my editor Henry Ferris for his unflagging support of this project from its inception and for his insight in posing the kind of questions that led me to make further discoveries. I also appreciate the careful attention to this book paid by his assistant, Danny Goldstein. I feel fortunate to have as my friend and literary agent Loretta Barrett, whose enthusiasm for books and interest in her authors make her exceptional.

I was able to visit Shpikov, Krasner's parents' remote shtetl in Ukraine, with the help of my friend Liya Chechik, a graduate student in art history in Moscow, and my husband, John B. Van Sickle, who shared the driving and the memorable adventure. I dedicate this book to John, who once again has accompanied me on my journeys, supported my work with his insights, and even documented some of it with his photographs. When needed, he has been there with sustenance and love.

# A NOTE ABOUT SOURCES

THE BIOGRAPHER'S TASK OF TELLING THE STORY OF A REMARK-
able artist and a courageous woman is rendered more
difficult because so many of the usual written sources
are lacking. Lee never told her own story, and she left behind
few personal letters or other written accounts. In the mid-1960s,
Krasner was urged to write a memoir by the literary agent, Oscar
Collier. He recommended one ghostwriter, but Lee rejected him,
through her trusted attorney, Gerald Dickler.[1] Collier next tried
to persuade her to work with Parker Tyler, a film and art critic
whom he had successfully represented, sending her Tyler's latest
book and its reviews.[2] Krasner, who knew Tyler, appears to have
let the project drop, because the next year (1968), she asked her
friend B. H. Friedman to write a biography of Pollock, a challenge
he accepted and met, telling not hers but Pollock's story, as she in-
tended. In the end, their long friendship broke up over her desire
to suppress his biography.[3] Krasner came to distrust biographers in
general.

Doing justice to Lee Krasner challenges biographers and art his-
torians alike, which may be one reason why some who have written
about her and the abstract expressionist movement have confused
dates and facts, garbled stories, and even overlooked her active role

at significant moments in art history. Most such errors have gone unchallenged, yet as they multiply and fester unremarked, there is the risk that the public will form false impressions.[4] My research was inspired and disciplined by a desire to give Krasner's qualities and achievements their full and accurate due. In my dual role as an art historian and a biographer, I have tried to sort out what could be known and proven from what was in fact hearsay and in some cases palpable fiction.

I have interrogated sources that have been previously accepted, casting doubt on their reliability. For example, Krasner's sister, Ruth Stein, who survived her, made disparaging remarks about Lee. Yet my interviews with other family members led me to conclude that Ruth was a tainted witness. When referring to their brother Irving, Ruth claimed that Lee "wanted Irving to be close to her, but he never was. *Never.*"[5] Yet Muriel Stein Dressler and Rusty Kanokogi, nieces to both Ruth and Lee, recalled a close relationship between Lee and her eccentric brother, who for years appeared at Lee's home for family dinners and even "collected art." Krasner's nephew, Ruth's son, Ronald Stein, referred to his Aunt Lee as his "alter-mother" and became an artist, modeling himself on his Aunt Lee and Uncle Jackson.[6] Moreover, Ronald's wife of many years, Frances, recalled that Lee had a troubled relationship with Ruth: "Lee and Ruth could get along for maybe seventeen minutes and then had to be dragged apart. Ruth fumed and seethed and made fists at Lee, who would get angry and then forget it."[7] In my view, Ruth was clearly determined to settle old scores with her deceased older sister. Her negative testimony about Lee seems to be the last shot of a jealous sibling.

Some art historians have challenged the validity of the "spoken word" as evidence and the reliance on interviews in the genre of biography in general. With regard to Krasner and Pollock in particular, concerned readers should consult what the art historian Anne Middleton Wagner has written about how various authors have tried to misuse oral sources "to invent a Pollock," mean-

ing that they sought to create a mythic figure that differs from Krasner's actual experience and testimony. Wagner argued that these authors' "fiction depended on Krasner—on both the woman herself and the character she was assigned to play in the Pollock drama." Wagner points out that all of these authors had to negotiate "a relationship" to Krasner as "the official repository of Pollock's memory."[8] Wagner suggested that they chose interviews as a means to reduce Krasner to "one among many witnesses, if a valued one; her word need not be taken as law."[9] It has been my aim to restore Krasner's voice. I have paid close attention to her spoken words, taking them as clues for further research, which often confirmed and expanded upon her statements. Her testimony almost always proved accurate, but I have pointed out rare cases where she contradicted herself or where she confused dates.

In their biography of Pollock, Steven Naifeh and Gregory White Smith ascribe to Krasner dialogue spoken by a fictional character in B. H. Friedman's 1975 novel, *Almost a Life*. Naifeh and Smith describe their sourcing as follows: "this novel is a fictional account of JP and Lee Krasner by a friend, in which many of the details are taken from their lives."[10] However, B. H. Friedman told me that his fictional couple was not modeled on Krasner and Pollock.[11] Indeed, the character of the wife in his novel is not even an artist. Friedman insisted to me that he invented these characters and all their dialogue. Even without Friedman's clear denial, dialogue from the novel ascribed to Krasner did not ring true to many who knew Krasner, nor is it consistent with the facts of her life and social environment as reconstructed by my research. Yet the words from Friedman's novel placed in quotation marks in a biography suggest an authenticity that is damaging to Krasner. For example: "According to one friend, she [Krasner] described herself . . . as 'an old maid. A fucking old maid.'"[12]

Naifeh and Smith also assigned Krasner an even more colorful bit of dialogue from Friedman's novel, spoken by his "LK character" as they call her: "It was an embarrassingly slow start for a

woman, who, at the National Academy of Design, 'never went anywhere without a diaphram [sic].' 'If a guy interested me, really interested me,' Lee once said of her student days, 'I slept with him because I wanted to know him better and wanted him to know me better. That was my morality.'"[13] These fictional quotes portray Krasner as promiscuous at a time when she was completely devoted to Igor Pantuhoff, as her contemporaries have testified. The credits for these quotations in Friedman's novel are available only in the source notes of the Pollock biography, and it is easy to understand how some readers would assume that Krasner made these statements in one of her many oral interviews, even though she did not.

Readers familiar with the literature on Krasner, Pollock, and abstract expressionism may note that I have omitted a few previously published stories about Krasner because of information that makes them unconvincing. In one instance, I discovered that two related, but conflicting stories appear in two well-known books. Both cannot be true, for, with the exception of Krasner, the main characters are not even the same, though the plots are almost identical. The authors in question, Naifeh and Smith in their Pollock biography and Andrea Gabor in an essay on Krasner in her 1995 book, *Einstein's Wife,* based their conclusions on interviews.[14] One story, recounted by Naifeh and Smith, who interviewed Fritz Bultman, purports to be about Krasner's interaction with Willem de Kooning and has been repeated in a 2004 biography of de Kooning by Mark Stevens and Annalyn Swan, who cite Naifeh and Smith's Pollock biography as their only source for this story.[15]

Andrea Gabor recounted the second, related story (without de Kooning), which she heard from Bultman's wife, Jeanne, who dated Igor Pantuhoff after Lee, but well before she married Fritz. The climax of each tale is that Krasner, fully clothed and dressed up at a party, got thrown into a shower—either by Fritz Bultman

in Naifeh and Smith's version or by Igor Pantuhoff in Gabor's account.[16] Since Jeanne Bultman also told me that Igor constantly talked to her about Lee, I conclude that she was surely Fritz's source for this story, which he or someone else garbled.[17]

Even though Krasner was present at the creation of the abstract expressionist movement, she had reason to complain that she was too often ignored in historical accounts focused on the "great men." In their biography of de Kooning, Stevens and Swan tell a story in which Krasner was a major player, but fail even to mention her: For the Works Projects Administration (WPA) de Kooning produced a study for an abstract mural, only to be forced from the project because he was an illegal Dutch immigrant and not an American citizen. Krasner's assignment was to enlarge his study, so she placed it on the studio wall where she worked.[18] Since she could not afford a space of her own, she was using part of a studio at 38 East Ninth Street shared by Igor Pantuhoff and George McNeil. She later recalled that de Kooning often dropped by to check on her progress.

Yet Stevens and Swan, misled by another of Bultman's faulty recollections, report that it was Igor Pantuhoff who "placed a study for one of de Kooning's WPA murals on his studio wall."[19] They identify the little-known Pantuhoff as Lee Krasner's "boyfriend." Bultman had spoken to Irving Sandler of "Pantuhoff, a Russian who was a friend of both Graham's and Gorky's. And he hung one of those very large murals that de Kooning did for the WPA in his loft on Ninth Street then."[20] Sandler tried to get George McNeil to confirm this, leading the witness: "And de Kooning was also working in this [building on Ninth Street]?" But McNeil replied with emphasis: *"No, de Kooning was not working in that building."* Sandler: "Or he had a big picture of de Kooning?" McNeil: "Penticof [Pantuhoff]?" Sandler: "Yes." McNeil: "Maybe. Could well be, I don't remember it though. *Penticof was Lee Krasner's boyfriend at the time.* I remember him

in that relationship. He had the studio in the front and I think I would remember if de Kooning had been [worked] there. Or he might have had it in his apartment."[21]

Neither Krasner's WPA assignment to enlarge and finish de Kooning's mural nor her identity as an artist was ever mentioned in Sandler's history, first published in 1970, as *Abstract Expressionism: The Triumph of American Painting.*[22] Sandler also left Krasner out of his subsequent accounts of the art of the 1950s and of later decades.[23] This despite the positive reviews he wrote of her shows at the time they took place. Even more inexplicably, in his recent return to the subject, Sandler still omits Krasner's work but now attempts to explain why she was left out: "Lee Krasner should be included in the Abstract Expressionist canon. She is not because she kept out of the New York scene for personal reasons; it would have threatened her marriage to Jackson Pollock. . . . Her first one-person show was in 1951 at the Betty Parsons Gallery."[24] Sandler's contention is simply not supported by the evidence, especially because Krasner showed her work in group shows in New York during the 1940s and the 1950s.

Sandler claims that "had she wanted to she could have been included among the Irascibles in their famous [1950] photograph in *Life,* but she did not."[25] Sandler never explains how he knows this; perhaps he imagines that Krasner could just have invited herself to join the group when the artist Barnett Newman phoned and asked if he could speak with Pollock. But this does not seem persuasive.

David Anfam, in a history of abstract expressionism written two decades after Sandler's first account, pays Krasner more attention and gives her what reads like begrudging credit: "suffice it to say that the woman tagged 'Pollock's girl' deserves a place, late developer as she was, in any balanced survey."[26] Anfam's description of Krasner as a "late developer" belies the fact that in the same discussion he also acknowledged that she was making "all-over paintings" before Pollock did, pointing out that her Little Images

"were more prescient than [Pollock's] in one notable respect. . . .
This 'all-over' structure makes the Little Image hypnotic in their
own right."[27] In fact, he makes her seem innovative and early, not
"late."

Gender-based attitudes, such as those of Sandler, Anfam, and
others, inspired revisionists like the art historian Ann Eden Gib-
son, who, in 1986, began to study abstract expressionist artists
who had been omitted from the canonical list due to their gender,
sexual preference, or racial identity. Her study was published in
1997.[28]

Despite such studies and recent publications focused entirely
on Krasner, untruths about her continue to proliferate. A Swiss
curator recently labeled Krasner "a committed Communist," who
"moved to Long Island with Pollock in search of a 'simple life,' fol-
lowing their marriage in 1945."[29] It is difficult to imagine how this
curator came to his conclusion; he cites no evidence to support it.[30]
Such false accusations must be taken seriously in a country that
has witnessed periodic Red Scares and where some municipalities
still attempt to ban books from schools. Belief that such an in-
vidious charge were true might even prompt provincial American
museums to cash in on Krasner's growing prestige on the interna-
tional market and divest their collections of major examples of her
work, acquired for modest prices at the time her reputation was
almost completely eclipsed by Pollock.

Both Krasner the artist and Krasner, Pollock's wife, were cen-
tral to the development of abstract expressionism. The catalogue
raisonné made reproductions of the entirety of her work accessible.
Finally, we can relate her extraordinary life and mind to the art
she struggled to make and to her achievement in bringing both
her own and Pollock's work to the public.

# SELECTED BIBLIOGRAPHY:
# FREQUENTLY USED SOURCES

The author wishes to acknowledge the use of the unpublished papers from:

The Archives of American Art, Smithsonian Institution, Washington, D.C. (and online):
Lee Krasner and Jackson Pollock papers
Harold Rosenberg and May Tabak Rosenberg Papers

The Getty Research Institute, Los Angeles:
Clement Greenberg papers (950085)
Harold Rosenberg papers (980048)

Museum of Modern Art, New York:
Archives

New York Public Library, New York:
Jeff Kisseloff papers
Yaddo Colony papers

Pollock-Krasner House and Study Center, East Hampton, New York:
Lee Krasner papers

## Frequently Cited Abbreviations

| AAA | American Abstract Artists (in text) |
|---|---|
| AAA | Archives of American Art, Smithsonian Institution (in notes) |
| Author | Gail Levin |
| CG | Clement Greenberg |
| EDACA | Eastern Diocese of the Armenian Church of America, New York, NY |
| Getty | Getty Research Institute, Los Angeles, CA |
| JPCR | Francis V. O'Connor and Eugene V. Thaw, *Jackson Pollock: A Catalogue Raisonné* (New Haven, CT: Yale University Press, 1978), 4 vols. |

JP        Jackson Pollock
LK        Lee Krasner
LKCR      Ellen G. Landau, *Lee Krasner: A Catalogue Raisonné* (New York: Harry N. Abrams, 1995)
LKP       Lee Krasner Papers
MS.       Manuscript
MoMA      The Museum of Modern Art, New York, NY
Morgan    The Morgan Library and Museum, New York, NY
ND        Not dated
NP        Not paginated
NYPL      New York Public Library
NYT       *New York Times*
PKF       Pollock-Krasner Foundation, New York, NY
PKHSC     Pollock-Krasner House and Study Center, Stony Brook Foundation, SUNY
WPA       Works Progress Administration

Other abbreviations given in left column below:

## Interviews with Krasner,
### as Published in Articles or Books or Unpublished, Chronologically Arranged
### (AAA Means That These Clippings Were Saved by Krasner and Are in Her Papers on Microfilm)

1950-Roueché  LK & JP to Berton Roueché, "Talk of the Town: Unframed Space," *The New Yorker,* August 5, 1950, 16.

1958-Time  "Mrs. Jackson Pollock," *Time,* March 17, 1958, 64.

1960-Rago  LK to Louise Elliott Rago, "We Interview Lee Krasner," *School Arts,* 60, September 1960, 32.

1961-Tenke  LK quoted in Lois Tenke, "Pollock's Widow Paints in His Old Studio," *Newsday,* August 28, 1961, 37.

1963-Barker  LK to Walter Barker, "Art Community on Long Island," *St. Louis Post-Dispatch,* September 15, 1963, LK papers, AAA, reel 3776, frame 1038.

1964-Seckler  LK to Dorothy Seckler, Interview of November 2, 1964, AAA.

1965-Forge  Lee Krasner to Andrew Forge, interview of 1965, AAA, reel, 3774.

1965-Rosenberg  Harold Rosenberg, "The Art Establishment," *Esquire,* January 1965.

1966-Mooradian  Lee Krasner to Karlen Mooradian, interview of May 6, 1966, published in Karlen Mooradian, *The Many Worlds of Arshile Gorky* (Chicago: Gilgamesh Press, 1980).

1966-Rose  LK to Barbara Rose, interview of July 31, 1966, AAA.

1967-du Plessix  Krasner quoted in interview by Francine du Plessix and Cleve Gray, "Who Was Jackson Pollock?" *Art in America,* May–June 1967, 51.

1967-Flora  LK quoted in Doris P. Flora, "Artist Would be 'Back-Tracking,'" *Tuscaloosa News,* 02-15-1967, AAA, LK papers, roll 3776, frame 1050.

1967-Glaser  Lee Krasner to Bruce Glaser, interview for Art Forum # 1, AAA, undated, 1967.

1967-Nation  Pat Nation, "The Artist Is Leading a Double Life, *Los Angeles Times,* fall 1967, AAA, Krasner papers, reel 1048.

1967-Parsons  Lee Krasner interviewed by Anne Bowen Parsons, AAA.

1967-Seckler  LK to Dorothy Seckler, interview of 12-14-1967, AAA.

1968-Campbell  Lawrence Campbell, "Of Lilith and Lettuce," *Art News,* March 1968, 62.

1968-Glueck  LK to Grace Glueck, "Art Notes: And Mr. Kenneth Does Her Hair," *New York Times,* March 17, 1968, D34.

1968-Wasserman-1  LK to Emily Wasserman, Interview of 1-9-68, LKP, AAA.

1968-Wasserman-2 Lee Krasner to Emily Wasserman, quoted in "Lee Krasner in Mid-Career," *Artforum,* March 1968, 43.

1970-Monroe Gerald Monroe interview with Lee Krasner Pollock, notes from taped interview of 5-23-1970.

1972-Gruen LK quoted from 1969 interview in John Gruen, *The Party's Over Now* (New York: The Viking Press, 1972), 232–33.

1972-Holmes LK to Dorothy Holmes, Interview, 1972, AAA.

1972-Rose-1 LK to Barbara Rose, interview of March 1972, AAA, roll 3774.

1972-Rose-2 Lee Krasner to Barbara Rose, "American Great: Lee Krasner," *Vogue,* June 1972, 12. 154.

1973-Barkas Lee Krasner to Janet Barkas, "Who's Who in East Hampton, Part I: Artists," *Paumanok,* vol. 1, no. 2, July 1973, 35.

1973-Freed LK to Hermine Freed, videotaped interview, 1973, PKHSC.

1973-Gratz Roberta Brandes Gratz, "Daily Closeup: After Pollock," *New York Post,* December 6 1973, LKP, AAA, roll 3776.

1973-Nemser Lee Krasner to Cindy Nemser, "A Conversation with Lee Krasner," *Arts Magazine,* April 1973, 44.

1973-Smith LK to Betty Smith, interview of 11-3-1973 in New York City, PKHSC.

1973-Wallach-1 Amei Wallach, "21/60 = A Grandad of a Show," *Newsweek,* July 22, 1973.

1973-Wallach-2 Lee Krasner quoted in Amei Wallach, "Lee Krasner, Angry Artist," *Newsday,* November 12, 1973, 4A.

1974-Hutchinson LK quoted by Bill Hutchinson, "Lee Krasner's an Artist, Too," *Miami Herald,* March 13, 1974, C4.

1975-Nemser-1 Cindy Nemser. *Art Talk: Conversations with 12 Women Artists* (New York: Charles Scribner's Sons, 1975).

1975-Nemser-2 LK to Cindy Nemser, "The Indomitable Lee Krasner," *Feminist Art Journal,* Spring 1975, IV, 6.

1976-Glueck LK quoted in Grace Glueck, "Art People," *New York Times,* June 18, 1976, AAA, reel 3776, frame 1165.

1976-Newsday LK quoted in "The Tops and Flops," *Newsday,* December 26, 1976, AAA, reel 3776, frame 1170.

1977-Diamonstein-1 LK to Barbaralee Diamonstein, interview transcript dated 1978 but took place in 1977, LKP, AAA, roll 3774; in Barbaralee Diamonstein, ed., *Inside New York's Art World* (New York: Rizzoli, 1980).

1977-Bourdon LK to David Bourdon, "Lee Krasner: I'm Embracing the Past," *Village Voice,* March 7, 1977.

1977-Glueck-1 LK to Grace Glueck, "Art People: How to Recycle Your Drawings," *New York Times* February 25, 1977, AAA, reel 3776, frame 1179.

1977-Glueck-2 LK to Grace Glueck, "The 20th Century Artist Most Admired by Other Artists," *Art News,* November 1977.

1977-Ratcliff LK to Carter Ratcliff, Interview of 8-7-1977, *Art in America,* September–October 1977.

1977-Rodgers LK to Gaby Rodgers, interview of 1977, AAA, roll 3774; published as "She Has Been There Once or Twice; A Talk with Lee Krasner," *Women Artists Newsletter,* December 1977, 3.

1977-Rose-1 Barbara Rose, outtakes for "Lee Krasner: The Long View," film, 1978, based on interviews in August 29, 1977, by Gail Levin and others during 1977.

1977-Tallmer Jerry Tallmer, "Scissors, Paste & Bits of Survival," *New York Post,* February 1977, AAA, reel 3776, frame 1175-B.

1977-Wallach Lee Krasner to Amei Wallach, "Lee Krasner's Collages May Finally Put Mrs. Jackson Pollock in the Shade," *Newsday,* February 20, 1977, reel 3776, frame 1177.

1978-Cavaliere LK to Barbara Cavaliere, interview of c. 1978, AAA, reel 3774.

1978-Glueck Grace Glueck, "Art People," *New York Times,* November 24, 1978.

1978-Howard  LK to Richard Howard, "A Conversation with Lee Krasner," 1978, in *Lee Kras-ner Paintings 1959–1962,* The Pace Gallery, 1979, reprinted in *Lee Krasner: Umber Paintings 1959–1962* (New York: Robert Miller Gallery, 1993), n.p.

1978-Rose-1  LK to Barbara Rose, in "Pollock's Studio: Interview with Lee Krasner," in Barbara Rose, ed., *Pollock Painting* (New York: Agrinde Publications Ltd., 1978).

1978-Rose-2  Barbara Rose, *Lee Krasner: The Long View,* film, American Federation of the Arts, 1978.

1979-Cavaliere  Krasner to Barbara Cavaliere in "Lee Krasner: A Meeting of Past and Present," *SoHo Weekly News,* February 1–7, 1979, 41.

1979-Munro  Eleanor Munro, *Originals: American Women Artists* (New York: Simon & Schuster, 1979).

1979-Novak  LK to Barbara Novak, unpublished WGBH-TV, interview, 1979, LKP, AAA.

1980-Bennett  LK quoted in Evelyn Bennett, "Homage to a Famous Husband: Lee Krasner: An Artist in Her Own Right," *Bridgehampton Sun,* August 20, 1980, LKP, AAA, roll 3776, frames 1298–99.

1980-Braff  LK to Phyllis Braff, "From the Studio," *East Hampton Star,* 8-21-1980.

1980-Cavaliere  LK in Barbara Cavaliere, "An Interview with Lee Krasner," *Flash Art,* Jan/Feb. 1980, 12.

1980-Portfolio  Lee Krasner in *Portfolio,* vol. II, no. 1, February/March 1980, special issue, "Women Artists on Women in Art," 68–69.

1980-Taylor  LK quoted in Robert Taylor, "Lee Krasner: Artist in Her Own Right," *The Boston Globe,* May 18, 1980, C1.

1981-Delatiner  LK to Barbara Delatiner, "Lee Krasner: Beyond Pollock," *New York Times,* August 9, 1981.

1981-Glueck-1  Lee Krasner quoted in Grace Glueck, "Art Talk," *New York Times,* November 6, 1981, C22.

1981-Glueck-2  LK to Grace Glueck, "Scenes from a Marriage: Krasner and Pollock," *Art News,* De-cember 1981, 60.

1981-Langer  LK interviewed by Cassandra (Sandra L.) Langer, transcript of lost tape of March 1981, recorded in part by Ann Eden Gibson and provided to the author with the cooperation of Langer.

1981-Tallmer  Jerry Tallmer, "Krasner's Season in the Sun," *New York Post,* April 4, 1981, 17, AAA, roll 3776, frame 1330.

1981-Wallach  LK quoted in Amei Wallach, "Lee Krasner: Out of Jackson Pollock's Shadow," *News-day,* 1981, 12, LK Papers, AAA, reel 3776.

1983-Hoffner  Lee Krasner to Marilyn Hoffner of The Cooper Union, letter of May 16, 1983, AAA, reel 3773, frame 1344.

1983-Johnson  Lee Krasner quoted in Patricia C. Johnson, *Houston Chronicle,* November 3, 1983, section 4, 1.

1983-Kernan  LK quoted by Michael Kernan, "Out of Pollock's Shadow: Her Life & Art Seen Whole at Last," *Washington Post,* October 23, 1983, L1, L2.

1983-Liss  LK to Joseph Liss, "Memories of Bonac Painters," *East Hampton Star,* Summer 1983, LKP, AAA, roll 3777.

1984-Cannell  Lee Krasner to Michael Cannell, "An Interview with Lee Krasner," *Arts Magazine,* vol. 59, September 1984.

1984-Kernan  Michael Kernan, "Lee Krasner, Shining in the Shadow," *Washington Post,* June 21, 1984, B9.

1984-Myers  LK to John Bernard Myers, "Naming Pictures: Conversations between Lee Krasner and John Bernard Myers," *Artforum,* vol. 23, no. 3, November 1984.

### Testimony from Others: Interviews Not by the Author, Published and Unpublished Memoirs

1957-Pollock  Interview with Selden Rodman, spring 1956. In Rodman, *Conversations with Artists* (New York: Devin-Adair, 1957).

1960-Gibbs  David Gibbs to Clement Greenberg, letter of 5-6-1960, copy sent to LK by Gibbs, Collection PKHSC.

1963-Friedman, S-1  Sanford Friedman to David Gibbs, letter of 1-22-1963, Collection PKHSC.

1963-Friedman, S-2  Sanford Friedman to David Gibbs, 2-3-1963, PKHSC.

1963-Friedman, S-3  Sanford Friedman for LK to David Gibbs, 2-20-1963, PKHSC.

1963-Spivak  Max Spivak to Harlan Phillips, 1963, AAA.

1964-Gorelick  Boris Gorelick to Betty Hoag, interview of 5-20-1964, AAA.

1964-Holty  Carl Holty interviewed by William Agee, December 8, 1964, AAA.

1964-Trubach  Serge Trubach interview, 12-5-1964, AAA.

1965-Block  Irving Block to Betty Hoag, interview of 4-16-1965, AAA.

1965-Newman  Barnett Newman interview with Neil A. Levine, "The New York School Question," *Art News*, vol. 64, no.5, September 1965, reprinted in John P. O'Neill, *Barnett Newman: Selected Writings and Interviews* (New York: Alfred A. Knopf, 1990), 262–63.

1965-Vogel  Joseph Vogel to Betty Hoag, interview of January 5, 1965, AAA.

1966-Greenberg  Clement Greenberg to Karlen Mooradian, unpublished taped interview, 1966, at the Eastern Diocese of the Armenian Church of America.

1967-de Kooning  Willem de Kooning to Anne B. Parsons, interview of 1967, AAA.

1967-Greene  Balcomb Greene to Anne B. Parsons, interview of 9-5-1967, AAA.

1967-Kadish  Reuben Kadish to Anne B. Parsons, interview of 1967, AAA.

1967-McNeil  George McNeil to Anne B. Parsons, interview of 11-14-1967, AAA.

1968-Bultman  Fritz Bultman to Irving Sandler, interview of 1-6-1968, AAA.

1968-McNeil  George McNeil to Irving Sandler, interviews of 1-9-1968 and 5-21-1968, AAA.

1968-Ossorio  Alfonso Ossorio to Forrest Selvig, New York, November 19, 1968, AAA.

1970-Rosenberg  Harold Rosenberg to Paul Cummings, interviews of 12-17-1970 and 6-30-1971, AAA.

1970-Spivak  Max Spivak to Gerald Monroe interview of 3-11-70, notes from taped interview.

1971-Groh  History/reminiscence by Alan Groh, 1971, unpublished ms., AAA, Reel 5823.

1971-Motherwell  Robert Motherwell interviews with Paul Cummings, November 24, 1971–May 1, 1974, AAA.

1972-Ashton  Dore Ashton, *The Life and Times of the New York School* (London: Adams & Dart, 1972).

1979-Hartigan  Grace Hartigan interview with Julie Haefley of May 10, 1979, AAA.

1980-Ossorio  Alfonso Ossorio interviewed by Judith Wolfe in *Alfonso Ossorio, 1940–1980,* Guild Hall Museum, East Hampton, N.Y., 1980.

1982-Bolotowsky  Ilya Bolotowsky, "Adventures with Bolotowsky," *Archives of American Art Journal,* vol. 22, no. 1 (1982), 16.

1982-Bunce  Louis Bunce to Rachel Rosenfield Lafo, Portland Oregon, December 3, 9, 13, 1982, AAA.

1982-Johnson  Buffie Johnson to Barbara Shikler, interview of November 13, 1982, AAA.

1982-Klein  Ralph Klein to Jeffrey Potter, 5-18-1982, recorded interview, PKHSC.

1984-Jonas  Robert Jonas to Judith Wolfe, interview of 11-13-1984.

1984-Little  John Little, "Remembering Lee Krasner," *East Hampton Star,* 7-12-1984, II-1.

1987-Kamrowski  Gerome Kamrowski to Martica Sawin, interview of November 1987, Ann Arbor, Michigan.

1990-Greenberg  Clement Greenberg to Florence Rubenfeld, transcript of interview, 2-16-1990, CG Papers, The Getty Research Institute.

1998-Gaines  Steven Gaines, *Philistines at the Hedgerow: Passion and Property in the Hamptons* (New York: Little, Brown and Company, 1998).

1998-Matter  Mercedes Carles Matter, transcript of audiocassette, "Remembering Pollock: A Dialogue of His Friends," Museum of Modern Art, N.Y., November 17, 1998, Kirk Varndoe, moderator.

2001-Freas  Jean Freas interview with Michael Brenson, December 11, 2001.

ND-Kadish  Reuben Kadish interviewed by Jeff Kisseloff, NYPL.

ND-Tabak-1  May Tabak (Rosenberg), "Lee and Igor," unpublished, n.d, ms., AAA.

ND-Tabak-2  May Tabak (Rosenberg), "Art Project," unpublished, n.d., ms, AAA.

ND-Tabak-3  May Tabak (Rosenberg), "Cops," unpublished, n.d., ms., AAA.

ND-Tabak-4  May Tabak (Rosenberg), "One-Liners," unpublished, n.d., ms., AAA.

ND-Hofmann  Hofmann left an undated essay, "Toward the True Vision of Reality," Hans Hofmann papers, AAA, box 7, roll 5808.

ND-Pantuhoff, Sr.  Oleg Ivanovich Pantuhoff, Sr. *Of Time Gone By*, a memoir, translation from original written in Russian.

ND-Southgate  Patsy Southgate, "Notes on Lee," unpublished memoir, n.d., PKHSC. Susan Larsen, "An Interview with George L. K. Morris."

## Books, Exhibition Catalogues, and Articles, Chronologically Arranged

1912-Maeterlinck  Maurice Maeterlinck. *On Emerson and Other Essays* (New York: Dodd, Mead, and Co., 1912), foreword and translated by Montrose J. Moses.

1926-27-Cooper  Catalogue for *Cooper Union for the Advancement of Science and Art, Woman's Art School,* New York, 1926–27.

1927-Gilman  Charlotte Perkins Gilman, "Progress through Birth Control," *The North American Review,* vol. 224, no. 888, December 1927, 628.

1936-Barr-1  Alfred H. Barr, Jr., *Cubism and Abstract Art* (New York: The Museum of Modern Art, 1936).

1936-Barr-2  Alfred H. Barr, Jr., *Fantastic Art, Dada, and Surrealism* (New York: The Museum of Modern Art, 1936).

1936-Cahill  Holger Cahill, *New Horizons in American Art* (New York: The Museum of Modern Art, 1936).

1937-Graham  John Graham, *System and Dialectics of Art.*

1939-Miller  Henry Miller, *The Cosmological Eye* (New York: New Directions, 1939).

1944-Janis  Sidney Janis, *Abstract & Surrealist Art in America* (New York: Reynal & Hitchcock, 1944).

1946-Guggenheim  Peggy Guggenheim, *Out of This Century* (New York: Dial Press, 1946).

1952-Rosenberg  Harold Rosenberg, "The American Action Painters," *Art News,* December 1952, 22–23, 48–50.

1952-Warner  Langdon Warner, *The Enduring Art of Japan* (Cambridge, Mass.: Harvard University Press, 1952).

1952-Zborowski  Mark Zborowski and Elizabeth Herzog, *Life Is with People: The Jewish Little-Town of Eastern Europe* (New York: International Universities Press, 1952).

1957-Morris  George L. K. Morris, "The American Abstract Artists: A Chronicle 1936–56," in *The World of Abstract Art,* eds. The American Abstract Artists (New York: George Wittenborn, 1957), 133–48.

* 1958-Ventura  A.V. [Anita Ventura], "Lee Krasner," *Arts Magazine,* April 1958, 60.

1959-Friedman  B. H. Friedman, "Manhattan Mosaic," *Craft Horizons,* 19, January/February 1959, 26.

1960-Guggenheim  Peggy Guggenheim, *Confessions of an Art Addict* (London: 1960).

1960-Robertson  Bryan Robertson. *Jackson Pollock* (New York: Harry N. Abrams).

1961-Raynor [V.R.] Vivien Raynor, "Lee Krasner," *Arts Magazine*, 35, January 1961, 54.

1961-Rosenberg Harold Rosenberg, "The Search for Jackson Pollock," *Art News*, 59, no. 10, February 1961, 58–60.

1961-Sandler I.H.S. [Irving H. Sandler], "Lee Krasner's," *Art News*, January 1961, 15.

1962-Sandler I.H.S. [Irving H. Sandler], "Lee Krasner's," *Art News*, March 1962, 12–13.

1963-Zinsser William K. Zinsser, "Far Out on Long Island," *Horizon*, May 1963, 9.

1965-Friedman B. H. Friedman, *Lee Krasner Paintings, Drawings and Collages* (London: Whitechapel Gallery, 1965).

1965-Robertson Bryan Robertson, *Lee Krasner Paintings, Drawings and Collages* (London: Whitechapel Gallery, 1965).

1965-Times "Pollock," Sunday *Times* (London), September 19, 1965, Krasner papers, AAA, reel 3776, frame 1043.

1966-Rosenberg Harold Rosenberg, *The Anxious Object Art Today and Its Audience* (New York: Horizon Press, 1966).

1970-Rembert Virginia Pitts Rembert, "Mondrian, America, and American Painting," doctoral dissertation, Columbia University, 1970.

1970-Sandler Irving Sandler, *Abstract Experssionism: The Triumph of American Painting* (New York, 1970).

1971-Monroe Gerald M. Monroe, *The Artists Union of New York* doctoral thesis, New York University, 1971.

1972-Ashton Dore Ashton, *The Life and Times of the New York School* (London: Adams & Dart, 1972).

1972-Glueck Grace Glueck, "Women Artists Charge Bias at Modern Museum," *New York Times*, April 15, 1972.

1972-Gruen John Gruen, *The Party's Over Now* (New York: The Viking Press, 1972).

1973-Friedman B. H. Friedman, *Alfonso Ossorio* (New York: Harry N. Abrams, 1973).

1973-Greenberg Clement Greenberg to the editor, *Arts Magazine*, vol. 98, no. 3, November 1973, 71.

1973-Tucker Marcia Tucker, *Lee Krasner: Large Paintings* (New York: Whitney Museum of American Art, 1973).

1974-Blum Eva Maria Blum and Richard H. Blum, *Alcoholism: Modern Psychological Approaches to Treatment* (San Francisco: Jossey-Bass Publishers, 1974).

1974-Kligman Ruth Kligman, *Love Affair: A Memoir of Jackson Pollock* (New York: William Morrow and Co., Inc., 1974).

1974- Schapiro, ed. Miriam Schapiro, ed., *Anonymous Was a Woman: A Documentation of the Women's Art Festival A Collection of Letters to Young Women Artists* (Valencia, Calif.: Feminist Art Program, California Institute of the Arts, 1974), 95–96.

1975-Baro Gene Baro, "Introduction," in *Lee Krasner: Collages and Works on Paper, 1933–1974*, (Washington, D.C.: Corcoran Gallery of Art, 1975).

1975-Friedman B. H. Friedman, *Almost a Life: A Novel* (New York: Viking Press, 1975).

1975-Taylor Robert Taylor, "Lee Krasner Claims Her Place in Art," *Boston Globe*, September 21, 1975, A9.

1976-Bandes Lucille Bandes, "Women and Art," *L'Official* Holiday Issue, 1976, AAA, reel 3775, frame 1163.

1976-Hurlburt Laurance P. Hurlburt, "The Siqueiros Experimental Workshop: New York, 1935," *Art Journal*, vol. 35, no. 3, Spring 1976, 238–39.

1976-Rose Barbara Rose, "Arshile Gorky and John Graham: Eastern Exiles in a Western World," *Arts Magazine*, 70, n. 3, March 1976.

1977-Diamonstein-2 Barbaralee Diamonstein, ed., *The Art World: A Seventy-five Year Treasury of Artnews* (New York: Artnews Books, 1977).

1977-Kramer Hilton Kramer, "Two New Shows—Lee Krasner and Mary Frank," *New York Times*, March 6, 1977.

1977-Rose-2  Barbara Rose, "Lee Krasner and the Origins of Abstract Expressionism," *Arts Magazine,* February 1977, 100.

1978-Berman  Greta Berman, *Mural Painting in New York* (New York: Garland, 1978).

1978-Levin  Robert Hobbs and Gail Levin, *Abstract Expressionism: The Formative Years* (Ithaca, N.Y.: Cornell University Press, 1978).

1978-Rothman  Sheila M. Rothman, ed., *Woman's Proper Place* (New York: Basic Books, 1978).

1979-Guggenheim  Peggy Guggenheim, *Out of This Century: Confessions of an Art Addict* (New York: Universe Books, 1979).

1980-Mooradian  Karlen Mooradian, *The Many Worlds of Arshile Gorky* (Chicago: Gilgamesh Press, 1980).

1980-Slobodkina  Esphyr Slobodkina, *Notes of a Biographer* (Great Neck, N.Y.: Urquart-Slobodkina, Inc., 1976–1983), 3 vols. of which vol. 2 is 1980.

1981-Cavaliere  Barbara Cavaliere, "Lee Krasner," *Arts Magazine,* vol. 55, June 1981, 34.

1981-Rose  Barbara Rose, *Krasner/Pollock: A Working Relationship* (New York: Grey Art Gallery and Study Center, New York University, 1981).

1983-Myers  John Bernard Myers, *Tracking the Marvelous: A Life in the New York Art World* (New York: Random House, 1983).

1983-Hughes  Robert Hughes, "Bursting Out of the Shadows," *Time,* November 14, 1983, 92.

1983-Kalil  Susie Kalil, "Lee Krasner: A Life's Work," *Artweek,* December 10, 1983, 1.

1983-Rose  Barbara Rose, *Lee Krasner* (New York: MoMA, 1983).

1984-Abel  Lionel Abel, *The Intellectual Follies: A Memoir of Literary Ventures in New York and Paris* (New York: W. W. Norton & Company, 1984).

1984-Memorial  "Lee Krasner Lauded in Memorial Service at the Met Museum," *New York Times,* September 18, 1984.

1984-Vetrocq  Marcia E. Vetrocq, "An Independent Tack: Lee Krasner," *Art in America,* May 1984, 143.

1984-Woodward  Catherine Woodard, "Lee Krasner Remembered," *Newsday,* June 26, 1984, 28.

1985-Potter  Jeffrey Potter, *To a Violent Grave: An Oral Biography of Jackson Pollock* (Wainscott, N.Y.: Pushcart Press, 1985).

1986-Conason  Joe Conason with Ellen McGarrahan, "Escape from Utopia," *Voice,* April 22, 1986, 21.

1986-Weld  Jacqueline Bograd Weld, *Peggy: The Wayward Guggenheim* (New York: E. P. Dutton, 1986).

1987-Siegel  Leonard I. Siegel, "Sullivan's Conceptual Contributions to Child Psychiatry," *Contemporary Psychoanalysis,* XXIII, 1987, 278–98.

1987-Solomon  Deborah Solomon, *Jackson Pollock: A Biography* (New York: Simon & Schuster, 1987).

1988-Silvester  Peter J. Silvester, *A Left Hand Like God: A History of Boogie-Woogie Piano* (London, Great Britain: Quartet Books, Ltd., 1988).

1989-Hoban  Phoebe Hoban, "Psycho Drama," *New York* magazine, June 19, 1989, 41–53.

1989-Kisseloff  Jeff Kisseloff, *You Must Remember This: An Oral History of Manhattan from the 1890s to World War II* (New York: Schocken Books, 1989).

1989-Naifeh  Steven Naifeh and Gregory White Smith, *Jackson Pollock: An American Saga* (New York: Clarkson Potter, 1989).

1990-Anfam  David Anfam, *Abstract Expressionism* (London: Thames and Hudson, 1990).

1990-Shapiro  David Shapiro and Cecile Shapiro, eds. *Abstract Expressionism: A Critical View* (Cambridge: Cambridge University Press, 1990).

1991-Hall  Lee Hall, *Betty Parsons Artist Dealer Collector* (New York: Harry N. Abrams, 1991).

1993-Greenberg  Clement Greenberg, *The Collected Essays and Criticism,* ed. John O'Brian (Chicago: University of Chicago Press, 1993), vol. 3, *Affirmations and Refusals, 1950–1956.*

1993-Hall  Lee Hall, *Elaine and Bill: Portrait of a Marriage* (New York: HarperCollins, 1993).

1993-Hobbs  Robert Hobbs, *Lee Krasner* (New York: Abbeville, 1993).

1993-Whipple  Enez Whipple, *Guild Hall of East Hampton: An Adventure in the Arts: The First 60 Years* (New York: Harry N. Abrams, Inc., 1993).

1994-Carroll  Peter N. Carroll, *The Odyssey of the Abraham Lincoln Brigade: Americans in the Spanish Civil War* (Palo Alto, Calif.: Stanford University Press, 1994).

1994-Jong  Erica Jong, *Fear of Fifty: A Midlife Memoir* (New York: HarperCollins, 1994).

1995-Friedman  B. H. Friedman, *Jackson Pollock: Energy Made Visible* (New York: McGraw-Hill, 1972; Da Capo Edition, 1995).

1995-Gabor  Andrea Gabor, *Einstein's Wife: Work and Marriage in the Lives of Five Great Twentieth-Century Women* (New York: Viking, 1995).

1995-Hyman  Paula E. Hyman, *Gender and Assimilation in Modern Jewish History: The Roles and Representation of Women* (Seattle: University of Washington Press, 1995).

1995-Sawin  Martica Sawin, *Surrealism in Exile and the Beginning of the New York School* (Cambridge, Mass.: The MIT Press, 1995).

1995-Wagner  Anne M. Wagner, "Fictions: Krasner's Presence, Pollock's Absence," in Whitney Chadwick and Isabelle de Courtivron, eds., *Significant Others: Creative and Intimate Partnership* (New York: Thames & Hudson Inc., 1995).

1996-Braff  Phyllis Braff, *The Surrealists and Their Friends on Eastern Long Island at Mid-Century* (East Hampton: Guild Hall Museum, 1996).

1996-Joosten  Joop M. Joosten and Robert P. Welsh, *Piet Mondrian: A Catalogue Raisonné* (New York: Harry N. Abrams, 1998), 2 vols.

1996-Wagner  Anne M. Wagner, *Three Artists (Three Women) Modernism and the Art of Hesse and O'Keeffe* (Berkeley, Calif.: University of California, 1996).

1997-Erenberg  Lewis Erenberg, "Greenwich Village Nightlife 1910–1950," in Rick Beard and Leslie Cohen Berlowitz, eds., *Greenwich Village Culture and Counterculture* (New Brunswick, N.J.: Rutgers University Press, 1997).

1997-Gibson  Ann Eden Gibson, *Abstract Expressionism: Other Politics* (New Haven: Yale University Press, 1997).

1997-Rubenfeld  Florence Rubenfeld, *Clement Greenberg: A Life* (New York: Scribner, 1997).

1998-Gaines  Steven Gaines, *Philistines at the Hedgerow: Passion and Property in the Hamptons* (New York: Little, Brown and Company, 1998).

1998-Karmel  Pepe Karmel, *Jackson Pollock Interviews, Articles, and Reviews* (New York: The Museum of Modern Art, 1998).

1998-Kirkham  Pat Kirkham, *Charles and Ray Eames: Designers of the Twentieth Century* (Cambridge, Mass.: MIT Press, 1998).

1998-Varnedoe  Kirk Varnedoe with Pepe Karmel, *Jackson Pollock* (New York: The Museum of Modern Art, 1998).

1998-White  William L. White, *Slaying the Dragon: The History of Addiction Treatment and Recovery in America* (Bloomington, Ill.: Chesnut Health Systems/Lighthouse Institute, 1998).

1999-Craven  David Craven, *Abstract Expressionism as Cultural Critique: Dissent during the McCarthy Period* (New York: Cambridge University Press, 1999).

1999-Friedman  B. H. Friedman, "Lee Krasner: An Intimate Introduction," in *Lee Krasner* (New York: Harry N. Abrams, 1999).

1999-Hobbs  Robert Hobbs, *Lee Krasner* (New York: Harry N. Abrams, 1999).

1999-Martin  Richard Martin, *Charles James* (New York: Universe Books, 1999).

2000-Matossian  Nouritza Matossian, *Black Angel: The Life of Arshile Gorky* (Woodstock, N.Y.: The Overlook Press, 2000).

2000-Harrison  Helen A. Harrison, ed., *Such Desperate Joy Imagining Jackson Pollock* (New York: Thunder's Mouth Press, 2000).

2001-Abeles  Anne L. Abeles, *James Brooks: From Dallas to the New York School*, doctoral dissertation, Graduate School of the City University of New York, 2001.

2002-Arnett  LK quoted in William Arnett, Alvia Wardlaw, et al., *The Quilts of Gee's Bend: Masterpieces from a Lost Place* (New York: Tinwood Books, 2002).

2002-Gill  Anton Gill, *Art Lover: A Biography of Peggy Guggenheim* (New York: HarperCollins Publishers, 2002).

2002-Harrison  See Helen Harrison and Constance Ayers Denne, *Hamptons Bohemia: Two Centuries of Artists and Writers on the Beach* (San Francisco: Chronicle Books, 2002).

2002-Hemingway  Andrew Hemingway, *Artists on the Left: American Artists and the Communist Movement, 1926–1956* (New Haven: Yale University Press, 2002).

2002-Rembert  Virginia Pitts Rembert, *Mondrian in the USA* (Parkstone Press Ltd., 2002).

2003-Herrera  Hayden Herrera, *Arshile Gorky: His Life and Work* (New York: Farrar, Straus & Giroux, 2003).

2003-Siskind  Amy B. Siskind, *The Sullivan Institute/Fourth Wall Community*: *The Relationship of Radical Individualism and Authoritarianism* (Westport, Conn.: Praeger, 2003).

2004-Dearborn  Mary V. Dearborn, *Mistress of Modernism: The Life of Peggy Guggenheim* (New York: Houghton Mifflin Co., 2004).

2004-Howard  Richard Howard, "Lee Listening," in *Paper Trail: Selected Prose, 1965–2003* (New York: Farrar, Straus & Giroux, 2004).

2004-Stevens  Mark Stevens and Annalyn Swan, *Willem de Kooning: An American Master* (New York: Alfred A. Knopf, 2004).

2005-Housley  Kathleen L. Housley, *Tranquil Power: The Art and Life of Perle Fine* (Glastonbury, Conn. and New York: Midmarch Arts Press, 2005).

2005-Tracy  Sarah W. Tracy, *Alcoholism in America: From Reconstruction to Prohibition* (Baltimore: Johns Hopkins University Press, 2005).

2006-Marquis  Alice Goldfarb Marquis, *Art Czar: The Rise and Fall of Clement Greenberg* (Boston: MFA Publications, 2006).

2006-Miller  Betsy Wittenborn Miller, in *Dialogue: Lee Krasner and Jackson Pollock* (New York: Robert Miller Gallery, 2006).

2006-Rose  Barbara Rose, "Lee Krasner and Jackson Pollock: Comrades in Art," in *Dialogue: Lee Krasner and Jackson Pollock* (New York: Robert Miller Gallery, 2006).

2006-Wilkin  Karen Wilkin, "Maverick Mondernists," *The New Criterion*, September 2006, 97.

2007-Landau  Ellen G. Landau, "Action/Re-action: The Artistic Friendship of Herbert Matter and Jackson Pollock," in *Pollock Matters,* ed. E. G. Landau and Claude Cernuschi (Boston: McMullen Museum of Boston College, 2007), 9–57.

2007-Levin  Gail Levin, *Becoming Judy Chicago: A Biography of the Artist* (New York: Harmony Books, 2007).

2008-Kleeblatt  Norman L. Kleeblatt, ed., *Action/Abstraction: Pollock, De Kooning, and American Art, 1940–1976* (New Haven: Yale University Press, 2008).

2008-Küster  Ulf Küster, *Action Painting* (Basel, Switzerland: Fondation Beyeler, 2008).

2008-Tucker  Marcia Tucker, *a short life of trouble: forty years in the new york art world* (Berkeley: University of California Press, 2008).

2009-Sandler  Irving Sandler, *Abstract Expressionism and the American Experience: A Reevaluation* (Lenox, Mass.: Hard Press Editions, 2009).

# NOTES

1. ND-Southgate.
2. ND-Kiesler.
3. Ronald Stein quoted in 1995-Gabor, 67.
4. In 1959, while her aunt was making her reputation as a painter and not just as Pollock's widow, Rusty Kanokogi, disguised as a man, won a medal at a YMCA judo tournament, because women were not allowed to compete. She later promoted women's judo all the way to its entrance into the 1988 World Olympics. Author's interview with Kanokogi, 6-18-2008.
5. Rusty Kanokogi quoted in Gary Smith, "Rambling with Rusty," *Sports Illustrated,* March 24, 1986.
6. Author's interview with Edward Albee, 12-19-2006.
7. 1983-Myers, 103.
8. Eugene V. Thaw to the author, 5-11-2007.
9. 1990-Greenberg.
10. LKP, AAA, roll 3774, frame 319.
11. 1977-Rodgers, frame 356.
12. 1977-Diamonstein-1.
13. 1973-Gratz.
14. 1973-Gratz.
15. Robert Hughes, "Introduction," *Lee Krasner Colleges* (New York: Robert Miller Gallery, 1986), n.p.
16. This appointment is documented by a letter dated January 14, 1971, on Marlborough Gallery letterhead to Krasner from Pamela Seager, secretary to Donald McKinney, president of the gallery, LKP, AAA, roll 3772, frame 97.
17. 1975-Nemser-1, 5.
18. 1977-Diamonstein, frame 390.
19. 1984-Myers, 71.
20. 1984-Myers, 71.
21. 1973-Freed.
22. 1968-Wasserman.

23. Sometimes these errors caused the misdating of paintings, which I have revised accordingly.
24. 1980-Cavaliere, 14.

## Chapter 1: Beyond the Pale: A Brooklyn Childhood, 1908–21 (pp. 13–30)

1. Her mother entered Ellis Island with only one *s* in the spelling of their surname, while her father chose to double the letter after his arrival. Lee would later drop the second *s*. The pronunciation in Shpikov, where there are still people with the name, would imply Krasner with the double *s*.
2. Lee Krasner, note in AAA, reel 3771, frame 6, says that Joseph Krassner arrived in the U.S. in September 1900. That would mean almost a nine-year span between Lena (Lee) and the last child born in Russia. However Rose, the last born before Lena, was only six at the time of Lee's birth. Lee Krasner note, AAA, reel 3771, frame 8, says that "Papa (Joseph)—[arrived in] 1905 during Russo, Japanese, skirmish."
3. S. M. Dubnow, *History of the Jews in Russia and Poland*, vol. III (Philadelphia: Jewish Publication Society, 1920), 69–75.
4. "Jewish Massacre Denounced," *NYT,* April 28, 1903, 6.
5. In 1905, at least 92,388 left Russia for America; in 1906, the number was 125,234; in 1907, 114,932 departed; and in 1908, when Krasner's mother and siblings left, they were part of a total of 71,978. Moses Rischin, *The Promised City: New York's Jews 1870–1914* (Cambridge, Mass.: Harvard University Press, 1962), 270.
6. "Guggenheim's Jewish View," *NYT,* April 27, 1909, 4.
7. "Guggenheim's Jewish View," *NYT,* April 27, 1909, 4.
8. "Rabbi Sees Peril in Intermarriage," *NYT,* May 10, 1909, 4.
9. "Future Americans Will Be Swarthy," *NYT,* November 29, 1908, 7.
10. "A Hard Year for Hebrew Charities," *NYT,* October 22, 1908, 9.
11. According to Lee Krasner's notes: Joseph Krassner was born December 10, 1870, so that he was not quite thirty-eight at Lena's birth. Anna Krassner, born July 17, 1880, was then twenty-eight. Her mother may have later lied about her age, making herself younger, as so many women did. These ages are confirmed by the author's interviews with several family members.
12. Born Isidor Krasner in 1896, Irving Krasner attended P.S. 109 from June 1909 through September 1910, LKP, AAA. Dates of birth and ages vary according to documents. For example, the 1910 U.S. Census completed in April lists Isidor as thirteen; Joseph is listed as forty and Annie as thirty-five. Esther was said to be twelve, Ida was said to be nine, and Lena was correctly listed as one and a half. The census taker appears to have confused the names and ages of the two eldest sisters, since in this author's interview with Rena (Rusty) Glickman Kanokogi, 6/18/2008, she made clear that her mother, Edith (or Ida), was the eldest sibling and was fourteen at the time of immigration. The census taker may not have been a fluent Yiddish speaker. These ages are taken from the passenger list of the *Ryndum,* on which the family arrived from Spikow, Russia, via Rotterdam, Holland.
13. LK note, AAA, reel 3771, frame 8.
14. 1983-Rose, 13.
15. 1979-Munro, 104.
16. 1979-Munro, 104.
17. 1987-Solomon, 112. Leo Rosten, *The Joys of Yiddish* (New York: McGraw Hill Book Company, 1968), 166.
18. 1979-Munro, 104.
19. 1979-Munro, 104.
20. 1979-Novak.
21. 1979-Novak. See also 1965-Friedman, 6, who wrote: "At home Russian, Yiddish, Hebrew, and English were all spoken." It is highly unlikely that the family spoke Hebrew, which would have been reserved for prayers that they read and chanted.

22. 1979-Novak.

23. 1972-Holmes.

24. Contrary to accounts in previously published biographies of Jackson Pollock, the United States Census Report for 1910 confirms this address and William Weiss's residence with the Krasners.

25. 1987-Solomon, 111.

26. James Gersing, grandson of Esther (Estelle) Gersing, to the author, 9-17-2006.

27. 1979-Munro, 103.

28. 1977-Rodgers.

29. 1952-Zborowski, 295.

30. 1952-Zborowski, 124.

31. 1964-Seckler.

32. 1979-Munro, 104.

33. 1979-Munro, 104.

34. LK in 1975-Nemser-1, 83. This is also a source for Jeffrey D. Grove, in LKCR, 300, who also states that Krasner's siblings spoke Hebrew, but this is highly unlikely—though they must have read Hebrew and recited prayers.

35. The Krasner family appears to have moved into various rental homes in East New York mainly on Jerome Street. By the time of the 1930 U.S. census, they were at 594 Jerome Street. At other times, they lived on Jerome Street at numbers 546 and 557.

36. See Eugene L. Armbruster, *The Eastern District of Brooklyn* (New York: 1912).

37. 1979-Munro, 103.

38. 1979-Novak.

39. 1979-Munro, 103.

40. "City Grows to His Cows and Then Tells New Lots Man to Move Them—He Won't," *NYT*, 12-17-1908, 1.

41. 1979-Munro, 103.

42. Today P.S. 72 is at a different location in a building from the 1970s.

43. 1987-Solomon, 110.

44. 1979-Munro, 104.

45. "City Grows to His Cows," *NYT*, 12-17-1908, 1.

46. 1964-Seckler.

47. Ruth Krasner Stein quoted in 1989-Solomon, 111.

48. 1965-Friedman, 5.

49. Krasner's notes in AAA, roll 3771, frame 48, probably for 1965-Friedman.

50. 1995-Hyman, 112–113.

51. 1995-Hyman, 113.

52. Daniel Bell, "The Background and Development of Marxian Socialism in the United States," in Donald Drew Egbert and Stow Persons, eds., *Socialism and American Life* (Princeton: Princeton University Press, 1952), 309.

53. Paul Buhle, *From the Lower East Side to Hollywood Jews in American Popular Culture* (New York: Verso, 2004), 38–39.

54. 1979-Munro, 104; 1965-Friedman, 5–6. See also, LKP, AAA, roll 3771, frame 48.

55. James Gersing to the author, September 17, 2006.

56. Maurice Maeterlinck, *News of Spring and Other Nature Studies* (New York: Dodd, Mead, & Co., 1913), 47.

57. 1968-Campbell, 43. This statement exists in LK's hand in her papers, LKP, AAA, roll 3771, frame 703.

58. Maurice Maeterlinck, *The Blue Bird* (New York: Dodd, Mead, & Co., 1910), 19. This play was also popular at Washington Irving High School when Krasner attended. See the student magazine, the *Washington Irving Sketchbook*, ed. by Margaret McLaughlin, 1926, 31, in which Mary Altstein wrote a poem about her reading: "Oh, I've forgotten to include Maeterlinck's 'Blue Bird.'"

59. 1973-Freed. LK quoted in letter from Donald McKinney in 1974-Schapiro, ed., 95–96.
60. See Kathryn Feuer, "Fathers and Sons: Fathers and Children," in John Garraard, ed., *The Russian Novel from Pushkin to Pasternak* (New Haven: Yale University Press, 1983), 68.
61. 1979-Munro, 106, gives the name as Wollrath. The Board of Education document lists Philip L. Walrath of 9230 110th Street in Richmond Hill, Queens, as a teacher in P.S. 72. He had been teaching there only since 1911.
62. 1979-Munro, 105–6.
63. 1972-Rose-1.
64. 1964-Seckler.

## Chapter 2: Breaking Away: Determined to Be an Artist, 1922–25 (pp. 31–40)

1. Graduation date recorded on a school pin; noted by LK, AAA, reel 3771, frame 7. Some accounts cite Lenore as her birth name, which was Lena; for example: 1983-Rose, 163, and 1996-Wagner, 107.
2. 1973-Cavaliere. The author found that a book of Poe's tales with an introduction by H. W. Mabre (New York: Century, 1924) was acquired by the Washington Irving High School Library in November 1925 as per the inventory still at the school.
3. 1973-Cavaliere.
4. I take for another example of Poe's influence on this generation that of my own father, born in 1912, just four years after Krasner. He loved Poe's poems and won awards in high school for reciting them.
5. Edgar Allan Poe, "The Oval Portrait," http://eapoe.org/works/tales/ovlprta.htm [2010/02/08:].
6. Edgar Allan Poe, "The Oval Portrait," http://eapoe.org/works/tales/ovlprta.htm [2010/02/08:].
7. 1973-Cavaliere.
8. 1912-Maeterlinck, 13, Montrose J. Moses, "Foreword."
9. "Public School Notes," *NYT,* October 7, 1922, 25.
10. Lee Krasner to the author, summer 1977 and again many times in the course of conversation.
11. 1975-Nemser-1, 83.
12. Aharon Ben Alexander Kaufmann, "Letter Regarding Education" (translation from the Hebrew title), in the second and last volume of *Pirhei Tzafon*, 1844, Vilna, 43–61, quoted in Israel Zinberg, *A History of Jewish Literature, volume XI, The Haskalah Movement in Russia* (New York: Ktav Publishing House, Inc., 1978), 100–101.
13. See "A Farewell to Girls High," *Herald Tribune,* June 14, 1964. James W. Naughton designed the building.
14. Gwendolyn Bennett was one of the first African American students at the school. See "6 Colored Pupils Will Attend Girls High Prom Tonight," *Brooklyn Daily Eagle,* April 23, 1920, 2.
15. 1977-Rodgers, frame 356.
16. 1975-Nemser-1, 83.
17. "Boys Say They Are Atheists," *Brooklyn Eagle,* Novemeber 23, 1913, 4. The following quotation is from the same article.
18. "Silence Strike Ended," *Brooklyn Daily Eagle,* November 24, 1913.
19. Arthur Schopenhauer, "Religion—A Dialogue," reprinted in Will Durant, ed., *The Works of Schopenhauer* (New York: Garden City Publishing, 1955), 467–68.
20. Joyce Antler, *The Journey Home: How Jewish Women Shaped Modern America* (New York: Schocken Books, 1997), 53.
21. 1979-Munro, 83.
22. 1964-Seckler.
23. The murals are by Barry Faulkner and feature the Dutch settlement of New York rather than the satire of *Washington Irving's A Knickerbocker's History of New York.* See *NYT,* 5-9-1920, X8.

These murals are discussed and reproduced in Michele Cohen, *Public Art for Public Schools* (New York: The Monacelli Press, 2009), 60–63.

24. Rollin Lynde Hartt, "New York and the Real Jew," *NYT,* 6-25-1921, 659. This large number of students is verified by another article: "A Seat for Every Child," *NY Tribune,* October 5, 1921, 22, that lists the enrollment as 5,835.

25. Obituary for James P. Haney, *NYT,* 3-8-1923, 16.

26. "A Seat for Every Child: Washington Irving High School," *NY Tribune,* October 5, 1921, 22.

27. 1977-Rodgers, frame 356.

28. 1980-Slobodkina, vol. II, 248.

29. 1979-Munro, 106.

30. 1975-Nemser-1, 83.

31. http://www.reelclassics.com/Actresses/Colbert/colbert-bio.htm as of 13 September 2006.

32. 1964-Seckler.

33. 1964-Seckler.

34. Rabbi Hillel, quoted in Beruriah Hillela bat Avraham, *Pirkei Avot* (Lulu.com, 2008), 18. See also Leonard Kravitz and Kerry M. Olitzky, *Pirke Avot: A Modern Commentary on Jewish Ethics* (New York: URJ Press, 1993).

35. St. Augustine as quoted in two encyclicals by Pope Pius XI (1922–39). See as of 1-4-2007, http://www.goacom.org/overseas-digest/Religion/pius11-CastiC(1930)&QA(1931).html.

36. Charlotte Baum, Paula Hyman, and Sonya Michel, *The Jewish Woman in America* (New York: The Dial Press, 1975), 8. See Gail Levin, "Censorship, Politics, and Sexual Imagery in the Work of Jewish-American Feminist Artists," *Nashim,* no. 14, fall 2007, 63–96.

## Chapter 3: Art School: Cooper Union, 1926–28 (pp. 41–50)

1. Report to the Ladies' Advisory Council for the Woman's Art School, Cooper Union, 1927. In an exhibition brochure, *Lee Krasner: The Education of an American Artist,* The Cooper Union, January 16 to February 22, 1985, Barbara Rose wrote that Krasner entered Cooper in the fall of 1926, but her school record card in the registrar's office documents her entrance in February 1926.

2. 1926-27-Cooper.

3. 1926-27-Cooper, 7.

4. 1983-Hoffner.

5. 1983-Hoffner.

6. Report of the Ladies' Advisory Council for the Woman's Art School, Cooper Union Annual Report, 1924–1926, Susan D. Bliss, Secretary.

7. 1926–27-Cooper, 11.

8. See, for example, George Madden Martin, *Emmy Lou: Her Book and Her Heart,* illustrated by Charles Louis Hinton (New York: Grosset & Dunlap Publishers), 1902.

9. According to the transcript obtained at Cooper Union's registrar's office.

10. 1964-Seckler; 1968-Campbell, 62, also claimed that Victor Perard taught Alcove III on the complete figure.

11. Woman's Art School, report card notes she entered in 2-1926. See LKP, AAA, roll 3771, frame 26.

12. "Cooper Union Opens for Its 68th Year," *NYT,* October 6, 1927, 14.

13. Ethel Traphagen's collection of nineteenth-century costumes is now in the Historic Costumes and Textile Collection at Ohio State University. She taught at Cooper Union from 1912 through 1931; see "Ethel Traphagen Leigh Is Dead; Founded Fashion School in '23," *NYT,* April 30, 1963, 34, and http://www.cooper.edu/history/extended/hi00004.htm as of 3/18/2010.

14. "Nature Painter," *Time,* March 10, 1941, see, as of 11-26-2007: http://www.time.com/time/magazine/article/0,9171,790057,00.html. Leigh painted background dioramas for the African

Hall of the American Museum of Natural History in New York. His entire collection of work is in the Gilcrease Institute of American History and Art in Tulsa, Oklahoma.

15. 1926-27-Cooper, 15–16. The 1927–28 catalogue is missing, but the description given in the next year's catalogue is consistent with this one.

16. "With the Artists," *The Pioneer,* Cooper Union, February 4, 1927.

17. "With the Artists," *The Pioneer*, March 25, 1927. This evidence contradicts Ellen Landau, who quite recently wrote: "Krasner (who did not take on the nickname Lee or change the spelling of her last name until the early forties)" in 2007-Landau, 10.

18. 1979-Novak.

19. Finding the "Krassner" family in the U.S. Census for 1930 on computerized data bases requires a misspelling of the surname as "Krasser."

20. See, for example, Anne Wagner, "Lee Krasner as L.K.," *Representations,* winter 1989, 42–56, who built an argument around Krasner's supposed concealment of her gender. 1996-Wagner, 188–89, argues unconvincingly that Krasner is "the bearer of a fictional masculinity."

21. "The 'New Woman' Studied by Experts," *NYT,* September 25, 1927, E 20.

22. 1927-Gilman, 628.

23. 1927-Gilman, 628.

24. "Unhappily Married Urged to Hide Rift," *NYT*, November 21, 1927, 30.

25. "Dr. Fosdick Urges Birth Rate Control," *NYT,* December 5, 1927, 30.

26. "Dr. Fosdick Urges Birth Rate Control," *NYT,* December 5, 1927, 30.

27. 1965-Friedman, 6.

28. A list of those who have had drawings hung at the monthly exhibition is in *The Pioneer* for November 11, 1927. Another list follows for Life Class, Antique, Preparatory, and First Alcove, listing Krasner in "Antique."

29. "With the Artists," *The Pioneer,* January 13, 1928.

30. This achievement was reported by Josephine Higgins, "With the Artists," in *The Pioneer,* January 20, 1928, 6, who misspelled Krasner's name, "L. Kassner."

31. "With the Artists," *The Pioneer*, February 17, 1928, 6.

32. *The Pioneer,* March 23, 1928, 4.

33. 1979-Novak.

34. Among Krasner's papers at the PKHSC is Victor Perard, *Anatomy and Drawing* (New York: Victor Perard Publisher, 1928, second printing, May 1929; manufactured by the Kingsport Press, Kingsport, Tennessee), inscribed "For Lee Krasner, a souvenir of your formative years—Love! Gail Levin." Comment from Krasner to author, 1978.

35. "Cooper Union Girls Win 110 Art Prizes," *NYT,* May 24, 1928, 13.

36. 1964-Seckler.

37. Ernestine Lassaw, Ibram's widow, recalled this to the author, 3-14-2010.

38. "Dykaar, Sculptor, Leaps under Train," *NYT,* March 11, 1933, 21.

39. "Bust of Coolidge on Exhibition Here," *NYT,* December 31, 1927, 4. See also "The Dykaar Memorial," *NYT,* March 23, 1934, 21. These two articles provide various information that does not agree. "Bitter" comes from LKP, AAA, reel 3771, frame 49.

40. "Bone and Muscle Man*," Time,* September 14, 1942.

41. Death certificate for Rose Stein is number 15164 in Kings County (Brooklyn). She was then twenty-six years old and died in the Jewish Hospital, Brooklyn. Her eldest child, her daughter Muriel Pearl, was born August 17, 1922. At the time of Rose's death, Lee was nineteen and her sister Ruth (b. 1910) was only seventeen. LKCR, 301, gives the erroneous information that Ruth married William Stein when she was just fourteen, in "late 1927 or early 1928." This is in error, since Ruth was already seventeen or eighteen at the time of Rose's death. Evidently Ruth lied about the age she married to make herself seem younger.

## Chapter 4: National Academy and First Love, 1928–32 (pp. 51–78)

1. On May 14, 1926, as recorded in *The Long Islander,* a newspaper based in Huntington, New York, Anna Krassner signed a mortgage for $10,000 buying from F. Ritter property on the "eastside of the road adjoining land of O. Anderson, Greenlawn, in the township of Huntington" (p. 16). Author's interview with Krasner's niece Muriel Stein Dressler.
2. This is documented by the U.S. Census of 1930.
3. Louise Dougher and Carol Bloomgarden, *Greenlawn: A Long Island Hamlet* (Charleston, S.C.: Arcadia Publishing, 2000), 122.
4. 1968-Campbell, 63.
5. That LK was right-handed was confirmed by 1965-Friedman, 16, note 3. Standing in front of a mirror to copy what one sees, what one sees to one's right is one's right hand with one's left to one's left; but from the standpoint of the person looking out from within the picture, my right is the outlooker's left, my left the outlooker's right.
6. Definitions of dyslexia are rapidly changing and beyond the scope of this study.
7. 175 West 109th Street: 1980-Slobodkina, 241.
8. Florence N. Levy, *American Art Annual Who's Who in Art,* vol. XXIV for 1927 (Washington, D.C.: American Federation of Arts, 1928), 314.
9. *Art Schools of the National Academy of Design,* One Hundred and Third Year Season of 1928–1929, 19.
10. Eliot Clark, *History of the National Academy of Design, 1825–1953* (New York: Columbia University Press, 1954), 211.
11. 1975-Nemser-1, 72.
12. 1980-Slobodkina, vol. II, 242. Slobodkina, born 9-22-1908, was just about a month older than LK.
13. 1980-Slobodkina, vol. II, 242.
14. According to LKP, AAA, roll 3771, frame 50. 1968-Campbell, 63.
15. 1968-Campbell, 63.
16. 1968-Campbell, 63.
17. Krasner later claimed to have painted this *Self-Portrait* after the first year to gain admission to life classes at the academy, but if this were so, she could not have been promoted to life on January 26, 1929, following her first term in the fall of 1928.
18. 1975-Nemser-1, 72.
19. Neilson had studied with William Merritt Chase in New York and showed in the Paris Salon, winning a silver medal in 1914: Florence N. Levy, *American Art Annual Who's Who in Art,* vol. XXIV for 1927 (Washington, D.C.: American Federation of Arts, 1928), 671.
20. 1968-Campbell, 62, based on his interview with LK.
21. 1980-Slobodkina, vol. II, 283 and 324. Slobodkina's greatest fame was as a children's book author and illustrator, especially *Caps for Sale,* first published in 1940 and still in print.
22. Eda Mirsky Mann quoted in "Woman Enough: Interview with My Mother," in 1994-Jong, 301.
23. Eda Mirsky Mann quoted in 1994-Jong, 302.
24. Author's interview with Erica Jong, February 3, 2010.
25. Molly Jong-Fast, *Sex Doctors in the Basement* (New York: Villard Books, 2005), 5. Molly's mother is Eda's daughter, Erica Jong.
26. Born in Russia on August 15, 1911, Igor registered as "Igor O. Pantuckoff. 1983-Rose, 16, claims that Bolotowsky was "a White Russian," instead of Jewish, but he appeared in the second edition of *Encyclopedia Judaica,* which notes that he showed abstract painting in the first exhibition of World Alliance of Yiddish Culture (YKUF) in 1938.
27. Joop Sanders (b. 1921) to the author, interview of December 12, 2007.
28. 1984-Jonas.
29. "Col. Oleg Pantuhoff, Served in Russian Imperial Guard," *NYT,* October 28, 1973, 60. This

obituary noted that he died in Nice, France, but that he had lived in the United States half his life. He was twice wounded in World War I and decorated for bravery; he was "founder of the Russian Boy Scouts." Oleg Ivanovich Pantuhoff was "a captain in the Imperial Russian Guards, and a man of considerable moral strength and organizational talent." See http://WRrXJMcatsAJ:histclo.com/youth/youth/org/sco/country/rus/hist/sr-hist.htm as of August 6, 2007. See *NYT,* 9-23-45, Igor's older brother, Major Oleg Pantuhoff, Jr., would later serve as a U.S. Army officer and as a Russian translator for Dwight Eisenhower. Oleg I. Pantuhoff (Igor's father) married Nina Michailovna Drobovolskaya in Vilnius, Lithuania, on May 11, 1908. Their first son, Oleg Jr., was born on May 2, 1910. See http://www.scoutmaster.ru/ru/news/Pantuhoff_Bday.htm as of August 6, 2007. See also ND-Pantuhoff, Sr.

30. *Slovo o polku Igoreve* (tr. by Vladimir Nabokov, Song of Igor's Campaign, 1960). Aleksandr Borodin's opera *Prince Igor* was first performed posthumously in 1890. Left unfinished at Borodin's death, it was completed by Rimsky-Korsakov and Glazunov.

31. See Major Oleg Pantuhoff, Jr., C.A.C., A.U.S., "Russia Revisited: An Emigrant Returns to His Native Country," in *Slavonic and East European Review:* American Series, vol. 3, no. 1. (May 1944): 71–76.

32. "Col. Oleg Pantuhoff, Served in Russian Imperial Guard," *NYT,* October 28, 1973, 60.

33. ND-Pantuhoff, Sr., 280.

34. ND-Pantuhoff, Sr., 280.

35. ND-Pantuhoff, Sr., 283.

36. "Col. Oleg Pantuhoff, Served in Russian Imperial Guard," *NYT,* October 28, 1973, 60.

37. This is documented in the U.S. Census of 1930.

38. http://64.233.179.104/translate_c?hl=en&u=http://www.scoutmaster.ru/ru/news/Pantuhoff_Bday.htm. A painting of St. George by Igor's mother survives in Australia. According to their granddaughter, Leigh Olshan, Oleg Sr. and Nina Pantuhoff earned money in America by painting "Chinese" screens for Sloan's furniture store. (Author's interview with Olshan, April 14, 2008.)

39. In the Life Schools class, Pantuhoff got the Cannon Prize of $100; for the Men's Night Class—Figure, the Suydam Silver Medal; for the Still Life Class, the School Prize of $10; Honorable Mention in the Composition Class, where honorable mention also went to William Steig [1907–2003], the future *New Yorker* cartoonist and children's book author and illustrator, who, like Krasner, was the child of Jewish immigrants.

40. See *National Academy of Design, Department of Schools Annual Distribution of Awards of Merit,* published annually each spring.

41. 1980-Slobodkina, vol. II, 283.

42. 1980-Slobodkina, vol. II, 283. Pantuhoff's name is variously transliterated from the Russian. Originally it was more often Pantukof, of which Pentukhov is a variation.

43. 1980-Slobodkina, vol. II, 372.

44. Quoted in Phyllis Blanchard and Carlyn Manasses, *New Girls for Old* (New York: The Macaulay Company, 1930), 61; as quoted in 1978-Rothman, 178. See also Paula S. Fass, *The Beautiful and the Damned: American Youth in the 1920s* (New York: Oxford University Press, 1977).

45. LKCR. Chronology gives an incorrect age for Ruth Krassner Stein at her marriage. The Pearl Movie House was located at 1901–1902 Broadway, just north of East New York. It was opened by Herman Weingarten and designed in 1914 by the architect Albert Kunzi, but by August 1927 the owner's name was Morris Stein, William Stein's father.

46. Available on Ancestry.com under the spelling "Krasser," misspelled by the census taker.

47. Author's interview with Muriel Stein Dressler, June 4, 2008. Muriel Stein was born in August 1922, so was probably about eight to ten during the time of these memories.

48. Author's interview with Muriel Stein Dressler, June 4, 2008.

49. Muriel Stein Dressler to the author, 10-10-06, and Muriel Stein Dressler to Lee Krasner, letter of October 29, 1965, AAA, LK papers, reel 3771, frames 1009–1010, which reminisces.

50.  Author's interview with Muriel Stein Dressler, 10-10-06 and 8-7-08. The 1931 film she recalled was *Susan Lenox: Her Fall and Rise.*

51.  Richard H. Pells, *Radical Visions and American Dreams: Culture and Social Thought in the Depression Years* (New York: Harper & Row, 1973), 44.

52.  1984-Abel, 12.

53.  Ivan Olinsky was born on January 1, 1878 (or 1879, as he claimed he later discovered). Olinsky was born in Elizabethgrad in the Ukraine, in the Russian empire. Ivan G. Olinsky is identified as a Jew in John Simons, ed., *Who's Who in American Jewry* (New York: National News Association, Inc, 1938–39), vol. 3, 787; Isaac Landman, ed., in collaboration with . . . Louis Rittenberg . . . al.], *The Universal Jewish Encyclopedia* (New York: Universal Jewish Encyclopedia, Inc., c. 1939–1943); and he is on the list of "Jews of Prominence in the United States" in Harry Schneiderman, ed., *The American Jewish Year Book 5683* (Philadelphia: Jewish Publication Society of America, 1922), 187. Olinsky returned from studying in Europe on September 12, 1910, passing through Ellis Island, where immigration agents noted with skepticism that for ethnicity, he "claims U.S.A." Ivan Olinsky married Geniève A. Karfunkle, whose name suggests that she was also Jewish. See also Alexander Beider, "A Dictionary of Jewish Surnames from the Russian Empire" (New Jersey: Avotaynu, 1993), there is an entry for Olinsky (Olinskij) giving the location where the surname occurred as Elisavetgrad.

54.  "Modern Art Museum Open Exhibitions Will Be Free to the Public Today," *NYT,* 11-8-1929, 6.

55.  "New Art Museum Visited by Scores," *NYT,* November 9, 1929, 24.

56.  1968-Campbell, 62–63.

57.  1975-Nemser-1, 84.

58.  1975-Nemser-1, 84. Krasner identified Dickinson and told this story in an interview with 1964-Seckler.

59.  1964-Seckler.

60.  Dickinson's success was such that in 1926 the founders of the new fine arts museum in Atlanta, Georgia, had commissioned him to paint the portrait of Hattie High, who donated her home on Peachtree Street to house the new museum, which took her surname.

61.  1979-Munro, 106–7.

62.  1979-Munro, 107. Krasner made a similar comment to the author, 1977-Rose outtake.

63.  Author's interview with Eda Mirsky Mann, February 24, 2010.

64.  1981-Langer.

65.  1980-Slobodkina, vol. II, 294.

66.  1982-Bolotowsky, 16.

67.  ND-Tabak-1.

68.  According to Fritz Bultman, quoted in 1985-Potter, 65, Pantuhoff "paid great attention to her as an artist."

69.  1965-Vogel. The author, who met Kroll in his old age (c. 1971), can vouch for his gregarious personality.

70.  LK to the author, recorded by 1977-Rose.

71.  1968-Campbell, 63, based on his interview with LK. See also 1965-Friedman, 7; 1979-Munro, 107.

72.  Ralph Flint, "Matisse Exhibit Opens Season at Modern Museum," *Art News,* November 7, 1931, reprinted in 1977-Diamonstein-2, 109.

73.  Beth S. Wenger, *New York Jews and the Great Depression: Uncertain Promise* (New York: Syracuse University Press, 1999), 3.

74.  1966-Rose and see also, 1979-Munro, 106.

75.  Forbes Watson, "The All American Nineteen," *The Arts,* 16, January 1930, 308–10.

76.  See Levin, *Edward Hopper: An Intimate Biography,* 239.

77.  Thomas Hart Benton, "Art and Nationalism," *The Modern Monthly,* 8, May 1934, 232–36.

78.  The group also included artists Phil Bard, Bernarda Bryson (later Mrs. Ben Shahn), James Guy, and Joseph Pandolfini.

79.  "3,500 Reds in Rally Protest on Job Aid," *NYT,* February 5, 1932, 16.

80.  1964-Gorelick.

81.  1979-Novak. In particular, she planned to teach at Thorton High School, which might have been Thornton Donovan High School, founded in 1901 in New Rochelle, New York.

82.  Karen Arenson, "Bulletin Board: Miller's City College Secret," *NYT,* October 31, 2001.

83.  1964-Seckler; LK often recounted this to the author and in interviews: 1972-Rose-1 and 1979-Novak.

84.  1984-Abel, 35.

85.  1979-Novak.

86.  1975-Nemser-1, 72–73.

87.  1970-Rosenberg.

88.  1979-Novak.

89.  1979-Novak.

90.  1970-Rosenberg.

91.  1970-Rosenberg.

92.  May Tabak Rosenberg, "Art Project," unpublished ms, p. 9. Archives of American Art.

93.  See Friedman, *Whitechapel,* 7. A list is also in Lee Krasner Papers, AAA, reel 3771, frame 50. See chapter on Joe Gould in Ross Wetzsteon, *Republic of Dreams. Greenwich Village: The American Bohemia, 1910–1960* (New York: Simon & Schuster, 2002), 418–30.

94.  "Bodenheim Vanishes as Girl Takes Life," *NYT,* July 21, 1928, 1, and "Keeps Missing Girl from Bodenheim," *NYT,* July 22, 1928, 1.

95.  "Keeps Missing Girl from Bodenheim," *NYT,* July 22, 1928, 1.

96.  "Bodenheim Vanishes as Girl Takes Life," *NYT,* July 21, 1928, 1.

97.  "Keeps Missing Girl from Bodenheim," *NYT,* July 22, 1928, 1.

98.  Lee Krasner to the author, many times in conversation.

## Chapter 5: Enduring the Great Depression, 1932–36 (pp. 79–116)

1.  ND-Tabak-1.

2.  Krasner to the author. This is in complete contrast to Jeffrey Grove's "Chronology," in LKCR, 302, which states that "despite their nearly ten-year relationship, Krasner characterized Pantuhoff as only 'a friend.'" See also 1996-Wagner, 119, who remarks upon LK's "singular reluctance to admit the extent of Pantuhoff's role in it [her life] to later interviewers, as if she feared that revealing their former closeness would impinge on her standing as Pollock's wife and widow. Wagner failed to interview those closer to Krasner (myself or her niece Muriel) who knew about her relationship with Igor.

3.  Authors interview with Joop Sanders, December 12, 2007.

4.  Wainwright Evans and Ben Lindsay, *The Companionate Marriage* (New York: Boni & Livright, 1927).

5.  Muriel Stein Dressler to the author, interview of 8-07-08.

6.  The possible dates of their visit are defined by 1935, when Webb first hired the teenaged Ella Fitzgerald after she won a talent contest at the Apollo Theater and redesigned his show around the singer, who provided him with his biggest hit record, "A Tisket-A-Tasket," in 1938, just before his death on June 16, 1939.

7.  Muriel Stein Dressler to the author, interview of 10-10-2006.

8.  Robert S. Lynd, "Family Members as Consumers," *The Annals of the American Academy of Political and Social Science,* vol. 160, March 1932, 91, quoted in 1978-Rothman, 180.

9.  Lillian Olinsey Kiesler to Deborah Solomon, AAA, and Ruth Appelhof to the author, 9-4-2007, among others.

10.  Igor Pantuhoff quoted by Fritz Bultman in 1985-Potter, 65.

11. 1984-Jonas. Some twelve to fifteen million people in the United States were out of work by 1932. See also Arthur M. Schlesinger, Jr., "The First Hundred Days of the New Deal," in Isabel Leighton, *The Aspirin Age 1919–1941* (New York: Simon & Schuster, 1949), 277.

12. 1964-Gorelick.

13. Reuben Kadish quoted in 1989-Kisseloff, 465.

14. Kadish quoted in 1989-Kisseloff, 467. Pollock did later trade a painting with Dan Miller, who owned the general store in Springs.

15. "Convention Throng Hails Roosevelt," *NYT,* July 3, 1932, 9.

16. "Job Goodman, 58, Abstract Painter," *NYT,* December 14, 1955, 13.

17. http://www.greenwichhouse.org/HISTORY.HTM as of July 16, 2007.

18. See Gail Levin, *Synchromism and American Abstraction, 1910–1925* (New York: George Braziller, Inc., 1978), 31–33.

19. Axel Madsen, "Jackson Pollock: The Hollow and the Bump," *The Carleton Miscellany,* vol. 7, no. 3, Summer 1966, reprinted in 1998-Karmel, 106.

20. Thomas Hart Benton, *An American in Art: A Professional and Technical Autobiography* (Lawrence: University of Kansas Press, 1969), 39.

21. See "Topics of the Times," *NYT,* 2-16-1933, 18. 1999-Hobbs, 30, speculated that publicity about the U.S. Customs Department's claim that the nudes on the Sistine Chapel ceiling were obscene might have "catalyzed" LK's interest, but this seems unlikely, given Goodman's teaching methods and the fact that this "scandal" lasted only one day.

22. 1970-Rosenberg.

23. "Independents to Barter Art Works at Show; Dentistry or the Rent Will Buy a Painting," *NYT,* March 15, 1932, 1.

24. *Art Front,* no. 1, November 1934. See also Patricia Hills, "Art Movements," in Mary Jo Buhle, Paul Buhle, amd Dan Georgakas, *Encyclopedia of the American Left* (Chicago: St. James Press, 1990), 67.

25. See 2002-Hemingway, 85–86.

26. "History of the Artists Union," *Art Front,* no. 1, November 1934, 3.

27. 1964-Gorelick.

28. 1965-Block.

29. Max Spivak, "Bread Upon the Waters," *Art Front,* no. 1, November 1934.

30. "Artists to Adorn Nation's Buildings," *NYT,* December 12, 1933, 28.

31. "Artists to Adorn Nation's Buildings," *NYT,* December 12, 1933, 28.

32. Franklin Delano Roosevelt, radio address from the White House on May 10, 1939, as printed in the *Herald Tribune* on May 11, 1939.

33. 1984-Abel, 39.

34. 1983-Rose, 34.

35. 1970-Rosenberg.

36. Krasner's first job on the PWAP was executing illustrations of Foraminifera for the textbooks of marine biology of a City College professor. This was her second job illustrating textbooks.

37. 1964-Seckler.

38. 1979-Munro, 106.

39. "Wages for Artists," *Art Front,* vol. 1, no. 4, April 1935, 1.

40. Lee Krasner to Judith Wolfe, interview of January 5, 1984.

41. 1983-Liss.

42. 1983-Liss. Krasner understood that Pantuhof had not made history while Pollock had.

43. 2004-Stevens, 92.

44. Many such ads for Capehart ran in *NYT,* December 16, 1934, 28.

45. 2004-Stevens, 91.

46. 1983-Liss.

47. 2004-Stevens, 113.

48. Leon Kroll to Elizabeth Ames, March 4, 1934, NYPL.

49. 1982-Bolotowsky, 30, note 5.

50. Leon Kroll to Elizabeth Ames, letter of April 20, 1934, Yaddo papers, NYPL.

51. Note from Igor and Lenore Pantukoff to Elizabeth Ames at Yaddo, NYPL, Yaddo papers, box 217.

52. ND-Tabak-3.

53. ND-Tabak-1.

54. Hofmann moved the school to 52 West Ninth Street in 1936 and moved to 52 West Eighth Street in 1938.

55. Address documented by her NYPL card, LKP, AAA.

56. LKP, biographical file, NYPL card dated 1934 gives this address. The rooftop was so accessible that jewelry thieves had crossed it just months earlier in a robbery. See "Burgulars Use Housetops," *NYT*, 1-30-1934, documenting a robbery at 209–11 West Fourteenth Street, for which the thieves crossed on rooftops from 221 West Fourteenth Street.

57. See Gail Levin, *Edward Hopper: A Catalogue Raisonné* (New York: W. W. Norton & Co., 1995), entry for *City Roofs* on CD-Rom.

58. LKCR misdates the study as c. 1934–35, when the canvas that followed is signed and dated on the rear lower right canvas: "Lee Krasner 1934."

59. ND-Tabak-3.

60. ND-Tabak-4.

61. 1980-Slobodkina, vol. II.

62. 1976-Slobodkina vol. I and online in part at http://www.slobodkina.com/about%20esphyr _autobiography.htm.

63. ND-Tabak-4.

64. 1965-Forge.

65. Kadish quoted in 1989-Kisseloff, 467.

66. See the ad in *Art Front*, no. 1, November 1934.

67. "History of the Artists Union," *Art Front*, no. 1, November 1934.

68. 1972-Rose-1.

69. "29 Store Pickets Seized," *NYT*, 12-18-1934, 18; "Girl Striker Heckels La Guardia," *NYT*, 1-21-1935, 17.

70. Tom Vallance, "Obituary: Dane Clark," *The Independent*, September 17, 1998.

71. 1972-Rose-1.

72. 1984-Jonas.

73. Gerald Monroe to Gail Levin, July 17, 2007.

74. 1985-Potter, 64.

75. 1985-Potter, 64.

76. 1985-Potter, 64.

77. 1984-Jonas.

78. 1984-Jonas.

79. His parents' anti-Semitism has been confirmed to the author in interviews with Pantuhoff's nieces, both of whom married Jewish men against their parents' wishes.

80. Letter with drawing is in AAA, roll 3771. Igor's two nieces married Jewish men. Their father, Igor's brother, refused to attend the wedding of one of his own daughters, since it took place in a synagogue. Author's interview with Igor's niece, Leigh Olshan, August 26, 2007.

81. LKP, AAA, reel 3771, frame 27, contains her entire WPA record of employment.

82. 1972-Rose-1.

83. 1980-Slobodkina, vol. II, 363.

84. 1963-Spivak.

85. 1963-Spivak.

86. 1963-Spivak.

87. 1970-Spivak.

88. 1972-Rose-1.

89.  May Tabak Rosenberg to William Shawn, letter of July 1978, Getty.

90.  ND-Tabak-2, 12.

91.  ND-Tabak-2, 17. 1970-Rosenberg concurs on this part of the story of how he got on the WPA.

92.  Harold Rosenberg attended City College in 1923–24 and graduated with a law degree from St. Lawrence University in 1927. For context, see also Alan M. Wald, *The New York Intellectuals: The Rise and Decline of the Anti-Stalinist Left from the 1930s to the 1980s* (Chapel Hill: The University of North Carolina Press, 1987), 222.

93.  1979-Munro, 108.

94.  1979-Munro, 108.

95.  This address and date are taken from Rosenberg's letters to *Poetry* magazine, which document that he was on Fourteenth Street from July 9, 1936, to at least May 18, 1937. Early letters with other addresses confirm that this must be the period when Krasner and Pantuhoff shared an apartment with the Rosenbergs, not earlier, as both LKCR, and 1999-Hobbs state. I am grateful to Rosenberg biographer Debra Bricker Balken for confirming this time and place. 1970-Rosenberg states that after he married in 1932, they lived on Paradise Alley (East Eleventh Street off First Avenue) and then in 1933 on Houston Street, before moving in December to Christopher Street. In 1934 they lived in two places on West Eleventh Street, before decamping to Brooklyn on January 9, 1935. They returned to Manhattan in Janaury 1936, but to 259 West Twelfth Street, moving to 333 West Fourteenth Street by that July.

96.  The telephone was recorded in the name "B. Dolen" from April 1936 through April 1937 in the Manhattan Address Telephone Directory at 333 West Fourteenth Street. Patia Rosenberg remembers from her childhood a friend of her parents named "Bobby Dolen," who was a pharmacist.

97.  ND-Tabak-1.

98.  1936-Cahill, 142 and fig. 51. Igor Pantuhoff's work was number 100 in the catalogue.

99.  LKCR no. 31, p. 35, imprecisely dates this work c. 1935–36, when it clearly was made in response to this show at the Museum of Modern Art, December 7, 1936–January 17, 1937.

100.  1936-Barr-1, figures 130 and 163.

101.  See LKCR, 34, nos. 29r, 29v, 30.

102.  1936-Barr-2, 288, includes this film among those shown. Years later, when she included images of disembodied eyes in her pictures, critics wrongly attributed this motif to Pollock's influence.

103.  Krasner and Pollock came to possess a copy of the 1933 book *The Art of Henri Matisse* by Albert Barnes and Violet de Mazia, which he inscribed to Marcel Duchamp, now at PKHSC, but acquired at a much later date.

104.  Henry McBride, *Matisse* (New York: Alfred A. Knopf, 1930), plate 38. This work is variously called *Interior, Nice; Still Life in the Studio*; *Nature morte dans l'atelier, Nice*; and *Interior with Phonograph*.

105.  See Greuze's *The Broken Eggs* of 1756, in the Metropolitan Museum collection since 1920, which is itself inspired by a seventeenth-century Dutch painting by Frans van Mieris the Elder (State Hermitage Museum, Saint Petersburg), which Greuze knew through an engraving. The broken eggs are said to symbolize the maiden's loss of virginity.

106.  1967-Parsons.

107.  B. H. Friedman, "Lee Krasner: An Intimate Introduction," in 1999-Hobbs, 23. The link of this story to Bultman is in Friedman's notes for the Whitechapel catalogue essay, LKP, AAA.

108.  1967-Parsons.

109.  Stuart Davis, quoted in Garnett McCoy, "The Rise and Fall of the American Artists' Congress," *Prospects*, 13, 1988, 328.

110.  2004-Stevens, 113.

111.  Arshile Gorky, in a lecture that he gave at the Art Students League in the early 1930s, is reported to have said: "Proletariat art is poor art for poor people." See Jacob Kainen, "Memo-

ries of Arshile Gorky," *Arts Magazine,* 50, no. 7, March 1976, 98; 1963-Spivak; Jody Patterson, "Flight from Reality? A Reconsideration of Gorky's Politics and Approach to Public Murals in the 1930s," in Michael Taylor, ed., *Arshile Gorky: A Retrospective* (New Haven: Yale University Press, 2009), 79.

112. 1965-Mooradian, 191. See also 202, where art historian Meyer Schapiro claimed that Gorky influenced Pollock despite Krasner's insistance that they only met for the first time in 1943.

113. Milton Resnick to 1980-Mooradian, 193. Resnick's wife, Patricia Passloff, conducted interviews for the 1956 show on "The Thirties, New York" at Poindexter Gallery, so this may have informed his opinion.

114. Stephen Polcari, "Orozco and Pollock: Epic Transformations," *American Art,* vol. 6, no. 3 (summer 1992), 40.

115. Harold Lehman, "For an Artists Union Workshop," *Art Front,* October 1937; quoted in Hurlburt, "Siqueiros Experimental Workshop," 239.

116. Charmion von Wiegand, "David Alfaro Siqueiros," *New Masses,* II, no. 5 (May 1, 1934), 16–21.

117. 1976-Hurlburt, 239.

118. "40,000 March Here in May Day Parade, Quietest in Years," *NYT,* May 2, 1936, 1.

119. "40,000 March Here in May Day Parade, Quietest in Years," *NYT,* May 2, 1936, 1.

120. 1976-Hurlburt, 238. Hurlburt based much of his research on his 1973 interview with Harold Lehman.

121. Some of the other workshop participants were Axel Horn (then spelled Horr), George Cox, Louis Ferstadt, Clara Mahl, Luis Arenal, Antonio Pujol, Conrado Vasquez, José Gutiérrez, and Roberto Berdecio.

122. 1967-Kadish.

123. 1967-Glaser.

124. 2008-Küster, 73, which incorrectly states in Lee Krasner's paragraph-long biography: "As a committed Communist, she moved to Long Island with Pollock in search of a 'simple life,' following their marriage in 1945." In the author's March 2007 interview with Ulf Küster, he admitted that he had no documentary source for this statement.

125. 1967-Parsons.

126. 1967-Glaser.

127. Gerald Monroe to the author, interview of July 17, 2007.

128. 1965-Friedman, 16, note 6.

129. 1970-Monroe.

130. 1970-Monroe.

131. 1970-Monroe.

132. Among the books in Krasner's library in PKHSC in Springs are: Leon Trotsky, *The History of the Russian Revolution* (New York: Simon & Schuster, 1936) and Leon Trotsky, *The Revolution Betrayed: What Is the Soviet Union and Where Is It Going?* (New York: Doubleday, Doran & Company, 1937). Inside the front cover, this volume is inscribed in pencil "Pantuhoff 38 E. 9th St."

133. 1971-Monroe, 141–42.

134. Leon Trotsky, *The Revolution Betrayed: What Is the Soviet Union and Where Is It Going?* (1937), http://www.marxists.org/archive/trotsky/1936/revbet/ch07.htm#ch07-3.

135. Lee Krasner interview with Christopher Crosman (assisted by Nancy Miller), both then of the education department at the Albright-Knox Art Gallery. Tape available at this museum in Buffalo, New York, or at the PKHSC. Crosman to the author, 10-31-2010, notes that Krasner was "delightful" to interview.

136. 1999-Hobbs, 194, n. 42. The author was also in attendance that weekend and does not recall Krasner ever bringing up this topic while she was present.

137. Leon Trotsky, *The Revolution Betrayed: What Is the Soviet Union and Where Is It Going?* (1937), http://www.marxists.org/archive/trotsky/1936/revbet/ch07.htm; nsch07-3

138. 1984-Abel, 55.
139. See Tim Wohlforth, "Trotskyism," in Mari Jo Buhle, Paul Buhle, and Dan Georgakas, *Encyclopedia of the American Left* (Chicago: St. James Press, 1990), 782–83.
140. Reuben Kadish quoted in 1989-Kisseloff, 471.
141. Willem de Kooning interviewed by Anne Bowen Parsons, AAA.
142. Max Margolies to 1980-Mooradian, 165.
143. 1972-Rose-1.
144. See Sam Sills, "Abraham Lincoln Brigade," in Buhle, et al., *Encyclopedia of the American Left*, 2–3. Called the Debs Column by the socialists, their open recruitment caused government suppression.
145. Picasso quoted in "Artists Congress Denounces Japan," *NYT,* December 18, 1937, 22.
146. The art education of Lincoln Brigade member Irving Norman (1906–1998) followed his participation in the Spanish Civil War.
147. 1965-Vogel.
148. 1983-Rose, 37.
149. 1967-Greene.
150. 1967-Greene.
151. 1964-Gorelick.
152. 2002-Hemingway, 39.
153. Joe Solman, "Chirico—Father of Surrealism," *Art Front,* January 1936, 6.
154. Harold Rosenberg, "The Wit of William Gropper," *Art Front,* March 1936, 7–8. 1970-Spivak.
155. "National Organization," *Art Front,* March 1936, 2.
156. "National Organization," *Art Front,* March 1936, 2.
157. Meyer Schapiro, "Race, Nationality, and Art," *Art Front,* 2, March 1936, 10.
158. LK to Dore Ashton, undated quote cited in 1972-Ashton, 31.
159. See John O'Brian, *Ruthless Hedonism: The American Reception of Matisse* (Chicago: University of Chicago Press, 1999), 47.
160. LK to the author recorded by 1977-Rose, 1977.
161. 1966-Rose.
162. 1977-Bourdon, 57.
163. 1966-Mooradian, 189.
164. Edward Alden Jewell, "Quickenings," *NYT,* May 27, 1934, X7.
165. A venerable institution, the Jumble Shop was once located in what had been the MacDougal Alley studio of James Earle Fraser, who produced the bison on the "Buffalo nickel." See Henry Wysham Lanier, *Greenwich Village Today & Yesterday* (New York: Harper & Brothers, 1949), 150.
166. See Matthew Spender, *From a High Place: A Life of Arshile Gorky* (New York: Alfred A. Knopf, 1999), 206.
167. Edward Alden Jewell, "Art in Review," May 2, 1932, 15, and Edward Alden Jewell, "Youthful Explorers in Form and Color Present Deep Problems for Lay Spectators," May 7, 1932, 21.
168. 1972-Holmes. This is contrary to LKCR, which ignores Krasner's interest in Pereira's work.
169. Among them Yvonne Pène du Bois, Felicia Meyer [Marsh], Lena Glackens, Minna Citron, Mary Hutchinson, Beata Beach, Eloisa Schwab, and Janet Scudder, for example.
170. 1984-Abel, 35.
171. 1970-Rosenberg.

## Chapter 6: From Politics to Modernism, 1936–39 (pp. 117–142)

1. 1979-Munro, 108.
2. 1979-Novak.
3. 1977-Bourdon, 57.
4. "Artists Increase Their Understanding of Public Buildings," *Art Front,* November, 1935, 3.

5. 1994-Carroll, 81.

6. 1984-Carroll, 81.

7. 2007-Landau, 9. See also these articles from December 2, 1936: "WPA Artists Fight Police; 219 Ejected, Many Clubbed; Crowd Protesting Dismissals Forms 'Human Chain,' Refuses to Leave Office–Scores Arrested, Dozen Treated by Doctors," *NYT,* 1; "231 Arrested in WPA Riot," *Daily Mirror,* 2; "250 Artists Arrested in Relief Battle," *New York American,* 1.

8. 1970-Monroe.

9. 1964-Trubach and the following quotations from this source.

10. 1979-Munro, 108.

11. 1979-Novak.

12. 1994-Carroll, 81. See also Mercedes Matter in "Remembering Pollock," symposium at MoMA, 11-17-98, tape 98, 164, no. 5.

13. "Pink Slips and the WPA," *NYT,* July 25, 1937, 137.

14. *Still Life* was no. 28 in the catalogue of the exhibition, but she later forgot which work she exhibited. Catalogue in Lee Krasner papers at AAA.

15. LKCR 33.

16. Ford Madox Ford, Foreword, *Pink Slips over Culture*. Ford's grandfather was Ford Madox Brown, an English Pre-Raphaelite painter.

17. Ford, Foreword, *Pink Slips over Culture*.

18. Lewis Mumford, *Pink Slips over Culture*.

19. For the night classes, see 1972-Rose; Pamela Adler in 1973-Tucker, 37, and the Web site www .HansHofmann.org/chronology lists the school as moving from this location to 52 West Eighth Street only in 1938, after Krasner was already enrolled. Rose-1.

20. 1979-Novak.

21. Hans Hofmann quoted by Lillian Olinsey Kiesler, oral history interview, Archives of American Art, 1990. Lillian Olinsey Kiesler to Deborah Solomon.

22. Lillian Olinsey Kiesler, oral history interview, Archives of American Art, 1990. The following recollections are also from this source.

23. 1972-Rose-1.

24. LK to the author; also almost verbatim in 1977-Diamonstein, and 1979-Novak.

25. 1956-Rose.

26. 1964-Seckler.

27. 1956-Rose.

28. *The Hans Hofmann School of Fine Arts*, brochure of 1937–38 in Lillian Olinsey Kiesler papers, AAA.

29. *The Hans Hofmann School of Fine Arts*, brochure of 1937–38 in Lillian Olinsey Kiesler papers, AAA.

30. *The Hans Hofmann School of Fine Arts*, brochure of 1937–38 in Lillian Olinsey Kiesler papers, AAA.

31. 1933-Rose, 20.

32. "Cubism and Abstract Art," March 2–April 19, 1936, 1936-Barr-1, no. 213, pp. 42, 43 (ill. fig. 27), 220. She might also have seen this work in "Beginnings and Landmarks, '291,' 1905–1917," Stieglitz's gallery, An American Place, New York, October 27–December 27, 1937, exh. cat. no. 38.

33. Perle Fine recalling LK quoted 2005-Housley, 36–37.

34. 1930-Braff.

35. 1972-Rose-1.

36. Hofmann left an undated essay, "Toward the True Vision of Reality," Hans Hofmann papers, AAA, box 7, roll 5808.

37. Ben Wolf, "The Digest Interviews Hans Hofmann," *Art Digest,* April 1, 1945, 52.

38. 1979-Novak.

39. See Hofmann's *Cathedral* of 1959 with its floating rectangles compared to LKCR 100.

40. Lillian Olinsey Kiesler, oral history interview, Archives of American Art, 1990.

41. 1979-Novak.

42. 1979-Novak.

43. See Cynthia Goodman, *Hans Hofmann as Teacher: Drawings by Hofmann and His Students* (New York: American Federation of Arts, 1982).

44. 1973-Freed.

45. Greenberg to Rubenfeld, unedited transcript of interview, 2/16/1990, CG Papers, Getty; see also 1997-Rubenfeld.

46. 1979-Novak.

47. 1965-Friedman, 7, claims incorrectly that LK first met Greenberg at Hofmann's lectures.

48. 1997-Rubenfeld, 50. According to Rubenfeld, who interviewed Greenberg at length, he attended three of the six public lectures by Hofmann during the 1938–39 school year.

49. 1966-Greenberg at EDACA.

50. Clement Greenberg to Florence Rubenfeld, unedited transcript of interview, 2/16/1990, CG Papers, Getty; see also 1997-Rubenfeld.

51. Greenberg to Rubenfeld, unedited transcript of interview, 2/16/1990, CG Papers, Getty; see also 1997-Rubenfeld.

52. 1979-Novak.

53. 1972-Rose-1.

54. Lee Krasner to the author, August 1977 and other times.

55. Hofmann quoted in "Mrs. Jackson Pollock," *Time,* March 17, 1958, 64.

56. 1984-Little, II-1. Little dated their meeting to the fall of 1936.

57. 1984-Little, II-1. Little was at the Hofmann school in New York and Provincetown from 1937 to 1942. He had previously studied at the Buffalo, New York, Fine Arts Academy and at the Art Students League under George Grosz. See "John Little, Painter," his obituary in the *East Hampton Star,* August 2, 1984, 2.

58. 1964-Seckler.

59. 1976-Slobodkina, vol. II, 380.

60. 1967-McNeil.

61. Lee Krasner to the author, recorded by 1977-Rose.

62. 1979-Munro, 108. See A Note About Sources for the story of how Irving Sandler misunderstood why de Kooning's study was in the studio Pantuhoff and McNeil shared and how he omitted Krasner from the story, which has been repeated in biographies of both Pollock and de Kooning.

63. 1966-Rose.

64. 1966-Rose.

65. 1968-Wasserman, recounts this meeting, this time recalling about "eight or ten artists."

66. 1966-Rose.

67. 1982-Bolotowsky, 22.

68. Susan Carol Larsen, *The American Abstract Artists Group: A History and Evaluation of Its Impact upon American Art* (Ann Arbor, Mich.: University Microfilms, 1975), 226–28.

69. 1968-Wasserman.

70. Aristodimos Kaldis quoted in 1980-Mooradian, 156–57.

71. 1966-Rose.

72. 1967-Parsons.

73. Greta Berman, *The Lost Years: Mural Painting in N.Y. City under the WPA Federal Art Project, 1935–1943* (New York: Garland, 1978), 215.

74. 1979-Munro, 108.

75. 1966-Rose.

76. Lee Krasner to Betty Smith, interview of 11-3-73 in New York City, PKHSC.

77. By this time, Anna and Joseph Krasner had given up the farm and moved into the center of Huntington to a house on Winfield near the corner of Delaware.

78. Rena Glickman (daughter of Krasner's sister) became known as "Rusty" Kanokogi, interview with the author, 6-18-08. This other man was Jackson Pollock.

79. Rosalind Browne to Karlen Mooradian in 1966 quoted in 2000-Matossian, 278.

80. See Tina Dickey, *From Hawthorne to Hofmann: Provincetown Vignettes, 1899–1945* (New York: Hollis Taggart Galleries, 2003), 68, fig. 2.

81. 1977-Ratcliff.

82. 1956-Rose.

83. 1958-Wasserman-1.

84. George Mercer to Lee Krasner and I. Pantuhoff, 44 E. Ninth St., New York, N.Y., July 29, 1939, Collection PKHSC.

85. Jean Cassou, *Paintings and Drawings of Matisse* (New York: 1939), Collection of the PKHSC.

86. These books are in the collection of the PKHSC.

87. Lillian Olinsey Kiesler, oral history interview, Archives of American Art, 1990. Also, author's interview with Jeanne Bultman.

88. See Merchandise for Sale, Radios, *NYT*, September 10, 1939, W14.

89. George Mercer to Lee Krasner, 9-18-1939, postcard from Provincetown, PKHSC.

90. Igor Pantuhoff to Lee Krasner, postcard from Baltimore, MD, PKHSC.

91. Igor Pantuhoff to Lee Krasner, October 24, 1939, addressed to Miss Lenore Krassner, 51 East Ninth Street, New York, N.Y. from West Palm Beach, Florida, PKHSC.

92. Igor Pantuhoff to L. Krasner, 51 East Ninth Street, New York, N.Y., October 31, 1939, PKHSC.

93. Lee Krasner to the author at the time that I was preparing to lecture on her work (at her request) at New York University in connection with the show, Pollock-Krasner: A Working Relationship, in 1981. She kept a copy of a handwritten letter of April 21, 1936, that Brown wrote about a group show of abstract art at the Municipal Galleries that a number of her friends were in, LKP, AAA.

94. Arthur Rimbaud, *A Season in Hell: Un Saison en Enfer,* translated by Delmore Schwartz (Norfolk, Conn.: New Directions, 1939), 27.

95. Lee Krasner to the author, repeatedly over many years, referred to her relationship with Pantuhoff as a "togetherness."

96. 1936-Barr-2, 29–30.

97. Harold Rosenberg, "The God in the Car," *Poetry,* 52, no. 6, July 1938, 342, cited by 1999-Hobbs, 194, note 21 and 31–32, who speculates that LK learned about Rimbaud from Rosenberg, ignoring her earlier fascinaton with Poe. Hobbs also quotes his conversation with Lionel Abel that he believed Krasner to have been "more knowledgeable" than Rosenberg; he considered her to be Rosenberg's "artistic mentor."

98. An announcement of publication appeared that day in the *New York Times.* Price at publication was one dollar.

99. 1984-Little, II-1. He misdated their meeting to fall 1936, when LK had not yet arrived at the Hofmann School.

100. Igor Pantuhoff to LK, letter of November 23, 1939, PKHSC.

101. Igor Pantuhoff to LK, letter of February 26, 1940.

102. Igor Pantuhoff to LK, letter of March 19, 1940, from West Palm Beach, Florida. By "Brodivish," Pantuhoff was referring to Alexey Brodovitch, the photographer and *Harper's Bazaar* art director.

103. "Bullitt Is Guest in Palm Beach," *NYT,* March 24, 1940, 36.

104. "Baseball Party Palm Beach Event," *NYT,* March 1, 1940, 24.

105. Igor Pantuhoff to LK, postcard of March 28, 1940, PKHSC.

106. Betheny Ewald Bultmann to the author, August 7, 2007.

107. Joop Sanders to the author, interview of December 12, 2007.

108. The following account is based on the recollections of Bethany Ewald Bultman, a writer and former editor for *House & Garden,* who grew up in Natchez. She became fascinated with the portraits she encountered there that resembled the Russian aristocracy more than Natchez's

traditional style. Bethany Ewald Bultmann to the author, August 7, 2007, recounting the stories told to her in Natchez.

109.   Oleg Pantuhoff, Sr., to Oleg Pantuhoff, Jr., letter of March 21, 1946, collection of Dwight D Eisenhower Library, Abilene, Kansas.

## Chapter 7: Solace in Abstraction, 1940–41 (pp. 143–176)

1.   George L. K. Morris, "Art Chronicle," *Partisan Review,* 6, no. 3, Spring 1939, 63.

2.   1964-Seckler.

3.   "Artists Denounce Modern Museum," *NYT,* April 17, 1940, 23.

4.   "Artists Denounce Modern Museum," *NYT,* April 17, 1940, 23.

5.   "Artists Denounce Modern Museum," *NYT,* April 17, 1940, 23.

6.   Larsen, "An Interview with George L. K. Morris," 484.

7.   See Paul Milkman, *PM: A New Deal in Journalism, 1940–1948* (New Brunswick, N.J.: Rutgers University Press, 1997), and Richard H. Minear, *Dr. Seuss Goes to War* (New York: The New Press, 1999).

8.   1977-Ratcliff.

9.   1966-Rose.

10.   1979-Novak.

11.   1966-Rose.

12.   1966-Rose.

13.   Krasner was listed as participating by Jerome Klein, "American Abstract," *New York Post* June 8, 1940, a review of the show.

14.   Edward Alden Jewell, "Melange of New Shows: A Group of Van Goghs at Holland House— Abstractions by American Artists," *NYT,* June 9, 1940, X7.

15.   1979-Novak.Years later, she remained perturbed that art historians at a conference on abstract expressionism (held in Charlottesville, Virginia, in 1978) spoke about her book by Jung as if it had been Pollock's, attributing all kinds of things to his having read it, which she doubted he had ever done. She insisted: "Now, I would have brought that [negative] attitude to Pollock when I joined him."

16.   George Mercer to LK, letter of August 14, 1940, from Provincetown, PKHSC.

17.   George Mercer to LK, November 24, 1940, PKHSC.

18.   George Mercer to LK, November 24, 1940, PKHSC.

19.   The fair was open for two seasons, from April to October each year, and was officially closed October 27, 1940.

20.   1987-Kamrowski.

21.   Lee Krasner to the author, summer 1977 and earlier, in 1971.

22.   In May 1933, A. E. Gallatin visited Mondrian's Paris studio and purchased his *Composition with Blue and Yellow,* 1932, for his Gallery of Living Art. The next year he bought another Mondrian. Serving as couriers for art, Harry Holtzman and I were the only two passengers on a cargo flight from New York to Paris in 1977, during which time we spoke at length. After I fell asleep, Holtzman photographed me, documenting our conversation and then sending the photographs to me as souvenirs.

23.   See Leonard G. Feather, "Art of Boogie Woogie," *NYT,* April 20, 1941, X7.

24.   Harry Holtzman quoted in Robert P. Welsh and Joop M. Joosten, *Piet Mondrian: Catalogue Raisonné* (New York: Harry N. Abrams, 1996), vol. II-III, 173.

25.   2002-Rembert, 50. Rembert also lists Peter Greene as having been present, but that was the nickname for Gertrude Greene.

26.   *Piet Mondrian: A Catalogue Raisonné,* vol. II-III, 174.

27.   2002-Rembert, 56.

28.   2002-Rembert, 56.

29.   1972-Rose-1.

30. 2002-Rembert, 56.

31. 2002-Rembert, 56.

32. 1977-Diamonstein.

33. George Mercer to Lee Krasner, letter of December 12, 1940, PKHSC.

34. Edward Alden Jewell, "Abstact Artists Put on Exhibition," *NYT,* February 11, 1941, 28.

35. Henry McBride, *New York Sun,* February 16, 1941, quoted in 2002-Rembert, 57.

36. E.S. [possibly Esphyr Slobodkina], *P.M.,* February 1, 1941.

37. 1972-Rose-1.

38. Mondrian to Holtzman, quoted in 1970-Rembert, vii.

39. 2002-Rembert, 56.

40. 1972-Rose-1.

41. 1972-Rose-1.

42. 1977-Ratcliff.

43. Harry Holtzman, statement for American Abstract Artists spring show, February 9–23, 1941, Riverside Museum, New York, quoted in 1970-Rembert, 47.

44. Harry Holtzman, statement for American Abstract Artists spring show, February 9–23, 1941, Riverside Museum, New York, quoted in 1970-Rembert, 47.

45. See Levin, *Edward Hopper: An Intimate Biography,* 197, for the words of Elizabeth Luther Cary and others.

46. George Mercer to LK, letter of January 4, 1941, PKHSC.

47. George Mercer to LK, letter of January 30, 1941, postmarked in Brookline, Massachusetts, and sent to 51 East Ninth Street in N.Y.C., PKHSC.

48. 2007-Landau, 43.

49. See James Johnson Sweeney, "Alexander Calder: Movement as a Plastic Element," *Plus 2,* [supplement to *Architectural Forum*], February 1939, which features a cover with a Calder photographed in movement by Matter. See also Matter's photographs of Calder's mobile in Alexander Calder, "What Abstract Art Means to Me: Statements by Six American Artists," *Museum of Modern Art Bulletin* 8 (Spring 1951): 8.

50. 2007-Landau, 43, letter of November 20, 1935, Hans Hofmann to Mercedes Carles, praising her fashion work as being of a "very high standard." She tried illustrating for *Vogue* and Saks Fifth Avenue.

51. The subject of a Matter photograph of Mercedes Carles is misidentified as Lee Krasner in 1995-Hobbs, 10, fig. 5.

52. Herbert Matter papers, Stanford University, the maquette masks the rest of Krasner's body out, and she wears goggles to protect her eyes from the strobe lights used. A list in Matter's handwriting notes: "Lee wa[l]king up stairs for N. W. Ayer." 2007-Landau, 44. See also Jeffrey Head, "Herbert Matter 1907–1984," A4 architects & designers diary (2005).

53. See Martica Sawin, *Surrealism in Exile and the Beginning of the New York School* (Cambridge, Mass.: The MIT Press, 1995), 169–70.

54. 1987-Kamrowski.

55. George Mercer to LK, letter of January 30, 1941, postmarked in Brookline, Massachusetts, and sent to 51 East Ninth Street in N.Y.C., PKHSC.

56. George Mercer to LK, letter of January 30, 1941, postmarked in Brookline, Massachusetts, and sent to 51 East Ninth Street in N.Y.C., PKHSC.

57. See George Mercer to LK, letter of November 3, 1941, in which he implies that he got drafted, PKHSC.

58. George Mercer to LK, letter of March 9, 1941, from Fort Belvoir, Virginia, PKHSC.

59. George Mercer to LK, letter of March 9, 1941, from Fort Belvoir, Virginia, PKHSC.

60. 1979-Novak. A copy of the collection's catalogue, *The Art of Tomorrow,* published in 1939, remains in the library of the PKHSC.

61. George Mercer to LK, letter of April 7, 1941, from Washington, D.C., PKHSC.

62. George Mercer to LK, letter of April 7, 1941, from Washington, D.C., PKHSC.

63. George Mercer to LK, letter of April 7, 1941, from Washington, D.C., PKHSC.
64. George Mercer to LK, letter of April 7, 1941, from Washington, D.C., PKHSC.
65. George Mercer to LK, letter of March 25, 1941, from Fort Belvoir, Virginia, PKHSC.
66. Nina Pantuckoff [Pantuhoff] to L. Krasner, letter of March 20, 1941, from West Palm Beach, Florida.
67. Igor Pantuhoff to Lee Krasner, PKHSC.
68. George Mercer to LK, letter of April 16, 1941, from Fort Belvoir, Virginia, PKHSC.
69. George Mercer to LK, letter of April 28, 1941, from Washington, D.C., PKHSC.
70. George Mercer to LK, letter of April 28, 1941, from Washington, D.C., PKHSC.
71. George Mercer to LK, letter of April 28, 1941, from Washington, D.C., PKHSC.
72. George Mercer to LK, letter of April 28, 1941, from Washington, D.C., PKHSC.
73. George Mercer to LK, letter of May 19, 1941, from Washington, D.C., PKHSC.
74. 1939-Miller, 4.
75. 1939-Miller, 5.
76. 1939-Miller, 4.
77. George Mercer to LK, letter of May 19, 1941, from Washington, D.C., PKHSC.
78. George Mercer to LK, letter of July 7, 1941, from Fort Belvoir, Virginia, PKHSC.
79. George Mercer to LK, letter of July 17, 1941, from Fort Belvoir, Virginia, PKHSC.
80. T. S. Eliot, "The Love Song of J. Alfred Prufrock," in *Poetry: A Magazine of Verses*, June 1915. http://www.bartleby.com/198/1.html.
81. George Mercer to LK, letter of July 17, 1941, from Fort Belvoir, Virginia, PKHSC.
82. George Mercer to LK, letter of August 11, 1941, from Washington, D.C., PKHSC.
83. George Mercer to LK, letter of August 16, 1941, from Fort Belvoir, Virginia, PKHSC.
84. George Mercer to LK, letter of August 16, 1941, from Fort Belvoir, Virginia, PKHSC.
85. George Mercer to LK, letter of September 11, 1941, from Reston, Louisiana, PKHSC.
86. George Mercer to LK, letter of September 22, 1941, from Shreveport, Louisiana, PKHSC.
87. George Mercer to LK, letter of October 18, 1941, from Fort Belvoir, Virginia, PKHSC.
88. George Mercer to LK, letter of October 18, 1941, from Fort Belvoir, Virginia, PKHSC.
89. George Mercer to LK, letter of October 18, 1941, from Fort Belvoir, Virginia, PKHSC.
90. LK to the author, 1977-Rose.
91. LK to author, 1977-Rose.
92. LK to author, 1977-Rose, and LK to 1977-Bourdon, 57.
93. 1966-Rose.
94. LK to author, 1977-Rose.
95. John Graham to LK, from Primitive Arts, 54 Greenwich Avenue, New York, N.Y., 11-12-1941, AAA, roll 3771.
96. 1966-Rose.
97. For Pat Collins, see Hollister Sturges III, "The Woodstock Art Colony," *American Art Review*, October 1999.
98. 1964-Seckler.
99. 1964-Seckler.
100. Joel Gunz, "Pioneer Artists of the Northwest: Louis Bunce," *Rose Arts Magazine,* February/March 1990, 24.
101. 1982-Bunce.
102. 1982-Bunce.
103. 1977-Diamonstein-1.
104. LK to the author; interview of 1977. Pollock, it turns out, kept all his books hidden away in a closet.
105. 1981-Langer.
106. 1968-Wasserman.
107. 1975-Nemser-2, 6.
108. 1979-Munro, 112

109.  1958-Time.
110.  1965-Friedman, 8.
111.  1985-Potter, 64.
112.  1961-Tenke.
113.  1968-Campbell, 63.
114.  2007-Landau, 19, 45, note 40. See also 1989-Naifeh, 394–95 for Betsy Zogbaum's recollections.
115.  1985-Potter, 66.
116.  JPCR, vol. 4, 225.
117.  1985-Potter, 51.
118.  JPCR, vol. 4, 225–26.
119.  1985-Potter, 63.
120.  JPCR, vol. 4, 226.
121.  1977-Diamonstein-1.
122.  1965-Friedman, 8.
123.  1985-Potter, 34.
124.  McNeil to 1985-Potter, 34.
125.  1968-Wasserman.
126.  1998-Matter.
127.  Herbert Matter to John G. Powers, letter of December 21, 1972, JPCR Archives, PKHSC.
128.  Quoted in James T. Valliere, "De Kooning on Pollock," *Partisan Review* 34 (Fall 1967): 603–05.
129.  1964-Seckler.
130.  Emilie S. Kilgore to Gail Levin, courtesy Barbara Rose, email of 10-4-2010.
131.  1985-Potter, 53.
132.  1985-Potter, 63.
133.  1985-Potter, 65.
134.  Krasner also told me about having had Byron Browne write these lines on her studio wall. This took place before she began to see Pollock.
135.  1965-Friedman, 8.
136.  1965-Friedman, 8.
137.  1985-Potter, 65.
138.  1984-Little, II-1.
139.  1967-Greene.
140.  See 1967-Parsons for her list: [Willem] de Kooning, [Jackson] Pollock, [Arshile] Gorky, [Adolph] Gottlieb, [Mark] Rothko, [James] Brooks, [Mark] Tobey, [Louis] Guglielmi, [David] Smith, [Reuben] Nakian, [Theodoros] Stamos, [William] Baziotes, [Philip] Guston, [Karl] Knaths, [Stuart] Davis, [Jack] Levine, [Ben] Shahn, [Louise] Nevelson, the Soyer Brothers [Moses, Isaac, and Raphael], [Philip] Evergood, Greene, [Giorgio] Cavallon.
141.  George Mercer to LK, letter of December 25, 1941, PKHSC.
142.  George Mercer to LK, letter of January 5, 1942, PKHSC.

## Chapter 8: A New Attachment: Life with Pollock, 1942–43 (pp. 177–196)

1.  George Mercer to LK, letter of January 17, 1942, PKHSC.
2.  George Mercer to LK, letter of January 17, 1942, PKHSC.
3.  1964-Seckler.
4.  1983-Liss.
5.  *Art Digest,* review quoted in 2006-Wilkin.
6.  *Art Digest,* review quoted in 2006-Wilkin. Willem de Kooning was then showing as "William Kooning."
7.  Perle Fine to LK, letter of January or February 1942, LKP, AAA, roll 3771.

8. Edward Alden Jewell, "57th Street Gets 2 New Galleries," *NYT,* November 25, 1941, 29. Founded in 1924 by Valentine Dudensing as Dudensing Galleries, the gallery was renamed F. Valentine Dudensing in 1926 and Valentine Gallery sometime later. The gallery closed in 1948.

9. E. A. J. [Edward Alden Jewell], "By European Moderns," *NYT,* January 25, 1941, X9.

10. 1984-Little, II-1. Little later confused Curt Valentine's gallery in New York with the earlier Valentine Dudensing, which showed Mondrian in January 1942. He also appears to have misremembered the title of Mondrian's lecture, which he called "Toward the True Vision of Reality."

11. "Water-color Show Will Open Tuesday," *NYT,* 2002-Rembert, gives the lecture title as "A New Realism."

12. 1957-Morris, 140.

13. The first was January 9, 1942.

14. 2002-Rembert, 71–72.

15. Piet Mondrian, "A New Realism," included in the Abstract American Artists book in 1946.

16. 1984-Little, II-1.

17. *Time,* October 21, 1940, and Barney Josephson, quoted in 1989-Kisseloff, 470.

18. 1982-Bunce. The following quotation is also from this source.

19. Harry Holtzman, Ilya Bolotowsky, Burgoyne Diller, Fritz Glarner, Charmion Von Wiegand, and Carl Holty also felt the influence of Mondrian's style.

20. 1977-Diamonstein-1.

21. 1977-Diamonstein-1.

22. LK to author, 1977.

23. 1977-Bourdon, 57.

24. 2002-Rembert, 76.

25. Charmion Von Wiegand, quoted in 2002-Rembert, 76.

26. 2002-Rembert, 76.

27. 2002-Rembert, 76.

28. 2002-Rembert, 76.

29. Piet Mondrian quoted in Jay Bradley, "Piet Mondrian, 1872–1944: 'Greatest Dutch Painter of Our Time,'" *Knickerbocher Weekly,* 3, 51, 1944, 17.

30. See 1998-Joosten, 174, and Geoffrey Hellman (as anonymous), "Lines and Rectangles," *The New Yorker,* no. 3, March 1, 1941, 8–9. See also Herbert Henkels, "Mondrian's Late Work: A Sketch," in *Mondrian in New York* (Tokyo: Galerie Tokoro, 1993), 12–13.

31. See LKCR 96; also 94, 95.

32. George Mercer to LK, letter of February 23, 1942, from Fort Bragg, North Carolina, PKHSC.

33. George Mercer to LK, letter of February 23, 1942, from Fort Bragg, North Carolina, PKHSC.

34. George Mercer to LK, letter of February 23, 1942, from Fort Bragg, North Carolina, PKHSC.

35. George Mercer to LK, letter of March 16, 1942, from Fort Belvoir, Virginia, PKHSC.

36. *Art News,* quoted in 2002-Rembert, 72.

37. Edward Alden Jewell, "Abstract Artists Hold Sixth Show," *NYT,* March 10, 1942, 24. Others included Krasner's close friend from the Hofmann School, Ray Kaiser.

38. *Art Digest,* quoted in 2002-Rembert, 72.

39. George Mercer to LK, letter of April 27, 1942, from Fort Belvoir, Virginia, PKHSC.

40. George Mercer to Lenore Krasner, letter of July 13, 1942, from Fort Belvoir, Virginia, PKHSC.

41. George Mercer to Lenore Krasner, letter of July 13, 1942, from Fort Belvoir, Virginia, PKHSC.

42. George Mercer to LK, letter of August 4, 1942, from Fort Belvoir, Virginia, PKHSC.

43. 1966-Rose.

44. 1979-Munro, 114.

45. 1979-Novak.

46. 1968-Wasserman.

47. 1937-Graham, 135. See comparison of Krasner's and Graham's drawings in 1983-Rose, 47.

48. 1937-Graham, 136.

49. 1937-Graham, 116.

50. 1979-Novak.

51. 1979-Novak; see also John Graham, "Primitive Art and Picasso," *Magazine of Art,* vol. 30, April 1937, 236–38.

52. Carl Holty interviewed by William Agee, AAA, December 8, 1964. He also recalled: "Graham had in his entourage de Kooning and Gorky, Pollock, and that's about it," conflicting with Krasner's assertion that she introduced Pollock to de Kooning.

53. LK quoted in 1967-du Plessix and Gray, 51.

54. George Mercer to LK, letter of June 8, 1941, from Fort Belvoir, Virginia, PKHSC. He mentions Joe Fontaine and "S.S." besides Bultman.

55. Reuben Kadish quoted in Kisseloff, *You Must Remember This,* 470.

56. 1988-Silvester, 145–46.

57. LK was aware of artists who went to the civil war in Spain. See 1972-Rose-1.

58. Café Society Uptown was on East Fifty-eighth Street, between Park and Lexington Avenues. See Barney Josephson with Terry Trilling-Josephson, *Cafe Society: The Wrong Place for the Right People* (Champaign: University of Illinois Press, 2009).

59. 1997-Erenberg, 366. See also 1988-Silvester, 145–60, which has ads and descriptions of the boogie-woogie craze at the club.

60. 1997-Erenberg, 367.

61. For reports of Eleanor Roosevelt at Café Society, see David W. Stowe, "The Politics of Café Society," *Journal of American History,* vol. 84, no. 4 (March 1998), 1403, and the Ivan Black papers in the NYPL. For the dives in Harlem, see 1977-Rose-1.

62. 1968-Wasserman.

63. 1979-Novak.

64. 1979-Novak. I first interviewed Krasner about Kandinsky in January 1971.

65. 1964-Seckler. LK in lecture, New York Studio School, December 14, 1977, AAA, reel 3774.

66. Lee Krasner to Barbara Cavaliere, interview, AAA, reel 3774, frame 286.

67. 1985-Potter, 68.

68. Matter quoted in 1985-Potter, 68.

69. "War-and-College Montage for the Pennsylvania Station," *NYT,* September 28, 1942, 19.

70. LK to author, 1977.

71. LKCR, 93, see LK papers at AAA.

72. LKCR, 93, see LK papers at AAA.

73. LKCR, 93–96, see LK papers at AAA.

74. "War-and-College Montage for the Pennsylvania Station," *NYT,* September 28, 1942, 19.

75. According to LKCR, 94, Ben Benn's signature appears on the lower right of a photograph of a cryptography design. For the first publication of these works since the year that they were completed, see 1978-Levin. See also War Services Project, Works Progress Administration, New York (O.P. 65-1-97-20763 W.P. 1).

76. 1972-Gruen, 230.

77. 1998-White, 80.

78. 1967-du Plessix and Gray, 49. Pollock's brother, Sande, older by three years, but next to him in birth order, changed his surname to their paternal grandfather's surname, which was replaced when LeRoy, their father, got adopted by the Pollock family.

79. 1967-du Plessix and Gray, 49.

80. 1998-White, 80.

81. 1998-White, 198.

82. For a discussion of the medical view of alcoholism prior to Prohibition, see 2005-Tracy, 226–272, and W. White, "The Rebirth of the Disease Concept of Alcoholism in the 20th Century, *Counselor,* vol. 1, no. 2, 2000, 62–66.

83. 1985-Potter, 67.
84. JPCR, vol. 4, p. 226.
85. George Mercer to LK, letter of September 6, 1942, from Fort Belvoir, Virginia, PKHSC.
86. George Mercer to LK, letter of September 4, 1942, from Fort Belvoir, Virginia, PKHSC.
87. George Mercer to LK, letter of September 4, 1942, from Fort Belvoir, Virginia, PKHSC.
88. 1981-Glueck-2, 59.
89. 1985-Potter, 66.
90. 1985-Potter, 66.
91. 1968-Wasserman.
92. John [a.k.a. Jean] Xceron was born Yiannis Xirocostasin in 1890 in Isary, Greece, and came to the United States in 1904 at the age of fourteen. In 1911–1912, he began studying at the Corcoran School of Art in Washington, D.C. Serge Trubach emigrated from the Ukraine, where he was born in 1912; he came to the United States and studied at the National Academy, where he and Krasner might have first met.
93. Pearl Bernstein, administrator, Board of Higher Education, to Audrey McMahon, general supervisor, City War Services Project, letter of October 1, 1942, AAA.
94. Pearl Bernstein letter of October 1, 1942, lists Krasner as being in charge of these artists listed as on the project, AAA.
95. Jeanne Bultman interview with the author, April 23, 2007.
96. George Mercer to LK, letter of October 26, 1942, from Fort Belvoir, Virginia, PKHSC.

## Chapter 9: Coping with Peggy Guggenheim, 1943–45 (pp. 197–230)

1. Frederick Kiesler quoted in Edward Alden Jewell, "Gallery Premiere Assists Red Cross," *NYT,* October 21, 1942, 22.
2. 1964-Seckler.
3. 1978-Cavaliere.
4. 1979-Novak.
5. 1980-Bennett.
6. 1980-Mooradian.
7. 2003-Herrera, 609, 621.
8. 1978-Cavaliere and LK to the author, 1977-Rose.
9. 1975-Nemser-1, 88.
10. 1979-Novak. Jean Connolly, "Art: Spring Salon for Young Artists," *The Nation,* 156, no. 22 (May 29, 1943), 786.
11. 1997-Rubenfeld, 64, 71.
12. Robert M. Coates, "The Art Galleries: From Moscow to Harlem," *The New Yorker,* 19 (May 29, 1943): 49.
13. JPCR, vol. 4, 228.
14. LK to Stella Pollock, undated letter, Morgan, quoted in JPCR, vol. 4, 228, D46.
15. LK to Stella Pollock, undated letter, Morgan, quoted in JPCR, vol. 4, 228, D46.
16. LK to Stella Pollock, undated letter, Morgan, quoted in JPCR, vol. 4, 228, D46.
17. LK to Stella Pollock, undated letter, Morgan, quoted in JPCR, vol. 4, 228, D46.
18. LK to Stella Pollock, undated letter, Morgan, quoted in JPCR, vol. 4, 228, D46.
19. LK's birth certificate number was 36035; she was born at 373 Sackman Street in Brooklyn.
20. 1944-Janis, LK's *Composition* is reproduced as plate 31; measuring 30 inches by 24 inches.
21. Ray Kaiser Eames's painting *For C in Limited Palette* was illustrated in *California Arts & Architecture* in 1943. See 1998-Kirkham, 38–39.
22. 1964-Seckler.
23. Sidney Janis quoted in 1972-Gruen, 245.
24. 1944-Janis, 112. Janis omitted the article in the title, *The She-Wolf.*
25. Sidney Janis to JP, September 27, 1943, in JPCR, D47, 229.

26. LK to Mercedes Matter, letter of 1943, Mercedes Matter estate.

27. Lee Krasner to Mercedes Matter, letter of 1943, Mercedes Matter estate.

28. Charles Eames ran the Molded Plywood Division of Evans Products Company in Venice, California, which produced splints for the U.S. Navy. See John Neuhart, Marilyn Neuhart, and Ray Eames, *Eames Design: The Work of the Office of Charles and Ray Eames* (New York: Harry N. Abrams, Inc., Publishers, 1980). Earlier Matter had designed propaganda posters for the U.S. government and had disliked doing so; see also 2007-Landau, 45. See also: http://www.herbert-matter.com/index.shtml.

29. LK to Mercedes Matter, letter of 1943, Mercedes Matter estate.

30. 2007-Landau, 41, n. 7. The Bennett School was located in Millbrook, New York. Ray Eames studied there from 1930 to 1931.

31. LK to Mercedes Carles Matter, undated letter of 1943.

32. LK to Mercedes Carles Matter, undated letter of 1943.

33. LK to Mercedes Carles Matter, undated letter of 1943.

34. LK to Stella Pollock, letter of 1943, JPCR, vol. 4, D45, states: "Rube [Reuben Kadish] came in town for two weeks. He is with the army as an artist correspondent. . . . He plans coming east when it's over." This photograph is reproduced in 1989-Kisseloff, insert, n.p.

35. See JPCR, vol. 4, 229. Reuben Kadish interview with Jeff Kisseloff, NYPL, states that he photographed Pollock in his Eighth Street studio.

36. Vita Petersen to the author, interview of 3-1-2010. See "Elizabeth Hubbard, Physician Since 1921," *NYT,* May 23, 1967, 47.

37. 1989-Naifeh, 492. See Elizabeth Wright-Hubbard, MD, *Homeopathy as Art and Science: Selected Writings* (Bucks, UK: Beaconsfield Publishers Ltd, 1990). Elizabeth Wright Hubbard graduated in medicine in 1921 from Columbia University School of Physicians and Surgeons and interned at Bellevue Hospital, New York. She went on to study homeopathy for two years with Dr. Pierre Schmidt of Geneva, Switerland, and returned to the United States to pursue a career that brought her international acclaim and affection. She was the first woman to be elected president of the American Institute of Homeopathy.

38. 1979-Novak.

39. 1972-Gruen, 230.

40. JPCR, vol. 4, D49, 229.

41. LK to Carles Matter, undated letter of December 1943 and James Johnson Sweeney, introduction, *Jackson Pollock*, Art of This Century, November 8–29, 1943.

42. The itinerary was to the Denver Art Museum (March 26–April 23), the Seattle Art Museum (May 7–June 10), the Santa Barbara Museum of Art (June–July), and the San Francisco Museum of Art (July), and then to New York City.

43. LK to Carles Matter, undated letter of December 1943.

44. 1981-Glueck-2, 60.

45. Mercedes and Herbert Matter's son, Alexander Pundit Matter, born July 1942, was named after his godfather, Alexander Calder. His middle name was in honor of Pandit [or Pundit] Jawaharlal Nehru (1889–1964), one of the foremost leaders of India's struggle for freedom. "Pundit" is a scholar, a teacher, particularly one skilled in Sanskrit and Hindu law, religion and philosophy. Alex was called Pundy.

46. LK to Mercedes Carles Matter, letter postmark unclear, from December 1943, from 46 East Eighth Street, New York City.

47. JP to Herbert and Carles Matter, letter postmarked March 4, 1944.

48. JPCR, vol. 4, 233, D54. Letter JP to mother dated Friday (probably February 4, 1944) and JP to Charles, April 14, 1944.

49. JPCR, vol. 4, 233, D55. Letter JP to Charles, May 1944.

50. 1975-Nemser-1, 88.

51. LK to Mercedes Carles Matter, undated letter of March 1944.

52. LK to Mercedes Carles Matter, undated letter of March 1944.

53. LK to Mercedes Carles Matter, undated letter of March 1944.

54. LK to Mercedes Carles Matter, undated letter of March 1944.

55. LK to Mercedes Carles Matter, undated letter of March 1944.

56. LK to Mercedes Carles Matter, undated letter of March 1944.

57. LK to Mercedes Carles Matter, undated letter of March 1944. The definite article was part of Pollock's original title for this painting.

58. George Mercer to JP and LK, letter of April 17, 1942, from Fort Belvoir, Virginia, PKHSC.

59. LK to Mercedes Carles Matter, letter postmarked June 29, 1944, from Provinctown, Massachusetts. The show was at the Philadelphia Art Alliance; see Howard Devree, "From a Reporter's Notebook, *NYT,* March 5, 1944, X6.

60. JPCR, vol. 4, 234, D58, JP and LK to Mother LoieSande, undated letter of 1944.

61. JP to Herbert Matter at 11013½ Strathmore, Westwood, Los Angeles, California, postmarked September 7, 1944; postcard image: Jade Horse's Head from Chinese Tomb at the Fogg Art Museum, Harvard University. See 1983-Rose, 29, who says LK painted in Hofmann's Provincetown studio during the summer of 1943, but it appears that LK, Rose's source, no longer recalled when they were actually in Provincetown.

62. 2009-Landau, 70, Note 75

63. Hans Hofmann to Jeannette (Mercedes) and Herbert, letter of October 14, 1944, Estate of Mercedes Matter, quoted in 2003-Dickey, 75.

64. Hans Hofmann to Mercedes Matter, letter of October 14, 1944, quoted in 2003-Dickey, 75.

65. George Mercer to LK, letter of December 4, 1944, from Fort Belvoir, Virginia, PKHSC.

66. George Mercer to LK, letter of December 4, 1944, from Fort Belvoir, Virginia, PKHSC.

67. George Mercer to LK, letter of December 4, 1944, from Fort Belvoir, Virginia, PKHSC.

68. LK to Mercedes Carles Matter, letter postmarked December 21, 1944.

69. LK to Mercedes Carles Matter, letter postmarked December 21, 1944.

70. LK to Mercedes Carles Matter, letter postmarked December 21, 1944.

71. Val Schaffner to the author, 11-10-2010, and Val Schaffner, "Perdita Macpherson Schaffner (1919–2001), http://www.imagists.org/hd/perdita.html. Macpherson married the poet, Bryher, who shared his love for the imagist poet H. D. [Hilda Doolittle], and they formally adopted H. D.'s child, Perdita, Val's mother. H. D. and Bryher spent the war in London, while Macpherson came to live in New York City. Some writers have characterized Macpherson as "homosexual"; see, for example 1986-Weld, 308–309, but see also 2004-Dearborn, 210, who concurs with Schaffner.

72. LK to Mercedes Carles Matter, letter postmarked December 21, 1944. Krasner was not yet married, but referred to herself as "Mrs."

73. 1985-Potter, 70

74. 1975-Potter, 70.

75. 1971-Motherwell.

76. LK to Mercedes Carles Matter, letter postmarked December 21, 1944.

77. LK to Mercedes Carles Matter, letter postmarked December 21, 1944.

78. 1960-Guggenheim, 108. Her claim that Putzel died of a suicide is not confirmed in his obituary, which lists the cause of death as a heart attack.

79. George Mercer to LK, letter of April 24, 1945, from Los Angeles, California, PKHSC.

80. George Mercer to LK, letter of April 24, 1945, from Los Angeles, California, PKHSC.

81. George Mercer to LK, letter of April 24, 1945, from Los Angeles, California, PKHSC.

82. 1964-Seckler, interview of November 2, 1964, AAA.

83. 1964-Seckler, interview of November 2, 1964, AAA. 1999-Hobbs, 64–66, attributes the gray slabs to hearing about the Holocaust, but this seems unlikely. If anything affected her beyond the impact of Pollock's art, it would have been her father's death in November 1944.

84. 1965-Forge.

85. 1972-Rose-2, 121, 154.

86. Edward Alden Jewell, "Toward Abstract or Away?" *NYT,* July 1, 1945, 22.

87.  Edward Alden Jewell, "Academe Remains Academe," *NYT,* May 20, 1945, X2.
88.  1985-Potter, 77.
89.  G. Baldwin Brown, *The Art of the Cave Dweller* (New York: R.V. Coleman, c. 1928–1932), 18, 57, 68, 224.
90.  Brown, *The Art of the Cave Dweller,* 156.
91.  George Mercer to LK, letter of June 24, 1945, from Los Angeles, California, PKHSC.
92.  George Mercer to LK, letter of June 24, 1945, from Los Angeles, California, PKHSC.
93.  George Mercer to LK, letter of June 24, 1945, from Los Angeles, California, PKHSC.
94.  George Mercer to LK, letter of June 24, 1945, from Los Angeles, California, PKHSC.
95.  These included Terrence Netter, Father Anthony Lauck, and Father Pierre Riches, a converted Jew then at the Vatican, however, Krasner never converted and remained self-identified as Jewish.
96.  George Mercer to LK, letter of June 24, 1945, from Los Angeles, California, PKHSC.
97.  George Mercer to LK, letter of June 24, 1945, from Los Angeles, California, PKHSC.
98.  "12 Artists in Prize Contest," *NY T,* January 16, 1946, 23.
99.  "Temptations of St. Anthony," *Time,* March 25, 1946. "Ernst Painting Wins Loew-Lewin Award," *NYT,* September 17, 1946, 10.
100.  Edward Alden Jewell, "Chiefly Modern Idiom," *NYT,* June 17, 1945, X2. Correct name is Loren MacIver.
101.  Lee Krasner to the author, 1977-Rose. Among the other women in the show were Janet Sobel (an immigrant housewife who was self-taught); Alice Trumbull Mason (a founder of American Abstract Artists); Charmion von Wiegand, a disciple of Mondrian's; and LK's good friend, Perle Fine.
102.  Stephen Birmingham, *Our Crowd: The Great Jewish Families of New York* (New York: Harper & Row, Inc., 1967), 344.
103.  2004-Dearborn, 70. Emma Goldman, *Living My Life* (New York: Alfred A. Knopf, 1931), vol. 2, chapter 56.
104.  1986-Weld, 74.
105.  1979-Guggenheim, 315.
106.  LK to Angelica Zander Rudenstein, March 6, 1981, *The Peggy Guggenheim Collection, Venice* (New York: Harry N. Abrams, 1985).
107.  LK to the author, in conversation and 1977-Rose.
108.  2002-Harrison, 75. This conflicts with JPCR, which claims incorrectly that the shack was in Amagansett, another village outside of East Hampton.
109.  David Slivka to the author, August 2007.
110.  George Mercer to LK, letter of August 3, 1945, from Los Angeles, California, PKHSC.
111.  George Mercer to LK, letter of September 18, 1945, from Los Angeles, California, PKHSC.
112.  George Mercer to LK, letter of September 18, 1945, from Los Angeles, California, PKHSC.
113.  George Mercer to LK, letter of September 18, 1945, from Los Angeles, California, PKHSC.
114.  George Mercer to LK, letter of September 18, 1945, from Los Angeles, California, PKHSC.
115.  George Mercer to LK, letter of September 18, 1945, from Los Angeles, California, PKHSC. Mercer misremembered the title of Mumford's book. He may have meant Lewis Mumford, *The Culture of Cities* (New York: Harcourt, Brace, and Co., 1938).
116.  George Mercer to LK, letter of September 18, 1945, from Los Angeles, California, PKHSC.
117.  Francis Newton, "Memorial Showing and Members' Art at Guild Hall," *East Hampton Star,* July 19, 1945, 1.
118.  American Watercolor Society, August 16, 1945, *East Hampton Star,* 3, reproduced Herbert H. Scheffel's *The Carrousel* from the watercolor show.
119.  See 1996-Braff, 7.
120.  1986-Weld, 336; 2002-Gill, 331; 2004-Dearborn, 230.

## Chapter 10: Coming Together: Marriage and Springs, 1945–47 (pp. 231–248)

1. JP, quoted in 1950-Roueché.
2. 1981-Glueck-2, 60.
3. 1981-Glueck-2, 60.
4. 1979-Novak.
5. May Tabak Rosenberg quoted in 1986-Weld, 343.
6. 1981-Delatiner; 1973-Freed.
7. "Real Estate Brokers Report Record Number of Sales and Rentals Here," *East Hampton Star*, November 8, 1945, 1.
8. LK to Mercedes Carles Matter, undated letter postmarked November 29, 1945.
9. LK to Mercedes Carles Matter, undated letter postmarked November 29, 1945.
10. 1979-Guggenheim, 108.
11. 1983-Liss, 43A.
12. 1972-Rose-1.
13. 1973-Freed.
14. 1973-Freed.
15. 1972-Rose-1.
16. 1973-Freed.
17. 1979-Novak.
18. 1972-Rose-1.
19. 1972-Rose-1.
20. 1963-Barker.
21. 1981-Glueck-2, 60.
22. 1972-Rose-1.
23. 1979-Munro, 114.
24. LK to Mercedes Carles Matter, undated letter postmarked November 29, 1945.
25. LK to Mercedes Carles Matter, undated letter postmarked November 29, 1945.
26. 1950-Roueché, 16.
27. LK to Mercedes Carles Matter, undated letter postmarked November 29, 1945.
28. LK to 1963-Barker.
29. 1964-Seckler.
30. 1964-Seckler.
31. 1979-Novak. It wasn't the end of East Hampton for Motherwell, who had Pierre Chareau build him a house in 1945, which was finished in 1946, but it was his last home in Springs.
32. 1999-Friedman, 20, journal entry of January 10, 1965.
33. JP, April 2–20, 1946, Art of This Century, 30 West Fifty-seventh Street, New York, featured eleven oils and eight temperas.
34. 1972-Rose-1.
35. Soglow's character first appeared in 1931 in *The New Yorker* and then ran as a syndicated comic in Hearst-owned newspapers from 1934 until 1975. Pollock's near silent first meeting with Herbert Matter is characteristic of such stories of Pollock's reticent communication.
36. That Pollock repainted *The Little King* does not appear in the JPCR, but in Pepe Karmel, "Pollock at Work: The Films and Photographs of Hans Namuth," 1998-Varnedoe, 104. Few seem to have realized the comic strip as a source. See William S. Wilson in 2000-Harrison, 204–205. The visible forms of *Galaxy* make clear its history, but Karmel does not account for the difference of several inches in each dimension, although he repeats those for *The Little King* in the JPCR, which were apparently inaccurately reported.
37. JPCR, vol. 4, 237, D64, JP to Wally & Ed Strautin, letter postmarked 8-14-1946. 1972-Rose-1
38. 1977-Ratcliff, 82.
39. 1981-Glueck-2, 60.
40. 1961-Tenke, 37.

41. 1981-Glueck-2, 60.
42. 1981-Delatiner.
43. 1981-Glueck-2, 60.
44. 1981-Langer.
45. 1967-Glaser.
46. 1965-Friedman, 9.
47. JPCR, vol. 4, 236, D61, JP to Ed and Wally Strautin, neighbors in New York City, card of 11-29-1945.
48. LK to 1986-Weld, 101, interview of 1979.
49. 1946-Guggenheim.
50. 1972-Gruen, 231. This account confused the dates of this book's publication and inscription, which took place after Krasner and Pollock were married.
51. 1981-Langer.
52. 1960-Rago, 32.
53. 1987-Solomon, 164.
54. 1978-Rose-1.
55. JPCR, vol. 4, 237, D63, JP to Wally & Ed Strautin, letter postmarked June 26, 1946.
56. Clement Greenberg to Florence Rubenfeld, interview of 2-16-90, Getty.
57. 1995-Friedman, 137.
58. George Mercer to LK and JP, letter of August 11, 1946, from Provincetown, PKHSC.
59. 1972-Rose-1.
60. 1964-Seckler.
61. 1965-Friedman, 10.
62. 1979-Novak.
63. 1979-Novak.
64. 1979-Novak.
65. 1979-Novak.
66. 1973-Nemser, 44.
67. 1968-Wasserman.
68. 1979-Novak.
69. 1978-Cavaliere.
70. See LKCR, 102, for the beach description of *Night LIfe*.
71. 1967-du Plessix, 51.
72. 1973-Nemser, 44.
73. 1975-Nemser-2, 6.
74. 1975-Nemser-2, 6.
75. LK at the Nassau County Museum of Art, Roslyn, New York, speaking in 1979 after a showing of Barbara Rose's film, recording at PKHSC.
76. 1973-Nemser, 44.
77. 1973-Nemser, 44.
78. 1973-Tucker and 1978-Levin, 86. Krasner repeated this account to me in 1977, when I was planning to write about her work, and I included the influence of her learning Hebrew as a child in my essay for the catalogue Hobbs and Levin, 1978.
79. See http://www.dys-add.com/define.html#history
80. 1991-Hall, 21.
81. Sarah W. Tracy, *Alcoholism in America,* 281.
82. David Slivka to the author, July 2007.
83. JPCR, vol. 4, 240, D70, JP to Mother and all, letter of September 3, 1947.
84. Lee Krasner to Grace Glueck, "Scenes from a Marriage Krasner and Pollock," *Art News,* December 1981, 60.

## Chapter 11: Triumphs and Challenges, 1948–50 (pp. 249–268)

1. JPCR, vol. 4, 241, D73, Stella Pollock to Frank Pollock, postmarked December 11, 1947.
2. 1977-Diamonstein-1.
3. Grace Hartigan to the author, 3-30-2007, and earlier, 1979-Hartigan.
4. Grace Hartigan to the author, 3-30-2007, and earlier, 1979-Hartigan.
5. Grace Hartigan to the author, interview of 3-30-2007.
6. 1989-Naifeh, 565. Grace Hartigan to the author, interview of 3-30-2007.
7. Grace Hartigan to the author, interview of 3-30-2007. Hartigan's marriage to Harry Jackson lasted only a year.
8. See Harry Jackson's own account on his Web site: http://www.harryjackson.com/biography.cfm.
9. JPCR, vol. 4, 242.
10. LK to the author, many times.
11. 2002-Harrison, 80. Artist friends who settled in Springs or on eastern Long Island included Nicolas Carone, Costantino Nivola, Charlotte and Jim Brooks, John Little and his wife Josephine, Balcomb Greene and his wife Gertrude "Peter" Greene, Ibram Lassaw, and Perle Fine.
12. Vita Petersen to the author, interview of 3-1-2010, says that she studied with Hofmann later than Lee and Mercedes, since she only arrived from Germany in 1938 and entered the Hofmann School after the birth of her daughter in 1942.
13. Vita Petersen to the author, interview of 3-1-2010.
14. Vita Petersen to the author, 3-11-2010.
15. Vita Petersen to the author, 3-11-2010. This photograph remains in the collection of PKHSC and was cited in 2007-Landau, 20. See cover of *Mercedes Matter,* 2009.
16. Vita Petersen to the author, 3-12-2010.
17. Vita Petersen to the author, 3-12-2010.
18. "House that 'Lives' Theme of Exhibit," *NYT,* September 20, 1948, 22.
19. "House that 'Lives' Theme of Exhibit," *NYT,* September 20, 1948, 22.
20. Ann Pringle, "Modern Houses Inside and Out," *New York Herald Tribune,* September 20 1948, 22, and "House That 'Lives' Theme of Exhibit," *NYT,* September 20, 1948, 22.
21. Aline B. Louchheim, "Gallery, Decorator and Work of Art," *NYT,* September 26, 1948, X9 Aline Bernstein Louchheim was later known as Aline B. Saarinen after her 1954 marriage to architect Eero Saarinen.
22. Ann Pringle, "Modern Houses Inside and Out," *New York Herald Tribune,* September 20 1948, 22.
23. "House that 'Lives' Theme of Exhibit," *NYT,* September 20, 1948, 22.
24. LKCR 225 notes Krasner's dismay at Schaefer's decision to ask Alexander Styne to transform this painting into the top of a black wood coffee table.
25. LKCR, 103, note for CR 212, identifies "interstitial 'images' in *Abstract No. 2* [that] resemble trap symbols from paleolithic caves," which she thinks Krasner got from the book they owned: G. Baldwin Brown, *The Art of the Cave Dweller* (1931).
26. Frederick Gutheim, "Arts and Architecture at Work in Two New Exhibitions," *New York Herald Tribune,* October 3, 1948, AAA, reel 3776, frame 1012.
27. 1977-Diamonstein-1.
28. 1973-Friedman, 32.
29. 1968-Ossorio.
30. 1968-Ossorio.
31. JPCR, vol. 4, 243.
32. JPCR, vol. 4, 243, D76, Stella Pollock to Charles Pollock, letter of January 10, 1949.
33. 1964-Seckler.
34. 1964-Seckler.
35. JPCR, vol. 4, 243, D77, Stella Pollock to Charles Pollock, letter of mid-April 1949.

36. JPCR, vol. 4, 245, D79, Stella Pollock to Frank Pollock, letter postmarked June 15, 1949.

37. Others in this show were Gina Knee, Julien Levy, Ibram Lassaw, David Burliuk, Ray Prohaska, and Lucia (Mrs. Roger Wilcox, who showed with Sidney Janis).

38. Stuart Preston, "New Group Exhibitions: Out of Town," NYT, July 17, 1949, X6.

39. Robert Alan Aurthur, "Hitting and Boiling Point, Freakwise at East Hampton," Esquire, June 1972.

40. Though a couple, Picasso and Gilot were not legally married.

41. Stuart Preston, "By Husband and Wife," NYT, September 25, 1949, X9.

42. 1964-Seckler.

43. 1958-Time, 64.

44. JPCR, vol. 4, 246, D82, Stella Pollock to Frank Pollock, letter postmarked 12-22-1949.

45. LK to Alfonso Ossorio, letter of 1950, quoted in JPCR, 247.

46. 1985-Potter, 121–22.

47. 1985-Potter, 122.

48. Stuart Preston, "Chiefly Modern," NYT, June 4, 1950, X6.

49. 1973-Nemser, 45.

50. Others included were Gina Knee and George Sakler.

51. "Guild Hall to Open Season with Abstract Art Show," East Hampton Star, June 29, 1950, Lee Krasner Papers, AAA, reel 3780, frame 396-A.

52. This point has been argued by 1996-Wagner, 164.

53. Life, August 8, 1949, 42–45.

54. 1985-Potter, 114.

55. JPCR, vol. 4, 247. This letter was published in the New York Times and in the Herald Tribune.

56. Recently, 2009-Sandler, 229, made the inexplicable comment: "Had she wanted to she could have been included among the Irascibles in their photograph in Life, but she did not." Sandler never tells us how he knows this; perhaps he imagines that LK could just have invited herself to join in after the fact of being passed over by Newman when he phoned, but this is not credible.

57. 1981-Langer.

58. For example, 1996-Wagner, 122–23.

59. For example, she taught the author a few of her favorite recipes.

60. 1950-Roueché, 16.

61. 1950-Roueché, 16.

62. 1950-Roueché, 16.

63. 1985-Potter, 200. 1989-Naifeh 750 erroneously places this event in 1955.

64. Time, November 20, 1950. JPCR, 253.

65. 1985-Potter, 130.

66. 1985-Potter, 130–31.

67. Josephine Little to Andrea Gabor, taped interview, claims that they were not present for this incident.

68. Reported by Peter Blake quoted in 1985-Potter, 131.

69. 1985-Potter, 133.

70. They were originally shown with numbers rather than these titles.

71. 1973-Friedman, 42.

72. 1985-Potter, 134.

73. Marvin Jay Pollock to Frank Pollock, letter of December 3, 1950, JPCR, 255.

74. 1985-Potter, 134–35.

75. Howard Devree, "Artists of Today: One-Man Shows Include Recent Paintings by Jackson Pollock and Mark Tobey," NYT, December 3, 1950, X9.

76. Robert M. Coates, "Extremists," The New Yorker, December 9, 1950, 110.

77. See B.K. [Belle Krasne], "Fifty-seventh Street in Review," Art Digest, December 1, 1950, 16, who called the work "richest and most exciting."

78.  "The Year in Review: 1950," *Art News,* reprinted in 1977-Diamonstein-2, 207.

79.  JPCR, vol. 4, 257, D94, letter of late January 1951, JP to Alfonso Ossorio.

## Chapter 12: First Solo Show, 1951–52 (pp. 269–288)

1.  1972-Gruen, 232–33.

2.  1985-Potter, 114.

3.  JPCR, vol. 4, 257, D93, letter of January 6, 1951, JP to Alfonso Ossorio and Ted Dragon.

4.  JPCR, vol. 4, 257, D94, letter of late January 1951, JP to Alfonso Ossorio, responding to Os-
    sorio's offer to pay for a painting with monthly installments of $200.

5.  LKCR, chronology, 310, erroneously reports that Pollock was already seeing the "Sullivanian"
    therapist Ralph Klein, but in fact that treatment began several years later. 1999-Hobbs, 116.
    repeats this error. On Fox's approach see, 1974-Blum, 174–75, 245.

6.  1998-White, 226, 229. Dr. Ruth Fox became the medical director of the National Council or
    Alcoholism.

7.  1974-Blum, 174–75.

8.  Linda Lindeberg quoted by 1975-Nemser-2, 7.

9.  Ruth Fox, M.D., "The Alcoholic Spouse," 158–59.

10.  1956-Fox, 151–52.

11.  1974-Hutchinson.

12.  1979-Novak.

13.  JPCR, 259–60, C96, C97.

14.  Among the other women artists in this show were: Perle Fine, Helen Frankenthaler, Joar
    Mitchell, Anne Ryan, Sonia Sekula, Day Schnabel, and Jean Steubing. Most artists, including
    Krasner, were identified by surnames only.

15.  JPCR, vol. 4, 261, D99, letter of late June 7, 1951, JP to Alfonso Ossorio and Ted Dragon.

16.  1985-Potter, 139.

17.  1979-Novak.

18.  1973-Nemser, 45.

19.  1973-Nemser, 45.

20.  1973-Nemser, 45.

21.  1965-Friedman, 11. LKCR, 123.

22.  1967-Seckler.

23.  See LKCR, 124, CR252. The catalogue raisonné does not associate this quotation with this
    work, though the link seems clear.

24.  John Bernard Myers, "Anne Ryan's Interior Castle," *Archives of American Art Journal,* vol. 15,
    no. 3 (1975), 8–11.

25.  See 1972-Holmes quoted in Chapter 17: The Feminist Decade, 1970–79, 392.

26.  Stuart Preston, "Among One-man Shows," *NYT,* October 21, 1951, 105.

27.  Stuart Preston, "Among One-man Shows," *NYT,* October 21, 1951, 105.

28.  See 1996-Wagner, 166–167, who argues strongly for Rice Pereira and 1983-Rose, 66, who
    argues for Mondrian. LKCR ignores 1972-Holmes, where LK says she knew Rice Pereira's
    work.

29.  Robert Goodnough, "Lee Krasner," *Art News,* November 1951, 53, photocopy given to the
    author by LK with her notations.

30.  Dore Ashton, "Lee Krasner," *Art Digest,* November 1, 1981, 59. Krasner remained proud of
    these reviews, copies of which she gave me for my files.

31.  Emily Genauer (1911–2002) [initials handwritten by LK seem to be E. G.], "Abstract and
    Real," *New York Herald Tribune,* unidentified newspaper clipping, LK papers, AAA, roll
    N6867, frames 123–33. LKCR attributes this review to Eugene Goosen, which seems impos-
    sible. According to his obituary, he was then "an art and theater critic for *The Monterrey Pen-
    insula and Herald* in California before joining the faculty of Bennington College in 1958." See

Judith Dobrzynski, "Eugene Goosen, 76, Art Critic," *NYT,* July 18, 1997. The author discussed Krasner with Genauer on several occasions during the late 1970s.

32. Emily Genauer [initials handwritten by LK seem to be E. G.], "Abstract and Real," newspaper clipping, LK papers, AAA, reel N6867, frames 123–33.

33. 1987-Soloman, 196 ; 2002-Harrison, 76.

34. Betty Parsons gave Alfonso Ossorio solo shows at her gallery in 1951, 1953, and 1956, but she had already given him shows when she worked at the Wakefield Gallery in 1941 and 1943 as well as at the Mortimer Brandt Gallery in 1945. He also helped to support her gallery.

35. Greenberg, "Art Chronicle: Feeling Is All," *Partisan Review,* January 1952, reprinted in 1993-Greenberg, 105–06.

36. Clement Greenberg interviewed by James T. Valliere, in 2000-Harrison, 255.

37. 1985-Potter, 146.

38. 1985-Potter, 145.

39. 1985-Potter, 145.

40. JP quoted in 1985-Potter, 156. See also 2000-Harrison, 29.

41. 1985-Potter, 150.

42. JPCR, vol. 4, 267, D103, letter of March 30, 1952, JP to Alfonso Ossorio.

43. 1985-Potter, 145.

44. 1952-Warner, copy inscribed on the half title page in the artist's hand: "Alfonso Ossorio '52 East Hampton," collection of the author.

45. Constance J. S. Chen, "Transnational Orientals Scholars of Art, Nationalist Discourses, and the Question of Intellectual Authority," *Journal of Asian American Studies,* vol. 9, no. 3 (2006), 215–42.

46. Benjamin Rowland, Jr., "Langdon Warner, 1881–1955," *Harvard Journal of Asiatic Studies,* vol. 18, no. 3/4, December 1955, 450. Warner served in the United States Army's Antiquities Division in World War II and became something of a legendary hero in Japan, where he was credited with saving the culturally rich cities of Nara and Kyoto from nuclear destruction.

47. Daisetz T. Suzuki, *Introduction to Zen Buddhism* (Kyoto: The Eastern Buddhist Society, 1934). New York artists were more likely to have read the edition published in 1949 by the New York Philosophical Library.

48. 1952-Warner, 101.

49. 1952-Rosenberg, 22.

50. JPCR, vol. 4, 271, D107, letter of October 20, 1952, Sidney Janis to JP.

51. 1972-Gruen, 238.

52. Langer-1981.

53. Cynthia Navaretta to the author, 3-5-2010.

54. Cynthia Navaretta to the author, 3-5-2010.

55. See chapter 17: LK certainly believed that the stories of JP's affairs were true. 1989-Naifeh, 211, dismissed rumors and claims by JP that he had slept with Rita Benton, who later told Gene Thaw that she initiated the young JP (author's interview with Thaw, 4-1-2010). Rita's conversation with Thaw took place in Chilmark on Martha's Vineyard after Thomas Hart Benton's death in 1975.

56. Cynthia Navaretta to the author, interview of 3-5-2010, recalled that George McNeil's wife, Dora, who was the head designer at Simplicity Patterns and the mother of two young children, found out about her husband's affair with Mercedes. Her other affairs are documented in many published sources. On Mercedes's "playing the field though married" sex life, see Ellen G. Landau, "To Be an Artist Is to Embrace the World in One Kiss," in *Mercedes Matter* (New York: Mark Borghi, 2009), 75, note 104.

57. For a description of this behavior, see Gail Levin, *Becoming Judy Chicago,* 111–12.

58. See journal pages at Getty, box 57, folder 3. This journal is dateable because he noted "Wednesday Memorial Day" on May 30, which was on a Wednesday in 1951.

59. Harold Rosenberg journal for May 29 and 30, 1951, Getty.

60. Harold Rosenberg journal for June 16, Getty.

61. Paul Brach discussed JP and Rosenberg and told stories of the abstract expressionists with the author in many conversations. 1989-Naifeh, 706, missed the larger implications in what Brach intuited about Rosenberg's motive. Matter used her closeness to and admiration for JP to provoke Rosenberg's jealousy.

62. Harold Rosenberg, journal for Wednesday, June 6, 1951, written on page printed for June 8, Getty.

63. Harold Rosenberg, journal for Thursday, June 7, 1951, written on page printed for June 8, Getty.

64. 2004-Stevens, 576.

65. 2004-Stevens, 346.

66. LK to the author, countless times in conversation.

67. Their open marriage is well documented in 2004-Stevens and in 1993-Hall. LK to the author.

68. The young boy in the photograph, who is much too young to be Greenberg's son from his first failed marriage, is probably the child of the unknown photographer.

69. Morris Louis to James McG. Truitt, "Art-Arid D.C. Harbors Touted 'New' Painters," *Washington Post*, December 21, 1961, A20. The interviewer was then married to artist Anne Truitt, a friend of both Greenberg and Louis.

70. Sidney Janis quoted in 1972-Gruen, 247.

71. Clement Greenberg to James Valliere, unpublished interview, March 1968, noted in 1987-Solomon, 236.

72. Howard Devree, "Ingres to Pollock," *NYT*, November 15, 1952, X9.

73. Clement Greenberg, "Jackson Pollock," quoted in 1997-Rubenfeld, 163. The show took place November 17–30, 1952.

74. 1997-Rubenfeld, 164.

75. 1997-Rubenfeld, 164.

76. Freas to Brenson, December 11, 2001.

77. Freas to Brenson, December 11, 2001.

78. Jean Freas to Michael Brenson, interview, December 11, 2001. As Jean Pond, she published a memoir, *Surviving* (New York: Farrar, Staus & Giroux, 1978).

79. After her divorce from David Smith, Jean Freas Smith worked as a TV reporter in Washington, D.C. She left television in 1969 and moved to NYC after marrying NBC on-air reporter Geoffrey Pond, from whom she was later divorced.

80. Freas to Brenson, December 11, 2001.

81. Freas to Brenson, December 11, 2001.

82. Freas to Brenson, December 11, 2001.

83. Clement Greenberg, "Jackson Pollock," quoted in 1997-Rubenfeld, 163.

84. Clement Greenberg, "Jackson Pollock," quoted in 1997-Rubenfeld, 163.

85. Clement Greenberg to Don Casto, letter of February 14, 1964, in response to Casto's questions, CG papers, Getty.

86. 1987-Soloman, 237.

87. Copy in LKP, AAA, roll 3777, frames 99–105.

88. 1979-Novak.

89. 1952-Rosenberg, 22.

90. 1952-Rosenberg, 23.

91. 1952-Rosenberg, 23.

92. 1952-Rosenberg, 48.

93. 1952-Rosenberg, 49.

94. 1985-Potter, 169.

95. Harold Rosenberg, "Painting Is a Way of Living," *The New Yorker,* February 1, 1963; reprinted as "De Kooning: 1. Painting Is a Way," in Harold Rosenberg, *The Anxious Object Art Today and Its Audience* (New York: Horizon Press, 1966), 90.

96. Clement Greenberg to Don Casto, letter of February 14, 1964, in response to Casto's questions, CG papers, Getty.

## Chapter 13: Coming Apart, 1953–56 (pp. 289–314)

1. 1987-Solomon, 238, East Hampton town police records.
2. LK to the author, many times in conversation.
3. Helen Gribetz to the author, 10-25-2010.
4. 1980-Slobodkina, vol. II, p. 365.
5. 1980-Braff. The following quotation is also from this source.
6. Stuart Preston, "A Melange of Summer Shows," *NYT*, August 2, 1953, X7.
7. Stuart Preston, "A Melange of Summer Shows," *NYT*, August 2, 1953, X7.
8. JPCR, vol. 4, 271, D109, letter of November 24, 1953, JP to Sidney Janis.
9. Clement Greenberg, "'American-Type' Painting," in 1993-Greenberg, 226.
10. Jackson Pollock quoted in 1985-Potter, 198.
11. 1985-Potter, 198.
12. 1985-Potter, 199.
13. Gertrude Sartain, "You and Your Car," *Independent Woman*, 18, May 1939, 134–35.
14. 1985-Potter, 201.
15. Peter Matthiessen to the author, March 24, 2010.
16. Clement Greenberg, "Jackson Pollock," quoted in 1997-Rubenfeld, 195.
17. Clement Greenberg, "Jackson Pollock," quoted in 1997-Rubenfeld, 195.
18. 2006-Marquis, 142–46; 1997-Rubenfeld, 194 and 316, n. 26. In a 1990 interview with Rubenfeld, Greenberg insisted he sent Krasner to Klein, 1989-Naifch 747, interviewed Pearce and says Greenberg sent Krasner to her.
19. 2006-Marquis, 144–46. I am referring only to the "Sullivanians," such as Pearce, Newton, and Klein—not the William Alanson White Institute.
20. Jane Pearce and Saul Newton, *Conditions of Human Growth* (New York: Citadel Press, 1963). See also 1986-Conason, 21.
21. 1987-Siegel, 278.
22. 1987-Siegel, 278.
23. Bonnie Bernstein, widow of Len Siegel, to the author, letter of 5-30-2010, is the source for his career and training. Len Siegel immigrated to Australia in July 1983. It is possible that he wanted to distance himself from the Sullivanians. See 1989-Hoban, 41–53; 1986-Conason, 19–26; David Black, "Totalitarian Therapy on the Upper West Side," *New York*, December 15, 1975, 54–67; 2003-Siskind.
24. 99-Friedman, 16.
25. Despite this, 1999-Hobbs, 116–17, has written at length about the impact of the ideas of Harry Stack Sullivan on LK, apparently unaware of Siegel's involvement with the Sullivanians or that they became a cult, some of whom were forced to surrender their licenses to practice in New York State. Nor do we know the exact duration of LK's therapy with Siegel. 1980-Cavaliere, 16, LK responded to a question about combining past and present in reworking some of her unresolved canvases: "I'm not in analysis, so I can't handle it analytically." See also chapters 14 and 15 for discussion of Krasner's interaction with Siegel.
26. Frances Patiky Stein to the author, interview, January 2008.
27. Cile Downs, interview with the author, 3-2-2010.
28. 1990-Greenberg.
29. 1990-Greenberg.
30. 1975-Nemser-1, 96.
31. 1979-Novak.
32. Ralph Klein to Jeffrey Potter, 5-18-82, recorded interview, PKHSC.
33. Ben Heller to the author, 11-10-210.

34. See 2003-Siskind, 57, 61, etc., and 1989-Hoban, 41–53. Pearce was divorced from Newton and forced out by him and his next wife.

35. 1985-Potter, 232.

36. Judy Collins, *Singing Lessons: A Memoir of Love, Loss, Hope, and Healing* (New York: Atria, 1998), 123, 135.

37. 1998-Collins, 141.

38. 1985-Potter, 265.

39. Patsy Southgate to Andrea Gabor, taped interview of 9-25-91.

40. Order by N.Y. State for suspension of license to practice as a psychologist, July 26, 1991, no. 10402, "professional misconduct" cited. See press release of the University of the State of New York, State Education Department, 6-26-91; see "In the Courts: Sullivanians Lose Licenses," *Cult Observer,* vol. 8, no. 7, 1991. See also Tamara Lewin, "Custody Case Lifts Veil on a 'Psychotherapy Cult,'" *NYT,* June 3, 1988 and Susan Reed, "Two Anxious Fathers Battle a Therapy 'Cult' for Their Kids," *People,* vol. 30, no. 4, July 25, 1988.

41. LKP, AAA, roll 3774, frames 678–79.

42. LK in conversation with the audience after a showing of Barbara Rose's film, *Lee Krasner: The Long View,* at the Museum of Fine Arts, Roslyn, New York, 1979.

43. Cile Downs to the author, interview of 8-21-2007.

44. Cile Downs to the author, 7-04-2008.

45. Cile Downs to the author, interview of 8-21-2007.

46. 1985-Potter, 175. Ironically, Stein also drank to excess.

47. 1979-Munro, 101.

48. 1979-Munro, 114.

49. Stuart Preston, "Modern Work in Diverse Shows," *NYT,* October 2, 1955, X15.

50. F.P. [Fairfield Porter], "Lee Krasner," *Art News,* November 1955, 66. My copy labeled by Krasner when she gave it to me.

51. Martica Sawin, "Lee Krasner," *Arts,* October 1955, 52, my copy labeled by Krasner herself when she gave it to me.

52. 1971-Groh, frame 983.

53. 1985-Potter, 202.

54. 1971-Groh.

55. Eleanor Ward to Wilfrid Zogbaum, October 14, 1957, 1996-Wagner, note 44, 310–11.

56. Wilfrid Zogbaum to Eleanor Ward, November 7, 1957, quoted in 1996-Wagner, note 44, 311.

57. 1985-Potter, 174.

58. 1985-Potter, 275.

59. 1985-Potter, 174.

60. Dan T. Miller to James T. Valliere, in 2000-Harrison, 233.

61. See 1985-Potter, 188–89.

62. JPCR, 273.

63. 1985-Potter, 215.

64. Cile Downs to the author, 07-04-2008.

65. JPCR, vol. 4, 275.

66. Paul Jenkins interview with the author, 6-26-2008.

67. Paul Jenkins interview with the author, 6-26-2008.

68. Jenkins in 2000-Harrison, 278.

69. Jenkins in 2000-Harrison, 278.

70. Paul Jenkins to Jackson & Lee, letter of April 17, 1956, PKHSC, left in the gift book *Zen in the Art of Archery.*

71. LKP, AAA, roll 3774, frame 686.

72. 1978-Howard.

73. 1978-Howard.

74. Related by Krasner, 1979-Munro, 116.

75. 1964-Seckler.

76. 1957-Rodman, 275.

77. Charlotte Park, diary entry for June 18, 1956, quoted in 2001-Abeles, 186.

78. 1985-Potter, 210, and author's interviews with Flack, 9-4-2010 and earlier.

79. 1985-Potter, 228. JPCR describes Kligman as "a fashion model," but she was then working as an assistant in a small art gallery. See also Will Blythe, "The End of the Affair," in 2000-Harrison, 289.

80. Audrey Flack to the author, 9-4-2010.

81. Abby Friedman quoted in 1985-Potter, 234.

82. 1985-Potter, 230–31.

83. 1985-Potter, 230–31.

84. 1973-Friedman, 33, and 1995-Friedman, 232.

85. 1995-Friedman, 232.

86. 1974-Kligman.

87. 1974-Kligman, 73 and again on 138.

88. 1985-Potter, 236.

89. Charlotte Brooks and Cile Downs, quoted in 1985-Potter, 233–34.

90. Paul Jenkins, "Excerpts of a Symposium," 1986, in 2000-Harrison, 280.

91. 1977-Rose-1.

92. JPCR, 276.

93. 1964-Seckler.

94. Listed by 1965-Friedman, 11, who cites the Uccello in the National Gallery, London, instead of that in the Louvre.

95. 1968-Wasserman.

96. 2006-Marquis, 141, states that the relationship with Frankenthaler ended definitively on April 10, 1955, but Frankenthaler's presence where Krasner was hints of Greenberg's continuing link to Frankenthaler.

97. Kay Gimpel to Peggy Guggenheim, letter of July 26, 1956, AAA.

98. Lee Krasner to Esther and Paul Jenkins, postcard dated July 30, 1956, Paul Jenkins Papers, AAA.

99. 1977-Rose-1.

100. Paul Jenkins interview with the author, 6-26-2008.

101. 1977-Rose-1.

102. "8 Killed in 2 L.I. Auto Crashes; Jackson Pollock among Victims," *NYT,* August 12, 1956, 1.

103. "8 Killed in 2 L.I. Auto Crashes; Jackson Pollock among Victims," *NYT,* August 12, 1956, 1.

104. 2006-Rose, n.p., note 34.

105. Clement Greenberg to John Gruen, quotation from interview, in draft of Gruen's book (sent 12-3-70), Clement Greenberg Papers, Getty.

106. 1985-Potter, 174. The words in italics are what Greenberg claims he said as opposed to what Jeffrey Potter quoted him as having said in his book of interviews. Greenberg took such issue with how Potter quoted him that when the statement was repeated in an *Art Monthly* article by Francis Frascina entitled "Krasner & Pollock," he protested in a letter to the editor to correct the record: "Mr. Frascina writes of Lee Krasner & me that 'neither liked each other much . . .' How does he know? It's quite untrue." Greenberg goes on to correct the text of his interview that appeared in Jeffrey Potter, *To a Violent Grave,* 1985.

107. 1985-Potter, 169.

108. Judy Collins to the author, 9-22-2010.

## Chapter 14: Dual Identities: Artist and Widow, 1956–59 (pp. 315–338)

1. 1985-Potter, 174.

2. 1973-Wallach-2.

3.   1985-Potter, 174.

4.   2001-Abeles, 188.

5.   Jeanne Lawson Bultman to the author, interview of 4-23-2007.

6.   1999-Friedman, 13.

7.   Chronologies of Motherwell claim that he met Frankenthaler in 1957, but Friedman's journal entry suggests that they could have met by New Year's Eve 1956. Friedman to the author recalls that the party may have been at the home of Manoucher Yektai.

8.   1973-Barkas, 35.

9.   1979-Munro, 116.

10.  Over the years she recruited people to sleep over at the Springs house so that she would not be there alone. Some were Patsy Southgate, Peter Matthiessen (interview with the author, 3-24-2010), and Abigail Little (the daughter of her good friends John and Josephine Little); Abigail Little Tooker to the author, interview of January 14, 2010. Another was Jill Jakes (interview with the author, January 15, 2010), then a recent Vassar graduate who then did some secretarial work for LK, before becoming a lawyer and a judge.

11.  Sidney Janis quoted in Les Levine, "A Portrait of Sidney Janis on the Occasion of His 25th Anniversary as an Art Dealer," *Arts Magazine,* 48, November 1973, 53.

12.  1985-Potter, 196, Robert Beverly Hale, curator at the Metropolitan, reported this price.

13.  1985-Potter, 272. Janis held a show of Pollock's drawings in November 1957 and a show of his paintings in November 1958.

14.  1981-Langer.

15.  Buffie Johnson to Barbara Shikler, interview of November 13, 1982, AAA.

16.  1967-Seckler.

17.  1960-Rago, 32.

18.  *Henri Matisse* exh. cat. (New York: The Museum of Modern Art, 1951), 10. Clement Greenberg, *Matisse* (New York: Harry N. Abrams, 1953), n.p.

19.  See Tetsuya Oshima, *The Figure Reemerging: Jackson Pollock's Cut-Outs, 1948–1956* (New York: Doctoral Dissertation, The Graduate Center of The City University of New York, 2008), 108.

20.  Pollock had even spoken to Patsy Southgate about wanting to keep both women, literally a menage à trois

21.  See Joan Marter, "Identity Crisis: Abstract Expressionism and Women Artists of the 1950s," in *Women and Abstract Expressionism, 1945–1959* (New York: Sidney Mishkin Gallery, Baruch College, 1997).

22.  1981-Delatiner.

23.  AAA-LKP; 1983-Rose, 98.

24.  'Signa Gallery Opens with Distinguished Guests," *East Hampton Star,* July 25, 1957, 1.

25.  This was the gallery's third exhibition. Krasner later painted over *Spring Beat* so that it is no longer extant to view. See LKCR, CR315, 166.

26.  Georgio Cavallon and Linda Lindeberg, letter of 8-8-57, LKP, AAA, roll 3771, frames 487–88.

27.  George Dondero, "Modern Art Shackled to Communism," *Congressional Record*, 81st Congress, 1st session (1949), vol. 95, pt. 9: 11584-5, as quoted in 1999-Craven, 97.

28.  Her file is no. 65-64976.

29.  1999-Craven, 83.

30.  "Martha Jackson Dies on Coast; Gallery Aided Abstract Artists," *NYT,* July 5, 1969, 19.

31.  Ben Heller to the author, 11-10-2010.

32.  See LK papers, AAA, reel 3776, frame 571. "Lee Krasner—Recent Oils," press release from Martha Jackson Gallery, lists the date of her marriage to Pollock incorrectly as 1944.

33.  B. H. Friedman, "Introduction," *Lee Krasner* (New York: Martha Jackson Gallery, 1958), n.p.

34.  1999-Friedman, 16.

35.  1978-Howard.

36. Ms. labeled "FINAL COPY SENT to [Sarah Campbell Blaffer] Foundation for Printing in catalogue, 1/19/79," LKP, AAA, roll 3773, frame 171.

37. Ms. labeled "FINAL COPY SENT to [Sarah Campbell Blaffer] Foundation for Printing in catalogue, 1/19/79," LKP, AAA, roll 3773, frame 171.

38. Stuart Preston, "The Week's Variety," *NYT,* May 2, 1958, X9.

39. 1958-Time.

40. 1958-Time.

41. A.V. [Anita Ventura], "Lee Krasner," *Arts Magazine,* April 1958, 60.

42. A.V. [Anita Ventura], "Lee Krasner," *Arts Magazine,* April 1958, 60.

43. A.V. [Anita Ventura], "Lee Krasner," *Arts Magazine,* April 1958, 60.

44. P.T. [Parker Tyler], "Lee Krasner," *Art News,* April 1958, 15, photocopy labeled in LK's hand and given to the author by the artist.

45. 1968-Glueck.

46. 1972-Holmes.

47. "The Jackson Pollocks' Work Shown Here, Abroad," *East Hampton Star,* 1958, 4, LKP, AAA, reel 3780, frame 398.

48. Brad Gooch, *City Poet: The Life and Times of Frank O'Hara* (New York: Alfred A. Knopf, 1993), 307.

49. Signa Gallery Papers, AAA, reel 3984, frame 29, includes price list for show.

50. The Artists Vision was on view from May 30 to July 19, 1958. Also showing were Enrico Donati, Philip Guston, Franz Kline, Richard Pousette-Dart, Day Schnabel, and Theodoros Stamos.

51. 2005-Housley, 177.

52. 2005-Housley, 176. See also 2004-Stevens, 382. Lisa de Kooning, whom her father subsequently adopted, was born January 29, 1956.

53. David Slivka to the author, 9-29-2006. Summer rental confirmed in 2004-Stevens, 406.

54. 1978-Howard. Painted in 1956, the work was misdated in the catalogue as 1951.

55. Martha Jackson to LK, letter of August 8, 1960, apologizing for the delay in payment to her.

56. 2005-Howard, 226.

57. "Signature Plates," *It is,* Autumn 1958, 22, 29. The others were George Cavallon (with two plates), Ray Parker, Joan Mitchell, Edward Dugmore, Peter Busa, Michael Goldberg, Michael Loew, Robert Richenburg, Paul Jenkins, Alfred Leslie, Perle Fine, Sidney Gordin, Israel Levitan, Patricia Passloff, and Jack Tworkov.

58. Oppositie Bowling Green, Battery Park, and the harbor of New York.

59. 1959-Friedman, 57; included Krasner's mosaic table.

60. 1979-Munro, 108.

61. Will Barnet to the author, 3-16-2010.

62. 1959-Friedman, 26. Stein became a sculptor, then began flying planes, and drank to excess, distressing Krasner. After her death, he converted to Catholicism and painted religious images.

63. 1959-Friedman, 26.

64. 1968-Campbell, 62.

65. 1981-Wallach.

66. 1978-Howard.

67. 1978-Howard.

68. 1972-Rose-1.

69. 1978-Howard. Through Ossorio, Krasner could have known that death, in Chinese Buddhist culture, "may be considered as a gate through which the consciousness departs from one life and begins the journey to a new life," according to Dr. Yutang Lin. "Crossing the Gate of Death in Chinese Buddhist Culture," June 17, 1995, Tan Wah Temple, Honolulu, Hawaii, online at http://www.originalpurity.org/gurulin/efiles/mbk16.html as of 3-22-2010.

70. 1978-Howard.

71. 2006-Marquis, 174.

72. Spencer [Samuels] to "Lee Pollock," letter of August 1, 1959, LKP, AAA.

73. 2006-Marquis, 172.

74. Clement Greenberg to the editor, *Arts Magazine,* vol. 98, no. 3, November 1973, 71; corrected draft in CG papers, Getty.

75. Clement Greenberg to the editor, *Arts Magazine,* letter of May 20, 1973, CG Papers, Getty. At the time, as noted in Greenberg's hand on this typed carbon copy: "Not sent? or was it sent, at time [Gregory] Battcock was editior of *Arts . . .*" is written on the draft in Greenberg's hands. In fact, as noted above, letter was published in issue of November 1973, 71.

76. Clement Greenberg to the editor, *Arts Magazine,* letter of May 20, 1973, CG Papers, Getty Research Institute.

77. Clement Greenberg to Florence Rubenfeld, unedited transcript of interview, 2/16/1990, CG Papers, Getty; her abbreviations are written out in full here. See also 1997-Rubenfeld.

78. Clement Greenberg to Florence Rubenfeld, unedited transcript of interview, 2/16/1990, CG Papers, Getty; her abbreviations are written out in full here. See also 1997-Rubenfeld.

79. Clement Greenberg to Florence Rubenfeld, unedited transcript of interview, 2/16/1990, CG Papers, Getty; her abbreviations are written out in full here. See also 1997-Rubenfeld.

80. Clement Greenberg to Florence Rubenfeld, unedited transcript of interview, 2/16/1990, CG Papers, Getty; her abbreviations are written out in full here. See also 1997-Rubenfeld.

81. Clement Greenberg to Florence Rubenfeld, unedited transcript of interview, 2/16/1990, CG Papers, Getty; her abbreviations are written out in full here. See also 1997-Rubenfeld.

82. 1983-Rose, 155, 157.

83. LK told this account over and over again, in conversation with the author from 1978 to 1982.

84. 1981-Langer.

85. Identified in the catalogue as *"Pittura,"* and dated 1958, this work is recognizable from the catalogue, which Krasner kept among her papers. LKCR 139, omits this exhibition from CR283, although it is clearly included in Krasner's papers, AAA, roll 3776, frame 1022.

86. Ted Dragon quoted in 1998-Gaines, 146–49. See also articles in the *East Hampton Star* on February 26, 1959, and July 16, 1959, and in *Newsday* for February 25, 1959.

87. Ted Dragon quoted in 1998-Gaines, 149.

88. Grace Hartigan quoted in 1998-Gaines, 152.

89. 1998-Gaines, 153.

90. Ted Dragon quoted in 1998-Gaines, 146.

91. Ted Dragon quoted by M. G. Lord, "Lee Krasner, Before and After the Ball Was Over,' *NYT,* August 27, 1995, H31. The following quotation is also from this source.

## Chapter 15: A New Alliance, 1959–64 (pp. 339–366)

1. Richard Howard to the author, interview of 1-18-2007.

2. Cile Downs to the author, interview of 8-21-2007.

3. According to his widow, David Gibbs was born May 22, 1926, and died June 8, 1998. He married his last wife, Angela, in 1982. His age is stated elsewhere with several variants.

4. "Atticus among the Art Dealers," Sunday *Times* (London), May 15, 1960, 9.

5. David Gibbs, quoted in 1995-Gabor, 86.

6. David Gibbs sold *Cool White* through the Robert Miller Gallery, which in turn sold it to the National Gallery of Australia in Canberra.

7. Bryan Robertson, *Jackson Pollock* (New York: Harry N. Abrams, 1960).

8. "Atticus among the Art Dealers," Sunday *Times* (London), May 15, 1960, 9.

9. David Gibbs to LK, letter from London with envelope postmarked December 21, 1959, on stationery of the Guards Club. Neither Gibbs's widow (who was at least his third wife—after the mother of his children and Geraldine Stutz, from whom he was divorced after twelve years) nor his daughter from the marriage that was then breaking up wish to have Gibbs's letters quoted here. Personal letters from Gibbs to LK, PKHSE.

10. David Gibbs to LK, letter with envelope postmarked December 21, 1959.

11. "Atticus among the Art Dealers," Sunday *Times* (London), May 15, 1960, 9.

12. David Gibbs to Clement Greenberg, letter of May 6, 1960, copy sent to LK by Gibbs, PKHSC. All of the following discussion refers to this long letter, which Gibbs's family refuses to have quoted. The Newman show opened on March 10, 1959.

13. Greenberg was accompanied by his wife, the former Janice Van Horne, then known as Jenny. They met Gibbs and his wife.

14. David Gibbs to Clement Greenberg, letter of 5-6-1960, copy sent to LK by Gibbs, PKHSC. Gibbs also told how he tried to meet art dealers Sam Kootz and Sidney Janis and how he had gone to Washington to meet Morris Louis, one of the artists whom Greenberg had promoted, giving him the second solo show at French & Company.

15. JP Papers, AAA, http://www.aaa.si.edu/collectionsonline/Polljack/container285922.htm. Gibbs's "business" correspondence is all in this online file.

16. Author's interview with Cile Downs, 8-21-2007.

17. Richard Howard to the author, interview of 1-18-2007.

18. Sanford Friedman to the author, interview of 1-17-07.

19. Sanford Friedman to the author, interview of 1-17-07.

20. 1997-Gabor, 89.

21. David Gibbs to LK, letter of May 7, 1960, Collection PKHSC.

22. "Atticus among the Art Dealers," Sunday *Times* (London), May 15, 1960, 9.

23. Clement Greenberg to Paul Jenkins, letter of 9-1-1960, Paul Jenkins Papers, AAA.

24. 1967-Glaser.

25. Vivien Raynor, "ART; In Kent: 2 Galleries, 3 Sites, 4 Shows," *NYT,* August 15, 1993.

26. "Atticus among the Art Dealers," Sunday *Times* (London), May 15, 1960, 9.

27. Roberta Smith, "Frank Lloyd, Prominent Art Dealer Convicted in the '70s Rothko Scandal, Dies at 86," *NYT,* April 8, 1998. Lloyd lost both of his parents at Auschwitz, though his non-Jewish mistress and his son survived in Austria.

28. By the early 1970s, Lloyd had obtained total control of Marlborough after Fisher, formerly a dealer of rare books, started his own gallery.

29. Howard Wise to LK, letter of February 23, 1960, LKP, AAA.

30. Howard Wise to LK, letter of August 8, 1960, LKP, AAA, reel 3771, frame 601. See also L. M. Angeleski to LK, letter of July 19, 1960, LKP, AAA.

31. See Howard Wise interview with Paul Cummings, February 2, 1971, AAA.

32. "In the Country," *The New Yorker,* September 3, 1960, LKP, AAA, reel 3776, frame 1023. The show was on until September 15 and was the gallery's third that summer.

33. 1960-Rago, 31.

34. 1972-Rose-1.

35. 1972-Rose-1.

36. 1968-Wasserman-2, 43.

37. 1978-Howard.

38. 1999-Friedman, 18.

39. 1967-Seckler.

40. 1978-Howard; LKCR, 186 and 192, claims inexplicably and without documentation that Howard named both of these works.

41. 1978-Howard.

42. LK to 1967-Seckler.

43. Ralph Waldo Emerson, "Circles," 1841, reprinted in Ralph Waldo Emerson, *Essays and Lectures* (New York: Library of America, 1983), 401–14.

44. LK to the author, 1980; 1978-Howard; 1967-Seckler.

45. Stuart Preston, "Art: Allusive Portraits," *NYT,* November 19, 1960, 43.

46. Emily Genauer, "Artists Turning to Dark Myths," *New York Herald Tribune,* November 20, 1960, 21.

47. [V.R.] Vivien Raynor, "Lee Krasner," *Arts Magazine,* vol. 35, January 1961, 54; a hand-annotated copy of this review given to the author by LK.

48. [V.R.] Vivien Raynor, "Lee Krasner," *Arts Magazine,* vol. 35, January 1961, 54.

49. [V.R.] Vivien Raynor, "Lee Krasner," *Arts Magazine,* vol. 35, January 1961, 54. Jeffrey Grove, LKCR, 315, is mistaken in calling "Irving Sandler, the sole critic who reviewed both shows" "of the Umber and White series, in 1960 and 1962."

50. I.H.S. [Irving H. Sandler], "Lee Krasner's," *Art News,* January 1961, 15; a hand-annotated copy of this review given to the author by LK.

51. I.H.S. [Iriving H. Sandler], "Lee Krasner's," *Art News,* January 1961.

52. 1975-Nemser-2, 6.

53. 1973-Nemser, 47.

54. Arthur Rimbaud, *A Season in Hell* (Norfolk, Conn.: New Directions, 1939), trans. by Delmore Schwartz, 15. Several writers on Krasner have cited these lines and referred to Schwartz's translation, while quoting from an unacknowledged later translation. No one has remarked, however, that to name her picture, she used a translation other than Schwartz's. The writers who failed to give the correct Schwartz translation, include LKCR, 192 for entry CR 360; 1995-Friedman, 71 (who first cited and perhaps himself translated the most repeated translation); 1979-Munro, 111; 1987-Solomon, 114; 1989-Naifeh, 390; 1993-Hobbs, 22 and 96, n. 23, and 1999-Hobbs, 37 and 194, n. 19, cites the second (bilingual) edition of Schwartz's translation and gives two different versions of these lines in his two books, only the former of which corresponds to Schwartz's second published translation of this poem. In the latter, Hobbs dates the Schwartz translation as 1932, years before it existed, and gives a page number of 27, which actually refers to the second edition, published in 1941, though the copyright page still stated 1939. On the other hand, 1983-Rose, 97, and 1995-Gabor, 58, correctly give the lines as Schwartz translated them in the 1939 edition.

55. Richard Howard to the author, October 2010, insists that he did not name this painting. Both 1979-Howard, the published version of this interview with Krasner, and the unpublished version support this assertion.

56. 1967-Seckler; despite this interview and one published by Howard quoted above, Landau in LKCR, CR360, 192, says that Howard renamed this painting, when LK named it herself.

57. David Gibbs to LK, at 147 East Seventy-second Street, New York City, telegram of March 23, 1961.

58. W. E. Johnson, "Modern North American Painting," *Guardian* (London), May 1, 1961, 7. Clipping sent to Krasner by "Margie & Jerry Weinstock via Epsteins," LKP, AAA.

59. Harold Rosenberg, "The Search for Jackson Pollock," *Art News,* 59, no. 10, February 1961, 58–60. Bryan Robertson, *Jackson Pollock* (New York: Harry N. Abrams, 1960).

60. 1960-Robertson, 36.

61. 1952-Rosenberg, 23.

62. 1999-Friedman, 18–19.

63. 1999-Friedman, 18–19.

64. 1960-Robertson, jacket copy.

65. 2004-Howard, 225.

66. 2004-Howard, 225, who says Ossorio suggested James, but 1999-Friedman, says Fritz Bultman made the suggestion; his wife, Jeanne, had worked for James.

67. 2004-Howard, 225. Krasner gave these garments to the Metropolitan Museum of Art's costume collection.

68. 1999-Martin, 8.

69. Bill Cunningham quoted in 1999-Martin, 13.

70. 2004-Howard, 225.

71. All information comes from documents in LKP, AAA.

72. LKCR 341 and 344. These works were illustrated as number 9 and 10 in the exhibition catalogue.

73.   Anita Brookner, review of "The New New York Scene," in *Burlington Magazine*, vol. 103, 1951, reprinted in 1990-Shapiro, 406.

74.   Edward Ranzal, "Art Patron Sues Pollock's Widow," *NYT*, June 9, 1961, 35.

75.   Betsy Wittenborn Miller to the author, 1-03-2007.

76.   1951-Tenke, 37.

77.   1951-Tenke, 37.

78.   Gerald Dickler to David Gibbs, LKP, AAA.

79.   I.H.S. [Irving H. Sandler], "Lee Krasner's," *Art News*, March 1962, 12–13, photocopy given to the author, annotated in LK's hand. Sandler was also reviewing for the *New York Post*, where on April 7 or 8, 1962, he repeated his own material, reiterating "explicit symbols such as fetishistic eyes have been eliminated" and "abandoned pictures now celebrate the act of painting rather than a mythological content." See LKP, AAA, reel 3776, frame 1037.

80.   Brian O'Doherty, "Krasner Works Have Sense of Activity—Four Other Abstractionists Exhibit," *NYT*, 3-14-1962. Vivien Raynor, "Lee Krasner," *Arts Magazine*, May–June 1962, 100–101.

81.   Gerald Dickler to David Gibbs, letter of September 14, 1962, LKP, AAA.

82.   Sanford Friedman to David Gibbs, letter of January 22, 1963, PKHSC.

83.   Quoted by 1999-Friedman, 20, recorded in his journal January 29, 1963.

84.   Sanford Friedman to David Gibbs, now of the Marlborough Gallery, February 3, 1963, PKHSC.

85.   Sanford Friedman to David Gibbs, now of the Marlborough Gallery, February 3, 1963, PKHSC.

86.   Sanford Friedman for LK to David Gibbs, now of the Marlborough Gallery, February 20, 1963, PKHSC.

87.   Howard Wise to LK, Letter of 7-15-1963, LKP, AAA, confirms this.

88.   Ronald Stein to David Gibbs, letter of April 19, 1963, copy in LKP, AAA, roll 3771.

89.   1963-Zinsser, 9, refers to "The Springs," but locals say "Springs," as I have elsewhere.

90.   1963-Zinsser, 9.

91.   1963-Zinsser, 9.

92.   See 2009-Valliere and some of his interviews in 2000-Harrison, ed. My own research and observations do not always concur with Valliere's assertions. For example, he claims Krasner sold her nephew the house adjoining hers in Springs, when, in fact, it was a wedding gift, as confirmed by Frances Patiky Stein.

93.   See LKCR, 208, CR 390–400.

94.   1964-Seckler.

95.   1979-Novak.

96.   1979-Novak. For the text of this prayer, see chapter 1.

97.   1979-Novak.

98.   1981-Langer.

99.   1979-Munro, 105. LK told this story to more than one interviewer, but this is the most complete version recorded.

100.   Barnett Newman quoted online at: http://www.cca.qc.ca/en/collection/922-a-model-for-a-synagogue-by-barnett-newman.

101.   Barbara Rose to the author, interview of 10-19-2006.

102.   Barbara Rose, *American Art Since 1900* (New York: Frederick A. Praeger, Publishers, Inc., 1967). Barbara Rose, "American Great: Lee Krasner," *Vogue*, vol. 159, June 1972, 118–21, 154. Barbara Rose, "The Best Game Is the End Game," *New York*, vol. 6, April 30, 1973, 92.

103.   Terence Netter to the author, 1-16-2009.

104.   Terence Netter to the author, 1-16-2009.

105.   Terence Netter quoted by M. G. Lord, "Lee Krasner, Before and After the Ball Was Over," *NYT*, August 27, 1995.

## Chapter 16: Recognition, 1965–69 (pp. 367–388)

1. As late as 1981, organizations called Double X and Arts Coalition for Equality demonstrated against LACMA and Tuchman specifically by showing up at the opening of a show called "Seventeen Artists of the Sixties" wearing Tuchman masks as a protest against his failure to include any women or minority artists. See 2007-Levin, 119.

2. 1965-Newman, 262-63.

3. 1965-Newman, 263.

4. 1975-Nemser-2, 6.

5. Lee Krasner, page of handwritten notes headed "Forest No. II (Collage) 1954 1965)," LKP, AAA, roll 3774, frame 703.

6. Rena (Rusty) Seymour Kanokogi to the author, interview of 6-18-2008.

7. See LKCR, 219 for a chronicle of these name changes.

8. Other twentieth-century American artists loved Melville, notably Edward Hopper, who read everything Melville wrote during the summer of 1941 and named a painting, *The Lee Shore,* after a chapter in *Moby-Dick.*

9. This history is from correspondence and photographs with canceled titles in LK's papers. For a list of all of these titles and their history, see LKCR, numbers 412 through 418.

10. Sanford Friedman to the author, interview of 1-17-2007.

11. Terence Netter to the author, interview of 1-16-2009, referring to a time he was working at the church, circa 1966.

12. "Close-Up/A Jesuit Makes a 'Painful, Purifying' Decision," *Life,* October 25, 1968, 46.

13. Terence Netter to the author, interview of 1-16-2009.

14. These lectures took place in 1968.

15. See Brad Gooch, *City Poet: The Life and Times of Frank O'Hara* (New York: Alfred A. Knopf, 1993), 341.

16. 1965-Robertson, 3.

17. 1965-Robertson, 4.

18. Clement Greenberg interviewed by Ruth Ann Appelhof, on May 29, 1975. Ruth Ann Appelhof, "Lee Krasner: The Swing of the Pendulum," M.A. thesis, Syracuse University, 1975, 4.

19. 1965-Friedman, 5, continues incorrectly "She was born Lenore." Though she was born "Lena," LK evidently chose not to correct this error.

20. Tejas Englesmith to the author, 3-24-2010.

21. "Pollock," Sunday *Times* (London), 9-19-1965, LKP, AAA, roll 3776, frame 1043.

22. "Pollock," Sunday *Times* (London), 9-19-1965, LKP, AAA, roll 3776, frame 1043.

23. "Pollock," Sunday *Times* (London), 9-19-1965, LKP, AAA, roll 3776, frame 1043.

24. "Pollock," Sunday *Times* (London), 9-19-1965, LKP, AAA, roll 3776, frame 1043.

25. "Pollock," Sunday *Times* (London), 9-19-1965, LKP, AAA, roll 3776, frame 1043.

26. "Pollock," Sunday *Times* (London), 9-19-1965, LKP, AAA, roll 3776, frame 1043; a paraphrase, not a direct quotation, appears in the article.

27. "Pollock," Sunday *Times* (London), 9-19-1965, LKP, AAA, roll 3776, frame 1043.

28. "Lee Krasner," *Evening Standard,* September 22, 1965, 6.

29. "Lee Krasner," *Evening Standard,* September 22, 1965, 6.

30. "The Abstract Art of Lee Krasner," *Times* (London), 9-22-1965, LKP, AAA, reel 3776, frame 1045.

31. Nigel Gosling, "A Portent from Brooklyn," *Observer* (London), September 26, 1969.

32. John Russell, "Germany's Other Man of Iron," Sunday *Times* (London), October 3, 1965, the comments on Krasner's show followed a review of Max Beckmann.

33. Sheldon Williams, "London Retrospective for Abstract Pioneer," *Herald Tribune Paris Edition,* October 4, 1965.

34. See Gosling, "A Portent from Brooklyn," *Observer,* September 26, 1965, and an anonymous review in *The Listener,* October 14, 1965.

35. Norbert Lynton, "London Letter," *Art International,* vol. 9, no. 8, November 20, 1965, 32.

36. 1965-Forge.

37. Wedding notice of David Gibbs to Geraldine Stutz, *Time,* Friday, September 24, 1965. Note that his age cited here does not reconcile with that given me by his widow, Angela Gibbs. See birth date of May 22, 1926, cited above. Stutz described in Shirley Clurman, "Gerry Stutz Is Hardly Just Window Dressing at Bendel's—She Owns the Store," *People,* vol. 14, no. 15, October 13, 1980, http://www.people.com/people/archive/article/0,,20077629,00.htm l.

38. "Geraldine Stutz and David Gibbs," *New York,* August 31, 1970. Clurman lists price Stutz paid for Henri Bendel.

39. 1975-Nemser-1, 98.

40. Nancy Schwartz to the author, 1-19-2010.

41. Igor Pantuhoff to Lee Krasner, letter of May 1965, LKP, AAA, May 1965, roll 3771.

42. Grace Glueck, "Patron," *NYT,* May 16, 1965, X21.

43. 1986-Weld, 401.

44. 1999-Friedman, 20.

45. The other five were the painter Morton Kaish, the printmakers Mark Freeman, Gerson Leiber, Louis Schanker, and Aubrey Schwartz. The show was open from August 23 to September 7, 1966.

46. Francis V. O'Connor to the author, 3-31-2010.

47. 1977-Diamonstein-1.

48. Joy Williams, "Krasner Show Opens University Art Gallery," *Birmingham News,* February 16, 1967, and AAA, Krasner Papers, reel 3776, frame 1004, clipping from *Crimson-White,* the school paper. Donald McKinney to the author, 1-19-2010.

49. LK quoted in Doris P. Flora, "Artist Would Be 'Back-Tracking,'" *Tuscaloosa News,* February 15, 1967, AAA, LK papers, roll 3776, frame 1050.

50. LK quoted in Doris P. Flora, "Artist Would Be 'Back-Tracking,'" *Tuscaloosa News,* February 15, 1967, AAA, LK papers, roll 3776, frame 1050-A.

51. Lee Krasner to Karen Hughes, "It's Harder for Women," *Crimson-White*, February 20, 1967.

52. LK quoted in William Arnett, Alvia Wardlaw, et al., *The Quilts of Gee's Bend: Masterpieces from a Lost Place* (New York: Tinwood Books, 2002), 54–55.

53. "Pollock Revisited," *Time,* April 14, 1967.

54. See 1998-Karmel, for reprints of all of these 1967 publications.

55. Harold Rosenberg, The Art World (The Art Galleries), "The Mythic Act," *The New Yorker,* May 6, 1967, 162, reprinted in Harold Rosenberg, *Art Works and Packages* (New York: Horizon Press, 1969), 63, 67.

56. 1967-Nation.

57. 1967-Nation.

58. Donald McKinney to the author, 1-19-2010.

59. Grace Glueck, "Man in the News; Collections Connoisseur: William Slattery Lieberman," *NYT,* January 21, 1987.

60. Grace Glueck, "The Met Makes Room for the 20th Century," *NYT,* September 18, 1983, LKP, roll 3777, frame 9.

61. Grace Hartigan to Lee Krasner, letter of 10-20-79, AAA, roll 3773, frame 379.

62. Ray "Buddha" Kaiser Eames to Lee Krasner, AAA, roll 3774, frames 713 and 714, and roll 3773, frame 215, undated letter of February 1979, sent with a heart drawing, "for Valentine's Day." Krasner introduced the author to Buddha Eames on one of her visits to New York.

63. Harold Rosenberg, "The Art World: Big," *The New Yorker,* August 26, 1967, 96.

64. Harold Rosenberg, "The Art Establishment," *Esquire,* 64, January 1965, 39.

65. 1978-Cavaliere.

66. 1963-Wasserman-2, 43.

67. Baker, *Time,* 1973. LK wrote out this recollection, which is found in her papers, LKP, AAA, roll 3774, frame 701.

68.  1968-Wasserman-2, 38.
69.  1968-Campbell, 43. This statement exists in LK's hand in her papers, LKP, AAA, roll 3774, frame 703.
70.  1968-Campbell, 43.
71.  David Biale, *Eros and the Jews: From Biblical Israel to Contemporary America* (Berkeley: University of California Press, 1997), 161.
72.  1968-Campbell, 64.
73.  Grace Glueck, "And Mr. Kenneth Does Her Hair," *NYT,* March 17, 1968, D34. Mr. Kenneth, LK's upscale hairdresser, was also featured in Barbara Rose's film, *Lee Krasner: The Long View.* See also 2007-Levin, 167–68 and Grace Glueck, "The Ladies Flex Their Brushes," *NYT,* May 30, 1971, D20.
74.  "Lee Krasner," *NYT,* March 16, 1968.
75.  Max Kozloff, "Art," *The Nation,* March 25, 1968.
76.  Cindy Nemser, "Lee Krasner," *Arts Magazine,* April 1968, 57.
77.  Bill King quoted in 1993-Whipple, 226–27.
78.  Bill King quoted in 1993-Whipple, 227.
79.  Bill King to the author, 3-21-2010 and earlier in conversation.
80.  LKCR, number 434, is incorrectly dated 1966, which is impossible, as Patiky's eyewitness photographs of 1969 document.
81.  Mark Patiky to the author, 1-21-2010.
82.  1979-Novak.
83.  [John Gruen, unsigned review labeled in LK's hand], "Frank Auerbach and Lee Krasner," October 13, 1969. LKP, AAA, reel 3776, frame 1073-A.
84.  L.C., "Lee Krasner," *Art News,* October 1969, 17.
85.  Alfred Frankenstein, "Mrs. Pollock's Fine Show," *San Francisco Chronicle,* November 15, 1969.

## Chapter 17: The Feminist Decade, 1970–79 (pp. 389–426)

1.  1972-Rose-2, 154.
2.  1972-Rose-2, 154.
3.  1977-Diamonstein-1; LK used the same reference to the Surrealists' "French poodle idea" of women with 1981-Langer.
4.  See 2007-Levin.
5.  1983-Kernan, L1.
6.  1972-Rose-1.
7.  1979-Munro, 107.
8.  1972-Rose-2, 118.
9.  1972-Holmes.
10.  1973-Wallach-1.
11.  1980-Taylor.
12.  1973-Nemser, 64.
13.  1972-Glueck.
14.  1972-Glueck.
15.  1972-Glueck.
16.  See Hilton Kramer, *NYT,* September 5, 1977, AAA, reel 3776, frames 1191 and 1196.
17.  1977-Ratcliff, 82.
18.  1972-Rose-1.
19.  1978-Cavaliere.
20.  1978-Cavaliere.
21.  1972-Holmes.
22.  1978-Cavaliere.

23. The others were Corita Kent, Lois Johnson, Leila Autio, Elinor Minkus, Fay Lansner, Rachel Toner, Jean Schiff, Shirley Cleary, and Joyce Blunk.

24. 2007-Levin, 229–30.

25. Jackie MacElroy, "Art Show Transcends Sexual Propaganda," *The Dakota Student,* March 1973, 4, LK, AAA, reel 3776, frame 1078.

26. Hilton Kramer, "Lee Krasner," *NYT,* April 28, 1973, 20.

27. Barbara Rose, "The Best Game Is the End Game," *New York,* April 30, 1973, 92.

28. 1973-Wallach-1, Part II, 4.

29. 1973-Wallach-1, Part II, 4. Also, " '21 Over 60' Show Talent Is Ageless," *NYT,* July 29, 1973.

30. 1995-Friedman, 232.

31. 1973-Freed.

32. Barbara Rose, "The Jackson Pollock Story," *New York,* vol. 5, no. 38, September 18, 1972, 64. At a dinner after the Krasner symposium that I organized in April 1977, I head Rose apologize to Friedman for this harsh review. What followed in terms of Pollock biographies and Hollywood film indicates that such stereotypes and distortions could go much further than anything Friedman wrote.

33. Donald McKinney to the author, interview of 1-19-2010.

34. At the time, the Dallas Museum already owned Pollock's *Cathedral,* a 1947 canvas acquired in 1950.

35. A. T. Baker, "Out of the Shade," *Time,* November 19, 1973, 76.

36. 1973-Wallach-2, 4A.

37. Hilton Kramer, "Lee Krasner's Art—Harvest of Rhythms," *NYT,* November 22, 1973.

38. Barbara Rose, "The Best Midwestern Museum in New York?" *New York*, December 10, 1973, 102.

39. Pamela Adler, Chronology in 1973-Tucker, 38.

40. 1973-Wallach-2, 5A.

41. 1973-Tucker, 7.

42. 2008-Tucker, 104.

43. 2008-Tucker, 104–05. Tucker to the author, interview of 2005, also stressed Krasner's stinting on food.

44. Author's interview with Eugene Victor Thaw, 9-9-2010 and earlier.

45. LK quoted in letter from Donald McKinney in *Anonymous Was a Woman: A Documentation of the Women's Art Festival: A Collection of Letters to Young Women Artists* (Valencia, Calif.: Feminist Art Program, California Institute of the Arts, 1974), 95–96. Statement adapted from interview for 1975-Nemser, 95.

46. Griffin Smith, *Miami Herald,* March 17, 1974, 10-G.

47. 1974-Hutchinson, 4C.

48. Margaret Harris, "Krasner Shows Her True Colors," *Philadelphia Daily News*, April 5, 1974, LKP, AAA, roll 3776, frame 1135.

49. Laurel Daunis-Allen to the author, 1-18-2010.

50. LK as reported by Victoria Donohoe, "Krasner Emerges from the Imposing Pollock Shadow," *Philadelphia Inquirer,* April 1974, 13-K.

51. 1975-Baro, 10.

52. Paul Richard, "Corcoran Openings: Krasner, Plus Four," *Washington Post*, January 11, 1975, B1.

53. Benjamin Forgey, "Three Decades with Lee Krasner," *Washington Star-News*, LKP, AAA, reel 3776, frame 1151.

54. See Gene Baro, "Art," *New Boston Review,* Fall 1975, AAA, reel 3776, fram 1160-A.

55. 1975-Taylor, A9.

56. 1975-Taylor, A9.

57. LK to Lucille Bandes, "Women and Art," *L'Official*, Holiday Issue, 1976, AAA, reel 3776, frame 1163-A.

58. Alex Rosenberg to the author, 3-14-2010. Krasner's design was printed at Chiron Press in New York.

59. Alex Rosenberg to the author, 3-14-2010.

60. Lee Krasner, *An American Portrait, 1776–1976: 33 Contemporary Masters Join in a Trilogy Celebrating the Bicentennial.* The line is from T. S. Eliot's "Little Gidding," No. 4 of *Four Quartets*

61. Ruth Appelhof to the author, interview of 9-4-2007.

62. Dyne Benner to the author, interview of 5-1-2008. Benner now works as a food stylist.

63. They include Ann Bridgeman and Alice Culbreth of Wilton, Connecticut; Elfreda Finch from Basking Ridge, New Jersey; Marjorie Michael, Mary Lou Harrison, and Gloria Conklin of Chappaqua, New York; Martha Martin of Carrollton, Georgia; and Helen Barnes of New Canaan, Connecticut. See "Lee Krasner Top Abstractionist at Schilling Conference," *Seaside Topics*, Watch Hill, Rhode Island, July 18, 1975.

64. Marjorie M. Michael and Virginia Olsen Baron, *A Woman's Journey* (New York: Alfred A. Knopf, 1974).

65. Marjorie M. Michael, journal for July 26, 1974, noted "Watch Hill, RI Dune House, Artist conference and Lee Krasner! Remarkable woman—excellent painter." Collection of Melissa Michael Sheldon.

66. Marjorie M. Michael to Gerald Dickler, letter of July 23, 1986, collection Melissa Michael Sheldon.

67. Marjorie M. Michael, journal for September 1977, Block Island, New York.

68. Dyne Benner to the author, interview of 5-1-2008.

69. Joan Semmel to the author, interview of 3-2-2010.

70. http://www.caroleeschneemann.com/interiorscroll.html

71. 1976-Glueck. For the Rothko estate story, see Lee Seldes, *The Legacy of Mark Rothko: An Expose of the Greatest Art Scandal of Our Century* (New York: Holt, Rinehart, and Winston, 1974).

72. See Grace Glueck, "Art People," *NYT,* January 21, 1977, and the ad "In Protest," which appeared there on page D23 on Sunday, January 23, 1977. The American art world was not unanimous; among those who thought the museum should be considered separately from government policy were artists Robert Rauschenberg and Larry Rivers, as well as the dealer Leo Castelli.

73. Lee Krasner quoted in "The Tops and Flops," *Newsday,* December 26, 1976, AAA, reel 3776, frame 1170.

74. 1977-Rodgers, 3.

75. 1977-Rodgers, 8.

76. 1981-Langer.

77. 1972-Holmes.

78. Bill King to the author, 3-21-2010.

79. "Rediscovered—Women Painters," *Time,* January 10, 1977, AAA, reel 3776, frame 1171.

80. Judy Klemesrud, "Joan Mondale Speaks Out for the Arts," *NYT,* September 30, 1977, AAA, reel 3776, frame 1193.

81. 1977-Rodgers.

82. 1977-Rodgers.

83. 1977-Rose-2, 96.

84. 1977-Rose-2, 100.

85. 1977-Tallmer.

86. Betty Friedan, *The Feminine Mystique* (New York: W. W. Norton & Co., 1963).

87. 1977-Bourdon, 57.

88. 1977-Bourdon, 57.

89. 1977-Bourdon, 57.

90. See Robert Hobbs, "Lee Krasner's Skepticism and Her Emergent Postmodernism," *Woman's Art Journal,* vol. 28, no. 2, Fall/Winter 2007, 3–10.

91.   1977-Tallmer.

92.   1977-Glueck-1.

93.   1977-Tallmer.

94.   1977-Tallmer.

95.   Sol LeWitt, "Paragraphs on Conceptual Art," *Artforum,* June 1967.

96.   Deborah Kass to the author, 1-28-2010, and follow-up e-mail of 1-29-2010.

97.   Hilton Kramer, "Two New Shows—Lee Krasner and Mary Frank," *NYT,* March 6, 1977.

98.   Hilton Kramer, "Two New Shows—Lee Krasner and Mary Frank," *NYT,* March 6, 1977.

99.   William Zimmer, "Rearranged Anatomy: Petals Made with a Compass," *SoHo Weekly News,* March 3, 1977, 20.

100.  See 2007-Levin, 153, 197–98, etc., and Judy Chicago, *Through the Flower: My Struggle as a Woman Artist* (New York: Doubleday, 1975).

101.  Simone de Beauvoir, *The Second Sex* (New York: Alfred A. Knopf, 1953), 348.

102.  Jenny Tango, "Lee Krasner at Pace Gallery," *WIA newsletter,* vol. IV, no. 8, May 1977, n.p.

103.  1977-Wallach.

104.  1977-Glueck-1.

105.  Robert Hobbs to LK, letter of 9-1-1977, LKP, AAA, thanks LK for her hospitality during our visit and notes: "As mentioned before Gail will contact you in Manhattan and look at some of your earlier work." Contrary to 1999-Hobbs, 194, n. 42, which places our visit in June, it took place from August 27–29, 1977. This is confirmed by this letter and Rose's film outtakes. See also 1993-Hobbs, 96, n. 3, where he lists the visit as taking place in August 1977.

106.  "Lee Krasner: The Long View," *New York Post,* October 30, 1978.

107.  1978-Glueck.

108.  Dianna Morris, "Balanced Gestures," *Women Artists News,* vol. 7, no. 4, January/February 1982, 10.

109.  1977-Diamonstein-1.

110.  1979-Cavaliere, 41.

111.  Hilton Kramer, "Art: Elegiac Works of Lee Krasner," *NYT,* February 9, 1979.

112.  LK quoted in *The Art Newsletter,* vol. IV, no. 3, October 3, 1978, 1.

113.  Even films such as *Who the #$&% is Jackson Pollock?* and many headlines have been made about questions of purported authenticity and Pollock.

114.  Harry Rand to Lee Krasner, letter of 12-12-1978, LKP, AAA.

115.  Ellen G. Landau to the author, 8-10-2006, LKP, AAA.

116.  Ellen G. Landau to LK, letter of 12-12-1978, LKP, AAA.

117.  Harry Rand to the author, 2-22-2010.

118.  Ellen G. Landau to LK, letter of 2-16-1979, LKP, AAA, roll 3773, frame 396.

119.  Harry Rand to the author, 2-22-2010.

120.  Ms. labeled "FINAL COPY SENT to Foundation for Printing in catalogue, 1/19/79," LKP, AAA, roll 3773, frame 171.This catalogue was never printed; the Foundation, which does not specialize in contemporary art, subsequently sold this painting.

121.  Ms. labeled "FINAL COPY SENT to Foundation for Printing in catalogue, 1/19/79," LKP, AAA, roll 3773, frame 171.

122.  1979-Cavaliere, 41.

123.  1979-Cavaliere, 41.

124.  Hilton Kramer, "Art: Elegiac Works of Lee Krasner," *NYT,* February 9, 1979.

125.  Eleanor Munro, "Krasner in the Sixties Free for the Big Gesture," *Art World,* February 16, 1979, AAA, reel 3771, frame 143.

126.  Barbara Cavaliere, "Lee Krasner," *Arts Magazine,* vol. 53, no. 8, April 1979, 24.

127.  Daniel Wildenstein to Lee Krasner, letter of 11-29-1979, LKP, AAA, roll 3773, frame 394.

128.  Lee Ann Miller to Lee Krasner, letter of 11-28-1979, AAA, reel 3773, frame 373.

129.  Archives of the author. I read: "I first met Lee Krasner in 1970 when interviewing her about Jackson Pollock. As I came to know and appreciate her work, I was able to include her in the

exhibition, Abstract Expressionism: The Formative Years held at the Whitney Museum in 1978. It is a pleasure for me to read to you her acceptance of this award." In fact I was in error, since a letter from Marlborough Gallery to Lee Krasner that survives in her archives dates my first interview to January 1971, LKP, AAA.

130. Wendy Slatkin, *The Voices of Women Artists* (Englewood Cliffs, N.J.: Prentice Hall, 1993), 240.
131. 1978-Cavaliere.
132. 1979-Cavaliere, 41.
133. 1979-Novak.
134. 1979-Munro, 107.
135. 1980-Portfolio, 68–69.
136. 1980-Portfolio, 68–69.
137. Letter is in the archives at MoMA.
138. On October 13, 1979, I spoke on "Richard Pousette-Dart's Painting and Sculpture: Form, Poetry, and Significance" at the conference in Charlottesville.
139. Ellen G. Landau, *Lee Krasner: A Study of Her Early Career (1926–1949),* University of Delaware, June 1981.
140. Ellen Landau to the author, interview of 8-10-06.
141. Krasner quoted in Ruth Latter, "Passionate Art Can Unleash Intense Emotion," *The Daily Progress*, Charlottesville, Virginia, F2.
142. Ellen Landau to William Rubin, letter of 10-15-1979, MoMA archives.
143. Helene Aylon to the author, 10-22-2007.
144. Helene Aylon to the author, 10-22-2007.
145. Helene Aylon to the author, 10-22-2007.

## Chapter 18: Retrospective, 1980–84 (pp. 427–452)

1. Stony Brook Foundation Award for Distinguished Contributions to Higher Education, March 27, 1980.
2. William S. Rubin to Harry Rand, letter of 1-11-1980, MoMA archives.
3. Harry Rand to William S. Rubin, letter of 5-20-1980, MoMA archives.
4. William S. Rubin to Harry Rand, letter of 5-28-1980, MoMA archives.
5. 1980-Bennett.
6. 1980-Braff, 8.
7. 1980-Bennett.
8. Archives of the Museum of Modern Art, Cur Exh # 1385.
9. Barbara Rose to the author, 3-15-2010.
10. Ellen Landau to Lee Krasner, letter 4-3-78, LKP, AAA, reel 3772, frame 1358.
11. LK to Gail Levin, letter of 3-15-1981, and Ellen Landau to LK, letter of 2-19-1981, LKP, AAA, roll 3773, frames 719–721 and 742 (LK to me) and 734 (LK to Barbara Rose).
12. Ellen Landau to LK, letter of 2-19-1981, LKP, AAA.
13. Eugene V. Thaw to the author, 4-1-2010.
14. Barbara Rose to the author, 3-15-2010. Landau soon turned her attention to Pollock, on whom she has written extensively, and eventually declared some recently discovered paintings to be authentic works by Pollock, while many leading experts on Pollock disagreed. Subsequent tests at Harvard's Straus Center for Conservation and Technical Studies showed that some of the paint used on the works in question was manufactured long after Pollock's death. See David Usborne, "Experts Pour Scorn on Pollock Finds after Tests," *The Independent*, February 1, 2007. http://www.independent.co.uk/news/world/americas/experts-pour-scorn-on-pollock-finds-after-tests-434567.html.
15. Lee Krasner to Prof. William I. Homer, letter of 3-19-1981, LKP, AAA, roll 3773, frame 749.
16. 1981-Cavaliere, 34.

17. 1981-Cavaliere, 34.

18. John Russell, "Lee Krasner," *NYT,* March 27, 1981, C17.

19. 1981-Tallmer, 17. The following quotations are from this source. Krasner marked the page number by hand and saved this article in her papers, AAA, LKP, roll 3776, frame 1330.

20. John Post Lee to Gail Levin, interview of 5-23-2007. Today John Post Lee is an art dealer in New York City. He got his start through LK's recommending him to Robert Miller, who introduced him to Tibor de Nagy, where he first worked.

21. See Grace Glueck, "Art World Figures Defend Director of the Whitney," *NYT,* February 3, 1990; Kay Larson, "Whose Museum Is It, Anyway? *New York Magazine,* February 12, 1990, 30–37.

22. John Post Lee to the author, interview of 5-23-2007.

23. John Post Lee to the author, interview of 5-23-2007.

24. 1981-Delatiner.

25. 1981-Delatiner.

26. William Pellicone, "Bombshell of a Sleeper," *Artspeak,* AAA, reel 3776, frame 1001, noted that this review was written in early August and was printed in several Suffolk County newspapers.

27. 1981-Delatiner.

28. 1981-Delatiner.

29. 1981-Delatiner.

30. 1981-Wallach, 34.

31. 1981-Rose.

32. 1981-Rose.

33. John Post Lee to the author, interview of 5-23-2007.

34. John Post Lee to the author, interview of 5-23-2007.

35. John Post Lee to the author, interview of 5-23-2007.

36. John Post Lee to the author, says he gave his only copy of his thesis to Robert Hobbs, who, despite my request, was unable to find it.

37. Edward Albee to the author, interview of 12-19-2006.

38. 1981-Glueck-1.

39. 1981-Glueck-1.

40. 1981-Delatiner.

41. Tim Hilton, "Filling the Gaps," *Observer* (London), March 14, 1982, 33, inscribed clipping is LKP, AAA, roll 3776, frame 1383.

42. 2006-Miller, n.p.

43. Nathan Kernan to the author and his draft of his unpublished ms., 1994–2010.

44. Grace Glueck, "Lee Krasner: The Late 50's," *NYT,* October 29, 1982, C19.

45. 1983-Rose, 160, note 6.

46. The author once attended a holiday dinner at Edward Albee's home in Montauk, attended by Krasner, the author as her houseguest, Moss, Albee's mother, and Joanna Steichen.

47. Ann Chwatsky to the author, interview of 8-7-2007.

48. Ronald Stein quoted in 1985-Potter, 222.

49. Darby Cardonsky to the author, 9-25-2010.

50. "The Artists Lee Krasner and John Little," *East Hampton Star,* August 19, 1982, LKP, AAA, reel 3777, frame 8, photograph by Rameshwar Das.

51. Steven W. Naifeh to LK, letter of 6-1-1983, LKP, AAA, reel 3773, frame 1377.

52. Author's interviews with Deborah Solomon, 2009 and 2010. See 1987-Solomon.

53. Eugene V. Thaw to the author, 4-1-2010.

54. 1985-Potter, 276.

55. Terence Netter to the author, 1-16-2009.

56. 1983-Kernan, L1.

57. 1983-Kernan.

58.   Lee Krasner quoted in Patricia C. Johnson, *Houston Chronicle*, November 3, 1983, section 4, 1.

59.   LKCR no. 599, possibly covering a painting from 1950.

60.   Israel Shenker, "A Pollock Sold for $2 Million, Record for American Painting," *NYT*, September 22, 1973, 25.

61.   Lee Krasner quoted in Patricia C. Johnson, *Houston Chronicle*, November 3, 1983, section 4, 1.

62.   Robert Hughes, "Bursting Out of the Shadows," *Time*, November 14, 1983, 92.

63.   1983-Hughes, 92.

64.   Judy Chicago to the author in conversation; many times during 2007.

65.   1983-Hughes, 92.

66.   Susie Kalil, "Lee Krasner: A Life's Work," *Artweek*, December 10, 1983, 1.

67.   William Wilson, "Woman behind Jackson Pollock Steps up Front," *Los Angeles Times*, AAA, reel 3776, frame 1000-A. For examples of Wilson's writing about feminist art, see also 2007-Levin, 140–41, 207, 248, 299.

68.   Thomas Albright, "Krasner: Energy Rather Than Power," *Review*, February 26, 1984, 12–13. Albright would die of lung cancer at the age of forty-eight later that same year.

69.   Thomas Albright, "Krasner: Energy Rather Than Power," *Review*, February 26, 1984, 12–13.

70.   Ed Hill and Suzanne Bloom, "Lee Krasner," *Artforum*, vol. 22, May 1984, 93.

71.   1984-Vetrocq, 143. She referred to Krasner's omission in 1970-Sandler and Henry Geldzahler, *New York Painting and Sculpture: 1940–1970* (New York: E. P. Dutton & Co., 1969).

72.   Irving Sandler in conversation with the author, 2007, claimed that he had made a mistake to leave Krasner out of his first book on the movement, but he did not say this in his book 2009-Sandler, 229, note 87. See above, chapter 11. Subsequent conversations with Sandler elicited only comments about the attitudes of the period.

73.   1984-Vetrocq, 143.

74.   1984-Cannell, 88.

75.   1984-Kernan, B9.

76.   Jason McCoy and Barbara Rose, separately, to the author, 2010.

77.   Draft of Lee Krasner letter to Henry Hopkins, 12-13-1983, LKP, AAA, roll 3774, frame 115.

78.   Edward Albee to the author, 12-19-2006.

79.   Bernard Gotfryd, *The Intimate Eye: Portraits* (New York: Riverside Book Co., 2006), 101, and Bernard Gotfryd to the author, 9-25-2010.

80.   Mark Stevens, "The American Masters," *Newsweek*, January 2, 1984, 67–68.

81.   Amei Wallach, "The Fierce Legacy of Lee Krasner," *Newsday*, June 24, 1984, Part II/17.

82.   Gretchen Johnson to LK, letter of March 1984, LKP, AAA, roll 3774, frame 167. Diana Burroughs (then married to LK's nephew Jason McCoy, to the author, 1-21-2010.

83.   1984-Kernan, B9.

84.   Eugene V. Thaw interviewed by the author, Tesuque, New Mexico, May 11, 2007. Thaw, born Jewish, converted to Episcopalianism at the age of fifteen while attending St. John's of Annapolis.

85.   1985-Potter, 279.

86.   Michael Brenson, "Lee Krasner Pollock Is Dead; Painter of the New York School," *NYT*, June 21, 1984, 25.

87.   Ted Dragon to Helen Harrison, interview taped while touring the Pollock-Krasner house in 2000. In fact, at Ronald Stein's death, he left the house that his aunt had given him to Cooper Union, which sold it, instead of to the PKHSC.

88.   1984-Woodard, 28.

89.   1984-Woodard, 28.

90.   1984-Memorial.

91.   1984-Memorial.

92.   1984-Memorial.

## A Note About Sources

1. Conrad, born Earl Cohen in 1912, was by then the author of books about the prison experience of Haywood Patterson, one of the Scottsboro Boys; a biography of the abolitionist Harriet Tubman; a book called *Jim Crow America*, and other books.

2. Oscar Collier to Lee Krasner, letter of 3-28-1967, on letterhead of Fleet Publishing Corporation, LKP, AAA, roll 3771, frame 1139.

3. 1995-Friedman, xi–xiii.

4. To cite just a few examples of errors of fact, 1996-Wagner, 107, wrote that Krasner "was born Lenore Krassner.... she occasionally adopted ... the romantic 'Lena.' " Yet the opposite is the case; Lee Krasner's given name was Lena and she adopted Lenore is high school. In a family photograph taken in Shpikov (not located "just north of Odessa," as is so often stated) before the family came to America, 1989-Naifeh, 368, finds "Lena on her father's knee," when in fact, she was not yet born. LKCR, 301, reports "Krasner was skeptical about Ruth's marrying William Stein [their sister's widower] because of her age (fourteen), when in fact she was eighteen in 1929 and, 311, an incorrect date for when she began seeing a therapist. 1996-Wagner, 138, gives 1942 as the date Krasner and Pollock met, which is 1941, except for their earlier meeting at a party in the 1930s; she gives the date of their marriage as 1944, when it is 1945.

5. 1989-Naifeh, 371.

6. 1995-Gabor, 69.

7. Frances Patiky Stein to the author, 1-17-2007. Diana Burroughs, who was married to Pollock's nephew, Jason McCoy, also recalled that Ruth and Lee did not get along (interview with the author, 1-21-2010). Ruth lied about her age and the date of her marriage. Her view of Krasner family dynamics was not shared by others whom I interviewed.

8. 1996-Wagner, 134

9. 1996-Wagner, 134

10. 1989-Naifeh, 857.

11. B. H. Friedman to the author, 4-13-2007 and 4-1-2010. The couple in Friedman's novel, set in the 1960s, are Jeff MacMaster, a leading photojournalist and his wife, Edys Askin, who was not an artist.

12. 1989-Naifeh, 393, taken from B. H. Friedman, *Almost a Life* (New York: The Viking Press, 1975), 162.

13. 1989-Naifeh, 395 and 857, source note; 1975-Friedman, 162.

14. 1989-Naifeh, 708. 1995-Gabor, 44.

15. 1989-Naifeh, 708, and repeated by 2004-Stevens, 335. The sources for this account, as acknowledged by Naifeh and Smith, were LK herself and Fritz Bultman, both of whom were dead before their book was published. See also Patti Doten, "A Lurid Picture of Jackson Pollock," *Boston Globe,* February 22, 1990, 73, 78.

16. 1995-Gabor, 44. Among others, Gabor interviewed LK and Jeanne Bultman.

17. Author's interviews with Jeanne Bultman, 4-23-2007 and 7-28-2007.

18. Lee Krasner to the author, 8-29-1977, outtake for Barbara Rose film. See also 1979-Munro, 108.

19. 2004-Stevens, 129–130. Their endnote cites Bultman's interview of January with Irving Sandler, 1-6-1968, AAA.

20. 1968-Bultman.

21. 1968-McNeil.

22. 1970-Sandler, omitted Krasner except in his acknowledgments as "Lee Krasner Pollock" in a list of persons interviewed and in the credits—as the owner of some art works by Pollock that are reproduced.

23. These books by Sandler include *The New York School: The Painters and Sculptors of the Fifties* (New York: Harper & Row, 1979) and *American Art of the 1960's* (New York: HarperCollins, 1989).

24. 2009-Sandler, 229, note 86.

25. 2009-Sandler, 229.
26. 1990-Anfam, 15.
27. 1990-Anfam, 122.
28. 1997-Gibson, ix.
29. 2008-Küster, 72.
30. Ulf Küster to the author, spring 2008.

# INDEX

Note: Page numbers in *italics* refer to illustrations.